VISUAL ART, MATHEMATICS AND COMPUTERS:

Selections from the Journal LEONARDO

VISUAL ART, MATHEMATICS AND COMPUTERS:

Selections from the Journal LEONARDO

Edited by

FRANK J. MALINA

PERGAMON PRESS

Oxford · New York · Toronto · Sydney · Paris · Frankfurt

U.K. Pergamon Press Ltd., Headington Hill Hall,
 Oxford OX3 0BW, England

U.S.A. Pergamon Press Inc., Maxwell House, Fairview Park,
 Elmsford, New York 10523, U.S.A.

CANADA Pergamon of Canada, Suite 104, 150 Consumers Road,
 Willowdale, Ontario, M2J 1P9, Canada

AUSTRALIA Pergamon Press (Aust.) Pty. Ltd., Box 544, Potts Point,
 N.S.W. 2011, Australia

FRANCE Pergamon Press SARL, 24 rue des Ecoles,
 75240 Paris, Cedex 05, France

FEDERAL REPUBLIC Pergamon Press GmbH, 6242 Kronberg-Taunus,
OF GERMANY Pferdstrasse 1, Federal Republic of Germany

This edition, first published in 1979, contains fifty-three papers published for the first time in collected form. The editor and publisher are indebted to the authors for permission to reproduce their articles.

This volume also contains an Introduction prepared by Anthony Hill especially for this edition and Frank J. Malina has compiled the Glossary.

British Library Cataloguing in Publication Data

Visual art, mathematics and computers.
1. Computer Art – Addresses, essays, lectures
2. Art – Mathematics – Addresses, essays
lectures
I. Malina, Frank J II. 'Leonardo'
702′ .8′54044 N7433.8 77–30656

ISBN
ISBN 0 08 0218547

Printed in Great Britain by A. Brown & Sons Ltd, Hull, England.

CONTENTS

Part IV. Pictorial and Three-Dimensional Art Works – Applications of Digital Computers

PREFACE

The first collection of original articles selected from *Leonardo,* International Journal of Contemporary Visual Artists, appeared in book form in 1974. Bearing the title *Kinetic Art: Theory and Practice,* it was manufactured by Dover Publications, Inc., New York. The number of copies of the book sold has encouraged my wife and me to prepare this, the second, collection of articles published in the Journal during the past ten years.

In one way or another, mathematics underlies the ideas and artworks discussed—only elementary echoes are evident in some, but there are sophisticated applications of the 'queen of the sciences' in others. To understand the nonfigurative or abstract artworks presented requires, in general, a comprehension of messages of a kind different from those that artists have traditionally used. It would be foolhardy to predict at present that such understanding will cause many art lovers to obtain aesthetic satisfaction from them.

What does seem certain is that theorizing about the visual arts will be transformed by procedures involving, in particular, cybernetic conceptions and that prodigious machine called a digital computer.

Those familiar with *Leonardo* realize that the Journal is dedicated to providing reliable information and not light verbal entertainment. The implications of the efforts of the 54 authors from 9 countries on the future development of the visual arts need to be taken into account by those who dream of a world in which the arts will help more effectively to mellow the applications of science and mathematics.

The present book would not have come into being without the imaginative support of Robert Maxwell and Gilbert F. Richards at Pergamon Press Ltd., for which I thank them. I also wish to express my appreciation to George A. Agoston, Assistant Editor of *Leonardo,* who has given unstinting help in the preparation of manuscripts for publication in the Journal.

Boulogne sur Seine, France
June 1977

FRANK J. MALINA
Founder-Editor of *Leonardo*

INTRODUCTION

It is helpful to review some definitions of mathematics in order to help elucidate 'mathematical visual art'. I have provided some that happen to appeal to me in my article on page 148 of this book. The definition of visual art by mathematicians is also of interest and one taken from the first issue of *Leonardo* is given in Ref. 1. I shall touch only in passing upon the subject called Foundations of Mathematics, contributions to which have been made by various groups of mathematicians, among them the formalists (David Hilbert et al.), the logicists (Bertrand Russell et al.) and the intuitionists (L. E. J. Brouwer et al.). I am sympathetic to the approach of the intuitionists because it involves constructivist mathematics, which however should not be confused with Constructivism in art, a domain of particular interest to me [2]. Before Brouwer's death, I was fortunate to have had several discussions with him [3], but I shall quote a statement by the mathematician Walter R. Fuchs that echoes the intuitionist's outlook: 'Mathematics is primarily a means of pure perception. This makes it more closely related to theoretical philosophy than to science. Most pure mathematicians do not care for the useful application of their discipline' [4].

Recently I encountered a proposed syllabus leading to a Bachelor of Arts degree in visual art and mathematics that was prepared by Leo Rogers of Digby Stewart College, London. Rogers' project drew my attention to the fact that contemporary artists could be divided into two categories: those for whom the utilization of mathematics in art is anathema and those for whom it plays a fundamental role. The work of mathematically oriented visual art is not easy to define, for it covers works that are related to different branches of mathematics and that are executed in a wide variety of styles.

Few mathematicians write anything except papers for mathematical journals. However, there are exceptions. Raymond Queneau is better known to the general public as a writer of fiction and Charles L. Dodgson is best known as the author of the Alice stories that he wrote under the pseudonym Lewis Carroll. Henri Poincaré gained additional fame as a popularizer of the work of mathematicians and physicists, mysterious activities for most people. Perhaps Cardano (1501-76) was the first mathematician to write an autobiography, and there have not been many since (there are only a few by artists, although the painter and sculptor Cellini, a contemporary of Cardano, is the author of a very well-known one).

In our own time, Norbert Wiener wrote a two-volume autobiography and more recently Stanislas Ulam [5] has published a book that is basically autobiographical, which I recommend to artists, because the final chapter entitled Random Reflexions on Mathematics and Science is exceptional for its clear presentation to the layman of the way a mathematician works. Ulam quotes Poincaré as saying: 'Mathematics is a language in which one cannot express imprecise or nebulous thoughts.' How many proposed mathematical theorems have been found subsequently to be false? Very few. Descartes' mathematics was of the highest order, but when he wrote on physiology, his proposals could not withstand the tests of truth. The same could be said of much of Newton's work outside of physics and of mathematics.

Concerning a broader approach to art and mathematics, I have found no piece of writing in our century that is comparable to a chapter in Oswald Spengler's two-volume *Decline of the West* [6]. Entitled The Meaning of Numbers, it appears in the first volume that is subtitled Form and Actuality. It is a historical review of nearly 40 pages on the relationships between the arts and mathematics. Spengler is now largely ignored. However, L. von Bertelanffy in the 1920's took account of Spengler's ideas [7] and in his book *General System Theory* (1968) [8] makes references to the chapter in Spengler's first volume.

Since the Renaissance, when the geometry of perspective was a lively subject among painters,

there has been little contact between art and mathematics. The communications engineer John R. Pierce (U.S.A.) has said: 'It would seem odd if mathematics had nothing to contribute to the arts, yet I think that its contribution has been small' [9]. In the 1930's an outstanding mathematician, G. D. Birkhoff (U.S.A.), startled scholars of art with his mathematical aesthetic analysis of visual art in a book entitled *Aesthetic Measure* [10].

As with Spengler and the 'Golden Section' dogmatists of recent times, Birkhoff's approach was not looked upon with much favour by those predisposed to the development of a science of aesthetics. Nevertheless, more than an echo of Birkhoff's work is found in the ideas proposed by, for example, N. Rashevsky, H. J. Eysenk, A. Moles, M. Bense, H. W. Franke and F. Nake. These have made, primarily, theoretical studies of information transmission and cybernetics to aesthetics.

But in pictorial art account must be taken of the period from Cubism to the present day, during which time the geometrical type of non-figurative or abstract art has steadily proliferated and during which also other kinds of mathematics have influenced the works of artists. This 60 years can be divided roughly into two periods, from Cubism to Constructivism and from Constructivism to computer art.

It is interesting to note that during the period of Impressionism, Seurat, for example, extended the concern with light and colour to a more 'calculated' approach to composition. In particular, there was a revival of interest in the Golden Section, often taken as the hallmark of Classicism, which is no guarantee of a successful work; many artists regard it as a manifestation of sterile Academicism. Nevertheless, some cubists were attracted to the Golden Section and exhibited their paintings in the Salon de la Section d'Or that was held in Paris in 1912, 1920 and 1925. For Juan Gris it was the key to his carefully made paintings, but he did not disclose the fact, as did not the composer Béla Bartók, who, according to Ernö Lendvai, was a secret 'sectionist' [11].

Cubism was a highly abstract kind of figurative painting. A possible direction of development was to remove all traces of familiar figurative subject matter by making contact with other manifestations of the visible world. The futurists made depictions of objects in motion, whereas some of the cubists introduced a geometric treatment of forms that provided a simultaneous depiction of two or more views of the same object as seen from different directions. One might say that realistic visual perception was giving way to cognition, that is, to knowledge of the appearance of an object that could not be obtained from a single viewpoint. It may also be interpreted as an identification with the then new theory of relativity in physics, which states that, although an event was to be regarded as absolute, interpretation of the event depends upon the location in time and space of its observer. While some non-figurative or abstract art developed from Cubism, which is partially true for the paintings of Piet Mondrian, it is not clear whether one can say the same for the works of Wasilly Kandinsky and Frank Kupka. Numerous authors in books and articles have attempted to chart the development of non-figurative art since its origins in about 1910, for example the aesthetician Harold Osborne recently published a useful study of this development [12]. As regards the Constructivism branch of the development, Hans Arp and El Lissitzky had this to say in 1925: 'These artists look at the world through the prism of technic. They don't want to give an illusion by the means of contours on canvas, but work directly in iron, wood, glass, etc. The shortsighted see therein only the machine. Constructivism proves that the limits between mathematics and art, between a work of art and a technical invention are not to be fixed' [13].

In 1966, Marshall McLuhan, looking back at that period, made an assessment that was rather grandiose, to say the least: 'The achievement of Constructivism was the abandonment of pictorial illusion in favour of a multi-faceted and multi-dimensional art and can be seen as the rediscovery, after centuries of visual space and three-dimensional pictorial space, of the whole human sensorium' [14]. In the same article he asserts: 'The conscious role of the artist is to explore and create awareness of the new environment created by new technology.' I do not think that very many artists will agree with him. At the 1977 exhibition of Marcel Duchamp's works at the Contemporary Galleries of the Georges Pompidou Centre in Paris, this artist's mathematical interests were well described. The dimensions of his piece 'Large Glass' were shown to be based on the Golden Section, and models and a film were presented to indicate his interest in traditional projective geometry and in the relativistic space-time continuum. However, Duchamp made very few, if any, works that can be called constructivist in the sense of the description by Arp and Lissitzky. The sculptors Antoine Pevsner and Naum Gabo, on the other hand, used mathematical demonstration models as points of departure for some of their works [14]. These models of aspects of differential geometry illustrate properties of surfaces of compound curvature with the aid of ruled lines drawn on the surfaces.

George Rickey in his book *Constructivism* [15] has a chapter entitled Mathematics and Concrete Art, which is illustrated with examples of the works of Georges Vantongerloo, Max Bill, Richard Lohse and Karl Gerstner. These artists seem qualified to state the case for mathematically based art. In the 1960's the journal *Structure* [16] devoted an issue to art and mathematics, which is a good source on the matter. Rickey draws attention to the following statement by Bill in the issue: 'I am of the opinion that it is possible to develop an art which is fundamentally based on a mathematical approach.... The primordial element of all visual art is geometry, the correlation of the divisions on a plane surface or in space.... The mathematical approach in contemporary art is not mathematics in itself and hardly makes any use of what is known as exact mathematics. It is primarily a use of processes of logical thought towards the plastic of rhythms and relationships....' This opinion of Bill is reflected in his series of sculptures first made in the 1930's based on the Möbius strip of topology, which was first described by Möbius in 1858.

The principal artists in the De Stijl group were Mondrian, Theo Van Doesberg, who was the Group's principal theoretician, and Vantongerloo. At one time each of these artists was attracted to some 'mathematical' way of organizing the elements in their works. Vantongerloo had already taken an interest in mathematics and art before he joined the Group. His text *'L'Art et son avenir'* of 1924 [17] and his book of 1948 entitled *Painting, Sculpture, Reflections* [18] show that Vantongerloo's approach was neither mystical nor traditional; I would call it idiosyncratic.

At the 9th Milan Triennial (1951) an International Congress was convened on the subject Proportion in Art: The Divine Proportion. The proceedings of this congress were not published, but Le Corbusier in his book *Modulor 2* [19] gives a list of the papers read and of the names of the participants. Amongst the participants, the only artists were Bill, Severini and Vantongerloo. The latter gave me a copy of the French typescript of his talk, which after his death in 1965 was published in *Leonardo* [20]. In his paper, after a brief account of the Golden Section (which I do not believe interested him very much), he discusses certain of his works that are not mathematics oriented, since in the 1950's he was particularly interested in the effects of motion on the perception of colour and form.

Can one look forward to a synthesis of art and mathematics? Prior to the emergence in the 20th century of certain developments in science and technology, in particular mass communications systems, cybernetics and electronic digital computers, such a synthesis may have been limited to an amplification of what a few artists had done in the past. But this would not have amounted to a synthesis as normally understood. Will these new developments bring about a synthesis of art and mathematics?

Digital computers offer many possibilities for the production of both figurative and non-figurative 2- and 3-dimensional visual art. Computer development goes back to Pascal in the 17th century, but even the pioneer work of Charles Babbage at the turn of this century gave no hint of the impact that present-day computers would have on the natural sciences, engineering, business administration, etc., or of the possibility that serious studies would be made of developing 'artificial intelligence' to assist or compete with the human brain, first posed by A. M. Turing in 1950 [21].

Some artists welcome the computer not only as a means for quantity production of objects of art but as an aid to creativity. However, at this stage, it seems to me that many are fascinated more by computer technology than by mathematically oriented visual art, exceptions will be found in this book. One of the unexpected consequences of computer and related science is the attack on speculative psychological aesthetics, including art criticism. Aesthetics is seen in a different light when viewed from the points of view of cybernetics, information theory and computer programming, which involve the application of numerous branches of mathematics. It remains to be seen whether artists, in general, will take a more serious interest in 'cybernetic' aesthetics than they did in the 'theories' of aesthetics of the past and, thereby, arrive at a synthesis of art and mathematics.

REFERENCES AND NOTES

1. The science writer, mathematician Francois Le Lionnais (France) defined the visual or plastic fine arts as 'a group of activities that aims at producing—through the use of appropriate techniques and procedures—emotions of an aesthetic character (that is, emotions independent of the quest for truth, of the search for utility and of obtaining sentimental satisfaction) by means of visual stimulation' [*Leonardo* **1**, 86 (1968)].
2. A. Hill, review of M. Holt's book *Mathematics and Art, Leonardo* **4**, 395 (1971).
3. L. E. J. Brouwer, Consciousness, Philosophy and Mathematics, in *DATA: Directions in Art, Theory and Aesthetics*, A. Hill, ed. (London: Faber & Faber, 1968). This paper, about half its original length, including minor changes and was reprinted with Brouwer's permission.

4. W. R. Fuchs, *Modern Mathematics*, Modern Mathematics Series (London: Weidenfield & Nicholson, 1967) Fuchs refers to Brouwer's work on Foundations of Mathematics as one of the 'most important scientific achievements of our century'. This is in the English translation from the German original, and I suspect that the term 'scientific' should read 'mathematical'. Brouwer also made important contributions to topology and to the application of mathematics in photogrametry.

5. S. Ulam, *Adventures of a Mathematician* (New York: Charles Scribners Sons, 1976).

6. O. Spengler, *Decline of the West*, Vol. 1 (1922). English Trans. (New York: Knopf, 1926).

7. L. von Bertelanffy, *Modern Theories of Development* (New York: Harper, Torch Books, 1962).

8. L. von Bertelanffy, *General Systems Theory: Foundations, Developments, Application* (London: Allen Lane, Penguin Press, 1971).

9. J. R. Pierce, Science for Art's Sake, *Astounding Science Fiction* (1950).

10. G. D. Birkhoff, *Aesthetic Measure* (Oxford: Oxford Univ. Press, 1933).

11. E. Lendvai, Duality and Synthesis in the Music of Bela Bartok, in *Module, Proportion, Symmetry, Rhythm*, G. Kepes, ed. (New York: Braziller, 1966).

12. H. Osbourne, Non-Iconic Abstraction. *Brit. J. Aesth.* **16**, 291 (Autumn 1976).

13. H. Arp and E. Lissitzky, *Die Kunstismen* (Munich: E. Rentsch, 1925).

14. An Interview with Marshall McLuhan, *The Structurist (special issue on art and technology)*, p. 61 (No. 6, 1966).

15. G. Rickey. *Constroctivism: Origins and Evolution* (London: Studio Vista, 1967).

16. *Structure*, 3rd series (No. 2, 1961).

17. G. Vantongerloo, L'Art et son avenir (Antwerp: De Sykkel, 1924).

18. G. Vantongerloo, *Paintings, Sculptures, Reflections: Problems of Contemporary Art 5* (New York: Wittenborn Schultz, 1948).

19. Le Corbusier, *Modulor 2* (London: Faber & Faber, 1958).

20. G. Vantongerloo, Symetrie et proportion, *Leonardo* **1**, 313 (1968).

21. A. M. Turing, Computing Machinery and Intelligence, *Mind* **59**, 433 (Oct.1950). 'I do not believe that the question "Can machines think?" is amenable to a reasoned discussion at present. Nevertheless, by the end of the century one might be able, without being contradicted, to speak of thinking machines.'

London, May 1977 ANTHONY HILL

PART I

ART, SCIENCE AND MATHEMATICS

General

SOME REMARKS ON VISUAL FINE ART IN THE AGE OF ADVANCED TECHNOLOGY*

Herbert W. Franke**

I.

The visual or plastic fine arts hold a relatively high place in Western culture. Considerable public and private funds are devoted to the making and sale of art works and to education for art appreciation. Yet, paradoxically, there is no general agreement as to what art is or what it is good for. This is causing an ever increasing uneasiness among artists and especially among art students. The incompatibility between values and instruction in traditional art education and the worlds of science and of technology is clearly evident [1]. Some of the essential factors that have led to this situation in art are the following:

1. New materials and techniques from science, industry and commerce are now available for artists to use. The best-known examples are cinema and television, pictorial techniques of social significance that are only slowly being used by artists. Only very few have come to realize that these media are suited not only for the transmission of information and of spectacles by performing artists but also for the contemplative fine arts. In addition, complicated equipment designed for technical and scientific applications is being introduced for the making of art, e.g. by the manipulation of electric light, by the polarization of light and by the use of lasers.

The use of digital and analog computers for artistic purposes is also beginning to influence the adoption of new methods and ways of thinking about art. With the help of program-controlled output devices, black and white and colored, static and kinetic images on display devices can be produced [2–4]. The use of computers is important because computers do not demand manual skill for making art objects but the application of aesthetic judgements or artistic innovation to technical problems of visual display methods of computer output. This is truly a revolutionary development in the history of the visual or plastic fine arts, to which but few artists and teachers of art have as yet responded.

2. The principles of classical art criticism no longer apply generally. It is now necessary to consider art within the context of new developments. The traditional idea of beauty is of limited validity as a standard of quality. It has been replaced by contradictory interpretations of the purposes of art. A rather large number of those concerned with art look upon it as a weapon to fight modern technology or as a domain of unbounded freedom in a world of constraining law and order. It is obvious that values based on such notions cannot accommodate new fruitful possibilities offered by advanced technology. In view of the new production and reproduction processes now available, the value of uniqueness of a handmade or 'original' art object is put in doubt. This is true even though in the Western world of art original art objects are considered among safer forms of investment and grotesque sums of money are paid for them by the wealthy.

The antitechnology, antiscience stance taken by so many art writers and teachers cannot, I believe, in the long run, prevent artists and designers from parting with tradition in order to take advantage of the new possibilities. It can, however, impede this development, for example by withholding recognition of it, by not including it in curricula of art education and by opposing sponsorship, promotion and exhibition of works arising from it.

3. A science of aesthetics is making itself evident, which contradicts some important traditionally accepted concepts of art. As in the natural sciences, the science of aesthetics allows only statements that can be analysed logically and then be verified to determine if they meet the truth of facts. Only in this way can one escape from the

* Based on a text published in the catalogue for the Summer Conference 'The Computer in the University' organized at Berlin by the Massachusetts Institute of Technology and the Technical University of Berlin, 1968, pp. 108–111.

** Physicist and artist living at D-8195 Puppling 40, Pupplinger Au., near Munich, Fed. Rep. Ger. (Received 6 August 1973.)

morass of verbal rhetoric of so much of today's hypothesizing on art.

Art students realize that they cannot accept much of what tradition-oriented instructors tell them, therefore, in principle, they are open-minded to new developments. But art students today rarely have the necessary background in scientific and technological fundamentals to understand what the new developments have to offer. The works of artists having such an inadequate background and understanding reveal embarrassing misjudgments. Often these artists expect to find formulas leading to the construction of objects that will bring them quick praise and recognition. At the other extreme, those sensing the inadequacy of their teaching and knowledge often retreat, reacting with a despair that leads them to hope for better results from mystification and magic.

II.

The discussion of the above three factors leads to a cardinal question: In a world where rational modes of thought have been provided and technology is taking over many former human activities, does art have a vital role to play? And, if so, what is it? The answer should have general validity and not represent merely personal opinions. I find that the answer is given by cybernetic art theory, which states that art as a human manifestation is a special case of communicative behaviour.

This is not the place for explaining the details of cybernetic art theory. One can, however, consider some of the conclusions of the theory to appreciate the rigor of analysis involved and the possibility of their being verifiable by anyone willing to expend the necessary effort.

If art is only one form of desirable communication between human beings, then a number of consequences are deducible. The conditions of optimum aesthetic communication can be obtained from a determination of the receptivity of viewers of works of art. Art then is a part of a process of regulation (in a cybernetic sense) in which an artist seeks to achieve the maximum of receptivity. From this it follows that an artist who is not interested in the reactions of the public is not likely to produce works that are effective in the sense of an aesthetic communication. Another conclusion is that an art that does not take into consideration the part technology is playing in human daily life is rendering itself ineffectual. Thus, there is no sense in rejecting the use of the means of advanced technology and

the conclusions of cybernetic art theory, because both have rational origins.

There are two essential processes associated with an art object: its making and its reception (viewing). In making it, an artist establishes a kind of order. In the case where he introduces innovation of presentation, a viewer of it is confronted with problems of decoding and recognition, which requires the application of explorative skills. Thus, in answer to the question posed above, I submit that the function of art is to stimulate the development of human explorative capabilities. In this connexion, it has been suggested, for example, that there is greater educational value in improvisation and extemporaneous expression than in old-fashioned training in manual or copying skills.

Furthermore, it appears beneficial to offer to viewers continually new artistic stimuli of possibly higher value. From this another important conclusion can be drawn: art requires continued innovation. There is no such thing as an absolute aesthetic value of a work of art; on the contrary, art must be considered in a relative manner in that the aesthetic value of a work is more or less dependent on the culture of a society at any point in time.

These considerations throw light on the question of whether the use of machines and of rational thinking in art is favourable to the achievement of aesthetic communication. First of all, I believe that the employment of technical aids need not obstruct innovation but, on the contrary, they can promote it. It is not sensible to do by hand what can be done just as well and more cheaply by machine. If a work of art is to have human value that is measured by the response produced in a viewer, then does it matter how it was made? I do not think so.

On the basis of what I have said above, I believe that one should expect that art objects in the age of advanced technology will be of even more importance to society than they were in the past, provided, of course, that artists become aware that they have a social responsibility for their work.

REFERENCES

1. F. J. Malina, Reflections of an Artist–Engineer on the Art–Science Interface, *Impact of Science on Society*, **24**, 19 (1974).
2. H. W. Franke, Computers and Visual Art, *Leonardo* **4**, 331 (1971).
3. H. W. Franke, *Computer Graphics—Computer Art* (London: Phaidon, 1971).
4. H. W. Franke and G. Jäger, *Apparative Kunst* (Cologne: M. DuMont Schauberg, 1973).

STRUCTURE AND PATTERNS IN SCIENCE AND ART

A. L. Loeb*

Abstract—*The author points out that art is concerned with the ordering of space; whatever the nature of the order or disorder may be, a work of art is the result of decisions on the part of the artist regarding the juxtaposition of entities, be they colored points or artifacts previously designed for a different purpose, as in collages. The structure of a pattern expresses the relations between the elements of a pattern, which the author demonstrates.*

The scientist searches for patterns and relations among observations; to this purpose he systematizes his observations. This systematization in exhaustively exploring all possible combinations of juxtapositions can expand the repertoire of the artist beyond the bounds of the rectangularity that has unfortunately left such a confining imprint on Western civilization.

I. DEFINITIONS

An *array* is any collection of entities. The entities of such an array may be ordered in some way, for instance, the entries in a telephone book, or in a genealogical family tree or the students in a class. When the entities that constitute an array are ordered, the array is called a *pattern*. A *structure* is an array whose entities bear a well-defined relation to each other; alternatively, the word structure is used to denote the set of relations between the entities of a pattern. *Pattern recognition* is the recognition of systematic relations between the entities in an ordered array.

A study of structure is therefore a study in relations. The *structure of society* is concerned with social relations, the *structure of an organization* may indicate reporting and funding relationships in that organization. In this article, we shall be concerned with two- and three-dimensional patterns and their structure.

II. THE CREATIVE PROCESS IN SCIENCE AND ART

Scientific investigations start with observations, which are followed by attempts to uncover correlations between previously isolated phenomena. Thirdly, attempts are made to construct a *model* or *theory* to account for these correlations and, finally, the model is applied to a broader range of phenomena in order to test its validity. The second phase, the correlation of observed facts, is, in a broad sense, a *pattern recognition* problem. The third phase is the formulation of a *structure*, that is, of a set of relations between the observations.

Part of an artist's creative process consists of almost continuous decisions regarding the spatial and color relations of entities with respect to each other and with respect to boundaries (picture frame or environment). These decisions more often than not are based on past experience and observations, and even on previously formulated theories. However, artistic creation tends to be a process of synthesis and has depended primarily on individual decisions by the artist, whereas scientific creativity is largely analytical. A scientist detects patterns, an artist makes them. Interaction between art and science may occur in two ways: (a) when a scientist studies the relations occurring in the patterns created by an artist and (b) when an artist uses relations discovered by a scientist. Examples of the former type of interaction are frequent in art history and art criticism: a very special example is the article 'Art and Mathesis: Mondrian's Structures', by Anthony Hill [1]. We shall concern ourselves with the second type of interaction in which an artist may use relations uncovered by a scientist.

Many artists absolutely refuse to have anything to do with relations uncovered by science. It is fashionable today to refute the restrictions imposed by scientific discipline and to compose by one's own untrammeled whim or by chance. There are, however, hordes of social scientists studying untrammeled whim, and, moreover, the laws of chance are

*Structure, systems and communications scientist and musician, Carpenter Center for the Visual Arts, Harvard University, Cambridge, MA 02138, U.S.A. (Received 15 February 1971.)

about as immutable and firmly established as any law of nature! Since an artist has a will of his own, no matter how negatively he wishes to display this will, art will have structure because the relations between entities in a work of art have been subject to artistic decisions. Conversely, a snow-flake, a crystal or an oscilloscope display, no matter how beautiful, is, by definition, not a work of art, unless it has been displayed in a special context by an artist who decided on a relation between it and other objects. A computer may produce any number of oscilloscope outputs but computer art involves either the selection of artistically acceptable images, hence, an artistic decision, or the programming of criteria that eliminate artistically unacceptable images, hence, again an artistic decision.

III. PERIODIC AND MODULAR STRUCTURES

Two technical developments, in particular, have made us acutely aware of assemblies of identical or equivalent modules. One is the mass production of identical building units on large ranges of scale. The other is the development of beams of very short wavelength, such as X-rays and electron- and neutron-beams that make it possible to view the structure of crystalline solids in which identical atoms and molecules are arranged in an immense variety of different patterns. The science of crystallography involves a systematic study of these patterns. The great variety of arrangements in which a small number of elements can distribute itself in a crystal may inspire architects and designers working with identical modules to produce better arrangements than the dreary rectangular boxes usually associated with mass production.

Systematization of patterns means, in essence, production of a catalog in which all patterns are listed in a meaningful order, such that relations between different patterns are evident. In crystallography, systematics is important for data storage and retrieval but, particularly, for predicting and understanding possible rearrangements of atoms as a result of changes in external conditions, such as pressure and temperature. In any kinematic situation, patterns tend to reorganize internally and transform from one into another. Kinetic art in two and three dimensions is assuming great importance and architecture, too, is tending to be more concerned with the internal rearrangement of patterns and their transformations from one to another.

When we deal with relations *between* as well as *within* patterns, we study a *structure* of *structures;* structure is apt to be hierarchal. To arrive at a hierarchy of structures and patterns, it is necessary to describe the patterns quantitatively. Two important quantitative systems of describing relations within and between patterns will be discussed in the next sections. These are *topology* and *symmetry;* we shall see that they are complementary.

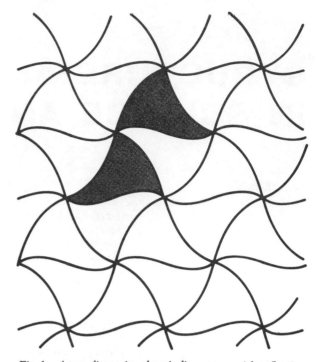

Fig. 1. *A two-dimensional periodic pattern with reflection symmetry.*

IV. TOPOLOGY

A topological description of a pattern is concerned not with exact values of distances and angles but rather with the number of connections. Consider as an example the pattern of Fig. 1. This pattern is two-dimensionally periodic, that is, it repeats itself identically in two non-parallel directions. (It is assumed that Fig. 1 shows only a portion of an infinitely extended pattern. The two shaded tiles in the pattern will be discussed later.) It may be observed that this particular pattern consists of identical domains, or tiles, placed edge-to-edge to cover the entire plane. The elements that constitute a topological description of such a pattern are: the number of edges that surround each tile, which we shall call u, and the number of edges that meet at each corner, which we shall call v. For the pattern in Fig. 1, $u = 3$ and $v = 6$. It will be noted that an *edge* is not necessarily a straight line (it is, in general, simply a curve bounding a tile, running from corner to corner).

A second pattern, with $u = 6$ and $v = 3$, is shown in Fig. 2. The curve accentuated in heavy black is continuous but passes through a corner, hence, counts as two edges. Each tile is thus surrounded by six edges. One notes that the patterns in Figs. 1 and 2 are related, for the value of u in one equals the value of v in the other. The relation between two such patterns is called *duality*. It is, furthermore, observed in both patterns:

$$\frac{1}{u} + \frac{1}{v} = \frac{1}{2} \qquad (1)$$

This same equation holds for the pattern of Fig. 3, where $u = 4$, and $v = 4$. This equation is quite

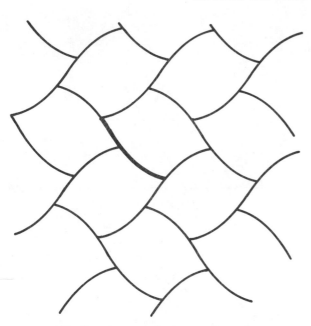

Fig. 2. *A pattern having u = 6, v = 3.*

Fig. 4. *A pattern topologically equivalent to that of Figure* 1 *(u = 3, v = 6) but having no symmetry.*

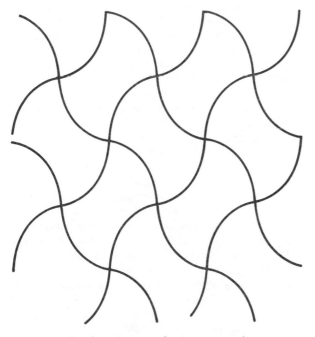

Fig. 3. *A pattern having u = v = 4.*

generally true and can be derived from a fundamental relation in topology first formulated by the mathematician Euler. The three patterns in Figs. 1, 2 and 3 illustrate the three possible solutions of the fundamental equation (1). All *regular tessellations* of the plane, that is, all the ways of covering the plane with identical tiles joined identically at their corners, fall into one of three categories, depending on their values of u and v. These categories are characterized respectively by the values $(u = 3, v = 6)$, $(u = 6, v = 3)$ and $(u = v = 4)$.

We have seen in this brief discussion of some fundamentals of topology that patterns can be categorized according to the number of connections

that converge at corners and the number of edges joining the corners, and that those parameters are related by a very simple but powerful relationship. That the scientist finds aesthetic satisfaction in discovering such relations is attested to by P. A. M. Dirac, who said: 'It is more important to have beauty in one's equation than to have them fit experiment...if one is working from the point of view of getting beauty in one's equation, and if one has a really sound insight, one is on a sure line of progress' [2]. (For a comment on the qualification '...if one has a really sound insight....' cf. F. J. Malina [2]).

V. SYMMETRY

The second quantitative way of characterizing spatial configurations is by their *symmetry*. In this description, the magnitudes of angles and distances are essential. If we return to Figs. 1, 2 and 3, we note that although the tiles in each of these figures are either directly or oppositely congruent, the topological descriptions of these patterns do not make use of these congruences and would be unaltered if the patterns had been distorted so that the tiles were no longer congruent (cf. Fig. 4). (Two configurations are directly congruent if one can move one to bring it into complete coincidence with the other; they are oppositely congruent if the mirror image of one can be moved to bring it into complete coincidence with the other.) In order to describe the congruencies occurring in a pattern, we must define quantitatively its *symmetry properties*.

In Fig. 1, we note that each tile is bounded by three edges, of which one is convex, one concave and one has a point of inflection in its center (in other words, is it S-shaped). If we place a pin at this inflection point and rotate this pattern (which extends indefinitely) through 180° around the pin,

the pattern in its new orientation is indistinguishable from its old orientation. The pattern is said to have *two-fold rotational* symmetry and the point of inflection is called a *two-fold rotocenter*. The pattern of Fig. 1 has two-fold rotocenters at every inflection point, moreover, each corner is also a two-fold rotocenter. In Fig. 1, the shaded pair of tiles are *oppositely congruent*: the *mirror image* of one can be brought into coincidence with the other. The pattern is seen to have *reflection symmetry*: half of the tiles are oppositely congruent to the other half. The pattern of Fig. 1, therefore, has both two-fold rotational and reflection symmetry. The reader is invited to convince himself that the patterns of Figs. 1, 2 and 3 are, from a symmetry point of view, entirely equivalent, although we have seen that topologically they belong to the three different categories.

It has been established that there are seventeen ways of combining rotational and reflection symmetries in a two-dimensionally periodic fashion. A complete enumeration of these can be found in References 3 to 6. In principle, any pattern could belong to one of the 17 symmetry configurations and one of the three topological categories, that is, to one of a possible 51 different classifications. In practice, not all symmetry configurations are compatible with each of the three topological categories, so that the total number of combinations in the plane is somewhat less than 51 but definitely more than 17.

This is all I want to say here about the analytical aspect of periodic patterns; it skims the surface but should suffice to give the reader some insight into the way in which mathematicians have quantified and classified patterns. The bibliography at the conclusion will be a guide for further study. The remainder of my article will deal with the synthesis of patterns.

VI. SYNTHESIS

We have noted that the scientist tends to analyse, categorize and systematize, whereas the artist synthesizes. These are not hard and fast distinctions: the chemist has for centuries been a synthesizer, being perhaps primarily a molecular architect. Recently, the invention and construction of computers has had a profound effect on scientific methodology. This effect goes far beyond that of having a capability for rapid and massive calculation. The digital computer is capable of carrying out a sequence of operations of any desired length, taking into account any number of contingencies that may or may not arise but that have been anticipated by the programmer. Given a number of rules of procedure or *algorithms*, a computer can generate patterns or other outputs of great complexity and variety, and do so in a systematic manner [7]. We have stated earlier that a programmer may incorporate certain rules of aesthetics into his program, thus imposing his own artistic criteria upon the generative process. It is not surprising that computer tech-

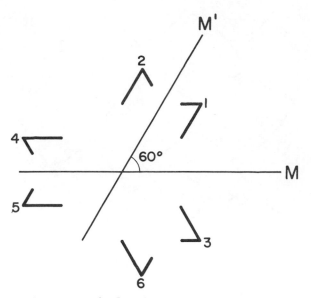

Fig. 5. *Motif reflected successively in two mirrors.*

nicians have been driven by curiosity to generate such patterns. Undoubtedly, this interest in synthesis by computer has given an impetus to the present science–art interaction [8].

The scientist is aided in his categorization and systematization by these so-called algorithmatic generating processes. It is important that he have an exhaustive list of all possible classifications before he starts labeling his patterns or structures. In the past, exhaustiveness could sometimes be proven by rigorous mathematics or it was assumed when a sufficient number of mathematicians could not think of any additional possibilities. The list of all 230 possible three-dimensional symmetry configurations printed in the *International Tables for X-ray Crystallography* was originally arrived at by the second method, resulting particularly from the independent efforts of Fedorov, Schoenflies and Barlow. (These 230 configurations in three dimensions are analogous to the 17 configurations in two dimensions alluded to earlier.) However, the algorithmatic method permits us to generate, with or without the aid of a computer, an exhaustive list according to a given set of rules, which also provides labels for each possible category. An example of this method is found in the author's *Color and Symmetry* [9]. In the next sections, we shall use this method to generate one particular configuration and show how much artistic freedom is still left to operate within this configuration.

VII. KALEIDOSCOPY

A kaleidoscope employs non-parallel mirrors and successive reflections in each mirror result in a pattern having rotational symmetry around the points of intersection of the mirrors. An example is shown in Fig. 5. The motif in the shape of the digit 7 is first reflected in mirrors *M* and *M'*, which are inclined at 60° to each other. These mirror images

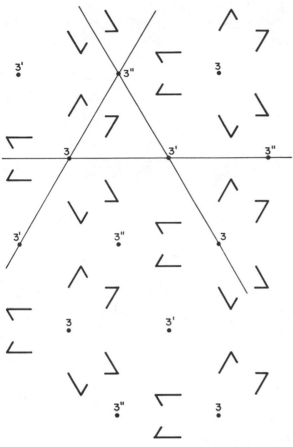

Fig. 6. *Pattern generated by a motif and three mirrors.*

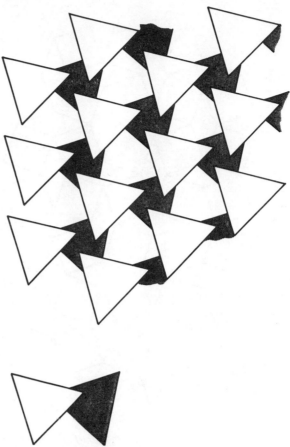

Fig. 7. *Threefold rotocenters of three different kinds and no reflection symmetry.*

of the motif are labeled with digits 2 and 3: the original motif bears the label 1. In turn, reflection of these two mirror images in the two mirrors produce the motifs labeled with digits 4, 5 and 6. The result is a pattern that has threefold rotational symmetry around the point where the two mirrors intersect. It should be noted that the motifs bearing labels 1, 4 and 6 are directly congruent to each other and are oppositely congruent to the other three motifs. It is generally true that two mirrors inclined at an angle to each other imply rotational symmetry; if the angle between the mirrors is θ degrees, then the rotational symmetry is $(180/\theta)$-fold and the rotocenter lies at the intersection of the mirrors.

If a third mirror is added to the configuration of Fig. 5 such that the three mirrors constitute an equilateral triangle, the pattern of Fig. 6 is generated. It should be noted that this pattern is infinite in extent; threefold rotocenters are generated at the intersection points of the mirrors and elsewhere, as marked. These centers are distinguished from each other by primes, because only those carrying the same label are surrounded by mutually congruent configurations.

Although the intersection of mirrors implies a center of rotational symmetry at their intersection, rotational symmetry can also exist without reflection symmetry. An example is shown in Fig. 7, which was generated as follows. A white and a black tri-

angle are put on top of a table so that the white triangle partly covers the black one (bottom left of Fig. 7). The pattern is generated by the rule that the center of each white triangle as well as the center of each black triangle be a rotocenter for the entire pattern. This rule demands that each black triangle be partially covered by three white triangles and that, in turn, each white triangle partly covers three black triangles. The result is an infinite pattern, part of which is shown in Fig. 7. It is worth noting that in addition to the threefold rotocenters at the centers of the black triangles and those at the centers of the white triangles, a third set of threefold rotocenters has emerged at the centers of the spaces between the triangles.

It is possible also to have mirror lines and rotocenters that do *not* lie on the mirror lines. An example is shown in Fig. 8, where fourfold rotocenters do not lie on mirror lines, while twofold rotocenters do. Half the fourfold rotocenters are oppositely congruent to the other half (cf. Fig. 9); these are denoted by 4 and $\bar{4}$, respectively.

It will be noted that in Figs. 6 and 7 there are three distinct sets of threefold rotocenters; within each set all rotocenters are mutually congruent but no rotocenter belonging to one set is directly congruent to one in the other set. In Fig. 9, there is a set of twofold rotocenters and there are two sets of fourfold rotocenters: any fourfold rotocenter is

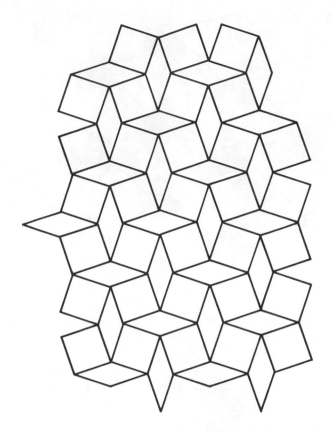

Fig. 8. *Pattern with twofold and fourfold rotational symmetry and reflection symmetry.*

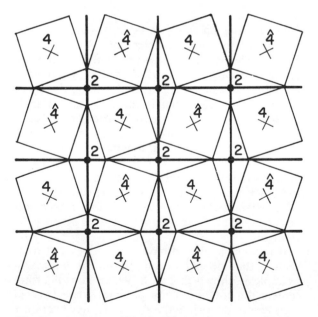

Fig. 9. *A portion of Fig. 8 showing symmetry elements.*

directly congruent to the centers of its own set but oppositely congruent to those of the other fourfold set. These combinations of symmetry values are examples of a fundamental general theorem, which states that the coexistence in a plane of a *k*-fold and an *l*-fold rotocenter implies the existence in that

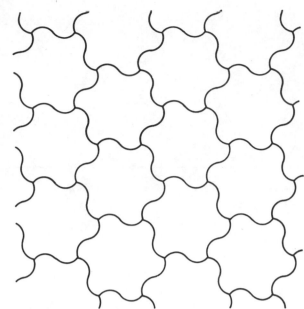

Fig. 10. *Pattern corresponding to* $k = 2$, $l = 3$, $m = 6$.

plane of an *m*-fold rotocenter, where

$$\frac{1}{k} + \frac{1}{l} + \frac{1}{m} = 1. \qquad (2)$$

Just as equation 1 was fundamental to the *topology* of periodic structures, so equation 2 is fundamental to their *symmetry*. In the examples shown, Figs. 6 and 7 correspond to $k = l = m = 3$. The intersections of the mirrors in Fig. 6 correspond respectively to k, l and m. In Fig. 7, the white triangles may correspond to $k = 3$, the black ones to $l = 3$ and the implied ones in the spaces in between to $m = 3$. In Fig. 8, the twofold rotocenters correspond to $k = 2$, the two sets of fourfold centers to $l = 4$ and $m = 4$. Equation 2 becomes, for these examples, therefore:

$$\frac{1}{3} + \frac{1}{3} + \frac{1}{3} = 1$$

and

$$\frac{1}{2} + \frac{1}{4} + \frac{1}{4} = 1.$$

There is also a solution $k = 2$, $l = 3$, $m = 6$ for equation 2. This is illustrated by Fig. 10. This pattern was generated from a *S*-shaped motif with the requirement that its center be a twofold rotocenter and its ends threefold rotocenters. The implied sixfold rotocenters are at the centers of the resulting tiles. Topologically, this figure corresponds to $u = 6$, $v = 3$ (each tile has six edges and three edges converge at each corner).

VIII. CASE HISTORY OF A TRIPTYCH

Figure 11 at the top contains a pattern that was generated using an equilateral triangle as motif in conjunction with a mirror line. It is required that the center of each triangle be a rotocenter. This

rotocenter corresponds to $k = 3$ and its mirror image to $l = 3$. Each triangle is cut by the mirror line, hence, partly overlaps its mirror image. Because of the threefold rotational symmetry, each triangle must be cut by three mirrors, hence, must overlap three other triangles, each being its image in one of the mirrors. (It should be remarked here that these geometrical mirrors are of the Alice-in-Wonderland type, since they permit their subjects to pass through them and to reflect themselves in both the front and the back sides of the mirror. Remember that Lewis Carroll was a mathematician!)

Figure 11 is a triptych called 'Gebonden Vrijheid' (Disciplined Freedom). The top panel shows the triangular motifs in light yellow, with the overlap portions somewhat darker, suggesting that the triangles are transparent, being more dense where they overlap. (Fig. 11, cf. color illus. A, p. 303).

The middle panel uses exactly the same pattern. Through the use of colors, attention is deliberately distracted from the original motif and centers instead on the spaces between the motifs and on the small quadrilaterals where the original motifs overlapped. The artist thus created a new motif, derived from the pattern generated by the triangular motif. The resulting middle panel, though based on the same pattern as the first, appears very different to the beholder. The difference is based on a purely artistic decision.

A third motif can also be picked out of the same pattern. It is the domain left over when the overlap region is scooped out of the triangle. Whereas the two topmost panels of 'Gebonden Vrijheid' are both periodic, that is, repeat endlessly, the bottom panel is not. It exploits all three motifs simultaneously and the tensions created by their juxtapositions. The number of purely artistic decisions was greatest in the bottom panel, yet it again is based on exactly the same pattern as were the upper two panels. The title of the triptych denotes the freedom of choice permitted within a rigidly generated pattern.

REFERENCES

1. A. Hill, Art and Mathesis: Mondrian's Structures, *Leonardo* **1,** 233 (1968).
2. P. A. M. Dirac, The Evolution of the Physicist's Picture of Nature, *Scientific American*, p. 45 (May 1963). F. J. Malina, Some Reflections on the Differences between Science and Art, in *DATA*, Ed. A. Hill (London: Faber & Faber, 1968).
3. N. V. Belov, *Derivation of the 230 Space Groups* (Leeds: Leeds Philosophical and Literary Soc., 1957).
4. H. S. M. Coxeter, *Introduction to Geometry* (New York: John Wiley, 1961).
5. H. S. M. Coxeter, *Regular Polytopes*, 2nd ed. (New York: MacMillan, 1963).
6. A. V. Shubnikov and N. V. Belov, *Colored Symmetry*, Ed. W. T. Holser (New York: MacMillan, 1964).
7. R. I. Land, Computer Art: Color-stereo Displays, *Leonardo* **2,** 335 (1969).
8. F. J. Malina, Comments on Visual Fine Art Produced by Digital Computers, *Leonardo* **4,** 263 (1971).
9. A. L. Loeb, *Color and Symmetry* (New York: John Wiley, 1971).

Suggestions for further reading

E. B. Edwards, *Pattern and Design with Dynamic D Symmetry* (New York: Dover, 1967). Reprint of 1932 edition.

G. Polya, *How to Solve It* (New York: Anchor Books, 1957). Reprint of 1945 edition.

d'A. Thompson, *On Growth and Form* (Cambridge: Cambridge University Press, 1942).

Aspects of Form, Ed. L. L. Whyte (New York: Elsevier, 1968). Reprint of 1951 edition.

H. Weyl, *Symmetry* (Princeton: Princeton University Press, 1952).

L. F. Toth, *Regular Figures* (New York: Macmillan, 1964).

C. M. MacGillavry, *Symmetry Aspects of M. C. Escher's Drawings* (Utrecht, Holland: Oosthoek, 1965).

A. L. Loeb, The Architecture of Crystals: in *Module, Proportion, Symmetry, Rhythm*, Ed. G. Kepes (New York: G. Braziller, 1966) p. 38.

S. Ulam, Patterns of Growth Figures, *ibid.* p. 64.

L. L. Whyte, Atomism, Structure and Form: in *Structure*, Ed. G. Kepes (New York: G. Braziller 1966) p. 20.

C. S. Smith, Structure, Substructure, Superstructure, *ibid,*, p. 29.

E. F. Sekler, Structure, Construction, Techtonics, *ibid.*, p. 89.

DATA: Directions in Art, Theory and Aesthetics, Ed. A. Hill (London: Faber & Faber, 1968). (cf. especially the article by Le Ricolais: '… as we have seen, the mathematical language and its symbols have been and will always be an enormous reservoir of unexploited forms…').

ON SYMMETRIES AND THE STRUCTURE OF OUR OWN NATURE

Roland Fischer*

There is a remarkable passage in a discussion given by the late Aharon Katzir-Katchalsky at the Art and Science Symposium in Tel Aviv, 19 April, 1971 [1]. He emphasizes that beyond all relative points of view there are absolutes and these absolutes are principles of symmetry. 'The symmetries of modern science are very abstract symmetries like balance in modern art', he concludes.

Are not these symmetries and balances very much reminiscent of Pythagorean *harmonia*? The meaning of that harmony was not—as it is today—a concord of several sounds but the orderly adjustment of parts in a complex fabric. Georgio de Santillana [2] views the cosmogony of the Egyptian Book of the Dead of comparable subtlety: 'I am Atum when I was alone in Nun' Atum, like the Monad, stands for 'that is all'. But—I am paraphrasing Santillana—the built-in guiding and corrective power provided by number and geometry carries the Greek system on to developments that were beyond the reach of archaic theory. I submit that the number principles—the ratios and symmetries—constitute the order and balance in a strange mirror that is our own brain. The Pythagorean harmonies or the symmetries of Katzir-Katchalsky are re-presentations of the nature of *our* thoughts and images. Numerical ratios seem to reflect the structure of our analytical, rational, sequential and verbal mode of cognition rooted in the 'major' or dominant (cortical) hemisphere, while symmetries and harmonies reflect the mode of cogniton associated with the synchronous spaces, the non-verbal hallucinatory and dreamy gestalts and geometrized fields of the intuitive 'minor' brain hemisphere.

How did Socrates explicate Protagoras who's 'man is the measure of all things'? ' . . . if anything else is beautiful besides beauty itself', concluded Socrates, 'what makes it beautiful is simply that it *partakes* of that beauty' (italics mine) [3].

*Maryland Psychiatric Research Center, Box 3235, Baltimore, MD 21228, U.S.A. (Received 11 Sept. 1973.)

Order, symmetry and beauty are thus in the eye of the beholder [4]. A system appears to an observer to be in harmony and balance in proportion to the amount of self-awareness (that is, information about *itself*) that the system exhibits. These conclusions, says Stafford Beer [5], may be tested in the cases of bees that have to be programmed to build a hexagonal honeycomb and a cloud of hot gas that has to be programmed to maintain a high temperature. They do not have to be programmed, in fact; only recognized for what they really are.

J. C. Baird in an article Psychological Study of Numbers, V [*Psychologische Forschung* **38**, 189 (1975)] describes how subjects generated numbers within selected regions of a scale (say, 1–1000) and then the frequencies with which different numbers were produced by a large group were computed. Not unexpectedly it was found that certain categories were clearly 'preferred' over others. These preferred numbers were multiples of 10, 5 and the lower boundary number used to delimit the range of responses. More careful analysis indicated that subjects responded as though they were preferring those numbers that contained a single significant digit (nonzero) and that could be obtained from at least one of the numerical systems based on 10, 5 and the lower boundary.

A preferred state, s, can be described mathematically by a power function:

$$s = kb^n$$

where b is the base system, n is the place integer and k the category integer (including zero). A similar pattern of preferred states emerged upon examination of the numerical responses used in judging physical stimuli with the method of magnitude estimation. Therefore, for the case of numbers it appears that the physical continuum is transformed by the subject into a new set of ordered, preferred states according to the specifications of selected base systems.

Baird's theory assumes that all stimulus continua are transformed in the manner just described for numbers but that different base systems are in operation.

In summary, then, preferred states are, according to Baird, selected multiples of each other (always possessing one significant digit) when viewed from the standpoint of the stimulus dimension and represent equally spaced values along an internal response scale. In the latter case this means that the zero point of the scale is arbitrary and can be assigned initially to any stimulus intensity.

Baird shows theoretically that the matching of stimulus continua transformed perceptually by different base systems can lead to the familiar logarithmic and power laws found to describe the relationship between stimulus intensity and a person's estimate of intensity. For example, the power law defended vigorously by S. S. Stevens [6], can be written as

$$R = \lambda S^{\eta}$$

where R is the magnitude estimate of the subject, S the physical magnitude of the stimulus, λ a constant having to do with the units of measure and η the exponent reflecting the nature of the response and stimulus attributes. Baird's theory suggests that the power function is the result of matching two attributes (response and stimulus) that are transformed perceptually by their unique base system(s). The exponent is produced by the relative perceptual sensitivity of the two attributes as reflected by the size of the base (high bases = high sensitivity). Of interest here is the fact that the power function is not the 'law of nature' once assumed but rather is the necessary result of a simpler underlying pattern (numerical base systems) found in man's perceptual transformation of stimulus inputs. On a more philosophical plane, we are tempted to conclude that the extensive use of the power function to represent scientific facts merely is an outward manifestation of the perceptual transformations inherent in the *theorist's* creation of preferred states in accord with fundamental mathematical laws operating in his own nervous system.

This power 'law', therefore, is not a law of nature but a law of our own nature as it reflects itself, reflecting itself. Braitenberg [7] comes to an analogous conclusion but 'topographically' by inferring isolated aspects of logic from aspects of histo-logics (types of symmetry, maximum logical depth, possible degree of complexity), that is the histological organization of our neuronal connection schemes.

When Leonardo da Vinci asserted that the guiding principle of the artist should be to hold up the mirror to nature, he could not have realized the partial identity of our brain with his mirror. The innumerable schemes from the Golden Section [8] to Birkhoff's formula (aesthetic measure equals order per complexity) [8] all attempt to account for aesthetic pleasure, harmony and balance in mathematical or geometrical terms. They represent a recurring attempt to devise a blueprint for an imaginative but imaginary common mirror for both natures.

REFERENCES

1. L. Alcopley, Art and Science: Exhibition, Film Program and Symposium at the Tel Aviv Museum with Concluding Remarks of the Symposium by Aharon Katzir-Katchalsky, *Leonardo* **6**, 149 (1973).
2. G. de Santillana, *The Origins of Scientific Thought* (New York: Mentor, 1961).
3. *Great Dialogues of Plato*, W. H. D. Rouse, trans. (New York: Mentor, 1956).
4. R. Fischer, On Separateness and Oneness, an I — Self Dialogue, *Confin. Psychiat.* **15**, 165 (1972).
5. S. Beer, *Decision and Control* (New York: Wiley, 1966).
6. S. S. Stevens, *Issues in Psychophysical Measurement, Psychol. Rev.* **78**, 426 (1971).
7. V. Braitenberg in *Nerve, Brain and Memory Models*, N. Wiener and J. P. Schadé, eds. (New York: Elsevier, 1963).
8. R. Fischer, Out on a Phantom Limb. Variations on the Theme: Stability of Body Image and the Golden Section, *Perspect. Biol. Med.* **12**, 259 (1969).

CHIRALITY*

Lancelot Law Whyte**

In his Boyle Lecture at Oxford in 1893 on molecular arrangements in crystals, Kelvin introduced the term 'chirality' from ($\chi\varepsilon\iota\rho$, *hand*). 'I call any geometrical figure or group of points "chiral", and say it has "chirality", if its image in a plane mirror, ideally realized, cannot be brought into coincidence with itself' [1]. He called forms of the same sense (e.g. all L-handed) 'homochiral' and equal forms of opposite sense 'heterochiral'. J. Larmor and A. S. Eddington used 'chiral' and the writer [2] analyzed the concept, listed the main chiral forms and gave a more explicit definition: 'Three-dimensional forms (point arrangements, structures, displacements, and other processes) which possess non-superposable mirror images are called "chiral".' This presupposes that the mirror image of the phenomenon, e.g. of a magnetic vector, is either known from observation or established by an acceptable convention.

'Chirality' is used in preference to similar but ambiguous terms (e.g. asymmetry, dissymetry) with associations which can mislead [2] when it is desired to refer to a general property defined in terms of spatial relations only (e.g. Cahn, 1966 [3]), not of particular physical or chemical effects (e.g. optical rotation, since some non-chiral structures can display optical activity, Wooster, 1946). The property of chirality is dual (L, left, or R, right, laevo or dextro), global, geometrical, three-dimensional, Euclidean and non-relativistic, spatial relations being separated from temporal. Moreover it refers to a structure at some specified level (or set of levels) in the structural hierarchies of the physical universe or of organisms. There is no necessary correlation between chirality at one level and its presence or absence at a neighbouring level. A chiral process is one, successive states of which are chiral. Chiral forms fall into two main classes: screws (conical or helical) ordered with respect to a line, and skews, ordered around a centre. Thus a chiral chemical group or molecule may be skew

(around an asymmetrical centre) or screw (arranged as a helix) and the two chiral forms are called *enantiomers*. A chiral form is (theoretically) converted into its mirror image by a rotation in four-dimensional space.

We cannot consider here the psychological and social connotations that *left* and *right* (or equivalents) possess in different cultures [4, 5] and turn to the history of chirality in physics and biophysics.

Interest in L- or R-handed arrangements of points or atoms and in chiral organic forms long preceded their scientific analysis. Plato considered the properties of mirror images; Aristotle discussed chiral forms; Lucretius devoted 100 lines of *On the Nature of Things* [6] to images in mirrors; Leonardo da Vinci used mirror writing; Kant found in the existence of chiral forms support for his theory of space; Goethe wrote an essay 'On The Spiral Tendency in Vegetation' and many early scientists were interested in the screw forms of plants and shells (cf. Figure).

Edith Sitwell's hand holding a helical shell. (From 1958 Christmas card of Eve and Lance Whyte.)

* This unpublished manuscript was written between 1969–1970 and is published with the permission of Mrs. Eve Whyte, 93 Redington Road, London, N.W.3, England.

** Lancelot Law Whyte (1896–1972), philosopher, scientist and investment banker, was a *Leonardo* Honorary Editorial Advisor.

The scientific mind looks for symmetry, so it is scarcely surprising that it was not until the 19th and 20th centuries that quantitative science came to grips with the chiral aspects of nature, which we now know to be of great importance. On six occasions from 1810 to 1957, chiral phenomena were unexpectedly discovered that involved a revision of previous theoretical assumptions. The bias in favour of symmetry has meant that the systematic study of skew and screw effects has only been taken up when the experimental facts compelled it.

A primary aim of science is the elimination of arbitrariness by the discovery of intelligible reason for everything being as it is and not otherwise. But no-one has yet conceived a sufficient reason for a fundamental or general chiral bias, say in favour of left-handed forms. So, if a bias has been found in any realm, the natural inference has been that it is due to some contingent local effect and that structures with the opposite bias may exist elsewhere in the universe [7]. Of the six discoveries of new chiral effects, two involved no bias, as both forms were found. We shall consider these first.

Crystal optics. Arago (1810) discovered the rotation of plane-polarized light (optical activity) by quartz crystals and Fresnel (1827) correctly ascribed this to a helical arrangement in the structure of the crystal. No bias was present in this work, as L and R rotations were produced by different specimens.

Crystal mechanics. During the 1950's non-symmetric tensors, representing screw stresses and strains, were discovered in crystals containing helical molecular arrangements. No bias; both forms of crystal exist.

The other four cases are more interesting, as they revealed a bias in nature calling for explanation.

Electromagnetic interaction. Oersted (1820) discovered the anomalous R-handed screw action of an electric current on a magnet. (Mach's 'shock' [8]). This bias was incorporated into classical Electromagnetic Theory but was modified and believed to be substantially explained in *Electron Theory and Quantum Mechanics* (Weyl, 1952).

Living systems and chiral molecules. In 1815, Biot discovered that many materials from organisms (sugar, tartaric acid, oil of turpentine, etc.) in the liquid state or in solution displayed optical activity and conjectured that this might be due to some structural asymmetry of the individual molecules. Pasteur followed this up and, in 1848, separated—by manually sorting out from a mixture the small crystals of the two mirror-image forms, a procedure seldom applicable—two optically active (R and L) forms of tartaric acid. He interpreted this as due to the existence of two mirror image structures (enantiomers) of otherwise identical molecules, only one of which is present in organisms, though both are present mixed in non-active materials from non-living sources. Pasteur inferred that only in organisms are chiral molecules present unmixed with their enantiomers and at one period he claimed that this capacity of organisms to produce molecules with chirality of one sense only drew a clear boundary between the living and the non-living realms. In 1874 Pasteur suggested that this organic bias was due to a universal cosmic bias (for some reason not appearing in inorganic materials), '*l'Univers est dissymétrique*' [9], though later he stressed the continuity of the two realms.

It was established, from 1920 onwards, that the organic realm is distinguished, as Pasteur had suggested, by the presence of chiral molecules of one sense only in any particular biochemical process. 'In living organisms all syntheses and degradations of dissymetrical molecules involve one enantiomorph alone' [10]. This must be carefully interpreted; it does not mean one universal bias. While more than 99% of natural amino acids are L, most sugars are R. Moreover, at different levels opposite chiralities may be present; for example, the L amino-acids form R macro helices in proteins. Moreover, as though to prove the capacity of organisms to break what human beings regard as simple rules, a highly active class of enzyme systems (D-amino acid oxidases) contain only R amino acids.

In spite of these complexities, one principle at present appears absolute: where two opposite forms of a molecule are possible, these are never used simultaneously. Mixed enantiomers are never found in cellular organisms. This suggests that the presence of structures of one chirality only in any situation is—at least at the molecular and conformational levels—an indispensable condition of organic stability and coordination. Living controls, it seems, require chirality of one sense only in any one region and at any one level.. 'Life is a linked set of reactions, and therefore their component molecules must depend on fitting their chirality, right- and left-handedness together' [11]. Chirality holds one of the secrets of the dynamic coordination which is 'life'.

But a major problem remains: What caused the almost complete predominance, probably in all cellular organisms, of L amino acids? Several alternative causes have been considered. (1) A predominance of (say) L-handed circularly polarized light reaching the Earth. This is believed to be inadequate. (2) Action by some contingent local factor (such as a chance excess of quartz crystals of one sense in some locality causing a bias in circularly polarized light) producing a slight bias in early forms of life, which then led rapidly to an

effectively complete bias by internal biochemical selection. Some have considered this the most likely cause [10] but it is not wholly satisfactory to ascribe such an important bias, apparently necessary to organic coordination, to some early unknown contingent local factor producing a slight bias. (3) The influence of some pervasive continuing bias in the physical environment. No such bias was known until the discovery (1956, see below) of chiral γ-rays producing an excess of left circularly polarized photons. This entirely unexpected identification of a bias in a widespread radioactive process offered a likely cause of the bias, for example, in natural amino acids. [The author had a question mark beside this statement. Ed.] In 1968, experiments [12] on the stability of L and R enantiomers of amino acids in the presence of radioactive sources showed that the dextro isomer decomposed more than the laevo. If further work confirms this result, the bias in natural amino acids can be regarded as a consequence of a still unexplained bias in the construction of matter (see below).

From 1870 onwards the science of stereochemistry (chemistry in three-dimensional space) and the study of chiral molecules in the inorganic as well as the organic realm has steadily advanced. Important achievements in relation to chirality are: (1) The ascription of optical activity in most cases to an asymmetrical carbon (or other) atom, combined with four different atoms. (2) The determination of the 'absolute configuration' (definite L or R arrangement) of optically active compounds [13]. (3) The development of a comprehensive system of classification of complex compounds using the conception of chirality [3].

Particles and Antiparticles. In 1931 Dirac, using a relativistic wave equation that he had previously proposed for the (negatively charged) electron, predicted the existence of a positively charged anti-particle to the electron and this new antiparticle, called the positron, was discovered in 1932/3. In quantum mechanics such particles in an abstract space (not in ordinary three-dimensional space) and their reflection properties in ordinary space depend on partly arbitrary conventions forming part of the theory. This technical point cannot be discussed here but on certain reasonable assumptions the positron can be regarded as the mirror image of the electron and the general laws show in this respect no chiral bias, both particles corresponding to permissible solutions of the Dirac equation. But quantum mechanics makes no assertion regarding the population statistics of the various particles in any system and here a difficulty arises. For there remains an awkward and fundamental anomaly—in the world as we know it, electricity is not symmetrical with respect to positive and negative charges, since electrons are present in myriads everywhere, while positrons are very rare and vanish in a flash by fusion with electrons.

Whether this contrast expresses a chiral bias present in all electromagnetic phenomena involving electrons is not clear but it is certainly directly or indirectly connected with mirror image properties. Moreover, it appears to be very deeply rooted in physical theory, as Larmor discussed the possibility of particles of antimatter with opposite electric charges and chirality in 1900 before 20th century physics was born. Indeed, it was Larmor's use of the term 'chirality' that brought it to the attention of 20th-century physicists.

Weak particle interaction. Between 1956 and 1958 it was established that all weak interactions (e.g. in γ-ray radioactive decay) display a marked bias ('failure of parity conservation'). This anomaly in the fundamental constitution of matter, as shown in the processes of atomic nuclei, constitutes a major challenge. What possible reason can there be for a left or right bias in the structure of atomic nuclei?

It could be that this nuclear bias and the electron/positron lack of symmetry are two expressions of one underlying factor, not yet identified, that has to do with the structure of electricity in atoms and nuclei. There appears to exist more asymmetry in the physical universe than is yet understood and it would not be surprising if this required a further revision of fundamental concepts. It has been known since 1956/7 (Time–Charge–Parity T.C.P. Theorem) that reflection symmetry must be regarded as a member of a closely linked triplet of invariances: under (i) reversal of the direction of motion, (ii) reversal of sign of electric charge and (iii) reflection. Any major advance of physical theory beyond this Theorem may be expected to throw light on three basic issues: the reversibility or not of the fundamental physical processes, the nature of electricity and the role of left- and right-handedness in the physical universe.

Thus there are indications that the role of chirality in the universe, or at least on this Earth, may be greater than has yet been understood. This accords with the view often put forward that greater attention should be paid to asymmetries as the necessary initiators of processes. ('*C'est la dissymétrie qui crée le phénomène*' [15].) For this a radical transformation in physical ideas may be necessary. We should probably be much surprised if we could look as long ahead, as Lewis Carroll did when he made Alice wonder: 'Perhaps looking-glass milk isn't good to drink' [16]. Today we know that only an Anti-Alice would be able to assimilate anti-milk but we have no idea why milk, and we ourselves, and perhaps the solar system, share one dominant bias. It is conceivable, perhaps, that this

bias in nature is only apparent and that it arises from a bias in our thinking. But, if so, whence came that bias in thought if we are part of nature?

Author's note: I have to thank George Wald for assistance.

ADDITIONAL BIBLIOGRAPHY

C. W. Bunn, *Chemical Crystallography* (2nd ed.) (Oxford: Oxford Univ. Press, 1961), p. 90.

P. A. M. Dirac, *Proc. Roy. Soc.*, **A18,** 610 (1928).

P. A. M. Dirac, Letter written in 1960. Cf. N. R. Hanson, *Concept of the Positron* (Cambridge: Cambridge Univ. Press, 1963).

G. F. Gause, Optical Activity and Living Matter, *Biodynamica*, **3** (70), 217 (1941).

F. M. Jaeger, *The Principle of Symmetry* (Cambridge: Cambridge Univ. Press, 1917), p. 104.

W. Ludwig, *Das Rechts-Links Problem im Tierreich und beim Menschen* (Berlin, 1932).

L. Pasteur, Deux leçons sur la dissymétrie moléculaire, *Oeuvres*, Vol. 1 (Paris, 1860), p. 361.

d'A. W. Thompson, *On Growth and Form* (new ed., 1942) (Cambridge: Cambridge Univ. Press, 1917).

H. Weyl, *Philosophy of Mathematics and Natural Science* (Princeton, N.J.: Princeton Univ. Press, 1949), pp. 84, 97, 107, 160, 208.)

H. Weyl, *Symmetry* (Princeton: Princeton Univ. Press, 1952).

L. L. Whyte, *Unitary Principle in Physics and Biology* (London: Cresset Press, 1949).

E. P. Wigner, Violations of Symmetry in Physics, *Sci. Am.* **213,** 28 (Dec. 1965).

REFERENCES

1. W. T. Kelvin, *Second Robert Boyle Lecture. On the Molecular Tactics of a Crystal* (Oxford, 1894). Also in *Baltimore Lectures* (App. H, p. 439, London, 1904).
2. L. L. Whyte, *Nature* (London), **182,** 198 (1958).
3. R. S. Cahn, C. Ingold and V. Prelog, Specification of Molecular Chirality, *Angew. Chemie.* (Int. edition) **5,** 385 (1966).
4. M. Gardner, *The Ambidextrous Universe* (New York: Basic Books, 1964).
5. V. Fritsch, *Links und Rechts in Wissenschaft und Leben* (Stuttgart: Kohlhammer, 1964). Translations: *La gauche et la droite* (Paris: Flammarion, 1967) and *Left and Right in Science and Life* (London: Barrie and Jenkins, 1968).
6. Lucretius, *De Rerum Natura*, Book II, ch. 1, p. 498. C. Bailey's translation (Oxford: Oxford Univ. Press, 1947).
7. H. Alfvén, *Worlds-Antiworlds* (San Francisco: Freeman, 1966).
8. E. Mach, *Science of Mechanics* (Chicago: Open Court, 1919), p. 27.
9. J. B. S. Haldane, Pasteur and Cosmic Asymmetry, *Nature* (London) **185,** 87 (1960).
10. G. Wald, The Origin of Optical Activity, *N. Y. Acad. Sci. Annals.* **69,** 352 (1957–58).
11. J. D. Bernal, *The Origin of Life* (London: Weidenfeld and Nicholson, 1967), p. 144.
12. A. S. Garay, Origin and Role of Optical Isomery in Life, *Nature* (London) **219,** 338 (1968).
13. A. F. Bijvoet *et al.*, *Nature* (London) **168,** 27 (1951).
14. J. Larmor, *Aether and Matter* (Cambridge: Cambridge Univ. Press, 1900).
15. P. Curie, *Oeuvres* (Paris, 1894), p. 119.
16. C. L. Dodgson, *Through the Looking-Glass* (London, 1871).

CYBERNETICS AND ART

Michael J. Apter*

Abstract—*This article is a non-technical introduction to cybernetics, the study of 'control and communication in the animal and the machine'. A number of fundamental cybernetic concepts are described including some of those involved in information theory (like the notion of a message and amounts of information), in control theory (like homeostasis, negative feedback and servomechanisms) and in automata theory (like algorithms, Turing machines and networks). The structure of cybernetics is outlined showing the relationship between work on the further development of the theory, on understanding organismic processes in cybernetic terms (especially through model building) and on constructing more purposeful hardware systems. Bionics, cybernation and artificial intelligence (which especially involves heuristic programming) are all fields concerned with the development of such hardware systems.*

It is argued that cybernetics is related to art in three ways: it may be used by the scientist in studying art, it may be used by the artist in creating works of art—and may have been one of the influences behind the development of the idea of machines as works of art and machines for creating art, as well as the increasingly process-oriented nature of contemporary art—and finally cybernetics may itself be regarded in certain respects as an art form in its own right.

I. INTRODUCTION

In recent years increasing attention has been paid by artists to a new scientific discipline called 'cybernetics'. Perhaps at least part of the reason for this attention is that cybernetics represents a development in science which holds out the promise of taking art seriously—in contrast to previous movements in psychology like psychoanalysis and behaviourism which have, in their different ways, tended to denigrate art.

Unfortunately, a great deal of confusion exists as to exactly what cybernetics is, not only among artists but among scientists themselves. The reason for this is not hard to find: the term 'cybernetics' is one which refers to a number of related tendencies in science and mathematics, to a number of developing areas and techniques which overlap each other in different ways. The situation is further confused by the emergence of a host of new names to refer to many of these overlapping areas: information theory, communication theory, servo-mechanics, control theory, automata theory, computer science, artificial intelligence, bionics, automation, cybernation and so on.

The aim of this article is firstly to provide a simple introduction to cybernetics by reviewing in a non-technical way some of its fundamental unifying concepts and by attempting to show how the different parts of the subject relate to each other. (In doing this I am sure to be accused of over-

*Psychologist, Dept. of Psychology, University College Cardiff, P.O. Box 78, Cardiff CF1 1XL, Wales, U.K. (Received 5 Mar. 1969.)

simplification. My defence is that it is impossible to do otherwise in treating such a complex subject in so short a space.) Secondly, the aim is to suggest briefly how cybernetics relates especially to art.

The word 'cybernetics', as defined by Norbert Wiener, the American mathematician, when he coined the word in its modern context in 1948 [1], means the science of 'control and communication in the animal and the machine'. The word is derived from the ancient Greek 'kybernetike' meaning, roughly, 'steersmanship'.

Underlying cybernetics is the idea that all control and communication systems, be they animal or machine, biological or technological, can be described and understood using the same language and concepts. Thus where the word 'machine' is used in cybernetics it tends to be used to refer to anything which is 'essentially constructible' and this includes cats and dogs and human beings, as well as aeroplanes and computers. To avoid confusion with the everyday use of the word 'machine', the word 'system' is used increasingly in cybernetics. Indeed the newer term *systems theory*, which covers much of the same area as cybernetics, may eventually replace it as the name of the field. Much of the content of cybernetics is not new or specific to cybernetics: but it is this general synthesizing attitude which characterizes it above all.

II. CYBERNETIC THEORY

Let us look at some of the basic concepts of cybernetics. They can be grouped reasonably meaningfully in terms of three theories.

Fig. 1. *Information transmission situation.*

Information theory

A number of formulations of information theory, or communication theory as it is sometimes called, have been put forward; but it is probably true to say that that of Shannon and Weaver [2] is the most widely accepted and used today.

Although deriving from the field of communication engineering, Weaver himself has said of the theory: "This is a theory so general that one does not need to say what kinds of symbols are being considered—whether written letters or words, or musical notes, or spoken words, or symphonic music, or pictures. . . . it is dealing with the real inner core of the communication problem—with those basic relationships which hold in general, no matter what special form the actual case may take" [2].

Indeed, the notion of a *message* is one of such generality that it refers in effect to any sequence of measurable events distributed in time. These events can be the symbols of a deliberately communicative message, and information theory has naturally been most interested in messages of this kind. But the theory can also be applied to other sequences of events and it is in these terms that, for example, biologists have tried to use information theory to measure the amount of information in an organism at different stages of its development [3, 4].

However, in order to be able to measure the amount of information contained in a message, the message must have a certain property. The events, or symbols, in the message must be ones to which it is possible to assign consistent probability values which express, for each such event, the probability of its occurrence. When this can be done, the amount of information in a given event occurring at a given time can be measured and the total information in a sequence of such events given an overall quantitative value. Information theory is therefore, in effect, part of the mathematical theory of probability.

In general, there is an inverse relationship between probability and the amount of information: the less probable an event, the more the information when it occurs. This may seem an odd way to think of information but if we examine it we find that it is not entirely inconsistent with our intuitive understanding of the meaning of 'information'. Thus if someone tells me in July that it is snowing in St. Tropez, there is more information in the message than if someone tells me in March that it is raining in London: the former event occurs less often and is therefore less probable than the latter. Similarly, a cliché contains less information than an original remark. In general, the more random and therefore unpredictable a sequence of symbols constituting a longer message is, the more the information in the message. (The contemporary artist's obsession with randomness may be seen as an attempt to increase the information he is conveying.) The average (rather than total) amount of information per symbol/event in the message is known as its *entropy*.

Communication engineers use information theory in the context of the information transmission situation depicted in Fig. 1. In the first instance this diagram most obviously represents situations like the transmission of information over the telephone, radio or television. The information is encoded, i.e. altered into some form suitable for transmission, then transmitted, when it may be interfered with by the intrusion of uncontrollable 'noise', and then decoded again into some form usable by the receiver. But the conceptualization is a general one and can represent a wide variety of communication situations including people talking to each other, artistic communication, operators controlling complex pieces of equipment, etc. Much of information theory is concerned with the question of how information can be encoded and subsequently decoded, so as to combat the effect of noise and to ensure that all the information reaches its destination. (Methods have been developed, too, which allow information theory to be applied to continuous as well as discrete forms of information.)

Control theory

When we take into account the effects that messages have in a system, we enter the realm of control theory. Control theory, however, as its name implies, is especially interested in systems which control themselves towards goals and which may therefore be considered as purposeful. What is of concern in this area is the way in which information is used within a system and between a system and its environment which allows it to achieve its goals (using the term 'information' in its widest possible sense).

The central explanatory concept of control theory is that of *negative feedback*. By negative feedback is meant that some part of the output of the system is fed back into the system again in a negative direction in order to control that system (cf. Fig. 2). This process is most easily exemplified in terms of what are called *homeostatic* systems: these are systems which maintain certain of their variables within

Fig. 2.　*Negative feedback.*

Fig. 3.　*The Watt governor.*

certain limits. For example, pressure cookers maintain pressure within certain limits, the human body maintains a large set of physiological variables (like temperature) within limits, viable business organizations maintain certain economic variables within certain limits and so on. Homeostasis may be achieved by means of negative feedback.

Let us look at this in terms of one of the first, and certainly one of the most famous, homeostatic systems in the history of engineering: the Watt governor (cf. Fig. 3). An engine using the Watt governor is homeostatic in that it is able to maintain its speed of operation within limits. Part of the output of the engine is to turn a set of weighted arms which are mounted on pivots so that they rise by centrifugal force as they revolve. This small part of the output is used to control the engine speed automatically because the arms operate a valve which

admits steam or fuel to the engine. What happens is that as the speed of the engine increases, so the weighted arms move at an increasing speed and therefore rise. As they do so they operate the valve, closing it in proportion as the speed of the engine mounts. The result of this arrangement is that the more the engine exceeds a given speed, the less it is supplied with steam, so that it slows down again. But as it slows down, so the valves are opened again to admit more steam, and so it can speed up again. This negative feedback counteracts the speed of the engine as it goes above or below the homeostatic point and the engine soon settles down to a stable speed. It is important to note that it is the speed of the engine itself which in effect controls the speed. This situation is represented diagrammatically in Fig. 4.

A thermostat controlling the temperature of a room represents a slightly more complex system in

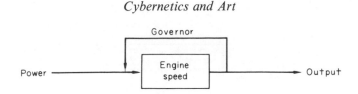

Fig. 4. Diagrammatic representation of the Watt governor.

that not only does it control a heating system (through negative feedback) but it maintains the heat of the room in relation to variations in the environment. Not only is it homeostatic, but also *adaptive*—the room is kept at the same heat whether it is snowing outside or the sun is shining. It does this by continually monitoring the temperature of the room and automatically turning on the heat when the temperature drops below a specified level and turning it off when it goes above a higher specified level. This is an example of what is known in engineering as a *servomechanism* [5].

Let us look at a biological example of a similar process. A man walking along a pavement normally tries to stay on the pavement: as long as he does so we can say that he is maintaining homeostasis in this respect. Any change of direction which causes him to move away from the pavement causes him to note that his direction of movement is no longer correct and to move in an opposite direction from the direction of error. So movement by him away from the desired direction of movement results in action being taken which corrects this error. This allows him not only to stay on a straight pavement but to adapt to changes in direction of the pavement itself. Here the negative feedback is in part (seeing himself move away from the desired position) more obviously informational (in the everyday sense of the term) than the negative feedback in the Watt governor example. And the error correction is less inexorable. But the principle is the same.

Many systems incorporate the converse of negative feedback—positive feedback. With positive feedback, part of the output of the system is fed back into the system in a positive direction. This has the effect of increasing rather than reducing deviation in the system. Typically this is unadaptive: for example, the more anxious one becomes the less able one may become at performing a certain skill which in turn leads to increased anxiety and further decreased performance. On the other hand, positive feedback can be related to negative feedback so as to increase the effectiveness of the latter. For example, power brakes amplify pressure on a brake, braking being a form of negative feedback controlling the speed of the vehicle.

A system may control its behaviour, using negative feedback, not only to maintain a state it is normally in but also to achieve some future state that it has not yet been in. For example, the man walking along the pavement may be going to the shops: the whole activity may be regarded as error-correction in terms of the desired end-state of being at the shops. A ground-to-air missile homing on its target would be another example of a future-directed, error-controlled system. The point may

seem trivial and yet it is of great philosophical importance. For centuries people have been able to argue that there is a fundamental difference between living and non-living entities in that animals, including man, are able to be purposeful, to act towards the future in some mysterious way. Non-living entities, on the other hand, were supposed to be always subject to cause-and-effect principles, to be explicable in terms of previous rather than future events. In terms of the examples we have just seen, this particular argument is clearly not valid. Purposeful behaviour by animal or machine can be explained in identical 'cause-and-effect' terms.

Automata theory

Although in terms of the definition of cybernetics, automata theory may seem to be less central than information and control theory, in practice it has been closely bound up with the development of cybernetics.

Its nature can perhaps be most easily understood by contrasting it with information theory. If information theory is essentially a part of probability theory and is concerned with quantities, automata theory is part of metamathematics and is concerned with proof. We could perhaps call automata theory 'the logic of systems'. The term *automaton* means in this modern sense essentially a system or machine which is deterministic and to which probability notions do not have to be applied. In automata theory an automaton is an ideal, an archetype, rather like a diagram in Euclidean geometry in which we do not have to take into account the thickness of the lines.

Automata theory is concerned with what kinds of behaviour can and cannot, in principle, be achieved by different kinds of systems. For example, what are the minimum properties which a system would need in order to carry out a computation of a particular kind? An especially striking question of this sort is: Is there any logical contradiction in the idea of a system being able to reproduce itself and, if not, what are the requirements? This particular question in automata theory has received much attention, the classic work being done by von Neumann [6].

Metamathematics, the field which automata theory derives from, is concerned with studying the notion of proof in mathematics. That is, it is concerned with questions like: In what sense are mathematical statements true? How can we justify the methods of deduction used in mathematics?

In order to carry out investigations in this area, Alan Turing [7], a British mathematician, proposed that for certain purposes (those relating to a general problem described by Hilbert and Ackermann [8]) it might be useful to think in terms of a theoretical

Fig. 5. Relations between the three different poles of interest of cybernetics.

$A{\rightarrow}B$ Using theory for practical purposes, e.g. control theory to construct missile systems.

$A{\rightarrow}C$ Using theory to increase understanding, e.g. automata theory to understand biological development.

$B{\rightarrow}A$ Development of theory due to practical problems, e.g. information theory developed for needs of communication engineers.

$B{\rightarrow}C$ Hardware systems used to increase understanding of organismic systems, e.g. computers programmed to help to understand human thinking. (Often A and $B{\rightarrow}C$.)

$C{\rightarrow}A$ Development of theory due to pure research problems, e.g. concept of homeostasis from study of physiological processes.

$C{\rightarrow}B$ Biological systems studied to help construct better hardware systems, e.g. study of human thinking to improve computer programming. (Often A and $C{\rightarrow}B$.)

machine, since called a *Universal Turing machine*, for carrying out mathematical computations by means of well defined programmes (sequences of instructions which specify how the machine will act). When automata theory developed, the use of Turing's archetype computer became a widely used way of carrying out investigations in the area. It also, incidentally, stimulated the realization in hardware form of the modern general purpose digital computer.

A successful programme for a Turing machine—that is, a programme which inevitably leads to a given end-product being achieved—is an example of what are called 'effective computational procedures' or *algorithms*. Much of automata theory, therefore, is concerned with discovering whether there are algorithms for achieving different mathematical and logical ends.

Another type of theoretical machine used in automata theory is the *network*. This type of automaton was first introduced into the theory by McCulloch and Pitts [9]. A network consists of a set of interconnected elements, information being able to flow under appropriate conditions between elements so connected. The network as a whole acts to transform information inputs of various spatial and temporal configurations into various outputs. The algorithm of a network is not represented by a programme as it is with a Turing machine but is implicit in its structure.

III. THE STRUCTURE OF CYBERNETICS

So far the impression may have been given that all of cybernetic research is devoted to developing various mathematical and logical ideas for their own sake. If this was the case, cybernetics would not have the pervasive influence which it is coming to have across a wide variety of subject-matters including engineering, biology, physiology, medi-

cine, psychology, psychiatry, anthropology, sociology, economics, education and business management. In fact, there is something of a two-way process involving abstract ideas from cybernetics becoming applied in various concrete situations, the latter sometimes giving rise to further developments of theory.

There is also something of a two-way process at the level of concrete systems in that cybernetics is in part, as implied by its definition, a comparative study of animals and machines. On the one hand, biological processes are studied in order to discover ways of designing more sophisticated (purposeful, intelligent, adaptive, flexible) machines for various purposes. On the other hand, study of the way in which engineering systems (like computers) achieve various ends (and also the building of special-purpose hardware models) may give insight into the way in which organisms achieve similar ends. In this way, continual interaction between the study of engineering and biological systems is mutually beneficial to both. Typically, however, this interaction will be mediated by ideas at the more abstract level of cybernetic theory. In doing this cybernetics is not so much reducing man to the level of 'machines' (in the conventional sense) as elevating machines to the level of man.

The whole situation, representing the relations between the three different poles of interest of cybernetics, is represented in Fig. 5. The six relationships that are involved are listed in the table below this figure.

Let us look at some examples of cybernetic research directed towards the ends of pure and applied science.

A widely used technique in pure science is that of *simulation*, of making a model of the process being studied in order to understand it better. A cybernetic model of a biological or psychological process

is a dynamic, or behaving, system, which is in some way directed by, or described in terms of, cybernetic concepts of the type described earlier. Two types of model are especially prevalent in cybernetics: hardware models and models in the form of computer programmes. A well known example of a hardware model is that of Grey Walter's mechanical tortoises [10]. These ingenious devices demonstrate that life-like purposeful behaviour can be produced by a comparatively simple hardware system. A mechanical tortoise is in fact not much bigger than a living tortoise and moves around on wheels searching for sources of light and finding its way around barriers placed between itself and the light source. An example of a computer model would be the General Problem Solver programme of Newell, Simon and Shaw, which can prove theorems in symbolic logic and in parts of mathematics, and which appears to do so in a similar way to human beings faced with the same problems [11].

When we turn to the practical problems of applied science, we are faced with a number of terms which refer to different aspects of the contribution of cybernetics to this area. The term *bionics* for example is used to refer to the technique of designing and constructing hardware systems using principles derived from the study of biological systems. And the term *cybernation* is used to refer to the application of cybernetics to industry. The aim of cybernation is to go further than automation by increasing still further the autonomy of an industrial system. Looking to the future, this might involve the construction of equipment which not only controls itself but also repairs itself when it goes wrong and also perhaps equipment which can learn for itself how best to carry out various tasks. The idea of automating the board room to some extent as well as the factory floor is also part of the brief of cybernation.

But the best established area of 'applied cybernetics' must be that referred to by the term *artificial intelligence*. Most of the work here has been on the question of how to programme computers to think more intelligently: to learn in various ways, to play games like chess, to prove theorems, to make decisions, to take intelligence tests, to recognize patterns, to control experiments, to translate, to understand and use ordinary language, to teach ('computer-assisted instruction') and so on.

The most important development in the attempt to programme computers to achieve the ends listed has been the idea of *heuristic* programming. A heuristic programme is one which uses a general strategy (rather like human beings appear to do) which gives good odds for the achievement of a solution even though it cannot guarantee, as an algorithm does, that the problem will be solved. This technique has two advantages over algorithmic programming: firstly it can increase the speed with which a solution is found, algorithmic methods tending to be lengthy and inefficient. Secondly, it can be used in situations where there are no known algorithms, so giving the computer a chance of coming up with a solution which would otherwise

be unobtainable. An example of this is Samuel's programme [12] to learn to play checkers and to improve its performance continually. Now checkers is a game which is complex enough to prohibit the use of algorithms for all practical purposes and this learning programme can be regarded as heuristic. A token of its success is that it has been able to beat Samuel himself and this brings out an important point: the ability or intelligence of a programme is not limited by the intelligence of the designer of that programmer. The old idea that 'you only get out of a computer what you put into it' is therefore, in an important sense, incorrect.

It would be possible to argue that the contribution of cybernetics to applied science is much greater than would be implied by the last few paragraphs alone. It could be pointed out for example that the attempt by the United States to put a man on the Moon involves the practical use of control theory, information theory and artificial intelligence. Such work as the Apollo project derives in a very real way from the work of Wiener and others during the Second World War on designing computational devices for use in anti-aircraft warfare—the work which led Wiener originally to the concept of cybernetics. However, the point at which cybernetics proper merges into other areas is difficult to determine.

Finally, in the light of the broad description of cybernetics given here it can be seen that there are many misinterpretations of cybernetics and that many of these are widespread. Cybernetics is not just another name for automation, or for information theory, or for computer technology. It involves more than the concept of feedback. It consists of more than a simple analogy between men and machines. What it does represent, above all, is a certain attitude to complex purposeful systems and a host of precise conceptual techniques for dealing with them.

IV. THE RELEVANCE OF CYBERNETICS TO ART

Let us now turn to the question of the relationship between cybernetics and art, using the term 'art' in its widest sense to include for example musicians and poets, as well as practitioners of visual fine art.

Understanding artistic behaviour

The first relationship that one can specify is this: cybernetics, in its quest to understand complex human behaviour may be able to throw light in due course on that highly complex type of behaviour called 'artistic'—a type of behaviour clearly involving control and communication.

By 'artistic behaviour' I am referring to the whole process of artistic communication which starts with various interacting emotional and intellectual processes in the nervous system of the artist himself, becomes transformed into a 'work of art' through a channel which may be noisy (e.g. incompetent technique, bad materials, random disturbance),

the work of art in turn communicating to an audience through another noisy channel (e.g. incorrect interpretation in music and drama, poor translation in literature, damage to a piece of sculpture, poor lighting of a picture and the various shortcomings of the audience itself, including the noise caused by preconceptions, physical incapacities, span of attention, etc.); finally it becomes involved in the interacting emotional and intellectual processes in the nervous systems of the spectators themselves. And this whole situation is one which involves many feedback processes including those between the artist and the work of art he is in the act of creating, between the work of art and its audience, and between the audience and the artist through criticism in the short-term and, in the long term, through the giving or withholding of financial support. A more precise and detailed understanding of this whole control and communication situation might help the artist himself in due course to improve his technique.

As can be seen, then, some of the concepts of cybernetics are directly applicable to art. Meanwhile much cybernetic-oriented research is helping to unravel the mysteries of human thinking and communication through, for example, computer models of problem-solving, pattern-recognition and so on. This may in due course help to provide a more substantial insight into art. A few workers like Pierce [13], Goldacre [14], Mueller [15] and, especially, Moles with his book on *Information Theory and Esthetic Perception* [16] have already started to investigate art directly using cybernetic ideas and techniques. In such cases the temptation to try to reduce art to something simpler has been avoided: it is accepted as complex in its essence. The Gestalt view is one which is entirely consistent with cybernetics, except that cybernetics now provides techniques unavailable to the Gestaltists for a precise and objective treatment of what one might term 'non-decomposable' systems. Indeed, I have argued elsewhere [17] that the work of art itself may be conceptualized from a cybernetic point of view as a complex dynamic system which in certain of its aspects may be similar to the functioning of a developing organism.

Creating works of art

We now come to the relationship of immediate interest to practising artists: the use of cybernetics in the creation of works of art. Although cybernetics has been used in a technical sense in, to give the major example, programming computers using information theory to compose music, its main influence has been rather different. That is, it appears to have captured the imagination of many artists, in a general way, and so stimulated new works of art or even new types of art. (It may also have changed the attitude of the spectator to some degree.) The reasons for all this are none too clear. But one can list the following speculative reasons: the promise that cybernetics holds out of taking art seriously (as mentioned at the beginning of this article), the

feeling that cybernetics is in some way bound up with exciting intellectual developments in other fields and that in some obscure way it points to the world of the future, and also possibly a feeling that a rapprochement between science and art would be beneficial to both and that cybernetics represents an ideal vehicle for such a rapprochement. None of this explains why artists have become attracted to some cybernetic ideas, like the idea of feedback, rather than other ideas. One cannot help but feel that if the idea of algorithms had been adopted by artists instead, then a quite different, more ordered, more deliberate, kind of cybernetic art would have emerged.

In this section I shall, then, be simply reporting on the ways in which cybernetics happens to have excited and influenced artists up to the present, rather than on what one might consider rigorous inferences to be made from cybernetics to art. It is possible to list these developments under three closely related headings.

1. *The idea of machines as works of art.* One way in which cybernetics may have influenced art is through helping to break down the widespread feeling that there is some necessary antagonism between art and machinery. If it had not been for the demonstration by cyberneticians of how intelligent and purposeful machine behaviour can be and how arbitrary the living/non-living distinction is for many purposes, it is conceivable that the negative connotations towards machinery might have been so great that, for example, kinetic art would have taken longer to develop.

2. *Machines to create works of art.* Some artists have thought in terms of not only creating works of art in the form of machines but creating machines to create works of art. Many examples of this were included in the exhibition of 'Cybernetic Serendipity' which took place in London in 1968 and represents a high point in the early development of a self-consciously cybernetic art [18]. Examples include pendulum drawing machines and Tinguely's painting machines. With Tinguely's machines both the machine in action and the results of this action may be regarded as art. Another notable example of a machine-artist is the robot painter of Hoenich [19].

In this category we must include computer programmes written to simulate (and even improve upon) the work of the artist. Examples of this include computer-generated visual patterns, e.g. Noll [20] and Mitchell [21], programmes to write poetry, e.g. McKinnon Wood and Masterman [22] and programmes to compose music. As far as the latter is concerned, the work of Hiller, Isaacson and Baker [23–25] represents probably the most detailed and serious work yet on computer-generated art of any kind and is related to their analysis in statistical and information theory terms of different types of music. Many other examples of computer art will be found in the catalogue of the 'Cybernetic Serendipity' exhibition [18].

3. *Art as a process.* The emphasis of cybernetics on process and change may have been one of the

factors generating an increasing feeling among artists that art should be regarded as a process rather than as the production of static objects. This feeling has manifested itself in a number of ways including the production of works of art which are impermanent, the advent of the 'happening' as an art form and the deliberate and creative utilization in some works of kinetic art of the participation of the spectator, i.e. of feedback between the spectator and the work of art. Ascott has argued forcefully [26] that the aim of art should be the process-oriented one of producing further artistic activity in the observer, and that this can be achieved by both the stimulation of art objects and also by certain kinds of social interaction, especially a type of social interaction which constitutes what he calls a 'cybernetic art matrix'.

One of the consequences of the developments under these three headings is the blurring of some of the traditional distinctions between the work of art and the system which creates the work of art, and between the work of àrt and the system which observes the work of art. How far cybernetics has really been instrumental in bringing this about and how far other major factors have been involved is impossible to estimate.

Cybernetics as art

As well as the two kinds of relationships outlined above between cybernetics and art, there is possibly a third and even more intimate kind of relationship: it may be the case that cybernetics is, in part, an art form as well as being a science. In a sense most applied branches of science (e.g. civil engineering) involve elements of art. But cybernetics appears to generate art even in its pure science aspects. It produces, especially through the process of model building, entities which often seem to possess aesthetic as well as scientific value.

Of course it could be argued that pure science and art are in any case not as incompatible as they are often assumed to be and that the same processes are involved in both. Koestler's idea of 'bisociation' for example demonstrates that creative activity in all fields may be essentially the same [27]. Nevertheless there could be a particularly close relationship between cybernetic model-building and artistic creation in that the cybernetician as modeller (at least in hardware) is creating as well as discovering, is expressing his ideas in concrete terms and, in doing so, has a flexible choice of methods and materials which to some extent allows him to express his own preferences and individuality. It is my own impression that a successful model often involves a combination of elegance and satisfying complexity which together are irresistibly pleasing. It could be said that models like Ashby's Homeostat [28] and Grey Walter's mechanical tortoises [10] were among the first, and are still among the most satisfying, pieces of kinetic art. It is perhaps not without significance that in introducing the exhibition of cybernetic serendipity, Jasia Reichardt was able to point out how difficult it was, without checking the notes relating to the works, to know whether one was looking at something made by an artist, engineer, mathematician or architect and she could easily have added biologist and psychologist to the list.

ACKNOWLEDGEMENT

I should like to thank Mr. Alvin Lewis for his drawing of a Watt governor shown in Fig. 3.

REFERENCES

1. N. Wiener, *Cybernetics* (New York: John Wiley, 1948).
2. C. E. Shannon and W. Weaver, *The Mathematical Theory of Communication* (Urbana: University of Illinois Press, 1949).
3. H. Quastler (Ed.), *Information Theory in Biology* (Urbana: University of Illinois Press, 1953).
4. M. J. Apter and L. Wolpert, Cybernetics and Development 1. Information Theory, *J. theoret. Biol.* **8,** 244 (1965).
5. L. A. MacColl, *Fundamental Theory of Servomechanisms* (New York: Van Nostrand, 1946).
6. J. von Neumann, The General and Logical Theory of Automata, in L. Jeffress (Ed.), *Cerebral Mechanisms in Behavior* (New York: John Wiley, 1951).
7. A. M. Turing, On Computable Numbers with an Application to the Entscheidungs-problem, *Proc. Lond. math. Soc.* **42,** 230 (1936).
8. D. Hilbert and W. Ackermann, *Grundzuge der Theoretischen Logik* (Berlin: Springer, 1928) Chap. 3.
9. W. S. McCulloch and W. Pitts, A Logical Calculus of the Ideas Immanent in Nervous Activity, *Bull. math. Biophys.* **5,** 115 (1943).
10. W. Grey Walter, *The Living Brain* (London: Duckworth, 1953).
11. Newell, A. and Simon, H. A., GPS, A Programme that Simulates Human Thought, in E. A. Feigenbaum and J. Feldman (Eds.) *Computers and Thought* (New York: McGraw-Hill, 1963).

12. A. L. Samuel, Some Studies in Machine Learning Using the Game of Checkers, in E. A. Feigenbaum and J. Feldman (Eds.) *Computers and Thought* (New York: McGraw-Hill, 1963).
13. J. R. Pierce, *Symbols, Signals and Noise* (London: Hutchinson, 1962) Chap. 13.
14. R. J. Goldacre, Can a Machine Create a Work of Art? *Actes du 2e Congrès International de Cybernétiques*, 683 (1960).
15. R. E. Mueller, *The Science of Art* (London: Rapp and Whiting, 1968).
16. A. Moles, *Information Theory and Esthetic Perception* (Urbana: University of Illinois Press, 1965).
17. M. J. Apter, *Cybernetics and Development* (Oxford: Pergamon, 1966) Chap. 8.
18. J. Reichardt (Ed.), *Cybernetic Serendipity*, A Studio International Special Issue (1968).
19. P. K. Hoenich, Kinetic Art with Sunlight: Reflections on Developments in Art Needed Today, *Leonardo* **1,** 113 (1968).
20. J. McCarthy, Information, *Scient. Am.* **215,** 65 (1966).
21. R. K. Mitchell, Computer Art, *New Scientist*, **357,** 614 (1963).
22. R. McKinnon Wood and M. Masterman, Computer Poetry from CLRU, in Reichardt J. (Ed.), *Op. cit.*
23. L. A. Hiller and L. M. Isaacson, *Experimental Music* (New York: McGraw-Hill, 1959).
24. L. A. Hiller, Computer Music, *Scient. Am.* **201,** 6 (1956).
25. L. A. Hiller and R. Baker, Computer Music, in H. Borko (Ed.), *Computer Applications in the Behavioral Sciences* (New Jersey: Prentice-Hall, 1962).
26. R. Ascott, The Cybernetic Stance: My Process and Purpose, *Leonardo* **1,** 105 (1968).
27. A. Koestler, *The Act of Creation* (London: Hutchinson, 1964).
28. W. Ross Ashby, *Design for a Brain* (London: Chapman & Hall, 1952).

I. NOTES FOR A SCIENTIFIC THEORY OF AESTHETICS*

Louis Rapkine**

I. ON AN EXPERIMENT IN PHYSICS

In Fig. 1 is shown a sketch of two hollow spheres, A and B, connected by a pipe provided with a stop-cock. Assume that flask A is filled with a gas made up of N molecules, N being a very large number and that in flask B there is a vacuum, i.e. there are no molecules in it.

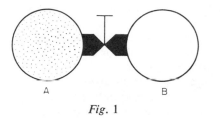

Fig. 1

Now, suppose that the stop-cock is opened. What is the probability that all the molecules in A will remain there? The answer is that the probability is extremely small—actually, it approaches zero.

What is the probability that the molecules of the gas will distribute themselves uniformly in the two flasks? It is very great, i.e. the probability approaches 1.

When the gas flows from A to B the gas expands and the *entropy*, as defined in thermodynamic theory, increases, that is, the entropy increases as the state of probability increases.

II. PROBABILITY AND ORDER

In the example above, the presence of all molecules in flask A and none in the other flask means that there was a certain order established among the molecules (they were all on one side of the system consisting of two flasks and the interconnection). When the stop-cock was opened there resulted, so to speak, a shuffling of the molecules.

Consider another example. If a pack of cards is arranged in suits and in the order of increasing numbers, i.e. 1, 2, 3, 4, etc., it is in a state of least probability for a shuffled deck, for the chances of the third card from the top being anything but a 3 is zero.

If the pack is shuffled thoroughly, the chance that the third card will not be a 3 is very great. Thus the state of *maximum probability* corresponds to the state of *maximum disorder*.

III. TIME AND IRREVERSIBILITY

Time does not appear to be reversible, i.e. it is unidirectional. A person grows older not younger. The process of shuffling a deck of cards entails the passage of time and an increase in disorder of the suits in the pack. Therefore, the *passage of time* is accompanied by an *increase* in the state of probability and an increase in entropy.

Another example: In an unmagnetized metal its molecules point in all directions. If the metal is placed in a strong magnetic field, the molecules will orient themselves in the direction of the magnetic lines of force. It has been found that when the metal is alternatively magnetized and demagnetized (an order-disorder process), its temperature will fall. The drop in temperature occurs at each demagnetization. (The physicist, Langevin, proposed the use of this process to obtain extremely low temperatures.)

Since the change in the orientation of the molecules in the metal above corresponding to the demagnetization is *irreversible*, unless acted upon by an external force, we conclude that an irreversible change in a system is accompanied by a drop in temperature or by an increase of entropy. But time is *irreversible*, therefore, its passage must also be accompanied by an increase of entropy (or by an increase in disorder).

For animate, organized beings the time factor is particularly important, since within a relatively short passage of time the organism ceases to exist, i.e. to be animate. This means that the physico-chemical processes involved in living matter of *life* must be of a highly irreversible character (there is a continuous loss of energy and, therefore, living matter ages).

Thus we can say that the process of ageing tends toward the maximum state of probability or the maximum state of disorder within the organism. Every living cell might be said to partake of the universal instinctive consciousness of the irreversibility of time.

* The basis for the text of this document was prepared in 1945 and remained unpublished.

**French bio-chemist, at his death on 13 December 1948 he was Head of the Department of Cellular Biology at the Pasteur Institute, Paris, France. (Document received from Jacques Mandelbrojt on 1 December 1969.)

IV. CONSCIOUSNESS AND TIME

Consciousness of time increases as the complexity of organization of living matter increases. A human being is a very complex organism who manifests aesthetic sensibility. An object of aesthetic value is accompanied by special emotional reactions. What is it that causes these reactions?

My answer is: *the desire to stop the flow of time.*

We have seen above that the process of ageing is a process that tends to maximum disorder in the system. *Art* is an expression of an urge to counter this phenomenon—it creates order. What is so emotionally powerful about art is that it combats ageing. Art is an attempt to stop the increase of entropy. A work of art is the realization of a state that is contrary to the process of ageing—a realization of order made to deter the tendency towards disorder.

The arrangements of tones in a musical composition define specific interrelationships or maximum order. The same objective is achieved by means of line, composition and color in painting and by lines, surfaces and volumes in a sculpture. One can understand why a form of order in motion is superior to a static form of order. While a pianist sits at the piano, the cells of his body are quietly dying but when he is playing, his muscles produce mobile states of order that oppose the flow of disorder in his body. The more mobile the order produced in a work of art, the more powerful its effect because of its truer juxtaposition but in the opposite direction to the natural, irreversible direction of flow of time in nature. Hence, the necessity in painting, sculpture and architecture of producing forms that convey the impression of mobility in order, so finely exemplified in the arts involving time, such as music, drama and dancing.

The more sensitive a creator is to the universal intuition of life and death, the greater will be his work of art.

Why are there qualitative differences in the arts of different periods?

Why is the order corresponding to more possibilities the more effective aesthetically?

In music, syncopation, the production of suspense, is like a rock poised on the edge of a precipice.

The great interpreter of music is the individual whose whole organism during a performance is in a state of multiple and proportional correspondence with the music he is playing. He is the one who can so control his physical and mental state that most of the interfering impulses that normally exist in an organism are reduced to a minimum—i.e. they are in a state of maximum order with reference to the musical composition.

The composer must have a keen sense of life and death, and, therefore, a greater awareness of the various emotions engendered by this sensitivity. He will have the tendency to purify, to crystallize his sensitivity into maybe conflicting but co-existent emotions. This is in contradistinction to the process that takes place in non-creative persons who rarely free one emotion from others. I believe this is what accounts for the overwhelming impression produced on us by the works of, for example, Bach, Mozart, Haydn and Beethoven.

We regard as beautiful all that possessing the values of order corresponding to our urge to arrest the flow of time, to stop the process of degradation. The painter and the sculptor must introduce many factors in order to make their works mobile. (My preference for sculpture is related to its having the greater mobility of form.)

Asymmetry creates a feeling of suspense. It is a property of biological material. Most of the molecules that are in our body are not quite symmetrical. Asymmetry is very important for giving a feeling of motion.

II. COMMENTARY ON THE AESTHETICS OF LOUIS RAPKINE*

Jacques Monod**

The fact that complex, fragile and unstable structures of living creatures can exist and reproduce themselves seems to constitute a permanent challenge to the second law of thermodynamics. [The law states: It is impossible for heat to go of itself from a colder to a warmer body. A measure of the degree of irreversibility of a thermodynamic process is known as the change of the *entropy* of the system.]

Living matter, at the price of increasing entropy in the rest of the system of which it is a part, maintains its own structure (complex and, thus, improbable; improbable and, thus, unstable) and gives birth to other structures that are just as improbable. In order words, living creatures achieve in their organism *an increase in potential relative to their environment*, they are *hot points* in the universe. These tiny islands of improbable events are finally overcome by *time* and in this sense they are challenged by time.

There are fundamental concepts in biology, for example, the *gene* in chromosomes, that are used to account for the paradox of living matter—the paradox of an improbable structure of atoms and molecules not only maintaining itself in time but also reproducing itself.

Man comes closest in his works of art to expressing the miracle of organization that is life—for a work of art is also one of the most improbable structures that can be imagined. One can, therefore, say that, at least *symbolically*, a work of art is an apparent exception to the second law of thermodynamics, for it produces a local increase in potential energy,

which persists in a definite region in space and resists the general evolution of the universe. The *aesthetic sensation* of a work, thus, gives the beholder an illusion of stopping time. That one can be conscious of this illusion implies that we have an intuition of the irreversibility of time, which may only be an aspect of our experience of the existence of time.

A work of art can be considered a *source of energy* for viewers, in that it possesses the properties of a structure with a high energy potential which may be transmitted to them.

There are two further remarks I would like to make. The first one is that, at present, we have no algorithm or procedure that allows one to determine the degree of order in a work of art. It would be a naïve misinterpretation of Rapkine's fruitful ideas to try to get from them a 'recipe' for judging the value of a work of art.

Furthermore, one encounters the problem of the *communicability* of a specific work of art when examining its aesthetic properties: that is, under what conditions can one recognize its degree of order. Rapkine's theory gives us an idea of the way to state this question, which can be described by means of the following tempting, physical analogy:

If a part of the energy of a physical system is to be transmitted by resonance to another one, there must be specific similarities between the two systems. Therefore, for a work of art, considered as a structure with a very high degree of order and with transmittable energy, to provoke resonance in a beholder, there must be a minimum of specific similarity of experience between the beholder and the content and sense of order in the work of art.

* Extracts from a lecture in French delivered in 1950 at the College Philosophique, Paris, France.

**French biologist and musician (1910–1976). Nobel Prize in 1965.

III. COMMENTS ON RAPKINE'S NOTES AND MONOD'S COMMENTARY

Jacques Mandelbrojt*

When Louis Rapkine wrote his notes in 1945 for a scientific theory of aesthetics, modern information theory did not as yet exist. Its foundations were laid in 1948 by Claude Shannon. It appears to me that this theory and the following developments involving linguistics, as, for example, Benoit Mandelbrot's study entitled 'Thermodynamics of Discourse', possibly provide a new interpretation of Rapkine's ideas. A clearer idea of the meaning of such concepts as *entropy* when applied to works of art can be obtained. Also, information theory gives a possible answer to the problem posed by Jacques Monod in his comments above of finding an algorithm or procedure for determining the degree of order in the structure of a work of art.

Information theory permits one to give precise meaning to the statement that 'human discourse is both highly structured and highly unpredictable' [1]. Low entropy of a work of art is interpreted as meaning that its content is not redundant or that it provides the largest amount of information with the least means.

For instance, the music of Webern gives me a maximum amount of emotional satisfaction and musical meaning in a highly concise form. (I feel the same way about certain oriental paintings.) Romantic music is very redundant. There have been numerous attempts in recent years to determine the most satisfactory amount of redundancy in a musical composition [2].

*Theoretical physicist and artist living at Le Bastidon, 13510 Eguilles, France.

The novel, *Ulysses*, by James Joyce is certainly not concise in form, however, it is 'dense', that is, the amount of information per word is large. When the reader understands the beginning of one of his paragraphs, he seldom knows how it will end. This means that each word or phrase introduces new information. Furthermore, the highly unpredictable character of his text provides the pleasure of surprise. The prose of Joyce is certainly not a manifestation of the principle of least action or effort, as is a hastily written message to one's daughter!

One can also apply this analytical approach to the comparison of classical and baroque art, to stochastic or aleatory art works and to 'minimal' art.

One very important point, which was central to Rapkine's ideas and which may not have been adequately taken into account in the recent studies I have referred to, is the importance of *potential*. The preference of Rapkine for an order difficult to maintain, as in the case for living matter, explains his preference for a mobile or kinetic order rather than for a static one. He found that some of Picasso's paintings, which contain heavy shapes supported by fragile shapes, have an order of this type—they can be said to have a *potentially mobile* order.

At the time that Rapkine wrote, the 'modern' phase of kinetic art had not as yet gotten under way but one can assume from his notes that he would have been well prepared to appreciate this form of plastic art.

ACKNOWLEDGEMENTS

I would like to thank Jacques Monod and Frank J. Malina for co-operating with me in preparing this document on the ideas of Louis Rapkine, which deserve to be better known to the world of art.

REFERENCES

1. B. Mandelbrot, *Information Theory and Psycholinguistics: A Theory of Word Frequencies*, Readings in Mathematical Social Sciences (Cambridge, Mass.: The M.I.T. Press, 1967) p. 350.
2. A. M. Yaglam et I. M. Yaglam, *Probabilité et Information*, 2nd. éd., traduit du Russe (Paris: Dunod, 1969).

SOME THOUGHTS ON RUDOLF ARNHEIM'S BOOK "ENTROPY AND ART"

Peter Lloyd Jones*

Abstract—*The author points out the attraction the concept of entropy in thermodynamics has had outside of the fields of the natural sciences, especially its philosophical interpretation to confirm a pessimistic outlook on life. He discusses the meaning of entropy in thermodynamics, its implications in the realm of the physical universe and the misunderstanding about it that are prevalent among psychologists, aestheticians and artists.*

Arnheim's book Entropy and Art *is analyzed to show that he fails in his attempts to apply the central metaphor of gestalt psychology of tension reduction in field processes to the interplay of entropy and energy factors in maintaining structure in the world, in particular, in the world of art. The author concludes by stating that artistic, like other human values are not deducible from scientific hypotheses or laws but are assertions of the will.*

I

'What the myth of Götterdammerung signified of old, the irreligious form of it, the theory of Entropy signifies today—world's end as completion of an inwardly necessary evolution.' These opening words are from Spengler's *Decline of the West* [1]. They sum up the extraordinary, even extravagant, impact of the Second Law of Thermodynamics upon the layman. Since artists usually derive their knowledge of such matters from popular accounts in the Spengler tradition, it is no accident that so many artists who have heard of the Law at all echo Spengler's pessimism. For him, under the impact of the scientific idea of entropy: 'Becoming, Become, Destiny and Casualty, historical and natural science are beginning to be confused. Formulae of life, growth, age, direction and death are crowding up.'

Arnheim in his book *Entropy and Art* [2] touches upon these sentiments most aptly when he quotes the sculptor Jean Arp, who found his release from destruction by playing along with fate—accepting humbly, even gladly, the principle of entropy. Casting down fragments of torn paper according to the laws of chance, he made his collages in which 'the dying of a painting no longer brought despair'. For as he says: 'Why struggle for precision, purity, when they can never be obtained?' Why rail against the inexorable processes of decay that destroy the finished painting: '. . . the greasy fingers of the admirer who subsequently breaks into wild enthu-

siasm and sprays the painting with spittle? Dust and insects are also efficient in its disintegration. The light fades the colours. Sun and heat make blisters, disintegrate the paper, crack the paint, disintegrate the paint. The dampness creates mould. The work falls apart, dies.' By accepting hazard in the creation of a work, though, Arp draws the sting from the processes of its decay: 'I had made my pact with its passing, with its death, and now it was part of the picture for me. But death grew and ate up the picture and life. Thus dissolution must have been followed by the negation of all action. Form had become Unform, the Finite the Infinite, the Individual the Whole.'

A principle that can collapse together so many antinomies in the minds of people as otherwise diverse as Spengler and Arp must indeed be worthy of enquiry. And not only these two, for countless artists, musicians and literary men exhibit in the face of entropy pronounced symptoms of what Lovejoy called 'metaphysical pathos'. Not that all sufferers necessarily exhibit Spengler's gloom. For every carrier of thermodynamic '*Sturm und Drang*' there are several laconic jokers in the idiom of Duchamp. This sort of cosmic 'gallows humour' is particularly common among art students and is, at the moment, the more commercially popular variety.

Arnheim is clearly against such negative responses. In particular, he is against certain kinds of art that are, in his view, prompted by a misreading of what it is that science really asserts. Not that Arnheim is exactly explicit about this. One of the

*Artist and teacher, Kingston Polytechnic, Knights Pk., Kingston upon Thames KT1 2QJ, England. (Received 24 Apr. 1972.)

troubles with his essay is the way that he shifts
between the roles of art critic and scientific commen-
tator. Though his artistic values do pop up in
critical asides and sarcastic footnotes, as well as in
his choice of illustrations of art works for appro-
bation. Moreover, at the end of the book he comes
right out and delivers a call for a return to 'articulate
structure' and a 'rehabilitation' of the principle
of order in the universe that looks very much like
a plea for another classical revival.

What is this physical principle that stirs such
violent feelings among artists and aestheticians?
How does it come about that Arnheim, a psycho-
logist, gives a physics lesson to reinforce his attack
on certain painters and sculptors and his support
for others? (A discussion of "entropy and art"
by three scientists can be found in *Leonardo* [3–5].)

II

The Second Law of Thermodynamics asserts a
fundamental asymmetry in natural or spontaneous
processes. This asymmetry is an empirical fact
and the law itself a generalization from common-
sense experience. The law has been stated in a
variety of forms but the formulation of R. Clausius
(1854) is a simple one to grasp: '*Heat cannot of
itself, without the intervention of any external agency,
pass from a colder to a hotter body*.' Let us consider
a commonplace example in thermodynamic terms.
The heat from a kettle of boiling water (the *system*)
always escapes *from* the kettle *into* the colder air
(the *surroundings*), which is thereby slightly warmed
up. Never does this occur in reverse. Once this heat
is dissipated, an *external agency* (again turning on
the gas or electric heat supply) is necessary to restore
the original temperature difference between the
system and its surroundings. Clausius defined a
simple quantity linking heat changes and tempera-
tures that for any *closed* or *isolated* system gives a
measure of this one-way dissipation or *irreversi-
bility*. This he called the *entropy* of the system.
If the Second Law is restated now in terms of this new
quantity, the same fundamental asymmetry comes
out in a new way: *In natural or spontaneous processes
the total entropy of the system and its surroundings
always increases.* (The First Law of Thermody-
namics says that the total *energy* of a system and its
surroundings is always constant, although energy
can be moved around and transformed in kind as
when, for example, the electric energy of the cooker
is changed into an equivalent amount of heat and
used to warm the kettle.)

Now, formally, all of classical thermodynamics
can be developed logically from this point. Here
entropy has been defined in terms of quantities such
as heat and temperature, which are directly acces-
sible to measurement. Problems do arise in giving
precise numerical values to the constants in the
equations of thermodynamics, since what is not
explicit in the discussion so far is the appropriate
baseline from which all measurements should be
made. Subsequent developments have enabled

these constants to be determined. But before dis-
cussing these developments, it is well to consider
first two matters that in thermodynamics up to
this stage have *not* been described or discussed.

First, thermodynamics is *not* concerned in any
way with *time*. The speed or rate at which some
spontaneous or natural process may proceed is not
treated. This is important, for a process that is,
thermodynamically speaking, spontaneous may,
in fact, proceed so slowly from the perspective of a
man's lifetime that we say that *effectively* it never
occurs. There are no immediate grounds for inter-
preting the Second Law as a kind of hourglass, with
the sands of the universe running out before our very
eyes, bringing us to a 'heat-death' that may occur
before we have finished our painting tomorrow!
A millennialism that sees 'the hour at hand' is a
psychological commonplace of many ages and
civilisations but the entropy principle does not
provide the current version with convincing evi-
dence. For one thing, the continuous entropy
increase applies only to *closed* systems. In *open*
systems or in local parts of larger systems, decreases
in entropy can and do occur. Life occurs in one of
these regions of decreasing entropy and, while
over infinite periods of time these enclaves will
doubtless vanish, this will not happen tomorrow.

Second, thermodynamics does not say anything
about *structure*. It is completely independent of any
notions about the composition of matter or about
the nature of energy (such as the atomic theory).
Thus, although its concepts are cast in terms of
concrete measurable quantities, they are highly
abstract. It operates, in fact, without any model
or picture of reality whatsoever. Unlike most other
concepts, entropy does not visualize in terms
familiar from everyday life ('billiard-ball' atoms,
for example) some properties of substances that it
thereby hopes to explain. On the face of it, therefore,
the Second Law seems an unlikely candidate for a
grandiose metaphor for degeneration and decrepi-
tude. Why then has it been so often thus construed?

An important reason seems to be the particular
form of the law itself, the way it is logically laid out.
It is an example of the type of formulation based on
extremal principles, namely, 'that such and such a
change proceeds in a manner such that some magni-
tude which represents possible configurations of the
system is maximized or minimized'. Nagel has
pointed out that, while in general *all* quantitative
laws can be so formulated, the general habit of
scientists is not to do so [6]. Now the more usual
formulation of scientific laws 'that some function
of state varies in a determinate fashion with respect
to another' is easily associated with the intuitively
mechanistic view of cause, since the two functions
can be visualized as isolated 'parts' moving with
respect to one another. Extremal principles, on the
other hand, easily acquire anthropomorphic over-
tones, since it appears that different 'parts' of a
change must 'conspire together' in order to obey
some more general global constraints. Nagel's
extremal reformulation of Boyle's Law makes the

point clear: 'Every gas at constant temperature alters its volume to keep the product of the pressure and the volume constant.' Nagel comments that 'physicists would find this preposterous or at best misleading'. For the natural question that comes to mind from such a statement of Boyle's Law is: 'How does the gas know how to do this?' The linguistic *form* of the statement is too suggestively close to that which we usually reserve for agents co-operating toward some goal. An inherently anthropomorphic response arises from the very sentence structure of laws laid out in this way. Spengler's 'twilight of the gods' is in this sense a *natural* layman's response to the entropy principle in its most general form. The neutral sentence structure of conventional formulations, on the other hand, reinforces the apparent impersonality of science.

It is, however, later developments that arose in the successful attempts to derive absolute values of entropy that provided the substance for the colourful prophecies of Spengler and his followers. In the reduction of thermodynamics (as discussed up till now) to statistical mechanics, the notion of *structure* (defined in a statistical manner) entered the discussion. It is this notion that relates entropy—in a new sense—to debates in psychology and in art.

Consider a pack of cards arranged in order—all the cards of one suit together and in ordinal array. Shuffling this pack produces progressively increasing disorder as the suits and numbers become more and more jumbled up. A similar process can be imagined for the molecules of gas in a box [3]. Random collisions gradually increase the disorder in the system. Now the chances of randomly shuffling the pack back into its original order are very low. Similarly, the chances of the gas molecules all fortuitously forming a patterned distribution are also low. There is thus an asymmetry in the direction of spontaneous processes characterized by the decreasing probability of their being in an ordered state. Boltzmann in 1896 defined a quantity called the *thermodynamic probability of state* that enabled him to connect entropy (in the old sense) with this new quantity. Entropy gives a measure of the degree or extent of disorder in the closed system compared with some ideal perfect pattern or order. Planck in 1912 put forward the idea that this perfect order was the pattern of all substances at absolute zero of temperature when all motion stops. This is the Third Law of Thermodynamics. It is now possible to interpret the Second Law in terms of *a continuing tendency for the disorder in the universe to increase.*

If this is so, we may well ask: 'Why are there any ordered systems at all? Why is not all chaos?' This is where energy comes in. Structural stability is due to the spontaneous tendency of systems to attain the lowest possible energy state. This lowest energy state is invariably characterized by some sort of long-range order or symmetry. Consider the ordered packing of balls in a box. It is easy to see, in a general way, why equal-sized balls will pack closely into an ordered array, with one layer stacked in the depression formed by the one underneath. If there are different-sized balls, then more complex patterns will arise simply from the economics of space packing. If one complicates the situation still further by assuming some force of attraction or repulsion between the balls, then this may modify the pattern still further. There is a vast multitude of physical configurations whose *raison d'etre* lies in combining maximally dense packing, or maximum overlap, or area of contact, or distance of repulsion etc. In all these cases, variously symmetrical or ordered solutions give optimal results in terms of lowest internal energy. The stability of the infinite variety of natural order in crystals can be explained with appropriate combinations of the factors outlined above.

It must be remembered, however, that in real life existing systems are *not* static like those photographs of crystals and diatoms so popular in art books but are in continuous movement of the most complicated kind. As a result, they may spend a considerable part of their time in distorted or strained configurations, a long way from perfect symmetry. The point is, though, that the fact that many things have some (but not perfect) internal order or structure does not, however, call for anything beyond the normal range of physical explanation. Moreover, in physics there exist precise mathematical techniques for predicting the configurations that will have minimum energy. A given geometrical form can be shown to be the consequence of minimizing the internal energy in a precise way, although often enough the calculations are complex and difficult.

III

Arnheim attempts to use the central metaphor of gestalt psychology—*tension reduction* in *field processes*—to describe this interplay between entropy and energy factors in maintaining *structure* in the world. And, since his world includes the perceptual world as well as that of art, it is not surprising that his notions crack under the load. It is remarkable that anyone should still attempt such an ambitious enterprise as the synthesis of physics, psychology and aesthetics—even armed with such an adaptable tool as the concept of the *gestalt*. In the event, gestalt makes a poor showing beside conventional physics. To lump together, as Arnheim does, a vast range of disparate (though determinate) interactions under one grandiose 'Law of Dynamic Direction' is to pin on them an honorific label with no predictive value whatsoever.

More important, though, is the way that continuous shifts of meaning in the discussion of order, structure and form make the relationship (if any) between art and physics remarkably obscure. Unless order is defined with mathematical rigour and the limits of the system pertinently drawn, almost anything can be blamed on thermodynamics. This is where Arnheim is fatally vague, for he tries to maintain a distinction between 'real order' and 'mere

orderliness' that depends on criteria completely extrinsic to physics. Some sense of this distinction can be gleaned from a quotation that Arnheim uses to open the book, a passage from Marcel Butor pointing the difference between the apparent order of the regular skyscraper grids of New York and the teeming chaos behind the patterning of the facade. Instead of 'real order' (i.e., a built form where regularity expresses some 'genuine' social organiz- ation) we have 'mere orderliness'. Arnheim's distinction is not helped by his own difficult writing on the matter, for example: 'Homogeneity is the simplest possible level of order because it is the most elementary structural scheme that can be submitted to ordering. Orderliness comes in degrees, order comes in levels. A structure can be more or less orderly at any level of complexity. The level of ordered complexity is the level of order.'

It is always important to remember that the interpretation of entropy in terms of structure (order and disorder) depends on the assumption of isolated or closed systems that contain astronomically large numbers of specifiable elements. Only then are the statistical assumptions of Boltzmann valid. The Second Law may well fail for systems with small numbers of elements. Thermodynamics will pre- dict that under certain conditions sugar will crystal- lise out at the bottom of the tea cup. It will not predict whether it will be in the form of one crystal or of many small ones. In such conditions it is better to avoid the use of entropy altogether— even as a metaphor. Certainly, when Arnheim takes a statistical notion and applies it to a single work of art (wherein the notion of a part or element is at best vague), as, for example, where he says that 'the work of art represents a state of final equili- brium, of accomplished order and maximum relative entropy', the scientific content of the term is drained away entirely.

Arnheim is, of course, right to assail the naive formalism that arises when notions like entropy are taken out of their context and used to reinforce theories of art. The snag is that his own apparatus of gestalt psychology is just as vulnerable. Its central concepts have little or no heuristic value in any art work of sufficient complexity to interest us. As a tool for art criticism, gestalt psychology has always run into the same trouble. If 'tension reduction' really is a universal principle shaping our percepts into the simplest available structure, should we not have a preference for just those art works that already have a very simple structure? In general we do not. We tend to find them banal or boring.

Total unity is, in the event, *less* interesting than 'unity in variety'. This is what Arnheim is groping at in his accounts of the 'clash of orders' in complex systems. Without some adequate technical des- cription of the variety of orders though, one is no better off than the traditional critic who points to major themes with their associated sub-plots. When Arnheim is describing the composition of the 'Madonna of Wurzburg', he notes the major axis running through the Madonna and its counterpoint

with the secondary centre of the infant Jesus, while the role of fold formations and the tilt of the Madon- na's sceptre are brought to our attention as rein- forcing the secondary variations. This is true enough but it could have been written before gestalt psy- chology and thermodynamics were heard of. Only windy rhetoric is added when it is explained that the composition is due to an 'interplay of forces in which each element has its appropriate form in relation to all the others, thus establishing a dis- tinctive order in such a way that none of them can press for any change of the interrelation. The play of forces is at a standstill, the maximum of entropy for a given system of constraints has been reached.'

Similarly, Arnheim's criticism of the use of infor- mation theory (which is in many ways connected with the idea of order as expressed in entropy) in art criticism is less incisive than it might have been. However, his analysis of the bizarre manner in which the scientific concepts of *information content* and *redundancy* have been borrowed from information theory by art critics and, in the process, sometimes come to signify the exact opposite of their original meaning is long overdue. In the mathe- matical theory of information, the information content of a sign sequence is defined as its *surprise* or *news* value, calculated from its statistical improbability. The more improbable the se- quence (i.e., rare in a given set of possibilities), the higher the information content. Formally, the equation for the information content of a sequence is identical with that for the thermodynamic probability of state as derived by Boltzmann, except for a difference of sign. For a while the term *negative entropy* was used instead of information content. Although the parallel is real, the usage proved confusing and was dropped. For the layman, however, *information content* is an equally confusing name. As defined, it is entirely a statistical notion in no way related to the commonsense meaning of the term that remains to him intractably concerned with interpretation—what a message 'means'.

Even worse is the confusion that arises over the word *redundancy*. Since a sequence that contains statistical regularities such as homogeneity, sym- metry or the iteration of pattern contributes little surprise value compared with an irregular one devoid of such regularities, it is called *redundant*. The layman, who is unaware that this is a purely tech- nical word for a concept that could well be otherwise named (perhaps by some synthetic Greek word) is puzzled by a usage that seems to imply that all those regularities that constitute the real *form* of the message are in some way redundant, that is to say, *superfluous*! Whether any artist has been misled into producing works more confused than he otherwise might is doubtful but, in any event, the mis- understanding *is* the layman's and not due to some wickedness or stupidity of the information scientist.

A closer look at the passages where Arnheim is discussing this problem reveals, however, that he is not simply taking to task would-be 'scientific' art critics who have not done their homework but is

himself lambasting the information theorist for his 'Babylonian muddle'. He is further castigated as a 'gambler' who: 'Takes a blind chance on the future, on the basis of what has happened in the past. The use of the word redundancy occurs because he is committed to economy: every statement must be limited to what is needed.' Arnheim then observes that the meaning of redundancy in reality depends on 'whether one chops up patterns into little bits or whether one treats them as structures' and continues 'a straight line reduced to a series of dots, for the purpose of piecemeal analysis or transmission can be highly redundant; in the drawing of a geometrician, engineer, or artist it is not. The procession of almost identical figures on the wall of San Appolinare Nuovo in Ravenna are not redundant. They are intended to impress the eyes of the beholder with the spectacle of a multitude of worshippers united in the same religious function. In our own day, Andy Warhol has presented one photograph in rows of identical reproductions in order to explore the connotations of mechanical multiplication as a phenomenon of modern life.'

What this commentary suggests surely is that no purely *syntactic* analysis, however fleshed up with the formal apparatus of science, whether thermodynamics, information theory or gestalt psychology, tells us anything of real interest about such works. Arnheim's analysis consists of an *ad hoc* disentangling of the sociological and historical context of the works cited, i.e. it is quite properly *semantic*. When Arnheim attempts to distinguish between mere orderliness and real order he is not talking about two types of *syntax*, for his descriptions of real order are always in terms of relations to another context, the context of meanings. It is these meanings (for example the felt diversity of social life obliterated by the skyscraper's bland facade) that are held to be more real. Arnheim has fallen between two stools. The art critic, concerned rightly with meaning and significance, has inadvertently got them muddled up with physics. The gestalt psychologist concerned with the interaction of systems into formal orders has got them muddled with the meaning of works of art. Not only does this confusion of categories lead to the Quixotic assertions about order and entropy discussed above, it continually deflects attention from the business of the art critic of probing the details of the context—and in the end to a blindness to formal subtlety, as well.

A telling example of this is the lack of critical grasp in Arnheim's remarks on Andy Warhol and on Minimal Art. The obvious fact one notices about most of Warhol's prints of multiple portrait sequences is that they are *not* identical. On the contrary, by establishing a *prima facie* similarity through our immediate recognition of a familiar face or object, Warhol then forces our attention to small variations in detail of the varying colour and overlap of the printing screens. These tiny and eminently aesthetic variations are in counter-point with the stunningly obvious image. We are forced into a consideration of their relevance in the context of the *significance* of the repeated image that is, after all, not just any image but that, say of Marilyn Monroe, the famous film star of her time. Warhol is not telling us about the graphic reproduction process but, obliquely, about Monroe, our society and ourselves. The minutiae of *formal* variation carry an enormous semantic load. A purely formal description of them, whether in terms of information theory or gestalt psychology, would miss the point entirely.

Ironically, Arnheim evidently dislikes Minimal Art. Taking up Robert Smithson's claim that his minimal geometric shapes provide a 'visible analogue of the Second Law of Thermodynamics', he asserts that the fact that such a claim could be made must be due to a change in our notion of entropy that used to 'deplore the degradation of culture (and) now provides a positive rationale for "minimal art" and the pleasures of chaos'. Later on he mentions in a footnote the (to him) odd fact that 'some people who profess to be repelled by the monotonous rows of identical human dwellings in so called sub-divisions, seem to admire rows of identical boxes in art galleries'. This is again, presumably, a reference to artists like Smithson, Don Judd, Sol Lewitt or Carl Andre, who have at some time been concerned with sequences of repeated cubic or other simple geometric modules. What is missing from such comments is once more an account of the context for these works. For although such simple matters as scale, proportion and visual weight have never mattered so much, these factors are, however, not considered primarily as matters of internal organization or form, as in traditional works such as cubist sculpture. The shapes *are* minimal. They are important rather in relation to the setting and to the spectator. It is *his* responses in the situation that are primarily in question. So much so that the debate on minimal art was overwhelmingly about semantics (and the favourite philosopher Wittgenstein).

It was the fantastic efflorescence of hairsplitting as to the *significance* of minimal boxes that prompted Harold Rosenberg's comment: 'The less there is to see the more there is to say.' But this is obviously bound to be the case. The smaller the number of words in a poem, such as, for example, Haiku (or even in a telegram for that matter), the more attention is shifted to the question: 'What does it mean?' Given this imperative to make sense of a highly attenuated situation in terms of its meaning, there is no earthly reason why a spectator *should* have the same response to homogeneous repetition in two contexts as different as the lot house and the art gallery.

Minimal art, like other art, operates as metaphor. In the case of Smithson, the terminal state of maximum entropy in a closed system has been taken as a metaphor for the boredom and enervation of affluent American life. Life is, of course, an open system in continuous interaction with its environment and the vagueness that overlooks such a distinction is characteristic of the level on which the

3

debate took place. This is not to say, though, that Smithson perceives this enervation any less sharply than Butor or Arnheim. His strictures on the foyer of the Union Carbide Building and 'Park Avenue geometry' are as savage as theirs. It is his reaction, however, that is different. Minimal art jerks us into an awareness of this enervation by giving us nothing else. Its technique is the alienation of the audience and the subversion of its learned responses to existing geometric art, which had up till then been the symbol of a technological utopia.

Alienation was achieved, for example, by combining familiar geometric forms with lurid commercial paint surfaces ('Hi-fi' from the Harley Davidson motor-cycle company). 'An exacerbated gorgeous colour gives a chilling bite to the purist context' remarks Smithson of such 'impure-purism' [7]. Unfortunately, the chill is only temporary. Our ability to stifle the alienation-effect with our own purely aesthetic perceptions has already made these works look like most modern art of other varieties, variously pretty but little else.

The attempt of minimal art to produce 'non-structures' was an equally sectarian inspiration—the interaction of Constructivism, with its emphasis on specified and programmatic structure and Dada nihilism, as represented by the artful solemnities of 'send-up' perfected by Duchamp in his 'scientific' works such as the 'Three Standard Stoppages'— bits of string dropped at random. But here again as anyone who had cared to remember the disappointment over 'free form' verse could have recalled, 'free form is only one more form and not freedom *from* form'. Not that any minimal artist could admit to hankerings after social reform or the invention of a new, more humane architecture. To do so would destroy the alienation effect that relies on insouciant equivocation. Even methodically to correct the errors in their use of thermodynamics is to miss the irony. In Smithson's polemic 'Entropy and the New Monuments', the quotation from Bridgeman on thermodynamics sits down on the page with *Alice Through the Looking Glass*.

It is hard to believe that this technique has in fact had any effect on the more crass optimists of modern science and it is certain that neither exploiters nor consumers have taken the hint. Nonetheless, it is crudely oversimple to range Smithson and his colleagues with the enemy. It is like assuming that in Antonioni's films the bleak geometry of modern interiors reveal him as a frustrated property-developer. Such unsympathetic and even naive critical misunderstandings must be cleared out of the way first before Arnheim's final question can be answered, for it may be in part simply a question about tactics.

IV

When Arnheim reaches into the world of affairs and asks rhetorically 'If all around is confusion and disorder who should we value most, he who expresses this state of affairs with disorder of his own (random ink blots or music scores played with dice) or he who stands against confusion with clarity and order?' he is asking a moral question not a physical or a psychological one. To a question about human values—what should we, as artists, do in a given historical situation, a situation as he sees it, of social chaos and spiritual bankruptcy?—any answer must be a personal one. It is individuals—artists and their publics—who must stand up and be counted. The art critic may judge them, as movements, more or less significant; as intelligent and courageous or, on the other hand, as frivolous, self-indulgent and intellectually shallow. Opinions will vary as to the place of Arp, Duchamp or Smithson on this scale. But a pusillanimous surrender to the real or imagined onslaught of entropy cannot be and does not need to be *refuted* by Arnheim's tortuous logic. It needs only to be juxtaposed with its opposite— a contrary assertion of the human will.

It is sad, but not too surprising, that this comes best not from an artist or a critic but from a scientist. These last words are from the founder of information theory, Norbert Wiener: 'The question of whether to interpret the Second Law of Thermodynamics pessimistically or not depends on the importance we give to the universe at large, on the one hand, and to the islands of locally decreasing entropy which we find in it on the other. Remember that we ourselves constitute such an island of decreasing entropy and that we live among other such islands Nevertheless . . . it is a foregone conclusion that the lucky accident which permits the continuation of life, even without restricting life to something like human life, is bound to come to a complete and disastrous end. Yet we may succeed in framing our values so that this temporary accident of living existence, and this much more temporary accident of human existence may be taken as all important positive values notwithstanding their fugitive character In a very real sense we are shipwrecked passengers on a doomed planet. Yet even in a shipwreck, human decencies and human values do not necessarily vanish, and we must make the most of them. We shall go down, but let it be in a manner to which we may look forward as worthy of our dignity' [8].

REFERENCES

1. O. Spengler, *Decline of the West* (London: Allen and Unwin, 1959), p. 423.
2. R. Arnheim, *Entropy and Art: An Essay on Disorder and Order* (Berkeley, California: University of California Press, 1971).
3. L. Rapkine, I. Notes for a Scientific Theory of Aesthetics, *Leonardo* **3**, 351 (1970).
4. J. Monod, II. Commentary on the Aesthetics of Louis Rapkine, *Leonardo* **3**, 353 (1970).
5. J. Mandelbrojt, III. Comments on Rapkines Notes and Monod's Commentary, *Leonardo* **3**, 354 (1970).
6. E. Nagel, *The Structure of Science* (London: Routledge and Kegan Paul, 1968), p. 407.
7. R. Smithson, Entropy and the New Monuments, *Art Forum* **4**, 26 (June 1966).
8. N. Wiener, *The Human Use of Human Beings* (London: Eyre and Spottiswoode, 1950).

COMMENTS ON DISCUSSIONS OF ENTROPY AND ART IN *LEONARDO* IN 1973

Richard I. Land*

Arnheim's book 'Entropy and Art: An Essay on Disorder and Order' [1] has stirred discussions in *Leonardo* [2–9] that appear to require considerable understanding of physics before one may grasp the criticisms and arguments that have been raised. Many of the confusions in the book and the justified criticisms arise from an incorrect use of the word entropy as related to order and meaning. At best, the concept of entropy is unfortunately awkward and challenging to the student of physics or engineering [10]. It is misused in many books and I am sorry to say that the trend is compounded by Arnheim. I assert that the concept of entropy has very limited significance or metaphorical power outside of the energy considerations that brought it into existence. Indeed, as a figment of our imaginations and as a quantity that can only be inferred from several direct measurements (certainly not observed by inspection), entropy is useful only when carefully applied.

In science, regularity is observed to many levels of penetration. The quantification and specific identification at each level and between levels must be unambiguous to be meaningful. My experience in the arts, in contrast, has led me to accept considerable ambiguity in addition to often superficial regularity. Many of the specific topics chosen for discussion in the book, such as entropy, equilibrium, diffusion, order and simplicity, require careful definitions and consistent use. The apparent contradictions arise from inconsistencies of meaning between the scientific use and a more common or free use of these words; they are strongly context dependent and the context must be consistent and clear. Further, an inaccurate concept of cosmic tendencies leads to a view in contradiction with scientific observations; most natural events tend toward diffusion, decay and homogeneity, and it is only with the expenditure of extraordinary amounts of energy that organic systems, man in particular, rescue some events so that they result in highly differentiated and so-called 'ordered' products.

At the root of the problem is the very concept of entropy. One has some feeling for the concept of energy. It is what one buys in foods, it is carried through electric wires or is associated with fuel for heating and running motors. Using concepts of energy (in general energy cannot be destroyed) in physics was only partially successful in describing what was happening in energy transformations. A preferred direction in the transfer of heat was observed for most processes but there was no measure for indicating this. One desired a parameter that would identify the direction in which a process might proceed and that would also give a measure of the efficiency of converting heat into work. The special significance of entropy lies in the fact that it never decreases spontaneously in closed systems and it demonstrates why perpetual motion is unobtainable. Entropy is defined only for equilibrium states and may be calculated only by differences in entropy along reversible process sequences. In many special cases where a system is not isolated or where equilibrium is not maintained, entropy concepts may be used because departures from the defined conditions are completely known and usefully accounted for. There are some processes in which entropy does not change, processes where events may go either way—there is no preferred direction.

The identification of entropy in association with information theory is even more carefully defined as pertaining only to a system where the processes are stochastic, Markoff and ergodic. These statistical terms characterize the element of chance, the extent of context importance and the insignificance of selecting a particular sample. The relationship of the two usages of the word entropy are *only* related by the observation made by Shannon: 'The form of H will be recognized as that of entropy as defined in certain formulations of statistical mechanics.'

Statistical mechanics and thermodynamics merge as physical descriptions of natural phenomena. However, experimental evidence has yet to demonstrate the existence of a physical relationship between the two usages of the word entropy in physics and in information theory. Neglect of this point has led many authors into fuzzy territory. As Hoare [3] suggests, Wright's paper on 'Entropy and Disorder' [11] should certainly be referred to by those interested in a clear, moderately technical and

* Engineer-artist, Division of Engineering and Applied Physics, Engineering Sciences Laboratory, Harvard University, Cambridge, Mass. 02138, U.S.A. (Received 10 April, 1973.)

careful discussion. Gal-Or [5] overstates a reaction to the many problems associated with teaching and applying entropy concepts and should accept the unqualified usefulness of the concept in many branches of engineering.

The Arnheim book begins with an appeal to the sense of order. Order is, unfortunately, not defined carefully. In most physical usages, the word *order* identifies a state of knowledge that is neither high nor low, merely the fact that some particular relation exists. Any order of playing cards is an order. When specified completely, all such orders are equally likely. It is only that thinking man invests meaning in certain orders and especially admires those that provide winning hands in a specified game. One will note that the order that is desired in poker is not the same order desired in bridge but one cannot say which is higher or lower without the game (context) being specified. In the book, order is related to physical processes and then carried into a discussion of disorder, a concept that shares with the unprefixed form many ambiguities and counterintuitive interpretations.

When considering information theory, one of the more persistent errors perpetuated by Arnheim is the use of entropy concepts in information theory where 'meaning' is involved. Nothing could be further from the truth than: 'To transmit information means to induce order.' The meaning of order here is ambiguous and, really, to transmit information is to reduce uncertainty or merely to let one know that a particular 'order' prevails (which may 'mean' nothing to the recipient after all!). The word *information* has been appropriated by a mathematical theory and the definition differs considerably from the common sense one. Perhaps for the same reasons that I disapprove of trying to use entropy in aesthetics, I should challenge the communications sciences for abuse of the word *information*, yet they make the word less ambiguous and have enriched its use.

Arnheim's several invocations of patterns as indicating the usefulness of the entropy concept are flawed. In many natural circumstances circles and spheres, while looking simple, represent maximum entropy situations, and straight lines and other particular geometrical configurations, thought less simple, represent lower entropy configurations. It must be remembered that the concept is in general only useful for a closed system. One must consider how much energy is required to achieve the pattern, the straight line requiring the most effort, the circle the least, if uniform forces are acting on the particles making the figure. From a statistical standpoint, the same results obtain from recognizing that there are many ways of arranging points in a circle and a circle will look the same but there are fewer rearrangements of the points in a straight line that will still look the same.

Many particular statements in Arnheim's essay bothered me to which I respond as follows: (1) The statement, '. . . few things in this world can be safely predicted' (on the basis of past events) could not be

further from the truth. Weather is forecast to an accuracy of 85% by simple extension of present patterns; the insurance industry is dependent on consistent accident statistics; clothing sizes stocked in stores are based on simple distributions learned from experience and business innovation, and political success is based on previous statistics. Driving a car is completely dependent on previous experience for future success. (2) The number of a lottery ticket has no meaning as a number (except to the printer). The numerals are a code or symbol that must merely be matched for success. Any graphics would do but numerals have an easy way of being reproduced and so tend to be used rather than say, finger prints. (3) Eddington's view of entropy and energy is very like 'simultaneous contrast' in perceptual events. Entropy without reference to energy is risky. The 'beauty' of entropy is that it provides a frame of reference for the energetic dynamics of the world. (4) Skylines are not random because civil laws, foundation requirements and business requirements produce groups or isolated buildings. Actually, randomness is something that must be carefully defined by testing procedures in order to have much meaning. (5) Equilibrium is not the opposite of disorder—it is not related to order but to the balance of forces. Spinning tops may be in equilibrium. (6) There is little question but that decay, erosion, dissipation and diffusion are processes on a cosmic scale that would lead to a dark, cold solar system. This is observed astronomically. (7) Weisskopf at the Massachusetts Institute of Technology gave a most fascinating talk, 'Quantitative Physics: of Atoms, Mountains, and Stars', revealing a physical basis for most sizes and their relationships to fundamental constants. The limits on biological proportions are beautifully presented by McMahon in 'Size and Shape in Biology' [12].

The second part of the book considers the place of art in human endeavors. An apparent discord is noted between the principle of entropy and a 'striving' towards order. It really is a battle, for at great expense to the environment (for example, by killing for food and rearranging materials for shelters) organisms using processes known to chemistry and biology appear to reverse the natural tendency toward decay. Behavior, we surmise, is a sophisticated way of enhancing the survival of organisms against the forces of nature that would destroy those organisms.

The 'ordering' process in inorganic nature is not absent. Carbon, one of the more abundant elements, only rarely comes in the 'ordered' form of a diamond crystal, hence its value. All the other natural riches of minerals are also rare because the extensive work required to produce the needed local decrease of entropy usually occurs only during violent natural events, the smallest example being an active volcano.

'No mature style of art in any culture has ever been simple' Here Arnheim uses the ambiguity of the word 'simple' to make a subjective judgment

with which I completely disagree. Most Japanese art is superb because of its 'simplicity'; caricature demands a kind of 'simplicity' and concrete poetry works best in less complex forms. Certainly the timeless melodies seem 'simple' and some modern art efforts (Rothko) also seem 'simple'. The most effective cave paintings and decorative art of prehistory rank as both 'simple' and mature. The term 'simple' is completely context dependent. Calling a scientific theory 'simple' is a compliment to its organization and concise statement, although the theory may be elegant and sophisticated as well.

The conclusions reached about the basic nature of art are not enhanced by the concept of entropy or the use of other terms from physics. Especially doubtful is the statement ' . . . the work of art also represents a state of final equilibrium, of accomplished order and maximum relative entropy, . . .' If this were so, art would be rather dull; there would be no tension, no challenge for our interest and engagement in a work of art. Generally, art is not complete without the observer to interact, to contribute his perception to the experience. The enrichment through the arts is, thus, participatory. Fortunately, Arnheim's false statement above is followed by one with which I fully agree 'the work of art concentrates a view of the human condition. . . .'

In summary, I found the book to be an unsuc-cessful attempt to merge scientific perspectives with artistic criticism. It fails mostly from a flawed understanding of the sophisticated concept of entropy (about which the scientific community today is not in agreement either) and the complexity involved in usage of words like 'order', 'simple' and 'information'.

REFERENCES

1. R. Arnheim, *Entropy and Art: An Essay on Disorder and Order* (Berkeley, California: University of California Press, 1971).
2. P. L. Jones, Some Thoughts on Rudolf Arnheim's Book 'Entropy and Art', *Leonardo* **6,** 29 (1973).
3. M. Hoare, Books, *Leonardo* **6,** 76 (1973).
4. R. Arnheim, Letters, *Leonardo* **6,** 188 (1973).
5. B. Gal-Or, Letters, *Leonardo* **6,** 188 (1973).
6. M. Hoare, Letters, *Leonardo* **6,** 282 (1973).
7. R. Arnheim, Letters, *Leonardo* **6,** 282 (1973).
8. P. L. Jones, Letters, *Leonardo* **6,** 283 (1973).
9. P. T. Landsburg, Letters, *Leonardo* **6,** 283 (1973).
10. W. Brostow, Between Laws of Thermodynamics and Coding of Information, *Science* **178,** 123 (1972).
11. P. G. Wright, Entropy and Disorder, *Contemporary Physics* **11,** 581 (1970).
12. T. McMahon, Size and Shape in Biology, *Science* **179,** 1201 (1973).

ON ORDER, SIMPLICITY AND ENTROPY

Rudolf Arnheim*

After perusing the various comments generated by my book *Entropy and Art: An Essay on Disorder and Order* [1], the readers of *Leonardo* have probably decided either to get hold of the book and see for themselves or to forget about some of the highly sophisticated discussions of issues involving the domains of physics and engineering. Therefore, instead of prolonging the play of claim and counter-claim unduly, I would like below to use some remarks by one of my critics, Richard I. Land [2], to carry the clarification of certain key concepts somewhat beyond where I left them in my book. I shall concentrate on order and simplicity.

It may be true that, as Land asserts, the term entropy in its strict technical sense has little meta-phorical value. Entropy, however, is the most familiar concept that has been offered to refer to a phenomenon that is fundamentally valuable as a metaphor and as an explanation, namely, the irreversible mechanical events occurring in a closed physical system. Historically, the notion of entropy was introduced with regard to the special limiting case of such a system, i.e. the case in which structural organization approaches zero. I made use of this notion only because it helped me to account for the puzzling contradiction between the physi-cist's use of the term order and the very different meaning it has for the psychologist and artist. While it may suffice for certain purposes of the physicist, although surely not for all, to call order any particular arrangement of units, the difference between organized and disorganized structures is crucial for the description of biological and mental systems and the term order is needed to characterize organized structure.

One speaks of order when the processes govern-ing a system as a whole are supported by all its parts. The concerted activities of all parts con-stitute an orderly system. Such a system may be more in the nature of a field, based on the direct and free interplay of its components or more like a machine, i.e. a network of rigidly established inter-locking mechanisms. I do not believe that there is a binding answer to the question, raised by Land, whether in the universe orderly systems are less typical or less frequent than is the catabolic tendency toward 'diffusion, decay and homo-geneity'. The answer depends on whether one's attention focuses on disorderly disintegration or, e.g. on atomic models, crystals and organic bodies. More fundamentally, this leads to the difference between one party saying that it takes very special efforts to create order and the other that if you leave any pattern of forces undisturbed it will inevitably create order. And may I mention in passing that when I wrote that destruction by friction, erosion or cooking is not 'the sort of orderly process we tend to have in mind when we speak of a cosmic tendency', I was using the term 'cosmos' in its traditional and indispensable dic-tionary sense of 'an orderly, harmonious whole'.

What can be agreed upon is that any order pre-supposes certain constraints. In perception, con-straints derive first of all from configurational properties of the stimulus, i.e. of the pattern recorded on the retina by the optics of the eye. These stimulus configurations interact with the further constraints imposed upon perception by the charac-teristics of the receptor mechanism. When the stimulus is strong, e.g. when one looks under favorable lighting conditions at a shape clearly drawn on paper, the patterns imprinted upon the retinae leave the visual system little freedom. But when the stimulus constraints soften, e.g. when the lighting is dim or when the perceptual objects are no longer present at all but merely remembered, the vis-ual system can actually modify the stimulus pattern.

The nature of the constraints determines how much effort or energy it takes to produce certain shapes. This, I believe, is Land's point concerning simplicity. In order to avoid confusion we must distinguish here between how 'simple' it is (i.e. how much effort it takes) to bring about a particular shape and how simple or complex is the structure of the shape itself. In the latter case, we mean by simplicity an absolute property of the pattern, say a circle or a straight line, regardless of how it was

*Psychologist, 1050 Wall St., Apt. 6C, Ann Arbor, MI 48105, U.S.A. (Received 7 September 1973.)

produced or received. This property can be determined by objective criteria, such as the number of structural features constituting the pattern. In the former sense, it is preferable to speak of ease (rather than simplicity) of production and reception.

The distinction is indeed fundamental. In perception one begins by analyzing the stimulus. In doing so one cannot limit oneself to the characteristics of the actually given shapes, e.g. the difference between a square and a pentagon or between a regular and an irregular contour. One must consider the simplicity of the patterns by which the given shapes can be organized perceptually through grouping, subdivision and restructuring. The simplicity of the resulting structural patterns varies and it is possible to determine objectively which pattern is the simplest. For example, a 2 : 1 rectangle becomes simpler by being broken down into two squares, whereas the halving of a circle decreases simplicity. Furthermore, in a less mechanical way, the simplicity of a stimulus depends on the kind of pattern that can be imposed upon it, e.g. when we describe the shape of a tree as pyramidal or a face as round.

These properties of the stimulus act as external constraints upon the perceptual process, which is governed by the tendency to organize stimuli according to the simplest pattern available. This means that the simpler the stimulus pattern, the greater the ease of processing in perception will be. (It is well known that ease of recording is aided by different stimulus properties, e.g. in pattern reading by computer.) Since the tendency toward simplest structure is a constant condition of the receptor mechanism, it is possible, within limits, to predict by the analysis of an organized pattern how it will be perceived. Granted that the stimulus does not rule unchallenged. The receptor system possesses further constraints that have a bearing on the ease of reception, e.g. the dominance of the vertical–horizontal framework, or the 'set' or expectation, which programs a receptive system to process certain shapes more smoothly than others. (If one expects to see triangles, a circle imposes itself with less ease than it otherwise would.)

In the arts, ease of production is relevant, e.g. in the mechanics of drawing and writing. In spite of the utter simplicity of a circular shape, to draw a perfect circle freehand is so difficult that, according to Vasari, Giotto used it as proof of his skill as an artist. In writing, the constraints of the human motor mechanism make it hard to produce visually simple letter shapes with ease; hence the changes from Phoenician or Greek capitals to modern cursive. The mechanical properties of certain artistic media make it difficult to produce some of the visually simple shapes, e.g. circular shapes on the weaver's loom or the visual electronic synthesizer. And psychologically we can speak of the stylistic constraints that, e.g. make symmetry come easy in ancient Egyptian statuary but meet resistance in the sculpture of the baroque.

When one refers to the simplicity of a pattern one does not mean ease of production; one means absolute properties inherent in the structure. In this sense, a circle is absolutely simpler than a triangle and a regular figure absolutely simpler than an irregular one. One uses these objective criteria when one tries to understand why at the mental level of children simple art forms prevail or when one wishes to characterize the structural differences between art products of different styles.

Absolute simplicity must be distinguished from relative simplicity. I was concerned with absolute properties when I asserted that 'no mature style of art has ever been simple'. Relative simplicity is intended when a scientist speaks of parsimony. Science and art both demand that any statement be as simple as conditions permit but no simpler. Significant works of art present the greatest wealth of complexity with the utmost simplicity. Such simplicity is hard to accomplish, and although it aids reception it does not make reception easy. The simplicity of the highly complex late works of Shakespeare, Beethoven and Cézanne, attained after a lifetime of struggle, is not easily grasped. Furthermore, a scientist or philosopher may present a beautifully simple theory in unnecessarily intricate and even disorderly language. This may be undesirable but it does not affect the simplicity of the theory. In the arts, such independence of form and content is impossible because the presentation is itself the final statement.

A discrepancy between form and content makes a work of art imperfect. Here something needs to be said about equilibrium. Land notwithstanding, I believe that equilibrium helps to create order, because the proper balancing of all the 'weights' is one of the necessary conditions for the finality required of an orderly system. An unbalanced system is in a transitory state that is not stabilized by any counterbalancing factors and, therefore, must be overcome, if the system as a whole is to be supported by its parts, i.e. if order is to reign. In the case of a work of art, any discrepancy between the statement visibly intended and the realization attained prevents the work from saying what it was intended to say.

Land rejects this requirement because 'generally art is not complete without the observer to interact, to contribute his perception to the experience'; therefore, a work in a state of final equilibrium would be 'rather dull'. To be sure, the order of a work of art is never total—certainly not in the mind of even the most sensitive, attentive and competent viewer. But to acknowledge this is different

from accepting, as Land does, 'considerable ambiguity in addition to often superficial regularity'. Ambiguity, of course, can be a legitimate aspect of a definitive structure, but if incompleteness is to be the source of it, one must object to this misinterpretation of what the viewer's 'participation' consists in. Far from requiring incompleteness, the viewer can receive the challenge to participate aesthetically only from a work in the state of its final order. The challenge derives from the work's fully realized power, depth and originality, which the viewer is called upon to live up to. What Land seems to have in mind is the kind of sensory raw material used by people to stimulate their capacities of organization, invention and imagination. Works of art are not particularly well suited for such exercises and, if someone misuses them in this fashion, he stands to lose more by what he does not receive than to gain from his unskilled attempts to take over where the artist supposedly left off.

REFERENCES

1. P. L. Jones, Some Thoughts on Rudolf Arnheim's Book, 'Entropy and Art', *Leonardo* **6,** 29 (1973).
2. R. I. Land, Comments on Discussions of Entropy and Art in *Leonardo* in 1973, *Leonardo* **6,** 331 (1973).

THE FORMAL GENERATORS OF STRUCTURE*

Stanley Tigerman§

Illustrations drawn by G. T. CRABTREE under the direction of the author.

Abstract—*The paper consists of six basic parti. Horizontal planar forms through historic repetition have evolved a formal tradition. The forms are: the* square, *the* rectangle, *the* cruciform, *the* pinwheel, *the* linked figure *and the* lozenge.
Four formal problems are simultaneously attacked in the paper:
What does a planar figure become volumetrically?
How does the structure reinforce axial properties?
What are the architectonic implications of axial reinforcement?
What are the phenomenological implications of multiple axonometrics?
Two fields are employed: Sparsity (single space/volume) and density (multiple spaces/volumes).
The first five parti represent rectilinear notions of the forms: the square, *the* rectangle, *the* cruciform, *the* pinwheel *and the* linked figure.
The sixth parti introduces the diagonal phenomena of the lozenge.

As the world of art, as well as that of science comes to grips with 'Systems Analysis' and 'The Field Theory', it is necessary to formally analyze certain two dimensional, man-made diagrams to ascertain their fundamental characteristics to better understand the role they will play in the forthcoming computerised world of networks and lattices.

Our fields of vision were secured early this century. Refinement or reaction have been the issues ever since. Now, for the first time, the constellating of the new optical qualities suggests liberation.

Two rationalizations of the Western World have focused on the unchanging qualities of the right angle. One has been synthesised in art as a formal universality in the form of the square. The other has been synthesised in religion as a spiritual universality in the form of the cross. The two visual symbols form the bases of a large part of those forms historically evolved by creative man.

The square, rectangle, cruciform, pinwheel, linked figure and lozenge are six of the more basic figures concerned with man's orthogonal preconceptions. Each, in its own way, while finite unto itself is linked with the others. The first five represent rectilinear notions while the sixth, the lozenge, introduces the diagonal phenomena.

By exploring four formal issues common to each of the six figures, certain characteristics of their respective geometries may be revealed:

Volumetric implications of planar extensions.
Axial properties of form reinforced by structure.
Architectonic extensions of axially reinforced figures.
Optical qualities of multiple axonometrics.

The square, as a discreet rectangle having four equal sides, has imaginary lines perpendicular to and through the center of its sides which forms its bilaterally symmetrical properties. The plans of the churches at Santa Sophia and San Lorenzo [1] are two examples of architects responding to the insistent geometry of the square. The four columns centered on each side of Mies' fifty by fifty house [2] honor the axial properties of the figure while simultaneously contending with the asymmetrical superimposition of the core, which lies in a state of shear relative to the structure. Albers' 'Homage to the Twilight Square' of 1951 [3] superimposes the notion of depth perspective onto the flat plane of multiple squares. Rowe and Slutzky [4] note Kepes' commentary on figure-ground phenomena: 'If one sees two or more figures overlapping one another, and each one of them claims for itself the common overlapped part, then one is confronted with a

*Initial research commissioned by the Keystone Steel and Wire Co., Peoria, Ill., U.S.A. The work represents part of a book in preparation, the remainder of which deals with multiple spaces and volumes concerned with density.

§Architect-painter, 233 North Michigan Ave., Chicago, IL 60601, U.S.A. (Received 25 Aug. 1967.)

contradiction of spatial dimensions. To resolve this contradiction one must assume the presence of a new optical quality'. Max Bill's 'White Element' [5] extends the axes of the square to a position that when new points are connected, a rotated square appears, while Mondrian's 'Lozenge with Gray Lines' of 1918 [6] deals with the square as a field phenomena terminated by the lozenge and thus implying extension. Vasarely extends the square toward three dimensions [7] while Bourgoin [8] documents many of the 'field' possibilities inherent in the two dimensional square, extended, connected and transformed. Clearly, the implications, extensions and potential deformations of the square have occupied a large segment of creative man's mind.

Illustrations 1a, 3a and 5a (Figs. 1, 3 and 5) deal with three extensions of the single space square. The sparse square in Fig. 1a is structured by points (columns). The abstract square on the upper left demonstrates Kepes' definition of figure-ground phenomena through four axonometric extensions of the square toward its inevitable three dimensional cubes. An optical quality different than Munari's cube-hexagon [9] is thus achieved. In addition, multiple axonometrics allow the perceiving of all faces of the cube simultaneously.

The structured and architectonic examples in Fig. 1a (top center and right) support the axial properties of the cube through the use of columns. The appropriate form of the column relative to the cube is necessarily square. Thus, if the column expands or contracts in scale, a similar residual space is left. The optical qualities obtained through equivocal figures has been supported historically by both 'Schröder's reversible staircase' and 'Thiery's figure' [10] which when seen in the light of Albers' constructions [11] begin to shed light on that which is phenomenologically extendable. 'Reye's configuration' [12] (the juxtaposition of lines and planes which form a cube) contain as matrix the potential of extension to a three dimensional network similar to the expansion potential of the square in Fig. 1a.

The square defined by planes illustrated in Fig. 3a continues the principle of tri-lateral axial reinforcement through extension into three dimensions. In this case, the wall thickness is such that through planar termination the negative space of the opening is also a square. Thus, while any wall thickness might have been employed, similar performance can be had only if the termination of the planes were to form a square. The architectonic extensions of the walled square in Fig. 3a (upper right) begin to demonstrate the spatial implications of trilateral symmetry as defined by clusters of planes constellating into L shaped elements.

The buttressed sparse square, curiously, begins to imply the cruciform which, as the square, is bilaterally symmetrical. This is natural since the form of four planar buttresses when disposed about a square, necessarily resemble a cruciform (Fig. 5a, center). It should be noted however, that the juxtaposition of multiple buttresses containing a cube imply the cube rather than the cruciform (Fig. 5a right).

The rectangle, architecturally speaking, has as its formal origins the Gothic style. The linear characteristics of this style reinforce a single axis, the termination of which has continued to be of considerable difficulty. The plan of the chapel of Saint Stephen [13] simply terminates the parti after five structural bays, while that of Sainte Chapelle weights one end of the axis by actually closing the other. Notre Dame, while similar to Sainte Chapelle, recognises a minor axis perpendicular to the nave [14]. If one assumes that the square is simply a discrete rectangle, then elongated forms of similar geometry may well contain similar properties. Thus, illustrations 1b, 3b and 5b show the articulation of the rectangle composed of two squares, weighting one axis more than the other due to the obvious effects of elongation.

The rectangle, like the Gothic parti has major and minor axes; thus when the figure is extended into space, the major axial termination becomes bilaterally symmetrical (similar to the cube). Thus, the longitudinal planar extensions are of the same proportion as the sides of the rectangle. That a close relationship exists between the rectangle and the square is inevitable.

While the columned sparse rectangle and the walled sparse rectangle focus on the linear aspects of the Gothic parti, the buttressed sparse rectangle in Fig. 5b (right) three dimensionally wraps the minor centroid, so that, while the major axis in all three cases deals with subjective visual penetration through the opening at either end of the form, a feeling of compression is established in the buttressed rectangle articulating its minor axial properties.

As the rectangle is an extension of the square in terms of its being the agglommeration of two squares, the cruciform is the agglommeration of three, two-square rectangles mutually and simultaneously disposed about the *x*, *y* and *z* axes. It, as well as the square, is trilaterally symmetrical in three dimensional terms to the extent that the negative space achieved by the juxtaposition of the four axonometrics form a cruciform as well (Figs. 1c, 3c and 5c).

Historically, the plan of the chapel at San Spirito in Florence [15] is an interesting demonstration of the transition from the Gothic to the Renaissance (or indeed the rectangle to the cruciform). San Spirito, while cruciform in plan, has its nave slightly elongated, thus combining the rectangle and the cruciform in an interesting manner. The history of classical city planning has shown the use of cruciform potentialities as at Versailles [16] and in the overall plan for San Pietro's [17]. J. Bourgoin has shown the use of this figure also in Arabian art decoration [18]. His 'Les Elements de l'Art Arabe' shows many permutations of the cruciform and other bilaterally symmetrical figures.

The cruciform structured by columns, Fig. 1c, continues the principles of the cube structured by columns. In Figs. 1c (right), 3c (right) and 5c (right)

the architectonic extensions of the cruciform are made with a flemish bond, as this is also a cruciform in organization. In Figs. 3c and 5c the negative spaces resulting from the walled and buttressed containers have protruding and receding spaces reinforcing the cruciform notion as well. In Fig. 3c (the walled cruciform) it should be noted that the proportion of the angle-shaped containing planes, while having similar sides, define a 2:1 axial entry to the center square, this proportion being consistent

with the 2:1 three-rectangle juxtaposition forming the structure of the basic figure.

Mies' *Brick Villa* of 1923 [19] demonstrates a loose compositional way of dealing with the pinwheel, while the plan of Wright's *Suntop House* of 1939 [20] shows a more compact organisation of this figure. There have been many attempts to articulate the shearing aspects of the pinwheel in the plastic arts. Albers' constructions have emphasised this quality through the weighting of lines [21].

Fig. 1. (a) *The sparse square with columns* (*top row*).
 (b) *The sparse rectangle with columns* (*middle row*).
 (c) *The sparse cruciform with columns* (*bottom row*).

Fig. 2. (a) *The sparse pinwheel with columns* (*top row*).
 (b) *The sparse linked figure with columns* (*middle row*).
 (c) *The sparse lozenge with columns* (*bottom row*).

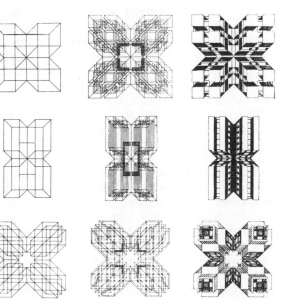

Fig. 3. (a) *The sparse square with planes* (*top row*).
 (b) *The sparse rectangle with planes* (*middle row*).
 (c) *The sparse cruciform with planes* (*bottom row*).

Fig. 4. (a) *The sparse pinwheel with walls* (*top row*).
 (b) *The sparse linked figure with walls* (*middle row*).
 (c) *The sparse lozenge with walls* (*bottom row*).

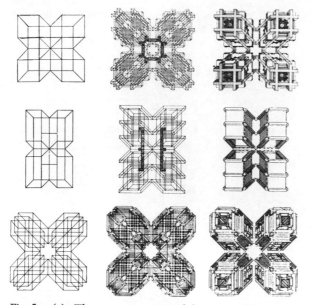

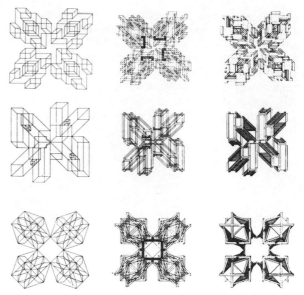

Fig. 5. (a) *The sparse square with buttresses* (*top row*).
 (b) *The sparse rectangle with buttresses* (*middle row*).
 (c) *The sparse cruciform with buttresses* (*bottom row*).

Fig. 6. (a) *The sparse pinwheel with buttresses* (*top row*).
 (b) *The sparse linked figure with buttresses* (*middle row*).
 (c) *The sparse lozenge with buttresses* (*bottom row*).

The *Rietveld House* at Utrecht of 1923–24 [22] shows some of the three dimensional possibilities of this parti.

The pinwheel in Figs. 2a, 4a and 6a is composed of a series of rectangles the juxtaposition of which constellate about a pinwheel or swastika figure in such a way, that the cruciform, the central negative space formed by the gathering of the four axonometric extensions, also forms a pinwheel. The abstract pinwheel figure in Fig. 2a (left) is a study of the distortions possible in the logical graphic rotation in this figure. More than the square, rectangle or cruciform, this parti justifies the four-axonometric postulate for showing all faces at once. This is a result of the parti not being symmetrical (at least in the sense one thinks of the square or cruciform).

The pinwheel structured by columns in Fig. 2a (center and right) establishes a cubic lattice, only the termination points of which define the pinwheel form. The walled pinwheel of Fig. 4a (center and right) is composed of both solid and void L-shaped forms extending from the planar four walls in Fig. 4a (center plan). The buttressed pinwheel in Fig. 6a (center and right) continues the shearing phenomena of this figure into a complex network of channel shaped containers, the negative spaces of which are also buttressed with channel shaped transparent planes.

The linked figure in Figs. 2b, 4b and 6b is the constellation of perpendicularly oriented rectangles linked and then extended into three dimensional space. If one considers the extension of the lateral elements of Blenheim Palace in Oxfordshire [23] they then form a linked figure with the central hall of the Palace. The Inland Steel Building in Chicago

by Skidmore, Owings and Merrill is a clear demonstration of the figure itself with minimum understanding of its axial properties (which might have otherwise created a more appropriate human penetration through entry).

The lozenge, illustrated in Figs. 2c, 4c and 6c, while having historic roots not unlike the five earlier parti, nonetheless have quite different axial properties. Assuming the square-cube to have axes perpendicular to its sides, then its formal generators are established. If the square is tilted 45°, and the x and y axes also turned 45°, the square simply becomes a square turned on its side with no particularly unique properties. However, if when the square is turned 45° the x and y axes remain in their original position, a completely new set of optical rules occur. This was never made more clear historically than in the work of two members of the Dutch movement—De Stijl—Mondrian and van Doesburg. During the years 1918 and 1919 Mondrian did three 'Lozenge' paintings [24] where only the periphery of the canvas was tilted. The interior field remained in a vertical and horizontal position. van Doesburg's reply to this was 'Elementarism' (a humanistic introduction) which in his paintings of 1924 and 1925 [25] the periphery remained orthogonal and the interior field was tilted. The Mondrian postulate has been clearly extended in John Hejduk's *Diamond House* of 1965 [26].

It should be noted in Figs. 2c, 4c and 6c that the axial properties of the lozenge are orthogonal, while the figure itself is the extension into space on the diagonal. One of the curious optical results of this juxtaposition is the completely different way in which axonometric extensions occur. The disposi-

tion of these paradoxical sets of principles establishes a new methodology of extension, marrying many of the principles of the square, cruciform and pinwheel, but simultaneously establishing a new visual language.

The square, rectangle, cruciform, pinwheel, linked figure and lozenge through great repetition have, on occasion, uplifted the creative mind to establish an order clearly defining the nature of these forms. The Golden Rectangle and 1st Modulor are but two of the many efforts in this milieu. One must assume that the three-dimensional, topological extensions possible in the future will establish yet another set of values defining the nature of those spaces possible when utilising the basic properties of these six parti.

REFERENCES

1. B. Munari, *Discovery of the Square* (New York: Wittenborn, 1965) p. 18.
2. W. Blaser, *Mies Van Der Rohe* (New York: Praeger, 1965) pp. 122, 123.
3. B. Munari, *Discovery of the Square* (New York: Wittenborn, 1965) p. 8.
4. C. Rowe and R. Slutzky, Transparency: Literal and Phenomenal, *Perspecta*, 45 (1963).
5. B. Munari, *Discovery of the Square* (New York: Wittenborn, 1965) p. 14.
6. M. Seuphor, *Piet Mondrian Life and Work* (New York: Abrams) p. 383.
7. V. Joray, *Vasarely* (Neuechâtel: Editions du Griffon, 1965) pp. 173, 174.
8. J. Bourgoin, *Les Elements de l'Art Arabe* (Paris: Firmin-Didot et Cie, 1879).
9. B. Munari, *Discovery of the Square* (New York, Wittenborn, 1965) p. 30
10. M. Luckiesh, *Visual Illusions Their Causes, Characteristics and Applications* (New York: Dover, 1965) pp. 70, 71.
11. F. Bucher, *Josef Albers Despite Straight Lines* (New Haven: Yale University Press, 1961).
12. D. Hilbert and S. Cohn-Vossen, *Geometry and the Imagination*, (New York: Chelsea, 1952) p. 134.
13. B. Fletcher, *A History of Architecture on the Comparative Method* (New York: Scribner, 1896) p. 501.
14. B. Fletcher, *A History of Architecture on the Comparative Method* (New York: Scribner, 1896) p. 475.
15. B. Fletcher, *A History of Architecture on the Comparative Method* (New York: Scbriner, 1896) p. 610.
16. S. Giedion, *Space, Time and Architecture* (Cambridge: Harvard University Press, 1941) p. 139
17. S. Giedion, *Space, Time and Architecture* (Cambridge: Harvard University Press, 1941) p. 142.
18. J. Bourgoin, *Les Elements de l'Art Arabe* (Paris: Firmin-Didot et Cie, 1879) plate 27.
19. W. Blaser, *Mies Van Der Rohe* (New York: Praeger, 1965) pp. 20–24.
20. S. Giedion, *Space, Time and Architecture* (Cambridge: Harvard University Press, 1941) p. 404.
21. F. Bucher, *Josef Albers Despite Straight Lines* (New Haven: Yale University Press, 1961) pp. 25, 27.
22. Stedelijk Museum Amsterdam, *De Stijl*, cat. 81 (1951) (opp.) p. 88.
23. B. Fletcher, *A History of Architecture on the Comparative Method* (New York: Scribner, 1896) p. 827.
24. M. Seuphor, *Piet Mondrian Life and Work* (New York: Abrams) p. 383, plates 297, 298, 299.
25. Jaffe, *De Stijl/1917–1931* (Amsterdam: Meulenhoff, 1956) plates 42, 43.
26. Catalog, New York Architectural League, *John Hejduk* November, 1967.

A COMPARISON OF THE ARTISTIC THEORIES OF LEONARDO DA VINCI AND OF WASSILY KANDINSKY

David L. Carleton*

1. Introduction

The origins of the principles of gestalt theory in Kandinsky's book, *Point and Line to Plane*, first published in 1925 [1], have been subjected to considerable investigation. L. D. Ettlinger concluded that Kandinsky had been inspired by the writings of the early gestalt psychologists [2], while, on the other hand, Paul Overy concluded that the publications on *Gestalttheorie* that had appeared in the twenties contain only confirmed ideas worked out earlier by Kandinsky [3]. Thus, the historical problem is to determine if Kandinsky synthesized his gestalt principles from writings published prior to *Point and Line to Plane* or if he conceived these principles independently. Some light was shed on this problem by Kandinsky himself [1] who stated; 'It can be assumed with complete certainty that painting was not always lacking in theory as it is today.' This statement leads one to suspect that Kandinsky was alluding to a treatise written prior to the modern era, possibly that of Leonardo da Vinci. It is this possibility that I consider here; namely, how Leonardo's *Trattato della Pittura* could have served as a model for Kandinsky's *Point and Line to Plane*.

The introductions to *Point and Line to Plane* and the *Trattato* begin on the same key. Kandinsky wrote: 'This book will deal with two basic elements [point and line] which are the very beginning of every work of painting, and without which this beginning is not possible.' Leonardo's introduction to the *Trattato* [4] declared that: 'The science of painting begins with the point, then comes the line, the plane comes third, and the fourth the body in its vesture of planes' [5]. Leonardo's directive on the science of painting can serve as an outline for a comparison of statements by the two artists. In the following sections, a careful analysis of the point, the line, and the plane, as seen by these two artists will be given in that order. Then some observations will be made on certain diagrams by the two artists,

and some comments will be made concerning their views on the relationship of sound to visual form.

2. The point

The term 'point' can be interpreted in either a mathematical sense or in a common sense way. In mathematics, the term 'point' is generally accepted without question. There are, however, innumerable examples of mathematical points, such as the number e, which is arrived at numerically, or the number π, which is arrived at through geometric description. The common sense idea of a point is also unspecified and again, there are innumerable examples, such as a mark made by a pen or a full-note on a sheet of music. Leonardo and Kandinsky differentiate clearly between a mathematical point and a common sense point, and they both employed modern methodology when they described a mathematical point to be of dimension zero and without material existence. Finally, the differences between the two terms were reconciled by the analogous observations that the common sense point contains the mathematical point. (The page numbers following the block quotes taken from Leonardo and Kandinsky refer to References 4 and 1, respectively.)

Leonardo da Vinci:
'The point is unique of its kind. And the point has neither height, breadth, length, nor depth, whence it is regarded as indivisible and as having no dimensions in space' (p. 127).
'For if you say that a point is formed by the contact of the finest conceivable pen with a surface, this is not true. But we may assume such contact to be a surface round a centre and in this centre the point may be said to reside' (p. 31).

Kandinsky:
'The geometric point is an invisible thing. Therefore it must be defined as an incorporeal thing. Considered in terms of substance, it equals zero' (p. 25).
'In the final analysis, all of these compositions—large or small, have been originated from points, to which point—in its original geometric essence—everything returns' (pp. 38–39).

3. The line

Kandinsky defined a straight line as a continuous force that acts on a point. Thus, to Kandinsky,

* Art historian and mathematician, Box 122, Marion, Texas 78124, U.S.A. (Received 6 February 1973.)

complex lines were the result of complex forces acting upon a point. Leonardo, on the other hand, defined a line to be a continuum of length; not possessing breadth, height or depth. However, both artists recognized the need for a categorical study of lines. Leonardo classified lines into three categories: straight line, curved line and undulating line. Kandinsky classified lines into two basic categories: straight line and curved line. He then reclassified curved lines into three sub-categories and studies each of these categories in detail. Thus, Kandinsky was essentially following Leonardo's directive that the undulating line must be categorically studied.

Leonardo da Vinci:
'The line is of three kinds, straight, curved, and sinuous, and it has neither breadth, height, nor depth' (p. 127).
'Consider with the greatest care the outlines of every object, and their serpentine ways. And these undulations must be studied separately, as to whether the curves are composed of arched convexities or angular concavities' (p. 129).

Kandinsky:
'The straight line and the curved line represent the primary contrasting pair of lines' (p. 80).
'A complex curved or wavelike line can consist of: 1. geometric parts of a circle, or 2. free parts, or 3. various combinations of these' (p. 85).

4. The plane

It is a well-known fact that a plane is composed of an infinite number of lines. Both artists were aware of this fact and they cited it in its special case, where an infinite number of lines intersect at a point to generate a plane.

Leonardo da Vinci:
'Therefore an infinite number of lines may be conceived as intersecting each other at a point, which has no dimensions and is only of the thickness (if thickness it may be called) of one single line' (p. 128).

Kandinsky:
'This is the axis [a point] about which the lines can move and, finally, flow into one another; a new form is born—a plane in the clear shape of a circle' (p. 60).

5. Drawings, of points, lines and planes

There are three diagrams appearing in Leonardo's writings that are resembled by certain diagrams in Kandinsky's writings and that suggest that Leonardo was contemplating gestalt principles (Fig. 1). While the diagrams of the two artists are similar, it must be discerned as to what role they played with respect to the writings that they accompany. The three diagrams (1, 2, 3) of Leonardo seem to demonstrate his ideas in the following statement:

'If one single point placed in a circle may be the starting-point of an infinite number of lines, and the termination of an infinite number of lines, there must be an infinite number of points separable from this point, and these when reunited become one again; whence it follows that the part may be equal to the whole' (p. 128).

Leonardo is saying that the point in diagram 1 (Fig. 1) can be taken to be 'equal to the whole' of the area of the circle in which it lies. Diagrams 2 and 3 show the 'starting-point' and the 'termination' of the infinite number of lines that form Leonardo's 'whole'. It is not necessary to point out how Kandinsky's diagram 4 resembles Leonardo's diagram 1. In the case of diagram 5, Kandinsky is demonstrating the process by which he allowed infinitely many lines to merge into a plane surface in the form of a circle. Consequently, these five diagrams suggest that both artists arrived at the plane through similar thought processes.

6. The sound of form

Leonardo's and Kandinsky's interests in relationships between music and art stem from the fact that they were both accomplished musicians. They were both aware of the way sound vibrations are formed and transmitted. This may be clearly seen in the following two passages, where Kandinsky's 'simplest element' upon a plane can be

Leonardo da Vinci:

Diagram I (p. 128).

Diagram 2 (p. 128).

Diagram 3 (p. 128).

Kandinsky:

Diagram 4 (p. 36).

Diagram 5 (p. 60).

Fig. 1.

interpreted as a generalization of Leonardo's 'stone flung into the water'.

Leonardo da Vinci:
 'Just as a stone flung into the water becomes the centre and cause of many circles, and as sound diffuses itself in circles in the air: so any object, placed in the luminous atmosphere, diffuses itself in circles, and fills the surrounding air with infinite images of itself' (p. 140).

Kandinsky:
 'This pulsation of the BP [Basic Plane], as was shown, is transformed into double and multiple sounds when the simplest element is placed upon the BP' (p. 134).

7. Conclusion

It should be noted that Leonardo da Vinci's thoughts are taken from a study of representational figurative painting, whereas Kandinsky's thoughts are taken from a study of non-figurative painting. It does not follow, however, that Leonardo's thoughts have been stated out of context. Throughout the *Trattato*, there occur numerous passages, many not mentioned here, that do not directly support analyses applied to painting. The precocity of Leonardo's thoughts in these passages reaches a pinnacle where he concludes that 'the part may be equal to the whole'. In fact, it was not until the advent of modern mathematics that it was shown by George Cantor [6] in his theory of equinumerous sets that for such sets the part is indeed equal to the whole.

References and notes

1. W. Kandinsky, *Point and Line to Plane* (New York: Solomon Guggenheim Foundation, 1947) p. 18.
2. L. D. Ettlinger, *Kandinsky's 'At Rest'* (London: Oxford University Press, 1961).
3. P. Overy, *Kandinsky: The Language of the Eye* (New York: Praeger, 1969) p. 142.
4. J. P. Richter, *The Literary Works of Leonardo da Vinci*, 3rd ed., Vol. I (New York: Phaidon, 1970) p. 32.
5. K. Lindsay refers to this passage in his unpublished Ph.D. dissertation, *An Examination of the Fundamental Theories of Wassily Kandinsky* (Madison: The University of Wisconsin, 1951), p. 21, note 44. However, Lindsay does not explore the possibility that Kandinsky was significantly influenced by the artistic theories of Leonardo da Vinci.
6. S. Drobot, *Real Numbers* (Englewood Cliffs, N.J.: Prentice-Hall, 1964) p. 81.

AESTHETIC TREE PATTERNS IN GRAPH THEORY

Frank Harary*

Abstract—*Tests of pattern recognition and construction were made using trees, which are the simplest structural configurations occurring in the mathematics of graph theory. This led to the discovery that certain types of tree patterns are regularly overlooked and others frequently duplicated. Following these tests, a number of student subjects expressed their personal aesthetic preferences for trees and more complex graphs, as well as for different presentations of the same tree structure. The data are given in tabular form and contain several surprises, which can be rationally explained by symmetry considerations.*

I. INTRODUCTION

Graph theory is the area of mathematics which is growing most rapidly, in accordance with the simple but crude criterion of the number of pages in *Mathematical Reviews* devoted to the summary of published papers in the field. The reason for this explosion of research activity is certainly due to its wide applicability to very many different fields. These considerations are summarized in the first paragraph of the Preface to my book *Graph Theory* [1]:

'There are several reasons for the acceleration of interest in graph theory. It has become fashionable to mention that there are applications of graph theory to some areas of physics, chemistry, communication science, computer technology, electrical and civil engineering, architecture, operational research, genetics, psychology, sociology, economics, anthropology, and linguistics. The theory is also intimately related to many branches of mathematics, including group theory, matrix theory, numerical analysis, probability, topology, and combinatorics. The fact is that graph theory serves as a mathematical model for any system involving a binary relation. Partly because of their diagrammatic representation, graphs have an intuitive and aesthetic appeal. Although there are many results in this field of an elementary nature, there is also an abundance of problems with enough combinatorial subtlety to challenge the most sophisticated mathematician.'

While teaching a course in graph theory at the University of Waterloo in the fall of 1970, I had a

captive audience of 38 enthusiastic students who cooperated in answering several questionnaires concerning tree construction and structural pattern preferences. It is, of course, possible that they did not fully believe my statement that their course grade did not depend on their cooperation.

Several years ago, Claude Faucheux of the University of Paris was intrigued by the psychological aspects of pattern recognition. In order to accomplish his study, he used the important, yet simple, graphs known as *trees* [1, 2], exhibited in the next section. To compile data, he instructed two groups of students to draw all the trees of 8 points. The first group was told that 23 is the exact number of 8-point trees but the second group was not!

Using my 38 'volunteers' as subjects, I proceeded to replicate (with modification) these experiments but used for simplicity the trees with 6 and 7 points. The results were both surprising and edifying. The class also was asked which graphs they liked best among those presented in several series of diagrams. Again, the results were striking. An analysis of these data is made, using the symmetry in a graph as a basis for differentiation.

The reader will be helped to understand the mathematical aspects of the following sections by referring to the article on 'Art and Mathesis: Mondrian's Structures' by Hill [3], published in *Leonardo*.

2. TREE GRAPHS

To explain the concept of a graph [1–6], without risking becoming lost in an abyss of formal definitions, we illustrate the ideas using all 11 graphs (cf. Fig. 1) having 4 points. Any other 4-point graph will be *isomorphic* (that is, it will have the same basic structure) to one of the eleven graphs. The six graphs on the right of Fig. 1 are called *connected* and

* Professor of Mathematics, University of Michigan. Artist living at 1015 Olivia Ave., Ann Arbor, Michigan 48104, U.S.A. (Received 27 October 1970). The data were kindly compiled by Miss Beverley Taylor.

E

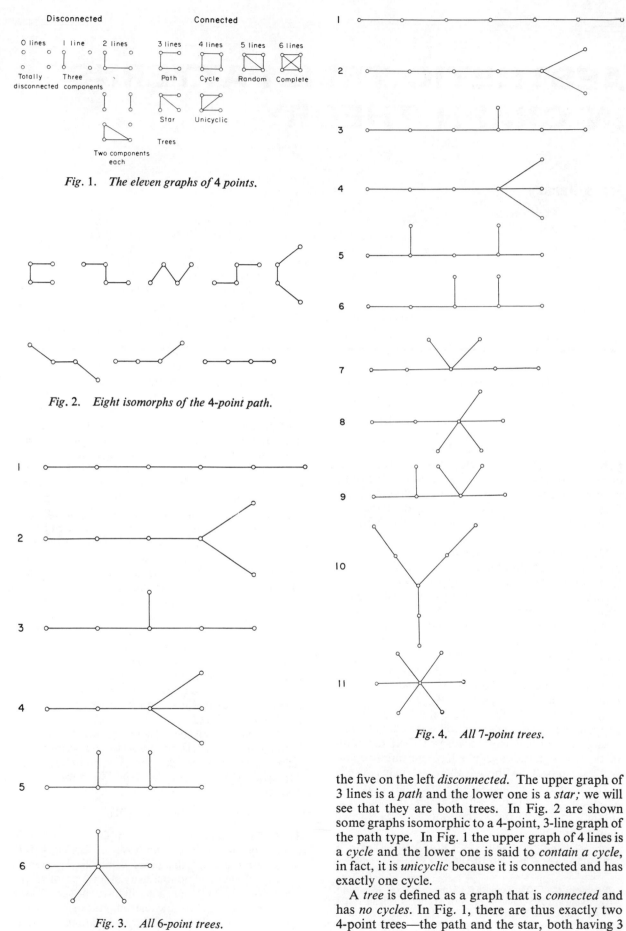

Fig. 1. *The eleven graphs of 4 points.*

Fig. 2. *Eight isomorphs of the 4-point path.*

Fig. 3. *All 6-point trees.*

Fig. 4. *All 7-point trees.*

the five on the left *disconnected*. The upper graph of 3 lines is a *path* and the lower one is a *star;* we will see that they are both trees. In Fig. 2 are shown some graphs isomorphic to a 4-point, 3-line graph of the path type. In Fig. 1 the upper graph of 4 lines is a *cycle* and the lower one is said to *contain a cycle*, in fact, it is *unicyclic* because it is connected and has exactly one cycle.

A *tree* is defined as a graph that is *connected* and has *no cycles*. In Fig. 1, there are thus exactly two 4-point trees—the path and the star, both having 3

lines. All 6-point and 7-point trees are shown in Figs. 3 and 4, respectively, up to isomorphism.

3. RECOGNITION—CONSTRUCTION TESTS

The first problem in tree construction I gave to my students was to draw all 6-point trees, without telling them that there are exactly six such trees. The students produced most of the trees plus one or two duplicates. On the average, the number of different trees correctly drawn was 5 and the total drawn was 6. Of the 38 students participating in this test, 11 found the required 6 different trees. The results are summarized in Table 1.

TABLE 1. CONSTRUCTION OF DIFFERENT 6-POINT TREES

No. of different trees found	1	2	3	4	5	⑥
No. of students	0	1	2	9	15	11

Tree No. 3 in Fig. 3 was the most frequently omitted (13 students) and also the most frequently duplicated (with an isomorph; 11 *other* students)! The star, tree No. 6, was the second most frequently omitted (10 students) but it was only duplicated by 2 students. None of the students omitted the path, tree No. 1, but 9 students included superfluous isomorphs of the path by including it in more than one form (cf. Fig. 2).

The second problem read: 'There are exactly 11 different 7-point trees. Draw them.' The number of different trees found by 38 students ranged from 6 to 11, the average being 9 trees. Two of the students found all 11 trees in the time allowed for solving the problem. The results are summarized in Table 2.

TABLE 2. CONSTRUCTION OF DIFFERENT 7-POINT TREES

No. of different trees found	6	7	8	9	10	⑪
No. of students	3	3	6	15	9	2

The most frequently omitted tree (by 20 students) was the subdivision of a star, No. 10 in Fig. 4. The second most frequently omitted tree was No. 8, almost a star (by 13 students). These two star-like trees were duplicated only once each. The most frequently duplicated tree was No. 3 (by 12 students); yet 7 students omitted it. Here again none omitted the path, tree No. 1, although 3 students included isomorphs.

4. STRUCTURAL PATTERN PREFERENCE

My next tests dealt with aspects of the aesthetic appeal of graphs. I presented to the students four sets of graphs and asked them to rate each one as specified. In the first set, each student was to indicate which of the three 5-point trees was his favorite, next favorite and least favorite one. The number of votes collected for each rating by each tree is indicated in Table 3. Clearly tree No. 2 was the favorite (18 students) and the path, No. 1, was least liked (25 students).

TABLE 3. THE FREQUENCY OF PREFERENCES OF THE 5-POINT TREES

Tree	Ranking		
	Favorite	Next favorite	Least favorite
1	3	8	25
2	18	11	7
3	14	18	4

In the second set, each student was to indicate which of the six proffered 6-point trees he thought was the prettiest, the ugliest, the funniest and the sexiest. The votes are shown in Table 4. One notes that No. 5 and No. 6 (the star) were thought to be the funniest; No. 5, the sexiest; No. 6, the prettiest; and Nos. 1 and 3, the ugliest.

TABLE 4. THE FREQUENCY OF PREFERENCES OF THE 6-POINT TREES

Tree	Ranking			
	Prettiest	Ugliest	Funniest	Sexiest
1		12		
2	1	1	3	7
3		12	7	2
4	5	7	6	7
5	12		10	15
6	18	4	10	5

The third set of 5-point, 4-line graphs proffered for evaluation on the basis of preference is shown in Table 5 together with the results. The spiral path, No. 2, was preferred. Paths No. 3 and No. 4 seemed equally liked and disliked. Path No. 1 was definitely the most unpopular.

TABLE 5. THE FREQUENCY OF PREFERENCES OF FOUR PRESENTATIONS OF THE 5-POINT PATH

Presentations of the 5-point path	Preferences			
	1 Like most	2	3	4 Like least
1	3	7	16	9
2	12	13	5	5
3	10	8	6	11
4	10	7	8	10

TABLE 6. THE FREQUENCY OF PREFERENCES OF THE FOUR PERMUTATION GRAPHS OF THE PENTAGON

The permutation graphs of the pentagon	Preferences			
	1 Like most	2	3	4 Like least
1	5	10	15	5
2	3	4	8	21
3	8	13	9	6
4	20	9	4	4

The fourth set of graphs, four variations on the pentagon graph, (as displayed on the front cover of my book [1]) proffered for evaluation is shown in Table 6. No. 4 was clearly liked the most and the permutation graph, No. 3, came in second. The prism, No. 1, was not popular and a distortion of it, No. 2, was particularly disliked.

5. DISCUSSION OF RESULTS

In each student's paper, some aspect of his manner of drawing was usually distinctive. For example, some filled in graphical points solidly, while others left them as open circles. Some drew solid line segments joining adjacent points and others drew timid lines without touching the points. Some graphs were drawn in a step-by-step manner— a point, a line, a point, and so on, which might suggest that the person was trying to decide on the graphical shape as he constructed it. Some drew all the points first and then the lines connecting them, perhaps with the thought that points are easier to erase. However, this manner might also be used by one who had a definite configuration in mind. The person who drew the lines first and then the points would appear to be more confident that he was drawing the correct tree!

In the second question, the most frequently duplicated trees (isomorphs) were No. 3 of the 6-point and 7-point trees (cf. Figs. 3 and 4). *One can conclude that trees with the least symmetry are the most difficult to distinguish from their isomorphs.* Stars were seldom duplicated because their obvious symmetry makes it easier to identify isomorphs as equivalent. On the other hand, stars tend to be omitted because their symmetry sets them apart in appearance from the other trees. In fact, it can be predicted from these findings that starlike trees having arms of approximately equal length will tend to be omitted. *The most frequent omissions among the more tree-like configurations are correlated with the most asymmetry.*

It is amusing to note in the fourth test (cf. Table 4) that the prettiest and funniest trees coincide, and that tree No. 5, the sexiest by a large margin, was also considered one of the two funniest ones.

The results of the tests of aesthetic appeal of structural pattern of graphs suggest that preferences depended upon the influence of symmetry, complexity, association to reality, size and shape. Simpler graphs were usually regarded as ugly and dull. A curved line graph was preferred over a zigzag type. The crossing of lines did not seem to influence preference.

REFERENCES

1. F. Harary, *Graph Theory* (Reading, Mass.: Addison-Wesley, 1969).
2. Terminology, *Leonardo* **1,** 465 (1968).
3. A. Hill, Art and Mathesis: Mondrian's Structures, *Leonardo* **1,** 233 (1968).
4. A. T. Balaban, R. O. Davies, F. Harary, A. Hill, and R. Westwick, Cubic Identity Graphs and Planar Graphs Derived from Trees, *J. Aust math. Soc.* **11,** 207 (1970).
5. F. Harary and G. Prins, The Number of Homeomorphically Irreducible Trees and Other Species, *Acta Math.* **101,** 141 (1959).
6. A. Hill, Some Problems from the Visual Arts, *Ann. N.Y. Acad. Sci.* **175,** Art. 1, 208 (1970).

PERSPECTIVE USING CURVED PROJECTION RAYS AND ITS COMPUTER APPLICATION

Horacio C. Reggini*

Abstract—*The author describes a novel way for generating line drawings of 3-dimensional objects and describes a computer programme that he used in plotting such drawings. Instead of being confined by the rules of linear perspective, which governs retinal and photographic images, he employs a more general mathematical model that provides a family of perspectives. Each member of the family is designated individually by a numerical value (between 0 and 1) for its index i. The lowest value, i = 0, leads to the linear equation that applies to linear perspective; application of the highest value, i = 1, results in axonometric projection. Sometimes linear perspective leads to a drawing or to a photographic image that seems grossly distorted in comparison with what one perceives in looking at an object. The author's method, employed with fractional values for i and with the same viewpoint, may be used to produce more acceptable drawings.*

I. INTRODUCTION

In 1972 I prepared a computer programme for making computer drawings of buildings for engineering and architectural purposes, both in traditional linear perspective and in axonometric projection [1, 2]. My interest in the properties of perspective was then kindled and I began to read about pertinent physiological and psychological aspects of vision and about perspective in art and in photography [3–23].

A drawing of an object, e.g. a building, in linear perspective on a sheet of paper amounts to the following: the projection of lines and points from corresponding visible lines and points of an object onto the sheet of paper held perpendicular to the *line of sight*. Projection occurs along straight rays that converge at the *viewpoint* (e.g. the eye) on the line of sight. Photographic images are produced on light-sensitive film in a geometrically similar way. But here light rays converge at the focal point of the camera lens (which corresponds to the viewpoint in monocular vision) before diverging again and striking the film.

The occasionally unnatural quality of linear perspective, such as that evident in a photograph showing a man holding what appears to be a grotesquely large outstretched hand toward the camera [24] or showing the sides of a skyscraper converging sharply to a point in the sky, drew my attention to the phenomenon in vision called *perceptual constancy* or *constancy scaling* [3, 7, 8, 14, 19, 20]. Thus, while in linear perspective the size of

the image of an object doubles when the distance between the viewpoint and the object is halved, in human vision the perception of that much of an increase in size does not occur. The word 'constancy' refers to the tendency of the brain to reduce the change in interpreting retinal images (retinal images are formed in accordance with the rules of linear perspective). The phenomenon of perceptual constancy, which has undoubtedly been observed time and again in the past, is one that is not completely understood (Descartes discussed the effect in 1637 [25]). Among the recent discussions of the subject that I have examined, I wish to point to Refs. 5, 26, 27 and 28.

II. THE THOULESS FORMULA

The English psychologist Robert Thouless attempted in the 1930's to obtain measurements bearing on perceptual constancy [29–31]. He conducted a systematic study of responses from different types of subjects under various conditions and used the following procedure (Fig. 1): A square card (the *object card*) of side 2r, where 2r = 40cm, was situated perpendicular to the line of sight at a specified distance d before the subject, e.g. d = 2·40 m. The subject was given an assortment of square cards of different sizes and was asked to select the one (the *image card*) that when held at a specified intermediate position t, e.g. t = 1·20 m, appeared to be equal in size to the object card. (The lines of sight of the object and the image card were arranged to diverge at a small angle to avoid an overlap in the retinal images of the cards.) In linear perspective the length r of a straight line in a plane perpendicular to the line of sight and at

* Consulting engineer living at Av. Santa Fe 3069, P14B, Buenos Aires, Argentina. (Received 11 Feb. 1974).

Fig. 1. *The Thouless experiment.*

distance d from the viewpoint, and the length s of the projection of that straight line on a plane parallel to the first and at distance t from the viewpoint, are related by the equation:

$$s = \frac{t}{d} r \qquad (1)$$

Thus, on the basis of Eq. 1, one would expect the image card to have a side $2s = 20$ cm at $t = 1 \cdot 20$ m. Actually, each of his subjects selected an image card having a side $2p$ that was greater than 20 cm.

The expression that Thouless had used for perceptual constancy is *phenomenal regression to the real object* but recently he wrote 'the effect would be better expressed by the term *phenomenal compromise*' [32]. He used the following formula to examine his test data:

$$i = (\log p - \log s)/(\log r - \log s) \qquad (2)$$

where *i* is the *phenomenal regression index.*

Since his subjects specified values for $2p$ that were greater than $2s$ for an image card located between the viewpoint and the object card, *i* was greater than zero (when $i = 0$, $p = s$, which is the condition for linear perspective). On the other hand, since under the same conditions his subjects specified $2p$ less than $2r$, *i* did not equal or exceed 1. (when $i = 1$, $p = r$). When the positions of the image and the object cards were reversed (i.e. such that *t* exceeded *d* and, by Eq. 1, $2s$ exceeds $2r$), the values for $2p$ were less than those for $2s$ and greater than those for $2r$. The values computed for *i* were again between 0 and 1.

Equation 2 is transformed readily to the following:

$$\frac{p}{r} = \left(\frac{s}{r}\right)^{1-i} \qquad (3)$$

Substitution for *s* in Eq. 3 yields:

$$\frac{p}{r} = \left(\frac{t}{d}\right)^{1-i} \qquad (4)$$

Equation 4 can be shown consistent with Eq. 1 by letting $i = 0$ and $p = s$. It is interesting that Eq. 3 is similar to the psychophysical relationship proposed by S. S. Stevens [33, 34], which states that the magnitude p of a sensation grows as a power function of the magnitude s of its stimulus.

III. AN ASSUMED MATHEMATICAL MODEL AS THE BASIS FOR PERSPECTIVE

It is well known that architects sometimes alter slightly drawings of buildings made according to the rules of linear perspective in order to overcome apparent distortions of shapes and exaggerations of sizes. Although the geometry of linear perspective had been elucidated clearly in the 15th century and there are outstanding works in which it was employed, artists at no time have been universally interested in applying it exclusively in their work. Instead, the development of a different kind of perspective has often been a very tempting project to undertake [35, 36]. In my case, Eq. 4 serves as the basis of such a project. I do not wish to deal here with hypotheses of depiction nor do I presume that what I propose below will contribute to an understanding of perception. My aim has been simply to provide architects and artists with a family of perspectives from which to choose.

A plot of *p* vs *t* (Eq. 4) is shown above the horizontal axis (line of sight) of Fig. 1 for $i = 0$ and $i = 0 \cdot 5$. A straight line or ray ($i = 0$) passes from the top edge of the square object card to the viewpoint, describing the top edge of a square image of $2s = 20$ cm at the image plane ($t = 1 \cdot 20$ m). A subject may have selected an image card having a side $2p = 28$ cm, for which the value for i computed from Eq. 2 is $0 \cdot 5$. The plot of *p* vs *t* for $i = 0 \cdot 5$ shows a pair of imaginary curved rays (a parabola) passing from the eye to the top and bottom edges of the object card and describing an image having a side $2p = 28$ cm in the assumed image plane. Although Eq. 4 does not strictly represent lines or rays in the lower quadrant (below the line of sight) shown in Fig. 1, it may be applied generally if a cylindrical coordinate system is employed, where the line of sight is the axis, distance *t* is measured along the axis from the viewpoint and distance *r* is measured radially to the axis. Eq. 4 can be applied in each member plane (designated by angle *a*) in the radial family of planes that contain the axis.

Curves for other values of *i* yielding corresponding values for $2p$ could be plotted on Fig. 1. Fig. 2 is a more general plot where dimensions *p* and *r* and distances *t* and *d* are expressed as dimensionless ratios *P* and *T*, i.e. $P = \frac{p}{r}$ and $T = \frac{t}{d}$. Figure 2

Fig. 2. *Plot of Eq. 4, P vs. T, for values of i from 0 to 1.*
$$P = \frac{p}{r} \text{ and } T = \frac{t}{d}.$$

applies irregardless of whether both dimensions are given in feet or centimeters and both distances in meters or miles. The plot shows only values of P and T between 0 and 1. But it could be extended indefinitely to higher values of T, in which case P also has values exceeding 1.

In order to make a drawing showing an object or a group of objects in a perspective given by a selected value for i, it is necessary first to establish the object or object group in a convenient coordinate system, generally the rectangular coordinate system. Then a viewpoint must be selected. The viewpoint is specified by giving its position with respect to the object or object group. The line of sight is determined by the viewpoint and the *centre of attention*, which is also arbitrarily selected. The location of the centre of attention along the line of sight is of no significance; it is used only for establishing the direction of the line of sight. Next, the distance t of the image plane (the transparent window or sheet of glass, in Leonardo da Vinci's terms) from the viewpoint along the line of sight must be assigned. As in linear perspective, a change in distance t results only in a change in the scale of the image drawing.

In order to apply Eq. 4, the coordinates (e.g. x, y, z) of each point on an object that is to be projected onto the image plane must be transformed into cylindrical coordinates (r, d, a). The corresponding coordinates on the image plane are given by (p, t, a). As in linear perspective, the distance r of each selected point is measured perpendicular to the line of sight; d, the distance from a selected point to the viewpoint, is measured parallel to the line of sight. A calculation of p (Eq. 4) is made for each of the points required for constructing the image.

IV. PROPERTIES OF THE MODEL

Certain properties of the assumed mathematical model are worthy of note here. The first concerns the shape of the rays (Fig. 2). As mentioned above, when $i=0$ the rays are straight and the condition for linear perspective (Eq. 1) applies. As the value of i increases from 0 to 1, the rays become more and more curved. When $i=0.5$, the curves are parabolic. When $i=1$, the rays are L-shaped with one leg parallel to the line of sight for values of T greater than 0. Thus, the image of an object when $i=1$ is identical to that obtained with *axonometric*

projection, where the direction of projection is given by the line of sight. Perhaps one can consider the condition of linear perspective to represent zero constancy but one cannot consider the condition given by $i=1$ to represent full constancy. In passing from $i=0$ to $i=1$, the projected images pass simply to axonometric ones.

For all values of i from 0 to 1, a 2-dimensional shape perpendicular to the line of sight casts a geometrically similar image upon all planes parallel to the shape. This becomes evident from Eq. 4 by considering the cylindrical symmetry of the family of rays and from showing that, given any two radial lines of lengths r_1 and r_2 in the shape, the ratio of the corresponding lengths p_1 and p_2 of their projections in a parallel plane is equal to the ratio r_1/r_2. Not only do straight lines in a plane normal to the line of sight remain straight on projection on another plane parallel to it but also so do any straight lines in a 3-dimensional object that intersect the line of sight. However, straight lines that are not in a plane normal to the line of sight are generally transformed into curved lines. But the curvature that I have obtained in architectural and engineering drawings generally seems almost imperceptible in the usual situations. According to the mathematical model, images of a 3-dimensional object projected upon planes normal to the line of sight are geometrically similar. That is to say, the shape of an image does not vary with the location of the image plane.

When the value of i is between 0 and 1, objects, or portions thereof, located beyond the image plane produce images that are larger than those predicted from linear perspective (Fig. 1). When they are located between the viewpoint and the image plane, then the converse is noted.

Tangent lines to the curved rays at points of intersection with a plane normal to the line of sight, at distance c from the viewpoint V (Fig. 3), converge at V' located at a distance $\frac{ci}{1-i}$ behind V. An image generated by the model for a given value for i consequently resembles an image generated by linear perspective from a pseudo-viewpoint V', a resemblance that improves as the object distance is increased. A technique for making a drawing in linear perspective with the viewpoint behind the artist was depicted by Albrecht Dürer in a woodcut (Fig. 4) [37]. The artist sights along a string that is attached, as shown, to a wall by a pin (the viewpoint).

V. COMPUTER PROGRAMME FOR THE MODEL

I have prepared a computer programme, called IMAGE, for making computer drawings with a plotter for the range of values for i from 0 to 1. The programme is written in FORTRAN-1130 language and it can operate in an interactive mode [38]. I have employed an IBM-1130 computer and an IBM-1627 plotter. The following are some

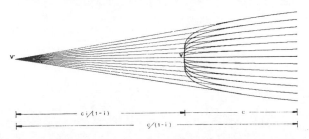

Fig. 3. A family of curved projection rays, where $i=0.75$. *Tangents to the curved rays at coordinate* x=c *converge at a pseudo viewpoint V'.*

Fig. 4. Woodcut by Albrecht Dürer showing the construction of a drawing in linear perspective with the viewpoint behind the artist [37].

significant aspects of the programme and its operation:

1. The form of an object is described principally by its *limit points*, i.e. those points that lie at maxima and minima of bulges and dips of non-planar surfaces, at intersections of planes, etc. In effect, a limited number of well chosen points with straight lines drawn between them can constitute an approximate representation of an irregular object's surface contours. The programme directs the plotter to draw such lines and the resulting picture resembles a drawing of a wire sculpture of the object. If it were desired, a programme could be written that directs the plotter to draw only lines visible from the view-point and to suppress the hidden lines, as has been done for computer drawings in linear perspective [39, 40].

The programme requires locating the object, e.g. a building or a group of objects, in the rect-angular coordinate system. The selected points are assigned numbers in sequence and the inter-connecting line segments are likewise numbered. A simple example of six points and nine lines is shown in Fig. 5 and the two corresponding sets of descriptive information are given in Table I. The sequential numbering of the lines represents the order in which the corresponding image segments are drawn by the plotter. The two information sets describing the object are fed to the computer by conventional means (punched cards, magnetic tapes, console typing). Non-numerical methods for feeding graphical information to computers are currently in development in order to reduce the preparation time [41]. Given the two sets of information, the computer prints out tabulations of coordinates for the following: the points representing the projection of the limit points in the x–y, x–y, and y–z coordinate planes, the *centre of points* (i.e. the centre of gravity of the spatial array of the selected points of the object where the points are considered to represent equal masses) and the *centre of lines* (i.e. the centre of gravity of a wire-construction of the object where each of the numbered lines is represented by a wire and all wires have the same mass per unit

length). In addition, the programme can be ordered to draw, in a selected scale, the orthogonal projection of the object upon the three coordinate planes.

2. The coordinates of the viewpoint and the centre of attention are then specified. The centre of attention is chosen to be either the centre of points or the centre of lines or another point

TABLE I. SAMPLE DATA FOR MAKING A COMPUTER DRAWING: COORDINATES OF POINTS AND DESIGNATION OF LINES DESCRIBING AN OBJECT TO BE DEPICTED (FIG. 5)

Data points

Point	Coordinates		
	x	y	z
1	0	0	0
2	24	0	0
3	0	−2	4
4	0	2	4
5	−2	−8	5
6	−2	8	5
centre of points	3·33	0	3·33
centre of lines	9·79	0	2·93

Data lines

Line	Points at ends	
	start	end
1	2	3
2	3	5
3	5	2
4	2	4
5	4	6
6	6	2
7	2	1
8	3	1
9	4	1

Fig. 5. Example of the assignment of numbers successively to points and lines describing an object (cf. Table I).

Fig. 6. A cube (i=0, 0·5 *and* 1) *as drawn for three viewpoints.*

generally in or around the object or group of objects. The computer is ordered to calculate the distance between the viewpoint and the centre of attention.

3. A value is assigned to index i. The computer is now employed to determine the coordinates defining the shape of the image for the given viewpoint and line of sight. The coordinates are for those points on the image plane through which the rays pass in going from the selected limit points on the object to the viewpoint. The image plane is located at the centre of attention. Thus t is given by the viewpoint-centre of attention distance and the image size is fixed. This information defining the image is stored in the computer memory.

4. Utilizing the stored information, the computer now selects the maximum scale for the drawing consistent with the size of the paper used by the plotter. Conversely, distance t, which is analogous to the focal length in photography, may be specified and the corresponding scale and dimensions p will be provided by the computer. Thus, with the selected curved rays, pictures can be drawn whose perspective is applicable for viewing at specified distances.

5. The drawing is made by the plotter under the control of the programme.

An informative series of computer drawings is given in Fig. 6 where a cube (of dimensions 6 × 6 ×6) made from wire is viewed from three different points A, B and C. The far corner at the base of the cube is at the origin of the rectangular coordinate system and the adjacent edges coincide with the x-axis (horizontal, forward from the far corner), y-axis (horizontal, to the right) and z-axis (vertical). The centre of attention is located at the cube's centre (3, 3, 3). The images corresponding to the three viewpoints A (15, 8, 10) (Fig. 6a), B (8, 3, 2) (Fig. 6b) and C (10, 5, 2) (Fig. 6c) are presented for $i=0$, 0·5 and 1. There is a different line of sight from each viewpoint and there is a different image plane perpendicular to each line of sight.

As mentioned earlier for $i=0.5$ (Fig. 1), or any value between 0 and 1, the rays are curved. Thus, lines that connect points in different planes perpendicular to the line of sight are, in general, curved. Such curvature is readily apparent in Figs. 6b and 6c ($i=0.5$). It is present, but hardly noticeable in Fig. 6a ($i=0.5$). The curvature tends to become more pronounced for viewpoints near to objects (usually large angles of view) or when the ratio of the distance from the viewpoint to the farthest point in the object to the distance to the closest one, measured along the line of sight, is high. All the drawings in Fig. 6, which are based on calculations corresponding to the respective image planes passing through the centre of attention, have been made using the same scale.

The computer drawings shown in Fig. 7 show some basic lines in the structure of the Palazzo Strozzi in Florence [42]. These drawings for $i=0$ and $i=0.25$ were based on 36 selected points and 68 joining lines. In both cases the coordinates of the viewpoint are the same, as are those of the centre of attention.

I maintain that my model for perspective is simply a system for drawing. It possesses flexibility by virtue of its index, whose value may be varied. One can speculate that, in the future, devices

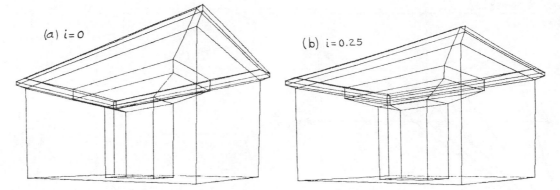

Fig. 7. Drawings of a part of the structure of the Palazzo Strozzi, Florence. (*a*) i = 0, (*b*) i = 0·25.

similar to photographic cameras will be made that alter, in effect, the shapes of rays of projection to obtain a desired kind of image, much as I have been able to do in making drawings by the use of a mathematical transformation.

REFERENCES

1. H. C. Reggini, Perspectivas mediante computadoras, *La Ingenieria* (Buenos Aires) **75,** 7 (Jan./Feb., 1973).
2. H. C. Reggini, Perspectiva, *Summa* (Buenos Aires) **74/75,** 68 (1974).
3. J. J. Gibson, *The Perception of the Visual World* (Boston: Houghton-Mifflin, 1950).
4. J. J. Gibson, Pictures, Perspective and Perception, *Daedalus* **89,** 216 (1960).
5. J. J. Gibson, *The Senses Considered as Perceptual Systems* (Boston: Houghton-Mifflin, 1966).
6. J. J. Gibson, The Information Available in Pictures, *Leonardo,* **4,** 27 (1971).
7. G. Kepes, *Language of Vision* (Chicago: Paul Theobald, 1952).
8. R. Arnheim, *Art and Visual Perception* (Berkeley: Univ. California Press, 1954).
9. R. Arnheim, *Visual Thinking* (Berkeley: Univ. California Press, 1971).
10. J. J. White, *The Birth and Rebirth of Pictorial Space* (London: Faber and Faber, 1950).
11. N. Goodman, *Languages of Art* (New York: Bobbs-Merrill, 1968).
12. D. Couzin, On Gibson's and Goodman's Accounts of Depiction, *Leonardo* **6,** 233 (1973).
13. M. H. Pirenne, *Optics, Painting and Photography* (Cambridge: Cambridge Univ. Press, 1970).
14. R. L. Gregory, *Eye and Brain* (London: World Univ. Press, 1966).
15. R. L. Gregory, *The Intelligent Eye* (New York: McGraw-Hill, 1971).
16. S. M. Antis, C. D. Shopland and R. L. Gregory, Measuring Visual Constancy for Stationary or Moving Objects, *Nature* (London) **191,** 416 (1961).
17. E. H. Gombrich, *Art and Illusion* (New York: Pantheon, 1960).
18. E. H. Gombrich, J. Hochberg and M. Black, *Art, Perception and Reality* (Baltimore: Johns Hopkins Univ. Press, 1973).
19. H. W. Leibowitz, *Visual Perception* (New York: Macmillan, 1969).
20. M. D. Vernon, *The Psychology of Perception* (London Penguin, 1971).
21. R. K. Luneburg, *Mathematical Analysis of Binocular Vision* (New Jersey: Princeton Univ. Press, 1947).
22. K. R. Adams, Perspective and the Viewpoint, *Leonardo* **5,** 209 (1972).
23. K. R. Adams, Cézanne and the Average Effect of Foreshortening on Shape, *Leonardo* **8,** 21 (1975).
24. V. Ronchi, Perspective Based on New Optics, *Leonardo* **7,** 219 (1974).
25. R. Descartes, *Dioptrics* (Leyden: 1637); quoted in Ref. **14,** p. 152.
26. R. L. Gregory, The Confounded Eye, in *Illusion in Nature and Art,* R. L. Gregory and E. H. Gombrich (eds.) (London: Duckworth, 1973) p. 75.
27. E. H. Gombrich, Illusion and Art, in *Illusion in Nature and Art,* cf, Ref. **26,** p. 229).
28. H. R. Maturana, F. G. Varela and S. G. Frenk, Size Constancy and the Problem of Perceptual Spaces, *Cognition* **1,** 97 (1972).
29. R. H. Thouless, Phenomenal Regression to the Real Object, I, *Brit. J. Psychol.* **21,** 339 (1931).
30. R. H. Thouless, Phenomenal Regression to the Real Object, II, *Brit. J. Psychol.* **22,** 1 (1931).
31. R. H. Thouless, Individual Differences in Phenomenal Regression, *Brit. J. Psychol.* **22,** 216 (1932).
32. R. H. Thouless, Perceptual Constancy or Perceptual Compromise, *Aust. J. Psychol.* **22,** 2 (1972).
33. S. S. Stevens, The Quantification of Sensation, *Daedalus* **88,** 607 (1959).
34. R. Fischer, On Symmetries and the Structure of Our Own Nature, *Leonardo* **7,** 147 (1974).
35. A. Barré and A. Flocon, *La perspective curviligne* (Paris: Flammarion, 1968).
36. R. Hansen, This Curving World: Hyperbolic Linear Perspective, *J. Aesth. and Art Criticism* **32,** 147 (1973).
37. *Dürer—L'oeuvre du maître, Collection de gravures* (Paris: Hachette, 1908).
38. W. M. Newman and R. F. Sproull, *Principles of Interactive Computer Graphics* (New York: McGraw-Hill, 1973).
39. J. M. Brun and M. Theron, *Le langage Euclid* (Paris: Laboratoire d'Informatique pour la Mécanique et les Sciences de l'Ingénieur, 1972).
40. I. E. Sutherland, R. F. Sproul and R. A. Schumacker, A Characterization of Ten Hidden Surface Algorithms, *ACM Computing Surveys* **14,** 1 (1974).
41. N. Negroponte, Recent Advances in Sketch Recognition, *Proc. National Computer Conf.,* New York, June 1973, p. 663.
42. B. Fletcher, *A History of Architecture* (London: Athlone, 1967).

COMPLEX CURVILINEAR DESIGNS FROM PENDULUMS

S. Tolansky*

Abstract—*The author points out that Bowditch in 1815 first discussed the striking curvilinear patterns produced by the graphical combination of two vibrations moving at right angles to each other. Similar patterns were described by Lissajous in 1857. Sophisticated electronic systems cannot create patterns which even remotely compare either in interest or in aesthetic appeal with those that can be formed by quite crude mechanical pendulum devices.*

Two devices are described in detail: one with two pendulums with variable inclination of axes and one with a single pendulum provided with a perturbing pendulum. He shows examples of the kinds of patterns that they produce and how they depend on factors controllable by the operator.

The fact that it is not possible ever to reproduce the same pattern, even with the same device, is demonstrated by the author—thus each design can be copyrighted by an operator, if he is so inclined. The patterns obtained depend entirely on the skill and knowledge of the operator.

The growth of a pattern, he states, is fascinating to watch and can easily be photographed on ciné film with obvious application in film captioning and other fields.

I. INTRODUCTION

Since 1815, when the idea was first discussed by Nathaniel Bowditch, it has been well known to physics students that the graphical combination of two vibrations moving at right angles to each other can produce quite striking curvilinear patterns. Indeed the simpler kinds of such patterns, which were first described in some detail by Jules Antoine Lissajous in 1857, have now become a commonplace to the electronics specialist, since they are simple to create on an oscilloscope. Yet it so happens that sophisticated electronics systems cannot create patterns which even remotely compare either in interest or in aesthetic appeal with those which can be formed by quite crude mechanical pendulum devices, as will be demonstrated here.

Bearing in mind especially the interest of both the designer of line pattern and of the calligraphist, I describe here two quite simple devices which are both capable of creating an infinite variety of exciting patterns, the main feature of any pattern being under control, although finer detail of most is often unexpected, adding indeed greatly to the charm of the product. The two arrangements described are essentially traditional designs of pendulum combinations but slight modifications which I introduce, can have very marked influence on the final pattern

created and this therefore largely justifies this report, which in any case looks at the product from the outlook of calligraphic design and not the outlook of the physicist [1].

The old, now classical, way of producing the Lissajous figures is to set into oscillation two bar pendulums which swing in planes *at right angles* to each other. The one pendulum swings a table bearing a sheet of paper, the other swings a pen. The pattern described on the paper is determined by four separate features, namely (1) the ratio of the times of swing of the two pendulums; (2) the phases, that is to say the relative position within the gamut of an oscillation at which the pen first touches paper; (3) the extent of the two swings i.e. the two amplitudes of oscillation and, finally, (4) the damping, i.e. the rate at which the oscillations die down. All four are subject to control. The times of swing can be varied by adjusting the position of the pendulum bob, the phase is under direct control, the amplitudes can be selected at will and, finally, by attaching large vanes to the pendulums the resulting air resistance can modify the damping.

Such a pendulum combination is highly sensitive to the vibration times. If the two pendulums have identical periods and the two amplitudes of vibration are equal, then according to the phase relation selected, the pattern which the pen should describe can range from a straight line, through differently eccentric ellipses, through to a circle; with the particular emerging pattern depending only on the

*Professor, Physics Department, Royal Holloway College, University of London, England. (Died in 1973.) (Received 23 January 1969.)

selected phase. Again, if one pendulum has exactly twice the period of the other, then anticipated patterns range from a parabola, through a distorted figure 8, finally to a symmetrical figure 8. As long as the vibration times are in the *exact* ratios of small simple numbers, such as 1:1 or 2:1 or 3:2 or 4:3 and so on, then quite simple straightforward predictable patterns emerge and, in fact, it is such simple ratios which operate effectively with the oscilloscope.

When, however, there is even quite a slight deviation in timing from the whole number ratio (it may be little more than 3 per cent) this can lead to a most elaborate confused sweep of lines, so interwoven as to bewilder. Such complex patterns have no aesthetic appeal at all, hence, if the intention be to create patterns of beauty, any departure from the strict simple numerical ratio must be quite slight.

Now every pendulum, when set into motion, slows down due to friction at the bearings and also due to air resistance, i.e. it damps. Consequently, even with an exact simple number ratio of swinging, there is a steady reduction in amplitude, leading to a repetitive spiralling inward, which is a most important feature of the patterns formed. This feature is absent in the oscilloscope pattern. [Even if a suitable damping were introduced into the oscilloscope, there is no easy means of freezing-in the successive variations with time.] Actually so sensitive to timing is the system, that the theoretically predictable very minor variation in timing caused by reduction of amplitude is noticeable, a feature of much interest to the physicist but somewhat technical from the viewpoint of the calligraphist.

Now it so happens that the strict symmetry which can result from the classical two-pendulum arrangement leads to rather dull patterns. Indeed if *asymmetry* can be injected into the same, there is a great livening up in design. It is my prime purpose here to describe two different pendulum systems in which controlled amounts of deviation from symmetry can be very easily injected. Some of the patterns which result (a few only, for an infinitude of arrangements is possible) will be illustrated and their formation discussed.

II. TWO PENDULUMS, WITH VARIABLE INCLINATION OF AXES

1. *Description of the device*

The new feature introduced here into the normal classical arrangement is, that by a simple arrangement, the two axes can be inclined *out* of the perpendicular. The device is shown in Fig. 1, in the classical arrangement first. The pendulum at the left, carrying the pen at the top, swings in the plane of the picture. The pendulum at the right, carrying a cylindrical table under the pen, whose centre of curvature is at the bearings, swings perpendicular to the paper, as it stands now. However the whole pendulum at the right and its bearing is on a graduated turntable (seen as a thin black line) and this

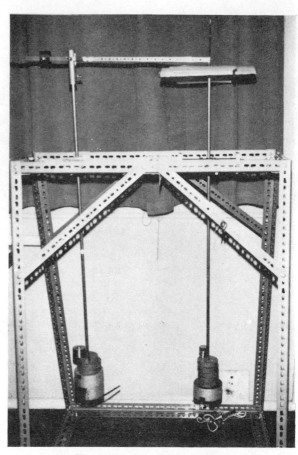

Fig. 1. *Two-pendulum system.*

can be rotated so that the two planes of swing are no longer perpendicular. Doing this injects an asymmetry, as we shall see later. Minor timing adjustment is secured by adding or subtracting small weights on the bobs, a preliminary time setting being made with the seconds-hand of a watch. Damping is varied by clipping a plate of area about a square foot onto one or other of the rods, timing being adjusted accordingly. Each pendulum is about a yard long and the bobs are quite heavy, to sustain long vibration. Accurately made bearings are a necessity. The pen is a refill for a ball-point pen and, as it can swing freely up–down, a weight controls writing pressure. We shall now examine the curves obtained, especially in relation to injected asymmetry.

2. *Two-pendulum patterns*

For two pendulums with *absolutely* identical periods, in general an ellipse results when the vibrating planes are at right angles. Since there must be damping, this spirals inward. The result of one such tracing is shown in Fig. 2. There are in fact about 70 spirals in the ellipse. Had the periods been *identical* all spirals would have been 'parallel'. As it is, the inner ones are about half a turn behind the outer ellipses. This means that the timing is a little out, indeed by only 1 part in 140. Thus a deviation of only 0·7 per cent affects the pattern markedly. However, we shall not pursue this aspect here any further but instead consider what happens if we rotate the turntable through 30°, to inject some asymmetry.

Fig. 2.

Fig. 3.

Of course in the repeat, the amplitudes will be accidently different so that the ellipticity of the ellipses will not be the same but this is a minor issue; what we are seeking is a pattern variation. Figure 3 shows the result. Some asymmetry has crept into the pattern. Now let us increase the turntable angle to 60°, a position in which the table is beginning to swing in a plane not far removed from that of the pen. Figure 4 is the resulting pattern from which we see that the asymmetry injected has introduced a striking modification into the pattern in Fig. 2.

In the above patterns some care was taken to ensure that the vibration times agreed to better than 1 per cent. Any appreciable increase in this devia-

tion produces a notable effect. With axes at right angles (the traditional setting) then the ellipse of Fig. 2 converts into the pattern of Fig. 5 when a timing deviation of a mere 4 per cent is introduced. Comparison of the two figures shows how sensitive the system is to timing and how elaborate a change emerges so easily. The outer figure is a distorted ellipse. Now, however, let us inject only slight asymmetry by a turntable setting of but 30° and Fig. 6 emerges. The outline has become trapezoid. Yet it will be noted that the asymmetry effects, although distinct in all that has been described, are yet of rather a minor character. This is only true because the two periods, so far, are not very different from

Fig. 4.

Fig. 5.

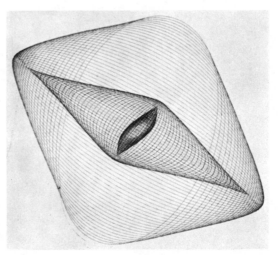

Fig. 6.

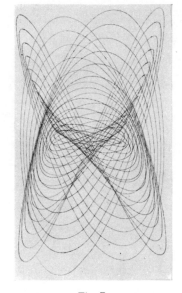

Fig. 7.

1:1. As soon as near equality is departed from, then the effects become marked.

There is a rapid run-away when time deviation is increased, once different number ratios are adopted. Consider for instance the curious pattern of Fig. 7. This has been created by a timing ratio somewhat, but not too far, distant from 3:4. It is an interesting straggly pattern and because of the departure from the near simple number ratio there is quick sweeping variation. Now with identical timing and more or less similar amplitude, the effect of injecting a 45° axis change on asymmetry is shown in Fig. 8. Clearly this is intimately related to its parent curve

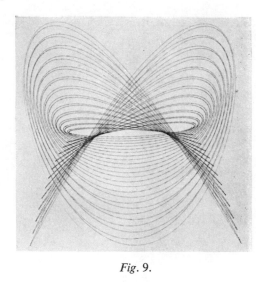

Fig. 9.

but is now much more elaborate, indeed rather unpredictable.

When the timing is brought nearer and nearer to the simple number ratio, the pattern becomes tighter, less straggly and more precisely repetitive. Thus the almost perfectly symmetrical beautiful pattern of Fig. 9 emerges with the *very near* 3:4 ratio, when axes are at right angles. Such a pattern is now highly sensitive to axial variation. An axis setting of 30° leads to the asymmetry of Fig. 10. This of course is very different at first viewing from its parent, Fig. 9, for it is only our sequential tracing of the direct relationship which reveals the true connection between Figs. 9 and 10. It will be recognized of course that the designer has available in the variable-axis system a virtual infinite variety of patterns and asymmetries at his disposal.

In the next section we shall deal with a simpler pendulum system that almost always leads to highly asymmetrical patterns. Here we have added little to what is already known, apart from exploring the possibilities from the special viewpoint here under discussion. Here too we find it advantageous to introduce controlled damping, controlled timing and so on. We have effectively adapted the technique from that used by others, with only slight modifications.

III. PERTURBED SINGLE PENDULUM

The device is shown in Fig. 12. A metal rod pendulum is suspended from a gimbal type of

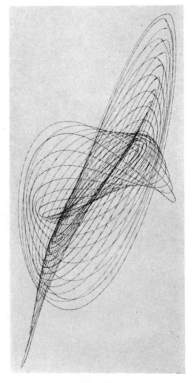

Fig. 8.

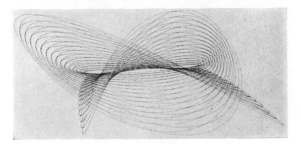

Fig. 10.

Fig. 11.

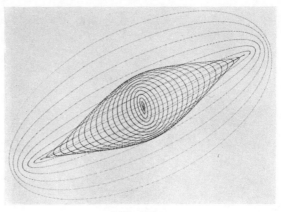

Fig. 13.

universal joint support so that the pendulum can swing in all directions but without torsion. (We have tried using simple string pendulums, which can also swing universally, but then torsion creates a new complication and it is really hard to avoid torsional oscillations. Patterns are complicated enough with-

out this extra distortion effect.) A table on the bob carries the paper. A rectangular table is shown but a circular table top is advantageous, as we have found. The ball pen is attached to the frame work and is pivoted in such a way that it can ride up and down. Writing pressure is weight-controlled. The special feature is a second perturbing pendulum, a lead bob suspended by a string from the main bob above it.

If the secondary bob is removed, then a pendulum on a universal gimbal should produce curves ranging from a straight line through an ellipse to a circle. A typical such curve is shown in Fig. 11. It constitutes merely a dull repetitive spiral of little interest or appeal. However once we inject into the system some degree of asymmetry, then we immediately find that the pattern transforms itself into that of Fig. 13. The asymmetry is created in a very simple fashion. In Fig. 11 the two pairs of knife edges in the gimbal support are co-planar. In Fig. 13 one pair of the knife edge supports has been raised an inch higher than the other, changing the periods in the two planes.

If we now attach the secondary string-bob pendulum, with its relatively small weight, below the massive main bob, a slight perturbation introduced by but a *gentle* displacement of this secondary bob converts Fig. 13 into Fig. 14. Several points are to be noted. First, Fig. 14 is an obvious daughter of Fig. 13. Secondly, it is curiously more attractive than the strictly symmetrical parent pattern. Thirdly, it is immediately obvious that we have at our disposal an enormous range of possibilities. For under control are the following variables: (a) the weight of the secondary bob, the size of which determines its influence, (b) the period of the secondary

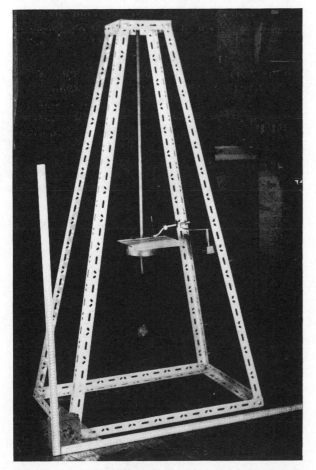

Fig. 12. *A single pendulum provided with a perturbing pendulum.*

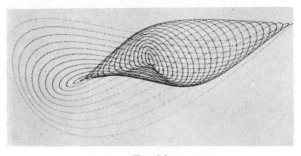

Fig. 14.

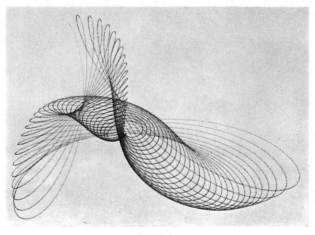

Fig. 15.

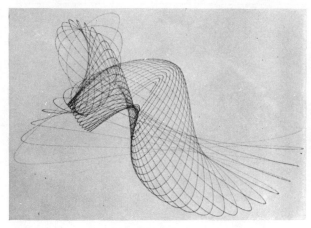

Fig. 17.

bob, through varying its length, (c) the phase of the perturbation, (d) the amount of damping and, finally, most important of all (e) the geometrical form of the perturbation, for the perturbing bob can be variously swung in a straight line, an ellipse, or a circle. The orbit chosen for the perturbing bob profoundly affects the final result, more than anything else. To show this, let us pursue sequences of curves with varying perturbations.

In Figs. 13 and 14, the close relationship is in part due to the fact that the periods of the main and secondary pendulums are close to each other and, in part, due to the fact that only a slight linear displacement has been given to the perturbing bob. If now the perturbing bob be displaced into a slight elliptical orbit, an astonishing pattern emerges as is shown in Fig. 15. This in fact is related to Fig. 14 but is much more exciting as a pattern. It is again essentially regular because the two vibrating times are close to each other.

Once the timing is changed, then the pattern begins to sweep into a complexity which progressss as the time difference increases. A slight timing difference leads Fig. 15 into the elaboration of Fig. 16 whilst further timing difference (still not very big) creates the highly elaborate asymmetrical pattern of Fig. 17.

In the patterns so far discussed, the main bob had primary control and the secondary bob was a relatively minor perturbation. A different situation arises if the secondary bob is violently displaced, whilst the main bob is left to be forced into movement by the secondary system. For instance, if the two timings are fairly close and if the secondary bob alone is given a strong *circular* orbital swing, a sympathetic resonance sets in and the secondary bob begins to push the main pendulum into a near circular motion. The curious pattern created under such condition is shown in Fig. 18. Throw the timing a fraction out of balance and the near circles of Fig. 18 degenerate into Fig. 19.

By suitable control of both phase and timing, one obtains an asymmetrical distorted figure-8 type pattern of the kind illustrated in Fig. 20. A slight phase alteration and a little ellipticity added to the perturbing bob secures for us the neat attractive pattern of Fig. 21.

There is little point in increasing the number of examples. The output from both types of pendulum is infinite in its variety and complexity. I have deliberately chosen the *simpler* from among many hundreds of different patterns I have made. Each

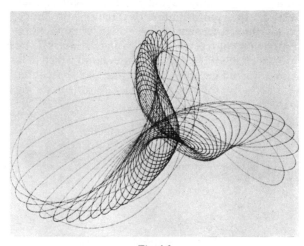

Fig. 16.

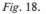

Fig. 18.

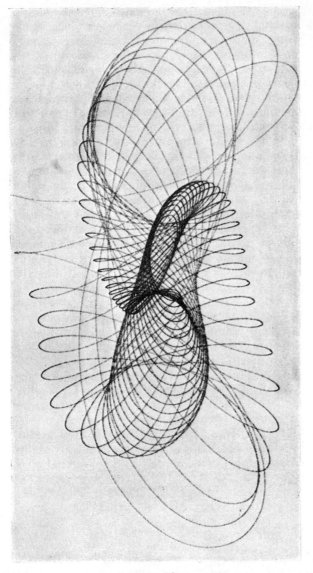

Fig. 19.

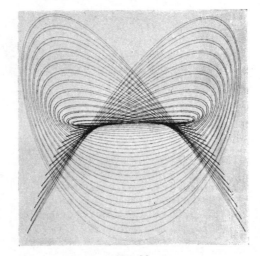

Fig. 21.

pattern is completed within 5 minutes and each is different. This variability raises the question of reproducibility and copyright. There are two aspects, namely, suppose someone else sets up a similar pendulum system: then (a) is there any likelihood that any curve I produce has already been made by the other operator and (b) is there equally any likelihood that the other operator can copy exactly one of the curves I have already made? The answer to both questions is in effect, *no*! For a curve to be repeated even on the *same* machine, it is necessary that *all* the conditions (timing, amplitude, phase and damping) be *exactly* reproduced and this is manifestly so highly improbable as to be virtually regarded as impossible in practice. In this sense then, every pattern is an original and can justly be copyrighted by the operator. Equally, there is no fear on issuing a pattern, that there is danger of infringing someone else's copyright. To begin with, the two operators will have differently responsive equipment and, in any case, even on one experimental arrangement I have never been able, after numerous repeats, to secure *identity* in pattern. With care one can obtain a close *approximation* but there are always obvious differences. Let us consider an example.

In obtaining Fig. 9, the pattern was gently removed from the table whilst the pendulums were slowing

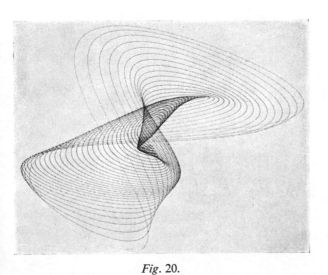

Fig. 20.

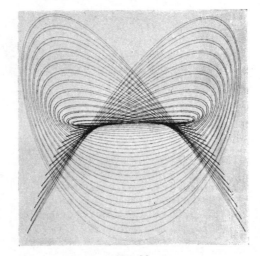

Fig. 22.

F

down and every care taken not to disturb the slowed-down motions (even the act of removal of paper changes the weight on the pendulum and this causes a minute but real change in timing). The pendulum amplitudes were gently increased, such that there was hardly any perceptible change in phase, period or damping and a repeat was taken. The repeat is Fig. 22. Now despite all care and precautions this differs in many respects from Fig. 9. To begin with, it is longer and narrower, showing that the two amplitudes were not identical, nor could they very well have been so. Then again, inevitably, extremely small phase changes must have been created in gently working up the amplitudes also, as already noted, a very minor frequency-time change was imparted by the paper removal. Consequently, despite the *first impression* of very close resemblance between the two figures, there are in fact numerous minor differences; in the separation of lines, in where they meet, in the number of lines and so on. Finally, it is quite impossible for two different pieces of equipment to have the same frictional constraints, hence damping must differ, consequently the spacings of successive lines on the two instruments must differ, even if by some extraordinary remote possibility other features were identical.

In other words it is impossible *exactly* to repeat, *even on the same equipment*. Copyright is thus always automatically valid.

We have here illustrated two simple devices but both can be subject to endless variation. In the two-pendulum device one could add perturbation systems. In either of the perturbing systems on any device one could use an iron bob and let this swing past a magnet; one could create variable timing by adding a container to a bob and siphon liquid into it during the operation; one can introduce if one wishes, much fiercer damping by attaching a vane to move in liquid; indeed possibilities are endless, yet truth to tell, there is complexity enough available in the simple systems described here. Although *exact* reproducibility is not possible, after some experience one quickly learns the tricks and characteristics of one's set up and according to whim, fair close approximations can very often be obtained, especially if no change in the timing is effected. In other words, phase, amplitude and damping are reasonably amenable to approximate reproduction but tampering with the timing leads to a very great loss in time before close timing conditions can be re-established.

My object here has been to put operations on a rational basis to guide any art designer who might wish to operate such a device. One further point is really worthy of mention. The growth of the pattern, which establishes its main character in a few seconds, is fascinating to watch. It can quite easily be photographed on ciné film. This results not only in a final beautiful pattern but creats a dynamics that is most highly attractive. Such a live scribing system has obvious application in film captioning and other fields. By reducing the damping, the system can go on oscillating smoothly for a matter of a few minutes, more than ample for most demonstrations of a live nature.

Finally, it must be insisted that these drawings are in no sense automatic and computerized. The patterns obtained depend entirely on the skill and knowledge of the operator and reflect the known perturbation or asymmetry injected. The figures are certainly not just due to chance, as this article indeed proves.

REFERENCE AND NOTE

1. H. M. Cundy and A. P. Rollett, *Mathematical Models* (Oxford: Clarendon Press, 1961). The authors describe two pendulum systems but without the modifications which are introduced here to inject desired asymmetries.

A PROPOSED NOTATION FOR VISUAL FINE ART

John G. Harries*

Abstract—*A notation system for the visual fine arts should provide the means for indicating certain visual aspects of a work as an aid to artists in formulating concepts and executing them. It also should permit the recording and transmission of these aspects to others in a simple manner. A notation for movements of the body in dancing, athletics, etc., the Eshkol-Wachman Movement Notation, has suggested to the author the employment of an analogous method in visual art. The basic assumption made is that two-dimensional shapes and three-dimensional forms can be generated by the motion of lines or chains of lines. Thus complex shapes can be described in the notation by specifying the synchronization of motions, the lengths of lines, the omission of lines etc. The rigour of the notation makes it suitable for computer use but the author stresses the notation's value as an aid to artists who deal manually with complex shapes in paintings or sculpture.*

I. INTRODUCTION

The need for notations is rarely, if ever, questioned in certain fields. Science and mathematics are unthinkable without the use of symbol systems. In Western music (ignoring improvisation) notations are taken for granted by composers and performers. (A discussion of the non-conventional type of notation used by contemporary composers is given in Ref. 1.) On the other hand, in the visual arts, discussions of the subject are virtually non-existent.

In easel-painting, a long and revered tradition supports the conclusion that the introduction of an analogic notation as an aid to the execution of such works is an irrelevant intrusion. Furthermore, a copy of a painting is considered to be of little artistic or commercial merit and the better the copy, the worse the transgression, for it is regarded simply as a forgery of a unique artifact [2]. A notation implies the formulation of criteria by which it is possible to identify different events or artifacts as separate examples of the same work of art. But clearly a notation in this sense is impossible for traditional painting, since tradition defines one and only one artifact as being a valid example of a given work.

This said, it must be noted that attempts—however few and however partial—have been made to formulate notational systems for the visual or plastic fine arts. Evidently, some artists have felt the need for a notation and it is instructive to consider which media have been approached in this way. Some have made use of systems of notation for colours, based, for example, on psychophysical and psychological concepts, which are widely used in industry [3, 4].

A few artists have developed notation systems for their own use, for example to indicate colours on cartoons for tapestries. Vasarely applies a kind of notation in order to describe compositional variations made up of a number of design units and Norman McLaren devised for the making of his animated films a notation to indicate their temporal organization. Shapes in two and three dimensions as well as their change with time can be described mathematically; however, the equations needed may become very complicated and their application requires considerable experience—well beyond that of most artists. It was primarily the spatial and temporal aspects that led me to investigate the possible usefulness of a special notation system in the visual fine arts.

Personal notations of artists have been used for the following purposes: (1) the designation of colours; (2) the indication of the location in a composition of a selected number of units of fixed design; (3) the indication of the variation in shape of an initial shape and its location in a composition and (4) the specification of the types of motion for a kinetic art object [5]. Of these, only a precise notation for the designation of colours has been developed for general use, for example the Munsell colour system [3, 4].

A generally useful notational system should permit an artist to record the essential visual aspects of a particular work. The notation should be capable of being learned readily, so that it can serve as a way of communication between artists. But, above all, it should be applicable to the working out of artistic visual conceptions to be executed in different

* Staff member, Research Centre for Movement Notation, Faculty of Fine Arts, Tel-Aviv University. Living at 5 Beth-Lehem Street, Holon, Israel. (Received 1 June 1974.)

media. Something approaching such a notational system has arisen in the context of the use of digital computers. The use of computers coupled to plotters and cathode ray tubes (CRT) has necessitated the development of special programming languages that enable an operator to command the operations to be carried out.

The information input to a computer contains a specification of relations between variables, such as a mathematical equation or a set of data and a set of instructions specifying values of variables to produce a visual display [6, 7]. The visual display can be repeated and modified by changing the instructions. Since a computer language is designed for a particular type of computer, it must take into account the technical characteristics of that type. Thus, the concepts that can be developed with the aid of a computer language are limited. A language used for communication between persons takes into account human adaptability, so that radical transitions can be handled in relatively simple ways. This type of adaptability is essentially lacking in computer languages. If a notational system is to permit the working out of artistic visual conceptions, it must be more readily adaptable than computer languages.

Concurrently with my work in visual art, I was engaged in studies of movement, including a notational system for dance, being conducted by Noa Eshkol. Her studies often suggested parallels for visual art as regards principles and procedures

employed. Her and my aims were also similar, in particular that of developing notations that would be free of unnecessary limitations of style and would allow conscious artistic exploration, variation and development. None of the existing dance notations was adequate for the approach of Eshkol for dealing with dance movements. The notation, subsequently developed by her and Abraham Wachman who was then also one of her students, is based on a quantified analysis of movement, which does not rely on arbitrary aesthetic assumptions [8].

My first efforts to develop a notation for visual art were in a direction having little in common with the Eshkol–Wachman (EW) Movement Notation. They were based on discrete variations and deformations of networks similar to certain programmes used for computer graphics in which, through a scanning process, each element is turned into a section of a net pattern [9]. I abandoned this approach when I realized that an application of the principles of EW Movement Notation would be more flexible and more comprehensive.

The EW Movement Notation permits a concise description of the movements of the parts of the body in a variety of physical activities [10], including classical [11] and modern dance, folk dancing

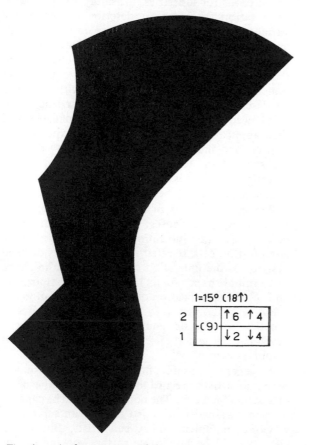

Fig. 1. *A shape generated by two linked generatrices (cf. Fig. 2).*

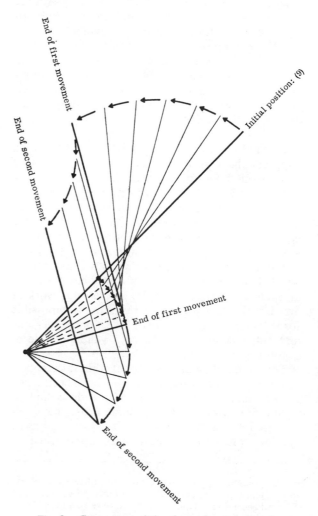

Fig. 2. *Generation of the shape shown in Fig. 1.*

[12, 13], athletics, such as track and swimming [14], and sign language for the deaf [15]. In the case of a particular folk dance [10], for example, the positions of a dancer's upper torso, legs, weight and front are given on a single score along with the score of the musical melody accompanying the dance. In this case the time scale for the movement makes possible the integration of the musical score with the movement notation.

The notation applied in this way to a dance can be regarded also as a means to designate the paths in space described by moving limbs. Since 2-dimensional shapes and 3-dimensional forms can be treated as areas or volumes generated by moving lines, it became clear to me that the notation could be used in visual art for generating the components of a picture or a sculpture.

II. GENERATED SHAPES

Before discussing the notation that I employ, one should note the versatility of the technique of generating planar shapes by means of a pivoting straight line (*generatrix*) or of a chain of lines (*generatrices*). A circular area is an example of a simple shape generated in a plane; it is formed by a straight line turning 360° about a fixed end. A more complex shape, such as the one shown in Fig. 1, is obtained if a second generatrix is attached to the free end of the pivoting generatrix just mentioned and if the free end of the second turns about the moving linkage point of the two (Fig. 2). Chains of any number of generatrices may be

used, with movement about the linkage points in the clockwise or counterclockwise direction.

Further variation can be obtained by not showing a generatrix during part or all of its rotation and, thus, leaving a gap in part of its movement trace. This is illustrated in Fig. 3(a), where one generatrix was turned clockwise through 180° with a gap occurring between 30° and 90°. A pair of shapes was formed in Fig. 3(b) by linked generatrices, the middle movement of which is not shown or *empty*.

The length of a generatrix can be varied during movement. Fig. 4 shows the area described by such a generatrix turned through 360° about one fixed end. In Fig. 5 two empty generatrices were used, one of which varied with length during rotation. The trace shown is in principle that of a generatrix of minimal length at the free end of a chain of two empty generatrices. Fig. 6 shows a pattern made by the same two generatrices used for Fig. 5 but in this instance they were empty only in certain zones, specified by the notation where generated areas overlapped.

Curved generatrices may be used also. Fig. 7 shows a shape generated by moving the curve shown below it (the pivot point is indicated). Since the notation requires reference to straight generatrices, I specify a curved generatrix as the trace of the free end of two straight generatrices, as in Fig. 5—but in this case empty ones.

III. A NOTATION FOR SHAPES

I have given a detailed description of my use of notation for visual art in a book published in 1969 [16]. I shall illustrate here some of the principles involved by reference to Figs. 1 and 2, where a small notation table, or *movement score*, accompanies the generated shape.

The notation refers to the positions and movements of linked straight generatrices. Each

(a) (b)

Fig. 3. Shapes whose generation required the use of an empty generatrix.

Fig. 4. A shape generated by a generatrix whose length varied.

complete row of the score contains the movement specifications for one generatrix. The length of each generatrix (here 2 and 1) is given at the left. The units of linear measurement are not specified in this example; the numbers 2 and 1 refer to relative lengths, meaning that one is twice as long as the other. The vertical order in which the generatrices appear in the 'score' is important (here 1 is given first and 2 is given second). My convention is to let the bottom row of the score represent the first generatrix, which turns about the fixed origin. (I call this one 'the first', because all movements and positions of the other generatrices are defined in relation to the origin.) The second generatrix is linked to the first, the third to the second and so on. The top row of the score refers to the generatrix at the free end of the chain.

Positions are established by determining the angular difference from (0), the vertically downward position. The expression of this angle, in units of the scale being used, defines the position of the generatrix. The scale here is 1 = 15°; thus the notation (9) for a generatrix indicates the position 135° from zero. In this case both generatrices had an initial position given by (9) and, since they are linked, they are shown as one line (diagonally) in Fig. 2, with the generatrix given by length 2 at the upper position.

The movement of a generatrix in a chain of generatrices is considered in relation to the next generatrix below in the score. In effect, the movement of a generatrix is considered to occur about the point of linkage with the neighbour below and for the purpose of analysis that point is imagined to be fixed. This convention is basic to the notation and applies even though all the linkage points in a chain may be displaced simultaneously during the movement of the generatrices. The free end of the top generatrix may move but the unlinked end of

the first generatrix in the chain is always a fixed point about which the chain may pivot.

Movement is designated by angular displacement. The unit of angular displacement (the scale) is given at the top left corner of the score (here the unit is 15°). While the first number (enclosed by parentheses) in the score refers to the initial position of a generatrix, the following numbers (not enclosed by parentheses) refer to the amount of angular displacement during each successive movement and the arrows refer to the direction of turning (in this example, upward pointing, counterclockwise; downward pointing, clockwise). In generating Fig. 1 there are two movements of the chain (Fig. 2). During the first, the upper generatrix is moved through 6 angular units (90°) (counterclockwise) while its neighbour below is moved through 2 units (30°) (clockwise). In the second movement the angular displacements are 4 units (60°) (counterclockwise) and 4 units (60°) (clockwise), respectively.

Fig. 2 shows clearly the pivoting of the lower generatrix about the fixed pivot point, with its position shown at the start and at 15° intervals during the first and second movements. The upper generatrix is shown in its initial and subsequent 6 positions. During the first movement, owing to its more rapid movement relative to that of the lower generatrix, the upper turns through 3 units (45°) when the lower turns through 1 unit (15°). The path shown for the upper generatrix may at first glance seem unlikely but it will be understood readily if attention is focussed on the change in angle at the linkage point using the lower generatrix as reference. Thus, the angular relations between the upper generatrix and the lower may be given successively for 15° intervals of the lower, as follows: 180° (initially), 135°, 90°, 75°, 60°, 45° and 30° (finally).

Fig. 5. A line generated by the point at the extremity of two empty generatrices, one of them of varying length.

Fig. 6. The complex shape obtained when certain of the overlapping areas were specified to be left white. Otherwise, the shape would have been an uninterrupted black area.

The illustration given in Fig. 1 concerns one situation where the generatrices are moved simultaneously. Countless other synchronizations of the same elements are possible and each would produce, by the interaction of the elements, a different resultant shape. If the generatrices were moved not simultaneously but successively, the movements of the one would not modify those of the other, and the result would be a pattern consisting of parts of circular traces.

If the length of a generating line is varied (Fig. 4), the changes of length are expressed in the notation as positive and negative increments of the original length or, when the rate of change is constant, as a total at the conclusion of a movement. When the overlapping of areas swept out by generatrices is automatically reflected by modifications of hue, value and chroma, for example, on a CRT screen, no special designation for this spontaneous change is given in the notation. But if these modifications are *not* those which normally result from overlapping in the given medium, such as in generating the pattern shown in Fig. 6, then an appropriate indication must be made in the score. The presence of empty generatrices (Figs. 3 and 5) must also be designated in the notation.

Above the beginning of the score a number with an arrow, enclosed by parentheses, designates the plane in which the movements are assumed to take place. In Fig. 1 a vertical surface is specified, at right angles to the line of sight, e.g. a wall, a CRT screen or a cinema projection screen. Three-dimensional works also can be treated with the notation. For such works, no designation is usually made for orientation in space. In the case of kinetic art objects, the duration of motions is indicated by writing the score on vertically lined paper, where each column represents a specified time interval.

IV. CONCLUSION

The idea outlined here is a single approach supported by a symbol system to provide a concise description of many types of visual art objects. Attention can be focussed not only, nor chiefly, upon static forms or shapes but also upon kinematic or dynamic aspects in their generation where processes of building, modifying and deleting may occur simultaneously. For this approach the only difference between the generation of shapes and forms for static art objects and for kinetic ones is in the technique, i.e. in the material of the medium, not in the principle of their notation. Means are available for automatically generating shapes with a movement notation as a guide, e.g. cinema film and CRT display. These means can be extended in order to accommodate more fully the scope of possible technique provided by the notation. The available techniques for constructing 3-dimensional objects moving and growing are at present more limited.

The existence of a rigorous notation makes the visual objects accessible for description in computer programmes. The automatic generation of the form of objects and its converse, the scanning of the forms and their representation in a standard notation, are also potentially important applications of notations. A programme exists by which the EW Movement Notation can be the input to a computer with an output both as detailed plotting directives (in terms of the EW Notation) and as hard copy from an on-line plotter.

However, because the notation permits the concise description of steps required to generate complex shapes, the aid of a computer for their generation becomes essential only for very complex procedures, if at all. Furthermore, when dealt with manually, the exercise of generating a shape is an activity that reveals to a worker additional insight into the mechanics of constructing a shape. I do not advocate a reactionary attitude towards computers in art but, on the contrary, propose restricting its use to situations when it is necessary. This means that one should know better what is being entrusted to a computer, rather than treating it as a fascinating and expensive toy that sometimes produces beautiful results.

I believe that artists will achieve greater subtlety in their work when they learn to define shapes and their transformations with precision. With a suitable notation, all shapes, including unfamiliar or complex ones, are clear; and it is not necessary to be restricted to common regular shapes to maintain a firm frame of reference. Properly used, the notation can liberate artists from habitual procedures but this does not imply that a magic recipe for good composition is being offered.

Fig. 7. A shape (above) generated by a curved generatrix (below).

REFERENCES

1. J. Evarts, The New Musical Notation—A Graphic Art ?, *Leonardo* **1,** 405 (1968).
2. N. Goodman, *Languages of Art* (Indianapolis: Bobbs-Merrill, 1968).
3. *The Munsell Book of Color* (Baltimore, Md.: Munsell Color Co., 1929).
4. R. M. Evans, *An Introduction to Color* (New York: John Wiley, 1948).
5. F. J. Malina, Kinetic Painting: The Lumidyne System, *Leonardo* **1,** 32 (1968).
6. R. I. Land, Computer Art: Color-Stereo Displays, *Leonardo* **4,** 335 (1969).
7. C. S. Bangert and C. J. Bangert, Experiences in Making Drawings by Computer and by Hand, *Leonardo* **7,** 289 (1974).
8. N. Eshkol and A. Wachman, *Movement Notation* (London: Weidenfeld & Nicholson, 1958).
9. H. Tsuchiya, *Monroe in the Net*, etc. (Tokyo: Computer Technique Group, 1968).
10. *Movement Notation Survey* **1973** (Holon, Israel: The Movement Notation Society, 1973).
11. N. Eshkol and R. Nul, *Classical Ballet* (Tel-Aviv: Israel Music Institute, 1968).
12. M. Shoshani and S. Seidel, *Folk Dances of Israel* (Tel-Aviv: Israel Music Institute, 1970).
13. N. Eshkol with S. Seidel et al., *The Yemenite Dance* (Holon: Israel: The Movement Notation Society, 1972).
14. Arad, Sonnenfeld, Eshkol, *Physical Training* (Tel-Aviv: Israel Music Institute, 1969).
15. N. Eshkol et al., *The Hand Book* (Holon, Israel: The Movement Notation Society, 1971).
16. J. G. Harries, *Shapes of Movement* (Holon, Israel: The Movement Notation Society, 1969).

PART II
COMPUTER ART

General

INTELLIGENT COMPUTERS AND VISUAL ARTISTS

Michael Thompson*

Abstract—*In order to be of value to artists, computers must be perceptive and knowledgeable in visual matters. Being 'perceptive' means that they should be programmed to deal with phenomena that artists perceive and find interesting. Being 'knowledgeable' means here that the computer can use information stored in it to take appropriate courses of action.*

This paper deals with techniques that might be employed rather than discussing what aesthetic phenomena might be of interest. The techniques described are drawn from the so-called 'linguistic' approach to graphics, which is interpreted very broadly to include descriptive, hierarchical, structural, grammatical, and proceedural methods. In short, nonnumerical rather than numerical methods *based on statistical criteria, information theory, evaluation of mathematical functions or optimization.*

The paper refers to the generation of shapes using grammars, analysis using grammars, picture description languages, explicit representation of semantic information using semantic nets and implicit representation using procedures. Human subjective observation of computer behavior is suggested as a sufficient guide to the valid application of these techniques.

I. ARTIST AND COMPUTER

One of the greatest problems confronting people who attempt to use a digital computer for artistic purposes is determining just what are the special capabilities of the man-machine combination. The practicality of visual output or stereo-display is an exciting idea and, when the user directly 'converses' with the machine by means of a keyboard or some nonalphabetic input [1, 2], the almost instantaneous replies immediately suggest the possibility of improvisations, as if on a musical instrument.

Disillusion may follow when he realizes that the link between a computer keyboard and the visual output is hardly analogous to a piano keyboard and the sound output. We are inclined to take the design of a musical instrument for granted and to forget that the whole structure of scales took centuries to develop. These scales are not based on the physics of sound but on the way our senses function and on accidents of historical and cultural development. They are abstract structures that have become so much a part of a person's life that to make sounds that deviate from them is often thought unmusical. Furthermore, the relationship between the frequency of vibration of sound (the physics) and what we hear is well understood, so that when music is generated using a computer we know just how to arrange for the physical output to be attuned to our ears. The computer, however, does its 'thinking' in terms of selected scales (i.e. music) and not in terms of the physical frequencies of vibration (i.e. sound). The whole body of well-defined theory available to the musician has enabled computer applications in music to outstrip the other arts.

A visual artist faces the computer with comparatively little theoretical support. In most computer programs he has to state requirements in terms of coordinate geometry or statistics [2–5] in order to manipulate shapes or forms. This represents form in a most 'nonhuman' manner. What is suggested in this paper is an approach to the development of computer systems that are perceptive and 'understand' visual matters.

I suggest below two areas in which the behavior of computers should guide our search for better understanding of visual matters and aesthetics.

1. *The Perceptive Machine:* Research into how a digital computer might perceive or generate images of interest to artists. Of concern here is the visual experience resulting from one's confrontation with an object or a scene. One is concerned with changes that one can make in an object and a scene so as to produce desired changes in the images of them. The perceptive machine maintains a description of the object (in physical terms, geometry, etc.) and a description of its images (in terms of aesthetic relevance, the outcome of the artist's communication with the machine). The machine can at least partially relate these images to the object using its perception programs designed to simulate human behavior.

*Operations researcher, 7 Leibovitz Road, Gedera, Israel.
(Received 16 April 1973.)

77

2. *The Knowledgeable Machine:* Research into how to represent the intentions of an artist. At present, an artist who intends a computer output to have a particular quality of appearance (for instance, heavy contrasts or muted colors) almost certainly cannot enter such an instruction as an input to a computer. If it were possible to enter such intentions directly into it, a computer might learn them gradually and tolerate some vagueness of definition, during the early developmental stages of an aesthetic idea. Even if a machine had the means of recognizing aesthetic phenomena, this would hardly be sufficient, for in any particular scene most occurrences of them would be irrelevant. A machine must be selective on the basis of knowledge of the intentions of its partner, the artist, and it must store this knowledge in a usable form.

The two research areas just mentioned clearly extend to many disciplines—from semantics and syntax of language to the sociology, psychology and physiology of perception. In this paper, however, I am limiting myself to a discussion of the use of so-called *linguistic methods* in computers. These methods might be variously characterized as descriptive, organizational, structural and grammatical and they imply an acceptance of an image as consisting of known parts arranged in some kind of structure. (For a broad treatment of these points, see Refs. 6 and 7.)

II. THE PERCEPTIVE MACHINE

The first area of research I proposed was 'how does a computer perceive or generate visual material of interest to an artist'. Here the key words are 'of interest to an artist' and the reader should bear in mind that much of the computer research cited here has been directed to the quite different goals of engineering. Their purpose is usually to analyse visual material so as to generate a description that can be used to control robot functions (to recognize an alphabet, an object or to steer a vehicle) [8, 9]. They refer to this activity as 'machine perception' but, clearly, it could be totally different from human perception.

Artistically, this engineering goal is hardly relevent, since of concern is an image that one experiences or invents when confronted with a real object. An artist is concerned with manipulating the image of an object, in order to emphasise aesthetic aspects of it. Data that reach a brain are determined by the brain's physiology and psychological development. Many aesthetic factors of importance originate at this level, and, although an intelligent machine may function well with quite different vision mechanisms, a machine with aesthetic capabilities must have at least some reactions analogous to ours when dealing with visual phenomena.

Even representational art is a giant problem, since little physical similarity is necessary between the artistic image and the real object or scene it represents. All that is necessary is that one accepts through one's cultural background that a correlation exists between them.

At present there are no adequate theoretical models for representing human sense perceptions and hardly any work has been done at all to develop exactly defined models of less well defined (or perhaps indefinable) aesthetic ideas. I have no solution to offer for these problems but should like to draw the reader's attention to a possible course of research distinct from the methods of experimental psychology, which is applied to subjects such as cognition, memory, language and perception. The approach is that of 'artificial intelligence', by which a complex subject is studied through observations of the behavior of computers. Thus, if the subject matter is the understanding of the English language, speculations on processes that might enable English to be understood are incorporated into computer programs and then the computer is asked questions. The computer's ability to answer them, tests the quality of the model of the processes involved in the understanding [10, 11].

III. GENERATION OF LANGUAGE AND VISUAL SHAPES

There are some similarities in the tasks of analysing language and analysing images; however, as both are very difficult, it has been found valuable to first try the reverse of analysis, i.e. synthesis or *generation*. In order to understand this it is helpful to look at the development as regards linguistics.

Consider how a natural language, such as English, is continually evolving and shows variation from place to place and speaker to speaker, so that the development of a grammar to fit it is a very difficult, perhaps impossible task. This problem was turned inside-out by Chomsky, who suggested in the 1950's that one start with an invented grammar and derive the language it generates which would consist of all possible sentences that the rules of this grammar can produce. One can sample this output and, by comparing it with natural language, test the quality of the grammar.

One can also propose languages of shapes as defined formally by Stiny and Gips [12]. The building of a picture is done by applying a set of 'shape grammar' rules. Each rule consists of two shapes and, if we find the first shape in the picture, then we replace it by the second shape. As the second shape is more complex and larger than the first, each application of a rule helps to build up the picture. They have produced over fifty classes of painting and sculpture and stress how their

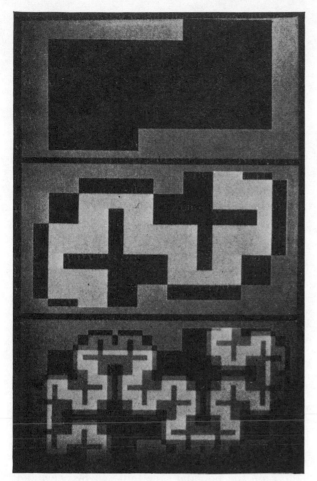

Fig. 1. *George Stiny, 'Urform I, II and III', computer pictures, each* 30 × 57 *in.,* 1970.

main task is deciding on the content of the shape rules. These provide a well-defined means of expressing an artist's decisions about shapes and their organization and representation. After this task, generating particular realizations follows automatically.

Some of the pictures of Stiny and Gips exhibit a rhythm due to regular growth in size and regular change in orientation (Figs. 1 and 2). However, it may be doubted whether these are 'grammatical' at all, for they are so context sensitive that a change made at the beginning of the growth process will propagate through the whole picture. Contrast this with language where many different beginnings can be invented for single sentences that otherwise remain unchanged. This localization of changes is an important and valuable aspect of language. Watanabe discusses this as applied to visual patterns in a very readable and valuable paper [13].

The disadvantage of generation is that it is not very easy to direct to some goal; given a specific meaning or content, it is not easy to generate a sentence to match it. I shall describe below some work in directing generation and analysis to a specific goal.

IV. SYNTACTIC PROCESSING OF THE VISUAL

One would like a machine to contain a description of an image that can then be used as a basis for a meaningful dialogue with an artist. It should also be possible to manipulate the description and generate from the changed description a new and possibly improved image. How can one go about preparing such a description of some given visual material? The linguistic approach is to look for structures i.e. specific parts and relationships between them. Now, in language the parts may be phrases, words and parts of words, such as the plural ending 's'. The relationships group words into a phrase and phrases into clauses, as specified by the rules of syntax.

To process visual material one must first decide on similar parts ('primitives') to be taken as the smallest level of detail. In a line drawing these could be thin lines, dots and junctions of various kinds. In pictures that are shaded one may decide that regions be primitives, as selected on the basis of sufficiently uniform color, texture or intensity on a grayness scale.

With a computer, a picture is first transferred into an array, of say 300 × 300 numbers, each providing data on the brightness or color of the corresponding part of the picture. Considerable processing of such a matrix may be undertaken to extract the primitive features of the picture. Features in the picture may have to be sharpened or simplified. The research into these highly complex processes may eventually link up with biological research (for a broad discussion, see Ref. 14). Such processes are not a part of the linguistic processing but rather preceded it, so I shall not discuss them any further here.

The next stage is to link these primitive entities into a structure that will fulfil the role of describing the picture. This can be thought of as a process of syntactic analysis. I have mentioned how syntactic

Fig. 2. *James Gips, 'Eve', computer picture,* 24 × 30 *in.,* 1969.

Fig. 3. Analysis of a chromosome shape.

analysis of natural language (e.g. English) sentences is very difficult and cannot always be carried out automatically. Fortunately, computer specialists can invent their own artificial languages (e.g. the computer programming language 'algol') and in doing so make sure that they have desirable properties. Indeed, languages can be defined so that there is a guarantee that anything written in them can always be analyzed to find its underlying structure. This true of all languages with a 'context free phrase structure'. Some visual images can also be described by such a structure and then the guarantee of analysis is very valuable. The illustrations 'analysis of a chromosome shape' (Figs. 3 and 4) give a clever application of this. The boundary edge of the chromosome shape is regarded as a one dimensional string of primitives but with the two ends of the string joined to make a loop. Use of this abstract structure to automatically count chromosome types for diagnostic purposes is described by Ledley [15].

It is worthwhile to describe this analysis in more detail. The computer receives the shape A (Fig. 3) and recognizes different features on the boundary curve, classifying them as a, b, c or d. The result of this is shown in B in diagrammatic form, although a computer might represent these data as a string of symbols: abcbabdbabcbabdb >.

The last symbol > indicates the string has not ended but repeats itself again from the left. This corresponds to the endless closed curve of the boundary. However, in order to refer to the diagram it will be more convenient to talk of shapes rather than symbols. Syntactic rules are applied to combine adjacent shapes, giving each larger shape so formed a name, such as (e=arm, s=side, l=left part, p=arm pair). For instance, in diagram C we have shape e to the left of and contiguous with shape c, so that a rule l = e+c

may be applied to replace them both with shape l as in diagram D. The complete set of rules [15] guarantees that we eventually combine all the shapes into one that has the name 'sm', in effect recognizing the shape as that of a submedian chromosome.

An aesthetic analysis of the chromosome shape in Fig. 4 is likely to proceed quite differently from one carried out for medical purposes. The leftmost diagram G shows a structure obtained when using syntactic rules designed to classify the chromosome as 'submedian' for medical purposes. This structure is asymmetric about both longitudinal and transverse axes and, hence, can hardly serve as an aesthetic analysis, for visually these symmetries dominate the form. The centre diagram H shows an analysis more in keeping with visual properties. In this particular way of looking at the form, the sides c are of hardly any significance and the tree structure groups together the arms into pairs. An alternative way of seeing the form (or rather the background) is indicated in the rightmost diagram I, in which I have reversed black and white to make the background obvious. Quite a different analysis would be needed for such an aesthetic viewpoint. Indeed visual form is highly ambiguous, and many aesthetic analyses usually apply to a single form.

When Ledley excluded all features other than those on the boundary, he imposed his viewpoint on the image. One can accept this and, indeed, extend it by insisting that the 'linguistic' constraints are not in the image but are in the cultural background for looking at the image. We then invent a picture description language (PDL) that implicitly specifies those features of the image that interest us. The computer is programmed to produce descriptions of pictures in this language and then it is the PDL description rather than the image itself that is subject to syntactic analysis [16].

In conclusion, no syntax has been found that is applicable to all visual material and, when a particular syntax is applicable to a particular type of material, a knowledge of the context is necessary to decide how to proceed. This is also true for

Fig. 4. An aesthetic analysis of a chromosome shape.

Fig. 5. *Decomposition of images into solid objects.*

natural language. How this problem may be dealt with is described in the next section.

V. GOAL DIRECTED PROCESSES

There is considerable development going on at present in the design of programs that, when analyzing a sentence or a picture, do not proceed in the mindless manner of most 'data processing' but rather at every stage try to make intelligent decisions.

This intelligent decision making requires a knowledge of the world and in current research it is usual to choose a narrow domain of applicability so that getting the necessary knowledge into the computer will not take up too great a proportion of the research effort. Domains of applicability have included baseball scores (starting in 1963), meteorology, temporal references, ownership and now the world of toy blocks is very popular.

The image of the wooden blocks (cubes, oblongs and pyramids) is captured using a television display and then processed into the form of a line drawing. It is possible [17] to classify all the junctions that can result from having three planes at each vertex. Whilst the computer is classifying a vertex, it can check for decisions already made about adjacent lines and planes. This elimination of inconsistent interpretations, carried out when each vertex is considered, results in an enormous saving of effort.

Figs. 5 and 6 indicate the logical conflicts that a computer may resolve. Fig. 5 (left): The 'background' must be reassigned as a surface. Fig. 5 (right): The computer must recognize that surface R1 is not adjacent to surfaces R2 and R3. In Fig. 6 the imperfect data supplied to the computer (top) are analyzed as being of the group of objects of the type at the bottom of the figure.

Most systems processing visual material have been built up in an *ad hoc* manner with the designers modifying and extending them to deal with practical problems encountered in the course of development. It is instructive to look at the research being done in natural language question-answering systems to find approaches that gain greater power and flexibility by use of uniform methods.

At the Massachusetts Institute of Technology (MIT) a system has been developed that answers questions put to it in English [11]. The grammar,

the dictionary items, even information that we would normally call 'knowledge', are all treated as computer programs. These programs call upon each other's services when needed and, as the necessity for such calls depends upon the particular sentence being analyzed, there is no fixed sequence in which the programs run. For instance, whilst a syntax program is parsing the sentence, it may break off to call a semantic program to decide on a point of ambiguity. Indeed, the meaning of the words themselves may not be sufficient to do this and the semantic program may in turn call upon a deductive program before the point is settled and the machine can return to parsing. The computer's ability to switch rapidly between syntax, semantics and deduction is enhanced by having every part of the system, even what would normally be stored as data, written as a computer program in the LISP language (or its extensions).

The analysis of natural scenes is a problem of strategy, for the system must choose from millions of possible objects as few as possible. Consider looking at a forest, does one examine each leaf before one recognizes types of trees? In a system designed for use by artists, a key feature would be the ability of the machine to ask pertinent questions to get at a strategy corresponding to the artist's personal interests. A great advantage of this 'linguistic' approach is that at the highest level of semantics the description of the visual material can be stored symbolically within the same framework as the information or an artist's intentions.

VI. THE KNOWLEDGEABLE MACHINE

I proposed above two areas of research, one of them being 'how to represent the intentions of an artist'. Well, it might help if an artist could talk

Fig. 6. *Decomposition of images into solid objects.*

CONSTITUENTS

PROPERTIES

Fig. 7. *A semantic network representing a sentence.*

from the entry to all the properties of the class. This model is naive and many better ones exist [10], nevertheless there is no general agreement on the subject.

Representation of semantic information is a complex problem and the following example (Fig. 7) can give only the merest indication of how it is done. Let a sentence describe a simple visual scene as follows: 'A small red cube is on the top of a larger green cube that rests on the table.' The objects in this scene are listed under the heading 'constituents' in Fig. 7. The third constituent is 'a cube' and by following the arcs we find out more about this cube. One path leads to another constituent, CUBES, indicating the class to which it belongs. The other arcs descend into the properties section of the memory. The leftmost of these leads us to the attribute COLOUR, and the appropriate hue 'green'. The next descending arc leads us to SIZE then to GREATER THAN and finally loops back to the constituents section, where it points to

to a computer instead of painfully communicating with it by use of numbers. He could say 'quality X is more important to me than quality Y'. No one can expect a computer to make anything of this unless it is told something about these qualities. However, an artist is unlikely to be able to provide such information in a strictly logical order and so one cannot have a system that will run only when it is provided with 'all the data needed to compute a solution to the problem'. Indeed, the nature of the problem may be obscure or even unknown at the outset. What is needed is a system capable of gradual growth and capable of functioning with gaps and temporary inconsistencies. In such a system, knowledge must be stored in manner such that it can be extended and reorganized from time to time.

One may wonder how such a 'difficult' property as meaning can be stored in an abstract theoretical structure. Here I can only sketch an answer. Logicians and philosophers have two definitions of class called *extension and intention*. The extension is a list of all the members of the class and the intention is a list of all the properties common to all the members. Now, an imperfect model will have a dictionary list in which arcs will point to an entry from all the members of that class and

Fig. 8. *Eight in a series of graphics, India ink*, each 40 × 40 cm., 1972. (Photo: D. Darom, Hebrew University, Jerusalem, Israel.)

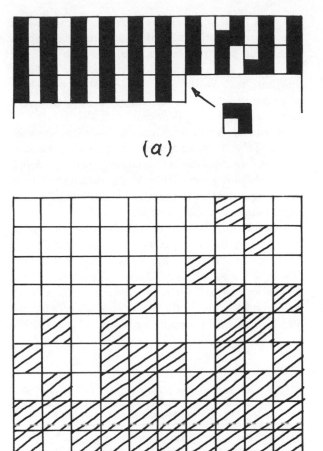

Fig. 9. *Diagram connected with the generation of the series of graphics shown in Fig.* 8.

quite subjective appreciation of textures generated by a matrix of black and white squares. The research concentrates on the contribution to the pictures of arrays of 3 × 3 squares and the method used enables the machine to select the right combination of black and white squares to get some required aesthetic effect.

The method for generating the pictures in Fig. 8 is as follows. Each picture is built by an addition of elements (Fig. 9(a)) by starting at the top left corner. The choice of an element for a particular grid position depends firstly on the texture required there. The series of 8 pictures in Fig. 8 is characterized by the use of two distinct textures in each picture and, although a different pair of textures is presented in every picture, the way they are

the entry representing the 'small red cube'. Notice that all the verbal material is listed on the left and only arcs and nodes are needed in the memory network: ideal material for storing in a computer.

Semantic networks can be augmented by procedures; indeed each vertex in the network could be a computer program. This provides an action-in-context capability, which is much more efficient than general logical problem solvers.

All the semantic networks existing today have a vocabulary of words [18], whereas, ideally, an artist would want to put into the dictionary shapes and colors and even more abstract items such as structures. For instance, the structures suggested by Hill [19] seem well suited to this purpose.

VII. ON THE MAKING OF A GRAPHIC

Recently I have been studying textures of the kind shown in Fig. 8. I do not attempt to force my methods into a particular formal scheme but they do exhibit a 'linguistic' approach and also accumulate aesthetic knowledge. The object of this work is to find a way in which to express explicitly and exactly, but without words, my own

Fig. 10. *Diagram connected with the generation of the series of graphics shown in Fig.* 8.

distributed over the picture surface is fixed. This distribution is shown in Fig. 9(b). The choice of a 2 × 2 element depends secondly on 'context'. Now, if one takes this context to be the 12 squares touching each element one has 2^{12} distinct contexts to consider, which is rather large. To gain a practicable system, I consider only the context of those five squares laying above and to the left of each element.

In Fig. 10 it is shown how the 'same' texture is generated by choosing a suitable element for each of six different contexts. These selections are made subjectively and visually, without logical or verbal justification. Nevertheless, these visual rules exactly define the texture they generate, in a manner analogous to the definition of a language by the grammer that generates it.

VIII. CONCLUSIONS

Development of linguistic methods for visual material in engineering and science is hampered by the enormous diversity of visual material, which fragments research into specialities each with its own particular computer equipment and systems. Putting 'real world knowledge' into a machine requires great effort entailing at present very narrow areas of application.

Advancement of linguistic methods in computer art will be best advanced by choosing narrow domains of application, studying them in depth and developing the ability of the machine to take action appropriate to the way human beings appreciate the same visual material.

Considering the rate of technological change, it seems likely that computers will in the next decade find application in many areas of visual importance. These activities will be conducted without regard for aesthetics (an artistic preoccupation) unless ways are found for giving them a knowledge of what we perceive and find visually satisfying.

REFERENCES

1. R. Land, Computer Art: Color-stereo Displays, *Leonardo* **2**, 335 (1969).
2. K. Nash and R. H. Williams, Computer Program for Artists ART 1, *Leonardo* **3**, 439 (1970). See also *Leonardo* **4**, 365 (1971).
3. J. Reichardt, *The Computer in Art* (London: Studio Vista, 1971).
4. H. W. Franke, Computers and Visual Art, *Leonardo* **4**, 331 (1971).
5. Z. Sýkora and J. Blažek, Computer Aided Multi-element Geometrical Abstract Paintings, *Leonardo* **3**, 409 (1970). Here the input is an incomplete 'sketch' of a painting that the computer completes and, as such, the requests from artist to the computer avoid the strain of using coordinate geometry.
6. *Graphic Languages*, *Proc. IFIF Working Conf.*, F. Nake and A. Rozenfeld, eds. (Amsterdam: North Holland, 1972).
7. A. Rozenfeld, Progress in Picture Processing: 1969–71, in *ACM Computing Surveys*, 5 (No. 2, 1973). Rather condensed and heavy reading but with 580 references.
8. A. Gusman, Decomposition of a Visual Scene into Three-Dimensional Bodies, *Proc. Fall Joint Computer Conf.* **33**, Part 1, 291 (1968).
9. T. Binford and J. Tenenbaum, Computer Vision, in *Computer* **6**, 19 (No. 5, 1973). A general article.
10. D. J. Mishelevitch, Computer Based Semantic Analysers, *J. Control and Inf. Sci.* **1**, 267 (No. 3, 1972). A general review of the subject.
11. T. Winograd, *Understanding Natural Language* (Edinburgh: Edinburgh Univ. Press, 1972). Describes work carried out at the Massachusetts Institute of Technology.
12. G. Stiny and J. Gips, Shape Grammars and the Generative Specification of Painting and Sculpture, in *Proc. Int. Fed. for Inf. Processing*, Booklet TA2, p. 166 (1971). (Address: James Gips, Computer Science Dept., Stanford University, Stanford, CA 94305, U.S.A.)
13. S. Watanabe, Ungrammatical Grammar in Pattern Recognition, in *Pattern Recognition*, Vol. 3 (Oxford: Pergamon Press, 1971), p. 385.
14. H. B. Barlow, R. Narasimhan and A. Rosenfeld, Visual Pattern Analysis in Machines and Animals, *Science* **177**, No. **4049** (18 August 1972).
15. R. S. Ledley, High Speed Automatic Analysis of Biomedical Pictures, *Science* **146**, 216 (Oct. 1964).
16. A. C. Shaw, Parsing of Graph-Representable Pictures, *J. Assoc. for Computing Machinery* **17**, 453 (1970).
17. P. Duda and P. Hart, *Pattern Classification and Scene Analysis* (New York: John Wiley & Sons, 1973).
18. M. R. Quillian, The Teachable Language Comprehender: A Simulation Program and Theory of Language, in *Communications of the Assoc. for Computing Machinery*, Vol. 2 (No. 8, 1969).
19. A. Hill, Art and Mathesis: Mondrian's Structures, *Leonardo* **1**, 233 (1968).

CAN COMPUTERS BE PROGRAMMED TO APPRECIATE ART?

Michael J. Apter*

Abstract—*The basic arguments of this paper are that art is not intrinsically mysterious and that there is no reason why art should not serve various functions for computers as well as for human beings. Asking what such functions might be for computers leads to an examination of the functions of art for humans from a new perspective. The author suggests that artworks are like computer programs and observers of artworks must develop compilers in their brains to decode them (music, however, may be said to be in machine code in certain of its aspects, that is, already decoded). One function of art is then to provide observers with practice in constructing de-coding compilers. Other functions of art are also suggested. It is further argued that more attention should be paid to semantic features of representational art and that from this point of view such an artwork can be regarded as a program that incorporates a model. Compiling here involves two processes: (1) reconstructing reality from a model and (2) inferring an underlying general theoretical construct that it exemplifies.*

I. INTRODUCTION

Many features of human behaviour have now been simulated by means of programs for digital computers. (I have discussed examples in two surveys [1, 2].) Taken together, these programs may be said to lend weight to the mechanist argument that human beings are no more than machines and that the brain itself is an elaborate kind of computer. However, if it can be shown that there is *any* category of behaviour that cannot, in principle, be simulated by machine (which at present usually means by computer), then the mechanist argument falls to the ground. A number of types of behaviour have been discussed in the context of this debate. These include creative, emotional and neurotic behaviour, none of which anti-mechanists claim can (for different reasons) be simulated faithfully by machines. Another type of behaviour that can be pointed to as characteristically human and, in principle, outside the domain of machine behaviour, is the appreciation of artworks. This is a point that does not appear to have been probed very much but one that, in my experience, comes up frequently in informal discussions.

The anti-mechanist assertion is that machines cannot genuinely participate in artistic appreciation. According to this argument, while computers might be programmed to 'go through the motions' of such appreciation (and even this appears not to have been attempted), the activity would necessarily be arbitrary from the point of view of computers

and have no significance for them. Yet, there is an expanding interest in computer art, i.e. in the production of artworks by means of computers. Such art has been discussed by numerous authors in *Leonardo* (cf. the especially interesting discussion of Gips and Stiny [3]).

Could computers be programmed to appreciate art works in the same way that humans do? Could computers be programmed to make works of art for themselves, i.e. for appreciation by other computers, rather than for human beings? This raises the question of the functions of art and whether they can be understood in machine terms. *The purpose of the present paper is to argue not only that is it possible to think of the whole artistic process mechanistically, but that it is in fact helpful in trying to understand the functions of art for human beings to consider what functions art might serve for appropriately programmed computers.* Some tentative ideas in this direction are suggested in the discussion that follows.

Of course the question of a computer's appreciation of art cannot be dissociated entirely from other questions in the man-machine debate; for example, whether computers can be said to be creative in a human sense or to feel conscious emotions. These important and interesting questions have been discussed by philosophers and others and, therefore, I shall avoid them as far as possible here. Instead, I shall focus on two essentially psychological questions: what is the way in which the brain processes information received when an artwork is viewed and what is the result of this processing? Answers to these questions would help to understand what artists are trying to achieve in their work. My strategy shall be to think of the brain as a kind of

*Psychologist, Dept. of Psychology, University College, Cardiff, P.O. Box 96, Cardiff CF1 1XB, Wales, U.K, (Received 11 Sept. 1975.)

computer in order to obtain some tentative answers. These answers in turn should suggest ways of programming computers to appreciate art.

I shall use the term 'art' in its general sense to include the visual arts, theatre, music, fiction, etc. For convenience, the term 'observer' will be considered equivalent to 'spectator', 'viewer', 'listener', 'reader', etc.

II. THE ARTWORK AS PROGRAM

If the brain is a kind of 'computer', then an artwork is a means of communication between an artist's 'computer' and at least one observer's 'computer'. It might seem that an artwork should be considered as a collection of data produced by an artist's 'computer' that is analyzed by an observer's 'computer'. But I suggest that it is more appropriate for an artwork to be thought of as a program, in the computer sense, rather than as a collection of data. This program is entered into the observer's 'computer'. What this artwork program then does, among other things, is to operate on the emotional subsystem of the observer's 'computer' so that certain emotions are automatically aroused. It is as if an observer's 'computer' was a musical instrument being played on by the artwork's program. Of course, as Schachter and Singer have shown, emotions also have a cognitive component and the emotions of observers may be expected to have a special quality due to the fact that observers are aware that the source of an emotion is an artwork and not some event in the 'real' world that may require an overt response [4]. What art does, therefore, is change the internal state of observers without causing them to take direct and immediate action. If something is produced that stimulates direct action, then it is called, for example, advertising, pornography or propaganda rather than art. Of course art may eventually or indirectly influence human action, but I do not regard this as the immediate function of art.

One function of art, then, is to arouse emotions. I shall argue below that other kinds of internal states are altered by art as well. There are a number of possible reasons why most humans appear to welcome or permit their emotions to be aroused by art, even though sometimes the emotions are ones that they would normally avoid (e.g. sadness). One possible reason is that the arousal of emotion (be it pleasant or unpleasant) subsequently reduces tension and this reduction is satisfying (cathartic). A totally contrary possibility is implied by an approach to the understanding of behaviour proposed by K. C. P. Smith and myself [5]. This approach assumes that under some circumstances it is the increasing tension or arousal itself that is pleasant rather than its subsequent reduction. Such heightened arousal, which is pleasant, is what people normally refer to as 'excitement'. In the case of art, as M. A. Noll has argued, '. . . the artist is trying to optimise or stabilize at a high level the parameter "excitement"' [6]. In either case, it

should be possible to make a model of this process in computer terms, perhaps in a way already pioneered by researchers who have attempted to simulate personality [7].

In the human brain, emotions are presumably aroused by certain spatial and temporal patterns of nerve activity, or perhaps they *are* such patterns. Either way, perception of an artwork has to be transformed into such a pattern. The simplest case to consider is that of music. It would seem that a piece of music has certain organizational properties that are perhaps isomorphous (similar in structure) with appropriate nervous system patterns or, if not, are easily and directly translated into them by the brain. For example, rhythm may be such a property. In fact, a number of neurophysiological experiments reviewed by E. Gellhorn show that high-frequency trains of electrical pulses applied to the brain stem increase arousal and low-frequency trains lower it [8].

A close relationship between features of brain activity and musical patterns is also suggested by the fact that the emotions aroused by a certain piece of music are similar in different cultures that have been studied (cf. the evidence of Voorhees as described in Ref. 9). Also children respond at an earlier age to music than to other kinds of art. These aspects of music have been considered in some detail by a number of authors including Susanne Langer [10] and, more recently, by T. McLaughlin [11]. One might say that music is, at least as regards its simpler features, already in the language of the nervous system and requires little in the way of translation. In computer terms, we could say that music is already in 'machine code' (the binary code actually used by the computer itself in its operations) and requires no compiling. (Compilation is the process by which a program in a 'high level language' like Fortran, the language used by the programmer to write his instructions is converted into a machine code program for the use of the computer itself. Compilation is carried out by the computer by means of a special program called a 'compiler'.)

What can be said about complex forms of music like symphonies? Here it can be argued that while certain features like rhythm can be responded to immediately, more complex features require some familiarity, gained through a number of listenings, before they produce an emotional arousal. In continuing the analogy with computers, it can be said that an observer must construct (consciously or unconsciously) by repeated listenings a compiler which will translate the various features of a piece of music of a certain style into an appropriately machine-coded program. The ability of humans to construct compilers for the nervous system would, it must be supposed, be an innate pattern-recognition capacity, perhaps related to the 'language acquisition device' (LAD) postulated by N. Chomsky [12].

New styles of music are generally not understood when they are first encountered and yet, in due

course, many people come to wonder how they could ever have been thought of as difficult. The Occidental music of Beethoven, Wagner and Stravinsky are good examples. Similarly, one thinks of the paintings of the impressionists and cubists. It is significant that when one is not emotionally aroused by an artwork, one is likely to say 'I do not understand it'.

Once a compiler has successfully been developed for an artwork, the work causes an immediate emotional response in observers when it is presented to them. This arousal however, does not remain at full strength for long and, furthermore, on subsequent exposures to the artwork the level of arousal will decline steadily. Thus, in order to obtain a high level of arousal, observers must continually search for artworks with different characteristics that require the development of new compilers. This suggests a function of art besides the giving of emotional satisfaction: it exercises and develops one's ability to understand new and complex structures. In adults the desire to do this may be a residue of the need of infants to make sense of visual and aural experiences and also of language. It is a way in which adults can continue the development processes of accommodation and assimilation studied by Piaget. In line with this, it has been claimed that '. . . the less the brain is confronted with surprise and challenge to its memory schemata, the more its capacity to process the unfamiliar diminishes' [13]. This claim should be amenable to empirical investigation.

The argument in this section is intended to apply in a general way not only to music but to other kinds of art, like non-figurative visual art, and to any art in its syntactic aspects.

III. THE ARTWORK AS MODEL

So far I have treated artworks from essentially a syntactic point of view. However, art, at least representational art (for example figurative visual art and theatre), also has a content or subject matter that refers to something other than itself and this semantic aspect must be taken into account. It is notable in this respect how far the content of an artwork has come to be overlooked by psychologists, except those working in the psychoanalytic tradition. For example, Berlyne's excellent book *Aesthetics and Psychobiology* [14] makes very little reference to content.

To resume the discussion of the previous section, I shall argue that the interpretation of the content or semantic aspects of an artwork also can be regarded as involving the need to construct a compiler so that the complete compiler for a work may involve not only the search for formal properties at the syntactic level but also their interpretation at the semantic level. In either case (or in both cases simultaneously) the result of the process typically involves some kind of emotional impact on an observer. In the semantic case this is mediated by

Fig. 1

the observer's coming to understand the meaning or signification of an artwork. These situations are depicted in Fig. 1.

From the semantic point of view I shall argue that figurative visual artworks can best be taken as modelling different features of the real world and to construct a compiler for such models an observer must establish the meaning of the models both in terms of what it is that they represent and in terms of what it is that an artist is saying about them.

Fig. 2

This should become clearer after one considers what is meant here by a 'model'. In fact, the term 'model' appears to be used in different ways in different fields of science. However, one definition that is consistent with perhaps most of these usages is: a model is a structure that is simultaneously an examplar of a theoretical construct of reality and a simplification of reality. The significance of models can be understood only if both these features are recognized: exemplification and simplification. The relationship of models to theoretical constructs and to the real world is depicted in Fig. 2. To interpret Fig. 2, the world can be thought of as being made up of many particular, usually complex, systems. A theoretical construct in science is general in that it relates to many different particular systems and also usually involves a simplification of reality. A model may be said to exemplify the theoretical construct and so constitutes a particular system like other particular systems in the real world that are also covered by the construct. However, a model must be simpler than the real world system to which it relates, so that the ideas embodied in the theoretical construct may be presented in it in a clear-cut, unambiguous fashion. An example is a model of an aeroplane used for tests in a wind tunnel; this is a model of a particular real or planned aeroplane that permits an investigation to be made of its aero-

dynamic characteristics more readily than with a full-scale aeroplane—the model is simpler than a real aeroplane while still exemplifying the theoretical constructs of aerodynamics.

As a further example, consider cybernetics, an area of science that makes extensive use of models. A widely held theoretical construct in cybernetics is that human brains are made up of elaborate and complex logical nets. There are many particular cybernetic models of brain acitivity consisting of logical nets that have different functions, such as that of recognizing certain spatial and/or temporal patterns or of learning to associate certain stimuli in the sense of classical conditioning. And such nets themselves are simpler than the nets in the brain that they model. Incidentally, such logical nets do not need to be realized in concrete physical form to constitute models but may remain in verbal or diagramatic form. This is why models and theoretical constructs have been differentiated in this article in terms of 'generality' and 'particularity' rather than in terms of 'abstractness' and 'concreteness'.

One function of models in science is to facilitate communication of theories, hypotheses and ideas by presenting them in a way that is easier for the brain to grasp. The point of this discussion of models is that artworks, such as figurative paintings, may be regarded as models. These works may be said to exemplify some general idea, theme or argument in a particular way and at the same time to represent in a simplified and selective manner chosen aspects of the real world.

Not only representational visual artworks but other types of fiction can be analyzed in this way. Each may be seen as a particularization of some general argument, an exemplification in terms of particular fictional characters and situations of some abstract idea. For example, Shakespeare's 'Othello' may be said to demonstrate the idea that jealousy destroys itself and the object of its love. Many of the plays of Ibsen may be said to 'have the message' that humans must live by illusion. L. Egri has given many examples of ideas underlying plays and has discussed how the plays were generated from them [15]. At the same time an artwork must involve simplification and selection; it cannot be as complex as real life.

Similarly, a figurative visual artwork contains an implication of the artist's attitude towards what was depicted. Minimally, this attitude is that some features of the real world, namely the features depicted, are visually attractive or beautiful or important or interesting and deserve being looked at. Very often, however, a more definite argument is embodied in a painting that may convey some abstract religious notion (e.g. that evil will be punished and good rewarded, as in medieval depictions of the Last Judgement) or some other idea (e.g. that war is corrupting and evil, as in many of Goya's paintings and engravings). At the same time, what appears on an artist's canvas or in a photograph cannot have the full complexity of a real scene. In some artworks this simplification is of an extreme form, a few lines representing a whole complex scene (e.g. some of the landscape drawings of Rembrandt).

In interpreting a representational artwork observers do two things. On the one hand they infer a general idea; on the other they reconstruct a reality from the work, putting complexity back into it. In doing the latter, they make use of an ability that has been much studied within psychology, especially by the Gestalt psychologists and by those who, following F. C. Bartlett [16], are concerned with the constructive aspects of memory. Reconstructing from partial information appears to be a fundamental characteristic of the human brain and this is consistent with what is known about the brain's equipotentiality [17]. Particularly relevant to painting and the graphic arts is R. L. Gregory's notion of 'object-hypotheses', that is, the hypotheses by means of which the features of 3-dimensional objects are constructed by the brain from 2-dimensional stimulus patterns [18]. He regards painters as presenting their own object hypotheses in their artworks and thereby causing an observer to see the world, as it were, through their own eyes. That is, each artist simplifies the world in a personal way and observers learn this mode of simplification; in terms of my article, each observer constructs an appropriate compiler. It is possible that, once this compiler has been constructed, it may have some influence on the way an observer perceives the real world as well as the artwork. Thus he may become more sensitive to the particular cues chosen by artists. If this is true, then both aspects of the interpretation (or 'compilation') of a model—the reconstruction of reality as well as the drawing of a general inference—may influence the way in which observers 'see things', i.e. the model may have two similar cognitive effects, one perceptual and the other conceptual. It has been said that 'pictures can establish the relation between thinking and immediate experience' [19].

Representational artworks therefore have formal similarities to models in science and both allow a general idea to be communicated more readily. Of course the kind of idea being communicated in representational art is typically of a different kind from that being communicated in science and the effect of the communication is rather different. The intention of the analysis in this section has been to point the way towards a mechanistic interpretation of the appreciation of art as regards its semantic aspects. There are many difficulties at the present stage in converting such a mechanistic interpretation into a viable computer program. More progress is probably needed in the computer handling of natural language and also in techniques of representing emotions in computer terms before the conversion could become practicable. Fortunately, real progress is now, at last, being made on computer processing of natural languages [20, 21] and a number of programs have been developed incorporating emotional subsystems [7]. In any

case, one can see in general, following the analysis here, the lines that a computer program for appreciating art might take.

IV. CONCLUSIONS

Many organs of the body serve more than one function, for example the mouth is involved in breathing, eating, talking and some sexual activity, and the genitals are involved in both excretion and reproduction. In a similar way, many kinds of human cultural activity may serve more than one end. It is probably naive to assume that any major form of human behaviour, for example science, religion and sport, satisfies one need and one need only. The same is likely to be true of art.

There is nothing inherently mysterious about art from the biological point of view. It is not that it does not satisfy any obvious needs but rather that it may be used in the satisfaction of a number of different ones, perhaps simultaneously.

I have mentioned a number of needs that art may satisfy in observers: catharsis, pleasurable tension and the improvement of cognitive abilities, especially through practice at constructing compilers. Artworks may also serve sociological/psychological functions as a way of communicating ethical, religious and other ideas. In the latter case, artworks should change the way observers see the world, but they should not lead to immediate action for, if they do, they are not works of art according to the definition I have adopted here.

The particular ideas of the function of art that I have presented are not generally accepted. However, my main aim has been to show that there is nothing intrinsically absurd in considering computers as appreciators of art and my discussion of this possibility is intended to be considered in this context. Concomitant with this, my aim has been to show that the existence of art does not in itself imply that the brain is not a machine. Indeed, thinking of the brain as a form of the kind of machine called a computer may, in fact, help to elucidate the process of art appreciation. Several ideas suggested by this general approach have been discussed in this paper. At the very least this approach provides a new way of asking questions and thinking about art and a new context in which to examine the functions of art.

As computers in the course of technological advance become more 'intelligent', more autonomous and generally more life-like, the need of art by computers may emerge. Thus computers may be developed with an ability to construct compilers for themselves and such computers may continually need new types of programs to exercise and improve this ability. Such programs would, if the arguments above are correct, be functionally equivalent to artworks; but they would be specially designed for computers. It may become more appropriate to communicate certain ideas to computers in the form of models. If these ideas concerned evaluations rather than more neutral information (i.e. if the models were more like artworks than scientific models), it could be said that the models were artworks for computers. If computers themselves were used to produce such artworks, then we should have the intriguing development of computer art for computers themselves.

REFERENCES

1. M. J. Apter, *The Computer Simulation of Behaviour* (London: Hutchinson, 1970; New York: Harper & Row, 1971).
2. M. J. Apter, The Computer Modelling of Behaviour in *The Computer in Psychology*, M. J. Apter and G. Westby, eds. (London: Wiley, 1973) pp. 125-149.
3. J. Gips and G. Stiny, An Investigation of Algorithmic Aesthetics, *Leonardo* **8**, 213 (1975).
4. S. Schachter and J. E. Singer, Cognitive, Social and Physiological Determinants of Emotional State, *Psychological Rev.* **69**, 379 (1962).
5. K. C. P. Smith and M. J. Apter, *A Theory of Psychological Reversals* (Chippenham, England: Picton Publishing, 1975).
6. M. A. Noll, The Digital Computer as a Creative Medium, *Bit International* **2**, 51 (1968).
7. J. C. Loehlin, *Computer Models of Personality* (New York: Random House, 1968).
8. E. Gellhorn, *Principles of Autonomic-Somatic Integrations* (Minneapolis: Univ. Minnesota Press, 1967) pp. 17-19.
9. C. Pratt, Aesthetics, *Ann. Rev. of Psychology*, **71** (1961).
10. S. K. Langer, *Philosophy in a New Key* (Cambridge, Mass.: Harvard Univ. Press, 1942).
11. T. McLaughlin, *Music and Communication* (London: Faber & Faber, 1970).
12. N. Chomsky, Recent Contributions to the Theory of Innate Ideas, *Synthese* **17**, 2 (1967).
13. P. F. Smith, Urban Sculpture: A Kind of Therapy, *Leonardo* **6**, 227 (1973).
14. D. E. Berlyne, *Aesthetics and Psychobiology* (New York: Appleton-Century-Crofts, 1971).
15. L. Egri, *The Art of Dramatic Writing* (New York: Simon & Schuster, 1960).
16. F. C. Bartlett, *Remembering: A Study in Experimental and Social Psychology* (Cambridge: Cambridge Univ. Press, 1932).
17. K. S. Lashley, *Brain Mechanisms and Intelligence* (Chicago: Univ. Chicago Press, 1929).
18. R. L. Gregory, *The Intelligent Eye* (London: Weidenfeld & Nicholson, 1970).
19. F. R. Hewitt, The Mind's Eye or the Eye's Mind, *Nova Tendencija* **3**, 75 (1965).
20. H. A. Simon and L. Siklossy, eds., *Representation and Meaning: Experiments with Information Processing Systems* (New Jersey: Prentice-Hall, 1972).
21. R. C. Schank and K. M. Colby, eds., *Computer Models of Thought and Language* (San Francisco: Freeman, 1973).

COMMENTS ON VISUAL FINE ART PRODUCED BY DIGITAL COMPUTERS*

Frank J. Malina**

I.

I have had no direct experience with digital computers either in applied science or in art, mainly because they were developed too long after I was born. I have read technical and philosophical studies of this intriguing device [1–5] and, as the editor of *Leonardo*, I have struggled with manuscripts by artists who have used the computer to aid them in producing visual fine art [6–11]. Furthermore, since I make kinetic art objects utilizing electric light and mechanical or electronic systems to provide motion, as well as traditional static images with paints and pen, I have a very critical attitude towards the output of computers instructed by artists.

For the purpose of my discussion, it is not necessary for me to go into the principles of operation of a digital computer, the differences between hardware and software, and the methods of programing. It is important, however, to stress that computers available today do what man tells them to do, provided the instructions are compatible with the computer's internal construction. The computer can imitate only a very limited part of the potential of the human brain. It does this at speeds vastly greater than is possible with our brains or our hands. Results that would have taken years to obtain two decades ago can now be achieved in a few hours or days.

Scientific and mathematical problems can now be solved with the aid of computers that before were put aside because of the enormous number of calculations that were required. Subjects such as meteorology and economics, which daily involve a great quantity of statistical analysis, may be expected to become more reliable in their power of prediction through the use of these machines. Astronauts have learned to depend on computers for the guidance and navigation of their space vehicles, although very reluctantly, for they at first feared that their skills as pilots were being taken over by a machine.

II.

The computer, in response to appropriate programed instructions, offers to the artist the following possibilities:

1. *Line drawings and compositions made up of typed symbols, in black and white or in color, on paper or a similar material, ready for framing*

Variations of these kinds of output of a computer can easily be made by changes in the instructions. One should bear in mind that these outputs can be produced without the computer, as far as the basic artistic conceptions of content are concerned. For example, the line drawings of a computer can be made by hand with a pen or pencil or by means of simple mechanical devices, such as the double pendulum [12]. Compositions of typed symbols can be made on a manually operated typewriter [7, 8, 11]. The advantage of computer graphic art is in the speed and quantity of copies that can be produced, perhaps at a lower price than by other traditional methods. This would allow a larger number of persons to purchase an example.

2. *Sculpture made by automatic machines controlled by a computer*

To make three-dimensional objects, a computer is provided with a program of instructions for conversion into commands to an automatic machine. A simple example is a symmetrical object turned in a wood or metal lathe. More complex cutting machines are available in industry for making irregular forms. Whether the traditional method in which the artist makes a prototype by hand, from which copies can be cast in plaster or metal, will be displaced by the new method is not obvious.

3. *Paintings made by an automatic machine controlled by a computer*

A computer would be used in the same manner as for making a sculpture, except that a special automatic machine would be required to apply paints to a surface. A painting machine is not at

* Text based on a talk given at the *Décade: L'homme devant l'informatique* at the Centre Culturel International de Cérisy-la-Salle, Manche, France on 18 July 1970.

** American artist and astronautical engineer living at 17 rue Emile Dunois, 92-Boulogne sur Seine, France. (Received 25 July 1970.)

present available but perhaps a sufficiently flexible one could be constructed to give interesting results.

4. *Displays on a screen of a cathode ray tube*

A computer can be instructed to command the formation of black and white or colored, static or kinetic images on the screen of a cathode ray tube similar to that used in television sets. The images may be viewed directly or recorded on still photographs, cinema film or video tape. It is also possible to give a viewer the visual experience of three dimensions by stereoscopic separation of images through the use of auxiliary devices [6]. One can expect in the near future computer-produced visual art recorded on video tape for projection on the screen of a television set in the home, whenever desired. This kind of application of a computer may be the most promising one for the future of the visual arts.

5. *Compositions made up of a number of basic elements arranged according to a predetermined combinatorial principle*

A computer would provide instructions on the location of each basic element on a surface according to prescribed rules, for example, to avoid the same color in a part of an element touching the same color in neighbouring elements and to avoid the same shape in a part of an element touching the same shape in neighbouring elements. The artist (perhaps one should say craftsman) then takes the computer instructions and paints the composition or assembles previously prepared elements made to the desired scale. The computer only serves as a labor-saving device in arriving at combinations prescribed by the artist [10].

III.

By the time computers became available to them, artists had already used other means to make static and kinetic, two and three-dimensional visual art, including audio-visual kinetic art. Since a computer must be told what to do in detail, artists are forced to fall back on images with visual conceptions of content that have already existed before—the computer then makes imitations of them. It does permit the production of many variations of the components of the programed image or object—lines, areas, volumes and color, and time sequences, if they are kinetic, can theoretically be varied endlessly.

The capability of a computer to produce easily variations of an artist's basic artistic conception may be a blessing for some artists. The artist in the past, in order to earn his livelihood, has been forced to make by hand a large number of art objects that are but minor variations of a given prototype. The pressures on the artist from the commercializers of art to make quantities of variants of a prototype bearing a clearly recognizable 'trade-mark' further aggravate the 'production' dilemma of the creative artist. This consideration is based on the conviction that only the prototype can be considered a significant creative act and that the artist becomes frustrated when he must make repetitions of the prototype with only minor variations. The fact that the works of an artist are divided into 'periods' can be blamed on the above considerations, although it is quite possible that the very nature of the human brain limits an artist to one or very few significant creative visual ideas during his lifetime.

No computer exists today that can be told to produce an image containing a specific content, say a reclining nude or a geometrical 'landscape', with an original visual conception of its own invention or *vice-versa* that will be aesthetically satisfying. If a computer is given instructions that exceed its capability, it may either come to a stop or make something classifiable only as 'garbage'. Furthermore, a computer can neither provide the artist with any new physical dimension beyond the two dimensions of drawings and paintings, the three dimensions of sculptures and constructions, and the added time dimension of kinetic art, nor make available new optical illusions.

In spite of the limitations of present day digital computers, artists will and, I believe, should make use of them. One cannot expect that, in the short time that a very few artists have had access to them, all of their possibilities have been explored. This exploration is severely limited by the high cost of computer time and by the reluctance of artists to learn the intricacies of computer operation and programing. Those artists who are interested in taking advantage of developments in modern technology generally look upon scientists and engineers as magicians who can do anything imaginable. From my experience, artists consider them as uncooperative because they tell the artist that their ideas violate the laws of nature, demand inventions that have not been made or would cost vast sums of money to be accomplished. There are, of course, scientists and engineers who mislead the artist by telling him that 'the difficult we will do immediately, the impossible will take a little longer'.

I believe the most important benefit to be expected from the use of computers by artists will be sociological. They will help to dispel the not uncommon view that computers are monsters rather than highly sophisticated devices that can serve man, if intelligently used.

REFERENCES

1. H. L. Dreyfus, Philosophic Issues in Artificial Intelligence, *Publications in the Humanities,* No. 80, Mass. Inst. of Tech., 1967.
2. L. Summer, *Computer Art and Human Response* (Charlottesville, Virginia: P. B. Victorius, 1968).

3. L. D. Harmon and K. C. Knowtton, Picture Processing by Computer, *Science* **164**, 19 (1969).
4. H. von Foerster and J. W. Beauchamp, Eds., *Music by Computers* (New York: John Wiley, 1969).
5. M. J. Apter, *The Computer Simulation of Behaviour* (London: Hutchinson University Library, 1970).
6. R. I. Land, Computer Art: Color-Stereo Displays, *Leonardo* **2**, 335 (1969).
7. F. Hammersley, My First Experience with Computer Drawings, *Leonardo* **2**, 407 (1969).
8. J. Hill, My Plexiglas and Light Sculptures, *Leonardo* **3**, 9 (1970).
9. R. Mallary, Notes on Jack Burnham's Concepts of a Software Exhibition, *Leonardo* **3**, 189 (1970).
10. Z. Sýkora and J. Blažek, Computer-Aided Multi-Element Geometrical Abstract Paintings, *Leonardo* **3**, 409 (1970).
11. K. Nash and R. H. Williams, Computer Program for Artists: *ART* 1, *Leonardo* **3**, 439 (1970).
12. S. Tolansky, Complex Curvilinear Designs from Pendulums, *Leonardo* **2**, 267 (1969).

AN INVESTIGATION OF ALGORITHMIC AESTHETICS

James Gips* and George Stiny**

Abstract—*This paper describes an investigation of aesthetics in terms of algorithms. The main result of the work is the development of a formalism, an aesthetic system, for the algorithmic specification of aesthetic viewpoints. An aesthetic viewpoint is taken to consist of a collection of interpretative conventions and evaluative criteria for art. Interpretative conventions determine how an object can be understood as a work of art; evaluative criteria determine the judged quality of such an object when it is understood in this way. Viewpoints vary for different people, different cultures and different art forms. These systems allow for the specification of different viewpoints in terms of a uniformly structured system of algorithms. An example of an aesthetic system for nonfigurative, rectilinear pictures is given. This system is applied to six pictures shown in the paper. The computer implementation of the system is described briefly.*

I. INTRODUCTION

Our research efforts in the past several years have been directed toward applying algorithmic methods to art theory and criticism. In particular, we are interested in using algorithms to model the many different aesthetic viewpoints used to interpret and evaluate works of art. As D. E. Knuth has stated: 'It has often been said that a person doesn't really understand something until he teaches it to someone else. Actually a person doesn't really understand something until he teaches it to a computer, i.e., express it as an algorithm The attempt to formalize things as algorithms leads to a much deeper understanding than if we simply try to understand things in the traditional way' [1].

The aesthetic viewpoints used by people to interpret and evaluate works of art are extremely varied and complex. While we certainly do not expect to be able to model exactly these viewpoints, we believe that an attempt to do so using algorithms can provide insight into their nature.

In this paper we report on some of our preliminary results. Our research has been directed toward the development of a formal system for the algorithmic specification of these viewpoints. In Part II, the viewpoints are characterized informally and a formalism, *aesthetic system*, is proposed for their algorithmic specification. In Part III, an example of a specific aesthetic system for a class of nonfigurative, rectilinear pictures is given. This system is applied to the six pictures 'Anamorphism I–VI' (Fig. 1). The computer implementation of parts of

this system is described. The program is responsible for the evaluation of 'Anamorphism I–VI' and the pictures in Fig. 1.

Discussion of the relations of aesthetic systems to traditional approaches to aesthetics and art theory are given in Refs. 2, 3 and 4. A detailed description of the computer implementation summarized in Part III can be found in Ref. 3. A mathematical treatment of such systems appears in Ref. 4. A discussion of the use of aesthetic systems for the representation and solution of design problems and criticism problems in the arts is given in Ref. 5. A greatly expanded treatment of aesthetic systems will be published in Ref. 6.

II. AESTHETIC VIEWPOINTS AND AESTHETIC SYSTEMS

(a) *Aesthetic viewpoints*

An aesthetic viewpoint determines how an object is understood as a work of art and how the quality of an object is judged when it is understood in this way. A viewpoint may be thought of as a construct of an observer used to consider objects as works of art and as a construct of an artist used to produce new works.

There are many possible aesthetic viewpoints. They vary for different people, different cultures and different art forms. The variety of viewpoints is apparent when two different people understand and appreciate the same object as a work of art in two different ways or when two different artists produce two different objects both of which are claimed to be good works of art.

Even though viewpoints vary, they may be considered to share a common, underlying structure. All viewpoints may be characterized as a collection

* Computer scientist, Dept. of Biomathematics, University of California, Los Angeles, CA. 90024, U.S.A.

**Aesthetician, 628 Hauser Blvd., Los Angeles, CA 90036, U.S.A. (Received 21 August 1974.)

of *interpretative conventions* and *evaluative criteria* for art. Interpretative conventions determine how an object is understood as a work of art and they have two aspects: They decide (1) the types of interpretations that can be made for objects as works of art and (2) which interpretations refer to which objects. Evaluative criteria determine the judged quality of an object in terms of its interpretation as a work of art and they have two aspects: They determine (1) the judged quality of an individual object and (2) the ordering of the judged qualities of two different objects.

(b) *The definition of aesthetic systems*

The definition of an aesthetic system provides a logical framework in which aesthetic viewpoints can be represented as uniformly structured systems of algorithms. Each such system consists of specific algorithms that model specific interpretative conventions and evaluative criteria. Because of the multiplicity of viewpoints, there are many possible systems. Where the content of different systems is as varied as the different viewpoints they model, the underlying structure of the systems is uniform. This uniformity of underlying structure

Fig. 1. *'Anamorphism I–VI'. Pictures produced on a color television using a PDP-10 computer, 1973.*

allows for a uniform approach to many problems in the arts.

Aesthetic systems provide for the formal definition of intuitive notions of interpretation and evaluation of objects. Here the notion of 'object' is used in its widest possible sense to include, for example, musical and theatrical performances as well as paintings and novels. An interpretation of an object is considered to have two parts: usually one is a description of the object and the other is a specification of how that description is understood. Simply, an interpretation consists of a pair of *symbol strings*. Two basic types of interpretation are distinguished in traditional aesthetics: external evocations and internal coherence. In an interpretation examining the external evocations of an object, the description of the object is associated with a specification of the response evoked by the object. This response could include the associations or emotions attached to the object. Interpretation of this type deals with extra-object relationships and is discussed often in terms of content, representation or expression. In an interpretation examining the internal coherence of an object, a specification of the underlying structure of the object is associated with the description of the object. This specification could contain rules for construction or principles of organization for the object. Interpretation of this type deals with intra-object relationships and is discussed often in terms of form or composition. An evaluation of an object is considered in terms of a value assigned to the interpretation of the object. In particular, an evaluation function is defined for interpretations that is similar to traditional aesthetic measures based on unity and variety or order and complexity.

An aesthetic system consists of four parts: (1) a *set of interpretations* I_A defined by an algorithm A; (2) a *reference decision algorithm* R that determines whether an interpretation in the set I_A refers to a given object; (3) an *evaluation function* E that assigns values to interpretations in the set I_A and (4) an *order* O that orders the values assigned to interpretations by the evaluation function E. Formally, an aesthetic system is given by the 4-tuple $<I_A, R, E, O>$. The first two parts of such a system model the two aspects of interpretative conventions discussed in Part II (a). The second two parts of the system model the two aspects of evaluative criteria discussed in Part II (a).

(c) *Modeling interpretative conventions*

For each aesthetic system, the set of interpretations I_A is defined by a fixed algorithm A. The set I_A contains all possible input–output pairs $<\alpha, \beta>$ for the algorithm A, where both α and β are finite, non-empty sequences of symbols. The pair $<\alpha, \beta>$ is an interpretation in the set I_A if and only if when given input sequence α, A terminates with output sequence β. Membership of an interpretation in the set I_A is independent of actual objects, depending only on the sequences α and β and the algorithm A. The set I_A is a potentially

infinite set of finite interpretations. The set I_A contains all possible interpretations for objects from the aesthetic viewpoint specified by the aesthetic system.

The reference decision algorithm R when presented with an interpretation in the set I_A and any real-world object decides whether the interpretation refers to that object. The output of R is 'true' if and only if the interpretation refers to that object. In general, there are many interpretations in the set I_A that do not refer to actual objects.

The schema for the reference decision algorithm R in Fig. 2 is appropriate for most aesthetic viewpoints. For an interpretation $<\alpha, \beta>$, either α or β, but not both, is used as the input for the determination of reference in this schema. S, the first part of the schema, shows a sensory input transducer linked to an algorithm which produces a finite and discrete canonical description λ of the presented object. For example, in music, drama, literature or architecture λ could resemble the score, script, text or plan. λ is the complete description of the object in the sense that only those attributes identified by λ are considered in interpretations. Different objects producing identical λ are indistinguishable for interpretation. This allows a single interpretation to refer to multiple reproductions of a picture, copies of a novel or performances of a concerto. The second part is a comparator that has as output 'true' if λ is identical to the input component of the interpretation and 'false' otherwise. This schema for R is especially important because it gives an operational definition of the canonical description λ of an object. The two cases of this schema, i.e., where $\alpha = \lambda$ and where $\beta = \lambda$, are paradigmatic for the two basic types of interpretation distinguished above.

We shall now consider aesthetic systems that model interpretative conventions dealing with (1) just external evocations (Fig. 3(a)), (2) just internal coherence (Fig. 3(b)) and (3) both internal coherence and external evocations (Fig. 3(c)). Detailed examples of systems of these types are given in Refs. 5 and 6. An example of interpretative conventions of the first type [7] and one of the second type [8] have been published in *Leonardo*.

An aesthetic system deals with just the external evocations of objects when α in each interpretation $<\alpha, \beta>$ that refers to an object is the description of that object (Fig. 3(a)). The reference decision algorithm R compares α in an interpretation with the description λ of an object (Fig. 2). β is a specification of the response evoked by this description. Given α, the algorithm A_e determines explicitly the content of this response. The description of an object is the input to A_e; the response to that description is the output of A_e. For example, β may be a symbolic encoding of the associations or emotions evoked by the description of the object. A_e embodies the interpretative conventions of a specific aesthetic viewpoint that determine what associations or emotions are attached to the description of an object. Discussions of an object in terms of content, representation, expression etc. can be based on interpretations of this type.

An aesthetic system deals with just the internal coherence of objects when β in each interpretation $<\alpha, \beta>$ that refers to an object is the description of that object (Fig. 3(b)). The reference decision algorithm R compares β in an interpretation with the description λ of an object (Fig. 2). α is a specification of the description of the object given by β in terms of its syntactic or semantic structure. The algorithm A_i determines implicitly the nature of acceptable underlying structures for the description of the object. For example, β could be specified by α consisting of a symbolic encoding of rules of construction or principles of organization based on the occurrence of patterns, motifs or themes. A_i embodies the interpretative conventions of a specific aesthetic viewpoint that determine how the description of an object can be constructed from α. Discussions of an object in terms of form, composition etc. can be based on interpretations of this type. The aesthetic system for pictures having generative specifications (presented in Part III) is an example of this kind of aesthetic system.

Systems in which neither α nor β in an interpretation $<\alpha, \beta>$ is the description of an object are also possible. An important example of this kind of system contains interpretations that deal with both the internal coherence and external evocations of objects referenced by interpretations (Fig. 3(c)). This third type of system sometimes can be

Fig. 2. *Reference decision algorithm schema.*

Fig. 3. *Three types of interpretative conventions: (a) external evocations, (b) internal coherence and (c) both.*

constructed by combining a system that deals with internal coherence and a system that deals with external evocations [4, 5]. In this new system an interpretation that refers to an object has the form $<\alpha_i, \beta_e>$, where α_i occurs in an interpretation that refers to the object in the first system and β_e occurs in an interpretation that refers to the object in the second system. The description of the object is produced internally in the algorithm A_c which defines the set of interpretations (Fig. 4). This new aesthetic system deals with the relationship between the internal coherence and external evocations of objects referenced by interpretations.

A set of interpretations I_A and a reference decision algorithm R embody particular interpretative conventions. I_A defines the potential scope of these conventions and R determines their empirical extent. Together I_A and R model the two aspects of interpretative conventions, deciding the types of interpretations that can be made for objects and which interpretations refer to which objects. Any interpretative conventions are allowable if the algorithms A and R can be constructed to conform with them.

(d) *Modeling evaluative criteria*

The second part of an aesthetic viewpoint consists of evaluative criteria. Evaluative criteria are modeled by an evaluation function E and an order O.

The evaluation function E computes the aesthetic value of an interpretation. The evaluation function E is defined on the set I_A. There are many possibilities for evaluation functions. An evaluation function for interpretations $<\alpha, \beta>$ may be defined in terms of just α, just β, or both. The function may consider the content of an interpretation, e.g., the occurrence of specific symbols in α or β, or the general characteristics of an interpretation, e.g., the lengths of α or β. O is an order defined in the range of E and may be partial or total. The evaluation function E together with the order O ranks elements of I_A. Together E and O determine the appropriateness of an interpretation from a given aesthetic viewpoint.

An interesting evaluation function for aesthetic systems is given by

$$E_Z(<\alpha,\beta>) = L(\beta)/L(\alpha)$$

where $L(\alpha)$ is the length of α and $L(\beta)$ is the length of β. Recall that α and β are finite sequences of symbols. The length of a sequence of symbols is defined to be the number of symbols in the sequence. The total order O_Z naturally associated with E_Z ranks two interpretations such that the interpretation assigned the higher value is aesthetically superior.

E_Z and O_Z can be combined with any set of interpretations I_A and reference decision algorithm R to form an aesthetic system. For a given set I_A, E_Z assigns high aesthetic values to interpretations $<\alpha, \beta>$ in which β is specified economically by α with respect to A. An interpretation where α is the description of an object (Fig. 3(a)) is assigned a relatively high aesthetic value when α has multiple external evocations, i.e. when β is long. Here the description α is connected with a large complex of associations as encoded by β. An interpretation where β is the description of an object (Fig. 3(b)) is assigned a relatively high aesthetic value when β has internal coherence, i.e. when α is short. Here the specification α of the description β is parsimonious. The value assigned to an interpretation by the evaluation function E_Z may be considered to be an effective quantification of traditional aesthetic measures defined in terms of unity and variety or order and complexity [3, 4]. For interpretations with identical β, the use of E_Z and O_Z produces a ranking of these interpretations which corresponds to the application of Occam's razor.

(e) *The evaluation function E_Z and algorithmic information theory*

Aesthetic systems can be considered in terms of information theory when the evaluation function E_Z is used. While information theory was formulated originally using statistical techniques, it has been reformulated by Kolmogorov [9] and others using the theory of computability and algorithms. This new formulation provides for the computation of the information-theoretic entropy or complexity of an individual sequence of symbols in terms of the length of the shortest algorithmic specification of the sequence instead of the likelihood of occurrence of the sequence among all possible sequences. We assume in this discussion that A is a universal computing algorithm and that α and β are defined over binary alphabets. If α is the shortest string such as $A(\alpha) = \beta$ then $L(\alpha)$ is the entropy of β with respect to A. If an interpretation $<\alpha, \beta>$ in the set I_A is assigned a high aesthetic value by the evaluation function E_Z then the entropy of β is low. E_Z assigns high aesthetic values to interpretations containing β that have a redundant, periodic or regular structure with respect to A as specified by α. (cf. Chaitin's discussion of the complexity of scientific observations [10].)

In general, no sequence β has entropy much greater than its length, as β can always be specified by the sequence 'write out β'. A sequence with entropy not smaller than its length can be considered random [11]. For an interpretation $<\alpha, \beta>$ in which $L(\alpha)$ is the entropy of β, the

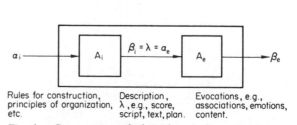

| Input | Algorithm | Output |

Rules for construction, principles of organization, etc. Description, λ, e.g., score, script, text, plan. Evocations, e.g., associations, emotions, content.

Fig. 4. Construction of algorithm A_c by composition of algorithms A_i and A_e.

aesthetic value assigned to $<\alpha, \beta>$ by E_Z is approximately equal to the entropy of a random sequence of length $L(\beta)$ divided by the actual entropy of β. This expression can be considered the reciprocal of the relative entropy [12] of β. It follows that any interpretation $<\alpha, \beta>$ in the set I_A that is assigned high aesthetic value by E_Z (i.e., E_Z ($<\alpha, \beta>)>1$) contains β which is not random. In general, it can be shown that a set of interpretations I_A is very sparse in interpretations assigned high aesthetic value by E_Z.

III. AN AESTHETIC SYSTEM FOR PICTURES HAVING GENERATIVE SPECIFICATIONS

(a) *Overview*

We now describe an aesthetic system that has interpretations for nonfigurative, rectilinear pictures. To illustrate, interpretations for the pictures 'Anamorphism I–VI' (Fig. 1) are given and these interpretations are evaluated.

The system described is concerned with the internal coherence of pictures (Fig. 3(b)). For interpretations $<\alpha, \beta>$ in the set I_A in this system, α gives rules of construction for the description β of a picture. The algorithm A embodies the conventions by which β can be constructed given α. The reference decision algorithm follows the form of the schema in Fig. 2 and compares β with λ. The evaluation function E_Z and the order O_Z are used. Parts of this system have been implemented on a computer.

(b) *The rules of construction α of nonfigurative rectilinear pictures in this aesthetic system*

In interpretations $<\alpha, \beta>$, α is given by a *generative specification* [13]. Briefly, a generative specification consists of a *shape specification* that

determines a class of shapes and a *material specification* that determines how these shapes are represented. The generative specification for 'Anamorphism I' is shown in Fig. 5. A shape specification consists of a shape grammar and a selection rule. A *shape grammar* [3, 4] is defined over an alphabet of shapes and provides for the recursive generation of shapes. A *selection rule* selects shapes from the language of shapes defined by a shape grammar and provides a halting algorithm for the shape generation process. A material specification consists of a finite list of painting rules and a limiting shape. *Painting rules* indicate how the areas contained in a shape are colored by considering the shape as a Venn diagram. The *limiting shape* has the property of a camera viewfinder, determining what part of a colored shape occurs on a canvas of given size and shape and in what orientation and scale. Here, pictures are material representations of 2-dimensional shapes generated by shape grammars.

The generative specifications for 'Anamorphism II–VI' can be obtained by substituting the rules shown in Fig. 6 for the first rule in the shape grammar in the generative specification for 'Anamorphism I'. Thus, the specifications of these six pictures differ only in the location of the markers (circles) in the right side of the first rule in their shape grammars.

(c) *The description, β, of nonfigurative rectilinear pictures in this aesthetic system*

In interpretations $<\alpha, \beta>$, β consists of shape, color and occurrence tables having the format in Fig. 7. The tables in this figure give the description of 'Anamorphism I', which is diagrammed at the top. Each entry (row) in the occurrence table corresponds to a distinct colored area in the picture. Each entry has seven items: item i_s is the index of a shape entry occurring in the shape table and specifies the shape of the area; item i_c is the index of a color entry occurring in the color table and specifies the color of the area; items x, y, θ, s, and m are transformations that map the shape

Anamorphism II

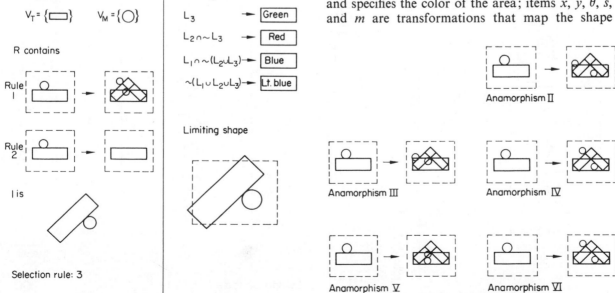

Fig. 5. *Generative specification (α) for 'Anamorphism I'.*

Fig. 6. *Rules for 'Anamorphism II–VI'.*

indexed by i_s from the shape table coordinate system to the picture coordinate system, where x and y determine translation, θ determines rotation, s determines scale and m determines whether the mirror image of the shape is used. Entries in the shape table correspond to the different shapes of the areas occurring in a picture. Entries in the color table correspond to the different colors of the areas occurring in a picture.

(d) *The aesthetic value of nonfigurative rectilinear pictures in this aesthetic system*

In the calculation of aesthetic value using E_Z the lengths of α and β ($L(\alpha)$ and $L(\beta)$) are defined to be the number of words of computer memory used to represent them in the computer program. The computer representation of α, a generative specification, is rather involved [3]. But the computer representation of the three tables of β can be described simply. The computer representation of each shape (each is closed and rectilinear) in a shape table is constructed by fixing two of the vertices of the shape and listing the angles and distances encountered in a counter-clockwise trace outlining the shape. A hole in a shape requires the construction of a straight-line (actually two lines, one superimposed on the other) between a vertex on the inner boundary and a vertex on the outer boundary so that the trace around a shape is continuous (cf. shapes 1 and 2 in the shape table in

Fig. 7). The number of words of memory used to represent each shape is given by $2V-3$, where V is the number of straight-line segments determining the shape [3]. The computation of the length of the shape table for Anamorphism I is shown in Fig. 8. Each entry in a color table is represented by three words of memory denoting the intensities of the red, blue and green components of the color. Each of the seven items in each entry (row) in an occurrence table is represented by a word of memory. One additional word of memory is used for each table to specify the number of entries in the table.

In the given interpretations for 'Anamorphism I–VI', the lengths $L(\alpha)$ of the computer representations of α (the generative specifications) are equal because these specifications differ only in the location of the markers in their respective shape grammars. Thus, here the details of the computer representation of an arbitrary generative specification need not be considered. The lengths $L(\beta)$ of the computer representations of β (the shape, color and occurrence tables) of these interpretations are given in Table I, as are the values assigned by E_Z, where E_Z ($<\alpha, \beta>$) = $L(\beta)/L(\alpha)$. Since $L(\alpha)$ is the same in each interpretation, the aesthetic value of each interpretation is directly proportional to $L(\beta)$. The ordering determined by O_Z of the aesthetic values assigned by E_Z to the given interpretations for 'Anamorphism I–VI' is, in order of decreasing aesthetic value, 'Anamorphism I, IV, II, III, VI and V'.

Outline of 'Anamorphism I' with painted areas as lettered:

β constructed for 'Anamorphism I':

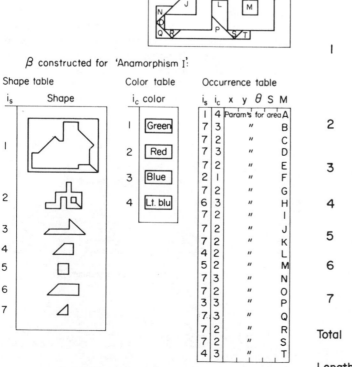

Fig. 7. The shape, color and occurrence tables (β) for 'Anamorphism I'.

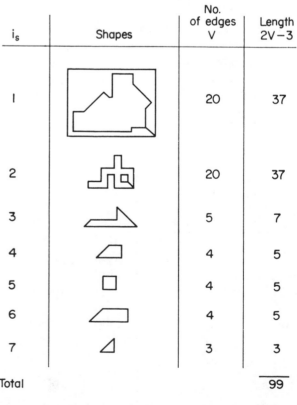

i_s	Shapes	No. of edges V	Length $2V-3$
1		20	37
2		20	37
3		5	7
4		4	5
5		4	5
6		4	5
7		3	3
Total			99

Length of table (total + 1) 100

Fig. 8. Length of shape table for 'Anamorphism I'.

TABLE I. TABULATION OF AESTHETIC VALUES FOR 'ANAMORPHISM I–VI'

'Anamorphism'	$L(\alpha)$ (words)	Shape table (words)	Color table (words)	Occurrence table (words)	$L(\beta)$ (words)	E_Z
I	41	100	13	141	254	6·20
II	41	95	13	141	249	6·07
III	41	82	13	141	236	5·76
IV	41	98	13	141	252	6·15
V	41	62	13	127	202	4·93
VI	41	95	13	113	221	5·39

(e) Discussion of the aesthetic system

The aesthetic system described above deals with the internal coherence of pictures having generative specifications. For interpretations $<\alpha, \beta>$ in this system, α is a specification of the underlying structure of the picture and β is the description of the picture (Fig. 3(b)). The algorithm A embodies the conventions by which β, the shape, color and occurrence tables, can be constructed given α, a generative specification. The set I_A is infinite, containing all possible generative specifications and their associated shape, color and occurrence tables. β is easily obtainable from a picture independent of its generative specification, allowing for a straightforward construction of a reference decision algorithm R having the β form of the schema of Fig. 2. The sensory input transducer of R could be a color television camera; the linked algorithm could contain an edge-following routine.

The evaluation function E_Z used in this system assigns high aesthetic value to interpretations having short generative specifications and long shape, color and occurrence tables. For an interpretation $<\alpha, \beta>$, $L(\alpha)$ may be considered to be a measure of the *specificational simplicity* of a picture having α as its generative specification and $L(\beta)$ may be considered to be a measure of the *visual complexity* of a picture having β as its description [13 and 14]. In this system, aesthetic value primarily reflects the variety and occurrence of shapes in a picture as given in its shape and occurrence tables and how these shapes can be generated as given in the shape grammar of its generative specification. Aesthetic value in this system is independent of the actual colors used in a picture. If two pictures differ only in the colors used, the aesthetic values assigned to their respective interpretations are equal. It is interesting to note that there is an implicit bias in this system against symmetry. This bias results because asymmetric pictures tend to have a larger variety and more occurrences of shapes than symmetric pictures. Thus the shape and occurrence tables of asymmetric pictures tend to have more entries than the shape and occurrence tables of symmetric pictures. The aesthetic values assigned to the interpretations given for 'Anamorphism I–VI' are an example of this phenomenon.

(f) Computer implementation

A computer program for the implementation of generative specifications and the aesthetic system just described has been completed [3]. The program is written in SAIL (an extended ALGOL) and runs on the Stanford Artificial Intelligence Laboratory PDP-10 computer (Digital Equipment Corporation, Maynard, Mass., U.S.A.). The program has facilitated the empirical investigation of both generative specifications and the aesthetic system.

The program allows generative specifications for rectilinear pictures to be defined interactively using a keyboard and display. Given a generative specification, the program can generate and display a line drawing of the shapes occurring in the specified picture. For example, it takes 16 seconds of CPU (Central Processor Unit) time and 42K (42 × 2^{10} = 42 × 1024 = 43008) words of memory to generate and display the line drawing of a picture having 4800 shape edges. Flicker is not a problem, because a raster-type display is used. If desired, the picture itself can be displayed via a video synthesizer in shades of gray or in full color on a color television connected to the PDP-10. Hard copy of the line drawing or a low contrast shades-of-gray version of the picture can be obtained using a Xerox Graphics Printer (Xerox Corporation, Rochester, N.Y., U.S.A.).

The pictures 'Anamorphism I–VI' shown in Fig. 1 were produced on a color television by the program on the PDP-10. 'Anamorphism I–VI' are simple and were used here for pedagogical purposes. Much more complicated pictures have been defined using generative specifications and have been produced using both the computer and traditional artistic techniques [3, 4].

The portion of the program that implements the aesthetic system can be called after a generative specification has been defined. Given a generative specification, the shape, color and occurrence tables for the specified picture are constructed. The lengths, i.e. the number of words of memory used for the encoding, of the generative specification and shape, color and occurrence tables are computed. The output of the program is the aesthetic value assigned to this interpretation of the picture.

The shape, color and occurrence tables for 'Anamorphism I–VI' and the aesthetic values given in Table I were computed using this program. Because of space and time restrictions, there is a limit to the number of lines occurring in pictures for which aesthetic value can be computed by the current program.

The reader may disagree with the aesthetic ordering made by the program. It should be re-emphasized that a universally agreed upon aesthetic system is neither expected nor desired. Suggestions for alternative systems for pictures definable by generative specifications are given in Refs. 3, 4 and 6. The system used does embody a coherent, well-defined aesthetic viewpoint for pictures definable by generative specifications and seems a good first order approximation of our personal aesthetic preferences for pictures of this type.

REFERENCES

1. D. E. Knuth, Computer Science and Mathematics, *American Scientist* **61**, No. 6, 1973.
2. J. Gips and G. Stiny, Aesthetic Systems, *Stanford Computer Science Report No. 337*, Feb. 1973.
3. J. Gips, *Shape Grammars and Their Uses*, (Basel, Switzerland: Birkhauser Verlag, in press). Also Ph.D. dissertation, Computer Science Department, Stanford University, Stanford, Calif., U.S.A., 1974.
4. G. Stiny, *Pictorial and Formal Aspects of Shape and Shape Grammars and Aesthetic Systems*, (Basel, Switzerland: Birkhauser Verlag, in press). Also, Ph.D. dissertation, System Science Department, University of California, Los Angeles, Calif., U.S.A., 1975.
5. G. Stiny and J. Gips, Formalization of Analysis and Design in the Arts, in W. R. Spillers (ed.), *Basic Questions of Design Theory* (Amsterdam: North Holland Publishing Co., 1974).
6. G. Stiny and J. Gips, *Aesthetics: An Algorithmic Approach*, monograph in preparation.
7. M. Thompson, Computer Art: A Visual Model for the Modular Pictures of Manuel Barbadillo, *Leonardo* **5**, 219 (1972).
8. Z. Sýkora and J. Blažek, Computer-Aided Multi-Element Geometrical Abstract Paintings, *Leonardo* **3**, 409 (1970).
9. A. N. Kolmogorov, Logical Basis for Information Theory and Probability Theory, *IEEE Transactions on Information Theory* IT-14, No. 5, 1968.
10. G. Chaitin, Some Philosophical Implications of Information-Theoretic Computational Complexity, *SIGACT News*, April 1973. Excerpted from *Information-Theoretic Limitations of Formal Systems* (New York: Courant Institute Computational Complexity Symposium, Oct. 1971).
11. P. Martin-Loff, The Definition of Random Sequences, *Information and Control* **9**, 1966.
12. C. Shannon and W. Weaver, *The Mathematical Theory of Communication* (Urbana, Ill.: Univ. Illinois Press, 1949).
13. G. Stiny and J. Gips, Shape Grammars and the Generative Specification of Painting and Sculpture, *Information Processing 71* (Amsterdam: North Holland Publishing Co., 1972). Also in O. Petrocelli (ed.), *The Best Computer Papers of 1971* (Princeton, N.J.: Auerbach, 1972).
14. E. L. J. Leeuwenberg, *Structural Information of Visual Patterns* (The Hague: Mouton, 1968).

COMMENTS ON THE ALGORITHMIC AESTHETIC SYSTEM OF JAMES GIPS AND GEORGE STINY

Michael Thompson*

1. When is an aesthetic system 'aesthetic'?

Gips and Stiny in Ref. 1 have provided an exactly defined framework called 'aesthetic system'. This author considers that such a formulation will lead to better understanding of aesthetics in general and shares their views on the value of an algorithmic approach. I am somewhat concerned, however, that the extreme generality of 'aesthetic system' readily permits its application to non-aesthetic matters. The system has four components I_A, R, E and O [1], which I shall examine now, in turn.

I_A is a set of interpretations of which there are two main types. In the first type, an interpretation (α, β) associates a set α of 'rules for construction, principles of organisation etc.' with a description β that can be a 'score, script, text or plan'. But scores, scripts, texts or plans do not have to refer to aesthetic material or, to be more precise, there is nothing in these material objects that makes them aesthetic of themselves. A score of birdsong may be used solely for recognition, a script for roleplaying in the training of salesmen and a text may describe the income tax laws. The interpretation (α, β) readily accepts the definition of Algol as α and a particular computer program in this language as β. How does it come about that any of these objects may be regarded as aesthetic? The answer is probably to be found in the theory of symbols (see, for instance, Goodman, Ref. 2), however I shall not discuss this in any detail here. Suffice it to say an observer in comprehending a work of art will use cognitive processes of an aesthetic rather than a non-aesthetic nature. Probably most of the output of the computer system of Gips and Stiny is strongly aesthetic, this being presumable only because they provide the input. It seems that they are essential for the aesthetic aspects of their system and, therefore, that they should have included themselves in it.

Another type of interpretation (α, β) associates the description of an object with its external evocations (cf. Fig. 3 in Ref. 1 for clarification of use of α and β). Gips and Stiny do not provide an example but they do say that evocations may include 'associations, emotions and content'. Non-aesthetic material thus still seems to be quite admissible, for instance most scene-analysis systems perform cognitive functions to discover what the image represents, i.e. its 'content' (cf. review of literature in Ref. 3). Pattern recognition is frequently concerned with the 'association' of an object with other objects in the same class. Even emotions need not be a matter of aesthetics.

The next component is the reference decision algorithm consisting of S and C (Fig. 1). This is aesthetically neutral, since for a particular aesthetic system the set of 'works of art' is defined as the output of the algorithm A_i; similarly, the evaluation routine E and the order O are neutral, because they do not influence the output of A_i. Even if the evaluation routine can provide a reliable guide to aesthetic quality, it does not influence the aesthetic or non-aesthetic nature of the material generated by the system. This latter function at present is informally reserved for the human operator.

In Fig. 1, an artist/viewer has been added to the aesthetic system to provide editing and guidance. Notice how his presence completes three loops. In one he views the displayed picture and takes action to modify the specification that generated it. In the second closed loop, he observes the computer's prediction of his own response and attempts to improve the accuracy of this by modifying algorithm A_e. In the third loop, he supplies an object and for the question 'is it a work of art according to the algorithm A_i?' he gets a reply 'true' or 'false' (T or F).

Gips and Stiny quoted Knuth as saying that a person does not really understand something until he teaches it to a computer, i.e. expresses it as an algorithm. That they use a human being to ensure the aesthetic content of their system is probably a sign that they do not really understand the aesthetic. They are not alone. No computer systems existing at present can be said to understand aesthetics or even the aesthetic aspects of some narrow range of visual material.

I have proposed [4] that a system should be knowledgeable as to the intentions of the artist, where being

*Operations researcher, 7 Leibovitz Road, Gedera, Israel.
(Received 31 December 1974.)

Fig. 1. *Aesthetic system completed by inclusion of an artist and/or viewers.*

'knowledgeable' means that the system can use information stored in it to take appropriate courses of action. The test of such a system would be its ability to generate visual material conforming to the intentions of the artist. Of course the artist would expect to get this output without having to provide any geometrical or statistical description of the output. Indeed, he would provide a request to the computer in terms of the visual qualities and visual images he wished to see in the output.

The sources of such knowledge are: (1) psycho-physical experimentation and (2) the building of visual models of a subjective nature. The first of these refers to the methods of the science of perception (see, for instance, Galanter, Ref. 5). Hopefully, there may be a similar science of aesthetics in the future, although at present neither the results of perception studies nor of scientific aesthetics can help us much in the formulation of knowledge-based computer systems for aesthetics. This is because development of these sciences is still at an early stage, with perception studies mainly concerned with very simple stimuli and aesthetic studies mainly concerned with measures of information content. Consider, for instance, how little our understanding has progressed beyond the 1935 formulation of the Gestalt laws.

The second source of such knowledge is nearer to artistic activity in spirit. Artists or their collaborators may build an exactly defined model of at least a part of their subjective responses to some visual phenomena (cf. Ref. 6, for an example). The model is not considered to be an analogy to the way human minds work but rather is intended to enhance the ability to manipulate visual material in a controlled manner. In essence, one takes the behaviour of the digital computer, programmed with such knowledge, as the guide to the validity of a model. Much of 'artificial intelligence' research uses this approach.

2. Perceptive picture generation

Gips and Stiny [1] have provided a well defined procedure for the generation of paintings. The method uses a generative specification that is attractive in its simplicity and clarity and that may well provide a basis for considerable generalization and development. In what follows, I suggest some prerequisites to such development.

It is possible to maintain a close visual relationship between the shapes in a generative grammar and its pictorial output by keeping to shape grammars with only a few terminal shapes exhibiting strong visual features and to a few simple shape rules. This avoids the problem of introducing into the algorithm logic to control the application of shapes rules in order to guide it towards a picture with specific perceptual or semantic features.

In addition to keeping to a few simple shapes with strong visual characteristics, Gips and Stiny introduce into their grammar, rules that cannot be regarded as 'grammatical' in a fundamental sense. It will be shown below that these rules are akin to group-theoretic rules.

It is difficult to define exactly what is 'grammatical' about the rules of grammar but a necessary feature is that they must allow for easy local substitution. For instance, having written a sentence, it is a remarkable fact that one can go back to it and make considerable changes to the beginning of it without much affecting the rest [7]. Indeed, for any noun we can usually

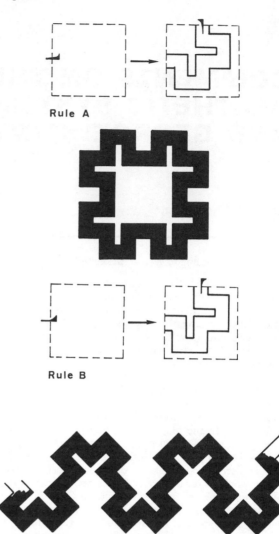

Fig. 2. Group-theoretic generation similar to the 'Urform' series of pictures.

substitute an adjective plus a noun without further changes. Satosi Watanabe writes [8]: 'If a grammatical rule becomes so strongly context dependent that any local modification of a sentence propagates to the entire sentence, it will cease to be a grammatical rule'.

Now, a characteristic of the shape rules already published [1, 9] is that they tend to extend themselves by repeated application of a few or maybe even a single rule in a manner analogous to crystal growth. The visual rules that I have proposed [4] are similar in this respect. In such situations a change may propagate itself rather than remain localized.

The shape rules in the published literature so far are not suited for easy replacement of a shape in an otherwise completed picture with some similar but otherwise preferable shape. This is a very natural way of working for painters using oils or sculptors working in clay, for it leaves artists free to change any part of a work as they wish. A system that is not well suited for 're-writing' a part of a text or of a picture can hardly be termed 'grammatical'. In this respect, the picture language of Shaw [10] is certainly grammatical. Unfortunately, the visual material generated by Shaw's language is not visually interesting and one still awaits a truly grammatical generative specification for aesthetically interesting pictures.

The shape rules used by Gips and Stiny are akin to

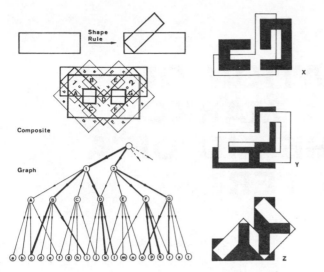

Fig. 3. *A flexible scheme for generating pictures similar to 'Anamorphism'.*

group-theoretic rules (see March and Steadman [11] for an introduction to groups with examples from architecture). As an example, two rules similar to those used by Stiny to produce the 'Urform' series of paintings are shown in Fig. 3 (cf. Ref. 4, p. 229 for a reproduction of these paintings). Applications of Rule A constitute a point group and applications of Rule B produce an infinite frieze pattern.

The necessary conditions for a group are somewhat limiting for artists and Gips and Stiny have seen fit to break some of the four necessary conditions (closure, association, identity and inverse). In particular, their paintings, along with snails and rams' horns, break the law of closure by having arbitrary initial conditions and halting rules. The law of inverse can also be broken by the rules that remove markers. Since information on their position is lost on removal, one will not know which form of the rule to apply in the inverse.

It is interesting to note that shape rules often have smaller markers on the right than those on the left, so that repeated application causes shapes to become smaller and smaller. This keeps the generated shapes within a finite domain, whilst allowing for more interesting results than point symmetry could provide. It also allows for the introduction of visual proportion.

Let us now consider a change of emphasis that will introduce a more 'grammatical' approach. A less constrained shape rule for the 'Anamorphism' series [1] is presented in this Note on the left of Fig. 3. On the right is shown a composite shape that can be generated by this shape rule. The letters and numbers on the composite on the left correspond to those on the directed graph directly below it. In the graph, each arrow represents an application of the shape rule that adds a new shape represented by the letter or number in the node to which it points. The graph, therefore, represents the generation of the composite. The heavy arrows in the graph correspond to the generation of 'Anamorphism I'. Little syntax is involved and, to get a picture, one merely has to select a directed sub-tree of the graph.

The syntax here constrains one little more than the constraints of physical possibility constrain an artist. The approach is more grammatical in that local changes can be made without altering the whole picture.

Freedom has its cost and the main problem now is one of choice. Random selection avoids the issue, as does the use of inflexible shape rules that uniquely determine the final outcome. It is relevant to ask how do artists make such selections. How did I choose pictures X, Y and Z in Fig. 3? Certainly neither at random nor through intuition alone but also through reasoning and judgement used in synthesizing the designs. An algorithm that would contribute to an understanding of such reasoning would have to deal with semantics. Symmetry, balance, illusions of depth and contrasting shapes are all full of meaning for artists, even when they represent nothing.

References

1. J. Gips and G. Stiny, An Investigation of Algorithmic Aesthetics, *Leonardo* **8**, 213 (1975).
2. N. Goodman, *Languages of Art: An Approach to the Theory of Symbols* (London: Oxford University Press, 1969).
3. A. Rozenfeld, Survey of Picture Processing 1973, in *Computer Graphics & Image Processing* **3**, 178 (1974).
4. M. Thompson, Intelligent Computers and Visual Artists, *Leonardo* **7**, 227 (1974).
5. E. H. Galenter, Contemporary Psychophysics, in *New Directions in Psychology* (New York: Holt, Rinehart and Winston, 1962).
6. M. Thompson, Computer Art: A Visual Model for the Modular Pictures of Manuel Barbadillo, *Leonardo* **5**, 219 (1972).
7. T. Winograd, *Understanding Natural Language* (Edinburgh: Edinburgh University Press, 1972).
8. S. Watanabe, Ungrammatical Grammar in Pattern Recognition, *Pattern Recognition* **3**, 385 (1971).
9. G. Stiny and J. Gips, Shape Grammars and Generative Specification of Painting and Sculpture, Paper presented at IFIP Congress Ljubljana (August 1971).
10. A.C. Shaw, Parsing of Graph-Representable Pictures, *J. Amer. Assoc. for Computing Machinery* **17**, (3), 453 (July 1970).
11. L. March and P. Steadman, *The Geometry of Environment* (London: RIBA Publications, 1971).

ON THE SIMULATION OF AN ART WORK BY A MARKOV CHAIN WITH THE AID OF A DIGITAL COMPUTER

Yves Kodratoff*

Abstract—*The author discusses mathematical analysis of works in the plastic arts by a Markov chain within the frame of the Monte Carlo method. The two procedures are discussed with particular references to their interrelations and their use in attempting to analyze artistic creativity with the aid of computers. He demonstrates that the two procedures can be applied together. Illustrations of several art works that were made in this way are presented.*

I. INTRODUCTION

It is common practice in the physical sciences to specify with care those processes that are *deterministic* and those that are *stochastic* [1, 2], that is, dependent on chance. In the first process, a chain of events or states occurs such that a knowledge of all the links before time T permits the determination of the event or state at time T. In the second process, a knowledge of the history of the chain of events permits the determination of only the probability for the occurrence of an event from among various possible events at time T. It should be pointed out that the number of phenomena, even of those that are extremely complex, that can be described by a deterministic process is very large. Thus it seems unwise to reject without a thorough examination the deterministic approach in the realm of the plastic arts. A number of efforts have been made to specify the aesthetic factors possessed by a 'cultivated' person for use in responding to an art work by data in the form of a simple arrangement of these factors [3]. A choice of factors can then be made to purposefully influence a specific outcome. But when there is a lack of the necessary information for one to select the factors with certainty, a stochastic series may be suitable for determining the probability of obtaining a desired result at time T that is far greater than the occurrence of other undesired results. My aim was to utilize available powerful stochastic methods that enable one to use computers in the attempt to analyze artistic creativity.

Principally two methods are used by physicists at the present time to deal with stochastic processes. The first is based on the *theory of Markov chains* and the second one is a 'crude' technique relying on the *Monte Carlo method* [4]. Before these methods are discussed and analyzed, it should be pointed out that in the present text the quantitative descriptions of the aesthetic factors of an art work (that is, the events of the series) are assumed to have been established. If it is assumed that it is possible to store in the memory of a computer aesthetic notions of form and of color and, especially to modify them within the computer memory bank, one should obtain results that are not trivial. I plan to publish the results of work obtained on these possibilities in a forthcoming article.

II. MARKOV CHAINS

For the Markov chain method it is not knowledge of the whole history of a process that determines the probability of various states occurring at time T but simply knowledge of the state of the process at time $T-1$. Thus, in an *irreducible chain* each state of the system E_i is related to all the other states E_k by a probability p_{jk} such that, E_i being the state of the process at time $T-1$, E_k is the state of the process at time T.

Events or states are very well defined in studies of physical phenomena. The notion of state is usually rather poorly defined in the plastic arts, however there is a large number of ways of analyzing a painting, each leading to different E_i's. Let it be assumed that a more precise method is followed. The picture is cut up in squares that are so small that each one is colored by a single hue. Their number is

*Computer scientist, Institut de Programmation, Université de Paris VI—U.E.R. 110, Tour 55–65, 4 Place Jussieu, 75005 Paris, France. (Received 6 May 1972.) (Original in French.)

very large, perhaps, but not infinite. One can then proceed with the analysis as in the general urn model equivalent to each Markov chain [5]. At position k on the picture, the probability of having color i is p_{ik}. Thus, here a factor is a choice of color. For the initial state, a position of the color is selected in accordance with an initial probability distribution. At this position, a color is selected at random. If the color is the jth, then one proceeds to position j and the process is repeated. When all of the places are occupied, the process is completed.

One can use another procedure in the analysis, which is a more classical one. It is to consider the sequence of positions of colors as implicit and to relate each hue E_i to the adjoining one E_k by a conditional probability p_{ik}. This procedure has been used very often by linguists, for in languages (contrary to the plastic arts) order is evident. A third procedure is to reduce the problem to one of card shuffling by defining a state as a random distribution of little squares. Each operation leading to a modification of this distribution can occur with a probability p_{ij}. If the picture is cut up into N little squares, then there are $N!$ (that is, $N(N-1)(N-2) \ldots (1)$) possible states [5], which at first seems enormous. Since the shuffling of cards leads to a random distribution, any particular distribution can occur and, if sufficient time is taken, all possible states or distributions become equally probable. Conversely, if only one kind of shuffling is permitted, then one obtains a periodic chain. Since it is desirable to avoid these two possibilities in the process (making of a painting), it is necessary to investigate the permitted modifications. In the case where their number is not too great, the Markov matrix of dimension $N!$ should be reducible and it should be possible to study it with the aid of a computer.

One can conclude that, even in a particularly simple case, the number of possible solutions is rather large. This means that it is illusory to hope to present, *a priori*, a general method permitting analysis of a work of art as a Markov chain. For this reason a program of study was proposed along the following lines.

1. Investigate various analyses that can be handled on a computer, i.e. the various Markov chains susceptible to solution.
2. Program these and produce series of sample results for each one.
3. Have an artist select one from among the series of sample results.
4. Program the Markov chain corresponding to the selected series and vary the conditional probabilities.
5. Determine with the aid of the artist the conditional probabilities desired for a type of work.

The above procedure may seem very complicated but one must not forget that finally there will be two valuable results. First, the possibility of generating an infinite number of works starting from the same idea but all different in appearance. Second, an analysis by the artist himself of his work in the process of executing it. The problem is whether an individual artist will accept this chore and 'play the game'. Work of this nature is being carried out by the author and the painter Vera Molnar.

III. NON-MARKOVIAN CHAINS

It is certain that the state of a chain representing an art work is not adequate for the determination of the probability of succeeding states because the Markovian hypothesis is no more than a useful simplification. There are, in fact, numerous types of chains that permit a study of the limiting state of a chain without resorting to Markov's theory.

As an example of this type of solution, one can start again with a picture cut up into N little pieces. A second process (which can describe a picture, a piece of music or the growth of a polymer) of N steps is introduced. If the second chain is in the order $61, 4, 3, \ldots, N, \ldots$ and the first element of the first chain is put into the place occupied by 61, the second at the place occupied by 4, etc., the order of the second chain determines that of the first. If the second is a Markov chain, it can be shown that the first is a non-Markovian stochastic process [2]. With a step-by-step approach, it is not difficult to generalize this process so that rather remote effects can be treated.

Another example is that of *chaînes à liaisons complètes* (completely linked chains), which 'depend little on the states of the path obtained after following very much earlier events and, in the limit, no longer depend on them at all, if the events occurred infinitely earlier' [6].

IV. THE MONTE CARLO METHOD

When the Monte Carlo method is utilized, the process under study is again put into the form of a chain of successive events or states. Instead of being linked one to another by a probability of transition, the states are equally probable, *a priori*, as in a Markov chain whose stochastic matrix would be constant. To achieve a particular process, it is acceptable to prohibit certain operations by means of a rule linking the states. To illustrate this kind of rule, one can take the example of a random walk in two-dimensional space in rectangular coordinates. The state of the system is given by the coordinates x and y (integer variables) of the particle being moved. It is assumed that the only transitions permitted are between (x, y) and $(x + 1, y)$ or $(x, y + 1)$ or $(x - 1, y)$ or $(x, y - 1)$. At each instant there are only four possibilities for making the chain progress and all have the same probability. Since the nth state depends only on the $(n - 1)$th state, the chain is a Markov chain. It is easy to alter this model to simulate a random walk responding to certain criteria. For example, one can forbid the particle to touch four points in a straight line. Then, at each step one must determine whether x or y was held constant during the three previous steps. If so, the fourth step is eliminated and a new start is made as

the first step. This process is repeated until the imposed condition is fulfilled. It quickly becomes obvious that there are numerous other ways (and certainly some very clever ones) for avoiding having four points in a straight line. But the Monte Carlo method, in spite of its simplicity, has demonstrated its strength in physical science applications. It utilizes explicitly the calculating power of the computer, which one must not overlook if one harbors some doubt.

To choose anything at random, it is necessary to have tables of random numbers. Since these numbers were calculated by a computer, it is quite clear that they are only pseudo-random. There is some discussion about the definition of these numbers. They have been described as 'a vague notion embodying the idea of a sequence in which each term is unpredictable to the uninitiated and whose digits pass a certain number of tests traditional with statisticians and depending somewhat upon the use to which the sequence is to be put' [7]. From the fact that the sequence of pseudo-random numbers is to serve to stimulate a random behavior within specified limits, it should be required that their digits pass a certain number of tests of non-correlation of such a kind that the only correlations existing in the process be those that have been expressly imposed. On the other hand, nothing requires that the method applied be limited narrowly to the one described. For example, in the case of the random walk not leading to four points in a straight line, the Markov matrix can be different from unity. The resulting chain is non-Markovian but the procedure can be useful for simulating a backward step during the act of creation.

V. ILLUSTRATIONS

Figures 1–8 were obtained starting with Markov chains having a constant matrix (that is, using the Monte Carlo method). Thus they illustrate only this aspect of the general method discussed where there is a minimal participation by an artist.

In Figure 1 the number of straight portions is 100 and their maximum length is 3·5 cm; in Fig. 2 the number is 200 and the maximum length 5·5 cm; in

Fig. 2. Untitled, ink drawing on paper (Benson drawing table), 30 × 30 cm, 1971.

Fig. 1. Untitled, ink drawing on paper (Benson drawing table), 30 × 30 cm, 1971.

Fig. 3. 'Hommage à Vera Molnar, I,' ink drawing on paper (Benson drawing table), 30 × 30 cm, 1971.

Fig. 4. '*Hommage à Vera Molnar, II*', *ink drawing on paper* (*Benson drawing table*), 30 × 30 cm, 1971.

Fig. 7. '*Zlatka*' *by Ludmila Kodratoff, oil on canvas*, 55 × 46 cm, 1971.

portion is given in descending order for discs from left to right and from top to bottom. In Fig. 7, discs and rectangles are presented at random in succession at regularly spaced center points. The dimensions of the discs and rectangles were determined randomly between 0 and a maximum value.

Figure 8 shows flat forms placed along a vertical rod. Each form results from a program simulating

Figs. 3 and 4 small rods are positioned in a regular order but with random direction. Figure 3, having a length to spacing ratio of one, is considered less satisfactory by Vera Molnar than Fig. 4 where the ratio is 6.

Fig. 5 (colour illus. B, p. 304 shows colored squares arranged at random. The constraints arise from the number of colors chosen and from the size of a square relative to the whole picture. In Fig. 6 the centers of the discs are spaced at regular intervals but their radii were determined randomly between zero and a maximum value (constraint). Their colors were also determined randomly. Where discs overlap, priority for showing an overlapping

Fig. 6. '*Grands Ronds*' *by Ludmila Kodratoff, oil on canvas*, 82 × 65 cm, 1971.

Fig. 8. '*Des informes connues, I*' *by Yves Kodratoff, aluminum*, 45 × 20 × 20 cm, 1972.

a pseudo-random walk in two-dimensional space (rectangular coordinates). The walk is biased (a constraint) such that it will pass through certain points in the grid. These points (60% of the total points in the grid) had been selected randomly in advance. Each form is a haphazard shape that differs from the others only by the series of random numbers that had generated it. All have a common point of departure marked by the vertical rod that connects them.

VI. CONCLUSIONS

In contrast to psychologists who seek to study the responses of a viewer to an art work, my idea is to construct a mathematical procedure permitting one to study the creative process of the artist. One of the more evident aims is to study the economic (based on the price of intelligence) production of different types of art work. Another more profound aim is to obtain a better understanding of the creative process and to find how to apply such knowledge to permit computers to aid artists.

REFERENCES

1. F. L. Whipple, Stochastic Painting, *Leonardo* **1**, 81 (1968).

2. W. Feller, *An Introduction to Probability Theory and Its Applications*, Vol. 1, 3rd. ed. (New York: John Wiley, 1968).

3. Michael Thompson, Computer Art: A Visual Model for the Modular Pictures of Manuel Barbadillo, *Leonardo* **5**, 219 (1972).

4. A. S. Householder, *Monte Carlo Method*, Applied Math. Series 12 (Washington, D.C.: Superintendent of Documents, 1951).

5. J. Kemeny and J. L. Snell, *Finite Markov Chains* (Princeton: Van Nostrand, 1960).

6. W. Doeblin and R. Fortet, *Bull. Soc. Math.* **65**, 132 (1937).

7. D. H. Lehmer, *Harvard Uni. Computer Lab. Ann.* **26**, 141 (1951).

COMPUTER ART: A VISUAL MODEL FOR THE MODULAR PICTURES OF MANUEL BARBADILLO

Michael Thompson*

Abstract—*From 1964 to 1968, Manuel Barbadillo based many of his pictures on a single black and white square module. Sixteen different forms (structural elements) can be generated from this module by rotation, mirror image and by interchanging black and white. Any of these structural elements can be used in each position of a 4 × 4 grid to construct a picture.*

Areas of the same colour in adjacent structural elements coalesce and lead the eye freely about the picture. In addition to this aspect of the picture, the artist used strong symmetry, which gives 'liveliness' to it. The ideas involved are very vague and the main purpose of this paper is to demonstrate how to render them amenable to computer programming.

Firstly, the author subjectively distinguishes 'tracking' movement and 'skipping' movement of the eyes and describes them in detail. Next, these concepts are 'temporarily closed' by definitions. These definitions define a subjective visual model but cannot define the real visual qualities of Barbadillo's pictures. They permit numerical analysis. Eight test pictures of 2 × 2 elements are presented with numerical results that seem plausible. It is hoped that the incorporation of this subjective visual model into a computer programme may enable the generation of pictures controlled by automatic processes of selectivity.

I. STRUCTURAL ELEMENTS

Computers are sometimes used in art to aid in arranging compositions made up of the repeated use of one or more modules [1–4]. The modules used in this manner by the Spanish artist Manuel Barbadillo are shown in Fig. 1. A typical example of his pictures is given in Fig. 2. Modules (a) and (b) in Fig. 1 appear most often in his works; each may be presented in sixteen different ways given by *rotation, mirror image* and *interchange of black and white*. I refer to each of these sixteen ways as a *structural element*. The painting shown in Fig. 2 is a 4 × 4 grid made up of 16 structural elements of eight different kinds.

Barbadillo has noted the following characteristics of pictures made from an array of structural elements:

a. The number of pictures that one can produce from a few structural elements is enormous but, comparatively, the number that is pleasing is very small.

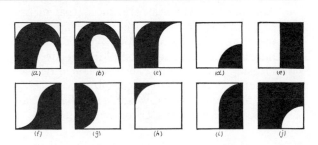

Fig. 1. *Modules employed in pictures by Manuel Barbadillo.*

b. When colours match along the common edge of two structural elements, new forms are produced. The fusing of forms into extended black and white areas sometimes leads to a feeling of a white form on a black background or *vice versa*.

c. A group of, say, 2 × 2 structural elements can be used as one element. In Fig. 2, the top left-hand quadrant may be regarded as a *structural group* that generated: the bottom left-hand quadrant by *repetition*; the top-right-hand quadrant by *point reflection* about the point in

*Operations researcher, 7 Leibovitz Road, Gedera, Israel.
(Received 21 July 1971.)

Fig. 2. *Manuel Barbadillo, 'Modular painting, 1966',
acrylic paint on four equal canvasses, 81 × 81 cm, mounted
together to give total size of 162 × 162 cm.*

the centre of the common boundary between
the two quadrants; and the bottom right-hand
quadrant by a point reflection about the centre
point of the picture. In addition, the top right-
hand quadrant may be regarded as being
subject to a point reflection about the centre
of the picture, so as to generate the bottom
left-hand quadrant.

d. The proper joining of edges of structural
 elements is critical and often extremely
 difficult. (I have written a computer pro-
 gramme for performing edge matching [5].)

e. The angle at which a form meets that of an
 adjoining structural element may be important
 in giving a feeling of rhythm. Poor matching
 may often be used to accomplish this effect.

f. Pleasing relationships can be obtained by the
 use of repetition, point reflection, mirror image,
 rotation and colour reversal. These have been
 utilized in computer art programmes [6,7].

II. SUBJECTIVE DECISIONS AND THE COMPUTER

Most artists who use computers for graphic
works make the decisions on subjective concepts
themselves, consciously or subconsciously, and then
use the computer as an aid in generating the final
pictures. My interests are rather different. I wish
to learn how to incorporate in computer pro-
grammes a capacity for making some of the sub-
jective decisions. The difficulty one faces is that
subjective concepts are usually described in terms
of *open concepts* [8] and, therefore, there is a lack
of sufficient and necessary definitions for them. The
mathematics in a computer programme is necessarily

precisely defined and, consequently, capable of
treating *closed concepts* only.

Typical open concepts that concern artists when
making graphic works are: *depth cue, form, 'move-
ment', 'tension', sensation of saturation* and *balance.*
In order to incorporate such notions in computer
programmes, it is proposed to specify a *subjective
visual model* in which the definitions of subjective
concepts are 'temporarily closed'. Such a model will
incorporate some of the viewer's subjective notions
as to what happens when he, personally, views the
picture. Naturally, he cannot *know* the physiological
processes taking place within him but, as to his
appreciation of the picture, his notions on what he
experiences are relevant. If some of these subjective
notions can be described (approximated) in a
'temporarily closed' manner, then they are amenable
to computer programming. A computer programme
incorporating a model of these concepts should be
able to generate pictures that will give rise to those
very experiences that have been 'modelled'.

III. THE SUBJECTIVE VISUAL MODEL

The eye movements of a viewer are, more or less,
dictated by a picture. The stimuli of the picture
channel the eyes along fairly well defined paths and,
although they can visit any part of the picture
surface, the most important paths can be identified
and represented graphically. Numerous tests of the
eye movements of picture viewers have been carried
out and reported in the literature of experimental
psychology [9, 10].

To utilize a digital computer, it is necessary to
restate a problem in terms of numbers. How can one
represent with only a few numbers the path followed
by a swiftly moving eye? I used a *network*, a simple
example of which is shown in Fig. 3. The numbered
circles are called *nodes*. The viewer's attention is
supposed to move between these nodes along the
arcs. This network does not explain why the
viewer's attention does this, e.g. why it travels
between nodes 2 and 3 but not nodes 2 and 5. The

Fig. 3. *An example of a network.*

Fig. 4. Module represented by four nodes and two arcs (cf. Fig. 1 (b)).

network merely states that this is what happens. It represents a closed definition of the situation and, although the definition may be changed at will, it provides the kind of precise material that a computer can handle.

The next questions to answer are: where on a picture surface do we put the nodes and how do we decide which pair of nodes involve an eye movement? Well, this is art, not science; I put them just where I liked. I did not engage 'twelve naive observers' for statistical testing with questionnaires but used rather my intuition backed by a great deal of study of modular compositions with my own eyes. I have found that most modules can be represented easily by about six nodes and around a dozen arcs but, in this paper, I have chosen a module that can quite usefully be represented by only four nodes and two arcs. How this is done is shown in Fig. 4.

I shall now describe the more obvious types of eye movement that I call *tracking* and present a very simple model for eventual computer application. The reader may discover that an important type of eye movement is omitted. This type, which I call *skipping*, will be described later in conjunction with another simple model.

IV. THE PHENOMENON OF TRACKING

Tracking is experienced when the eyes seem to be guided by elements of the picture. It appears to be a continuous smooth movement but studies [9, 10] have shown the opposite. The eyes move in a series of incredibly fast jumps or jerks, called *saccades*, during which they are effectively blind. Between the saccades, the eyes look at particular points on the picture surface, called *fixation points*. Evidently, the images of these points fall upon the most sensitive part of the retina. The saccades are so fast that 95% of the viewing time is spent with the eyes almost

motionless. This means that tracking movement is an illusion. The eyes, in fact, look at a series of points on the picture surface, which are possibly the same as those to which the mind is attending [9].

I consider that a network is a plausible model, for the arcs might represent saccades and the nodes fixation points. In a model for tracking, however, the arcs may be thought of as paths along which I have found my attention tends to move but no information is supplied by them as to the direction of movement of the eyes along them. When direction is not stated, the network is usually termed an *undirected graph* or just *graph* and the arcs are called *edges*. More detailed models use networks in which the direction of movement along the arcs is stated; they are usually termed *directed graphs*. Reference 10 is a simple introduction to networks; reference 12 is more advanced. Applications by Anthony Hill and by Frank Harary of graph theory to art can be found in previous issues of *Leonardo* [13, 14].

V. SUBJECTIVE VISUAL MODEL FOR TRACKING

Here are the main rules for a very simple subjective model to describe the tracking movement, e.g. when looking at a 2×2 modular picture by Barbadillo (Fig. 5(a)–5(h)) built from the module shown in Fig. 1(b):

1. Each structural element is represented by two arcs, one in the lobe, having an *arc value* of 2, and one in the curving area surrounding the lobe, having an arc value of 3 (Fig. 4).
2. One may connect a pair of the nodes in adjacent structural elements with a *connecting arc*. This may be done only if:
 (a) the whole length of the connecting arc lies in the same *colour zone* (i.e. a continuous area of a single colour) and the two ends of the arcs being connected and the connecting arc itself all lie on a smooth line that is nearly straight. Such a connecting arc is given an arc value of 2. (This rule emphasizes continuity in colour and in direction, which encourages tracking.)
 (b) either the whole length of the connecting arc lies in the same colour zone but the two ends of the arcs to be connected are at such angles that the connecting arc must contain a sharp bend—or the connecting arc crosses one or more boundaries between colour zones but the connecting arc and the arcs to be connected do lie on a smooth line that is nearly straight. In either of these two cases, the connecting arc is given an arc value of 1. No other connection may be made.
3. When all permitted connecting arcs have been put into the picture, we have one or more *connected networks*. Each connected network is given a score obtained by multiplying together all the values of the arcs that comprise

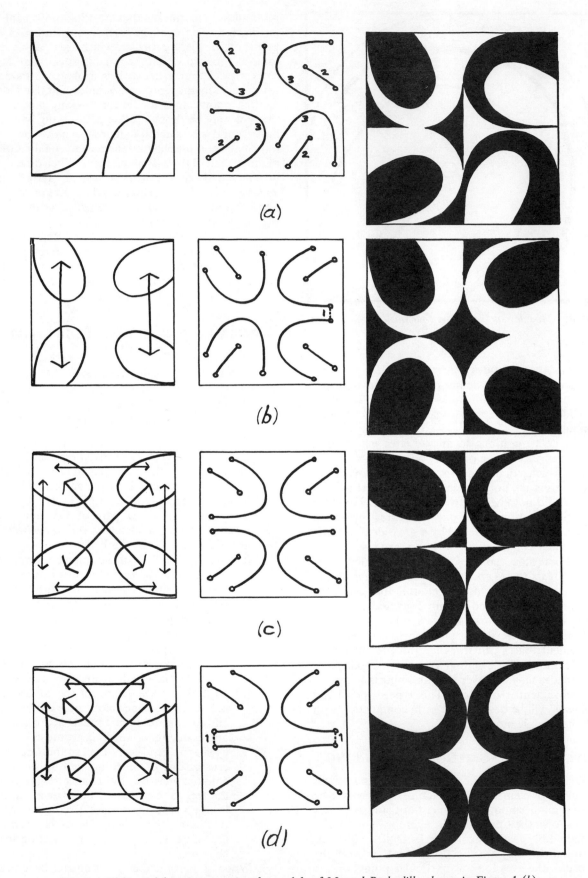

Fig. 5. *Eight modular pictures using the module of Manuel Barbadillo shown in Figure 1 (b).
For each of them is shown a diagrammatic analysis of tracking (centre) and of skipping (on the
left). (Fig. 5(e) to 5(h) on opposite page.)*

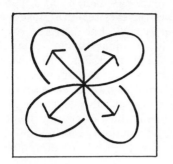
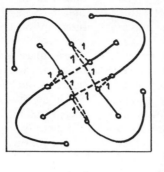

(e)

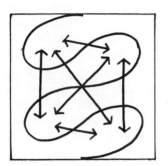

(f)

(g)

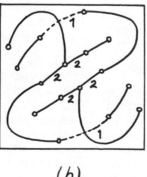
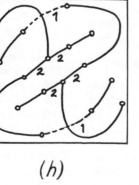

(h)

Fig. 5(e)–5(h)

it. An arc value of 1 contributes nothing to the product, yet it may link other arcs of value greater than one, which will themselves contribute. This is the reason why I have assigned a value of 1 to the arcs that represent parts of a picture that do not stimulate movement but link features that do stimulate. Where there are no arcs, arcs having an arc value of zero can be shown for the purposes of programming. The scores obtained from each connected network are added together to give a score for the whole picture. It is proposed that this score represents the content of tracking movement in the picture. This rule provides for the interdependence of different arcs along a single tracking route.

These rules are almost closed, therefore, a computer application may be possible. However, as they stand, it is not feasible to specify a computer programme to compute tracking scores without further definition. Clearly, 'nearly straight line' needs to be defined better. However, I was able to calculate 'by hand' the tracking scores in Table 1 for Figure 5(a)–5(h).

TABLE 1. TRACKING SCORES (cf. Fig. 5(a)–5(h)).

| Figure number | For each type of *connected network* | | | | Total for picture |
	Structure	Value	Frequency	Total	
5a	3	3	4	12	
	2	2	4	8	20
5b	3	3	2	6	
	2	2	4	8	
	3, 1, 3	9	1	9	23
5c	3	3	4	12	
	2	2	4	8	20
5d	2	2	4	8	
	3, 1, 3	9	2	18	26
5e	3, 1, 2, 1, 3, 1, 2, 1, 3, 1, 2, 1, 3, 1, 2, 1	1296	1	1296	1296
5f	2, 2, 3, 2, 2, 2, 3	288	2	576	576
5g	3, 1, 3, 2, 2	36	2	72	
	2	2	2	4	76
5h	3, 2, 2, 2, 3, 1, 2	144	2	288	288

VI. THE PHENOMENON OF SKIPPING

Barbadillo often uses the term 'rhythm' in connection with his pictures. For instance, he wrote to me in 1971: 'I very strongly believe rhythm to be the main, the meaningful element of a painting, whether it is an abstract or figurative one.' Tracking movement did not provide a sufficient explanation of this, especially for certain pictures with little tracking movement. To deal with this, I developed the concept of *skipping* movement of the eyes.

Skipping movement is a transference of the observer's attention from one part of the picture to another. Subjectively, the process seems to be that the shape of a part of a coloured area is perceived and held in the observer's memory as a 'perceived object'. Sometimes the eyes seem to move without interruption in a straight line between two such 'perceived objects' for purposes of comparison. These lines are sketched in Fig. 5(a)–5(h) in the diagrammatic representation of skipping movement, which is the left-hand diagram of each set of three. Skipping movement is possibly a search for symmetry that will enable the viewer by perception to more easily store information in his mind.

The following pairs or classes invite skipping:

1. Repeated coloured areas.
2. A coloured area and its mirror image.
3. A coloured area and its point reflection.
4. A coloured area and a second coloured area that looks similar to but not exactly like the repetition or the mirror image or the point reflection of the first one.

It should be noted that the first three pairs are geometrically identified. The simple subjective visual model presented below in Part VII omits class 4 but classes 1, 2 and 3 are assigned numerical values that are chosen to conform to the writer's subjective judgments.

The reason for omitting class 4 from the model at this stage is that the definitions involved are very difficult to close. Consider, for instance, Fig. 5(a). It has no geometric symmetry but it is visually sufficiently symmetric for the viewer to want to try to understand it. The viewer attempts to simplify the picture by establishing symmetry. This accounts for most of the eye movements. I do not include this predominantly conscious searching in the class of skipping movements.

Skipping movements are enhanced by the following features:

1. Areas of the same colour.
2. Coloured areas emphasized by strong tracking.
3. Coloured areas isolated by the picture edge.
4. Coloured areas lying on the diagonals of the picture.
5. The line of skipping being vertical in the picture plane.
6. The axes of the coloured areas lying on the line of skipping.

Only the first three enhancing features in the above list are included in the simple model. The reason for this is merely that the other three became clear to me whilst I was carrying out studies on the model and I do not yet know how to incorporate them. Another reason is that simple calculations can be made without a computer. A more complex model would introduce much more difficult calculations, necessitating computer use.

As with the model for tracking, I have not fully closed the definitions for skipping. The enhancing feature, 'coloured areas emphasized by strong tracking', is particularly difficult to treat. We could say, for instance, referring to the tracking model, that if a certain score is exceeded, then tracking is

'strong' and we presume that skipping has been enhanced. This problem has been ignored for the present and I have made the decisions intuitively.

The numerical values for skipping are added, not multiplied. I consider that each instance of skipping is independent of the others.

VII. SUBJECTIVE VISUAL MODEL FOR SKIPPING

I shall now define a simple subjective visual model that describes the skipping movement, as follows:

1. The skipping takes place between the lobes in pairs of structural elements (Fig. 5(a)–5(h)).
2. The score accorded to each pair of lobes depends partly on the presence of any of the following relationships:
 A. The lobes are mirror images of each other across the common edge of a pair of adjacent structural elements.
 B. The lobes are repetitions of each other.
 C. The lobes are point reflections of each other across the centre of the picture.
 D. The lobes are point reflections of each other across the mid-point of the common edge of the structural elements containing them.

 These are the four basic relationships (Table 2). Their occurrence in the pictures in Fig. 5(a)–5(h) is recorded in Table 3 under the heading 'Relationship: Type'.
3. The score accorded to each pair of lobes depends also on the existence of the following enhancing features (cf. Table 2):
 P. Both lobes are the same colour.
 Q. Both lobes are emphasized by 'strong tracking'.
 R. Both lobes are isolated by the picture edge.

 Their occurrence in the pictures in Fig. 5(a)–5(h) is recorded in Table 3.
4. The values are totalled for each picture.

VIII. RESULTS OF CALCULATIONS

The presentation of results here is superficially similar to a scientific paper in which measurements are published. Here, however, the link between the scores (totals) for tracking and skipping movement (Tables 1 and 3) and the eye movement analysis (Fig. 5(a)–5(h)) are subjective and personal matters. It would be equally possible for a qualified viewer

TABLE 3. SKIPPING SCORES (cf. FIG. 5(a)–5(h)).

Figure number	Type	Enhancing features P	Q	R	Score	Frequency	Total	Total for the picture
5a	None				0	0	0	0
5b	A	Yes	No	Yes	4	2	8	8
5c	A	No	No	Yes	2	4	8	
	C	Yes	No	Yes	5	2	10	18
5d	A	Yes	No	Yes	4	4	16	
	C	Yes	No	Yes	5	2	10	26
5e	C	Yes	Yes	No	5	2	10	10
5f	B	Yes	Yes	No	3	2	6	
	C	No	Yes	No	2	1	2	
	C	No	No	No	0	1	0	
	D	No	Yes	No	1	2	2	10
5g	C	No	No	Yes	2	1	2	
	C	No	Yes	No	2	1	2	4
5h	C	No	Yes	No	2	2	4	4

to rank these pictures in a different order from mine for both tracking content and skipping content but I would hope for some similarity in ranking.

The pictures in Fig. 5(a)–5(d) have very little tracking. I consider that they are arranged in the order of ascending skipping content, starting with a score of zero for 5(a) and ending with a maximum value of 26 for 5(d), which is the highest possible for the model used.

The pictures in Fig. 5(e)–5(h) all have obtained high scores for tracking. Those in Fig. 5(g) and 5(h) have the same scores for skipping. Although 5(h) contains lobes 'isolated' by strong tracking, 5(g) contains a pair of lobes 'isolated' by the edge of the picture. Fig. 5(e) and 5(f) have the same score for skipping, despite their very different structure, point reflections across the centre in 5(e) and repetitions in 5(f). The huge score for tracking obtained for 5(e) (in fact, the highest I have been able here to obtain) arises from every arc in all the structural elements being incorporated into a single connected network. The fact that only connecting arcs of value 1 were used suggests that it might be possible to find a 2×2 specimen of this kind with more tracking.

IX. CONCLUSIONS

Manuel Barbadillo wrote to me in 1971: 'Could you make the program in such a way that the modification of the structure of the initial picture would be made in several steps (according to an

TABLE 2. NUMERICAL VALUES ASSIGNED TO RELATIONSHIPS THAT PRODUCE SKIPPING MOVEMENT (cf. PART VII).

	Sufficient relationships	Value			
A	Mirror image	4	3	2	2
B	Repetition	3	2	1	1
C	Point reflection through centre of picture	5	3	2	0
D	Point reflection through mid-point of common edge	2	1	1	0
	Enhancing features:				
P	Same colours	Yes Yes Yes	Yes No	No No	No
Q	Lobe emphasized by strong tracking	Yes No Yes	No Yes	Yes No	No
R	Lobe isolated by edge	Yes Yes No	No Yes	No Yes	No

ascending scoring table) so that they would show progressive phases in the interconnection of networks? I don't know what criteria for the table could be, but I believe this would be useful because of the process nature of the art research. It could help us to know more about skipping.'

In this paper, I have presented some of the answers to his question. But the difficulties here that face the computer programmer are mainly of an artistic, rather than of a technical nature. For instance, what is meant by the 'ascending scoring table' is not given in terms of completely closed definitions. Thus, the problem cannot yet be handed to a computer programmer. My hope is that my approach will aid the computer artist in the task of closing definitions of subjectively experienced visual phenomena.

I wish to thank Barbadillo, whose many letters have helped me develop these ideas, and Josephina Mena for translating texts from the Centro de Calculo de la Universidad de Madrid. I am much indebted to Peter Struyken for his clear ideas on visual research [4, 15].

REFERENCES

1. M. Barbadillo, (a) El ordenador, Experiencias de un pinter con una herramienta nueva and Materia y Vida, in *Ordenadores en el arte*, ed. E. Garcia Camarero (Centro de Calculo de la Universidad de Madrid, June 1969) pp. 13–23. (b) Above articles in French in *L'ordinateur et la créativité* (Madrid: Centro de Calculo de la Universidad de Madrid, 1970) pp. 50–64.
2. M. Barbadillo, Modules/Structures/Relationships: Ideograms of Universal Rapport, *PAGE 12*, Bulletin of the ComputerArts Society (November 1970).
3. Z. Sýkora and J. Blažek, Computer-aided Multi-element Geometrical Abstract Paintings, *Leonardo* **3**, 409 (1970).
4. P. Struyken, The Problem, *Electronic Music Reports 2* (Utrecht, Holland: Institute of Sonology, Utrecht State Uni., July 1970) p. 53.
5. M. Thompson, Building Pictures with Modules Using Computer Selection, *Computers in Creative Arts* (Manchester, U.K.: National Computer Council, 1970) p. 33.
6. L. C. Soto, Programma de analisis de la obra de M. Barbadillo (in the publication described in Ref. 2).
7. F. Briones, Peintura Modular, *Boletin del Centro de Calculo de la Universidad de Madrid*, 3 (January 1970), trans. into French, Peinture Modulaire in *L'ordinateur et la créativité* (Madrid: Centro de Calculo de la Universidad de Madrid, June 1969) p. 65.
8. M.Weitz, The Role of Theory in Aesthetics, *J. Aesthetics and Art Criticism* **15**, 27 (September 1956). Reprinted in *Philosophy Looks at the Arts*, ed. J. Margolis (New York: Scribners, 1962).
9. A. L. Yarbus, *Eye Movements and Vision* (New York: Plenum, 1967).
10. D. Noton and L. Stark, Scanpaths in Eye Movements during Pattern Perception, *Science*, **171**, 308 (22 January 1971).
11. J. Kemeny *et al.*, *Introduction to Finite Mathematics* (New York: Prentice Hall, 1966).
12. C. Berge, *The Theory of Graphs* (London: Methuen, 1962).
13. A. Hill, Art and Mathesis; Mondrian's Structures, *Leonardo* **1**, 233 (1968).
14. F. Harary, Aesthetic Tree Patterns in Graph Theory, *Leonardo* **4**, 227 (1971).
15. P. Struyken, Manifesto, *P. Struyken*, 1963–1968.

A MATHEMATICAL APPROACH TO NONFIGURATIVE MODULAR PICTURES

Frank Harary*

Michael Thompson's analysis in *Leonardo* [1] of the black and white modular pictures of Manuel Barbadillo [2] has suggested to me a systematic way to construct a nonfigurative composition using the branch of mathematics known as graph theory [3, 4].

Thompson states that 'each Barbadillo module may be presented in sixteen different ways given by *rotation*, *mirror image* and *interchange of black and white*'. Such representations of a square C_4 (cycle of length 4) are known in graph theory [3] as the *symmetries* or *automorphisms* of C_4. The collection of these symmetries is known in the mathematical theory of permutation groups as the *dihedral group* D_4 of degree 4 and order 8. Fig. 1 shows the eight presentations of a square; a total of 16 possibilities result when the black and white colorings of areas within the square are interchanged.

Thompson's graphical representations of Barbadillo's modules show *nodes* ('fixation points') and *lines* or

* Mathematician living at 1015 Olivia ave., Ann Arbor, MI 48104, U.S.A. (Received 21 June 1975.)

arcs ('saccades'), which he describes as follows: 'The eyes move in a series of incredibly fast jumps or jerks, called *saccades*, . . . Between the saccades, the eyes look at particular points on the picture surface, called *fixation points*'. A graphical representation of a module consists of four nodes appearing at the extremities of two lines or arcs. Each pair of arcs are disjoint (mutually exclusive or non-intersecting), with one arc representing the black area and the other arc the white area.

One of Barbadillo's modules is shown with alternate coloring in Fig. 2. The presentation shown in Fig. 2 is represented schematically in Fig. 3f. The arrows shown in Fig. 3 indicate the assumed directions of eye movement when viewing the module in each of its eight possible presentations. In one case the eye follows a curved arc in the curved shape from its narrow portion to its broad portion; in the tongue shape it follows a curved arc from the border to the tongue tip.

Thompson notes the frequent use that Barbadillo makes of 'the term "rhythm" in connection with his pictures'. He adds, 'To deal with this, I developed the

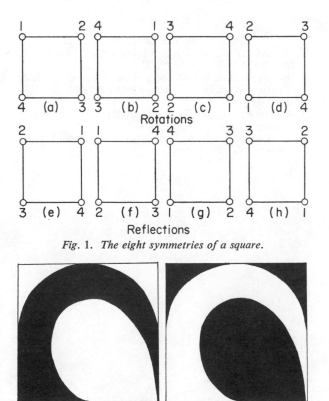

Fig. 1. *The eight symmetries of a square.*

Fig. 3. *The eight representations of the Barbadillo module (following Fig. 1).*

Fig. 2. *A Barbadillo module. Alternate Coloring.*

Fig. 4. *Color-coded directed graphs for Fig. 2.*

117

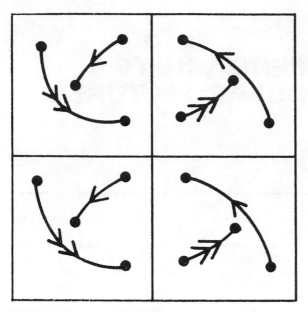

Fig. 5. Color-coded directed graphs for Thompson's Fig. 5f [1].

Fig. 6. Connection of the directed graphs of Fig. 5.

concept of *skipping* movement of the eyes'. From this I was led to the idea of joining the lines of eye movement in the modules comprising a picture to obtain a connected path.

The lines in Fig. 3 can be coded, using one arrow for white and two arrows for black. Thus Fig. 2 can be represented by Fig. 4.

Thompson presents (in his Fig. 5) a series of modular pictures based on the module reproduced here in Fig. 2. Each picture is comprised of four modules having different presentations and sometimes alternate coloring. One of these (his Fig. 5f) is shown graphically here in Fig. 5, following the convention that I used in drawing Fig. 4.

The eye movement for a picture, such as the one represented by Fig. 5, can be specified hypothetically as follows: Whenever the extremity of a curved arc is near one end of a straight arc of the same color (code), they may be joined as shown by the dotted lines in Fig. 6. Also, whenever two curved arcs of the same color are close, they may be joined as shown by the dashed lines. If the connecting arcs of one color are reconstructed as smooth continuous curves, a rather

accurate conceptualization of the 'flow' in the picture's composition may be obtained.

The above idea can be extended for more general application in graphic art. For example, one can start with a chosen disconnected oriented planar graph whose arcs are colored (coded) differently. Then one joins the arcs of the same color that are sufficiently close. The proximity criterion is left to an individual's subjective response but perhaps it is quantifiable, as in the completion perception of Gestalt psychology. The resulting continuous curves are used as guides in constructing areas, which are finally colored.

References

1. M. Thompson, Computer Art: A Visual Model for the Modular Pictures of Manuel Barbadillo, *Leonardo* **5**, 219 (1972).
2. M. Barbadillo, L'Ordinateur et la créativité (Madrid: Centro de Calculo de la Universidad de Madrid, 1970), pp. 50-64.
3. F. Harary, *Graph Theory* (Reading, Mass.: Addison-Wesley, 1969), ch. 14, Groups.
4. F. Harary, Aesthetic Tree Patterns in Graph Theory, *Leonardo* **4**, 227 (1971).

COMPUTER PROGRAM FOR ARTISTS:
ART 1*

Katherine Nash and **Richard H. Williams***

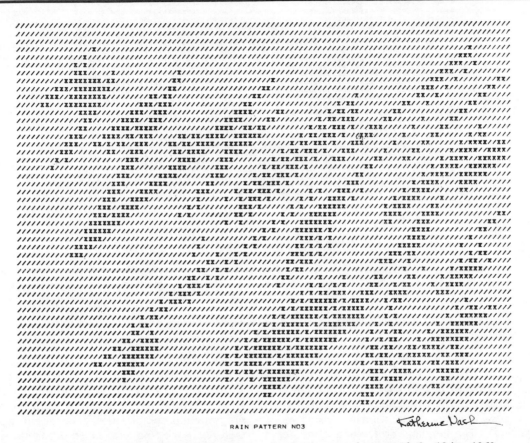

RAIN PATTERN NO3

Fig. 1. 'Rain Pattern, No. 3', digital computer drawing on paper by K. Nash, 9 × 12 in., 1969.

Twenty years of a computerized society make it apparent that twenty years hence no artist can ignore the computer. He will have to adjust to it, cope with it or use it. He cannot reject it. It will influence his creative thinking, as all aspects of society have always influenced the artist. The computer will be another tool for creativity.

There are three ways in which an artist can creatively approach a computer.

1. He can set aside a portion of his time to learn a computer language and then write a program for the making of a work of art.
2. He can collaborate with a computer engineer in the making of a work of art.
3. He can work with a computer that already has

within its memory bank an art language upon which he can draw to make a work of art.

The average artist finds difficulty even contemplating the first. He doesn't want to take his time to be either a mathematician, or an engineer, or a scientist and logic is not always to his liking. But if he is willing to assume the responsibility of learning a language to write a program, there is still the almost insurmountable problem at present of finding a computer that he can afford and a situation that will accommodate him.

Some artists attempt the second solution. An imaginative man (the artist) attempts to verbally describe the requirements to a man of logic (the computer programmer). Too often a compromise results and the artist, in attempting to make a personal statement, finds the statement no longer is personal.

The third alternative has been answered by a program called *ART 1*, which was developed at the Department of Electrical Engineering and Com-

* This note is based on a text published in *Page 7, Bulletin of the Computer Arts Society*, March 1970.

** Artist, Department of Studio Arts, University of Minnesota, Minneapolis, Minnesota 55455, U.S.A.

***Electrical engineer, Dept. of Electrical Engineering and Computer Science, University of New Mexico, Albuquerque, New Mexico 87110, U.S.A. (Received 13 May 1970.)

SPHEROIDS

Fig. 2. *'Spheroids', digital computer drawing on paper by K. Nash, 9 × 12 in., 1969.*

puter Science at the University of New Mexico. It does allow the artist to use his imagination to make a personal statement. It also permits him to gain a nodding acquaintance with the digital computer. *ART 1* results from the collaboration of an artist and an engineer. It is a language stored in a computer memory bank upon which an artist can draw. It is just a beginning. It does not require a computer programmer to hold the artist's hand. It is written to use the simplest and least expensive equipment. It is meant as a bridge between the artist's world and the world of technology. For the artist this language presents a simplified introduction to the computer, as well as presenting new horizons for creativity. This language makes it possible for an artist to work with a computer without a primary need of computer knowledge. The designs are rendered by a high-speed printer controlled by a digital computer which, of course, is controlled by the artist. Examples of designs produced by this technique are shown in Figs. 1 to 3.

The computers presently being used are the following: An IBM 360/40, with an IBM 1403 printer that is capable of printing a line of 120 characters at the rate of 1100 lines per minute (located at the Computer Center of the University of New Mexico, Albuquerque, New Mexico) and a Control Data 6600, with a 501 printer (located at the University of Minnesota, Minneapolis, Minnesota).

ART 1 in all its detail is somewhat involved. It contains approximately 350 separate statements written in FORTRAN IV, a programming language. An artist, however, need not concern himself with programming complexities, since the entire program is stored in the computer's memory bank. The program may be obtained by simply using one card that had been key-punched:

/INCLUDE ART1

ART 1 causes the computer to reserve in its memory two arrays of storage spaces. It is these storage spaces into which the artist will put characters that the printer will ultimately print to make the design. Each array is considered to be a rectangle of 50 rows by 105 columns. Since the printer places the columns closer together than the rows, the proportion of rows to columns produces a printed field of approximately 4 by 5.

The contents of the two arrays are controlled by the artist as described below. When the artist completes his design, he signals the computer and this causes the printer to print the contents of one array over the other. The value range available to the artist by one over-printing of any character over another is significantly greater than that produced by the characters themselves. The value range, however, is not significantly extended by additional overprinting. *ART 1* contains only one overprinting.

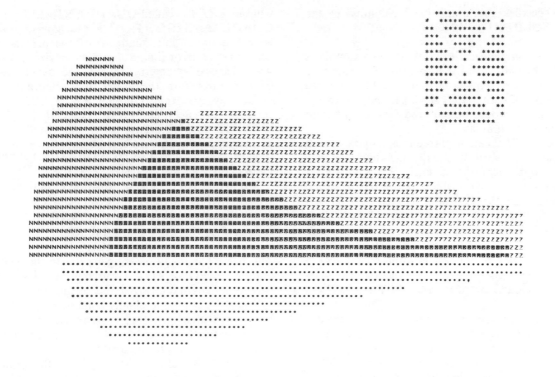

Fig. 3. *'N and Z, No.* 1', *digital computer drawing on paper by R. H. Williams,* 9 × 12 in., 1969.

After the artist obtains the program by the /INCLUDE ART1 statement, he lists several *data cards*. The first data card pertains to *initializing* the arrays in the computer's memory. Much of this initializing involves details that need not be discussed here. Suffice it to say this data card is used to enter the design's title into the computer (see Figs. 1 to 3) and to state how many copies of the design are desired (1 to a maximum of 6 copies).

All data cards, after the initializing data card, begin with 01, 02, 03, . . . or 09. If an artist begins a data card with 02, the computer enters a LINE into one of the arrays. The proportion of the LINE and the location of the LINE in the design's field are specified to the computer by a relatively short code word (14 data card spaces) on the data card, following the 02. The code word also specifies into which of the two arrays the LINE will be entered, as well as which specific character is to be used. Given a starting point in the design's field, the artist can control the LINE's placement horizontally, vertically or in any intermediate direction. One data card is required to place one LINE in one array. However, if the artist desires to repeat at a different location a LINE already specified on a data card, then a labor-saving feature is available. The same LINE may be repeated in a different location by stating a new starting row and column on the same data card, using spaces 21 through 25. A third repeat may be specified in data card spaces 26 through 30 and so

on, to a 10th repeat specified in data card spaces 66 through 70. This same system of repeating a specified shape is available with other shapes in *ART 1* besides LINE. If the data card spaces reserved for repeating figures are left blank, then no repetitions are made. Extensive use was made of the repetition technique in Fig. 1, a design composed of LINE elements. The background of this design was specified on the initializing card; only the superimposed design was made using LINE.

If the artist begins a data card with 03 or 04, the computer is instructed to generate rectangles, 03 specifies SOLID RECTANGLES and 04 specifies OPEN RECTANGLES. As before, the character used to make the rectangle, as well as its location and proportions, are determined by a code word following either the 03 or 04 as the case may be. For example:

03 called SOLID RECTANGLE;

 0 specifies the character (symbol) to be used;

 2 specifies that the character is to be put into second array;

 14 specifies the row of the upper left starting point;

 019 specifies the column of the upper left starting point;

 010 specifies the number of rows in the SOLID RECTANGLE and

0026 specifies the number of columns in the SOLID RECTANGLE.

Thus, the complete code word in this example is 0302140190100026 and it is placed in the first 16 data card spaces. This is all that would be required to place a SOLID RECTANGLE in a drawing. One data card would be required for each different rectangle in each array.

A TRIANGLE can be placed in a design by starting a data card with 05. Again, the character proportion and location of each TRIANGLE is specified by a code word which follows 05. The kind of TRIANGLE that can be generated by *ART 1* is limited. Typical kinds are illustrated in Fig. 3. Each TRIANGLE is an isosceles one and the diagonal edges are limited to slopes of one column by one row. This latter restriction is imposed in *ART 1* because other slopes may present a stairstep appearance, which tends to detract from the TRIANGLE's form.

An ELLIPSE may be specified to the computer by starting a data card with 06. The design in Fig. 2 was made in this way. In addition to specifying the printed character and the location of each ELLIPSE, the code word following 05 determines whether either the vertical axis is longer or the horizontal axis is longer, or whether the two axes are equal, in which case a circle is generated. Figure 2 shows examples of the latter two cases. Here two large ELLIPSES are overlapped and slightly displaced one from the other. A smaller ELLIPSE and a circle of 'blanks' is placed in each of the larger ELLIPSES to make the effect of a hole. This is an example of the use of the 'blank' as a character in its own right.

Data cards beginning with 07 and 09 generate what in *ART 1* is called QUADRANTS LEFT and QUADRANTS RIGHT. 07 takes whatever design is in the upper left quadrant of the arrays and generates a mirror image about the horizontal and vertical axes of symmetry. 09 does the same thing as 07 but starts with the upper right quadrant. An artist may find that QUADRANTS LEFT will produce an effect entirely different than QUADRANTS RIGHT. The reader can visualize this by imagining the drastically different effects on Fig. 3 that would result when QUADRANTS LEFT or QUADRANTS RIGHT was used.

A different kind of shape called EXPONENTIAL is generated by a data card starting with 08 (cf. Fig. 3). The reader may recognize that EXPONENTIAL is defined by the mathematical function

$$y = Ax \exp(Bx).$$

This curve has many pleasing aspects to the second author. EXPONENTIAL is used as an asymmetrical component that an artist may include in a design.

When the computer finally comes to a data card beginning with 01, the design assembled in the arrays is automatically printed by the high-speed printer and the program is terminated.

The reader should note that *ART 1* is the result of a study effort that extended over 18 months. It began in rather simple form when the engineer–author began to work under the aegis of the kinetic sculptor, Charles Mattox. A number of professional artists and art students influenced the program's development. Some of the results of using *ART 1* have already been reported in the literature [1, 2]. The program was given the name *ART 1* not only to signify that there may be an *ART 2* but also to symbolize that fruitful interactions of the arts and technology are legion. There may be, some day, an *ART 1000*.

REFERENCES

1. F. Hammersley, My First Experience with Computer Drawings, *Leonardo* **2**, 407 (1969).
2. J. Hill, My Plexiglas and Light Sculptures, *Leonardo* **3**, 9 (1970).

STATISTICAL SHADING USING DIGITAL COMPUTER PROGRAM *ART2*

Richard H. Williams*

Computer art should look different from other art forms and should display some characteristics of 'computerness'. This premise ought always to be kept in mind by a computer artist as he searches for new ways to express his ideas. An example of the application of the premise and how it led the author to devise statistical shading is described here in connection with *ART1*, a drawing program for a digital computer with an on-line printer [1].

Briefly, *ART1* allows artists to specify shapes made up of characters (letters, numbers and symbols) to be printed with an on-line printer. The shapes are limited to lines, rectangles, ellipses, triangles and a few others; their size and location on

*Electrical engineer, Department of Electrical Engineering and Computer Science, University of New Mexico, Albuquerque, New Mexico 87110, U.S.A. (Received 23 March 1971.)

the drawing are controlled by the artist who key-punches codes on data cards. *ART1* also allows a design to be overprinted *once* on another design. For example, a design made up of one set of characters can be over-printed with another set.

The computer-controlled on-line printer is a rather limited medium for artistic expression when compared to, say, a plotter. However, the number of characters available and the feature of overprinting permits a variety of possibilities to an artist [2,3]. One challenge in the use of *ART1* has been the technique of rendering shaded values.

Initial attempts at shading involved overprinting different characters. The shading values ranged from the white unprinted paper to an O overprinted by an X, which gave the darkest value. The range of values is not very large. Different overprintings produce nearly the same values, for example, an O

Fig. 1. *'Triangle Shading Test' by Katherine Nash, digital computer drawing, program ART2, on paper*, 9 × 12 in., 1969. (Permission given by artist to reproduce the drawing.)

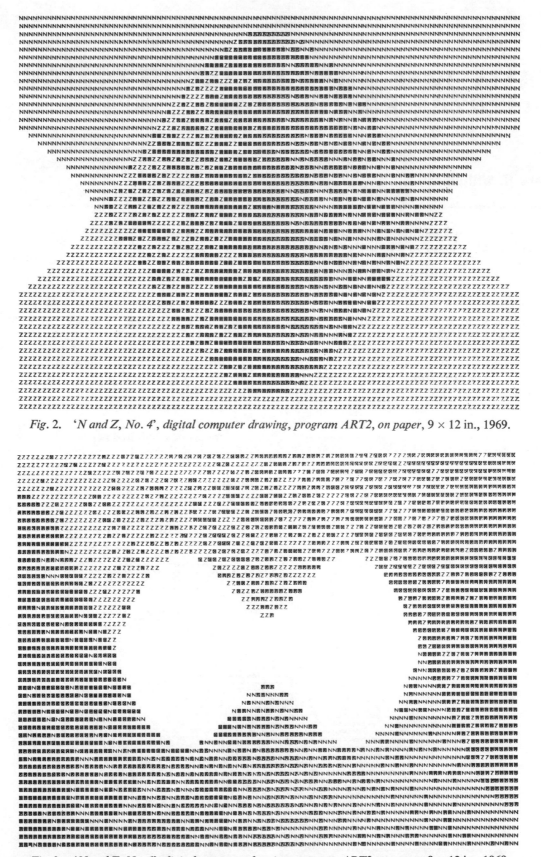

Fig. 2. '*N and Z, No. 4*', *digital computer drawing, program ART2, on paper,* 9 × 12 in., 1969.

Fig. 3. '*N and Z, No. 6*', *digital computer drawing, program ART2, on paper,* 9 × 12 in., 1969.

overprinted by an X and an N overprinted by a Z. Various other techniques of shading were considered, such as using crayons or cutouts of colored paper but these were not employed because they do not conform with the idea of 'computerness'. Finally, the idea of statistical shading occurred to

me and I explain it below but, in order to implement the idea, some drastic changes had to be made to the *ART1* program. The resulting shading program is called *ART2*.

As a demonstration of *ART2*, let us consider an equilateral triangle printed entirely of O's. It is desired to shade this triangle continuously from the lightest value on the right to the darkest on the left. Obviously, no character should overprint the O's at the far right. Also, a symbol such as an asterisk* should overprint all the O's at the far left (cf. Fig. 1). A variety of characters could be used to overprint the columns in between these limits to produce a uniform gradient of values. I, however, decided to use only the asterisk*, overprinting more frequently toward the left.

It would be unduly tedious to determine what characters should be overprinted in each column to achieve a desired gradient. However, the computer can be used to make these choices quickly. Suppose that one decides to characterize the shading by a mathematical function that increases linearly from zero at the left side of the triangle to a value of one at the right. Then, suppose one uses a subroutine that generates a random decimal number between zero and one. At each point in each column the computer is programmed to ask: Is a new random number from the subroutine greater than the linear function at the column in question? The answer to this question is either yes or no. If yes, then the computer can be programmed to command an overprint. If no, then the computer can be programmed to allow no overprint. Thus, at the left side of the triangle the linear function is zero. All random numbers generated are greater than zero, so there is over-printing along the entire left side. At the right side of the triangle, the linear function has the value of one. Every random number generated is less than one, so no character is overprinted. At the column in the middle of the triangle, the linear function is one-half. Statistically, half of the random numbers generated are less than one-half, so that approximately 50 per cent of the characters in the middle column are overprinted—and so on. This example demonstrates the basic principles of statistical shading.

Examples of statistical shading used in more complicated shapes than a triangle are shown in Figs. 2 and 3. In Fig. 2, the basic outline is defined by the mathematical function $(\sin x)/x$. In the overlapping section, the probability of overprinting on the vertical center-line is 100 per cent. The probability of overprinting decreases linearly to the right and to the left of the center-line. In Fig. 3, the curved outlines are given by different cosine functions. Statistical shading is used to give the illusion of overlapping.

The technique of statistical shading is a solution to the problem of shading that employs the intrinsic nature of computers, namely the process of computation and comparison. In this case, the value of a linear function and of a random number are computed. These numbers are then compared with each other by the computer and it, in effect, decides on the basis of the comparison whether there shall be an overprint or not. The use of random numbers in art is, of course, not original with statistical shading. Hopefully, artists using a computer will find statistical shading evocative of new ideas to apply to their work.

REFERENCES

1. K. Nash and R. H. Williams, Computer Program for Artists: *ART1*, *Leonardo* **3**, 439 (1970).
2. F. Hammersley, My First Experience with Computer Drawing, *Leonardo* **2**, 407 (1969).
3. J. Hill, My Plexiglas and Light Sculpture, *Leonardo* **3**, 9 (1970).

COMPUTER-ASSISTED FACIAL SKETCHING

Mark L. Gillenson*, B. Chandrasekaran, Charles Csuri** and Robert Schwartz****

1. Introduction

What is it about a sketch of a face, merely a few lines drawn on a piece of paper, that makes a viewer recognize them as the face of a specific person? Clearly, an artist makes a remarkable series of decisions about which aspects of a face are information-bearing for the purpose of recognition and transforms these decisions into a collection of lines. But an untrained or untalented person who desires to sketch a face is generally at a loss to know what to draw or how to draw it. Can today's state of technology provide him with a sketching tool that will augment his artistic ability in the sense of aiding him in how to draw a face?

Using state-of-the-art techniques in the fields of computer graphics and artificial intelligence and some of the latest hardware in the computer graphics field, we have developed such a tool. The WHATSISFACE SYSTEM, described below, is a man-machine system with which an artistically untrained person can draw on a graphic display any male, Caucasian facial image from a photograph in front of him. The computer system contains pre-stored facial features, an average face used as a starting point and a heuristic strategy that guides the user in the generation of a 2-dimensional image. The user makes the visual decisions and makes changes in the displayed image by adjusting analog input devices.

The human interaction is restricted to providing the kinds of information that non-artists, unfamiliar with computers, can be expected to provide. They are not expected to draw arbitrary curves corresponding to 'free-hand' drawing. The burden of developing the image is, as much as possible, placed on the computer and its heuristic strategy, while most of the human intervention is restricted to pressing various keys in a typewriter-kind of keyboard and to providing size information by setting various dials.

The WHATSISFACE system runs on a Digital Equipment Corp. PDP-11/45 computer connected to a Vector General Corp. cathode-ray tube (CRT) graphic display. With this system, pictures stored in the computer's memory can be displayed on the CRT under the control of instructions in the form of programs also stored in the computer's memory.

For the purposes of this project, the face has been divided into 17 features, seven of which are paired, e.g. the eyebrows, for a total of 24 independently selectable and manipulable features. These are: hair outline; chin; and pupil shapes (paired); upper eyelids (paired), optional; lower eyelids including crow's feet (paired), optional; eyebrows (paired); forehead lines, optional; upper part of the nose; lower part of the nose; upper lip; lower lip, including center mouth line; auxiliary mouth lines, optional; naso-labial lines (paired), optional; ears (paired) optional; auxiliary chin lines, optional; cheek lines (paired), optional; and neck lines. 'Optional' indicates that a particular feature may or may not be present in a given face.

This procedure takes several things into account. The features, when combined, must produce a recognizable image of any male, Caucasian face. The number of features must not be so small that the number of basic variations for each feature becomes too large. The features must be reasonably familiar to users, that is, their designation and character must be fairly widely known.

Several variations of each chosen facial feature are stored in the computer memory. Each of these, at a time determined partially by the procedure strategy and partially by users, can be modified by users using the analog dials and switches. Specifically, they can manipulate them with respect to translation, 1- and 2-dimensional scale, rotation and intensity variation. The number and choices of these stored features is an important aspect of this project. Clearly, the stored variations of a given feature must differ in basic line shapes, since, for example, their widths and heights can be

* IBM Systems Communications Div., 2651 Strang Blvd., Yorktown Heights, NY 10598, U.S.A. (Received 16 May 1975.)

** Computer Graphics Research Group, Ohio State University, Columbus, Ohio, U.S.A. (This work was supported in part by National Science Foundation Grants Nos. GJ–204 and GN–534.1.)

changed later, as stated above. Thus the problem is one of defining a reasonably minimal feature set and a set of variations within each feature such that given the above mentioned manipulation facilities any typical (male, Caucasian) face can be constructed from them. Many of the decisions involved here were based on work by Zavala and Zavala [1], Bertillon [2] and Goldstein, Harmon, and Lesk [3].

2. The Procedure

We shall now discuss the chosen features in alphabetical order:

1. Two pairs of *cheek lines* have been chosen to differentiate their directions of curvature. They produce the effect of sunken cheeks, when needed.

2. Basically, a *chin* can be either single, double or jowly. In our scheme the chin lines come up to the ears, thus defining the cheeks too to a large degree. There are six single chins (pointy, bilobed, round, square and two average kinds), four double chins and three jowly chins. *Auxiliary chin lines* provide dimples, clefts and 'balls' of chins.

3. The chosen four pairs of *ears* differ in their pointy or rounded tops and attached or unattached lobes.

4. Since *eyebrows* are patches of hair and are therefore rather variable in appearance, ten pairs have been chosen. The types include three straight and two evenly curved variations, four with bends at the outer ends and one 'sinuous' (Bertillon's usage) or S-shaped type.

5. The *lower eyelids* include both the lids and crow's feet. There are seven choices for the lid and three choices for the crow's feet. In both cases, the variations are a question of the number of lines making up these features. In general, the number of these lines increases with age. There are only three types of *upper lids* and the most interesting aspect of them is whether they are present or absent in a given face. In the case of older people with overhanging upper lids, the lines visually merge into the shape of the eye itself, which is where they are represented.

6. The *eyes* are formed from one of seven choices for their shape and one of five choices for the shape of the pupil. Three of the seven include overhanging upper eyelids and vary in the amount of overhang. The other four vary mostly in the structure of the inner corner. The different pupils account for the 'openness of the eye' at the instant a photograph was taken.

7. Fig. 1(a) shows the four *forehead line configurations* and other, smaller lines occurring at the top of the nose.

8. The top row of Fig. 1(b) shows the five choices for the *top of the hairline*, while the second row shows the five choices for its *bottom border*. The last row shows the three bald head possibilities.

9. The *lower lip* (Fig. 1(c)) actually consists of a line that defines the lower border of the lower lip and a middle mouth line at the joining of the upper and lower lips. The former has three variations while the latter has four, for a total of 12 lower lips The *upper lip line* (Fig. 1(d)) can have one of five shapes for its middle portion, with its ends being curved upward, straight or curved downward, for a total of 15 possibilities. In addition, there are *auxiliary mouth lines* that can be used beneath the lower lip, at the corners of the mouth or between the upper lip and the nose.

10. The *naso-labial lines* run approximately from the lower sides of the nose to the corners of the mouth and thus define the interiors of the cheeks. There are four pairs: straight, bent outwards or bent downwards in one of two ways.

11. Most *neck lines* are straight but in addition to these, there are neck lines that are bowed inward and bowed outward.

12. There are 12 choices for the *lower part of the nose*. In six of these the tip or lobe of the nose is roughly even with the nostrils, while in four of them the lobe is lower and in two the lobe is higher than the nostrils. Within these groups the tip and nostrils differ in pointiness and breadth and curvature of the lines. The *upper part of the nose* can be vertically straight, slanted outward and curved outward and straight or curved inward.

The execution of the procedure is as follows. Fig. 2 shows a target photograph of a face (bottom right) and 11 drawings at various stages photographed (and photographically reversed) from the computer display. The user, with the target photograph in hand, sits at the computer CRT display and has the keyboard terminal, dials and function switches within easy reach. The procedure begins with a mathematically calculated average, male, Caucasian face appearing on the screen (Fig. 2A) and this face serves as the base for succeeding variations. The basic face is one of many 'heuristics' incorporated in the procedure. A

Fig. 1 Types of facial features.

heuristic in a computer procedure is a means of solving a problem that, while not guaranteeing an optimal solution, usually aids in the production of at least a good solution.

Next the procedure asks the user to make an input to the computer of an estimate of the subject's age and signs of aging (e.g. the addition of forehead lines) (Fig. 2B). Then the user executes height-breadth adjustment routines designed to secure an image of the basic outline of the face (Fig. 2C). It should be noted that these steps are ordered from most to least important in terms of recognition in an attempt to 'home-in' on the traits of the target as quickly as possible.

At this point the user can adjust individual features or logical sets of features through a hierarchical manipulation scheme (Fig. 2D). This scheme groups features based on their physical proximity to each other and to common relationships (e.g. a group called 'mouth' consists of the upper lip, the lower lip and the auxiliary mouth lines).

It is at this point that the retrieval phase begins by means of which major shape changes in the individual features are made. The order of the feature retrievals is important in that, in keeping with the general approach, features are changed in the order from most to least important. First, the outline of the face is modified, as follows: The hairline is done first (Fig. 2E) and then the chin and the auxiliary chin lines (Fig. 2F). After this, the face height-breadth adjustment and the hierarchical manipulation scheme are again used for fine adjustments based on these changes.

The rest of the features are worked on in the order: neck, eye and pupil shapes, upper eyelids, eyebrows, lower eyelids (Fig. 2G), upper lip, auxiliary mouth lines, upper part of the nose, lower part of the nose (Fig. 2H), ears, naso-labial lines, forehead lines and cheek lines (Fig. 2I).

The user selects replacement features, guided by procedure directions. In general, either the user responds to questions about the features at the keyboard terminal of the computer or makes a visual selection upon the presentation on the CRT of several feature variations in the context of the latest face depicted.

Hair is added (Fig. 2J) and, finally, eyeshade (Fig. 2K). By means of specialized computer programs the user can introduce straight hair at any desired angle, curly hair (with the curls placed at random and at any desired density throughout the hair outline), wavy hair (again placed at random) and vertical wavy hair to form a distinctive and not uncommon vertical wave.

The evaluation of the procedure consisted of the depiction of faces on the CRT by persons of varying skill in freehand drawing and these results were evaluated by a jury as to their effective representation of a basic face. A set of sixty 8 × 10 in. photographs of male, Caucasian adult faces was used for basic faces.

The first author, acting as a non-artist who had experience with the procedure, produced images of five of the basic faces. Each of 10 subjects, who used the procedure for the first time (with about one half hour of instruction), produced a final image of one basic face. These 10 also attempted a freehand sketch of the same face. Figure 3 shows two sets of the resulting triplets consisting of the photograph of a face, a user's free-hand sketch of the face and the WHATSISFACE image of the photograph obtained by the user.

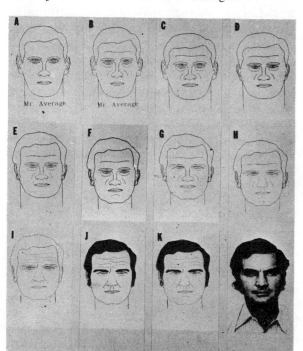

Fig. 2. Image sequence in the production of a face by means of a computer procedure.

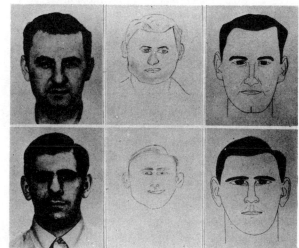

Fig. 3 Two sets of a photograph of a face, a subject's depiction of it by free-hand drawing and by means of the computer procedure.

The jury evaluated 10 separate times the recognizability of the 15 computer depicted images and the 10 free-hand sketches. The jury consisted of 62 people, none of whom performed more than six evaluations. An evaluation consisted of each juror's selecting from 60 photographs of basic faces those that corresponded to one of the computer depicted images and the free-hand sketches. The results showed that the recognition rate for the free-hand sketches was 62% while that of the computer produced images was 87%; a significant difference.

Those interested will find a detailed discussion of this work in Ref. 4.

References

1. A. Zavala and R. T. Zavala, The Dimensions of Facial Features in *Personal Appearance Identification*, A. Zavala and J. Paley, eds. (Springfield, Ill.: Charles C. Thomas, 1972).

2. A. Bertillon, *Signaletic Instructions*, (Chicago, Ill.; The Werner Co., 1893).

3. A. J. Goldstein, L. D. Harmon and A. B. Lesk, Identification of Human Faces, *Proc. IEEE* **59**, 748 (May 1971).

4. M. L. Gillenson, The Interactive Generation of Facial Images on a CRT Using a Heuristic Strategy, Ph.D. Thesis and also a technical report, Computer Graphics Research Group, Ohio State University, Columbus, Ohio, 1974.

ON PRODUCING GRADED BLACK AND WHITE OR COLOR COMPUTER GRAPHICS IN COMBINATION WITH A PHOTOGRAPHIC TECHNIQUE

Herbert W. Franke*

Digital computers are being applied in various ways in the visual fine arts [1–3]. One way is to use the computer to provide data for the design of a manually executed painting. Z. Sýkora [4] obtains from a computer, in accordance with a set of specified rules, instructions on the arrangement of arrays of squares containing geometrical designs. M. Barbadillo makes pictures comprised of variations of shapes contained in an initial modular square. He selects the variations from print-outs of a computer appropriately programmed. M. Thompson has analyzed Barbadillo's procedure in Ref. 5. The sculptor, O. Beckmann [6] obtains computer print-outs of shapes from a computer on the basis of which he makes his works. The program for the shapes involves the use of a random number generator.

Artists also have used various mechanical and electrical display devices developed in connection with computers [1–3]. They involve cathode ray tubes (CRT), optical benches, diaphragm screens or laser beams and, generally, produce images made up of lines.

R. I. Land has reported in *Leonardo* [7] on his work on computer produced color-stereo images on a cathode ray tube, which are made up of lines in different colors. I shall describe below experiments undertaken to produce images in black and white or in color wherein there are smooth gradations of color. The experiments were carried out under the direction of Hein Gravenhorst at the Department of Photography and Cinematography of the Hochschule für Gestaltung (University of Design) in Kiel, Federal Republic of Germany.

In these experiments the Siemens Data Processing System 4004 and a CalComp Drum Plotter were used together with the 'Drakula 4/71 a' computer program that I developed in 1971 to produce line drawings (Fig. 1). These drawings were converted into photographic negatives and then processed photomechanically and photooptically by Karl Siebig, as described below.

For photomechanical processing, a transformation table was designed by Gravenhorst to permit precise focussing by means of translational and rotational movement of the table [3]. Images or parts of an image on a photographic black and white or color negative are projected onto another photographic negative placed on the transformation table to produce superimposed images of the type shown in black and white in Fig. 2. The motion of the table is controlled manually.

The photooptical process makes use of the diffraction phenomenon to diffuse the projected lines of an image on a photographic negative before they impinge on another negative placed on the Gravenhorst transformation table. Examples of computer pictures produced by this process are shown in Fig. 3.

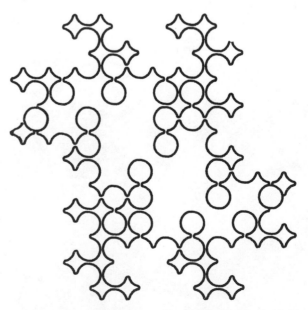

Fig. 1. *Computer drawing produced using H. W. Franke's program 'DRAKULA 4/71 a', 1971.*

* Physicist and artist living at D–8195 Puppling 40, Pupplinger Au, near Munich, Fed. Rep Ger. (Received 26 March 1973.)

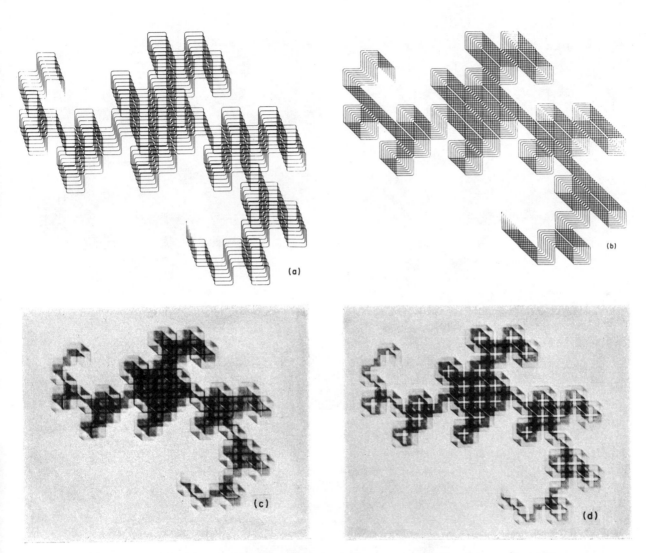

Fig. 2. *K. Siebig, 'Photomechanic Transformations' of a computer graphic, photographic positive prints, 1972.*

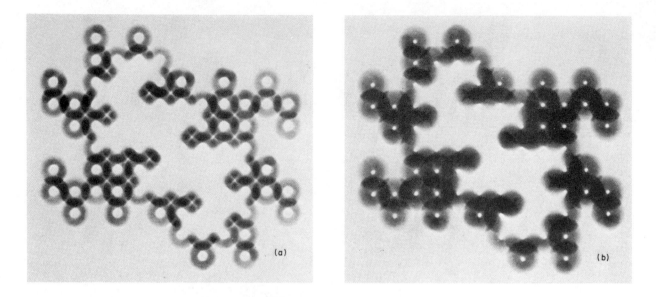

Fig. 3. K. Siebig, 'Photooptic Transformations' of a computer graphic, photographic positive prints, 1972.

REFERENCES

1. F. J. Malina, Comments on Visual Fine Art Produced by Digital Computers, *Leonardo* **4,** 263 (1971).
2. H. W. Franke, Computers and Visual Art, *Leonardo* **4,** 331 (1971).
3. H. W. Franke and G. Jäger, *Apparative Kunst* (Cologne: DuMont Schauberg, 1973).
4. Z. Sýkora and J. Blažek, Computer-aided Multi-element Geometrical Abstract Paintings, *Leonardo* **3,** 409 (1970).
5. M. Thompson, Computer Art: A Visual Model for the Modular Pictures of Manuel Barbadillo, *Leonardo* **5,** 219 (1972).
6. H. W. Franke, Computer Graphics-Computer Art (London: Phaidon, 1971).
7. R. I. Land, Computer Art: Color-Stereo Displays, *Leonardo* **2,** 335 (1969).

PICTORIAL AND THREE-DIMENSIONAL ART— APPLICATIONS OF MATHEMATICS

THE CYBERNETIC STANCE:
MY PROCESS AND PURPOSE

Roy Ascott*

Abstract—*There is apparently a paradox in that, as artists, some of us become progressively* process-oriented, *but continue to produce art* objects. *For me this is necessary since I work on two levels from a common set of attitudes: on the social level, elaborating plans for a Cybernetic Art Matrix; on the intimate level making individual art works. Both processes are concerned with creating* triggers—*initiating creative behaviour in the observer/participant. Modern art is characterized by a behaviourist tendency in which process and system are cardinal factors. As distinctions between music, painting, poetry, etc. become blurred and media are mixed, a* behaviourist synthesis *is seen to evolve, in which dialogue and feedback within a social culture indicate the emergence of a* Cybernetic vision *in art as in science.*

My artifacts come out of a process of random behaviour interacting with pre-established conditions. The Cybernetic Art Matrix is seen as a process in which anarchic group behaviour interacts with pre-established systems of communications, hardware and learning nets. In both cases the processes are self-generating and self-critical. Basically they are initiated by creative behaviour, and in turn give rise to its extension in other people.

I

The paradox we face as artists writing about our work is that the future is all that interests us, and that is precisely the part of our activity which must remain necessarily unpredictable. For many of us there is a further paradox; we can see that, as the value of the commercial gallery declines and our interest in the art object as *object* diminishes, so the need for new channels of communication between people increases, free access to new technology and media becomes imperative, and a new cultural situation inexorably evolves. The paradox lies in the fact that we continue to throw off art objects in the course of our creative work, while our eyes are set on the new horizon. We have undoubtedly become *process-oriented* but we still deal with objects. For my part this must be so.

When I come later to describe a plan for a Cybernetic Art Matrix (CAM) which is, as it were, *all* process, I shall have already discussed a body of related work which is realized in terms of objects. And when I say that these art objects are models for CAM, I do not mean that they represent an architectural plan, or a diagrammatic configuration, or a pictorial expression of ways and means. I mean to say that they realize a fundamental *stance;* they constitute at once a general set of attitudes to human

*English artist-teacher, San Francisco Art Inst., 800 Chestnut St., San Francisco, CA 94133, U.S.A. (Received 14 August 1967.)

behaviour and a particular concrete behavioural situation—ideas about individual identity and the manifestation of a specific identity. I am concerned, in short, with some kind of tangible philosophy, with ideas in action. Both CAM on a social scale and my individual artifacts on a intimate scale are essentially *triggers*. They contain nothing but the possibility of future action; that is to say they exist only in so far as the spectator participates in their evolution by, on the one hand, interacting with other people within a complex social situation, and on the other hand by conducting a private interior dialogue.

If the modern era in science and art and human affairs can be differentiated from previous eras, as the outward aspect of events would suggest, it must contain some unifying quality, some basic characteristics which are shared by artists, scientists and politicians alike. If we examine the apparently divers tendencies in all these fields, we may discern a common vision. This vision, still clouded and imprecise, is characterized by a fundamental and mutual tendency: a tendency to the creation of *dialogue*. In previous periods of western society, art, science and politics have tended to be deterministic, absolutist, hierarchic. The channels of communication have been one-way channels, the flow of information has been in one direction. In each area of activity we find a closed system: an image is projected, a principle expounded, a social relationship established, in each case, only to

reinforce a fixed point of view, an absolute ideal, a permanent set of values.

But now *change* is everywhere apparent. Human beings are mobile geographically and socially; the scientist not only observes an experiment, he participates in it; the artist's interest lies more in the process of working than in the finished art work, and his audience expects, not a fixed attitude or viewpoint to the work, but a field of uncertainty and ambiguity in which they can, endlessly, take part. In every area the system, so regarded, is open-ended; nothing is fixed. Today we are concerned less with the essence of things as with their behaviour; not what they are but what they do. This unified tendency is evidently *behavioural*, and we can see how the vision of our time is ultimately cybernetic.

This new vision contrasts forcibly with the old attitudes. Henri Bergson, living in that period which served, so to speak, as the fulcrum of these two eras, revealed repeatedly in his *Philosophy of Change* the nature of the new situation. 'The role of life is to insert some *indetermination* into matter' . . . 'The living are relatively stable, and counterfeit immobility so well that we treat each of them as *thing* rather than as *progress*, forgetting that the very permanence of their form is only the outline of a movement.' At the beginning of this century he is warning against 'dealing only with the evolved, which is a result, not with evolution itself, which is the act by which the result is obtained' [1]. A shift of human interest is from the thing, the object, the product to the process, the system, the event in which the product is obtained. The history of modern art, with its roots in that same period, is the history of this shift; a radical move which, as it evolves, may take us into a culture more exhilarating and free than previously we might have imagined possible.

II

I am suggesting that a *behaviourist* framework can be constructed from which to examine, not only the internal relations of modern art, but its social implications, and its potential contribution to our forming cybernetic culture. Everwhere in modern art, particularly in the visual/plastic arts, but also in the more experimental reaches of music and literature, the emphasis is on behaviour, on what happens, on process and system, the dynamic interplay of random and ordered elements. And this is so whether we consider the artist's subject-matter (or starting point), the importance he attaches to the act of making, or the artifact which is produced.

As for the spectator, he no longer expects to receive a ready-made experience, or the expression of an experience, but rather to participate at a deep level, either in his consciousness or, more physically, by immediate action. The artist no longer decides everything and projects it as a whole in some definitive and final composition; he now initiates a dialogue, or set of events, which, when taken up by the audience, whether in a group or individually, will be shaped into totally unpredictable and indeterminate forms and experiences.

Modern art is *process* and it is open-ended. The old art was deterministic, concerned with discrete objects, with things and fixed relationships. Now everything tends to a fluid state, a continual changeability. We are entering an era in which everyone takes responsibility for the common culture, by participating in the decisions and actions which will inform it.

As feedback between persons increases and communications become more rapid and precise, so the creative process no longer culminates in the *art work*, but extends beyond it deep into the life of each individual. Art is then determined not by the creativity of the artist alone, but by the creative behaviour his work induces in the spectator, and in society at large. Where art of the old order constituted a *deterministic vision*, so the art of our time tends towards the development of a *cybernetic vision*, in which feedback, dialogue and involvement in some creative interplay at deep levels of experience are paramount. But a *vision* of our time if it is truly representative must embrace more than the aspirations of its artists; it will include scientists, technologists, economists, all those fields of human endeavour in which creativity is prime. And a common spirit which can be called *cybernetic* infuses all these fields today.

What after all is cybernetics? We know it to be the study of control and communication in animal and machine. We know that it is *integrative*, bridging disparate areas of knowledge. It pursues a branching path deep into the sciences of Information, Human Behaviour, and Environmental Engineering. And we know of its economic and social effects. Many sociologists and commentators in other spheres have predicted the far reaching impact of applied cybernetics, W. Gordon and Herbert Marshal McLuhan, for example, in terms of automation and the 'electric age' [2,3]. But, as I have argued at greater length elsewhere [4], at an even more profound level the cybernetic spirit, more than the method or the applied science, creates a continuum of experience and knowledge which radically reshapes our philosophy, influences our behaviour and extends our thought.

The mythology of cybernetics is now well established, and although the romance of automata and artificial intelligence often obscures the reality, there can be no doubt that the *cybernetic vision*, as it emerges in our consciousness, will rapidly effect great changes in the human condition.

III

I have suggested that modern art may be best understood if it is examined in the context of behaviour, that there is a forming aesthetic of *process* and *system* in which the cardinal factors of feedback and interplay are consistent with a *cybernetic vision*.

Briefly, how might such an analysis be conducted? Where the behaviour of the artist is uppermost,

where the focus is on the artist's activity for its own sake, as for example in the case of Jackson Pollock, the action painter in his arena, we can see that aspect of art as *behavioural ritual*. Action in which chance plays a large part was a characteristic of Surrealism, and, as in the case of Duchamp, the act of random choice can become ritualized to the degree of dispensing with the fabrication of art objects altogether. Once the action or event becomes all-important, 'happenings' are an inevitable consequence. People interacting freely in groups, producing unfamiliar situations, catalysing perhaps further group responses, constitute an art situation.

Where the artist is interested less in his own behaviour than in the behaviour of the spectator his work may be seen specifically as a *behavioural trigger*. The response in an observer might be elicited in a number of ways: *physically*, in the immediate sense of a highly intensive optical activity induced by visual stimuli creating flicker, after-images, spatial ambiguity and uncertainty of figure-ground relationships; or *manually*, where the nature of the artifact induces the spectator to alter the position of its parts; or again a *postural response* may be effected, with the observer moving about, shifting position, so that images merge and transform, and in so doing encourage this activity as the sole relationship possible between artifact and the human being.

Art works may also trigger off responses of a polemical or social kind encouraging in their audience changes in individual or group behaviour by questioning preconceptions, destroying illusions by means of the shock of unfamiliar, absurd or incongruous imagery. Within the same context a more sober, dialectical construction of abstract values has been developed to present the observer with the possibility of new social behaviour.

Again, the artist's main interest may lie not in his own behaviour, nor in that of the observer, but more especially in the behaviour of the objects he makes. These *behavioural structures* literally behave in the sense of articulating their various parts in response to internal or external stimuli. The medium may be light moving onto surfaces, themselves moving perhaps, or fins of metal dependant on the impact of air currents to push themselves round. They may be structures internally powered by electricity or some hydraulic device. Another possibility, dramatically demonstrated by Tinguely, is the built-in capacity to systematically destroy itself. We must look to the future and the research of, for example, Beer or Pask, for those 'fungoid systems' and chemical–colloidal computors which might make possible the creation of *behavioural structures* invested with the properties of growth.

Another aspect of this behavioural continuum, not without significance, is that where the artist's central interest lies in the behaviour of his subject matter, or of his relationship in behavioural terms, to that subject matter. We can think of those *behavioural analogues* where the Cubists reconstructed on canvas the space–time experience of a still-life, of moving around it, viewing it inside and out, taking it to pieces; or of the futurists' analogues of the dynamism of the city, of machines and of living organisms. But this is in a sense to look at the roots of modern art not at what is really happening today and what seems to be evolving in our general culture. The *behaviourist tendency* is not confined simply to painting and sculpture, nor is its fullest expression developed in the examples just cited. This tendency, so much of our time, implies a *total* behavioural involvement in which all our senses are brought into play, not simply visual, but postural, tactile and including the sense of hearing and even of taste and smell. In short, a *behaviourist synthesis* is forming where the boundaries between the once highly differentiated arts of music, poetry, painting, architecture, sculpture and acting are becoming less distinct. The media merge, and at the same time the distinction between the roles of artist and audience becomes blurred. The art work or event is a matrix between two sets of behaviour, which through it become one, continuous and inter-related. Inevitably a state of perfect feedback will emerge, where we all both initiate and involve ourselves in total creative situations.

Although this is beginning to happen it is by no means entirely with us yet. There is no doubt, in my mind, that this *behaviourist synthesis* is rapidly forming. There have been many recent experiments with *behavioural environments* which should be noted: mazes, labyrinths and sense boxes, projects such as those initiated by the Groupe Recherche d'Art Visuel in Paris, and, in the commercial sector, by the instigators of Carnaby Street who provide an audio-visual setting for adolescent role-playing with disposable and ever-changing costumes.

IV

There are points at which all our individual attitudes and art works touch upon and contribute to the behaviourist esthetic in some sense. I now turn to discuss how my own work, at the social level of CAM and at the intimate level of individual artifacts, relates to this tendency and to its future.

I have already said that both these artifacts and the CAM-complex are intended to function as *triggers*, and that the former are in some good sense models for the latter. They are part of the same overall process, they proceed from the same *stance*. That is, to initiate dialogue, to involve other people in creative behaviour, engaging more of the senses than the purely visual one alone. Presenting, not a set of ideas or a personal expression of feelings, but a situation in which other people's ideas and feelings can be set in motion, generating quite unpredictable experience. This process is deterministic only in the sense that it is aimed at eliciting creative thought and action in the community. The specifics of that action and of the directions my processes may take are equally unpredictable and

open ended. Each situation, as it emerges, will have its own controlling energy, and thus my work, in its implications, is essentially cybernetic. A function of the output variable (social/individual response) is to act as an input variable in my working process and in the art-work/experience, so introducing continually more and more variety into the system.

So when I say one models or mirrors the other, they are analagous not in terms of product or thing, i.e. a particular art object or a given CAM-complex, but in terms of process. Just as Constructivist art mirrored in its *structures* those kinds of spatial organizations thought to be excellent at the large architectural levels, so my studio work mirrors in its *processes* the behavioural possibilities I am intending when I plan, at the larger social level, the requirements of a Cybernetic Art Matrix.

What is the factor which is common to all my working processes? I am concerned with the interaction of random behaviour and pre-established conditions, of anarchy and flexible containers, of the unpredictable and the determined, of entropy and order. This applies to my working procedures, to the artifacts which are produced and their relations with other people, as well as the Cybernetic Art Matrix. Fundamentally it constitutes anarchy resolving itself into sets of organization, which emerge out of necessity from the initial generative process.

Let us call the creative process which produces artifacts, CP1 and that which is concerned with the wider social creativity (Cybernetic Art Matrix), CP2. CP1 involves human behaviour (my own) randomly interacting with certain pre-established formal conditions, i.e. the dimensions of a board or a number of linear grids, this or that pigment, a specific marking instrument, a cutting tool. CP2 involves human behaviour (a group of people) anarchically interacting with certain pre-established formal conditions, i.e. architectural containers,

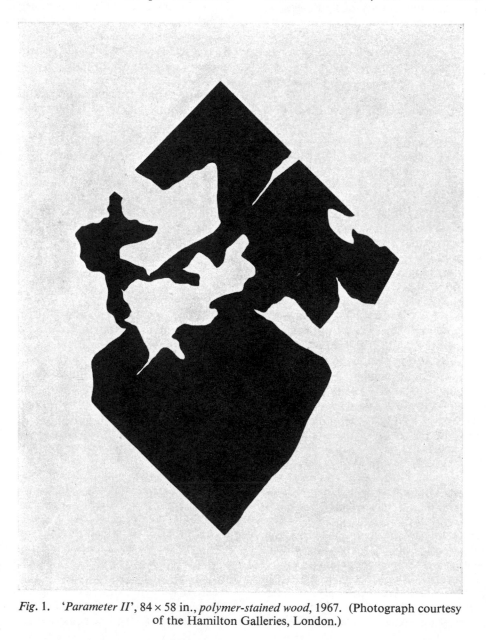

Fig. 1. '*Parameter II*', 84 × 58 in., *polymer-stained wood*, 1967. (Photograph courtesy of the Hamilton Galleries, London.)

communications media, learning and playing hardware, etc. In both cases formal organization and control is not applied from outside, the legality of CP2 and the authenticity of CP1 come from within the process which creates them. Decisions concerning morality (CP2) or style (CP1) are never made outside of the context in each case.

until a grid or linear net is marked out. Then a great complexity of lines and marks is built up on the surface: gestural configurations are applied blindfold to the board from all sides; irregular shapes and objects of all kinds are traced in outline onto it. Systematically, at intervals, small counters or markers are thrown down in random order and where

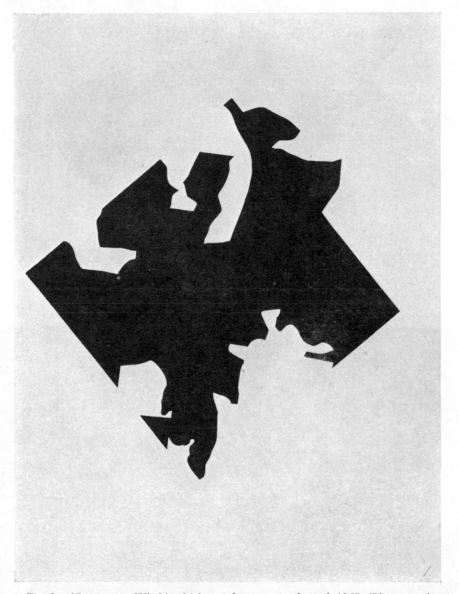

Fig. 2. *'Parameter III'*, 81 × 84 in., *polymer-stained wood*, 1967. (Photograph courtesy of the Hamilton Galleries, London.)

Given that one's processes are constantly changing, what specific example can be given to illustrate CP1? The illustrated artifacts, shown in Figs 1, 2 and 3 ('Parameter II', 'Parameter III', and 'Parameter V') came out of the following procedures. A board is selected of dimensions wider than those of a person with arms outstretched, i.e. about 7 ft × 7 ft or larger. This is laid down on a rigid bench in the centre of a bare studio. A long metal rule is thrown at random onto the board and a line drawn across the board to mark where it fell; this is repeated

they land on a line that line is erased to the point at which it crosses another. This process of erasure is then applied to areas bounded by lines, those on which markers land are cut out with a jigsaw. At the critical point where further cutting would result in the board physically falling to pieces the process stops. What then remains is a confusion of marks and spaces, a mutilated surface, an area totally disturbed and disorganized, the board bounded now by an edge which is a combination of the original grid and the random lines. This is then sanded

down, all marks are removed, a deep acrylic stain saturates and unifies the whole surface and a bland, cool, cut-out area is resolved.

Within this apparently mechanical procedure there is room for one's whole history of images and

With its previous history thus encapsulated and hermetically sealed off, the artifact becomes an outfacing, open field. From this point its specific identity in the conciousness of a spectator depends on his involvement in it. This bland exterior is a

Fig. 3. *'Parameter V'*, 48 × 120 in., *polymer stained wood*, 1967. (Photograph courtesy of the Hamilton Galleries, London.)

Fig. 4. *'Lebesgue'*, 132 × 50 in., *polymer-stained wood*, 1965. (Photograph: Roy Beston.)

forms and experience generally to impress itself through the intuition onto the board. But this rich history and all those particular marks and lines which are conditioned by it, are systematically erased—leaving a mere outline, a cut-out container, a minimal silhouette, the frozen parameters of a process.

trigger, a starting point for the observer, the variables of the edge impressing on his conciousness a minimal configuration, from which he builds or infills (Fig. 4. Fig. 5, cf. colour illus. C, p. 305).

A dialogue, private and interior, is set up within the observer's experience of this open field which

emits not hot information, complex relationships and rigid ideas, but a simple steady beam, as it were, of pure information, unmade information. The container is its own content. In these works the very coolness of the format calls for less of a purely visual reading and, because they are almost all outline, demands a more tactile response. Moreover these visual-tactile devices, because of their scale (always over 7 feet wide, and as high), are capable of wrapping round the spectator's visual field and increasing the sense of involvement.

I am now experimenting with single continuous sounds to be emitted from each individual piece; a kind of audio-tactile visual parameter will then exist. And I am planning work in which as the given sound for each piece is modulated, so its sound-source moves around the modulations of the edge. Sound is not essential, but it brings into play another element to mirror the diversity of CAM media.

V

Having made the point that these artifacts are part of a process which in many senses mirrors CAM, it is now appropriate to indicate in general terms just what a Cybernetic Art Matrix is all about. I have argued that as artists we are responsible not simply for behaving creatively, but for triggering creative behaviour in other people. CAM is intended for this purpose at a wide social level, as a catalyst within large urban groups; ultimately forming a network of CAM-complexes within that kind of world brain which instant-information technology promises us.

CAM at this present stage does not exist in any physical sense, although a number of small-scale experiments have been made and then only, out of economic necessity, within the somewhat anomalous constraints of an art school [5]. CAM, as a set of proposals, (published elsewhere, and codified and elaborated in some detail [4]) aims at establishing a process for generating processes, a self-organizing system, a learning organism. This self-creating artform, in which human beings are their own media (properly extended and amplified with technological and bio-chemical hardware), constitutes a cybernetic art process, capable of growth and change.

The characteristic of a CAM complex would be in practice the ability progressively to define itself *as a process* in relation to the changing activity of its constituent parts (human participants) and of the outer social environment. CAM would impose no rules, laws or codes of behaviour on its human participants, and thus would permit their free interaction to evolve new human values, rituals of behaviour and a kind of legality likely to be of value in the day to day world of events.

There is a sense in which CAM is an endless happening, a continuous creative event, a sum of all the behaviours initiated and learned within its parameters. Physically it would demand flexible architectural containers adaptable to the changing needs of new activities, varieties of hardware and environmental amenities. It would need a memory and a store of information; it would acquire an identity, a changing identity to be sure, perhaps in some good sense an embryonic conciousness. The flow of information within a CAM and between CAMs and the world at large would be endless. Communications nets would demand the effective deployment of all media; it is well seen that creative ideas and activity are most efficiently maximized by rapid and clear transfer of information between persons.

But perhaps most important to the evolving nature of CAM is the question of location. To think of it as an urban sub-structure would be to see it in terms of 'thing' rather than 'process'. Undoubtedly pooling of certain technical resources might be required in some city areas, as well as plaza-spaces for large group activity; but the electronic facility of advanced cybernetic systems of control and communication will permit the parameters of CAM an endless variability. The effective communications of person to person, group to group, tool to material, event to event no longer demands a proximity in space or in time. A creative situation, event or artifact can thus be developed within the CAM facilities by individuals in Tokio, London and Los Angeles, say, on a location in the Sahara, or in the shared space-time continuum of T.V.

VI

So CAM acting primarily as catalyst to creative behaviour in our communities is not a building or collection of buildings, nor is it an institution of immutable rules or goals, it is a *process* of variable processes and sub-systems.

It will not only accommodate the forming behaviourist synthesis which our new culture comprises, it will nourish it and promote its growth. The Cybernetic Art Matrix will spread creative involvement and responsibility over the whole community to the extent that the specialist term 'artist' becomes redundant. The almost universal leisure of the cybernated society will enable everyone to participate in creative play and learning.

CAM reinforces and extends feedback between persons, initiates dialogue, triggers social change. That at all events is the intention behind my proposals for CAM, and that equally on a different scale, is implied in the artifacts I make.

REFERENCES

1. Henri Bergson, *Creative Evolution*, A. Mitchell, Translator. (London: Macmillan, 1920) pp. 132–135.
2. W. Gordon, Economic and Social Effects of Automation, *Cybernetica* **VII**, No. 4 (1964).

3. H. M. McLuhan, *Understanding Media*. (London: Routledge & Kegan Paul, 1964).
4. R. Ascott, Behaviourist Art and the Cybernetic Vision, *Cybernetica* **IX**, No. 4 (1966) and **X**, No. 1 (1967).
5. R. Ascott, The Construction of Change, *Cambridge Opinion* **37**, 37. (1964).

ON THE MATHEMATICS OF GEOMETRY IN MY ABSTRACT PAINTINGS

Crockett Johnson*

Abstract—*The artist, who is not a mathematician, describes his use of geometry as an artist's tool both in his earlier non-figurative paintings, which are freely based on historic theorems of geometry, and in his more recent work, much of which is based on his own mathematical constructions. Two of his earlier paintings and five more recent ones are described together with their origins. One painting is a rendition of the problem of squaring the circle, two concern the Delos problem of doubling the volume of a cube and two involve the division of areas by 'conic' rectangles.*

INTRODUCTION

It strikes one as odd, especially so with the recent resort to the use of the computer by those who make non-figurative or abstract geometric paintings and drawings, that this or any art seldom has had more than a nodding acquaintance with the mathematics of geometry. One significant meeting did occur in the Renaissance, when artists sought a visual illusion of three dimensions on a two-dimensional surface and found it in perspective geometry, from which, in turn, mathematicians derived the exquisite concept of the projective plane that revitalized the geometry of Greece. In recent times, art has echoed the language of geometry with terms like 'the golden-mean canvas', 'dynamic symmetry', 'cubism' and 'geometric', all of which have had little relation to the geometry of the mathematicians.

In my geometric paintings, I use, as intrinsic tools, the mathematical geometry and mathematical methods I, as a desultory and very late scholar, have been able to absorb. References 1 to 16 are texts I have found stimulating and helpful, though major portions of many of them still are beyond me.

DISCUSSION OF THE PAINTINGS

A decade ago, upon belatedly discovering aesthetic values in the Pythagorean right triangle and Euclidian geometry, I began a series of geometric paintings deriving from famous mathematical theorems, both ancient and modern. Theorems generally are universal in application and can be adapted in constructions of nearly any size and

shape. The paintings were executed, as is my current work, in hard edge and flat mass, with colors focusing in intensity or contrast upon the sense of the theorems. Thirty of the panels were exhibited in New York City in 1967 [17] and, though the title of the show, 'From Pythagoras . . . to the Twentieth Century', was pretentious, it did commemorate some of the major milestones of geometry and mathematics in their development over the past 2500 years.

The painting entitled 'Calculus' (Fig. 1) derives from the basic concept of that mathematical method,

Fig. 1. *'Calculus', oil on pressed wood,* 49 × 49 in., 1966. (Photo: J. Curtis, Norwalk, Conn., U.S.A.)

*Artist and writer (1906–1975). (Received 10 March 1971.) Permission from Mrs. Crockett Johnson, 24 Owenoke, Westport, CT 06880, U.S.A.

Fig. 2. '*Aligned Triangles and Projections*', *acrylic on pressed wood*, 32 × 32 in., 1968. (Photo: J. Curtis, Norwalk, Conn., U.S.A.)

arrived at independently in the seventeenth century by Isaac Newton and Gottfried von Leibniz. The painting is an inversion of the usual textbook depiction of the method, which is one of bringing together a fixed part and a 'moving' part of a problem on a cartesian chart, upon which a curve then can be plotted toward ultimate solution. The elements, as mathematician H. W. Turnbull puts it, 'are symbols of two lines of thought—the kinematical and the geometrical' [16].

The painting shown as Fig. 2 is called 'Aligned Triangles and Projections' and derives from a theorem of Gerard Desargues, the early seventeenth-century founder of projective geometry, which states that 'when two triangles have corresponding

Fig. 3. '*Squared Circle*', *oil on pressed wood*, 48 × 48 in., 1969 (*cf. Fig. 4*). (Photo: J. Curtis, Norwalk, Conn., U.S.A.)

Fig. 4. *Construction for the 'Squared Circle' painting shown in Fig. 3.*

vertices joined by concurrent lines, then the intersections of corresponding sides are collinear' [1]. In this construction, the collinear intersections fall on the straight line that is the bottom edge of the painting.

Much of my more recent work derives from my own investigation and discovery. Figure 3, entitled 'Squared Circle', is one such painting. A preliminary drawing of it (Fig. 4) appeared in the British journal, *Mathematical Gazette*, described aptly as 'a geometric look at π' [18]. Any attempt to square the circle with a compass and straightedge becomes a search for the number π, the value of the area of a circle when its radius is 1. The number π begins 3·141592 . . . and computers have established it to more than a hundred thousand decimal places but it cannot have a finite value. It is a transcendental number and certainly it cannot be arrived at by means of a compass and a straightedge. Though the later Greeks squared the circle with transcendental curves, it remains the most famous of impossible problems in the context of Euclidian geometry. However, the painting is conceived as a construction 'moving' back and forth between close plus and minus limits across the point describing the solution. Its mathematically provable accuracy is such that, were the circle large enough to include our entire solar system, the plus or minus error in the square would not exceed the distance from Paris to Calais. Were it somehow possible to arrive at a finite value for π, the 4 × 4-ft painting would be the same painting, for any difference would be less than a thousandth of the thickness of one hair of a sable paint brush. And so its title has validity, if not a mathematical one. A drawing of the construction can be made available by me to anyone interested and copies of it are on file as a folder in several mathematical libraries.

The paintings in Figs. 5 and 6 are concerned with another problem of antiquity, the doubling of the volume of a given cube, or *The Problem of Delos*.

Fig. 5. '*Problem of Delos, I*', *oil on pressed wood*, 39 × 33 in., 1970 (*cf. Fig.* 7). (Photo: J. Curtis, Norwalk, Conn., U.S.A.)

Fig. 6. '*Problem of Delos, II*', *oil on pressed wood*, 45 × 24 in., 1970. (Photo: J. Curtis, Norwalk, Conn.)

Plutarch mentions it, crediting as his source a now lost version of the legend written by the third century B.C. Alexandrian Greek astronomer Erastosthenes, who first measured the size of the Earth. Suffering from plague, Athens sent a delegation to Delos, Apollo's birthplace, to consult its oracle. The oracle's instruction to the Athenians, to double the size of their cubical altar stone, presented an impossible problem. The cube was doubled, as the circle was squared, after the Greeks had developed higher curves. It could not be done with the compass and an unmarked straightedge, and it still cannot be done.

The problem can be presented as solved if one mark is made on the straightedge but, in a sense, the one-mark solution is an observation after the fact. No marks are permitted in compass-and-straightedge geometry, which in actual practice means that the construction can be built only with one logical step at a time from the five Euclidian axioms. Nonetheless, pictures drawn with marked straightedges can be just as true. In his 'Arithmetica Universalis', Newton has drawn the neatest of one-mark solutions to the Delos problem (Fig. 7). From it, I arrived at my visually more complete presentation of the doubled cube (Fig. 5).

Figure 6 is a painting from my own construction of a solved Delos problem. I know little algebra and I avoid using it because algebra, or my ineptness with it, tends to make me lose a graphic grasp of a picture. Instead, as I did in approaching the problem of the squared circle, I played with what I knew in advance to be the elements of the problem, imagining them as a construction in motion, an animated film

sequence with an infinite number of frames running back and forth between plus and minus limits across the point of solution. When the search is for geometric numbers and transcendental numbers such as π play no part, there is apt to be, among the infinite number of frames, a recognizable unique frame that depicts the answer. In this case, as the two large squares, harnessed by diagonals, approach each other, there is one frame or moment when the small light-colored area in the painting appears as a square, and that moment can be fixed and indicated with a quarter turn of a compass. If the area of each large square has the value of 1, which is the area of a face of the original cube having a volume of 1, then the height of each face or any edge also is 1. And 1 added to the height of the small square is equal to $\sqrt[3]{2}$, the sought dimension of an edge of the cube of twice the volume. Across the top of the painting there are three significant dimensions: the width of the first band on the left (equal to the side of the light-colored square), which is $\sqrt[3]{2}-1$; the combined width of the first two bands, which is $\sqrt[3]{2^2}-1$ and the

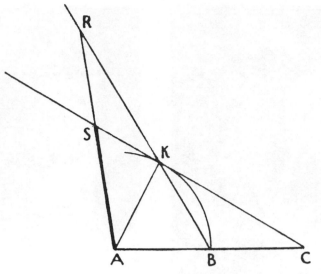

Fig. 7. Newton's geometric observation employed in Fig. 5.

total width, which is $^3\sqrt{2^3}-1$ or 1. The ratio of the first width to the second width is in the same ratio as the second is to the third. The diagonals indicate and prove that the areas of the two pairs of rectangles are equal. And the quarter-circle arcs indicate and prove that the areas of the squares are equal. Granted a width of 1, the painting makes a finite statement and demonstrates its proof.

The construction for the painting in Fig. 8 (color illus. D, p. 306) began with the intention merely of putting three 'conic rectangles' together in a single picture. 'Conic rectangles' often arise in geometric constructions and are useful as proving tools. They were named by the third-century B.C. Greek mathematician Apollonius of Perga after the conic curves: parabola, ellipse and hyperbola. In any set of such rectangles, where all three are of equal area, the ellipse is shorter by its width than the height of the parabola and the hyperbola is longer by its width than the height of the parabola. It is easy to change the height and shape of any two of them and keep them in relationship but juggling all three for aesthetic reasons can be tedious. The arc lines, defining shaded areas in the finished work tended at first to present added problems and then, suddenly, seemed to take over the placing of the three rectangles. Finally, I arrived at the arrangement used in the painting, in which the relationship of the rectangles, the coincidence of points and the sweep of the arcs all added up to a strong feeling that the construction, which was not expected to make any particular mathematical sense, was aesthetically 'right'. Only then did I realize that I had discovered a minor theorem, one that seems to have gone unremarked in the mathematical literature, perhaps for lack of importance. It states that: 'When the height of an ellipse rectangle and its width, plus the width of a parabola, form a rectangle with a diagonal of length x, and the combined widths of the parabola, ellipse and hyperbola also equal to x, then the combined heights of the ellipse and hyperbola equal $2x$. The painting is finitely 'right'.

Customarily, I do not go about appraising the 'rightness' of other artists' works mathematically. However, on one rather astonishing occasion I did just that. Related to the painting in Fig. 8 is Fig. 9, entitled 'Division of a Square by Conic Rectangles', in which the center panel is an ellipse to the left panel as a parabola and the left panel is a hyperbola to the right panel as a parabola—a very complicated bit of juggling of finitely equal areas. I had just finished it when I happened to come upon a reproduction of a 15,000-year-old cave painting at Lascaux, France in a book by Philip Van Doren Stern [19]. A study of Stern's source material made it evident that the etched outlines of the color masses waver because of the rough cave wall (a tracing from the reproduction is shown in Fig. 10) and that the Cro-Magnon artist had designed a divided square

Fig. 9. 'Division of a Square by Conic Rectangles', oil on pressed wood, 33 × 33 in., 1970. (Photo: J. Curtis, Norwalk, Conn., U.S.A.)

Fig. 10. Pattern of a 15,000-year-old painting in a cave at Lascaux, France.

like mine. The coincidence is noteworthy, but quite amazing are the additional lines etched in the rock surface at the left and bottom of the square, forming extra areas, or gnomons, that had not been painted. The caveman's design has more areas than mine but he had colored only those appearing in my painting. Attempting to make mathematical sense of the gnomons is nonsense; however, they seemed to be a challenge. Finally, on the bottom diagonal I erected a tilted square, the upper left corner of which marked off the width of the gnomon on the left. The complete cave painting fitted the mathematics of my painting. I should say, as the mathematics came a hundred and fifty centuries later, that the mathematics fitted the cave painting. Anyway, I made a second painting including the gnomons, entitled 'Square Divided by Conic Rectangles With Gnomons Added at the Suggestion of a Paleolithic Colleague'. I think the prehistoric artist would have been delighted to know how 'right' the mathematics of his painting is.

REFERENCES

1. H. S. M. Coxeter, *The Real Projective Plane* (Cambridge: The University Press, 1955).
2. F. Klein, *Famous Problems of Elementary Geometry*, translated by W. W. Beman and D. E. Smith from the German, 1897 (New York: Dover, 1956).
3. E. Kamke, *The Theory of Sets*, translated by F. Bagemihl from the German second edition (London: Constable, 1940).
4. W. W. Ivins, Jr., *Art and Geometry: A Study in Space Intuitions* (Cambridge, Mass.: Harvard University Press, 1946).
5. G. Gamow, *One, Two, Three . . . Infinity* (New York: Viking, 1947).
6. *The World of Mathematics*, ed. J. R. Newman (New York: Simon and Schuster, 1956).
7. H. Dorrie, *One Hundred Great Problems of Elementary Mathematics: Their History and Solution*, translated by David Antin from the German, 1958 (New York: Dover, 1965).
8. H. Levi, *Foundations of Geometry and Trigonometry* (New York: Prentice-Hall, 1960).
9. L. Hogben, *Mathematics in the Making* (London: Rathbone, 1960).
10. W. W. Rouse-Ball, *Mathematical Recreations and Essays*, revised by H. S. M. Coxeter (New York: Macmillan, 1962).
11. E. G. Valens, *The Number of Things: Pythagoras, Geometry and Humming Strings* (New York: Dutton, 1964).
12. A. Hill, Art and Mathesis: Mondrian's Structures, *Leonardo* **1**, 233 (1968).
13. J. Schnier, The Cubic Element in My Sculpture, *Leonardo* **2**, 135 (1969).
14. F. Harary, Aesthetic Tree Patterns in Graph Theory, *Leonardo* **4**, 227 (1971).
15. H. S. M. Coxeter, The Mathematics of Map Coloring, *Leonardo* **4**, 273 (1971).
16. M. Holt, *Mathematics and Art* (London: Studio Vista, 1971).
17. *Exhibition Catalog* (New York; Glezer Gallery, April, 1967).
18. C. Johnson, A Geometrical Look at Pi, *Mathematical Gazette* (February, 1970).
19. P. V. D. Stern, *Prehistoric Europe* (New York: Norton, 1969).

A VIEW OF NON-FIGURATIVE ART AND MATHEMATICS AND AN ANALYSIS OF A STRUCTURAL RELIEF

Anthony Hill*

Abstract—*The author discusses some interpretations of the term mathematics and what can be meant by mathematical abstract or non-figurative visual art. He then presents an analysis of the mathematical content of his structural relief entitled 'The Nine'—Hommage à Khlebnikov, which he made in 1976. The mathematical notions employed are from the domain of combinatorics.*

I.

S. Giedion coined the slogan 'mechanization takes command' [1] for application to architecture in 1948 and, for some time now, it has become equally applicable to mathematics as a result of the development of digital computers and of computer science. The trend of *mathematization* has long been visible in philosophy (Leibnitz's *Mathesis*) and, since the times of Copernicus, Galileo and Newton, in the physical sciences, and in recent decades it has played a steadily larger role in the life sciences and technology, as well as in psychology and the social sciences.

In France, mathematics is called an 'exact science', as is presumably the domain of logics, but the term science in French has not meant the same as science in English, for in France the term refers to any kind of systematic scholarly study of questions, not only those the answers to which require either experimental or observational verification. Whether anything of value is achieved by calling mathematics a 'science' in the English sense of the term seems doubtful to me.

Consider for example the following passage: 'The only example known to me of a scientific doctrine which is unlikely to be shown to contain mistaken assumptions is the mathematical theory of the 230 crystal groups. This rests only on the three-dimensionality of physical space and the spatial repetition of equivalent and equivalently placed units' [2]. This passage raises a number of questions, for example, am I to accept that 'scientific doctrine' (I assume this to mean 'scientific theory') can be synonymous with a 'mathematical

theory'? Clearly, in the English sense of the term, it cannot.

It seems equally clear to me that, while definitions of mathematics are useful if they point to important features of the activity, few are confronted with the problem of preparing an all-embracing definition. I shall briefly consider some attempts that have been made. The French group of mathematicians called *Bourbaki* [3] has agreed that 'it is a study of abstract structures or formal patterns of connectiveness'.

The Swiss mathematician Paul Bernays says that 'it can be regarded as the theoretical phenomenology of structures' [4] and the philosopher C. S. Peirce (U.S.A.) maintained that it is concerned with the 'observation of artificial objects of a highly recondite character' and that 'as the great mathematician Gauss has declared—algebra is a science of the eye' [5]. Peirce also took a lively interest in topology, which he described as 'the science of spatial connections', adding that this branch of mathematics would be better called 'synectics'.

In this article I shall discuss the meaning of a kind of non-figurative or 'abstract' visual art that can be described as being, in part, 'mathematical'. This property is not to be taken as a physical characteristic or parameter of this art, such as the dimensions of length, time and mass of different kinds of art media. However, a work of art classified as 'mathematical' is one in which some aspects of its organization can be shown to involve the manipulation of concepts or ideas that, at least in part, stem from those found in some branch of mathematics.

I shall not present my views of the historical precedents for 'mathematical' visual art nor attempt to show whether much that is claimed to be an art of this kind really is, such as art objects

* Artist living at 24 Charlotte St., London, W1, England.
(Received 5 Aug. 1976.)

148

that incidently include common geometrical shapes or mystical numerological concoctions.

In some non-figurative pictures artists employ a kind of 'calculation' to organize the composition of shapes [6] and/or of colours, others take into account what psychologists of visual perception have learned about visual illusions, drawings of impossible objects and colour after-image phenomena. 'Calculation' may, incidently, be necessary when artists apply scientific and technological developments, such as holography and digital computers.

There may also be a kind of 'calculation' involved when artists make use of the visual material provided by scientific and technological research, especially photographs obtained with the aid of microscopes and telescopes of various kinds. Such material is, of course, meaningless without a framework for making sense of it, although some people may obtain aesthetic satisfaction from it by misconstruing the sense of it.

The popular words one finds in texts on 'scientifically oriented' art tend to be drawn from the latest 'sensational' press reports on new developments in science and technology. The new disciplines of cybernetics, semiotics and computer science have especially fascinated some artists and writers on art. What is called General Systems Theory has had a particular attraction for a number of artists. In my opinion, the visual fine arts are more likely to breed pretentious claimants of effective innovations than music. Musical works of this century have also undergone radical changes in form and content, although I doubt that some of them will withstand the test of time. The organization of musical material has in the past offered a broad scope for 'systematization'; even some Oriental music takes advantage of this possibility. But I shall not pursue this aspect of the arts further here.

In 1961 I exhibited some of my constructional or structural reliefs in the British Section of the Paris Biennale. The then Minister of Culture, André Malraux, on looking at them expressed the opinion that they appeared to exemplify the so-called French 'System D' (The 'D' stands for *debrouillard*, which means resourceful in getting what one wants, including resorting to tricks to get out of a difficulty). The remark was, of course, meant in a denigrative sense and I do not think that it was at all germane. Two of the works shown were the subject of an analysis published in 1966 [7]. One of these, *'Prime Rythms'*, which I made in 1958, is shown in Fig. 1.

II.

One of the artists who shaped an outlook on the visual arts of this century was Marcel Duchamp. In 1919 he referred to himself as a 'chess maniac' [8]. Although it has not been said explicitly either by him or by his admirers that he took up chess very seriously because he was bored by his art or because he wanted to show that the brain of an

Fig. 1. *'Prime Rhythms', relief structure, laminated plastic,* 91.5 × 91.5 × 1.9 cm, 1958 (Photo: Cooper, London.)

imaginative artist need not be addled by alcohol and egomania, I think that these two reasons featured largely in his decision to spend so much time at the chessboard.

I have not been attracted to chess, nor to any other board or card games; life and my art work seem 'games' enough for me. On the other hand, I would not like to be thought an artist who indulges in 'art gamesmanship' or in the mathematical Theories of Games and of Metagames.

This is not true of John Ernest, whom I met in London in 1954, the year in which we began making relief structures instead of non-figurative paintings. He did not, however, convert me into a chess enthusiast, although he was then a fair club chess player.

I did learn from him some techniques for making art works of better craftsmanship. We also shared an interest in mathematics and in the ways certain of its notions might be applied in relief structures. Before taking a closer look at qualitative mathematics, we explored mathematical formulations that have been used in art, such as the Golden Ratio. (I had come to this in 1950 after reading Le Courbusier's book entitled *Le Modulor* [9].).

At that time, a number of English painters (Victor Pasmore, Kenneth and Mary Martin, Adrian Heath and I) formed a loosely knit group to investigate notions behind constructivist works ranging from those of Max Bill to those of Charles Biederman. We were interested in geometrical non-figurative works and abhorred Tachisme and Action Painting. While my interest centered on a kind of synthesis of Neo-Plasticism and Constructivism, there was then, as there is now, an aspect of my personality that draws me to the study of the works by Marcel Duchamp, whom I consider

to be this century's most daring innovator in the visual arts [10].

Duchamp's artistic innovations were numerous. I consider the most important one to be his introduction of the idea of a 'ready made'; a utilitarian object, for example a urinal, upon which an artist confers the status of an art object. This does not apply to natural objects, such as a pretty stone. While this idea is usually taken to be an anti-art Dadaist trick, the ramifications of the idea can be interpreted to go much further. For example, if an artist finds that a 3-dimensional or pictorial mathematical model is for him charged with visual aesthetic properties, he may appropriate it as it exists, call it an art object and ask money for it. Of course, mathematicians could enter this form of business also.

In my article Constructivism—the European Phenomenon [11] a sculpture by Naum Gabo is shown together with a line drawing taken from *Encyclopeadia Britannica* that clearly was the source of inspiration for his work. He has not denied my finding. Another interesting example is the illustration (Fig. 2) in an essay by the celebrated English mathematician J. E. Littlewood that represents what he calls '. . . "the hippopotamus", a well-known character in the theory of "prime-ends", but only now baptized in imitation of the crocodile . . .' [12].

In 1958, Ernest and I became engrossed in a problem that had not been formulated before in the mathematical literature and to which we supplied a tentative solution that still has been neither proved nor disproved [13]. The problem is stated as follows: If more than four arbitrarily placed points on a plane are joined by straight lines so that each point is joined to the others, it is possible to join the points so that a certain minimum number of the lines are crossed. In the case of five points, one crossing is unavoidable. What is the minimum number of crossings when one has any specified number of points larger than five?

The unexpected pay-off of our venture lead me into what I might describe as a one-man gambling syndicate in mathematics. I say 'gambling' because, on looking back, this seems to express an important aspect of the venture. The motivation certainly was not that of monetary reward. In fact, the time and effort I have spent working in the field of mathematics that might best have been left to the professionals has since then jeopardized the income I earn from my vocation as an artist.

Have I done this to escape the boredom of art? Was I trying to prove that an 'illiterate' in mathematics, an innumerate, could show interesting notions to mathematicians of which they were not previously aware? My reply to both questions is, in part, yes.

III.

I have presented the above discussion as a preamble to the following analysis of a recent work of mine in which I shall point out the kind of mathematical notions I have 'put to work' within the context of present-day 'mathematical' non-figurative or abstract art.

The work is a low relief structure that I call 'The Nine—Hommage à Khlebnikov' (Fig. 3), which was made between 1975 and 1976. It consists of a white plastic laminated octagonal panel on which are graved the lines shown in Fig. 4. Within this graved configuration are attached 27 L-shaped pieces of the same white plastic material. Each L shape measures 2×1 in (5×2.5 cm) with a thickness of $\frac{1}{8}$ in (3 mm). The sides of the L-shaped pieces are black. A photograph taken from directly in front of the work does not provide sufficient information on its characteristics. They can be observed only when a viewer looks at it from different angles and notes the black sides of the L-shaped three-part clusters.

I have dedicated the work to the Soviet poet and aesthetician Velimir Khlebnikov (1885–1922). He was an important figure in the Formalist Movement in the arts. His poetry is well known in the U.S.S.R., but his theoretic aesthetics are not available at

Fig. 2.

Fig. 3. *'The Nine—Hommage à Khlebnikov', relief structure, laminated plastic, 91.5 × 91.5 × 1.9 cm, 1976.*

Fig. 4. *Location of graved lines on the panel of the relief structure* (cf. Fig. 3).

tion differ, but each of them is mathematically identical to the tree variant A.

Fig. 5. *'Co-structure, No. 2, Hommage à Roberto Frucht' (Version 3), welded stainless steel,* 1975. (Photo: R. Scherman, London.)

present. What I know of his work and of the Formalist Movement in general interests me greatly. It is noteworthy that a line of development from this Movement runs from Roman Jakobson, one of its founders, who left the U.S.S.R. to settle in Prague, where he headed the 'Prague School'. He then emigrated to the U.S.A. where his linguistic work influenced, among others, Noam Chomsky. I have dedicated my structural relief 'The Nine . . .' to Khlebnikov in admiration of his work and so I hope it will not be taken as a pretentious act.

Earlier, I dedicated a piece of sculpture (Fig. 5) to Roberto Frucht, a German mathematician living in Chile, who greatly helped me to develop ideas in which he was much interested.

'The Nine . . .' (Fig. 3) is the last of three relief structures bearing the same title. The other two have a square format and the same L-shaped elements are employed. With the help of the diagrams in Fig. 6, I shall explain what are the characteristics of the nine configurations of the L-shaped elements in Fig. 3 and why there are only nine distinct configurations. This explanation involves the mathematical domain—Graph Theory. A good introduction to the subject can be found in Ref. 14. Readers of *Leonardo* will find Refs. 15 to 18 helpful as regards the meaning of the special terms that are used below.

In Fig. 6, the *trees* labeled A, B and C are, by definition, the same mathematical type of tree, but they differ in appearance because each is embedded (or laid out) in a different type of grid or lattice— that of A is hexagonal, of B, square, and of C, tri-angular. The hexagonal lattice permits the tree A to be embedded in it in eight different ways. If each of these is *rotated* in all possible ways around the *nodal points* (a nodal point is a point from which at least three lines emanate), one finds that there are a total of 8 × 12 or 96 trees whose configura-

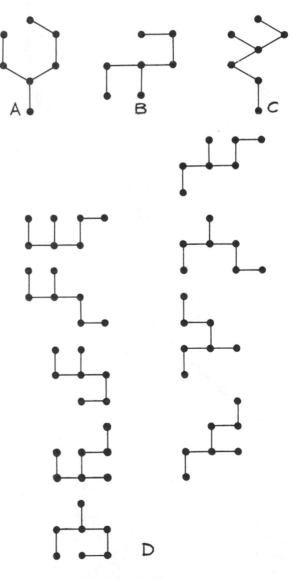

Fig. 6. *Tree configurations.*

In the case of tree variant B, one obtains 8×65 or 520 trees of different configuration and for tree variant C, the product of 12×733 or 8796 trees of different configuration.

The numbers 96, 520 and 8796 are a 'function' of the *symmetry group* of the chosen tree type, which in this case is asymmetric, that is, its *automorphism group* is restricted to that of *identity* (it has no other automorphism). In Graph Theory such a tree is called an *identity tree* and the type I have chosen (A, B and C) is the smallest of *group order* 1, having seven points and six lines, Fig. 8.

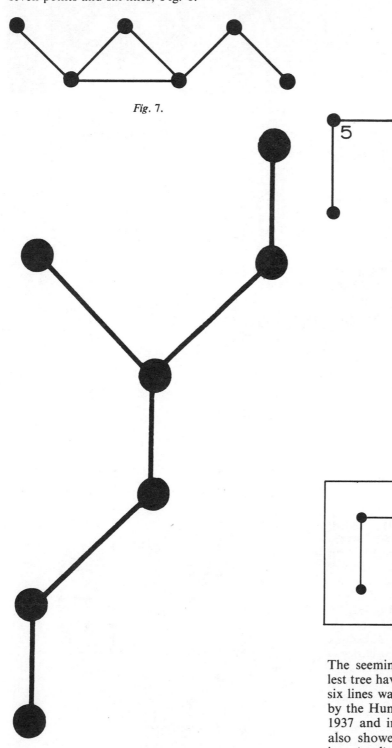

Fig. 7.

Fig. 9.

Fig. 10.

Fig. 8.

The seemingly simple observation that the smallest tree having group order 1 has seven points and six lines was communicated in a well-known paper by the Hungarian mathematician George Polya in 1937 and independently by Frucht in 1938. Polya also showed that the smallest *asymmetric graph* is *unicyclic* (as can be seen in Fig. 7, it has one

cycle or circuit and the same number of points and lines). The asymmetric tree was the basis of a recent relief I made and the eight configurations associated with tree A in Fig. 8 served as the basis of a series of reliefs that immediately preceeded the relief I have analyzed (Fig. 3).

I shall now explain what is common to the nine trees shown in Fig. 6 D, which were selected from the 65 associated with the tree B. Each of the nine has two common features, each has five right angles (Fig. 9) and each can be drawn by connecting three graphs of L-shape, thus allowing sets of two lines to be within an area that can be coloured (Fig. 10).

In my serigraph 'Parity Study' (1971), which is based on the above ideas, the areas enclosing the trees are coloured red and blue. The relief 'The Nine ...' is white throughout, except for the black sides of the L's. The decision to use in 'The Nine ...' graved fragments of a lattice and the four long lines emanating from alternate corners of the octagon, a cyclical symmetry (Fig. 4), thus contrasting with the 3×3 array of configurations made of elements of L-shape, was made on the basis of my aesthetic trials.

I shall not here present other aspects of 'The Nine...', such as the way the nine configurations of L-shaped elements are individually disposed in the array; they will be seen to follow discernible rules.

I hope that readers will be helped by my analysis to understand the process I used to 'put to work' in an art work an abstract idea from the domain of mathematics. As I pointed out, decisions of an artistic character were made and they were arrived at on the basis of my personal experience. I took a structural theme, which is essentially qualitative, and realized it in a presentation that involves measured modulations. The theme derives from the domain of combinatorics (which embraces Graph Theory), but I have also made use of some of my own small mathematical discoveries.

REFERENCES

1. S. Giedion, *Mechanization Takes Command: A Contribution to Anonymous History* (New York: Oxford Univ. Press, 1948).
2. L. L. Whyte, The Unity of Visual Experience, *Bull. of the Atomic Scientist*, p. 20 (Feb. 1959).
3. N. Bourbaki, *General Topology* (Paris: Hermann, 1966).
4. P. Bernays, Comments on Wittgenstein's Philosophy of Mathematics, *Ratio II* (No. 1, 1959).
5. *C. S. Peirce. Collected Works*, P. Weiss, ed. (Cambridge, Mass.: Harvard Univ. Press, 1931).
6. C. Johnson, On the Mathematics of Geometry in My Abstract Paintings, *Leonardo* **5**, 97 (1972).
7. A. Hill, The Structural Syndrome in Constructive Art, in *Module, Proportion, Symmetry, Rhythm*, G. Kepes, ed. (New York: Braziller, 1966) p. 168.
8. F. Le Lionnais, Marcel Duchamp as a Chess Player, *Studio Int.*, p. 23 (Jan/Feb 1975).
9. Le Corbusier, *Le Modulor* (Paris: Collection Ascoval. Editions d'Architecture d'Aujourd'hui, 1950).
10. A. Hill, The Spectacle of Duchamp, *Studio Int.*, p. 20 (Jan./Feb. 1975).
11. A. Hill, Constructivism—the European Phenomenon, *Studio Int.*, p. 144 (April 1966).
12. J. E. Littlewood, The Zoo, in *A Mathematician's Miscellany* (London: Methuen, 1953) p. 214.
13. F. Harary and A. Hill, On the Number of Crossings in the Complete Graph, *Proc. Edinburgh Math. Soc.* **13**, p. 333 (1963).
14. R. J. Wilson, *Introduction to Graph Theory* (Edinburgh: Oliver and Boyd, 1972).
15. F. Harary, Aesthetic Tree Patterns in Graph Theory, *Leonardo* **4**, 227 (1971).
16. F. Harary, A Mathematical Approach to Nonfigurative Modular Pictures, *Leonardo* **9**, 215 (1976).
17. A. Hill, Art and Mathesis: Mondrian's Structures, *Leonardo* **1**, 233 (1968). See also Program: Paragram: Structure, in *DATA: Directions in Art, Theory and Aesthetics*, A. Hill, ed. (London: Faber & Faber, 1968) p. 260.
18. F. Nake, *Ästhetik als Informationverarbeitung* (Berlin: Springer, 1974), see Mondrian Strukturel-Topologische, p. 311.

THE MAKING OF A PAINTING

Stanley W. Hayter*

Abstract—*The artist gives an account of his process in making a painting to the extent of the factors of which he is conscious. He states that he believes that the most important factors will remain unknowable.*

He points out that he has some experience in the fields of physics and mathematics and with the general methods of scientific research. He has specially been interested in fluid motion and structure and wave motion in air and in water. He believes that an artist who cannot feel the difference, for example, between various wave shapes lacks a most valuable sensibility.

The subject of his painting 'Transformations' was determined by his interest in various wave forms. The general plan of the painting is described. Before describing the process used in the making of the picture, he discusses the human preference for directions towards the right rather than to the left and from the top downwards rather than from the bottom upwards. By the use of these preferences or asymmetries he believes that a static painting can give an illusion of motion, provided that the eyes can be compelled to follow simultaneously two lines at different speeds.

In the final section he describes in detail the seven steps which made up the process he used in making the painting.

He concludes by stating that 'Transformations' might on the one hand transmit to an observer the relationship between the painting and various kinds of wave patterns in nature. On the other hand the painting might give the observer an understanding and experience of combinations and contrasts of wave forms in general.

I. INTRODUCTION

I propose in this paper to give a factual account of the making of the painting 'Transformations' (Fig. 1, cf. colour illus. E, p. 307) with a few digressions which are needed to establish a background of theory to make the operation understandable. First, my feeling is that any work of mine starts from a physical situation which must be one offering a large number of possibilities of development which can be continued by definite stages of successive transformations. The consequent stages are not necessarily logical successions; they may be analogical or irrational, but are still felt as consequences. A mathematical parallel would be the development of permutations of series or a succession of matrices having some terms in common.

The incentive and motivation that compel me to undertake a work are not consciously known to me and I doubt that they can ever be known. Furthermore, those qualities which determine the affective power of a work, whether it is emotionally satisfying or not, can only be expressed in terms of the subjective reaction of a person not involved in its creation. I have suggested elsewhere that a work

of art can be considered to come into existence only at this point [1].

For the following descriptive text to be understandable, it is necessary for me to refer to some of my previous conditioning experiences. My absorbing interest in fluid motion and structure, wave motion in air and water and rhythm in general, will become obvious. Some experience in the field of physics, mathematics and the general methods of scientific research may account for my view of art as an enquiry into reality by means other than those of science [2–11].

Mathematics is axiomatic and starts in all cases with 'let there be ...' meaning 'let there be nothing but ...' That is to say with the exclusion of matters not considered relevant to the subject of investigation. Having arrived at the end of an operation it is often necessary to re-examine the initial assumptions to see that no matter operative in the result has been excluded. In graphic expression an artist who is unable to feel the difference of configuration between helicoidal, spiral, elliptical, parabolic, catenary, trochoidal and sinusoidal curves is lacking a most valuable sensitivity. However, if he be able to examine a mathematical expression formulating these curves he may add to the awareness of their graphic implication the knowledge of those forces that determine them.

*English artist living at 12 rue Cassini, 75014 Paris, France. (Received 29 May 1968.)

154

II. PLAN

My interest in general conditions rather than in specific incidents determined the choice of the subject of the painting. Thus there was no intention to reproduce the appearance of a specific wave formation or of a rippled surface. The objective presentation of a phenomenon as existing independent of the observer was not attempted, as my feeling is entirely in agreement with the attitude of present day science that this is illusory. A knowable 'fact' is a complex *phenomenon ⇄ observer* relationship so the subject of a painting is a fluid pattern of understanding in the mind of the artist and the viewer. Each successive operation extended over the entire surface of the work so that at each stage its appearance was totally transformed. Hence the process was a development by means of successive metamorphoses rather than one of accretion or elimination. Since transparent glazes or open webs were used, all of the stages remain visible in the finished work. Although each operation followed a systematic plan, the interference between operations after the first two or three steps became apparently erratic, in any case unforeseeable. The superposition of serial elements, as it were, out of step, ensured that no configuration would repeat within the scope of the canvas. Some degree of error in execution, due perhaps to unconscious variation of form, might introduce ambiguity which would extend the possibilities of communication.

III. SITUATION OF DEPARTURE

From the observation of the form of standing ripples due to obstruction in the flow of a stream it was noted that they were approximately assymptotic to a V with an angle of 60° (Fig. 2). This suggested to me a general rectilinear structure in which the equilateral triangle, the exchange of trigonometrical ratios for 60 and 30° could be used as a unifying principle. Consequent upon this, a system of trochoidal wave profiles, having a ratio of amplitude H to wave length L equal to 1:7, were to be stepped upwards with crests following at 30° to the horizontal. This ratio gives an angle of 120° at the crest, which is a minimum in sea waves as a steeper crest will break. Another system of sinusoidal curves with the same $H:D$ ratio were to be superimposed upon the trochoidal waves with their crests on a descending diagonal towards the right, also at 30° to the horizontal. The possibility was seen of completing the work by superimposing a system of two interfering parallel harmonic curves on descending diagonals with increasing amplitude and wave length.

The characterization of diagonals as ascending or descending depends upon some mirror image experiments first made in the 1940's. We found that when the interval of observation was made sufficiently short, a visual field is invariably followed by the eye from left to right. We found that this tendency was not affected by left-handedness, reading habits (as Arabic, Hebrew) or other conditioned reflexes.

There is a well known incongruity in the mirror image of certain asymmetric forms as the helix, all tetrahedra with the exception of the regular 60° tetrahedron, etc. That is, by no manipulation, except another inversion in a second mirror, can the mirror image be made to coincide with the original.

This phenomenon led me to the formulation of a hypothesis which can be illustrated as follows: If the three dimensions of convention are represented by axes X, Y, Z, intersecting at a point O at right angles (Cartesian co-ordinates) and, as all of the directions are reversible and commutative, our model is symmetrical. Now, if we draw a circle in space, we appear to return to the point of origin and to have completed a closed figure. However, as this demonstration took some measurable time to execute, the point of departure had receded into the past and the 'return' was to a similar point but not to the point of origin. Thus the figure traced was an open helix and not a closed circle. Seen in a mirror its direction is inverted and its image will not coincide with the helix as traced.

To return to the original model—in order to include the unidirectional flow of time—we must add a fourth axis, as an arrow. Consideration of this co-ordinate system shows that in only two ways can symmetry be preserved: with the observer situated in the axis of time, either with the arrow directed towards or away from him. But these situations would require him to remove himself from the flow of time, so that in one case he would see everything from a point in the past (which for him no longer exists) or in the future (which for him does not yet exist). As he can only exist in a moving present, he cannot be in the axis of time, and so the arrow symbol will appear to him directed either to his right or to his left. His space is thus asymmetrical. The experiments referred to above suggest that the arrow points to the right; confirmed somewhat by the use of the word for 'right' in all languages as more favourable than 'left'. (In French *gauche*, *maladroit*; in Italian, *sinistra* etc.) This unidirectional time factor thus imposes a clockwise helical distortion on observed space. (The hands of a clock describe a plus 1 helix in four dimensional time-space.) Thus a diagonal in a SW. to NE. direction is read as ascending and the NW. to SE. direction as descending. We have furthermore noted a failure of symmetry from top to bottom; as a syncline curve is read as convex and an anticline as concave and the inversion interchanges these figures.

If it is intended to use either actual motion or implied velocity in a work of art, it is clear that these asymmetries and the time factor must be taken into account. As with the well known example of the two trains of Einstein, the experience of motion is concrete whether your train or the other is moving. If then we can compel the eye to follow two curves at once at different speeds, the experience of motion has been transmitted as effectively as if actual motion had been employed. Thus the work can become a kinetic object, although no actual displacement occurs in it.

Fig. 2. Sketch of trochoidal waves showing lines along their crests.

Fig. 3. Sketch of superposed trochoidal and sinusoidal waves.

IV. PROCESS USED IN MAKING THE PAINTING

1. The size of the canvas of 'Transformations' is 6 ft 8 in. × 13 ft 4 in. With acrylic base titanium white mixed with 0·1 per cent of a fluorescent compound, straight lines, spaced at random, were traced at an angle of 60° to the vertical in succession, descending from the left more frequently than from the right. These lines provided a network upon which

trochoidal and sinusoidal waves were superimposed.

2. A transparent wash of Phthalo blue merging into Phthalo green was applied along the diagonals from the upper left to the lower right. The intensity of hue was increased towards the lower right, reaching the maximum saturation of hue possible with these pigments at the bottom of the canvas.

3. A wash of alkali blue (blue violet) in the form of narrow diagonal bands was painted descending from right to left across the diagonals in Step 2. The

white lines (Step 1) were still visible, the transparent washes were thinned by rubbing with benzine (Cf. Fig. 1).

4. Trochoidal wave lines in acrylic black were then introduced. The angle of the wave crests was 120° and the ratio of amplitude to wave length was taken as 1:7 (Cf. Fig. 2). These curves were constructed on circles representing the circular paths of water particles caused by a passing surface wave in deep water. The trochoidal wave lines were placed with their crests on a descending diagonal at 30° to the horizontal. These lines will not be parallel: they come closer together on the line of the crest (Cf. Fig. 1).

5. Fluorescent red lines were next painted in the shape of sinusoidal waves with the ratio of amplitude to wave length of 1:7 and with the same intervals as for the trochoidal waves in Step 4. The crests were also placed on a descending diagonal at 30° to the horizontal (Cf. Fig. 3).

6. In this step, parallel harmonic (sinusoidal) lines of increasing amplitude and wave length, spaced between one to three times the width of the lines, were traced on the surface in fluorescent yellow. The lines start concave at the left of the painting and end convex at the right (Cf. Fig. 1).

7. In the final step, parallel sinusoidal curves of increasing amplitude and wave length (with intervals similar to those in Step 6), starting with a convex shape at the upper left of the painting and ending with a concave shape at the lower right, were traced in transparent ruby lithol B. These curves coincide with those in Step 4 on an ascending diagonal at 30° to the horizontal about two-thirds of the way across the canvas from the left. The sinusoidal waves of Step 6 and Step 7 intersect at maximum angle of approximately 60°.

V. CONCLUSIONS

In conclusion, I wish to state that I believe my painting 'Transformations' might on the one hand transmit to an observer the immediately observable relationship between the painting and the wave patterns on the surface of the sea, of a stream flow or of wind driven clouds. Another observer might be reminded of the periodic character of footsteps, respiration, heart beats or sound and light waves. On the other hand the painting might give an observer understanding and experience of combinations and contrasts of wave forms in general.

REFERENCES

1. S. W. Hayter, Of the Means, *Trans/Formation*, No. 1 (1950).
2. S. W. Hayter, *Possibilities No.* 1 (New York: Wittenborn, 1947).
3. S. W. Hayter, Line and Space of the Imagination, *View* (1944).
4. D'Arcy W. Thompson, *On Growth and Form*, Second ed., reprinted, 2 vols. (Cambridge: Cambridge University Press, 1952).
5. N. Feather, *Vibrations and Waves* (Edinburgh: Edinburgh University Press, 1961).
6. Bascomb, *Waves and Beaches* (New York: Dover, 1964).
7. D. Hilbert and C. Vossen, *Geometry of the Imagination* (New York, 1952).
8. W. Heisenberg, *The Notion of Nature in Modern Physics* (New York, 1964).
9. T. Schwenk, *Le Chaos Sensible* (Paris, 1963).
10. H. Weyl, *Symmetry* (Princeton: University Press, 1952).
11. G. Kepes, Ed., *Nature and Art of Motion* (New York: Braziller, 1965).

UNIFIED DRAWING THROUGH THE USE OF HYBRID PICTORIAL ELEMENTS AND GRIDS

James W. Davis*

Abstract—*The author presents a concept of unity in drawn compositions involving combinations (hybrids) of disparate or analogous pictorial elements. He discusses a series of hybrid types that concern him particularly. Reference is made to particular types of imagery and their effects, such as the feelings of direction, movement and expansion. The effects of repetition and the use of grids are discussed. He points out that grids can be employed to emphasize imagery and to give the feeling of the passage of time.*

In the concluding section, the author outlines the use of grid structures in Western art, beginning with functional purposes from the time of Ancient Egypt to the Renaissance, and their aesthetic application up to the present.

I. HYBRIDS IN MY WORK

Every work of art involves combinations of elements, even when its composition is simple. These combinations unite effectively to produce a whole. Hans Hofmann once wrote 'metaphysically, a thing in itself never expresses anything . . . it is the relation between things that gives meaning to them and that formulates a thought' [1]. In relation to perception, Mondrian claimed that isolated 'sensations are not transmissible', whereas, 'only relations between sensations can have an objective value . . .' [2]. Similarly, Robert Morris stated that 'a single, pure sensation cannot be transmissible precisely because one perceives simultaneously more than one as parts in a given situation: if color, then also dimension; if flatness, then texture' [3].

I am particularly conscious of combinations of diverse elements in my work. Some might consider them to be incongruous. Yet, I feel that hybrid elements do combine and that they can be united in a whole to comprise a complete drawing.

Some of the hybrids that concern me are:

1. *Image hybrids.* Combinations of images. They may be realistic, symbolic or non-figurative. My hybrid drawings have included both natural and man-made elements (cf. Fig. 1).

2. *Style hybrids.* Combinations involving more than one technique or style. Here I include variations and degrees of texture, symmetry, clarity, curved and straight lines etc. (cf. Figs. 2 and 3).

3. *Area or space hybrids.* Combinations of discrepant pictured surfaces or illusions of varied depths and volumes (cf. Fig. 4 and Fig. 5, cf. color illus. F, p. 308).

4. *Size or scale hybrids.* Combinations of objects depicted in incongruous sizes or scale relations (cf. Figs. 2 and 6). Samaras has spoken of 'mental' scales in reference to his figurative work in a manner that relates to mine [4]. Scale is of special concern today to those working with minimal imagery [5].

5. *Time hybrids.* Combinations of elements and concepts representing different historical periods or epoques. They often result from 'flashbacks' within an artist's life. Gorky's work, for example, contains images from both his earlier experience (cf. 'Garden in Sochi') and previous paintings [6]. Similarly, Tzara stated that 'a form plucked from a newspaper and introduced in a drawing or picture incorporates a morsel of everyday reality into another reality constructed by the spirit' [7].

6. *Manifestation hybrids.* Works made by a group of people. Some of the frescos of the Renaissance are good examples. Apprentices working under a master frescoer occasionally left traces of their own ideas and style (a style hybrid). One of the best known fresco cycles of the Proto-Renaissance, the St. Francis series in the chapel of San Francisco in Assisi, has been attributed not only to Giotto but also to Giotto's assistants and followers [8, 9]. The present St. Peter's church in Rome is an excellent example of an architectural manifestation hybrid. The building was designed as a centralized structure in 1506, elongated into a

*Artist living at 216 N. Normal St., Macomb, IL 61455, U.S.A. (Received 5 September 1970.)

1

Fig. 1. '*Metamorphosis*', *ink, acrylic paint, pencil, polymer transfer*, 46 × 61 cm, 1966.
(Collection of University of South Dakota, U.S.A.)

Fig. 2. '*Epidermic Structure Section*', *pencil, ink*,
38 × 38 cm, 1969.

Fig. 3. '*Lunar Landscape Series: Diffusion*', *ink, pencil,
acrylic paint, spray paint*, 38 × 51 cm, 1969.

naved church between 1607 and 1615, and given an elegant Baroque Colonnade a half-century later [10]. Other examples are Post-Columbian wall paintings in Latin America that contain Pre-Columbian symbols as well as Christian imagery [11] and the large murals painted by groups of artists under the Works Progress Administration (W.P.A.) program in the United States during the 1930's. In a previous article in *Leonardo*, I described the method of making a 'conversational drawing', that is, a spontaneous drawing by two or more persons [12]. This is a favourable method for making a manifestation hybrid.

II. IMAGERY IN MY WORK

After I had begun to use grids in my drawings (1966), several stylistic characteristics became prominent: (1) *Direction*—a result of figure sequences in which the image is repeated through stages (cf. Figs. 1, 4 and 7). There is the sensation of image 'thrust' through repetition (cf. Fig. 4).

Fig. 4. 'Lunar Landscape Series: Projectile Tract', pencil, ink, acrylic paint, 61 × 46 cm, 1969. (Collection of Allan Schindle, East Lansing, Michigan, U.S.A.)

Fig. 6. 'Lunar Landscape Series: Patellar Movement', pencil, ink, 38 × 38 cm, 1969.

(2) *Transformation*—a feeling of progression and change expressed through stages (cf. Figs. 1, 3, 8 and 9). (3) *Symmetry* and the sensation of *expansion* (cf. Figs. 6, 7, 8 and 9).

Certain images used in my work have reappeared in modified form in later drawings. The most obvious one is the crater image in my 'Lunar Landscape' series (cf. Figs. 4, 6 and 9). I have used such an image repeatedly in contrasting ways. For example, I have employed symmetrical/asymmetrical presentation, precise/imprecise execution, geometric/organic forms, figurative/non-figurative content and static/dynamic relations.

I feel that visual dichotomies stimulate a parti-

cular response due to the existence of dualities in human character. One of the most challenging dualities studied by psychologists resulted from the recognition of the limitions of the behaviorist psychological concept of human activity as a direct response to environmental conditions. The behaviorists often did not take into account self-causal (including hereditary) influences on human activity. The human organism may be viewed as the controller of, as much as the responder to, his environment. The two together might be said to be of a hybrid kind.

Past and present experiences, the environment and the imagination serve as primary sources for artists. John Elderfield has described some processes of drawing [13] that I feel are hybrid in nature in that they combine multiple sources. These include an artist's past experiences (called by him *drawing on*), as well as the environment and the immediate conditions under which the drawing is made. He coined the expression 'suspension of narrative' to describe drawings in which the depiction of certain remembered fragments of an experience serves to represent or reveal that experience in a condensed form.

Arnold Rockman described two distinct forms of artistic perception in a recent issue of *Leonardo* [14]: one that involves direct acceptance, regardless of predispositions toward specific characterizations and subject matter within an art object and its context, and another that operates from a hierarchical point of view. The hierarchies often controlling perception include a wide variety of subject matter, media and formal relationships that have developed within the traditions of a given culture. These can insulate the perceiver from, or open him to, the actual properties of a work of art. For artists, they can serve as inhibitors to what might otherwise develop in their work.

Rockman borrows Sorokin's concept of *sensate* v. *ideational* forms of social interaction and applies it to these variant aspects of artistic perception. The *sensate* form embodies experiences that are directly tied to and formed through the nature of the objects of perception. As Mandelbrojt and Mounoud point out, on the basis of Piaget's theory of the visual arts, each human being possesses an internal organization that has its own history and determines the level of structuration that can be imposed on the universe of objects. Thus artists assimilate reality to what could be called their 'form awareness of the moment' [15].

It is important to realize that art does not develop from a vacuum, nor does the experiencing of it. Much of the information needed to assimilate external phenomena is already present within the artist as it is applicable to what he is 'making' and for the perceiver a similar body of information can be used in the 'seeing' of art. It is a matter of each 'triggering' the other. Internal data is (or becomes) misinformation if it provides only insulatory material (such as the oft used dictum: good art is only asymmetrical, therefore, one should never respond

Fig. 7. 'Inner-Outer Earth', pencil, ink, 36 × 43 cm, 1969.

Fig. 8. 'Suspended Landscape', pencil, ink, 36 × 41 cm, 1969.

Fig. 9. 'Lunar Landscape Series: Expansion/Contraction', pencil, ink, 36 × 36 cm, 1969.

positively to symmetrical forms) and accommodation to a new art form is, under these conditions, impossible. Further, accommodation (acceptance of both exhibited and implied properties), by its very nature, precedes assimilation (understanding).

Piaget's theory dealt with the individual's internal structure as the basis of the organizing process in the development of ideas [16]. I can see no reason why the same principle cannot be considered as useful

in the perception of external reality. The *ideational* form of perception relies upon prior introduction or explanation before the experiencing can take place and be considered legitimate [17]. The conflict between sensate and ideational forms of experiencing stem from several factors inherent in the latter, including: (a) a high social regard for linear and logical orders of perception, which are assumed to be

preceded by definite linear explanations (conveyable as verbal 'meaning'); (b) that art should not directly enter or draw upon the fibre of the everyday world but should remain 'above' it in a pre-ordained role and (c) that deviations from the norm disrupt the expectations for a kind of aesthetic experience.

The 'cognitive dissonance' caused by unexpected groupings in art should not, although it often does, close the door to perception [18]. There are some works of art that can be more easily assimilated than others but the perceiver must try to respond to whatever is present or suggested in the work. Pictorial elements, whether intentional or not, in a successful art work are grouped to provide a whole. It is my responsibility as an artist to make accessible or understandable pictures. Beyond the singular values of self-expression for its own sake, lies the domain of communication through art. I differentiate between accessibility and acceptability. Acceptability depends on taste; it is based upon a priority system that often rejects those things for which one has had no 'preparation'.

There are certain established types of visual groupings (particularly those of imagery and compositional elements) that the public, and to a lesser extent the artist, is predisposed to accept as 'usable' in a work of art. There are also certain hybrids toward which there are predispositions of non-acceptance. I realize that my 'bizarre' image hybrids, showing contrasting opposites, fall within the second category. But I do not feel that any of the elements in my works are as bizarre as those present in the 'funky' works of several American Pacific Coast artists [19].

Part of the reason for limiting my choices of imagery and materials may be due to my desire for my work to be more broadly comprehensible. The characteristics of 'Funk' art are unusual imagery and, especially, the hybridization of the comprehensible and the incomprehensible. Of course, such hybridization does not necessarily detract from the quality of a work.

One of the combinations I have used involves allegorical meanings. In several drawings, I have coupled lunar-surface imagery with a variety of allegorical 'life-associated' subjects, such as bones and muscle-like images (cf. Fig. 6). The lunar images when so linked seem to become 'death-associated'. The grays in the lunar surface have been rendered with a silver pencil and, thus, the Moon seems to be hard, almost metallic. Yet, its aged and monotonously scarred surface gives the appearance of a solar system headstone. In 'Patellar Movement' (cf. Fig. 6), the 'death-mask' is tied to the twisting volumes of muscle and bone. I do not see this as a struggle between life and death but as an interaction between the two.

Just prior to my 'Lunar Landscapes', the most common non-figurative element in my work was a grid pattern. I first had the idea of using grids when I was working on paintings consisting of concentric circles superimposed on subject matter derived from works by Vermeer. I was interested in the way the

introduction of these circles transformed the compositions. The eclectic content of these earlier painted works was eventually tempered by the introduction of imaginary landscape motifs that I had developed in the early 1960's.

In several of my other landscapes, I have used grids and the lunar surface motifs to depict a topographical view of the ground plane (cf. Figs. 6, 7 and 9). I have found grid patterns also to be effective for images in series (cf. Figs. 1 and 6) and images that change continuously (cf. Figs. 1, 4, 5 and 9).

It has been suggested by Laurence Alloway that the effect of repetition of images across a surface is 'non-relational', as opposed to the 'relational' effect present when the sizes and shapes of images are different [20]. Alloway's underlying contention is that 'wholistic art' is intrinsically non-relational and consists exclusively of equal and repeated units, each building upon another. This idea serves as a compositional basis for artists working in a strictly serial or minimal manner but avoids wholistic concepts involving variations.

Hilton Brown has stated that the repetitiveness of his grids (done in a highly derivative manner from Mondrian and Fritz Glarner) *is* relational [21]. The ordering of parts in the works of those artists is asymmetrical. A distinction should then be drawn as to the function of rigid repetition and variation, even of a slight amount for both appear simultaneously in several of my drawings (cf. Figs. 1, 3, 4, 6, 7, 8 and 9). I feel that all parts existing in a given whole are relational. While repetition produces a homogeneous effect, I do feel there is little challenge in dealing exclusively with it and other artists feel similarly [22]. There exist natural systems like crystalline formations that are highly ordered. It seems to me that if repeated units have a function in nature, it is to bond them to different kinds of units.

One may ask how grids interact with figurative images of different sizes and shapes. In reference to an art form that differs from mine, Jack Burnham has stated that 'a property of all systems is stability and its counterpart, instability' [23]. On this basis, the grid parts in my drawings may produce stability but then they also draw attention to opposing elements in the composition (cf. Figs. 1, 3, 4 and 7).

My work with grids and craters coupled to other images led me to make map-like structures showing the topography of sites within a grid (cf. Figs. 4 and 7). The documentary drawings and photographs of some of the American 'earthwork' artists reveal a similar interest [24]. Maps containing elevations and cross-sections have drawn my attention because of my interest in the space within and immediately surrounding an object (cf. Figs. 2, 4, 7, 8 and 9).

I have concluded that at least two types of wholeness can result from the use of grids: one that arises from repeated elements and another that derives from a combination of images associated with the grid. Grids can give the feeling of a void or a solid, depending upon the extent to which they are used as individual shapes or as spaces within which other

images exist (cf. Figs. 1 and 3). By grouping some grids into larger primary modules, I have been able to emphasize portions of the composition (cf. Fig. 3).

My consideration for voids as structural elements is shared by other artists, although their application of such spaces may differ [25]. In referring to his sculpture, Tony Smith has said of voids and matter: 'voids are made up of the same components as the masses . . . in this light, they may be seen as interruptions in an otherwise unbroken flow of space . . . if you think of space as solid, there are voids in that space . . . while I hope they have form and presence, I don't think of them as being objects among other objects; I think of them as being isolated in their own environments' [26].

A grid may induce a feeling of time. Each grid square may be viewed as a 'time module', varying in size and placement. Thus images related to portions of the grid are placed in a time structure. When these images are beyond the grid divisions, a feeling of time duration is implied [27].

Multiple views of various images seem to fit well with grids (cf. Fig. 4). I have been impressed by the 'split-screen' effect used in recent television and motion picture productions. Exciting combinations have appeared in which different views of an event or an object are shown simultaneously. Sometimes the action is stopped, reversed or repeated. Such effects can be presented in a drawing through juxtapositions of similar images depicted from various points of view (cf. Fig. 4). In my drawings, sometimes I find that a suggestion of a dramatic change with time is produced on me (cf. Figs. 1 and 4).

Since the Renaissance, artists have been concerned primarily with the visible. In the sixteenth century, Alberti's treatise *Della Pittura*, was representative of such a thinking process. He stated that 'no one would deny that the painter has nothing to do with things that are not visible' [28]. This was quite true for an artist at that time when his own awareness of the world was limited to what he could see. Modern instruments have enabled man to see submicroscopic as well as cosmic structures. I have been interested in the invisible forces associated with matter that physicists study. One method of exploring this in my work is my use of 'invisible' relations between images by transparently drawn connections (cf. Figs. 3, 5, 8 and 9).

The Earth when viewed from outer space appears to be comprised of fluid layers because of surrounding cloud formations (cf. Fig. 7). On the other hand, the Earth's internal structure also consists of layers (cf. Fig. 8). While the make-up of the internal and external layers of the Earth differ, their interdependence as a hybrid formation may be vital. Layer structure is common in nature as, for example, in the human skin when viewed through a microscope (cf. Fig. 2).

Mondrian discussed a 'process of intensification' that occurs through relationships between the parts of a whole [2]. This concept is true of art works in which the parts reinforce adjacent elements through either likenesses or differences. Two distinct types of intensification may be possible through the application of diffuse (cf. Fig. 3) and centralized symmetries (cf. Figs. 7, 8 and 9). A diffuse symmetry is one in which there is overall balance but no evident geometrical symmetry. In my overall grid works (cf. Fig. 3), there are usually diverse points where asymmetrically placed clusters of imagery produce intensifications. An explicit use of details also seems to contribute to image intensification (cf. Figs. 4 and 7.)

III. THE ILLUSION OF MOTION

I have found that a feeling of a contractive or expansive movement can result from concentric placements of imagery. In my drawing 'Expansion/Contraction' (cf. Fig. 9), the dominant feeling of movement is contractive. The eye tends to return to the central focal point but then moves outward again. I feel that such 'pulsations' increase the liveliness of the composition.

Many artists have achieved a feeling of movement in their works through the use of types of lines that affect eye movements, such as those that fade from thick to thin [29]. I believe that this feeling of movement infuses a life-like energy into a work. I have used this in my drawings to relate various parts (cf. Figs. 5 and 6).

While a drawing can give the feeling of motion in a certain direction, alternate possibilites can be suggested by 'invisible lines' (lines that are produced by *not* drawing in an area of the paper) (cf. Fig. 8). Similar results can be obtained from using a variety of line types that range from extremely articulate ones to light ones (cf. Fig. 5).

Robert Morris has stated that the shapes most accessible to the viewer are those within which the parts form a whole [3]. Perhaps a good example may be found in my works that involve concentric circles (cf. Figs. 8 and 9) where the formation of the whole from its parts is especially evident. In my concentric drawings, the central point is my idea of a pictorial equivalent to a center of consciousness. Under these circumstances, I feel that the concept of the infinite can be experienced within the finite. Similarly, George Harrison of the Beatles, a British rock group, poeticized: 'when you've seen beyond yourself—then you may find, peace of mind, in waiting there—and the time will come when you see we're all one, and life flows on within you and without you' [30].

IV. GRID STRUCTURES IN WESTERN ART

A brief description of the traditional uses of grids in art has appeared in *Leonardo* [31]. I do not believe an extensive treatment of this topic has been published recently and, therefore, I shall discuss other ways in which grids have been used.

Grids in art have had both artistic and functional purposes. The Egyptians used grids to establish a

canon of figure proportioning in wall frescos during the Middle Kingdom at Thebes [32]. This method for establishing size relations for the human body remained a traditional device into the Renaissance and after, and was used by artists such as Leonardo da Vinci and Dürer. The main difference between the Egyptian concept and that of later periods is in the Egyptian emphasis upon unnatural size relations. A more natural proportioning in figure depiction was begun by the Greeks and was developed to a sophisticated level during the Renaissance. Byzantine mosaics provide an example of an early artistic function that is both repetitive and rhythmic. Basic units or patterns were usually repeated with only slight variations over an entire surface.

During Medieval and Gothic times grids were used as a transference device from a sketch on paper to the *arriccio* (plaster wall surface). As in ancient Egypt, the purpose of the grid was to establish size relations in respect to an existing canon. For larger compositions, more lines were 'snapped' on the painting surface with a pigment-coated string. A somewhat clumsy version of this approach was described earlier in Cennini's *Libro dell'arte* [33]. During the fifteenth century, Alberti devised a new technique for applying the grid pattern. The tool used was called the *rete* (net); it provided the artist with a means for transferring small drawings directly onto a large painting surface [34].

Millard Meiss has mentioned that the more selective use of grids during the High and Late Renaissance allowed for a greater degree of individuality in art works, for the artist could study and alter his work as it developed [34]. In several Mannerist cartoons (sketches), the degree of completion in the drawings may cause one to consider the grids as intentional parts of the work. No documentation as to such an intention seems to exist, however [35].

The process used by Alberti and later by Pontormo involved a veil, a fine mesh fabric, that contained a grid pattern. The veil was placed over the sketch and each unit was executed individually on the wall. Although the Renaissance artist probably did not view his grids for their aesthetic value, the modules often contributed to the continuity of the fresco when allowed to remain. This, however, was rare.

During the period following Impressionism, transference techniques were used by several artists including Degas and Gorky. In the case of Degas, the use of grids may have been influential in the artist's development of a 'tilted' type of space [36].

Cézanne, the Cubists, the Futurists, the Constructivists, Mondrian and Malevitch all used grids in the form of grid-like imagery. The grids used by the Cubists are, perhaps, the best known. Their approach involved juxtaposing two or more facets of an image on the picture plane. The edges of these facets closely resemble a grid. The Cubist system emphasized relationships between outer sides more than contained volumes. Volumes were only slightly revealed through minor modulations of color values within the grid. The use of a centralized grid appeared during the Analytical Cubist phase when the more articulate edges and darkest colors were placed toward the center of the format [37].

One of the first artists to apply the linear units of a grid in a symmetrical manner was Gorky. His 'visceral' nature drawings done in Virginia during the late 1940's commonly contain such elements. Earlier, Gorky had used grids only for transference in his 'Portrait with Mother' but in his later drawings the units appear within the finished work [38].

Grids that were broadly defined through repeated figurative images appeared in Pop Art, for example in the work of Andy Warhol. Warhol's 'Campbell Soup Cans' and 'Marilyn Monroe,' contain a homogeneity achieved through a progression of almost identical figurative units.

Another Pop artist working with serial structures is Fahlström, whose comic-strip-type presentation gives views of several combined themes. Fahlström has said of his work that he desires an 'experiencing of fusion . . . reached through impurity or multiplicity of levels, rather than by reduction' [39].

In Op art, one way to produce visual illusions of motion or image fluctuations is through repetition of points or lines. Victor Vasarely had started using grids in the 1930's but it was his later work and that of numerous other artists that led to what is called the Op art movement [40, 41]. Larry Poons, in particular, has been working in a manner similar to mine in that he places 'elliptical' images within a grid and varies their location to give a feeling of floating. The visual illusion of floating dots in front of a ground plane results from his use of points of contrasting colors within a network of shapes [42].

Samaras has used grids in his drawings to effect what he terms a 'dissection of seeing'. Samaras' linear networks were applied to transparent cubical volumes and serve the purpose of identifying size, shape and position [4]. Jack Stites, an American Pacific Coast artist, is one of the few who has applied grids in connection with figurative content. Others who employ grids in a somewhat similar manner are Darby Bannard, John Walker and John Graham [5, 43, 44].

Robert Swain has used symmetrical grid layouts for highly schematic color variations [45]. On the other hand, Ellsworth Kelly has employed a symmetrical distribution of shapes and colors. As is often the case in the work of Poons and Bridgit Riley, the grids in Kelly's pictures are painted out so that their initial presence is implied only by the positions of his color dots [46]. Such an effect has been attempted occasionally by all three artists to give the illusion of randomness even though the basic composition was carefully planned [47]. Shusaku Arakawa has used grids to convey visual dichotomies of flatness and recession by projecting angled lines from various points within a drawn schema [48]. Frank J. Malina has recently made kinetic-Op art paintings in which various kinds of grids are introduced to produce the *moiré* effect [49]. The principles of the *moiré* phenomenon,

produced by grid-like patterns, have been studied extensively by Gerald Oster [50] and he has also applied them in Op art constructions.

Ordinary graph paper has become a relatively common drawing surface for artists in the last few years. Artists using this type of working surface do not usually consider the direct visual effect of the underlying grids upon the applied imagery. In several drawings by Carl Andre, the grids are utilized for the transfer of the image into a sculptural form. It appears that both Morris and Arakawa have used this approach as well, but not necessarily for transference purposes [51]. In the work of Morris, the images have appeared in topographical map form and can be 'read' as mental 'sites'. These drawn and photographic forms were considered by the artist as 'proposals' for Earth constructions. I consider these drawings to be as provocative as the actual work proposed.

Serial imagery is a common factor in minimal works constructed during the last few years by such artists as Donald Judd, Robert Smithson and Sol LeWitt. In the work of Judd and Smithson, a basic unit is often repeated on a large scale and in three-dimensional form, whereas LeWitt's individual cubic objects are 'caged' by grids [52].

REFERENCES

1. H. Hofmann, *Search for the Real* (New York: M.I.T. Press, 1967) p. 40.
2. P. Mondrian, Plastic Art and Pure Plastic Art; in *Modern Artists on Art*, Ed. R. L. Herbert (Englewood Cliffs: Prentice-Hall, 1964) p. 115.
3. R. Morris, Notes on Sculpture, *Artforum* **4**, 44 (February, 1966).
4. L. Samaras, An Exploratory Dissection of Seeing, *Artforum* **6**, 26 (1967).
5. B. Rose, ABC Art, *Art in America* (November 1965).
6. E. K. Schwabacher, *Arshile Gorky* (New York: MacMillan, 1957).
7. M. Osborn, The Mystery of Arshile Gorky, *Art News*, **59** (Fall, 1967).
8. E. T. DeWald, *Italian Painting, 1200–1600* (New York: Holt, Rinehart and Winston, 1964) p. 132
9. M. Meiss, *Giotto and Assisi* (New York: New York University Press, 1960).
10. H. W. Janson, *History of Art* (Englewood Cliffs: Prentice Hall; New York: Harry N. Abrams, 1964) pp. 354 and 407.
11. A. Neumeyer, The Indian Contribution of Architectural Decoration in Spanish Colonial' America, *Art Bulletin* **30**, 104 (1948).
12. J. W. Davis, Visual Dialogue through 'Conversation' Drawing, *Leonardo* **3**, 139 (1970).
13. J. Elderfield, Drawing as Suspended Narrative, *Leonardo* **4**, 15 (1971).
14. A. Rockman, Four Experiments in the Sociology of Aesthetics, *Leonardo* **4**, 134 (1971).
15. J. Mandelbrojt and P. Mounoud, On the Relevance of Piaget's Theory to the Visual Arts, *Leonardo* **4**, 155 (1971).
16. J. Piaget, *Biologie et connaissance* (Paris, Collection Avenir de la Science, Gallimard, 1967).
17. P. Sorokin, *Social and Cultural Dynamics* (New York: Bedminster Press, 1962).
18. Cf. Ref. 13.
19. P. Selz, *Funk Art* (Berkeley: University of California Press, 1967).
20. L. Alloway, Systemic Painting; in *Minimal Art*, Ed. G. Battcock (New York: E. P. Dutton, 1968) p. 45.
21. H. Brown, Some Thoughts About My Work, *Art Scene* **2**, 20 (1969).
22. P. L. Jones, The Failure of Basic Design, *Leonardo* **2**, 158 (1969).
23. J. Burnham, *Beyond Modern Sculpture* (New York: George Braziller, 1968) p. 318.
24. S. Tillim, Earthworks and the New Picturesque, *Artforum* **7**, 43 (1968).
25. S. Glyn, Void or Pattern, *Leonardo* **2**, 175 (1969).
26. D. Smith, in *Tony Smith: Two Exhibitions of Sculpture* (Hartford: Wadsworth Atheneum and College Station, Taxes: The Institute of Contemporary Art, 1966–67).
27. J. Burnham, Real Time Systems, *Artforum* **8**, 50 (1969).
28. L. Alberti, *On Painting*, translated by J. R. Spencer (New Haven: Yale University Press, 1956).
29. J. W. Davis, *Polarity and Expansion* (Houston: Museum of Contemporary Art, 1969).
30. G. Harrison, *Within You Without You* (England: Lyric copyright for the world by Northern Songs Ltd., 1967).
31. G. Wise, Quantities and Qualities: Some Notes on Working Ideas in Art, *Leonardo* **1**, 43 (1968).
32. I. Woldering, *The Art of Egypt* (New York: Greystone Press, 1962) p. 120.
33. C. Cennini, Libro dell'arte; in *A Documentary History of Art*, Vol. 1, Ed. E. Holt (New York: Doubleday Anchor, 1957) p. 137.
34. U. Procacci; *The Great Age of Fresco: Giotto to Pontormo* (New York: The Metropolitan Museum of Art, 1968) p. 29.
35. W. Ames, *Italian Drawings from the 15th to the 19th Century* (New York: Shorewood, 1963) pp. 51, 83 and 92.
36. J. H. Hamilton, *Painting and Sculpture in Europe: 1880 to 1940* (Baltimore: Penguin, 1967) pp. 10–11.

37. H. H. Arnason, *History of Modern Art* (Englewood Cliffs: Prentice-Hall and New York: Harry N. Abrams, 1969) p. 127.
38. J. M. Jordan, *Gorky: Drawings* (New York: M. Knoedler, 1969).
39. O. Fahlström, Take Care of the World; in *Pop Art Redefined*, Eds. J. Russel and S. Gablik (New York: Frederick A. Praeger, 1969) p. 68.
40. W. C. Seitz, *The Responsive Eye* (New York: Museum of Modern Art, 1965).
41. C. Barrett, *Op Art* (London: Studio Vista, 1970).
42. K. S. Champa, New Paintings by Larry Poons, *Artforum* **6**, 39 (1968).
43. J. Von Adlemann, *L.A.–N.Y. Drawings of the 1960's* (Boulder: University of Colorado, 1967) p. 9.
44. I. Sandler; John D. Graham, The Painter as Esthetician and Connoisseur, *Artforum* **7**, 50 (1968).
45. E. Wasserman, New York (Review), *Artforum* **7**, 63 (1968).
46. J. Coplans, The Earlier Work of Ellsworth Kelly, *Artforum* **7**, 48 (1968).
47. G. Rickey, *Constructivism: Origins and Evolution* (George Braziller, 1967) p. 154.
48. W. S. Leiberman, *The New Japanese Painting and Sculpture* (New York: Museum of Modern Art, 1966).
49. *Exhibition Catalogue of the 27th Salon de Mai* (Paris: Salon de Mai, 1971).
50. G. Oster, *The Science of Moiré Patterns* (Barrington, N.J.: Edmund Scientific Co., 1969).
51. J. Burnham, Systems Esthetics, *Artforum* **7**, 33 (1968).
52. L. R. Lippard and Sol LeWitt: Non-visual Structures, *Artforum* **5**, 42 (1967).

CHANGE, CHANCE AND STRUCTURE:
RANDOMNESS AND FORMALISM IN ART

Michael Challinor*

Abstract—*The author seeks, within the realm of aesthetics, an alternative to the idea of the mutual exclusiveness of chance and determinism. He believes this search is relevant to questions concerning artistic creativity and the purely formal content of an art work.*

He considers the topics of randomness and structural order, and discusses their interrelatedness. He avoids a subjective approach in favor of a more technical discussion of concepts and methodology. References to texts are provided from which the reader may obtain details on the forms and logical content of the mathematical ideas incorporated, and may possibly find further artistic uses of the theories pertaining to statistics and communication.

He gives examples of his art works based upon probabalistic programmes. It is not intended that, as logical constructs, they should be compared with the products of fantasy and intuition. They are intended as probes of new areas of creativity and sensibility and as part of a search for a stronger association of abstract thought and its realization as a visually approachable entity.

I. INTRODUCTION

It is my purpose to seek, within the realm of aesthetics, an alternative to the idea of the mutual exclusiveness of chance and determinism. This type of discussion has acquired considerable importance in contemporary scientific thought. I believe it to be also relevant to questions concerning artistic creativity and the purely formal content of an art work.

In the first two of the three main sections of this paper, I consider the topics of randomness and structural order in isolation, partly to describe them in terms appropriate to aesthetic problems and also to elucidate those features common to both, in preparation for a more detailed account of their interrelatedness. A subjective approach is avoided, in favour of a more technical description of concepts and methodology, with frequent references to fundamental aspects of the theory of probability and information theory.

The paper is deficient in so far as it has not been possible to incorporate explanations of mathematical procedures, such as integration and derivations of formulae; so that the reader will be required to accept unquestioningly the validity of some of the arguments. However, a list of appropriate texts is included (cf. Refs. 1–11), so that the reader may see for himself the forms and logical content of the mathematical ideas and possibly find further artistic uses of the theories pertaining to statistics and communication.

The drawings shown in Figs. 1, 2 and 3 are the result of calculation and measurement. They exist as prototypes of a series of automated graphics, designed to explore the possibility of a stable co-existence of conscious decision-making and logical processes in the creation of art works according to a predetermined set of directives. Each of the drawings is identified by a serial number (the common prefix 'St/Ga' being a contraction of 'Stochastic—Gaussian Distribution') referring to the type of probabalistic programme employed in their formulation. The numerical suffixes indicate their positions in their respective series. It was not intended that these works should attempt a comparison of logical constructs with the products of fantasy and intuition but that they should probe new areas of creativity and sensibility, and search for a stronger association of abstract thought and its realization as a visually approachable entity.

II. THE CONCEPT OF RANDOMNESS

A *random* sample is said to be one in which all events are equiprobable. True randomness is rarely exhibited by natural phenomena and attempts to create random patterns artificially can sometimes

*Artist and teacher at Kingston Polytechnic, Knights Park, Kingston upon Thames KT1 2QS, England. (Received 8 December 1969.)

Fig. 1. '*St/Ga/1-01*', *drawing*, 20 × 41 in., 1969.

Fig. 2. '*St/Ga/1-03*', *drawing*, 18·75 × 25 in., 1969.

Fig. 3. '*St/Ga/c1-02*', *drawing*, 15·75 × 23 in., 1969.

suggest that the term is incapable of describing any real situation.

If we consider an experiment consisting of the spinning of a coin, in which the two possible scores *head* and *tail* have equal probabilities, repetition of the experiment will eventually show that the numbers of heads and tails occurring converges to a limit. This limit represents the ideal condition in which the numbers of occurrences of each of the two possible scores are equal. From experience, we know that the score yielded by a single spin of the coin is, for practical purposes, quite unpredictable; that is, it cannot be deduced from the nature of the experiment or any known behavioural laws pertaining to it. In spite of this total lack of *a priori* knowledge of the outcome of such an experiment, the long-term tendency of large numbers of scores to approach a limit value might be seen to imply some deterministic influence on their behaviour.

If, in addition to the definition that random events are equiprobable, we postulate that no relations of a *cause and effect* type exist between the elementary events, that they are *stochastically independent*, then we are in a position to investigate the sequential layout of the sample as a means of identifying it as being random or not.

Testing for randomness is made possible by the *Gaussian* or *Normal Probability Law*, according to a pre-determined level of certainty.

The following sequence consists of fifty binary digits:

00101100001101011000001111100111000101011
000011000

This sequence is to be tested at a *significance level* of $\alpha = 0.05$, which means, in effect, that the outcome of the test will have a level of certainty of 95 per cent.

Denote by n_1 the number of 1's, by n_2 the number of 0's and the number of runs by x. A count of the elementary events, 0's and 1's and runs or collections of identical events, gives the values: $n_1 = 22$, $n_2 = 28$, $n = n_1 + n_2 = 50$ and $x = 23$.

Using the above values, compute the *mean*, μ, when

$$\mu = \frac{2n_1 n_2}{n} + 1,$$

and compute the *standard deviation*, σ, using the formula,

$$\sigma = \sqrt{\frac{2n_1 n_2 (2n_1 n_2 - n)}{n^2(n-1)}}.$$

Consequently, $\mu = 25.64$, and $\sigma = 3.59$. These values are then substituted in the equation,

$$z = \frac{x \pm 0.5 - \mu}{\sigma}$$

using $+0.5$ if $x < \mu$ and -0.5 if $x > \mu$.

The value of this equation is $z = -0.596$. Using a table of *Areas Under the Normal Frequency Curve*, we find that when $z = -0.596$, $P_z = 0.278$ and, since $P_z > \alpha$, the hypothesis that the sequence of

binary digits is random is accepted at the 0.05 significance level.

Although this type of 'runs test' for randomness yields a positive or negative result within a given realm of certainty, it fails to give any further knowledge of the sample. It frequently happens that the question of whether a given array is random or not is irrelevant, it being more important to define the array in terms of a measure of its degree of disorderedness. Such a measure is provided by *Shannon's equation:*

$$H = -\sum p_i \log_2 p_i,$$

where $H =$ the entropy and p_i the probability of an elementary event. The mensural unit is the *binary unit* or *bit*.

Given a variable which assumes the values, $x_1, x_2 \ldots x_n$, having probabilities $p_1, p_2 \ldots p_n$, the entropy of the system is given by:

$$H = -(p_1 \log_2 p_1 + p_2 \log_2 p_2 + \ldots + p_n \log_2 p_n).$$

Although Shannon originally intended his 'Mathematical Theory of Communication' [1] to be applied to telephonic and radio transmission channels, the theory is sufficiently general to be applied to any communicative medium, including the aesthetic one. The entropy formula can be demonstrated in its application to variously irregular geometric figures (cf. Fig. 4).

Having 3 equal sides,
$H = -\sum p_i \log_2 p_i = 0.80$ bits

(a)

Having 2 pairs of equal sides,
$H = -\sum p_i \log_2 p_i = 1.00$ bits

(b)

Having 2 equal and 2 unequal sides,
$H = -\sum p_i \log_2 p_i = 1.50$ bits

(c)

Having 4 different lengths of side,
$H = -\sum p_i \log_2 p_i = 2.00$ bits

(d)

Fig. 4. Application of the entropy formula to variously irregular geometric figures.

The introduction into communications and aesthetics of the *uncertainty relation*, H, can be seen to deny any rigid differentiation between order and chaos; a theme which will be returned to later in another manner.

III. FUNDAMENTAL NOTIONS OF STRUCTURE

Structure, with its connotations of uniformity, stasis and invariability together with the added conditions of coherence and the mutual dependency of parts within a whole, is vital to any organizing process and to any continuity of thought. Similarly, it is a prerequisite of any learning or perceptual process, for the absence of structural characteristics would reduce any aesthetic or linguistic form to an incomprehensible collection of unconnected elements. In the visual arts, the term *structure* usually denotes a formal principle underlying the purely optical phenomena, making visually accessible those relations and connexions between heterogeneous features that comprise an aesthetic entity.

The consideration of structuration as a factor advantageous to communication (aesthetic or otherwise) stems from its function as a limiting device, which, although facilitating comprehension of the particular message, severely restricts the range of single messages and the numbers of different messages that may issue from a pre-determined source. These views of structures, as representing systems of organization essential to understanding and as a constraint on the transmission of information, can be illustrated quite clearly by the most basic structural forms (cf. Fig. 5).

The network in Fig. 5 (a) is a structure whose fundamental component is the isosceles triangle. By borrowing from musical terminology, this component can be described as existing in 'original' and 'inverted' forms, yielding a completely regular network. It is possible to measure its entropy using the equation:

$$H = -\sum p_i \log_2 p_i \ldots \text{bits.}$$

If the information count is based on the numbers of different figures appearing, the entropy of the network will be 0 bits, and this would not differentiate it from other regular geometric grids. A measure based on the linear intervals between points of intersection would give more knowledge of this particular pattern (cf. Note 1).

The fundamental component has only two different lengths of side, having the probabilities of $\frac{1}{3}$ and $\frac{2}{3}$ and giving an entropy of 0·90 bits. The regularity of the structure makes possible its extension to infinity without requiring any alteration of its internal ordering and, thereby, without affecting its level of orderedness.

Figure 5 (b) shows a network having as its fundamental component the scalene triangle in 'original', 'inverted', 'retrograde' and 'inverted retrograde' forms. It comprises a set of three linear intervals, each having a probability of $\frac{1}{3}$, giving an entropy of 1·58 bits.

It will be apparent that a form which is symmetrical about a vertical axis is its own retrograde and that one whose axis of symmetry is horizontal is its own inversion. In addition, the entropy of a regular network is the same as that of its fundamental component; and that networks whose fundamental components are regular figures, such as the square, equilateral triangle and regular hexagon, have an entropy of 0 bits.

Equality and symmetry as attributes of structure are not restricted to purely metrical schemes. An example of a structure unqualified by mensural characteristics is provided by the *algebraic theory of groups*. A group of operations has the property that, if one operation of the group is applied to any one of an appropriate set of objects, it automatically reproduces another of the set.

A simple example of a group is that of the substitutions of three elements taken in order. Denoting by S the operation of changing *abc* into *bca*, we may write:

$$S.abc = bca.$$

Hence,

$$S(S.abc) = S(bca) = cab.$$

This may be written as:

$$S^2.abc = cab.$$

(a)

(b)

Fig. 5. (a) *Network whose fundamental component is the isosceles triangle.*
(b) *Network whose fundamental component is the scalene triangle.*

Similarly,

$$S^3 . abc = abc.$$

This last operation may be written as, $S^3 = 1$, which indicates that the operation S applied three times in succession will reproduce the original object abc.

From the foregoing it follows that $S^{3n+r} = S^r$ where n and r are positive integers, and that any succession of such operations will be equivalent to 1, S and S^2.

The inverse operation S^{-1} is defined by the identity $S(S^{-1}) = 1$, so that,

$$S^{-1} . abc = cab = S^2 . abc \quad \text{or} \quad S^{-1} = S^2.$$

An operation consisting of any combination of successively applied operations of the set 1, S or S^2 will be equivalent to one of these three; then these comprise a group of the third order, since the number of distinct operations in the group is three.

Let T, U and V be operations such that, $T.abc = acb$, $U.abc = cba$ and $V.abc = bac$.

Then, $T (T.abc) = T.acb = abc$ and, therefore, $T^2 = 1$.
Similarly,

$$U^2 = 1 \text{ and } V^2 = 1.$$

Also,

$$U(V.abc) = U(bac) = cab = S^2.abc.$$

So that,

$$UV = S^2.$$

Note that while $UV = S^2$, $VU = S$.

The operations 1, T, U, V, S and S^2 form a group of the sixth order. It includes one sub-group of the third order, 1, S and S^2; and three sub-groups of the second order, 1, T; 1, U and 1, V.

The one factor intrinsic to all structures is *redundancy*. Redundancy constitutes a restriction of the choice of combinations of symbols or objects. A linear pattern consisting of two or three lengths of lines might take on a highly varied aspect but the formation of these lines into triangular units as in Figures 5 (a) and (b) places a constraint upon the combinatorial properties of the linear elements. Redundancy is most clearly manifested in repetition or any kind of invariance. The algebraic group of finite order is essentially a primary form, such that combinations of operations equate an existing operation within the group and such combinatory operations can be said to be redundant.

An excellent example of redundancy is exhibited by language. If we consider the Roman alphabet as consisting of twenty-seven characters, that is as twenty-six letters and a space; the number of combinations of these twenty-seven characters, taken 1, 2, 3 ... n at a time, is very great, in fact, the source entropy is very high.

Owing to the fact that certain characters and combinations of characters have varying probabilities, according to the accepted statistical rules governing the language, it is possible to evaluate the entropy of a received message. The ratio of the *received entropy* to the *source entropy* gives the *relative entropy*. If, as in the case of the English language, this relative entropy is 0·5, this means that the language, in its choice of symbols to form a message, is about 50 per cent as free as it could possibly be.

If we denote by H the *source entropy*, and by H' the *received entropy*, the *relative entropy* is given by,

$$H_R = \frac{H'}{H}$$

and the redundancy is,

$$R = 1 - \frac{H'}{H}$$

The redundancy represents that fraction of the message determined by pre-existent rules and the relative entropy indicates the extent to which the language permits freedom of choice with the same set of symbols. The redundancy of a language has a considerable bearing on its expressive range and the ease with which it may be learnt. If it were possible to have a language with only 5 per cent redundancy, learning it would be virtually impossible, conversely, a language which was 95 per cent redundant would be so simple and so limited that it would not be worth while learning it at all.

These discussions of structure and randomness have, for both concepts, reached a point at which neither phenomenon can be satisfactorily described in absolute terms. By invoking the *uncertainty relation*, H, and the concept of redundancy, however, we have been able to consider events and forms in a purely relative way. But this relativity, far from being inferior to precise definition, actually makes possible the measurement of the presence or absence of organizing principles, granting us an objective view of physical and aesthetic situations.

IV. THE ORDER—DISORDER TRANSITION AS A STOCHASTIC PROCESS

In both ancient and modern Greek the word *stochastic* means *focus (of thought)* or *point of aim*. Jacques Bernoulli, at the beginning of the eighteenth century, introduced the term into mathematics in his paper, 'Ars Conjectandi', in which he propounded the *fundamental law of large numbers*. He used the word '*stochastic*', since the law of large numbers states that the more numerous the phenomena, the more they tend towards a determinate end. It now has a very general usage in describing situations governed by probabilities.

Since, in this study, chaos and structural order are viewed as only limiting cases of physical reality, that is, as the extreme ends of a continuous 'sliding scale' of orderedness, it is now possible to consider the creation of an aesthetic system, embodying a transition between relative states of order and disorder, as a controlled process. The problem is largely a technical one and a solution may be reached through recourse to the mathematical theory of probability.

In Figs. 1 and 2, there are arrays of standardized features (the black discs), whose displacements from pre-determined Cartesian co-ordinate positions constitute a variable having the *Gaussian distribution:*

$$f(x) = \frac{1}{\sqrt{2\pi}\sigma} e^{-\left[\frac{1}{2}\left(\frac{x-\mu}{\sigma}\right)^2\right]},$$

where x = the variate, μ = the mean and σ = the standard deviation.

Figure 6 shows a typical frequency curve of the

Fig. 6. *Typical frequency curve of a Gaussian distribution.*

Gaussian distribution. The function is continuous and the curve is asymptotic to the x axis. The value of the integral:

$$\frac{1}{\sqrt{2\pi}\sigma} \int_{-\infty}^{+\infty} e^{-\left[\frac{1}{2}\left(\frac{x-\mu}{\sigma}\right)^2\right]} \, dx = 1.$$

The mean, μ, is set at the origin and the probability of the variate assuming a value in the interval a, b is given by (cf. Note 2):

$$P_{(a<x<b)} = \frac{1}{\sqrt{2\pi}\sigma} \int_{a}^{b} e^{-\left[\frac{1}{2}\left(\frac{x-\mu}{\sigma}\right)^2\right]} \, dx.$$

The *standard deviation*, denoted by σ, measures the tendency of the values assumed by the variate to concentrate about the mean value, μ. The value of σ is a critical factor in the degree of orderedness of the distribution, such that a very small standard deviation indicates that the distribution has a relatively high degree of order.

In an earlier section the measure of disorder was given as, $H = -\sum p_i \log_2 p_i$ but this formula is only applicable to discrete samples in which changes in the value of the variate take place in a *step-wise* manner and probabilities can be assigned in a definite way to these distinctly differing values. In the present case, however, where summations and probabilities are replaced by integrals and probability densities, a measure must be found which is capable of determining the entropy of the distribution of the continuous variable, x. The entropy formula which satisfies this condition for a *univariate, Gaussian probability density function is* (cf. Note 3):

$$H_x = \log_2 \sqrt{2\pi e}\, \sigma.$$

In Fig. 1 there are three unidimensional arrays of

black discs that form horizontal bands across the surface. These bands of discs are Gaussian distributions in which the mean value, μ, is the same for all three but with an increasing value of σ from the uppermost to the lowest band. It can clearly be seen that the topmost band consists of two lines of discs suggestive of a tendency toward parallelism, whereas the central and lowest bands exhibit a partial and complete disintegration of recognizable formal properties, respectively. The changes in entropy over the surface area are shown in Fig. 7.

Fig. 7. *Changes of entropy over the surface area of the drawing shown in Fig. 1. The horizontal broken lines show the relative positioning of the three arrays or 'transition states'.*

In the drawing shown in Fig. 2, the arrays are presented two-dimensionally with regard to their format. The distribution functions are, as in the previous example, functions of single variates. In this drawing, the discs are displaced from regular Cartesian co-ordinate positions in groups of five and, in addition, a relative element, the square, is introduced. The sides of the squares represent the mean displacements of the discs in the horizontal and vertical axes from origins that are set at the centres of the squares.

The transition from a lower to a higher entropy takes place across the surface, from left to right. This process is, as in Fig. 1, in three stages and the entropy levels of these stages are unchanged. At the far left of the drawing, the discs exhibit a very strong tendency to play about the corners of the squares and the five-fold groupings of discs are quite clearly apparent. At the centre of the surface, the disposition of the discs obscures the grouped nature of their distribution, while at the far right, they display highly irregular formations. The three transition states of Fig. 2 are shown schematically in Fig. 8.

Fig. 8. *The three 'transition states' of the drawing shown in Fig. 2.*

The drawing in Fig. 3 differs from the first two in so far as it presents transition states in the guise of forms of continuity and the process of transition between the limits of chaos and orderedness has been broken down into six stages. The drawing consists of a number of harmonic wave forms of constant wavelength, in which the vertical distances between the maxima and minima points of inflexion, and uniformly spaced, horizontally parallel datum lines have the Gaussian distribution. The confusion caused by the haphazard intersection of individual wave forms, at the left, gradually gives way to a lesser degree of wave form interference and, at the far right, to a fairly high level of uniformity of contour. Figure 9 shows the entropy over the indicated areas of the surface.

1·04	0·46	0·04	-0·27	-0·54	*H*=-1·27 bits

Fig. 9. Values of entropy over areas of the surface of the drawing shown in Fig. 3.

The determination of probabilities, so as to create a distribution having a desired level of statistical order, constitutes only one part of the process resulting in the three aesthetic systems described. The probability density function, used in assigning probabilities to various values of the variate, does no more than give a completely generalized view of its behaviour. It is evident that the consideration of a distribution as an aesthetic entity will naturally involve spatial configurations and sequences of events, neither of which are influenced by the density function and so the one-to-one relationships between individual phenomena must be resolved by another procedure. Since the level of orderedness of a distribution is an invariant property of that distribution, irrespective of the sequential layout of the elementary events concerned, it follows that all possible sequences of those events are permissible and that no one of those possible sequences is deemed more 'advantageous' than another.

With the above facts in mind, the drawings shown in Figs. 1, 2 and 3 were brought to completion without the intervention of conscious decision-making and their final forms are entirely the result of random sampling.

The evaluation of probability densities of events within a given distribution made possible the construction of a hypothetical, normally distributed universe, from which samples could be drawn at random, with replacement. Each universe was of a

size of 1000 objects and the technique of replacement sampling ensured that, however many samples might be drawn, that the universe would at no time become exhausted and so it was effectively infinite. This procedure offered two main advantages, one being its extreme simplicity, and the other, the non-existence of any upper limit on sampling magnitudes. The drawings shown in Figs. 1 and 2 were based on samples of a size of 100 objects drawn from each of three universes. In the case of Fig. 3, there were six universes, from each of which samples of two-hundred objects were drawn, making available one thousand two hundred points to be plotted. Fig. 10 shows the six sets of sampling data required for this work.

The graph in Fig. 11 shows the variations of entropy encompassed by the drawing shown in Fig. 3, as a function of the standard deviation of the

Fig. 11. Variations of entropy encompassed by the drawing shown in Fig. 3, as a function of the standard deviation of the Gaussian distribution.

Gaussian distribution. The expression of the degree of orderedness of the distribution, in relation to one of its parameters, supplemented by simple mathematical tests, made possible the predetermination of the relative variability or confinement of that distribution and also the economy or complexity of the resulting visual image.

V. CONCLUSIONS

The premise upon which my discussion has been founded is the relativity of chaos and order, and the lack of any definite boundary separating these two contrasting aspects of experience. I have assumed that the interrelatedness of structured and non-structured phenomena would bring the chance variable into the domain of mathematics and permit its analysis in terms of deterministic laws. On the basis of such analyses, predictions can be made concerning its activity in the future. Working from this kind of supposition, it was of interest to me to find a way of subjecting aleatory events first to calculation and, subsequently, to a greater or lesser degree of control, as a purely aesthetic exercise.

Fig. 10. The six sets of sampling data required for the drawing shown in Fig. 3. The positive
and negative signs indicate the maxima and minima points of inflexion of the wave forms; the
oblique lines to the right of each column are merely check marks.

| H | −1.27 | −0.54 | −0.27 | +0.04 | +0.46 | +1.04 |

The translation of statistical theory into visual reality brought about the separation of artistic intention and the task of making drawings, so that the act of drawing became a mechanical activity, guided by sets of data resulting from initial choices on my part and the inherent automatism of a succession of accidental happenings. This bilateral division of the generative process excluded completely the *feedback* essential to free drawing, in which actions are performed with regard to earlier actions and where the result of any particular action is conditioned, in part, by its 'history'. In this situation, the retrospective aspect of drawing is overridden. The aesthetic problem and its solution are imagined and stated in specific terms. The consequences of a particular course of action are foreseen and accounted for in advance, with the intention of creating an aesthetic edifice using formulae and logic, in which abstract laws and hypotheses may become an integral part of artistic experience.

NOTES

1. The entropy of any aesthetic or linguistic entity is determined by those aspects of it that are subjected to measurement. The entropies of the networks shown in Figs. 5(a) and (b) might have been evaluated on the basis of the numbers of symmetrical rotations of the fundamental components, the numbers of different internal angles, as well as the linear intervals between points of intersection. In each case, the entropy might have a different value but the important fact in this instance is that the entropies remain stable, irrespective of the addition or deletion of cells in the networks. A more detailed treatment of the problem of entropies, influenced by criteria, is given by Moles (cf. Ref. 5).

2. In order to aid the evaluation of the probability integral:

$$P_{(a<x<b)} = \frac{1}{\sqrt{2\pi}\sigma} \int_a^b e^{\left[-\frac{1}{2}\left(\frac{x-\mu}{\sigma}\right)^2\right]} dx,$$

tables are available of the functions,

$$\phi_1(t) = \frac{1}{\sqrt{2\pi}} \int_{-\infty}^t e^{-z^2/2} dz \quad \text{where } -\infty < t < +\infty$$

and

$$\phi_2(t) = \frac{1}{\sqrt{2\pi}} \int_0^t e^{-z^2/2} dz \quad \text{where } 0 \leqslant t < +\infty.$$

To use whichever of these tables is available in evaluating a probability integral, one makes the change of variable $z = (x-\mu)/\sigma$ to obtain:

$$P_{(a<x<b)} = \frac{1}{\sqrt{2\pi}} \int_{\frac{a-\mu}{\sigma}}^{\frac{b-\mu}{\sigma}} e^{-z^2/2} dz$$

$$= \phi_1\left(\frac{b-\mu}{\sigma}\right) - \phi_1\left(\frac{a-\mu}{\sigma}\right).$$

3. The formula, $H_x = \log_2 \sqrt{2\pi e}\, \sigma$, gives a measure of the randomness of the continuous variable in terms of its standard deviation. If the units in which σ is expressed are changed, then the entropy will, in most cases, be changed.

REFERENCES

1. C. E. Shannon, A Mathematical Theory of Communication, *Bell System Tech. J.* (1948).
2. C. E. Shannon and W. Weaver, *A Mathematical Theory of Communication* (Urbana: University of Illinois Press, 1949).
3. J. R. Pierce, *Symbols, Signals and Noise* (London: Hutchinson, 1962).
4. N. Abramson, *Information Theory and Coding* (New York: McGraw-Hill, 1963).
5. A Moles, *Information Theory and Esthetic Perception* (Urbana: University of Illinois Press, 1968).
6. A. L. O'Toole, *Elementary Practical Statistics*, Allendoerfer Mathematics Series (New York: MacMillan, 1964).
7. J. R. McCord and R. M. Moroney, *An Introduction to Probability Theory*, Allendoerfer Mathematics Series (New York: MacMillan, 1961).
8. B. V. Gnedenco, *The Theory of Probability* (New York: Chelsea Pub. Co., 1961).
9. P. S. Alexandroff, *An Introduction to the Theory of Groups* (London: Blackie, 1959).
10. J. Venn, *The Logic of Chance*, 4th ed. (New York: Chelsea, 1962).
11. M. R. Cohen and E. Nogel, *An Introduction to Logic and Scientific Method* (London: Routledge and Kegan Paul, 1936) pp. 316 and 357.

STOCHASTIC PAINTING

Fred L. Whipple*

The word *stochastic*§ derives from the Greek word for *target*, indicating something random in character. It is now a widely used technical word in mathematics and physics, representing completely random assemblages or processes. Thus, stochastic paintings are those in which shapes and/or colors are structured randomly.

The reader immediately asks *why*? Can there be any creativity or self-expression in random processes? Can there be any beauty, charm, or interest in a painting that is not planned or organised and does not spring from some internal need for expression or communication on the part of the one who paints it?

The answers to these questions may be satisfying only to a minority of those interested in painting, but there are indeed answers. First, a stochastic painting must be based on a set of rules governing the nature of the randomness. Establishing a set of rules is a creative process and, of course, the actual application of the colors is a type of expression in texture, shading or structuring of the application. Thus, stochastic painting does involve creativity and self-expression, although not of the classical type.

Next, random processes can produce form and pattern, although not repetitive. Most people confuse *irregularity* with *randomness*, which are actually different concepts, although related. Out of any aggregate of random numbers, random colors, or random distributions of colors, there is a high probability of structured patterns, which do not repeat but may be conspicuous. The monkeys with the typewriters will indeed compose poems, even though one must look over considerable manuscript to find them.

Since random numbers by means of rules can, in fact, produce forms and color distributions, the question of beauty arises next. Here we must define our term. If, to be beautiful, a painting must express feelings, moods or ideas, or communicate them, then stochastic paintings cannot be beautiful. If these traditional assumptions are discarded, as they are in certain forms of modern painting, then stochastic painting may be 'charming, interesting, beautiful, and ugly according to diverse viewers.' If the purpose of a painting is only to produce an emotional response in the viewer, then stochastic paintings qualify along with many other modern efforts.

An important point concerns the painter himself. Stochastic painting can be fun because the outcome of a specific set of rules is so unpredictable. Until the painting is completed, one cannot really visualise how it will look, and cannot make the last difficult decision: which side should be up? The vagaries of randomness have a charm of their own. Most viewers find their own interpretation or objective representations in these paintings. Finally, a philosophical overtone: is nature, is a planet, or is man himself anything more than the consequence of a set of physical rules carried out by random processes in the physical universe?

And now for the rules.

Here, of course, one finds a googol of possibilities. My first effort was to develop closed areas on a surface from pairs of random numbers, selected from a random-number table§ and utilised according to the following rules:

1. The first pair give x and y on a canvas coordinate system for the starting point.

2. The first of the second pair, taken as a decimal of 360°, gives a direction from the starting point; the second, multiplied by a unit distance, say a centimeter or half an inch, measures a distance in this direction.

3. From the end of the first line the first number of the next pair measures a distance; the second, multiplied by 15°, measures an angle turned counter-clockwise from the tip of the previous line.

4. Successive lines are developed by successive number pairs from the ends of the previous lines or from the outer sides of closed areas.

5. We now must have a rule for closing the areas. I first tried a rule that produces areas that are all triangles or polygons with no internal angles greater than 180°. I chose to join the figure at the end of a line when any projection of a line was pointed towards the originating side of the polygon. This rule

*Astrophysicist, 35 Elizabeth Rd., Belmont, MA 02178, U.S.A. (Received 19 October 1967.)

§The definition in the Merriam–Webster's Third New International Dictionary is the following: 'Stochastic, Gk Stochastikos, skillful in aiming, proceeding by guesswork, fr. (assumed) stochastos (verbal of stochazesthai to aim at, guess at, fr, stochos target, aim, guess): random (~processes) (~variables).'

§Flipped coins or dice can, of course, substitute for the random-number table, with or without a binary or hexagesimal number system.

7

Fig. 1. 'SS-1', *stochastic painting*, 20 × 16 *in.*, 1956.

Fig. 2. 'SC-2', *stochastic painting*, 24 × 18 in., 1960.

leads frequently to several lines radiating from a point, which gives some sense of three-dimensionality to the final painting. (See Fig. 1).

6. At the edges of the canvas I first adopted the simple rule of extending the line by equal-angle reflection.

7. When the canvas is completely covered, the choice of colors can be made by successively numbering each closed area by a number taken in sequence from a random-number table. The nature of the painting can be quite affected by ruling that contiguous areas may or may not receive the same color. In Fig. 1 I chose to eliminate contiguous areas of the same color thereby ending up with colored areas all of polygonal character.

8. If the tubes of paint are numbered successively, in any order, ten random numbers distribute the ten colors among the numbers from 0–9.

9. The remainder of the operation, as in any number painting, permits the painter to choose textures and shades at will. Or, if he wishes, he can mix a certain amount of white with the paint for each area by means of a second random number in each area.

Whereas in my first effort I chose the colors but distributed them by random numbers, later I chose the colors themselves at random and allowed contiguous areas to be colored alike when the numbers called for it.

A possible next step is to incorporate curves into a random painting. This I did by making ten circles whose diameters range from half an inch, increasing according to the Golden Rule of Greek art and architecture, i.e. the ratio of successive diameters is $1/0.6180340... = 1.6180340....$ Eleven radii are: 1.00, 1.62, 2.62, 4.24, 6.85, 11.09, 17.94, 29.03, 46.98, 76.01 and 122.99. On each circle one lays out ten angles of $36°$ each to complete the circle. For the larger circles, smaller angles may be preferred.

With these circles one is then able to develop other stochastic paintings according to a variety of laws. My first effort was to start as in case 1 above with a direction and use three random numbers for each operation (see Fig. 2). The first chooses the circle, the second the fractional distance around it, and the third even or odd for left or right development, each successive circle being tangent to the previous one at the point of intersection. One then needs a rule for reflection at the edges of the canvas, the equal-angle reflection, or reflection by a random angle, chosen again from the random-number table. Circles developed in this fashion require a decision as to when to stop, since eventually one would fill the entire canvas with parts of circles. One may choose an arbitrary number of steps at the beginning, or simply stop when one feels that there are enough areas outlined on the canvas.

Obviously there are any number of combinations of straight lines and circles that can lead to further developments or rules for these developments. One can superimpose independent patterns of circles and straight lines (Fig. 3, color illus. G, p. 309). One can combine the two in the development of a continuous curve about the canvas and of course one could develop other curves than circles. One also could make the curves themselves the object of interest on the canvas.

to dilute all of the others, thereby reducing color shock in my own stochastic paintings. As color shock has become one of the objectives of certain abstract paintings, perhaps I should choose complementary color systems and make some stochastic paintings emphasising this eye-strain inducer.

Anyhow, it is all innocent fun! The reader can decide for himself whether or not it is an art form.

ON THE APPLICATION OF SYSTEMS MODELS TO VISUAL ART BASED UPON MY EXPERIENCE AS A PAINTER: A MEMOIR

Daniel E. Noble*

Abstract—*The author feels that current analyses of art have much in common with the scholasticism that preceded the development of the bases of modern science several centuries ago. He believes that art will become a more vital force in the lives of more people than it is now, if systems methodology used in advanced technology is applied to the analyses of the working methods of artists, of the objects that they make and of the reactions of viewers to their objects. After discussing his views on free will and creativity, he describes simplified systems models of these processes in terms of information processing by the human brain.*

He then outlines his approach to making paintings in the light of the system models that he presents and comments on several of his works to guide viewers to an understanding of their intended content.

I. INTRODUCTION

Sometimes I feel that current analyses of art have much in common with pre-modern science discussions of a few hundred years ago when the scholars of the day argued about the number of angels that could alight on the head of a pin. In highly industrialized countries, technology has, through the development and exploitation of muscle-extension systems, greatly reduced drudgery and made available leisure time to many more people. Leisure time makes it possible for people to experience and to share experiences in a technology-related life style, which expands freedom of choice. Over the past 50 to 75 years, while life style has been revolutionized, the theorizing of most aestheticians has remained rooted in the philosophical concepts of the distant past. Furthermore, I believe that much of current art criticism in the U.S.A. is a form of intellectual self-indulgence. While sounding profound, it actually confuses artists, art students and the general public. There is a desperate need in discussions of art of an approach that will parallel Galileo's concept of controlled experiments to test the validity of scientific hypotheses. This is difficult to accomplish in the domains of art because of the subjective factors involved. The difficulty is made

evident by the work of those concerned with the new field of experimental aesthetics [1–4].

Science is a very complex and highly disciplined human activity. Even for the so-called 'hard' science of physics, it is understood that there are but few absolutes; its truths are approximate and applicable only in proper context. The physicist Niels Bohr proposed one of the first atom models that proved to be very useful for explaining the then available experimental data but, when further data were obtained that would not fit the model, Bohr, de Brogelie, Franck, Hertz and others contributed to the construction of a better one. This model, based upon quantum mechanics, can be expected to require further modification in the future. The point I wish to make: I am convinced that the model approach is also essential for understanding and developing complex forms of art. I know of no useful painter/painting/viewer models available at present and I am well aware of the difficulties that will confront those who try to construct them. Below, I propose a greatly oversimplified first approach to such models.

II. FREE WILL AND CREATIVITY

I believe that *free will* is an illusion. There is no free will but there is *unique will*. The admittedly oversimplified model of the brain that I shall describe assumes that the brain is a very complex

* Electronics research engineer and artist living at 4227 Upper Ridge Way, Scottsdale, AZ 85253, U.S.A. (Received 20 Aug. 1974.)

organic computer that receives information through the senses, processes it and stores it. Information-processing occurs both at the conscious and the subconscious levels but I believe that substantial subconscious correlations between new information (inputs) and stored information in the brain (memory) take place to influence or even to determine the conscious results of mental activity (outputs). In other words, when new inputs enter the brain, in particular through the ears and/or eyes, they are translated into electrical and/or chemical codes that then undergo a correlation process in the brain information storage system, leading to conscious interpretations of the new information. Emotion may be involved in the processing as well as logic. I believe that one of the primary functions of human beings is the processing of information.

The processing capacity of the brains that persons have is determined by the quality of the brains they were born with and by the information received, processed and stored thereafter. Thus interpretations of new inputs are characterized by both conscious and subconscious correlations that the brain makes with stored information. I feel that, ultimately, research will demonstrate that human beings have a unique will, however it seems reasonable to me, because each person's brain has its own processing characteristics and its own store of information, that no two persons are likely to experience precisely the same correlations and, therefore, the same outputs for the same inputs. Even for those who grew up under the same cultural influences, an exact duplication of their stored information seems to be highly improbable. A work of art therefore, it seems, is not the product of a free will but of a unique will.

A creative painter needs not only an appropriate brain but also training and experience to enhance its correlation and logic processing capabilities. His creativity is measured by his ability to produce works that, through his visual interpretations of aspects of the world, give significant emotional stimulation or aesthetic satisfaction to enough persons to affect the understanding of their society or at least the understanding of the work of artists.

III. ON THE PROCESS OF CREATIVITY

Very little information is available on creativity in any domain but as a tentative hypothesis, I shall assume that it is concerned with the formation of novel ideas that require substantial correlation activity at both conscious and subconscious mental levels. Whether one is searching for a solution to a particular problem in science, in technology or in the art of painting, the subconscious correlation process seems to be necessary. Personal experience convinces me that this is true as I review my work in both the domains of electronic engineering research and of the art of painting.

In engineering research, new inputs sometimes may be correlated almost instantaneously with stored information at the subconscious level. But the conscious emergence of a useful novel invention may occur only after a long period of gestation. Why this is so is not understood.

Once I was working on an electronic system for automatically turning on the radio-telephone loud-speaker in an automobile for receiving an FM radio-telephone voice-message transmitted from a base station. When no message was being transmitted, the loudspeaker in the automobile was not to operate, so that there would be no disturbing background noise. I developed a circuit that would complete the connection when the radio signal was received but, unfortunately, the connection was completed also by the electrical noise generated by the ignition systems of passing vehicles. After a week or so of testing a variety of circuits, I reviewed the problem one night before going to bed and awoke the next morning with the details of a new circuit clearly in mind. Tests proved the circuit to be satisfactory. The new circuit insured that electrical noise from a passing vehicle would not open the loudspeaker connection; it would, in fact, close it more tightly. The circuit was patented and for many years it became standard for use in portable and mobile FM radio-telephone equipment. The invention process described above is not unlike the processes that I follow when I paint a picture.

IV. A MODEL FOR THE PROCESS OF PAINTING A PICTURE

When I paint a picture, I may first consciously formulate a generalized concept that I hope will express the content that I have in mind. Then I rapidly develop the basic structure of the composition of the picture. I am at this point concerned primarily with lines and shapes and with color relationships between chosen colors. I also begin to develop a feeling for the patterns that emerge. This 'feeling' has been called 'intuition' but I prefer to call it 'subconscious correlation'. The subconscious correlations between my new visual inputs that develop as I paint and the relevant stored information produce decisions that direct nearly every subsequent brush stroke on the painting. It is true that a certain amount of conscious planning also takes place during this stage, however it is limited, because the number of pictorial variables in most of my pictures is too large for useful step-by-step conscious planning. In response to the subconscious correlations, I may feel that the color of one part should be a shade of green, that a certain line should be extended to meet another line and that a shape displaced from a diagonal should be of a particular size and color. As these subconscious decisions reach the conscious level, I continue to paint until my subconscious supplies me with no further directions. I then move back 15 or 20 ft from the picture and study it until my subconscious again impels me to proceed. Sometimes, in an hour or two, I may feel that a picture

is finished; other times I may work on one for a year or more.

I believe that this approach to painting is the most fruitful one and that it is widely used by painters. In order to piant an aesthetically satisfying picture, substantial information relevant both to visual art and to the social/political/cultural environment must be processed and stored in the artist's brain to be available for correlation with the fresh inputs that accompany the painting process.

When a viewer looks at a painting, visual information is coded and correlated in the brain's memory. Significant new inputs from a painting are correlated with stored information. Hopefully, these correlations stimulate the generations of new aspects of art appreciation and new emotional experiences. A viewer is aware only of the correlations that reach his consciousness and their kind and extent are a measure of his understanding and appreciation of the painting. As pointed out above, the brains of viewers do not lead to precisely the same correlations, however one would expect individuals of similar cultural and educational backgrounds to reach similar correlations.

V. INHERITED ARTISTIC SENSITIVITY

In some exceptional cases children do produce aesthetically pleasing pictures. This is due mainly to an inherited aesthetic sensitivity and muscular coordination, for a child's brain has only a limited store of relevant information on art. Some brains possess inherited muscular and visual coordination that may mistakenly be labeled 'artistic talent'. However, such talent does not necessarily lead to the production of works of a 'creative' character. Thus, I suggest that neither 'artistic talent' of a physiological kind nor solely the *conscious* application of reason and logic is adequate for the production of 'good' art works. The correlations that may be contributed by the subsconscious are of critical importance. Sometime in the future, brain-extension systems like the computer can be expected to make correlations of information on art to supplement the correlations made in the brain of an artist.

VI. ON THE COMPOSITION OF A PICTURE

The composition of a picture may involve very complex correlations because there are interrelationships among lines, shapes and colors, often with a simulation of three dimensions and with analogs, signs and symbols related to motion and to abstract concepts. Color relationships alone are very complex, since not only hue, saturation and lightness (brightness) are important but also life-experience associations that one has for different colors, which vary from person to person. How can artists contend with this complexity?

I believe that good composition produces in the brain a sense of *order*. For the sake of simplicity,

I shall assume that there are two basic kinds of pictorial order: (1) order possessing static balance of pictorial elements and (2) order possessing a quality of simulated dynamic balance. A picture might be expected to increase the degree of freedom of viewer responses to it as simulated dynamic balance increases. I feel that aritsts who produce *minimal art* works may fail to go beyond static-balance compositions because they fear complexity. Perhaps they are unable to achieve order among the unavoidable complexities that result from the introduction of both static and simulated dynamic balance.

Unfortunately, a description of pictorial order in terms of brain correlation processes is difficult. Perhaps one can understand order better if one analyzes disorder, starting with the assumption that disorder is related to a lack of either static or dynamic analog-energy differences in a closed system, such as a picture. Analog-energy differences exist between parts of any painting composition where there are color, intensity, line and shape differences. While energy differences cannot be avoided in a painting, they must be balanced to achieve compositional order.

Both a picture of uniform color and one with random scribbling (no analog-energy differences) represent the maximum disorder. A picture with a static balance of pictorial elements represents a high degree of order but I believe that it lacks capacity to stimulate interest to the degree associated with more complex compositions with simulated dynamic symmetry. While I sometimes wonder just how essential order in a work of art is for some people, I do know that it is most essential for my satisfaction and I believe that my response to order is related to my subconscious mental processing of information. The reader will find an extensive discussion of the question of order and disorder in an art work in Refs. 6–9.

Both the making and the viewing of a painting must involve conscious and subconscious processing in the brain memory and logic systems. Unfortunately, nothing is known about such processing in a quantitative sense and very little in a qualitative sense. How can one, with such limited positive references, judge the quality of pictures in terms of the impact that artists seek to make upon viewers?

VII. APPLICATION OF SYSTEMS METHODOLOGY TO VISUAL FINE ART

While my simplistic model of a painting is valid within limits, a better model would require a more precise understanding of information processing that takes place in the brain of viewers. An improved model should take into account the fact that a work of art is a complex communication system involving a painter, his work and its viewer.

Perhaps an effort should be made to develop a special art version of Arthur Hall's Systems Methodology [10] to better understand the art

communications system. I am not proposing the use of a rigid mathematical model to help to understand art, since major forces to be accounted for include qualitative coupling forces that bind artists and viewers to aspects of their culture, to their changing environments and to their personal conceptions of the universe. I assume that an art-systems methodology would make use of time-proven art techniques and concepts.

A comprehensive picture-painting model would, I am certain, provide an effective basis for the improved judgment of paintings. For those who argue that mental models are being used by theoreticians of art, I suggest that such models are inadequate constructs. My criticism is applicable also to the mental models of the social, political and economic systems of today, because they do not take account of the prodigious increase in complexity caused by rapid changes arising from technological developments.

Valid conscious and subconscious brain correlations will become more and more difficult to achieve in the future as the complexity of life increases, because memories will be saturated by a flood of information, both valid and invalid. Therefore, brain-extension systems must be developed to take advantage of systems methodology and to make use of experimentally verifiable models.

VIII. THE APPLICATION OF COMMUNICATIONS SYSTEMS INFORMATION THEORY

Instead of applying the concept of order-disorder to pictures, one might apply analogs of information theory as applied to telephone, radio and television communications systems. Total disorder is comparable to 'white' noise in a communications channel. The reference to 'white' noise is readily understood if one looks at a television set when the set is switched to a channel where there are no signals being transmitted. The electrical 'noise' appears on the screen of the set as a maze of randomly dancing white dots. There are no energy differences in the constantly changing amorphous display. While the display represents total disorder from an energy difference point of view, it represents total noise ('white' noise) from a communications point of view.

A useful analogy for use in a painting communications system might be the term *signal-to-noise ratio* used in communications theory. The quality of the transmission of information over a given communications channel can be expressed in terms of the ratio between the desired signal level and the level of the interfering noise. In good communications circuits, the signal-to-noise ratio is very high and, in fact, the noise in such circuits can be neglected in so far as the interference with signal recovery is concerned. While ordinary noise is produced by thermal effects and unwanted signals there is another form of noise caused by channel overloading. Without attempting to explain the

theory, it can be stated simply that when the signal input to a channel exceeds the carrying capacity (bandwidth) of the channel, the resulting distortion produces the equivalent of noise. Severe overloading may produce such a poor signal-to-noise ratio that the recovery of the signal becomes impossible.

An analog application to painting might consider 'white' noise on a canvas as an all-over random scribbling. A desirable signal-to-noise ratio for a good painting would be one where there is a high ratio of needed elements for the interpretation of the content to the noncontributing or 'noise' elements in the painting. In good paintings, the noise level should be negligible. When a painting is overcrowded (equivalent to channel overloading), one can reach a point of pictorial complexity where it is impossible to decipher the message. This would mean that the signal-to-noise ratio is very low. In my opinion, some scribble or drip-type nonfigurative paintings have a very low signal-to-noise ratio. Perhaps they are accepted by some people because they consider the expression of high visual noise level to be artistically important. On the basis of my analogy, one must conclude that paintings with a low signal-to-noise ratio provide very poor communication of content, if, indeed, they have any content.

IX. REFLECTIONS ON THE DEVELOPMENT OF CULTURES

Present day technological culture was not planned; it was the result of correlated responses of generations of human beings to the vast number of forces that affect human behavior. In the U.S.A. the most significant socio-economic development over the past 70 years has been the widespread application of many new forms of muscle-power-extension systems. The Industrial Revolution, which greatly expanded the application of muscle-power-extension systems, was characterized by an associated orders-of-magnitude increase in worker productivity. Over the years of the exponential growth of advanced-technology societies, there has been a phenomenal increase in the speed of transportation, the speed of communications, the rate at which new information is generated and the speed of printing and distributing information. All of this adds up to a very great increase in the complexity of the socio/political/economic systems, to the point where the human brain can no longer cope with the vast flow of information. One might say that the signal-to-noise ratio of the inputs for processing in the human brain has decreased markedly. The use of mental models will not yield viable decisions because the noise level is so high that decisions are often related to an analysis of symptoms and no proper consideration is given to root causes. The problem is not so much one of human inability to adapt to rapid changes as it is the failure to cope with the rising complexity. The poor signal-to-noise ratio of the information flow

and our inability to filter out noise to the degree that would enable us to select the most important forces have made it practically impossible for us to structure the information so as to render evident the trade-offs between alternate decisions. There has been much reluctance to apply computer-aided modeling methods to people-systems but the realization is growing that only through the use of such methods is there a hope for overcoming the permeating complexity. Our only hope to regain sufficient control to deal with the socio/economic mess in the U.S.A. is in the use of such methods in order that the quality of decision-making is substantially improved.

People-systems complexity, material requirements and energy demands in the U.S.A. have been doubling at intervals of a few years (this is exponential growth) and such growth, obviously, cannot be sustained indefinitely. The unmanageable complexity and the shortage of materials and of fossil fuels are forcing a leveling off to an equilibrium state of no growth. The leveling-off process is a traumatic experience. It is causing both social and economic disruptions and our people may even find themselves facing famine.

If I were a dictator, I would introduce the teaching of computer-aided model-making techniques at secondary school level in order to accelerate brain-conditioning for the increased use of brainpower-extension systems. This would shorten the transition from the termination of exponential growth to the new era that will be characterized by the widespread and effective application of brain-extension systems. I suspect that several generations will pass before a sufficient number of brains will be trained to make possible a rational approach to decision-making, including the designation of social priorities and goals.

What has all this got to do with art? In my view —everything. Brain-extension systems are essential for any kind of effective communication, including that achievable by visual fine art. I believe that art will become increasingly important if it reaches out into uncorrelated areas to suggest interrelationships that have not been apparent before. I also believe that the fine arts have something in common with the philosophical concern for the search for truth. My brain-correlation model suggests that human beings may be capable of producing subconscious correlations to extend understanding beyond the level permitted by conscious processing of information. If art in the future can stimulate viewers to carry out subconscious correlations of brain-stored information with various aspects of their life experiences so that new truth will be appreciated, art will become a more vital force in the lives of more people.

X. ON MY PAINTINGS

While my paintings have ranged widely in subject matter, those selected to illustrate my memoir are closely related to the outlook that I have discussed.

I have attempted to make paintings of significant content regardless of what some may consider to be the appropriate content of fine art, although I have also dealt with subjects that are considered beautiful in a classical sense.

I frequently make use of the techniques of relief painting on masonite panels. By combining fiber-glass with clear acrylic medium and with acrylic overpainting, I can extend relief structures as much as 1 or 2 in. from the surface of the panels without fear of reducing the lifespan of the painting. Sometimes I make use of acrylic caulking compound for direct application to the panel from a caulking gun. (Oil paint used for such extremely heavy impasto would crack and fall from the panel.) I prefer paintings with relief texture because of the variety of effects produced by light striking a relief surface from different angles. I have made about 150 paintings, most of them on 3 × 4 ft panels but some as large as 4 × 6 ft and a few as small as 2 × 3 ft.

My comments on the paintings illustrated should not be taken too literally. They are guides to help viewers toward the content that I had in mind. Perhaps they represent some of the thoughts that coursed through my mind while I was painting them. Analog symbolism may be a proper term to characterize much of my work.

1. 'Lost Identity' (Fig. 1)

From the brain-model that I have discussed in this paper, I would assume that identity is related to the total store of information in one's memory bank and to the correlations that result in reactions

Fig. 1. 'Lost Identity', Masonite panel, acrylic paint, 48 × 36 in., 1973. (Photo: L. Zbiegien, Phoenix, Ariz., U.S.A.)

Fig. 3. *'Information Flow Saturation', acrylic painting on Masonite panel*, 48 × 36 in., 1967. (Photo: L. Zbiegien, Phoenix, Ariz., U.S.A.)

Fig. 4. *'Dynamic Systems Model-Maker', relief painting on Masonite panel, fiberglass/acrylic, acrylic caulking compound and acrylic paint*, 48 × 36 in., 1972. (Photo: L. Zbiegien, Phoenix, Ariz., U.S.A.)

and conclusions when new information is processed. Loss of identity can occur in the crowded slum sections of a city. The struggle for survival dominates the brain-processing and the associated

Fig. 5. *'The Heuristic Programmer', acrylic on Masonite panel*, 48 × 36 in., 1966. (Photo: L. Zbiegien, Phoenix, Ariz., U.S.A.)

responses of a person. Loss of identity is the loss of freedom of choice and the power of selection in dealing with social and environmental forces. Loss of identity, as I have attempted to define it, can be the ultimate in personal tragedy.

2. 'The Mind Extender' (Fig. 2, color illus. H, p. 310)

Engineers will recognize this as a free interpretation of an integrated circuit system of the type used in the construction of computers and artificial intelligence devices. While artificial intelligence is now in the primitive stage of development, the electronic brain-extension systems of the future can be expected to outperform man's brain far beyond the calculation superiority of present-day digital computers.

3. 'Information Flow Saturation' (Fig. 3)

This picture is a subjective interpretation of the overwhelming flood of information that is saturating man's brain-processing capability beyond his ability to cope. The circle is a symbol that will be recognized readily by scientists and engineers as an analog for closed-loop feedback or, with an extension of meaning, as a unit of information, a subsystem or a system.

4. 'The Dynamic Systems Model-Maker' (Fig. 4)

This painting suggests symbolically an answer to the problem depicted in Fig. 3. Since the brain cannot cope with decision-making when many variables are involved in a problem, it is essential that effective techniques be developed for the use of

Fig. 6. 'The Investigating Committee', minimal relief painting on masonite panel, acrylic caulking compound and acrylic paint, 48 × 36 in., 1970. (Photo: L. Zbiegien, Phoenix, Ariz., U.S.A.)

Fig. 7. 'The Search'. relief painting on masonite panel, acrylic caulking compound and acrylic paint, 48 × 36 in., 1973. (Photo: L. Zbiegien, Phoenix, Ariz., U.S.A.)

systems, models, and computers to help the brain. The painting suggests that a model for selecting, organizing and structuring information (symbolized by the circles) is essential in order that interrelationships, interdependence and other correlations may be made 'visible'. The model will not make decisions but it will make 'visible' the trade-offs for alternate decisions.

5. 'The Heuristic Programmer' (Fig. 5)

This painting is intended to suggest that since there are no absolutes as a guide on the journey of life, people must approach the pattern of their life-style through the utilization of an empirical examination of environmental forces. While exercising a certain creative response to these forces, they can achieve a degree of apparent freedom as opposed to the slavery that characterizes the existence of those who have lost their identity.

6. 'The Investigating Committee' (Fig. 6)

The picture is meant to have a touch of humor and a note of sadness. While it was completed before the Watergate scandal in the U.S.A., the following original comment seems to apply: Moral, legal and ethical investigations are often absurd and sometimes uproariously funny. Unfortunately, they also are touched with the breath of tragedy.

7. 'The Search' (Fig. 7)

This picture is intended to express the fact that,

Fig. 8. 'The Dissenter', relief painting on Masonite panel, fiberglass/acrylic, acrylic caulking compound and acrylic paint, 48 × 36 in., 1968. (Photo: L. Zbiegien, Phoenix, Ariz., U.S.A.)

when alienation deepens, the questions 'Where did I come from?', 'Why am I here?' and 'Where am

Fig. 9. 'Pardon Me a Moment while I Control My Environment', relief painting on Masonite panel, fiberglass/clear acrylic and acrylic paint, 48 × 36 in., 1970. (Photo: L. Zbiegien, Phoenix, Ariz., U.S.A.)

I going?' rise into consciousness with increasing intensity. It can also be interpreted as a lonely search for answers during the short lifespan that, for man, connects the infinity of time past and the infinity of time to come.

8. 'The Dissenter' (Fig. 8)

The idea of a dissenter ties in with my suggestion that there is no free will. Persons must react according to the new input-induced correlations produced on the basis of information stored in their brains. Radical dissent of individuals in a society must be related to their special kind of brain structure and/or to unusual life experiences. The brain memory and conditioned processing barriers to dissent are formidable.

9. 'Pardon Me a Moment while I Control My Environment' (Fig. 9.)

The subtitle of this painting is 'Now if I Can Get This Damned Umbrella Open'. I intended this as a humorous comment on the futility of individual effort when systems thinking is ignored while trying to influence the ecological balance of nature.

REFERENCES

1. F. Molnar, Experimental Aesthetics or the Science of Art, *Leonardo* **7**, 23 (1974).

2. M. Marcus, Experimental Aesthetics, Letters, *Leonardo* **7**, 379 (1974).

3. E. H. Duncan, Ref. 2, p. 380.

4. F. Molnar, Ref. 2, p. 381.

5. E. H. Duncan, Letters, *Leonardo* **8**, 89 (1975).

6. R. Arnheim, *Entropy and Art: An Essay on Disorder and Order* (Berkeley, Calif. Univ., California Press, 1971).

7. P. L. Jones, Some Thoughts on Rudolf Arnheim's book, 'Entropy and Art', *Leonardo* **6**, 29 (1973).

8. R. I. Land, Comments and Discussions of Entropy and Art in *Leonardo* in 1973, *Leonardo* **6**, 331 (1973).

9. R. Arnheim, On Order, Simplicity and Entropy, *Leonardo* **7**, 139 (1974).

10. A. D. Hall, III, Who Is Afraid of Systems Methodology? *IEEE: Systems, Man and Cybernetics Society Newsletter* **4**, 1 (March 1975).

ART AND MATHESIS:
MONDRIAN'S STRUCTURES

Anthony Hill*

Abstract—*The author introduces extracts from his study of the relationship of the works of Mondrian to mathematics. They are part of his research into mathematical thinking and abstract art. Concepts of structure, especially topological concepts of connectivity, are applied to the linear schemes in Mondrian's compositions. The schemes, to be regarded as* networks, *are then analysed in terms used in Graph Theory.*

The idea of the linear infra-structure *is introduced as well as the idea of the* formal topological image. *The notion of symmetry is restated for structures, where congruence is defined topologically; as a result, the discussion of symmetry and asymmetry as applied to Mondrian's compositions is broadened.*

The possibility of computing the information content *of linear infra-structures is discussed by the author. He investigates Mondrian's 'axioms' treating them as a restricted sub-set of possibilities allowed when composing on a square lattice.*

The author hopes to have shown how we could enrich our pleasure and interest in looking at Mondrian's paintings—through asking different kinds of questions relating to their structure and geometry. Furthermore the approach may be used consciously by the artist in creating his works.

'Science says the first word
on everything, and the last
on nothing.'

Victor Hugo [1]

I. INTRODUCTION

In the first issue of *Leonardo* readers were presented with a number of definitions of visual fine art.

Now a question of kind 'What is Art?' can be construed as a *directed* question of a rather special kind; one could say that it is caused by a state of doubt (or unknowing) and answered with the tacit assumption that the doubt (or some of it) has been dispelled. Simpler questions raise no further questions, especially those of the kind that ask 'but is that really a question/answer?' To special questions, answers are often given by persons whose field of study includes the *subject* of the question. Now in the case of Art we can ask who best to answer 'What is Art?' and there could be two quite different candidates for the best answer here:

 (a) the artist, as he is engaged in making Art,
 (b) the philosopher, as he is engaged in framing and answering questions.

This leads us to ask the following: need the artist familiarize himself with philosophy and, conversely, need the philosopher familiarize himself with art?

Clearly each has a need to be partially familiar with the other's work, and the very state of being 'partially familiar' becomes the link between the two.

I have called this paper *Art and Mathesis* and, as with any paper whose title employs the form 'Art and ...', the issue is presumably that of *bringing into question* the possible relationships existing *between art and some other discipline.*

Let us assume for the present purpose that examples tacitly cited here as *Art* promote no question of the kind 'but *is it* Art?' This leaves us with the question 'but what is *Mathesis*?' (especially since this word does not figure in smaller dictionaries —such as the *Concise Oxford.*)

Now in defining something, one says first what *the word means,*—an explanation—and then what *the explanation amounts to our saying.* Had the word been *mathematics* instead of *mathesis*, the problem of whether it would be necessary to *define* mathematics would certainly be *pertinent* but perhaps not *essential.** So why *Mathesis*?

Mathesis is a euphonious but rather grandiloquent word, it belongs with *Ars magna* and *Ars combinatoria* and in the hands of Descartes it was *Mathesis universalis.*

Possibly the last author to use the word was Husserl, who spoke about 'pure Mathesis'—a

* Artist living at 24 Charlotte Street, London W.1, England. (Received 28 November, 1967.)

* If asked for a definition, I would choose that of N. Bourbaki (cf. Note E) for whom mathematics is none other than the study of abstract structures or formal patterns of connectiveness.

universal science to include all the pure 'structures' of thinking [2].

My purpose in using the word *Mathesis* is deliberate, although it is perhaps not as yet well defined, for I am persuaded that at least some part of the general point of view adopted in my approach can be described as phenomenological.

I am not too well acquainted with the inner workings of this philosophical tendency,* but have noticed that the subject of abstract art has recently been approached from the standpoint of phenomenology. Some time ago I chanced to read the following:

> 'If the adherents of phenomenology and Neo-positivism had paid any attention to it, their epistemological assumptions would have let them to a recognition of abstract art' [3].

More recently I came upon the following statements by the Swiss mathematician Paul Bernays:

> 'In the region of colours and sounds the phenomenological investigation is still in its beginning and is certainly bound with the fact that it has no great importance for theoretical physics, since in physics we are induced, at an early stage, to eliminate colours and sounds as qualities. In fact, what contrasts phenomenologically with the qualitative is not the quantative, as is taught by traditional philosophy, but the structural, i.e. forms of being aside and of being composite, etc. with all the concepts and laws that relate to them—Mathematics, however, can be regarded as the theoretical phenomenology of structures' [4].

In my analysis of Mondrian's compositions—that is to say their structure—the point of view, vis-a-vis the mathematics cited, can be taken as phenomenological in the sense expressed above.

I am interested to explore concepts of structure hitherto ignored or taken for granted—such as connectivity—when describing a compositional scheme. This means that attributes normally singled out as 'mathematical' (those dependent on measurement, such as ratios and the symmetry based on metrical congruence) are to be 'bracketed', i.e. put to one side, even where they seem to be part of the immediate data of perception.

The material in Section II is extracted from a much larger sketch that sets out to show how Mondrian's compositions can be classified, and also explores the basis and the application of the criteria used.

In the former part a detailed survey has been made based on available sources to date [5], while in the latter the researches have been wholly in the province of mathematics; i.e. topology, graph theory, group theory and combinational analysis. The final aim would be to offer these findings to aesthetics, but an aesthetics phenomenologically orientated.

To give a specific example of what is envisaged, it would be necessary to examine around 130 of Mondrian's compositional schemes and to compute *the topological information content* of each scheme . . . and, in invoking *the theory of information*, I am restricting this specifically to the linear network of the composition and not to the composition as a whole.

Ultimately findings from research, for example the topological information content, would become valuable data for a statistical account of the changes and of the stable factors (invariants) in Mondrian's structural syntax. And this in turn could lead to establishing the '*set of Mondrian axioms*'.

Mondrian's 'axioms' allow for a very large range of syntactical usage, of which his own works drew upon only a significantly small range. I believe it would be valuable to explore fully the entire set of these lattice structures and, within them, the subset that was drawn upon by Mondrian. I believe this could provide us with part of the essential material with which to tackle the obvious but puzzling question—what lay behind Mondrian's choice?

The remaining source material needed is, of course, Mondrian's recorded views; with particular attention to the account he gave of his working methods and ideas—which unfortunately does not amount to very much.*

It is generally accepted that Mondrian employed no calculation or measuring when composing his pictures; it follows from this that no 'laws of composition' were *consciously* applied by Mondrian. The main evidence for believing this to be true comes from two sources: (a) Mondrian's own assertions and (b) the evidence of the paintings themselves. Thus, those who would seek to prove that Mondrian did employ laws or rules, would have to take as their premise the idea that he did so unwittingly and/or unconsciously. This, too, must rest on the assumption that the compositions do in fact approximate to 'mathematical proportions'. As a consequence, we are left with the contention that Mondrian was a classical artist, without his being aware of the fact.

If it is the *compositions* that are taken as providing evidence for this contention (or for its refutation), we shall need to be quite objective in any demonstration that seeks to show a valid correspondence

* In psychology an unprejudiced attitude (i.e. without prior assumptions) is referred to as *descriptive* or *phenomenological*, and in philosophy, phenomenology attempts to analyse consciousness, taking as its sole absolute—'objectivity.' The founder of modern phenomenology was Edmund Husserl.

* Piet Mondrian (1872–1944). Since his death, the number of publications on Mondrian has remained small (see Note A) (there were none during his lifetime) and we still await publication of his complete writings and eventually an authoritative *catalogue raisoné*—in *chronological* order. Due to the very high prices that his paintings commanded (as soon as he died) there are unquestionably forgeries at large and this is a further reason for hoping that Mondrian's works should be studied in the best traditions of disinterested scholarship. One could hope to see the foundation of a Mondrian museum or a Mondrian institute.

with such 'rules,' and to be equally objective regarding the validity of the 'rules,' 'systems' etc. that are invoked.

In the event of concluding one or the other contention to be 'proven,' we would still not be satisfied. The conclusion would still be spurious, since any judgment of this kind would not rest solely on our knowledge of the work and the artist alone (his psychology, etc. of which we are, clearly, not well acquainted), but tacitly we would be invoking as evidence the responses of both the investigation and his subjects. . . .

I have looked into numerous published 'analyses' of Mondrian's compositions (see Note B) and, in my opinion, they contribute nothing to our understanding of Mondrian's actual procedure. However, looked at from another viewpoint, these analyses command our attention as evidence of a significant trend within the field of 'aesthetic analyses' (whether it be numerological mysticism, Gestalt psychology or, simply, empirical laboratory investigation.) The basis of my investigations is one of non-metrical considerations of Mondrian's compositions and, therefore, has little or nothing to say by way of overlap with researches into 'the painter's secret geometry,' be it Mondrian's or any other artist.

The analyses presented in Sections II and III have no recourse to 'number lore' and, although some numerical computation is required (things are counted, etc.), nothing is measured against a scale (a ruler) nor do ruler and compass constructions play any part.

However, let me make it quite clear in advance that the ideas presented here are in no way offered as being amongst those that Mondrian is known to have employed.

So, while the implications of this last statement indeed call for a detailed discussion, they remain outside the scope of the present article. It also follows that Mondrian's interest in mathematics (where this *can* be shown) and in philosophy, cannot be explored here, for example, his possible interest in authors other than Schoenmaekers, such as L. E. J. Brouwer, Note C, must be set aside as having no essential bearing on the procedures adopted here.

II. BASIC NOTIONS FOR THE ANALYSIS

Essentially, a *graph* is to be taken as an abstract structure but, in practice, particularly in Graph Theory, it is usually interpreted as a *network*. In the analysis that follows, a *network* is treated as something actually visualized, such as an elastic net made from elastic thread and held together with knots that can slide freely. Such an object should be kept in mind as a model.

An elastic network is a structure that can be given innumerable forms—it is a deformable structure allowing continuous deformation from any chosen form into any other; the other restrictions to bear in mind are that:

(1) We do not undo or add knots, or add or remove the threads.
(2) We do not allow cutting of the threads.

This kind of *network* consists only of knots and the lengths of thread spanning the knots. The knots are the *nodes* of the network and the lines which span the knots are called alternatively *lines*, *edges*, *members* or *bonds*, depending on the field of study that uses networks or graphical models.

In what follows, wherever possible, the procedures in Graph Theory are used, introducing terms as they are required. *Networks*, it should be emphasized, consist of an assemblage of connected *lines* and *points* and, in a diagram of this kind, the lines are obviously less 'abstract' than the points.

Three basic kinds of *points* are referred to in Graph Theory: *nodal* points (already discussed), *terminal* points, and what can be referred to as *arbitrary* points. A nodal point is therefore any point from which emanate *three or more lines*, arbitrary points—*only two lines*, and terminal points—*only one line*.

Only one kind of point figures in the 'elastic' model, *the nodal point*, so the arbitrary and terminal points have to be 'added' (in the form of 'beads' with which we could represent all the kinds of points).

For the mathematician the 'fundamental particle' of Geometry is the *point* and the foundation of modern Topology is the discipline known as *Point Set Theory* (the Theory of Sets was due to Cantor in 1879). For us the fundamental element in a network is the *line*, and there are no *points* as such.

'Graphical Models' can either present the *lines* as the objects (or elements), with *points* representing the relationships—or vice versa, the objects are the *points* and the *lines* the relationships, as with the atoms and bonds in molecular structures.

In the diagrams I have used, arbitrary points (called *nodes of degree two*) represented by small white circles. Points of *degree n* (*n* being any integer greater than two)—called *nodes of degree n* —and terminal points (terminal nodes) represented by small black circles.

A *formal topological image* is a graph drawn in such a manner as to visually emphasize the structure; the containing circuit is to be drawn in the form of a perfect circle and lines are drawn with equal length wherever possible and distributed with the greatest possible symmetry.

III. MONDRIAN'S LINEAR INFRA-STRUCTURES

During the two decades 1918–1938 Mondrian painted over one hundred and ninety pictures, of which at least a hundred exhibit the following 'mathematical feature':
the linear infra-structure is a *polyhedral network*.
Since Mondrian's paintings present us with a purely two dimensional structure, it must seem irrelevant at the outset to invoke a three dimensional image—the polyhedron. What do we mean by a polyhedral network? For our purposes a polyhedral

network is simply of the class of plane networks characterized by the following:

(1) It is a system or network (or structure) of connected lines that can be drawn in a plane. It is a *planar* graph, meaning that it can always be drawn so that none of the lines produce a cross-over.

(2) Every line in the network belongs to two and only two cells (regions, circuits, cycles) and, as a result, the graph is said to be *triply connected*, i.e. it is only possible to disconnect the graph (to product two connected graphs) by cutting *at least three* lines.

(3) Every cell (cycle or circuit) is made up of at least three lines, this means the graph can be conceived as a planar projection (a Schlegel diagram) of a *simply connected* polyhedra (i.e. a map on a plane or a sphere).

Thus a flag can be seen as presenting a network that is also the projection of a square based pyramid (Fig. I).

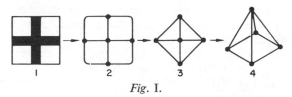

Fig. I.

If we imagine the thick cross in the flag to shrink to a thin linear cross and re-draw the figure as a graph, including only *the nodal points*, we arrive at a network which is essentially that of a poly-hedron.

But 'seeing it' this way might require that we examine other 'ways' of seeing it (Fig. II).

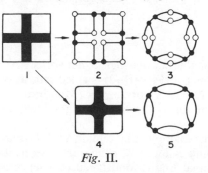

Fig. II.

The scheme of reduction in Fig. II shows that II (1) can be seen as composed of twenty 'lines' (instead of the eight shown in Fig. I); the sequence II (1), II (4), II (5), treats the figure as *a map*, which in turn can be considered to exhibit a linear structure where the sequence II (1), II (2), II (3) shows II (1) as essentially a graph but of a different kind from that shown in Fig. I.

The reduction shown in Fig. III takes III (1) to be interpreted as III (2) or III (3) i.e. with the interior lines *crossing*, and not meeting at a point, and, if as III (3), then it is again a polyhedron (the tetrahedron represented as the projection III (4) and as the solid III (5)).

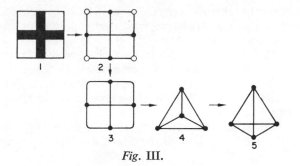

Fig. III.

We can see what happens if we replace the flag by a version where the cross is a thinner form— where the flag has the cross suppressed by a counter-change pattern (Fig. IV).

We see, from the standpoint of a linear network, that IV (1) and IV (2) are indistinguishable, despite

Fig. IV.

the fact that in IV (1) we say that we see 'lines' and in IV (2) only squares.

Finally, in further pursuit of the question of lines, or more specifically *the number* of lines in a configu-ration, we could take as a criterion the *traversability* of different graphs (Fig. V).

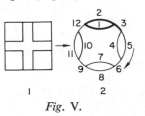

Fig. V.

Figure V shows how the flag can be traced (or drawn) by a minimum of four continuous sweeps of the hand, that is, four necessarily discontinuous trajectories (if we trace each line once and only once). The first trajectory takes in lines 1, 2 and 3, and this configuration can be repeated in a clockwise direction three more times. (There are of course other ways of setting out and completing the tracing with only four trajectories.)

In deciding to make the reduction shown in Fig. I we arrive at a graph (or network) composed of eight lines and five points or, considered as a map, we would also refer to the regions as cells, in this case 1 four-sided cell divided into 4 three-sided cells. In calling them *cells* we retain the idea of two-dimensional areas; while in graph theory we would see them as one dimensional and call them *cycles* (or *closed circuits*). If we had decided on the reduction scheme in Fig. II, the outer cell or cycle

would be taken as *twelve* sided (as in II (2)) composed of *twelve* line segments, and *twelve* points, or in the case of II (4) *eight* sided.

Thus we would seem to have changed our terms considerably as we developed a way of 'looking at' partitions of rectangles (or squares) into rectangles and/or squares. We now show how a reconciliation can be affected.

Let us consider *the network* in Fig. VI. Figure VI (2) is to be taken as *the formal topological image*

Fig. VI.

of VI (1); in mathematical language VI (2) is a *homeomorphically irreducible graph* on five points. In reducing VI (1) to VI (2) we have ignored the 'corners' of the 'square' VI (1) and in doing so we have also ignored four of the points.

Before proceeding, we must complete our definition of reducing a graph to a *topological* (or homeomorphically irreducible) graph (Fig. VI).

In Fig. VII the reduction VII (2) can be considered as a representation of the continuous trajectory that could describe VII (1).

Fig. VII.

In the Graph VII (2) we ignore the four points *d* but not the point *a*. The *d* points are points of degree two, and the point *a* is a terminal point. In VII (1) there are seven points in all and eight lines.

The reduced graph VII (2) has three points and four lines; point *a*, a terminal point; *c*, a point of degree three and *b* of degree four. Thus a topological graph is simply a graph with no points of degree two. (In Fig. VII (3) we show VII (2) on a lattice.)

Incidental here, but of importance to us in Fig. VII, is that whereas VII (1) is a graph *whose group is the identity*—which means it is asymmetric, VII (2) is symmetric ... and not only because it is 'drawn' symmetrically.

Returning to Fig. VI, what we see is the 'square with a cross' VI (1) transformed into an *elastic topological network* presented as a *formal* topological image VI (2)—and this is then laid over the lattice VI (3).

We shall call the operation of transferring a formal topological image *F* on to a lattice—making a *lattice embedding* of *F*.

We are in a position to define *F*, now to be taken as a *topological lattice network T*.

The topological network becomes a network on the lattice and, as such, becomes an $n \times n$ or $n \times m$ array. The smallest array on the lattice with a topological network that is polyhydral has $n = 2$, n^2 being the number of cells enclosed. Arrays are necessarily convex, as are the cells in the interior.

In a lattice embedding *F*, all the points of *F* lie on lattice points and all the lines must span lattice points by lines of unit length, that is all lines will be of length one, two, three etc.

For any *F* to be a *T*, the containing cell (cycle) must be composed of points of degree three, and no independent cycles can be composed of less than four lines; a cell with only three edges must share at least one edge with the containing cell.

Our interest is in enumerating the number of distinct *F* and then the number of distinct *T* employed by Mondrian, with specific regard to symmetry and asymmetry and/or the topological information content.

Our first question might well be this: are there compositions where the linear network takes a lattice embedding requiring the minimal array n^2 when $n = 2$?

As a start, let us examine the possible networks within the 2^2 array (Cf. Fig. VIII).

In Fig. VIII we show five possibilities allowing for every kind of network (excluding all reflections, rotations, etc., which would bring the total to fifteen).

We note that VIII (2) and VIII (3) are indis-

Fig. VIII.

tinguishable as *topological* networks. As a set of lattice networks VIII (2) is ruled out, as one of the interior cells is not convex (Mondrian never used the bent line—the 'left or right hand bend in a path').

Of the examples that remain VIII (1) is not a graph we would call a network in our sense, as it contains a terminal line (Mondrian used such graphs, but not this minimal example). We are left with VIII (4) and VIII (5); VIII (4) is the minimal *polyhedral* network (Mondrian never employed it) while VIII (5) is a *complete lattice*.

It is this last example that we discover to be the smallest *F* employed by Mondrian but with this reservation, while it is a lattice network, Mondrian employed it in a non-lattice format, i.e. a lozenge. (Cf. Fig. IX).

The two paintings represented by the *F* in Fig. IX are 'Composition with Black and Blue', 1926, and 'Composition with Two Lines', 1931. (We note that for Mondrian the linear structure is conceived as comprising *two* 'lines' ...)

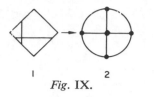

Fig. IX.

Amongst his compositions in a rectangular (and/or square) format—the majority of Mondrian's paintings—the smallest arrays employed are rectangular, 3×2, as shown in Fig. X (1) and (2).

Fig. X.

If we examine the relative sizes of arrays used by Mondrian between 1918 and 1944, we find that at the beginning he used 'complete' lattices (arrays of 16^2 and 15×16) but by 1930 had moved to lattices of half as much, 8^2, to rise slowly and almost attain the same density as in 1918, namely in the paintings called 'New York City', 1942 and 'Broadway Boogie Woogie', 1942–1943, each of which employ an array of 12×13. (However in these final paintings it is no longer possible to see the lines as comprising a *planar* arrangement.)

Before examining in detail the polyhedral networks, we should briefly mention the exceptions, namely:

(a) graphs with terminal lines;
(b) networks which are less than triply connected.

Of the first group, there exist at least ten compositions (6 of 1921 and 4 of 1922) and it is interesting to note that the terminal lines, if extended, would reach the containing cycle without crossing any other lines, thus they always paint 'outwards'.

Of the second group, there is only one example from the period ending in 1938. It is the 'Composition with Blue and White', 1936, shown in Fig. XI (1) and (2).

Fig. XI.

This network is not polyhedral, for it can be disconnected by cutting the lines a and a', which separates it into two connected graphs.

Other features of this graph are: (i) that it is *point-regular*—all the points are of the same degree, and (ii) that the lines in the interior comprise two *trees* (a tree being a connected graph with no cycle).

Amongst the one hundred or so polyhedral networks, well over two thirds are networks con-

taining independent cycles. However between 1922 and 1936 there are at least 23 compositions where the networks contain no independent cycles—the interior lines forming a single *tree*. The earliest examples of a composition with no independent cycles is unique on two counts; it contains the largest *tree* employed by Mondrian (it has fourteen points).

In Fig. XII we show a sketch of the line structure of the 'Composition with Red, Yellow and Blue', 1922 (XII (1)); the lattice network XII (2) and the formal topological image XII (3).

From the size of the reproduction shown in Seuphor's catalogue, the linear infra-structure of

Fig. XII.

this composition would appear to be a cubic network. But on closer inspection we see that this is not the case, and that it has a free terminal line.

We find in all the linear infra-structures containing single *trees* that they reduce to only nine distinct *trees*; ranging from *trees* with seven points right through to fourteen points.

IV. SYMMETRY/ASYMMETRY

The major purpose of nearly all that was included in Section II has been to set out the essential background for the treatment of symmetry/asymmetry in a linear infrastructure.

I attempted in an article on structure [11] to explain briefly the concepts of symmetry/asymmetry in graphs and the related topic of the topological information content.

I chose there for my example a painting by Mondrian exhibiting the smallest asymmetric network on the lattice (Cf. Fig. XIII).

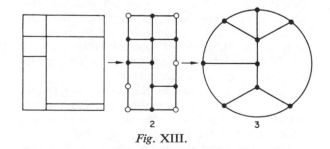

Fig. XIII.

It is not difficult to show that Mondrian's avoidance of symmetry was real, but this can only be done by a careful examination of a large enough quantity of his works. Once we have reached agreement on this, we will have 'defined' *symmetry/asymmetry* in a manner that is quite acceptable.

It is my intention here to attempt a similar definition, i.e. by showing in this case how we arrive at a *different* concept of symmetry.

Let us start the attempt not with the examples in Scheme VIII but something different:

In Fig. XIV we show a lattice network XIV (2)

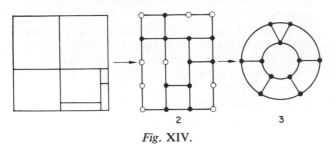

Fig. XIV.

employed in at least three of Mondrian's compositions made between 1930–1932 (XIV (1) indicates the kind of proportions used).

Now no lattice arrangement of XIV (3) (the formal topological image) can result in a *symmetrical* disposition of the lines. This becomes obvious in observing the structure of XIV (3), which at the same time we see drawn with its lines *disposed symmetrically*.

This means that when we take a network off the lattice we will often find that it is symmetrical.

Before focusing sharply on the distinction between symmetry/asymmetry on the lattice, as against that of the formal topological image, let us consider Fig. XV.

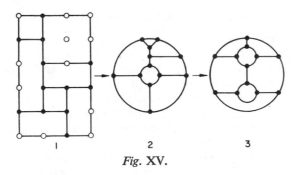

Fig. XV.

The graph in Fig. XV (2) does not reveal the fact that it is symmetric. To show this, we must resort to a mapping of XV (2) into itself; the result of which XV (3) is plainly symmetric. However, as with XV (2), there is no possible arrangement of XV (3) on the lattice because one of the independent circuits contains only three points.

To return to the graphs XV (2) and XV (3), we note in Fig. XVI how the graph (2) in XVI has been mapped into itself, i.e. into the cycle of *bb'c'c*, which now becomes the 'containing cycle'.

The points *a* and *a'*, *b* and *b'*, *c* and *c'* and *d* and *d'* are said to be *interchangeable*; the remaining points are *distinguishable*, i.e. they cannot be interchanged with any others.

Thus for a graph to be asymmetric, we have to show that *all* of its points are distinguishable, and this is the case in the examples shown in Fig. XII (1)

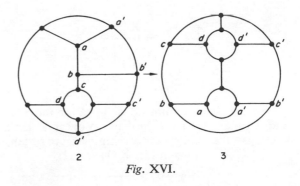

Fig. XVI.

(a *non-topological* graph) and in Fig. XVI (3) (a *topological* graph).

The subject under discussion is given its fullest treatment when we ask: 'what is the *group* of a given graph?' Obviously, we depend on just this treatment, which is perhaps too large a topic to pursue here any further.

However there is a further example that it would be useful to show. We pose the following problem:

> Given two cubic asymmetric graphs, both containing the conjectured minimum number of points (namely twelve), we ask: which of the two provides us with the greater number of distinct lattice embeddings?

The problem can be stated in the following terms: of the two *trees* (a) and (b) shown in Fig. XVII, which

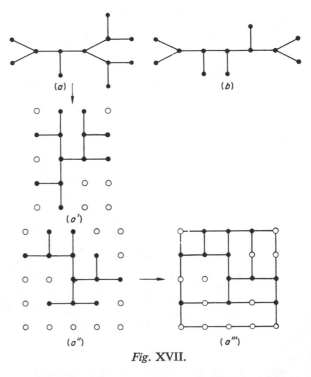

Fig. XVII.

one has the greater number of distinct 'citings' on the lattice such that all the terminal points can lie on a convex cycle?

In Fig. XVII we show the two distinct topological trees that give rise to networks whose group in each case is the identity (i.e. they are asymmetric).

In XVII (*a*) we show a possible lattice citing of XVII (*a*); and in XVII (*a*″) a further example which

requires that we lengthen three of the terminal lines, so as to arrive at the lattice in XVII (*a'''*).

At a first count I have obtained 30 for XVII (*a*) (240, if we include all rotations, reflexions, etc.) and 36 for XVII (*b*) (288 with rotations, etc.)

There are two factors of interest here; first, that a network can be point regular and yet have all its points distinguishable so that it is asymmetric; and second, that two such networks can exist while being topologically distinct as seen in the example of the two cubic graphs on twelve points.

In constructing these two networks, each from a distinct tree, we notice that in the case of one, XVII (*a*), it has only one planar embedding while with the other, XVII (*b*) has two more embeddings as shown in Fig. XVIII.

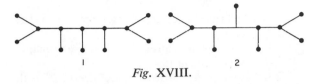

Fig. XVIII.

All distinct lattice citings of a tree are topologically congruent, as are the networks that can be made by joining their end points to a circuit. But distinct embeddings of a given tree in the plane (if it should have more than one)—prior to citing on the lattice—give rise to distinct networks (i.e. not topologically congruent).

With the networks derived from XVIII (1) and XVIII (2), there are at least 24 lattice embeddings that are distinct (producing 172 with all rotations) for the former, and 12 (76 with rotations) for the latter.

V. THE TOPOLOGICAL INFORMATION CONTENT

In an article [11] already referred to, I outline the application of the topological information content to networks. Broadly speaking, this amounts to giving a quantitative index to a qualitative feature in networks, namely *the amount of symmetry/asymmetry*.

We have seen that if all the points of a network* are distinguishable, then it is asymmetric and, in this case, the topological information content is maximal. Thus the network shown in Fig. XIII has an information content expressed by:

$$\log_2 9 = 3 \cdot 17,$$

since there are nine points, all of them distinguishable. In the same article I pointed out that I could find no example where Mondrian employed a network whose information content was zero.

I have mentioned that on a lattice we can have only one kind of point-regular graph, the cubic. Now amongst planar graphs there is a class of polyhedral networks that are point regular and symmetric, that is point *and* line symmetric. In

* A 'strict' topological graph, connected and containing no multiple lines or loops (one- or two-sided cells).

such graphs all the respective components are interchangeable; as a result no points, lines or cycles are topologically distinguishable. These graphs are therefore completely symmetric and their information content is zero.

There are three graphs of this kind that Mondrian *could* have used. I show two of these. They are the networks of the tetrahedron and the cube shown in Fig. XIX (1) and (2).

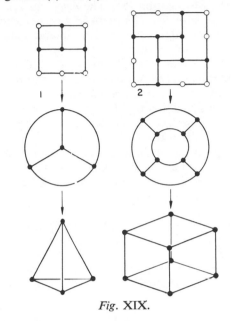

Fig. XIX.

In Fig. XX we show the four distinct lattice embeddings of the network in XIX (2)—giving sixteen

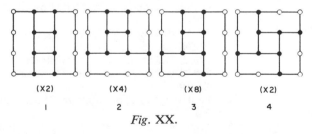

Fig. XX.

in all—(XX (3) being *asymmetric on the lattice*, it gives rise to seven other embeddings by permuting the reflexions, rotations, etc.).

VI. CONCLUSIONS

Up till now, the 'conventional' view of mathematics and its relevance to art has obscured the possibility of looking into Mondrian's compositions for any features other than those of an 'arithmetical' character (ratios, proportions, etc.) The search for a 'hidden geometry' in his works has so far found nothing of importance, therefore it must remain in the realm of conjecture. I hope in the analyses presented here to have shown how we can enrich our pleasure (and interest) in looking at Mondrian's paintings—through asking different kinds of questions relating to their structure and 'geometry'. Furthermore this approach is, in general, extendable to many other types of work and may be used consciously by the artist in creating his works.

Of the questions discussed, the idea of Mondrian's 'axioms' seems to me probably the most worthwhile for further investigation. The idea of being able to perceive simple examples of *topological symmetry* and *asymmetry* also raises questions of interest in the study of visual perception.

NOTES

A. The standard work on Mondrian to date is Seuphor's Monograph [5]. The *catalogue raissoné* (the first attempted) puts the works into categories of 'subject matter' and 'compositional features' (for the abstract works).

B. See Bouleau's *The Painter's Secret Geometry* [7], Biederman's *The New Cezanne* [8], and Ragghianti's *Mondrain e l' Arte del XX Siecle* [9].

Bouleau's analysis of Mondrian's 'Composition with Two Lines', 1926—undertaken to show that the work utilizes the Golden Section—is worth a study in itself, on the basis of the errors in measurement and other inadmissible assumptions. In an article by Seuphor [6], drawings were reproduced bearing the caption: 'Etude pour le tableau 24 Losangique,' these were mathematical-looking schemes in which the symbol π appeared. The reader was left to draw the conclusion that Mondrian made such studies . . . and at least one serious journal (that of the Modular Society) was tricked into reproducing them, credited to Mon-

drian, as evidence of his manner of composing. However in a later edition of the magazine that carried Seuphor's article, Seuphor explained that they were not by Mondrian but by Georges Vantongerloo. In Seuphor's book he explains that Vantongerloo, who had made numerous analyses of Mondrian's compositions, finally abandoned these studies as he considered them to be quite incorrect!

C. See Joost Baljeu's 'Problem of Reality' [10]. In the present author's view the account that Baljeu gives of Brouwer's philosophy (and his assessment of Brouwer's position in Science) is deceptive, to say the least.

D. Bourbaki's concept of structure recognizes three basic kinds, from which all other kinds are to be derived:

(1) Algebraic structures whose prototype is the *group*.
(2) The order structures, one of whose principal forms is the *lattice*.
(3) Topological structures concerned with *continuity*.

(I found both their definition of mathematics and the above categories only recently and was interested to note the coincident, although superficial similarity, to my own categories in analysing the networks.)

REFERENCES

1. Victor Hugo, Things of the Infinite, essay in Hugo's *Intellectual Autobiography* (Postcriptum de ma Vie), translated by Lorenzo O'Rourke (New York: Funk & Wagnallis, 1907).
2. Armando Asti Vera, Epistemology, Science of Structures, *Transformation* 1/3 (New York: Wittenborn Schultz, 1952).
3. Wladyslaw Tatarikiewicz, Abstract Art and Philosophy, *Br. J. Aesthet.* **II**, 3 (1962). See also Irving L. Zupnik: Phenomenology and Concept in Art, *Br. J. Aesthet.* **VI**, 2 (1966).
4. Paul Bernays, Comments on Wittengenstein's Philosophy of Mathematics, *Ratio* **II**, No. 1 (1959).
5. Michael Seuphor, *Piet Mondrian* (London: Thames & Hudson, 1957).
6. Michael Seuphor, Piet Mondrian et les origines du Neo-Plasticisme, *Art D'Aujourd'hui*, No. 5 (1949).
7. Charles Bouleau, *The Painter's Secret Geometry* (London: Thames Hudson, 1963).
8. Charles Biederman, *The New Cezanne* (Red Wing Minnesota: Art History, 1958).
9. Carlo Ragghianti, *Mondrian e l'Arte del XX Siecle* (Venice: Neri Pozza, 1963).
10. Joost Baljeu, Problems of Reality—Marginal notes on the Dialectic Principles in the Aesthetics of Mondrian, Tatlin etc., *Lugano Review*, **1** (1965).
11. Anthony Hill, Program: Paragram: Structure, in *Data—Directions in Art, Theory and Aesthetics*. (London: Faber & Faber, to appear in 1968).

PROJECTIVE GEOMETRY IN THE COLOUR DRAWINGS OF H. P. NIGHTINGALE

Charles Nightingale*

Abstract—*The beginning of projective geometry, its early relationship to perspective in art, from which it sprung, and its application to the production of imaginative and complex art forms, as embodied in the work of the late H. P. Nightingale, are discussed. The concept of perspective divorced from nature is presented together with a method for making such a class of drawings.*

I. ON ART DERIVED FROM PROJECTIVE GEOMETRY

1.

The application of projective geometry to art is by no means a new venture. Perspective has provided a structure for representational painting and drawing for hundreds of years. Perspective is rooted in projective geometry and hence the mastery of representational art involves a grasp of certain fundamental ideas of projective geometry. An interesting parallel can be drawn with representational sculpture in which projective geometry plays no part. The sculptor works in the three-dimensional Cartesian space, the representational painter on a two-dimensional projective plane. A sculptor who has mastered the technique of sculpting a perfect sphere has mastered all spheres. A painter who has mastered the technique of drawing a circle has mastered only the ability to draw wheels, plates, vase-rims and other circular objects seen from a point lying on the normal to the plane of the disc and through its centre. Such a view of the natural world is limited, for one rarely sees circles but mostly ellipses and that is what artists usually draw. The mathematical art of my father, H. P. Nightingale, who died in London on 25 June 1965, goes as much farther from this simple concept as Cubism and the schizophrenic cat painter, Louis Wain, have gone from traditional representational picture making.

Yet, Nightingale's drawings cross no artistic discontinuity any more than those of the Cubists or of Wain. As Wain's work has gradually evolved into glittering and exotic webs of colour without abandoning the central idea of a cat, so the drawings of Nightingale have retained the essential geometrical concepts of Desargues and Pascal. Desargues was himself influenced by what, in his day, was a form of Surrealism; his mathematics was composed more like an artistic structure than a mathematical one and here he is linked, via the evolution of both art and geometry, to Nightingale. Desargues invented projective geometry in spite of Pappus' classical ventures. The invariance of the cross-ratio, the intersection of parallels at infinity and the closing of the projective plane, these are the dies from which projective geometry was stamped.

Descartes himself admired Desargues much as Louis Armstrong might have admired Charlie Parker, Tolkien might have admired Mervyn Peake or a grower of roses might admire the terrible *Raffelsia* of Malaya. Desargues devised the most absurd mathematical jargon that the seventeenth century ever witnessed, or indeed any century until, unhappily, the twentieth. His pupils were mystified by it, except Pascal, who gave it crystal clarity. But Pascal, a deeply religious person, left mathematics for metaphysics whilst still in his youth, leaving the field clear for the great battle of synthetic versus algebraic projective geometry that raged for about a century and a quarter, leaving the algebraic as victor. Yet Pascal's brilliance could never overshadow the imagination of Desargues. Evolution involves mutation and Desargues was a mutation; it continues with adaptation and Pascal was the adaptation; and it ends in struggle and the battle with algebraic geometry was the struggle. Desargues was finally defeated and his synthetic geometry seemingly died. The algebraists led by P. de la Hire stood victorious for three hundred years. Yet we have witnessed in the last fifteen years the sudden death of algebraic projective geometry, whilst the

*Telecommunications scientist living at 39 Quilter Road, Felixstowe, Suffolk, England. (Received 29 September 1972.)

synthetic is finding an evolutionary niche where the algebraic cannot live—the field of art. In the following paragraphs I shall try to explain why.

2.

Perspective is a special case of projective geometry, just as a snake is a kind of reptile. Not all reptiles are snakes and similarly not all projective geometry is perspective. It is reasonable to inquire whether the geometry could sustain an artistic life independent of perspective. The striking perspectives of Renaissance painting catch and fascinate the eye with their infinite depth of focus, which is unattainable in photography. Yet, nature still rules. Remove the figures, the windows and all detail, leaving only the geometric structure and one is still firmly trapped in the observed world. Nightingale stepped away from the observed world, away from perspective and into a more general conception. The effect on the mind is electrifying. One sees landscapes that have rules of perspective beyond nature. One visits, in the pictures, the insane dreams of H. P. Lovecraft, where horizons hang in lurid mockery of our intuition and one is immersed in a whirling cosmos of triangles and conic sections. One sees drawings of frames of reference that our brain assumes to be Cartesian as seen from oblique angles. One believes that one sees perspective but one does not.

To fix on some readily observed characteristics of perspective and projective geometry, it is helpful to consider a circle. If one looks at a circle obliquely, it appears as an ellipse. Thus, in perspective any circle may be an ellipse and any ellipse a circle. A circular flower bed seen from any position but from vertically above it appears as an ellipse. But in projective geometry the flower bed may appear as any conic section: hyperbola, parabola, ellipse, circle or a pair of crossing straight lines. The circle may be validly drawn as a pair of lines! The ellipse may be seen as a hyperbola.

Speaking synthetically, the most unlikely, yet logical, changes come over the world. If an ellipse might be a hyperbola, what then might become of a flower? Such matters await a mathematician not preoccupied with computers but lured on by the rewards of beauty and mystery.

3.

From an algebraist's point of view we are saying nothing more than the following dull equations:

Let $XY = Z^2$ (The equation of a conic section)

$$(\text{Eq. 1})$$

and

$$X = a_{11}x + a_{12}y + a_{13}z$$
$$Y = a_{21}x + a_{22}y + a_{23}z$$
$$Z = a_{31}x + a_{32}y + a_{33}z \qquad (\text{Eq. 2})$$

then $(a_{11}x + a_{12}y + a_{13}z)(a_{21}x + a_{22}y + a_{23}z)$
$$= (a_{31}x + a_{32}y + a_{33}z)^2$$

or $(a_{11}a_{21} - a_{31}^2)x^2 + (a_{12}a_{22} - a_{32}^2)y^2$
$$+ (a_{13}a_{23} - a_{33}^2)z^2$$
$$+ (a_{11}a_{22} + a_{12}a_{21} - 2a_{31}a_{32})xy$$
$$+ (a_{12}a_{23} + a_{13}a_{22} - 2a_{32}a_{33})yz$$
$$+ (a_{13}a_{21} + a_{11}a_{23} - 2a_{33}a_{31})zx = 0 \qquad (\text{Eq. 3})$$

The above equations say that a homogeneous second degree expression becomes another homogeneous second degree expression under a linear transformation. Geometrically, they say that a projection of a conic section is a conic section. Artistically they say nothing. Similar equations express other important facts about projective geometry. They may be consulted by the masochist in E. A. Maxwell [1]. As an illustration, one may now ask what happens to the expression

$$F(x) = 0 \qquad (\text{Eq. 4})$$

under the transformation $\mathbf{x} = A\mathbf{x}'$, where \mathbf{x} is the vector (x, y, z), \mathbf{x}' is the vector (x', y', z') and A is a 3×3 matrix with constant coefficients.

The construction of projective designs from Eq. 4 would generally be a difficult task indeed. Unlike Cartesian co-ordinates, generalized homogeneous co-ordinates do not lend themselves to a simple method of construction. To all but the initiated, the construction of the point $(17, 144, -3)$, for example, given only the four determining points $(1, 0, 0)$, $(0, 1, 0)$, $(0, 0, 1)$ and the unit point $(1, 1, 1)$, would be impossible. An explanation of the method would require a long and rather cumbersome dissertation, yet would be easy to communicate by a demonstration.

So much for the algebra. The sudden death of algebraic projective geometry is not likely to be regretted.

Synthetically, the construction of Fig. 1 is far more complex than the simple equations above. It involves a technique originated by my father, which I shall present in Part II. With the present slump in interest in projective geometry in mathematics, there is little likelihood that a competent geometer will continue further with the method in the near future. The surface of the subject has been dented

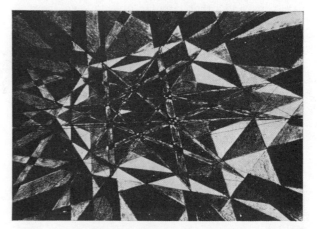

Fig. 1. H. P. Nightingale, 'Hexagons', crayon, 11 × 15 in., 1954. (Collection of H. Levy, Wimbledon, England.)

and only that in spite of the great efforts of my father. The construction of further projective drawings with curves of higher order than two promises to lead to paintings whose effect could be mesmeric. There is no royal road to mastery in projective art. Nor are there divine rules to govern it. Why use only Eq. 4? Why a quadratic projection? There is no reason. Yet the required amount of study and insight might be great indeed.

The artist who reverses the often observed phenomenon that significant developments are unintelligible to contemporaries and works on the principle that if he produces unintelligible work it will be significant will not venture into this field. An artist wishing to polish, refine and develop these techniques will be honest above all. Such an artist will confirm my own opinion that in art, as in all else, evolution rolls over revolution like a Brontosaur stepping on some ill-adapted and unknown phylum of animal born of mindless mutation. What Desargues started let someone adapt and perhaps produce his own lord of creation or doomed dodo.

II. THE CONSTRUCTION OF A REGULAR HEXAGON IN THE PROJECTIVE PLANE

1.

Since many of Nightingale's drawings are based on figures with six sides or multiples of six sides, it is of interest to show the construction of a regular hexagon in the projective plane. More complex figures may be built up from such a beginning and some of the fundamental principles demonstrated.

In the Euclidean plane, a regular hexagon is defined as a six-sided polygon having equal sides and equal interior angles. In the projective plane, neither equal lengths nor equal angles are meaningful concepts, so we must find other properties of six-sided polygons that are not lost by projection. These properties are the intersection of all the diagonals at one point and the parallelism of the diagonals to opposite sides. These properties have analogues in projective geometry. Before considering the projective analogues we should note Fig. 2, showing a hexagon with the above properties

that is not regular. This does not mean that the definition is wrong, since Fig. 2 can be projected into a regular hexagon.

For the projective plane, we ask ourselves what is the analogue of: (a) intersecting diagonals and (b) sides parallel to diagonals? For (a) the answer turns out to be simple: the intersection of the diagonals is as valid in the projective plane as in the Euclidean. For (b) we observe that parallel lines meet at infinity. In the projective plane, the line at infinity is conveniently at hand on the page. Thus our sides and diagonals must intersect on some line that we choose to call infinity.

2.

With the above information, we set ourselves the task of drawing a polygon of six sides such that: (a) its diagonals intersect at a point (say U) and (b) its opposite sides and diagonals taken in triplets intersect at points on a line (say P, Q, R).

The construction of such a figure cannot proceed by haphazard methods, so we follow the procedure outlined as follows (Fig. 3): First draw a straight line. Then select three points on it arbitrarily, say P, Q, R. Further select an arbitrary point U and draw line QU. Select a point anywhere on line QU, say Y. Draw lines PY, RY. Let the intersection of RU with PY be A and that of PU with RY be C. Let the intersection of QA with PC be Z and that of QC with RU be X. Then the following holds true:

The intersection of PX and RZ (say B) lies on the line QY.

The resulting figure AYCXBZ is then a regular hexagon in the projective sense.

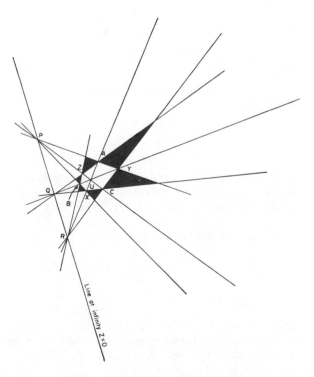

Fig. 2. Figure projectable into a regular hexagon.

Fig. 3. Projected regular hexagon.

3.

Of course, if the statement at the end of the construction is false, then the diagonals would not intersect and the conditions chosen would be violated. Thus, it is necessary to prove that Q, B, U are collinear, using homogeneous co-ordinates.

To find if the points are collinear, we must test that:

$$\begin{vmatrix} Q_1 & Q_2 & Q_3 \\ B_1 & B_2 & B_3 \\ U_1 & U_2 & U_3 \end{vmatrix} = 0$$

where
$$Q \equiv (Q_1 \quad Q_2 \quad Q_3)$$
$$B \equiv (B_1 \quad B_2 \quad B_3)$$
$$U \equiv (U_1 \quad U_2 \quad U_3)$$

are the co-ordinates of the points.

First, we fix the co-ordinate system by making the equation of PQR

$$x + y + z = 0 \qquad (\text{Eq. 5})$$

We set U as the *unit-point* of the frame of reference and set $P \equiv (-1, -1, 2)$ $Q \equiv (-1, 2, -1)$ and $R \equiv (2, -1, -1)$.

We then wish to find the co-ordinates X, Y, Z, A, B, C. First, we need the equation of PY. Since Y has not been fixed, we may set the co-ordinates as $Y \equiv (0, 1, 0)$, since this satisfies the condition that it lie on line QU, whose equation is

$$\begin{vmatrix} X & Y & Z \\ 1 & 1 & 1 \\ 1 & 0 & -1 \end{vmatrix} = 0$$

or $Z = X$ $\qquad (\text{Eq. 6})$

The line PY is given by the equation

$$\begin{vmatrix} X & Y & Z \\ 0 & 1 & 0 \\ -1 & -1 & 2 \end{vmatrix} = 0$$

or $2X + Z = 0$ $\qquad (\text{Eq. 7})$

We may also insert the following equations by symmetry:

$$RU \equiv Z = Y$$
$$PU \equiv X = Y$$
$$RY \equiv 2Z + X = 0$$

Now we may easily obtain the co-ordinates of A and C. A is the intersection of PY and RU and is easily seen to be $(-1, 2, 2)$. By symmetry: $C \equiv (2, 2, -1)$.

We now obtain equation for QC as:

$$\begin{vmatrix} X & Y & Z \\ -1 & 2 & -1 \\ 2 & 2 & -1 \end{vmatrix} = 0$$

or $Y + 2Z = 0$

and similarly $QA \equiv 2X + Y = 0$. $\qquad (\text{Eq. 8})$
X is thus the intersection of $Y + 2Z = 0$, with $Z = Y$, which yields: $X \equiv (1, 0, 0)$. Similarly $Z \equiv (0, 0, 1)$.

The reader familiar with homogeneous co-

ordinates will recognize XYZ as the triangle of reference.

We now obtain B as the intersection of PX, RZ. PX is given by:

$$\begin{vmatrix} X & Y & Z \\ 1 & 0 & 0 \\ -1 & -1 & 2 \end{vmatrix} = 0$$

or $\qquad 2Y + Z = 0 \qquad (\text{Eq. 9})$

and $\qquad X + 2Y = 0 \qquad (\text{Eq. 10})$

The intersection is the ratio solution of Eqs. 9 and 10 given by:

$$\frac{X}{\begin{vmatrix} 2 & 0 \\ 2 & 1 \end{vmatrix}} = \frac{-Y}{\begin{vmatrix} 1 & 0 \\ 0 & 1 \end{vmatrix}} = \frac{Z}{\begin{vmatrix} 1 & 2 \\ 0 & 2 \end{vmatrix}} = (2, -1, 2).$$

Thus, we may assemble the co-ordinates of the points Q, B, U and observe that:

$$\begin{vmatrix} -1 & 2 & -1 \\ 2 & -1 & 2 \\ 1 & 1 & 1 \end{vmatrix} = 0$$

that shows that Q, B, U are collinear.

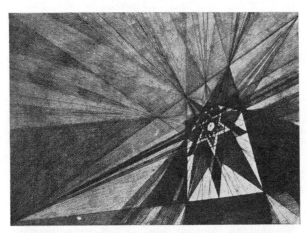

Fig. 4. H. P. Nightingale, 'Regular Hexagon', crayon, 11 × 15 in., 1958. (Collection of H. Levy, Wimbledon, England.)

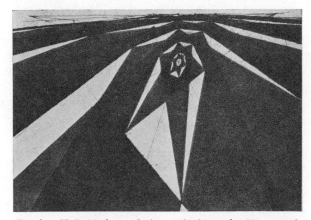

Fig. 6. H. P. Nightingale, 'Inscribed Regular Hexagons', crayon, 15 × 22 in., 1959. (Collection of H. Levy, Wimbledon, England.)

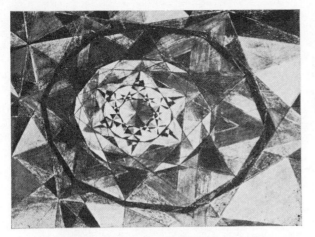

Fig. 7. H. P. Nightingale, 'Double Hexagons', crayon, 11 × 15 in., 1961. (Collection of H. Levy, Wimbledon, England.)

Fig. 9. H. P. Nightingale, 'Stars', crayon, 11 × 15 in., 1960. (Collection of H. Levy, Wimbledon, England.)

The central stars in, for example, Fig. 4 are projected regular hexagons, as are those in Figs. 5 to 9 (Fig. 5, colour illus. I, p. 311).

My sincere thanks are due to my colleague, David Wise, who obtained the construction from first principles, thus obviating the necessity for a laborious sifting of material.

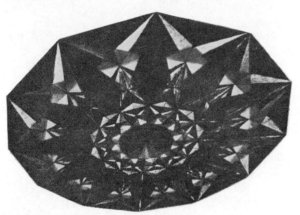

Fig. 8. H. P. Nightingale, 'Duodecagon', crayon, 11 × 15 in., 1953. (Collection of H. Levy, Wimbledon, England.)

REFERENCE

1. E. A. Maxwell, *The Methods of Plane Projective Geometry Based on the Use of General Homogeneous Co-ordinates* (Cambridge, England: Cambridge Univ. Press., 1957).

4.

The sides of the hexagon exhibit a pleasing algebraic symmetry:

$$X + 2Y = 0$$
$$2Y + Z = 0$$
$$2X + Y = 0$$
$$X + 2Z = 0$$
$$2X + Z = 0$$
$$Y + 2Z = 0$$

EXAMPLES OF MY VISUAL NUMERICAL ART

Richard Kostelanetz*

1.

The graphic works that I shall describe are both visually and numerically organized and they were made to give aesthetic pleasure. Their 'meaning' is primarily, though not exclusively, in terms of numbers. (The mysticism of numerology does not concern me.) In my art, the numerical relationships are those of simple arithmetic; and since these relationships are not arbitrary, the works might be considered systemic. Though at first viewing they

*Artist and writer, P.O. Box 73, Canal St., New York, NY 10013, U.S.A. (Received 2 March 1976.)

Fig. 1. '*1024*', *numerical art, silkscreened print on Arches paper*, 56 × 78 cm, 1974.

Fig. 2. '*Indivisibles*', *numerical art, silkscreened print on Arches paper*, 56 × 78 cm, 1974.

might appear rather elementary, further contemplation reveals a complexity of relations that is nonetheless empirical. I think of my antecedents as being the constructivists, Mondrian [1] and van Doesberg in particular, Moholy-Nagy (cf. my documentary monograph [2]) and the composer John Cage (cf. my documentary monograph [3]). From the former, as well as the serial composers, comes my interest in rigorous structure; from the latter, the realization that one can try to make art of anything. Other texts of mine are listed in Refs. 4 and 5.

2.

The four examples of my numerical art that I shall discuss were all made in 1974.

'*1024*' (Fig. 1)

This array consists of 9 sections, each containing repeated numbers that add up to 1024, and first or topmost section containing only the number 1024.

```
12569034781 23670145892 34781256903 45892367014 56903478125    18743096521 29854107632 30965218743 41076329854 52187430965
45892367014 56903478125 67014589236 78125690347 89236701458    41076329854 52187430965 63298541076 74309652187 85410763298
56903478125 67014589236 78125690347 89236701458 90347812569    52187430965 63298541076 74309652187 85410763298 96521874309
89236701458 90347812569 01458923670 12569034781 23670145892    85410763298 96521874309 07632985410 18743096521 29854107632
90347812569 01458923670 12569034781 23670145892 34781256903    96521874309 07632985410 18743096521 29854107632 30965218743
23670145892 34781256903 45892367014 56903478125 67014589236    29854107632 30965218743 41076329854 52187430965 63298541076
34781256903 45892367014 56903478125 67014589236 78125690347    30965218743 41076329854 52187430965 63298541076 74309652187
67014589236 78125690347 89236701458 90347812569 01458923670    63298541076 74309652187 85410763298 96521874309 07632985410
78125690347 89236701458 90347812569 01458923670 12569034781    74309652187 85410763298 96521874309 07632985410 18743096521
01458923670 12569034781 23670145892 34781256903 45892367014    07632985410 18743096521 29854107632 30965218743 41076329854
12569034781 23670145892 34781256903 45892367014 56903478125    18743096521 29854107632 30965218743 41076329854 52187430965

67014589236 78125690347 89236701458 90347812569 01458923670    63298541076 74309652187 85410763298 96521874309 07632985410
90347812569 01458923670 12569034781 23670145892 34781256903    96521874309 07632985410 18743096521 29854107632 30965218743
01458923670 12569034781 23670145892 34781256903 45892367014    07632985410 18743096521 29854107632 30965218743 41076329854
34781256903 45892367014 56903478125 67014589236 78125690347    30965218743 41076329854 52187430965 63298541076 74309652187
45892367014 56903478125 67014589236 78125690347 89236701458    41076329854 52187430965 63298541076 74309652187 85410763298
78125690347 89236701458 90347812569 01458923670 12569034781    74309652187 85410763298 96521874309 07632985410 18743096521
89236701458 90347812569 01458923670 12569034781 23670145892    85410763298 96521874309 07632985410 18743096521 29854107632
12569034781 23670145892 34781256903 45892367014 56903478125    18743096521 29854107632 30965218743 41076329854 52187430965
23670145892 34781256903 45892367014 56903478125 67014589236    29854107632 30965218743 41076329854 52187430965 63298541076
56903478125 67014589236 78125690347 89236701458 90347812569    52187430965 63298541076 74309652187 85410763298 96521874309
67014589236 78125690347 89236701458 90347812569 01458923670    63298541076 74309652187 85410763298 96521874309 07632985410

14589236701 25690347812 36701458923 47812569034 58923670145    10763298541 21874309652 32985410763 43096521874 54107632985
81256903478 92367014589 03478125690 14589236701 25690347812    87430965218 98541076329 09652187430 10763298541 21874309652
70145892367 81256903478 92367014589 03478125690 14589236701    76329854107 87430965218 98541076329 09652187430 10763298541
47812569034 58923670145 69034781256 70145892367 81256903478    43096521874 54107632985 65218743096 76329854107 87430965218
36701458923 47812569034 58923670145 69034781256 70145892367    32985410763 43096521874 54107632985 65218743096 76329854107
03478125690 14589236701 25690347812 36701458923 47812569034    09652187430 10763298541 21874309652 32985410763 43096521874
92367014589 03478125690 14589236701 25690347812 36701458923    98541076329 09652187430 10763298541 21874309652 32985410763
69034781256 70145892367 81256903478 92367014589 03478125690    65218743096 76329854107 87430965218 98541076329 09652187430
58923670145 69034781256 70145892367 81256903478 92367014589    54107632985 65218743096 76329854107 87430965218 98541076329
25690347812 36701458923 47812569034 58923670145 69034781256    21874309652 32985410763 43096521874 54107632985 65218743096
14589236701 25690347812 36701458923 47812569034 58923670145    10763298541 21874309652 32985410763 43096521874 54107632985

69034781256 70145892367 81256903478 92367014589 03478125690    65218743096 76329854107 87430965218 98541076329 09652187430
36701458923 47812569034 58923670145 69034781256 70145892367    32985410763 43096521874 54107632985 65218743096 76329854107
25690347812 36701458923 47812569034 58923670145 69034781256    21874309652 32985410763 43096521874 54107632985 65218743096
92367014589 03478125690 14589236701 25690347812 36701458923    98541076329 09652187430 10763298541 21874309652 32985410763
81256903478 92367014589 03478125690 14589236701 25690347812    87430965218 98541076329 09652187430 10763298541 21874309652
58923670145 69034781256 70145892367 81256903478 92367014589    54107632985 65218743096 76329854107 87430965218 98541076329
47812569034 58923670145 69034781256 70145892367 81256903478    43096521874 54107632985 65218743096 76329854107 87430965218
14589236701 25690347812 36701458923 47812569034 58923670145    10763298541 21874309652 32985410763 43096521874 54107632985
03478125690 14589236701 25690347812 36701458923 47812569034    09652187430 10763298541 21874309652 32985410763 43096521874
70145892367 81256903478 92367014589 03478125690 14589236701    76329854107 87430965218 98541076329 09652187430 10763298541
69034781256 70145892367 81256903478 92367014589 03478125690    65218743096 76329854107 87430965218 98541076329 09652187430
```

Fig. 3. 'Two Intervals', numerical art, silkscreened
print on Arches paper, two images, each 56 × 78 cm, 1974.

The repeated number in each section is equal to one-half the number in the next section above. Also, the number 1024 is obtained when the following multiplications are performed, where the multiplicands are selected consecutively from the top and from the bottom of the array, and concluding with 32, which is multiplied by itself: 1024 × 1; 512 × 2; 256× 4; 128 × 8; 64 × 16; 32 × 32.

'Indivisibles' (Fig. 2)

This visually haphazard arrangement is a collection of prime numbers. (A prime number is a whole number that can be divided only by 1 or by itself.) It follows that they are all odd numbers with the exception of 2, which seems incongruous. I chose a haphazard arrangement to indicate that there is no other recognizable relation or pattern in the sequence of prime numbers.

'Two Intervals' (Fig. 3)

I call these arrays of numbers 'Two Intervals', because each number in them is related to the four numbers immediately surrounding it, vertically and horizontally, by adding or subtracting the numbers 1 or 3. A qualification is that since there are no two-digit numbers in the array, the number 1 functions as both 1 and 11 simultaneously, and 0 as both 0 and 10. For example, the top horizontal row in the upper-left-hand array reads 12569034781. When going from left to right, the next number in the row is obtained by adding 1 (1+1 = 2) and then 3 (2+3 = 5) and so on alternately, remembering that 9+1 = 10 = 0 and 8+3 = 11 = 1. When going from right to left, 1 and 3 are alternately

subtracted from the previous number. The system works vertically also. It is further possible to perceive in the diagonals both numerical regularities in the intervals and visual bands of parallel diamonds that are produced by repeating numbers.

Fig. 4. 'Parallel Intervals', numerical art, silkscreened prints on Arches paper, 56 × 78, 1974.

Richard Kostelanetz

'Parallel Intervals' (Fig. 4)

This array has been constructed so that: (1) All pairs of numbers in geometrically opposite (mirror) positions to the right and left of the vertical line of zeros add up to 10. (2) If the numbers in the horizontal rows are added, starting at the bottom, the sums obtained are 0, 10, 10, 20, 20, 30, 30, 40, 40, 50; and the sums are then repeated in inverse order continuing upward. (3) The ten numbers in any slanting line add up to 45. (4) Any four numbers forming a diamond shape have the same sum for two opposing numbers; for esample, for the four-number diamond at the left the sum is 5 or $(4+1 = 5; 8+7 = 15 = 5)$. (5) All slant lines of numbers parallel with the top-right edge, beginning with a number at the top-left edge, have the same sequence of intervals or differences between two successive numbers: $+4, +1, +2, +4 (11 = 1), +1, +6, +1, +4, +3$. This set of numbers appears

in the first vertical column of numbers to the right of the zero axis, when read downwards (e.g. 412416143). I have found several other similarly systemic properties in this rich numerical array and there are probably more yet to be discovered.

References

1. A. Hill, Art and Mathesis: Mondrian's Structures, *Leonardo* **1**, 233 (1968).
2. R. Kostelanetz, *Moholy-Nagy* (New York: Praeger. 1970). (Out of print, but available from the author.) (Also, London: Allen Lane, 1971.)
3. R. Kostelanetz, *John Cage* (New York: Praeger, 1970). (Out of print, but available from the author.) (Also, London: Allen Lane, 1971, and, in German, Cologne: DuMont Schauberg, 1973.)
4. R. Kostelanetz, *Numbers: Poems & Stories* (New York: Assembling, 1976).
5. R. Kostelanetz, Constructivist Fiction, *Tracks*, 1/3 (Fall, 1975).

QUANTITIES AND QUALITIES
SOME NOTES ON WORKING IDEAS IN ART

Gillian Wise*

Abstract—*The author discusses briefly the present limited understanding of the aesthetic qualities of an art object conceived as a set of quantities (elements and relationships).*

The possibilities of organizing simple forms is demonstrated and illustrated with diagrams and the author's own works—relief structures made from industrial materials (transparent and opaque plastics and metalic sheet, polished and matt surfaces).

The author expresses the hope that visual art will become a form of communication through sensation that will influence functions in a rational manner rather than through the appeal to magic or indulging the artist with misplaced reverence.

I

Should the artist bother to communicate verbally, and if so how? As soon as the artist has taken up the pen he has answered the first question (for himself at least), but still has to deal with the second.

As an artist I expect to find aesthetic pleasure from ideas about work as much as in the work itself. So although I hope to explain what interests me because it seems to make sense—it is not the only criterion involved. By writing I am trying to convey something of the motivation behind working, whereas the professional aesthetician wants to deduce something from the art work itself and its effect on the spectator. Therefore there are different needs involved in the vocabulary and methods of talking about art, according to the standpoint taken. One method I like to use is that of taking ideas from other fields and trying to see if they are adaptable to a framework for the discussion of art. In this article there is an emphasis on quotations taken from the work of psychologists because there I found comments on the analogy between physical and mental constructs dealt with in a way that interested me.

The idea of the importance of structure may be far from new, both in the sphere of the arts and the sciences, but, even so, any change in the degree of its application is difficult to adapt to. Many of the writers who advocate the study of composition in art are often indifferent to the work of the scientist—who composes facts to make or prove an hypothesis

—finding science uninteresting and even uncultured. Even a writer such as Coleridge, who was exceptional in the 19th century for the active interest he took in the development of science, showed alarm when nature seemed to be revealing more structure than he had expected (cf. Note 1).

The plastic arts, which deal directly with tangible form, rely on their effectiveness coming from a particular sequence of concrete relationships. What makes some of those relationships effective and others not? Should the artist want to know, or simply put his faith in cultivating inspiration or sharpening his sense of composition?

If science can interpret nature in terms of 'modes of arrangement', which explain the different types of 'power' exhibited, surely plastic art, which is self-evidently modes of arrangement, could lend itself to a similar classification. That is, in an attempt to understand both the urge to make art and the varied power it has over us. Behavioural psychology has already done a great deal to demonstrate effects on the spectator of physical phenomena, and this has probably influenced the shift of emphasis by the artist in exploiting the known power of visual effects—from an earlier preoccupation reflecting unknown inner drives, with its Freudian overtones, (e.g. Op Art and Happenings—the calculated play with audience response vs. abstract expressionism—pure subjectivism).

Although it is not enough to be proficient with the grammar of what looks nice (or acts powerfully) and what does not, any artist working with visual material has to pick up some rudiments of this grammar—up till now generally a trial and error process. After the vast output of art that man has achieved, only a small proportion of which is

*Artist living at 62 Courtfield Gardens, London SW5 ONQ, England. (Received 27 July 1967.)

accepted as outstandingly effective, (cutting across differences both in time and civilization) hardly anything survives that could be used as a universal body of teaching about the creation of art works. The control of spatial illusion by the laws of perspective is one, and the use of the golden section proportion

formula with consistency and imagination, and, if he changes the formula, an internal balance is still retained.

This implies that a special kind of spatial and volumic ordering of elements is developed and carried in the head of the artist. If this is so, how

Fig. 1. '*Countermovement on Eight Levels*', 25 × 25 × 3 in., vinyl sheet and rubber, 1967.
This work is based on a 3 : 5 ratio with the smaller square of nine units embedded into one of twenty-five units. Every vertical row increases in depth from the base—starting from the right hand side, and making in all eight different levels. This creates a counter movement between the two planes.

tion is another. But so far no one could say that, for example, this artist tends to use this particular set of relationships to achieve the effect we associate with his name. Later, though he preferred to use another type of 'solution' that can be recognized as his late period, and these relationships can be formulated—he can be given a sort of formula. The 'good' artist reiterates and plays variations on his

can one define it? The difficulty in any communication of this kind is: (a) the artist can say that aesthetic communication has been evolved simply because of its power to do what nothing else can, and, (b) why should it have to stand the test of translation into another discipline? It can be compared to demonstrating the principle of a tensegrity structure by a brick laying process.

You cannot learn to respond to art's power to give pleasure by a painstaking analysis of each of its component parts. Nor is it possible to draw a diagram of the balance achieved that gives a visual harmony. On the other hand, works of art that are taken seriously sometimes look very like diagrams (Mondrian, Vantongerloo, Vasarely). So what is the connexion between the diagram which stands for a set of related thoughts, and the art work which represents a set of relationships? Is one an abstraction of the other, emphasizing an aspect of cognitive processes? (cf. Note 2). In other words, perhaps the abstraction plays with the mental concepts we have been trained to make in life by trying to track down those which are the most pleasure giving. This may explain its 'detensing' effect on the psyche, as well as linking up with the 'aesthetic experience' claimed by scientists and mathematicians from their own activities.

By general consensus an object stops being an unexplained symbol or diagram, and starts being called a work of art when the overall arrangement of its quantities (component parts) produces a quality which is recognized as aesthetic. The components parts themselves play only a minor role, as pawns in the game of arrangement, although every artist will find some components more amenable than others and concentrate on using them. Vasarely, for example, has gone so far as to propose that an art based on variations of identical units be taken as the physical content of the art of the future, since such a basis would allow computer programmed art to be easily produced. Unit composed art in this sense has already had a long history dating back at least to Balla's (1912) futurist works, and is more generally used now than ever before, but it has never been the *raison d'être* of a movement, a method in itself, as suggested by Vasarely's 'Notes for a Manifesto' [3].

In my works, illustrated here, the square is used as a unit of composition. (Figs. 1–6). They are ordered in a way that is sometimes clear, and sometimes needs explanation. The materials used are limited to those currently available in industrial products, and aesthetically acceptable to me. In a sense the works are not intended to be seen as carrying a particular emotional or literary message, but as experimenting with their own processes.

II

In the following section I try to give an indication of the ideas used in my work, both specific and general, and the way one idea may suggest another. I will start with some of my reasons for choosing the square (and the cube) as a unit to work with. Apart from the important and well known mathematical properties (which need not be listed here) I find:

(1) It is well defined and understood as an independent structure, both singly and in assembly.

(2) It is amenable to numerical calculation and enlargement.
(3) Its form implies expansion rather than enclosure (compared with the circle, for example) giving more inter-action between units.
(4) The square can be used equally well for emphasizing point, line, or plane, or combinations of all three.

The square unit can be combined in a number of ways: adjacent (one beside the other), embedded (one in the other), overlaying (with the use of transparent planes) stacked (one above the other), or used to imply or define cubic volume.

The distinction that is always drawn between works in two and three dimensions (not considering three-dimensional illusion on the plane) (cf. Note 3) underlines the different capacities they have in making formal relationships. Take, for example, six adjacent squares drawn two-dimensionally (cf. Fig. 7) and six squares joined together three-dimensionally to make a cube. Suppose one wanted to deploy the areas to make three white squares and three black squares in each set. Whereas on the cube there are only two variations possible (discounting mirror image sets), the two-dimensional format offers six. If the cube is simply unfolded in the shape of a cross, and not rearranged into a rectangular shape as shown, there are fourteen variations possible. The advantage of working in the form of a relief structure is that both the precise articulation of a two-dimensional surface and the physical complexity and undefined viewing point of three-dimensional form can be utilized.

Given a format made up of identical units in a grid, since no two units can occupy the same place simultaneously, they can never be identical, but they can be exchanged physically, like counters on a board. The boundary of an art work is of prime importance, for without knowing where this is, no relating to it can take place, (a practice of television is to show works with the camera wandering over the surface in close up, which often renders the work almost meaningless.) Once the relationship of the inside to the outside is stressed, the next step is that of the boundary to the environment, and that of the human eye to all three.

A good way to articulate space (cf. Note 4) is to draw a space filling grid of regular units (2D squares, 3D cubes). The two-dimensional grid has always served as a method for accurate copying in art, both directly from the subject and from other paintings, because of its power of plotting exact relative positions on the plane. It becomes interesting in its own right too, for example, when working in a square format (divided up, say, into nine equal squares or sixteen equal squares as in Figs. 8a and 8b). It may become necessary for one reason or another, to count the number of points where the lines touch or cross, or the number of individual lines in the set. In the particular diagram shown, we note the number sequences: plane, point, and

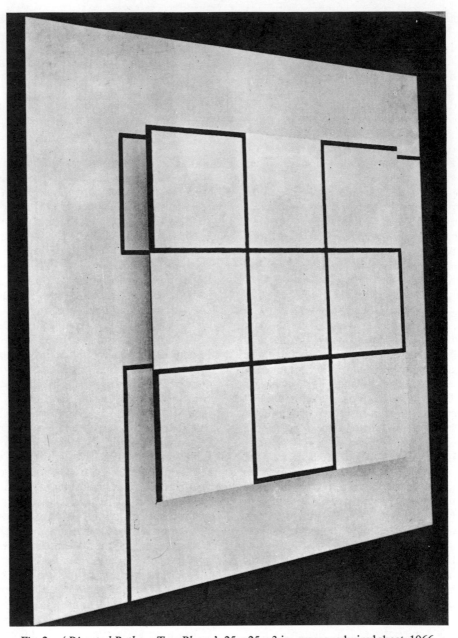

Fig. 2. '*Directed Path on Two Planes*', 25 × 25 × 3 in., engraved vinyl sheet, 1966.
Both this work and Fig. 3 have the same basic structure as Fig. 1. Here the nine unit plane is arti-
culated by a continuous channel that falls either to one side or the other of the grid. It is reiterated
on the larger plane.

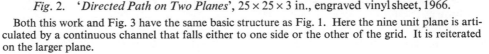

line, each reveal a resemblance to a Fibonacci ratio
(cf. Note 5). This information may have no bearing
on the immediate reason for calculating the series
of numbers, but, as it is a ratio used in other works,
the coincidence is interesting, and suggests ways
of using and developing it. Without the stimulus
of having to put down some concrete facts about
the format, this idea would not have suggested itself.

To take another instance—suppose on a square or
cubic grid I decide to use a basic four line unit, and
to experiment with possible variants of composition.
The first step is to find out the range of shapes
available. This is not difficult, coming to sixteen
variants (cf. Fig. 9). As soon as these elements are
established, the next step has to be one of aesthetic

choice—and this requires a different kind of judge-
ment. I have to decide which is the best unit or
combination of units for the kind of effect I want
to achieve, and, perhaps, make semi-random tests
of arrangement/sequence/ tone and colour differen-
tiation.

What I am trying to imply here is that, contrary
to what is usually held to be the case, working with
a concrete form with discipline (alongside aesthetic
considerations) leaves one more conscious of the
irrational or non-rationalized element in taking
decisions, and, in making very precise choices, the
range of possibilities often seems overwhelming.
(cf. Note 6). The limitation of the range of possi-
bilities lies in the fact that even on the physical

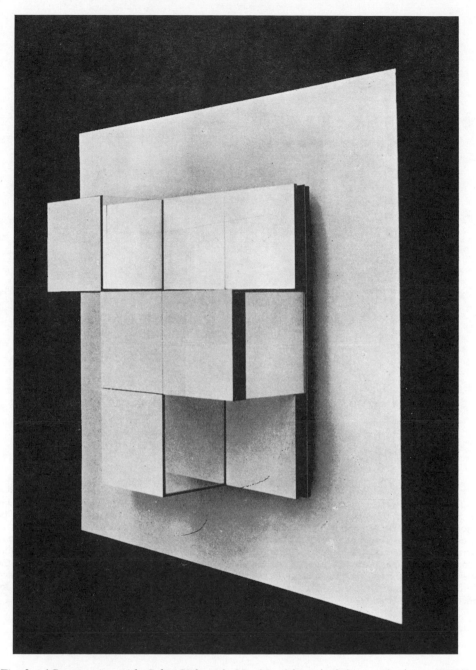

Fig. 3. '*Construction with Cubic Volumes*', 25 × 25 × 6 in., vinyl sheet and mirror, 1966/7.

This takes the areas on the plane defined by the continuous channel and emphasizes the ones that are completely enclosed by the line, making them into cubes. The side planes of the cubes are covered in mirror which explains the light effects in the photograph.

level two criteria have to be satisfied—that of the system and that of aesthetic judgement—and many 'good' effects will have to be abandoned because they can't be 'fitted in.' (The idea of fit being relative to the number of demands to be complied with) (cf. Note 7). The advantage of working this way is that it keeps providing material for inventiveness out of its own content, often in unexpected and interesting aspects, and this precise handling of dimension brings with it the need for a new kind of focus on the work itself. A different order of priorities has to be evolved right from the conception of an idea, and this sets it apart from comparison with the 'normal' process of self-expression in modern art.

Although formerly I worked by constructing or assembling orthogonal units into a 'whole'—relying on the assessment of the eye alone, the imprecision of this method was relieved when working in a metric framework, although this introduced new problems. The emphasis changed from the prime consideration being one of playing with the effects of form phenomena, to taking an equal place with a metric discipline (cf. Note 8).

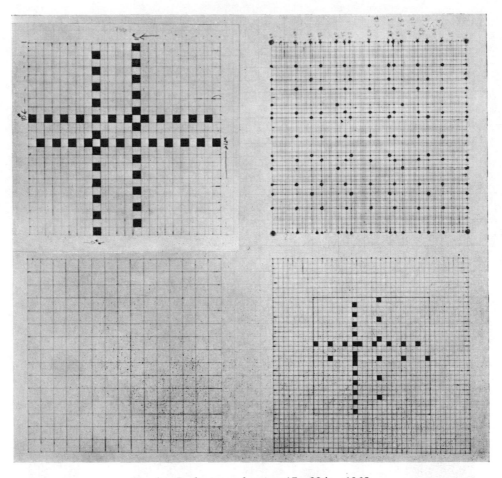

Fig. 4. Preliminary drawing, 17 × 22 in., 1965.

This drawing serves as a key to Fig. 5. It consists of 3 grids in a multiple Fibonacci series, i.e. 3:5:8 increased to approximately 15:25:40 (as this was plotted on a 120 unit grid it had to be modified to 15:24:40) and a fourth grid where all three are super-imposed. Here the points of cross connexions between the grids are picked out in dots revealing a kind of snowflake or flower arrangement. In the top left grid I took a dotted line down the ninth row of vertical squares (counting from the left), then revolved it at right angles onto the tenth line down (from the top right) then the eleventh at the next revolution and finally the twelfth. In the bottom right drawing, this unit is embedded into a larger square, since the grid is finer, and the same numbering used. The spaces between each dot increase at each turn.

NOTES

1. In a letter to Sir Humphrey Davy (who was at that time doing experimental work in chemistry and crystallography at the Royal Institution), Coleridge wrote, 'That which most discourages me is that I find all *power* and vital attributes to depend on modes of *arrangement*' [1]. Although the progress of scientific ideas was considered something of a curiosity and entertainment by the Victorian public that went to the Institute lectures, the more serious followers, such as Coleridge, tried to reconcile the philosophical implications.

2. *Cognitive maps* is the phrase used to describe mental constructs of ideas. In the following extract taken from Edward Chace Tolman, he speculates on what he has observed from experiments with rats [2]. 'Learning consists not in stimulus response, but in the building up in the nervous system of sets which function like cognitive maps, and . . . such cognitive maps may be usefully characterized as varying from a narrow strip variety to a broader comprehensive variety.' He already suggests that there are good and bad, or perhaps good and better types of cognitive maps. In other words, one may may seem to be more psychologically satisfying than another. If this idea is reversed, and the map is seen as something external (for the use of communicating) you can say that at the practical level of maps and diagrams some will tell you much more, much more clearly than others. Beyond that, some might offer an extra type of psychological satisfaction that could be categorized as 'aesthetic.'

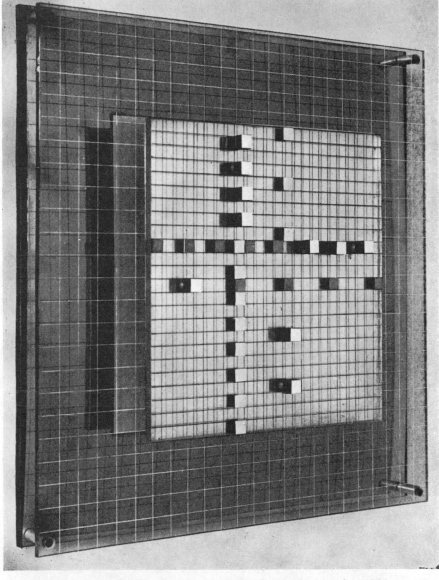

Fig. 5. '*Expanding Revolving Line No. 2*', 15 × 15 × 2·5 in., 1966.

Here the theme is translated into three dimensions with slight variations; for instance, the base grid is an enlargement of the smaller one. Where each line is dissected by another, the shorter ends in deep relief (black with a white facing), make a spiral motif of 1,2,3,4, that moves anti-clockwise.

3. One of the statements made by Piaget in his work on the learning processes of children is: 'Drawing or imagining a straight line presupposes a projective or Euclidean space, so that in actual practice such a notion is far from elementary' [4]. This idea may help in explaining the extraordinary spatial quality conveyed in a small number of straight lines on a surface (particularly as used in the Suprematist paintings of Malevich and Lissitsky). This effect seems to be as powerful when the lines are not attempting to portray a co-ordinated figurative picture of the world as when they are. This does not mean the lines can be placed at random, the composition has to be controlled by an idea of articulating space, and by a generalized knowledge of perception. A lifetime's conditioning to the interpretation of one straight line (perspective)

is exploited, rather than portraying the physical objects themselves.

4. Koffka suggests that we respond to a field of vision that has a number of well defined and understood markings on it with more ease than with an all-over, equally-defined field, and states that 'Homogeneous space is not as stable as well articulated space' [5]. The all over, homogeneous effect is often used in art in a way where the artist knowingly manipulates its instability. A blank surface can disorientate, since the spectator expects to find a message here—is it then to be interpreted as a Dadistic or philosophical comment? Is it at once no space and infinity? Its very lack of information is relaxing too, as well as disturbing, and so creates 'mood'. The intensity with which we have to become involved with a network of inform-

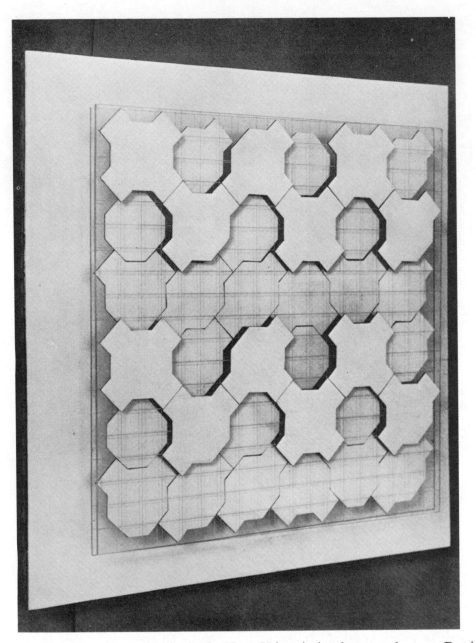

Fig. 6. '*Six Units Covering a Plane*', 15 × 15 × 1·75 in., vinyl and perspex sheet on a Darvic
base, 1966.

Sets of six non-identical units fit together to cover the plane (comparable to a jig-saw). This is based
on a square grid format and gives possibilities of formal variation. It could also be used on different
levels, as shown here in a very simple form.

ation, even at an aesthetic level, is at once more
dogmatic, demanding and ambitious. In his book
Understanding Media Marshall McLuhan insists
on the power of the mosaic format of inform-
ation to involve the spectator at a physical level
[6].

5. Fibonacci series: 'The series of numbers
1,1,2,3,5,8, . . . of which each is the sum of the
preceding two, and which converges to 1–618 . . .
the numerical equivalent of the 'Golden Mean'
(see the footnote in D'Arcy Thompson's *Growth and
Form* [7]).

6. Does proposition always precede expression?
In disciplines such as the sciences this is a self-evident
fact, since the results of work are presented to
demonstrate or elucidate a proposal. In *Logic and
Scientific Method* Cohen and Nagel state that
'Logically proposition is prior to expression' [8].
If art can be considered as expressing logical
processes, we have to stand before a work of art
with the question, what was the proposition of the
artist? What did he say he was doing and what do
others feel in response to it? How much did he feel
himself to be in the service of a collective philosophy
or attitude, and how much did he attempt to influ-
ence and change general ideas by individual effort.
For example, an artist like Kandinsky wanted to
break with the formal expression of art of his day—

Fig. 9

Plane / Point / Line
 9 16 24

(a)

Plane / Point / Line
 16 25 40

(b)

Fig. 8

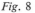

Fig. 7

to make entirely abstract work—but he still wanted to put it to the service of expressing traditional religious and mystical ideas. Although Kandinsky wrote extensively about his attitude to art, he seems to disclaim any thought of exact analysis. In his essay *Reminiscences*, in reply to critics who accused him of 'going astray in brainwork', he writes 'Nothing was farther from my mind than an appeal to the intellect, to the brain. This task would still

have been premature today, and will lie before artists as the next, important, and unavoidable step in the further evolution of art. Nothing can and will be dangerous any longer to the spirit once it is established and deeply rooted, not even therefore the much-to-be-feared Brain-work in art' [9]. Mondrian, too, remained mystical in his outlook, and probably expected his work to reflect this. It is paradoxical that while an art work may not succeed in expressing all of the artist's stated intentions, it can often contain ideas that are important to him, but which he has been unable to formulate verbally. These ideas may be no less precisely understood than those which have been clearly verbalized.

The idea that concepts cannot be taken seriously until they are handled in a verbal or in a symbolic form (i.e. mathematical) is understandable, since, if ideas cannot be talked about lucidly, they cannot be held up for examination and argument, and norms of discussion established. So what possibility of success has the artist, who would like to write about his work in a way more satisfying than unco-ordinated reports of his feelings—these feelings being the preferences that influence him to work in a certain way? Should one be optimistic that means of expression will be found if they are sufficiently needed? If the material aspect of life has been understood and classified to the extent it has, surely there is hope that with the help of that material knowledge and the methods used, we might get something better from art writing and criticism, than chaotic lyricism or stockbroking. A contemporary American philosopher, Paul K. Feyerabend, in discussing the difficulties of writing philosophically about ideas based on feelings (which every individual accepts as existing, pain for example)

suggests that there is no reason to assume automatically that only materialistic notions can be expressed clearly. Rather it might be seen as the poverty of our development in this field. '... the relative poverty of mental notions is by no means a common property of all languages. Quite the contrary, it is well known that people have at all times objectivized mental notions in a manner very similar to the manner in which we today objectivize materialistic notions' [10].

7. This analogy of fitting has already been adapted to the aim of architectural design and town planning of the future in *Notes on the Synthesis of Form* by Christopher Alexander [11]. He proposes to revive what in primitive societies was a balance between improvisation and tradition in the design of objects and buildings, but which in industrialized societies has atrophied. In primitive society the social needs were much more limited, and what was required could be more easily tailored to their needs; hence what was made reached a higher degree of individual and collective 'comfort' than in our own situation. Koffka describes 'fittingness' in this way, '... all problem solutions can be said to consist in finding the *fitting* part which will relieve the existing stress, a law of fittingness would be the most universal law to explain thinking, and with it the arousal of new processes' [5].

8. As an artist I have two alternatives, that of saying 'I am an instrument, a medium for the expression of certain responses and feelings I do not understand, but for some reason I am constantly concerned and involved with them. I have faith that they must have a meaning, and I will try and express them to my own satisfaction, and hope that they will communicate some satisfaction to others.' Or I can say 'I notice that this has a powerful effect on perception, perhaps I will try and fit it in with what I am doing, so I can be more sure of effective communication and attention.' Whether this is looked upon as gamesmanship, or control of technique, or a tool for philosophical expression, one begins to make the sort of observation that psychologists make. Once you start making observations you start to compare—then you want to try and classify—and here the artist comes to a virtual dead end. As I understand it, Feyerabend suggests we extend the range of our mental concepts to adapt them to cope with the *felt* as much as the *observed*. In art both these aspects are interdependent (if it can be interpreted as a felt proposition objectivized), therefore it can also be treated materialistically, at the level of studying the objects as evidence.

REFERENCES

1. L. Pearce Williams, Letter from Coleridge to Sir Humphry Davy, *Michael Faraday, A Biography* (London: Chapman & Hall, 1965).
2. Edward Chance Tolman, Cognitive Maps in Rats and Men, in: *Collected Papers in Psychology* (Berkeley: University of California Press, 1951).
3. Victor Vasarely, Notes for a Manifesto (Cineticism), originally published in the catalogue of the exhibition *Le Mouvement* Paris: Galerie Denise Rene (1955).
4. Jean Piaget: Piaget and Inhelder, *A Child's Conception of Space* (London: Routledge, Kegan, Paul, 1956).
5. Kurt Koffka, *Principles of Gestalt Psychology* (New York: Harcourt, Brace, 1935).
6. Marshall McLuhan, *Understanding Media—The Extension of Man* (New York: McGraw-Hill, 1965).
7. D'Arcy Thompson, *Growth and Form*, Chap. 15, f.n. pp. 923–924. (London: Cambridge University Press, 1952).
8. Morris Cohen and Ernest Nagel, *An Introduction to Logic and Scientific Method*, (London: Routledge, Kegan, Paul, 1957).
9. Wassily Kandinsky, Reminiscences 1913, in: *Modern Artists on Art*, ed. by Robert L. Herbert (New Jersey: Prentice Hall, 1964).
10. Paul K. Feyerabend, Problems of Empiricism, in: *Beyond the Edge of Certainty—Essays in Contemporary Science and Philosophy*, ed. Robert Colodny (New Jersey: Prentice Hall, 1965).
11. Christopher Alexander, *Notes on the Synthesis of Form* (Cambridge: Harvard University Press, 1964).

CONSTRUCTION AND CHANGE:
NOTES ON A GROUP OF WORKS MADE BETWEEN 1965 AND 1967

Kenneth Martin*

Abstract—*A group of the artist's recent works is considered in order to study the role of change in the making of a work, of change in sequential works and of change in an end product itself.*

Eleven works are discussed. The first is 'Screw Mobile, 1965', which is fundamentally a programmed work. Three elements are used in its design— parabola, circle and vertical line. These are made in brass metal as bar, ring and rod. The work is an exploration of the complexity of the field of motion within a simple, screw-like rotation, which was realized through the medium of change.

The eleven works are tabulated and are considered according to the nature of changes that take place. The circle can become either a continuous cylinder or a series of rings. The rod can be either central and used for suspension, or discarded, or returned again as a support or suspended as a screw thread around which activity can take place. The bar may cease to be parabolic and become straight. A square-section tunnel (compounded of a bar and a cylinder) is also included. In the penultimate work cited, the curved bar has a hyperbolic form.

Notions of expressive universal and fundamental forms (such as cup, tunnel and box) enter in the work.

A work is regarded as a play of interrelated, broken rhythms of position and dimension. Rhythm becomes a constructive force. A work is also considered as a structure of events. Interest in the possibilities of change in transformable works leads to an interest in the limitations to be used in their construction.

In the study of processes of constructing, three kinds are given: (1) pre-designing, (2) predetermination of a system allowing for decision-making by the artist throughout the construction of a work and (3) work growing automatically out of the first act without previous planning.

I. INTRODUCTION

In the following pages I have undertaken a study of the interrelationship of a group of my recent works. My purpose has been to attempt to clarify changes, by regarding the work of art through the process of making, and, going further, by considering the process of change in sequential works.

The appearance of a work is the result of its content. A work is the sum of facts and the artist's manipulation of them; their selection, manipulation, supplementation and change are the product of the artist working in a milieu of temporal conditions.

It is difficult to define an attitude, for it is constantly shifting and changing, no matter how objective one is. It is also difficult to pin down words, since they can have varied meanings, and it is often necessary to use the same word for different things. Words like 'rhythm' and

'twist', for instance, are related to movement in time, but we use them to say 'rhythmic sequence' or 'twisting line' with regard to things which are at rest or still. In the following discussion, such words are used to express acts of construction as well as to describe actual motion within the object. It is, in fact, with the acts of construction that this essay is primarily concerned, and construction is, by its very nature, temporal.

Any one involved with making things can reflect on the nature of the works made, can have some clear sense of the parts and the developments that have taken place. He can profitably take stock of these changes. However, in order to avoid the barren post-mortem or sentimental memory journey, it is necessary for the artist to regard his work as objective inventions aiming at the subjective. The binding of the two, objective and subjective, is essential, otherwise one has at best good design, good taste.

The abstract artist looks for expressive universals.

*Artist living at 9 Eton Ave., London, N.W.3, England. (Received 9 December 1967.)

One must consider the nature of expressiveness and the qualities that might constitute a universal in the world around one and in one's own work. The cup, the tunnel, the box are of a family of fundamental forms, that is, they are universally familiar. We can find and feel a relationship of fundamentals in disparate things—hence metaphor. Forms make their effect on us according to their nature, magnitude and position relative to us. The greater and the lesser can, in their effect, be both varied and similar.

The matchbox is as real and has the same identity whether open or shut, but its appearance is different. Parallelepiped, box, tunnel, cup and column can all be observed in it. It can be pleasing to the touch and have a size pleasing to our nature. It is not, however, a work of art.

Fig. I. '*Screw Mobile*' *brass, height* 35·5 in. *and diameter* 8 in., 1965. (*Collection of Mrs. E. B. Stern.*)

I had not been happy with the notion of a work of art being modified by the active participation of a spectator. It had always seemed to me that, if the public is given the power to transform a work, its character will be misunderstood. One knows the public will do that with no choice at all. But, on the other hand, is the search for the one and only solution, for the finite rightness of each part to the whole, the most important task of the artist? The kinetic artist is interested primarily in work whose realness is expressed through change and movement. So that realness becomes a matter of the indeterminate. However, as soon as one is interested in the possibilities of change, one becomes interested in their limitation. It is obvious that the system for a changeable object will not be the same as for a fixed structure, but how will it differ? The articulation, the mechanism, becomes of prime importance and it is this that has to be constructed through rhythm.

And this would apply whether the mechanism is simple, articulated or electrical.

Rhythm is a constructing force for me in my work. The construction as a process commences with an event which is fundamental and practical. Each such event leads to a limited number of other possible events. The particular character of one of a small family of events can be seen and compared clearly with every other one. The character of an event has an effect on things relative to it (e.g. a joint on the parts joined) and this is seen as part of its character. A series of the same family of events, organized as a rhythmic sequence will define the character of the whole work. It is essential, therefore, that the nature of the event and of the rhythm should both be understood in their relationship. Limitations and conditions must be found to bring out to the maximum the expressive character of the rhythmic event.

I have been interested in the practical consideration of frames of discipline, actual processes of construction—the form of the process. There are three categories of process that I will mention here:

1. Designing and then making (the latter being done by oneself, by a factory department or, under direct supervision, by an assistant).
2. Predetermination of a system that would still leave the artist free to respond to the stimuli of constant decision-making, since he makes the work himself.
3. The progress of the work growing automatically out of the first act without any previous planning.

In the first process all invention must go into the original design, which is then executed. This is a practical and imaginative procedure. The factory or the assistant may spare one from too much tedious work. Machine production, methods of assembly and workshop philosophy may develop the character of the design beyond the limitations of the artist in his own workshop-studio.

The second category holds most for the artist who makes his own work from beginning to end, since in the most limited field of decisions he can constantly have the choice of either-or. The act of programming will be in operation throughout the whole progress of the work.

In the third process there is a pre-ordered system of growth, a pattern of activity that develops itself inexorably. The artist can be spectator and participant in the inevitable progress from a primary act or acts.

These categories, one is aware, tend to mingle in certain ways. But if one is to have ordered construction and, leaving out considerations of genius, then the more lucid the programming of work and idea the more powerful may be the result. However, it is difficult to predetermine a system for forms whose properties one is in the way of discovering. For the naturalness desired requires that system and properties must go together. It is process that one is inventing.

In the following analyses of my works, I shall begin with an extract from notes I made for a projected *screw mobile* for limited quantity production. In this discussion the term 'movement' is used to describe the change of position of an element in a rigid, static structure. 'Change' is considered as the act of structure-making. The note I make on *number rhythm* will, I hope, become clearer as the article proceeds. Photographs of works are denoted by Roman numbers and drawings by Arabic numbers. In Table 1, I list for each work the type of element used; its character—suspension, movement, qualities etc....; and constructing systems expressed by number.

II. EXTRACT FROM NOTES FOR A 'SCREW MOBILE' for *Nova Tendencija 3, Zagreb*, 1965 [1]

This work (Cf. Figs. I, 1, 2, 3 and 4) is of the same nature as many that have occupied me in the past. All these works have been compounded of movement regarded as a sequence of discrete events. They have all been simple in character; all have been made through the ordering of fundamental movements (translations, rotations, twists) and all have used simple elements (line, circle, parabola, etc....).

An essential aspect of these works is that they are made from commercially mass-produced metal stock. The width and thickness of the pieces act as the bases of rhythms. I have tried to see how varied and how expressive an object constructed with these materials can become. What will be the expressive nature of the variations produced?

This work is fundamentally a programmed one and is based on a system comprising two sets of numbers: 2,3,4, and 1,1,2,3,5.

These numbers are ordered by permutation.

The elements are made in three forms: parabola, circle and vertical line. These materialize in bars, rings and a rod.

The focus of a parabola may be considered as the centre of a circle whose circumference touches its vertex. Either this circle can roll along the parabola or the parabola can move around the circle (Figs. 1 and 2). This rolling movement can be considered as a sequence of fixed steps or 'stillnesses'. Thus in Fig. I and Fig. 2 we can see that each parabolic bar and position of the ring in the work corresponds to steps. By a vertical translation, a circle becomes a cylinder. Since in the work a parabola is fixed to a circle, it too must take part in this translation. Furthermore, the thirteen components in the work are fixed relative to each other in a clockwise or anti-clockwise sense around the cylinder. In the work the vertical distances between elements are fixed, however the work as a whole can be rotated.

In this work the elements of a parabola and circle (starting from the bottom) are arranged vertically with a clockwise displacement (Cf. Figs. 3 and 4). Starting with element 9, the circle (freed from the focal centre) appears on the outside of the parabola (it is, of course, the parabola which has

Fig. 1. *Plan and elevation of parabolas with rings on the inside.* (Cf. Fig. I).

Fig. 2. *Plan and elevation of parabolas with rings on the outside.* (Cf. Fig. I).

been moved). The point of contact between the elements is now displaced in an anti-clockwise direction, while at the same time the parabola moves around the axis. The circle-parabola relationship for the lower elements is an inversion of that of the upper elements.

The work under consideration in the above notes can, when hanging, be rotated by motor or by hand. While there is no actual variety of motion, variety becomes apparent because of the rotation. Movement is integral to the act of making and to the character of the work.

The appearance or sensation caused by the change of position of the circle with the parabola at its vertex (though made through rigid steps) is very different from that caused by change of position along the two arcs. The former is dynamic with a strong swing from left to right or right to left, the latter is slow and progressive. The parabola, itself,

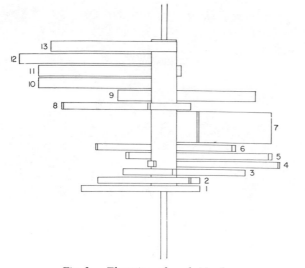

Fig. 3. *Elevation of work No.* I.

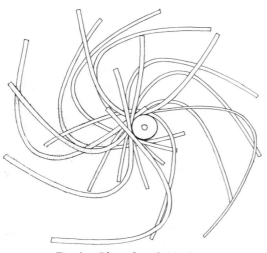

Fig. 4. *Plan of work No.* I.

sweeps space differently with each position in which it is orientated.

One could term the whole activity as an exploration of the complexity of the field of motion within a simple, screw-like rotation, realized through the medium of change.

III. ANALYSES OF THE WORKS SHOWN IN TABLE 1

The circle becomes a continuous cylinder (Cf. Fig. I).

The cylinder in the works shown in Figs II, III, IV and V instead of being around a central rod, becomes small and separate units and the notion of rolling and stopping is used as position defining. The cylinders not only roll along a surface but serve as small columns on end or turned so that their sides are parallel with the direction of the plane. They are used as the unions between two planes whose relationship they control and to which they give character.

Orientations of the cylinder on the plane are shown in Fig. 5: standing, lying across it or parallel to it. They are placed in a rhythmic sequence. (Figs. IV, V, VI and VII.) All possible kinds of union are noted. (Fig. 6.) These are given numerical signs from which number rhythms are made that control the whole work.

In the works shown in Figs. VI and VII, the cylinder is a thin-walled tube. By placing one inside the other, a turning joint is made.

In the works VIII, IX, X and XI, threaded cylinders are located on a central rod around which they can be moved spirally. In the works IX, X and XI, a series of rings is attached to the cylinders and they describe circles as the cylinders are rotated.

Returning to work I, we see that the rod around which the washers are placed is vertical and suspended. This determines the work as to balance and the nature of its movement. It is the rigid support for all that is attached to it. It can be set in motion by a spectator who may then observe it close up or at a distance.

Consideration of the relationship of the parts to each other in work I leads one to the possibility

Fig. II. *'Tunnel in the Air'* (*first version*), *brass,* 3·25 × 6 × 3 *in.,* 1965. (Photo: John Webb.)

Fig. III. *'Tunnel in the Air'* (*second version*), *brass,* 3·75 × 6·75 5·25 *in.,* 1965. (Photo: John Webb.)

of discarding the rod in favour of a group of separate joints as shown in works II and III.

In works IV and V, the cylinder becomes the vertical support for an independent arrangement of elements. The rigid arrangement is free to be turned around the support.

Works VI and VII can stand or rest on the ground in varying positions according to the configuration imposed. They can be taken apart and put together differently. The parts can be turned relative to one another according to the limitations imposed by the nature and position of the joints. The rod in works VIII, IX, X and XI is a screw thread around which activity can take place according to the bounds set by a thread. Parts can be removed and their order rearranged, they can be turned to give different orientations. Movement can also be an actual, independent, sensory fact. In order for the works to be maintained vertically, the spectator must rotate the horizontal component parts to achieve balance.

The bar in work I is a parabola whose shape is determined by the diameter of the washer round which it turns. I have taken further in this work the notions of the rhythm of position of identicals together with that of differences. Every piece in a series may be identical except with regard to position, so that position can become of acute importance. Then, having fixed the positions, all pieces may be similar save in thickness and width, whose variety then assumes an important role. This is particularly so when position is relatively neutralized by a specific sequence giving a simple, overall character to the work. This work is a play with interrelated, broken rhythms of position and dimension. I have sought to give to each element a character of its own while being bound by a comprehensive rhythm to all the others. This I have attempted to do by using rhythm as a constructing force.

The number sequence 2.3.4 is related to the thickness of the bars. The series 1.1.2.3.5 is used for their widths and in the general construction of

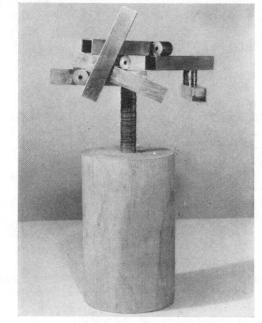

Fig. IV. *'Tunnels and Cylinder', brass and wood, height* 14·5 in., 1965. (Photo: John Webb.)

the work. All is governed by the ordered progressions, by the use of a permutation in the service of notions of discontinuity, oscillation and reflection.

The parabolic bars are more characterful than the uniform, circular section, straight rods I have used in earlier works. The parabolic bars have a shape with six sides, four of which are curved in one of their dimensions. Their two ends are rectangles. The bars so to speak, epitomize the horizontal and vertical, the radial and tangential.

Looking at works II to VII, we can see that the tunnels can be considered from the aspect of their four outer sides, or of their eight sides (four exterior, four interior), or of their having two open ends.

Fig. 5. *Positions of a cylinder on a bar (Cf. Figs. II–V).*

Fig. 6. *Union of two bars with a cylinder, showing degrees of possible rotation. (Cf. Figs. IV–VII.)*

Close the two ends and the tunnel would become a box. One might compare the ends of the parabolas with the ends of the tunnels and consider the difference in a progression along the two kinds of form.

The sides of a square-section tunnel can become separate entities (Cf. Figs VI and VII). Then one has two different elements, flat bar and square tunnel, which can be treated alike as to the measuring of interval and which can act in the same way but also differently in conjunction with another object. This was part of the nature of the *Tunnels in the Air* (Figs. III and IV) which passed over into the *Transformables* (Figs. VI and VII).

When we look at work VIII we note that the parabolas, four in number, are different in width but not in thickness. They are fixed to the cylinders at different positions determined by the imaginary rolling and stopping of the cylinders. Each parabola and its attached cylinder has different characteristics from the others and one of these has to do with weight. All the parabolic bars attached to the cylinders are cantilevered. In order to balance the hanging arrangement the spectator must select an appropriate position for each element.

The groups of elements in the first 'rotary rings' (Cf. Fig. IX) were formed around four threaded cylinders, the same in number and size as those of 'variable screw' (Cf. Fig. VIII). The cylinders were 7/8 × 3/8, 7/8 × 4/8, 7/8 × 4/8 and 7/8 × 7/8, where the first number is the diameter and the second is the depth. The rings in work IX were cut from cylinders of ⅛-in. wall thickness and with outside diameters of 7/8, 11/8 and 18/8 cut to depths of 3/8 and 4/8. Although it was intended that each of the horizontal series of rings should be transposable on the vertical rod, rhythm was considered as a vertical sequence of single rings. There was no overall discipline for the placing of

the rings relative to each other. But this was being sought through study of their interaction, possibilities of radial and tangential alignment and properties of actual joining—inside, outside, up and down.

In work X each of the four groups of elements ends in a hyperbolic bar. These bars were of the dimension 3.4.4.7 in width. The curve of the hyperbola was arrived at from the ring whose dimension was 11/8 and was fixed to the top ring of each section. Again the notion of rolling and stopping is used to determine the position of the contact point which varies on each of the hyperbolas.

In the third version of 'Rotary Rings, 1967' (Fig. XI) all the five threaded cylinders are identical. Each of the horizontal groups of elements is composed of four rings and two flat bars. One of the bars terminates the group; the other is locked into it and is of varying length. It is of the depth of ⅝ in. and ⅛ in. in thickness and the lengths are of the proportion 1.1.2.3.5. (5/8 being the unit; the face of the bar of proportion 1 is a square, of 2 a double square and so on). The dimensions of the rings follow the same system as the two preceding versions in both depth and diameter, i.e. 3.4.7.11. So that there are two proportional systems used throughout. In the Table for work XI, the order of development was in the form of a magic square; A to D gives the widths of the rings (A being greatest), E is the flat bar. 1 to 5 are widths with 1 greatest. (This notation, as well as others shown in the Table, was used in the conception and making of the work and is not shown here solely to describe it).

Each group of elements begins with a threaded cylinder and ends with a flat bar. These are identical in each case. They are at the opposite ends of each ordered sequence and are not contained in it, but are related proportionally to it. Each terminating

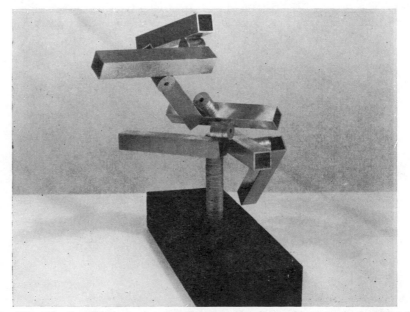

Fig. V. *'Tunnels in Black', brass, formica and wood, height* 11·25 *in.,* 1965. (Photo: John Webb.)

Fig. VI. *'Transformable'* (*first version*), *brass, four pieces each* 12·25 in. *long*, 1966. (Photo: Martin Koretz.)

Fig. VII. *'Transformable'* (*second version*), *brass, five pieces each* 15 in. *long*, 1966. (Photo: Martin Koretz.)

bar is divided symmetrically by its juncture with the piece to which it is attached. While the whole work was predetermined, the arrangement of each group was developed empirically.

The appearance of the works I and VIII to XI in motion is of a variety of movements and stillnesses within the occurrence of a simple rotation. The observation and the understanding of these pheno-

mena is part of my stimulus to construct. Since all these works are metal (brass), reflected light plays its part in the resultant rhythms.

My aim throughout all the cited works has been to construct a single homogeneous whole out of a variety of facts, to select these facts, to see what will be the resultant of their fusion, to observe its character and to proceed again.

Fig. VIII. '*Variable Screw*', *brass, height* 13·25 in., *greatest radius* 7·5 in., 1967. (Photo: Martin Koretz.)

Fig. IX. '*Rotary Rings*' (*first version*), *brass, height* 16·75 in., *greatest radius* 5·75 in., 1967. (Photo: John Webb.)

REFERENCES

1. Catalogue of the Exhibition *Nova Tendencija 3*, Zagreb, Jugoslavia, 1965. (For their competition on a serial production art work I submitted drawings and notes on my work shown in Fig. I.)

 Other positions of the works cited in the text can be seen in the following references:

2. A. Forge, Some Recent Works of Kenneth Martin, *Studio International* **172,** 305 (1966)ʼ (Work V).

3. K. Martin, Notes on Rotary Rings, *Studio International* **173,** 257 (1967), (Work IX).

4. F. Popper, Movementivity, *Art and Artist* **2,** 48 (1967), (Works VIII and IX).

5. K. Martin, Construction and Movement, *Art International* **11,** 32 (1967), (Works VI, VIII and IX).

6. Kenneth Martin, Catalogue, Axiom Gallery, London (1967), (Works VII, VIII and X).

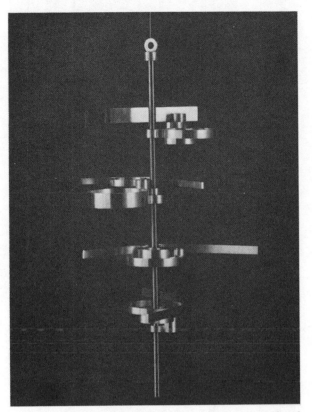

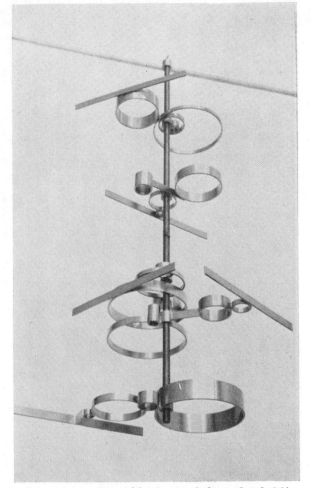

Fig. X. '*Rotary Rings*' (*second version*), *brass, height* 21·25 in., *greatest radius* 7 in., 1967. (Photo: Martin Koretz.)

Fig. XI. '*Rotary Rings*' (*third version*), *brass, height* 36 in., *greatest radius* 10 in., 1967. (Photo: Martin Koretz.)

TABLE 1

Work	Elements — Rod	Cylinder	Bar		Performance		System
I	Vertical rod	Washers (Rings) continuous round rod	Parabolic bars	Suspended	Rotatable	Rigid	2,3,4. Thickness of bars 1,1,2,3,5, Width of bars
II	—	Washers making discontinuous cylinders	Flat bars and square tube (tunnel)	Suspended	—	Rigid	(2,3.)(3,4.)(4,3.)(3,2.) Position of cylinders 4 = 1+1+1+1+½+½ Relationship of tunnel to bars
III	—	Washers making discontinuous cylinders	Flat bars and square tube (tunnel)	Suspended	—	Rigid	[(1,2.)3.](4,5.)(6,7.) Position of cylinders 4+2 = 1+1+1+1+1+1 Relationship of tunnel to bars
IV	V Rod and washers as rotating support (circular wood base)	Washers making discontinuous cylinders	Square tubes (tunnels)	Standing	Rotatable part	Movable at two points	Do not have work or notes. Construction similar to work V
V	V Rod and washers as rotating support (rectangular base)	Washers making discontinuous cylinders	Square tubes (tunnels)	Standing	Rotatable part	Movable at two points	4,7.3.1.6.2.6.3.7.4.2.1. 4 5 1 3 6 2 Top row is position of cylinders. Sequence derived from a line of a permutation of 7, ignoring 5, whose position is constant. Bottom row is system of all orientations of union of tunnel — cylinder — tunnel. Sequence is a line of a permutation of 6. ∧ Denotes on same tunnel ⌢ Denotes union of two tunnels by cylinder
VI	—	Thin walled tube around thin walled tube, discontinuous cylinders	Flat bars and square tube (tunnel)	Standing and resting	Rotatable parts	Movable at three points. Parts interchangeable	Do not have work or notes
VII	—	Thin walled tube around thin walled tube, discontinuous cylinders	Flat bars and square tube (tunnel)	Standing and resting	Rotatable parts	Movable at four points. Parts interchangeable	4,8.5.1.3.7.6.2. Position and orientation of cylinders
VIII	V Threaded rod	Threaded discontinuous tube (bushes)	Parabolic bars	Suspended	Rotatable with freely screwable parts	Movable at four points. Parts interchangeable	3,4.7.11. Width of bars
IX	V Threaded rod	Threaded discontinuous tube (bushes and rings)	—	Suspended	Rotatable with freely screwable parts	Movable at four points. Parts interchangeable	3,4.7.11. Width and Diam. of rings
X	V Threaded rod	Threaded discontinuous tube (bushes and rings)	Hyperbolic bars	Suspended	Rotatable with freely screwable parts	Movable at four points. Parts interchangeable	3,4.7.11. Width (bars, rings). Diam. rings Bushes: 1/3 1/4 1/4 1/7 Rings: 1/7 2/4 3/4; 3/4 4/4; 4/4 3/7 2/3; 2/4 4/7 1/4 Bars: 4/3 2/7 1/4 1/7 3/3 1/3 Numerators: relationship of diameters Denominators: Widths
XI	V Threaded rod	Threaded discontinuous tube (bushes and rings)	Flat bars	Suspended	Rotatable with freely screwable parts	Moveable at five points. Parts interchangeable	3,4.7.11. Width and diameter of rings 1,1,2,3,5. Length of bars A/1 B/4 C/2 D/5 E/3 E/2 A/5 B/3 C/1 D/4 D/3 E/1 A/4 B/2 C/5 C/4 D/2 E/5 A/3 B/1 B/5 C/3 D/1 E/4 A/2 A–E Relationship of widths (A greatest) 1–5 Relationship of diameters with 1 widest All bushes identical All outside bars identical Bars in system represented by E with 1–5 as lengths

MY TRANSFORMABLE STRUCTURES BASED ON THE MÖBIUS STRIP

Sebastián (Enrique Carbajal G.)*

In 1966 I made a number of small sculptures of folded paper and cardboard. These objects, which I call *desplegables* (Spanish for 'unfolding'), were responsible for directing my attention to the branch of geometry called *topology* [1, 2]. I read about *topological spaces* with the hope of finding something to serve me in my art. In this quest I became acquainted with and much fascinated by the *Möbius strip*. It can be described as follows: A long rectangle (e.g. a strip of paper, 2 × 30 cm.) is held fixed at one end and turned through 180° at the other end. The two ends are then joined yielding a one-sided surface [1]. On such a surface, if one places one's finger at any point on it and then moves the finger along the strip, the finger will return to the starting point after traversing the surface on both sides of the untwisted strip.

My first object, a folding sculpture, (1967) utilizing the idea of twisting and joining in a ring (40 cm. diameter) was made from a paper strip containing creases delineating a chain of equilateral triangles. This strip was given three twists (540°), instead of just one (180°), as in the Möbius strip. The resulting one-sided surface can be transformed, by folding, into five different 3-dimensional forms and one 2-dimensional shape that has a hexagonal perimeter; hence the name that I gave to this type of construction is 'Hexaflexagono'. Art objects made of elements that can be rearranged by a viewer are called transformables [3] and paintings and sculptures of this kind have been devised by numerous artists in recent years [4].

I then wished to see whether other objects with flexion characteristics similar to those of a 'Hexaflexagono' could be made and whether other polygons might be formed. I found that they could and I devised a procedure in which the folding and twisting were varied. Although the formation of a Möbius strip represents one stage in their fabrication, the topological property of the Möbius strip is not preserved in the final folded objects. The 'Tetraflexagono', which I constructed in this way, can be arranged into a 2-dimensional square and into other forms including that of a cube. I have prepared a printed edition of a 'Tetraflexagono', with colored circular and linear stripes on the

surface of the elements to add interest to the various forms into which it can be transformed [5].

My earlier studies of crystallography [6] and my experience with the Möbius strip influenced the design of my next object. I made of paper a ring of tetrahedrons that can turn on its central axis. I then devised a scheme (called 'structural strategy'

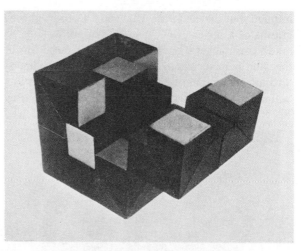

Fig. 1. '*Estructura Articulada*', *transformable sculpture (one of its possible forms), wood, lacquer*, 30 × 30 × 30 cm. (1970).

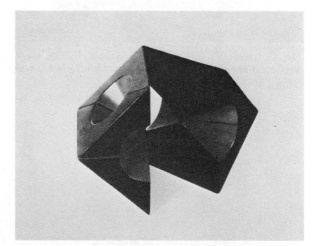

Fig. 2. '*Cubo Hexacónico*', *transformable sculpture (one of its possible forms), cardboard, acrylic paint*, 30 × 30 × 30 cm. (1970). (Cf. Figs. 3 and 4.)

* Artist living at Cda. Protasio Tagle 33, Mexico City, 18 D.F., Mexico. (Received 19 Nov. 1973.)

by Jürgen Claus [7] for cutting, folding and twisting a chain that permits the making of transformables with geometrical and architectonic forms (Figs. 1 and 2) [8]. Figs. 2 and 3 show two of the transformations obtained with the object 'Cubo Hexagonico'.

Fig. 4 shows the final layout for 'Cubo Hexagonico', which represents the first step in making one of my paper transformables. To arrive at a layout that leads to a feasible 3-dimensional transformable is quite complicated and requires considerable experience.

My ideas about architectonic structures were influenced by reading a book on architecture by Michel Ragon [9] and by the sculptures and architectural work of Mathias Goeritz [10, 11]. I am much interested in the housing of people and, in particular, in the need to adapt housing to radically different ways of living. Thus, I have begun to investigate habitable underground, underwater and

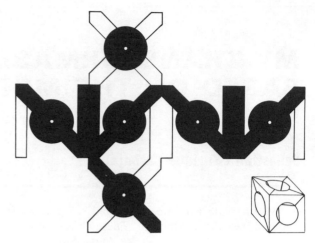

Fig. 4. Layout for the transformable sculpture 'Cubo Hexacónico'. (Cf. Figs. 2 and 3.)

air-borne structures. I am aware of the many obstacles (technical, psychological, economic and political) that confront the execution of such projects. However, I hope that my studies, including the construction of transformables, will contribute to the development of the architecture of the future.

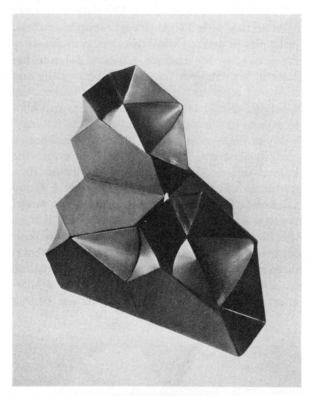

Fig. 3. 'Cubo Hexacónico', transformable sculpture (one of its possible forms). (Cf. Figs. 2 and 4.)

REFERENCES

1. Hu Sze-Tsen, *Homotopy Theory* (New York: Academic Press, 1959).
2. A. H. Wallace, *An Introduction to Algebraic Topology* (Oxford: Pergamon Press, 1957).
3. Terminology, *Leonardo* **2**, 81 (1969).
4. K. Martin, Construction and Change: Notes on a Group of Works Made between 1965 and 1967, *Leonardo* **1**, 363 (1968).
5. E. C. G. Sebastián, *Tetraflexagono, Eduque jugando* (Mexico City: Universidad Nacional Autonoma de México, 1969).
6. E. Flint, *Principios de Cristalografía* (Moscow: Paz, 1966).
7. J. Claus, *Expansion del Arte* (Mexico City: Extemporáneos, 1970).
8. *Homenaje a los* **5** *cuerpos regulares*, exhibition catalogue (Mexico City: Instituto Nacional de Bellas Artes y Literatura, 1974).
9. M. Ragon, *Los Visionarios de la Arquitectura* (Mexico City: Siglio XXI, 1969).
10. M. Goeritz, The Sculpture 'The Serpent of El Eco': A Primary Structure of 1953, *Leonardo* **3**, 63 (1970).
11. C. B. Smith, *Builders in the Sun* (New York: Architectural Book Publ. Co., 1967).

SCULPTURE: GROWTH STRUCTURES

Barbara Freeman*

For the past two years I have been making what I call 'growth structures', which are small constructions made by combining together equal-sized units of metal, wood or plastic according to certain rules. When I begin a piece, I have only a vague idea as to how it will appear when completed.

The problem I posed for myself was to do justice to my sense of the variability of life and to combine spontaneity with calculation. I decided to make structures whose bounds would be variable and each new part of which would be determined by a species of genetic ordering.

The method of construction I use varies but it has the following general outline. First, I select a unit or element, such as a short bar of steel or a square piece of Perspex. In the past I favoured very simple shapes for the units but more recently I have made works from curved tubes. Second, I try various possible relationships or 'joints' between the units. I use up to five different types of joints in one structure. Then I choose a rule of ordering the joints between units, e.g. nine units to be connected by three types of joints and each type to occur at least twice. Or I may decide that a number of small groups should be made first using joints of type A and B and that they should be linked together with joints of type C and D. Sometimes I choose the sequence of joints randomly before assembling a piece but, of course, such a structure may not be possible to make.

When a specific rule is selected, there may be several arrangements of the units that obey it. I am then confronted with the question as to which arrangement or arrangements are aesthetically satisfying to me and, hopefully, to others. This method of working allows the isolation of each decision and enables me to evaluate a piece as it is being made. Some of the decisions are innovative, some are not, and I treat subjective evaluations as though they were objective ones.

I use a simple notation employing letters and dashes to specify the arrangement of units in a structure. In making a rule, the kind of units is not specified and is indicated by dashes. For example, let a growth structure consist of 12 units connected by means of three types of joints A, B and C, which are to be used twice each as a palindrome:

$$- C - (\,) - B - (\,) - A - (\,) - A - (\,) - B - (\,) - C -$$

where the empty brackets indicate a type of joint still to be specified. Let them be in the irregular sequence C A C B B, then the rule is:

$$- C - C - B - A - A - C - A - B - B - B - C -$$

This rule, in practice, lead to an unsatisfying arrangement, because of the too frequent repetition of the joint A in the central position of the chain-like structure. Therefore, I broke the chain after the seventh joint and made a structure according to the following rule:

$$
-C-C-B-A-A-C-A-\!\!\mid\ \begin{matrix}\mid\\B\\\mid\\B\\\mid\\-C-B\end{matrix}
$$

where \dashv represents a unit with three joints. This growth structure is shown in Fig. 1; it was a project that I carried out with a group of students.

Two other examples of my growth structures are shown in Figs. 2 and 3 [1]. My work with growth structures led me to be invited to talk about them to a group working on problems of artificial intelligence at the University of Leeds in England. They were interested in the way I made rules for the structures and then tested them.

Related to my growth structures are the non-figurative paintings of Z. Sýkora [2]. He divides his canvas into square grids and initially fills part of the squares using several different basic elements or units. With a set of rules and with the aid of a computer he then determines which elements should fill the remaining squares.

* Artist living at 19 The Green, Guiseley, near Leeds, Yorkshire, England. (Received 16 January 1973.)

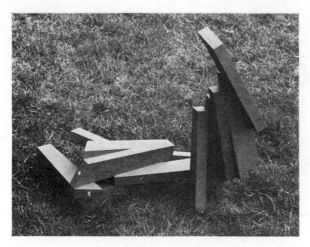

Fig. 1. *'Growth Structure in 12 Units'*, *wood*, 3 ft. largest dimension, 1972.

Fig. 3. *'Growth Structure No. 8'*, *steel*, 12 × 12 × 8 in., 1972. (Collection of The University of Bradford, England.)

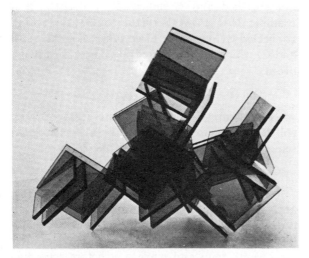

Fig. 2. *'Growth Structure, No. 11'*, *Perspex*, 10 × 7 × 8 in., 1972.

I have recently also had the opportunity to use a computer to help explore my ideas. I was introduced to the subject of automata theory [3], some concepts of which now influence my work; e.g. the concept of *neighbourhood*. However, I must add that I do not make computer art. In this connection, I have found useful the article by Apter in *Leonardo* [4].

I imagine that each unit in a piece has its own *neighbourhood* and that the piece consists of a *population* of units. This approach has led me to try to develop a template device that indicates the alignment of each unit with respect to those in its immediate neighbourhood.

My growth structures are a part of the constructivist tradition, though I no longer limit them to right angles as regards either the shape of units or their arrangement. My rules might be taken by 'conceptual' artists as sufficient. I do not subscribe to this view, however, and find that it is the object I make by adjusting the rules that finally decides whether the rules have any aesthetic value.

I have found growth structures a useful teaching aid. They cause a student to think about decisions involved in making a work of art.

REFERENCES

1. B. Freeman, *Exhibition Catalog* (Bradford, England: University of Bradford, Feb. 1973).
2. Z. Sýkora and J. Blažek, Computer-aided Multi-element Geometrical Abstract Paintings, *Leonardo* **3**, 409 (1970).
3. *Essays on Cellular Automata*, A. Burks, ed. (Urbana, Ill.: University of Illinois Press, 1970).
4. M. J. Apter, Cybernetics and Art, *Leonardo* **2**, 257 (1969).

THE MULTI-MEDIA PERFORMANCE '987' BASED ON THE GOLDEN RATIO

Jeffrey B. Havill*

1. Introduction

On the evening of 19 February 1974 a performance, entitled '987', was staged by students of the advanced design course given in the Department of Art, California State University, Humbolt, Calif., U.S.A. The primary purpose of the project was to produce multi-media presentations through which the ratio called the *Golden Mean* or *Golden Section* might be experienced directly rather than understood by the usual didactic explanation.

The project was carried out by 30 students under my general direction. Faculty members of the departments of mathematics, of physics and of music participated as advisors. J. E. Householder of the Department of Mathematics through his adventurous spirit and patience contributed greatly to the execution of the project.

A student, selected as technical director, was responsible for delegating jobs to be done, arranging for the procurement of materials and overseeing the construction of special devices. Since only seven weeks were available for the completion of the project, in the form of a performance, the initial plan prepared had to be carried out as scheduled.

The performance was conceived in terms of a ritual to last for about 16·5 minutes in a darkened room. It began slowly and quietly with simple effects, speeded up and became more complex until a climax was reached and then subsided to a calm ending. At the climax, some spectators said that they suffered from sensory overload as features of the performance multiplied and intensified. The performance began and ended in the darkened room with only the sounds produced by two metronomes. One spectator commented at the end: 'I feel as though I had been taken somewhere and then safely brought back.'

The spectators at the performance sat on chairs arranged in the shape of a pentacle or five-pointed star. The result was that from some chairs, viewing was awkward, but, since the spectators were told that the arrangement was made to be in harmony with the mathematical basis of the performance, few actually moved their chairs.

A poster for publicizing the performance was printed with a design based on the Golden Ratio.

2. The Golden Section or Ratio

The name Golden Section was given in the 19th century to the proportion called by Euclid the 'extreme and mean ratio'. In the case of a line made up of a shorter part of length a and a longer part of length b, the Ratio is given by $a/b = b/(a + b)$. The Golden Rectangle is one in which the Ratio applies to its sides of lengths a and b.

The numerical value of the Ratio is the irrational number $(\sqrt{5}-1)/2 = 0·618033 \ldots$, and its reciprocal is $1·618033 \ldots$. It is interesting to note that the ratios of successive numbers in the Fibonacci series approach $0·618033 \ldots$ as a limit. Thus, for 1, 1, 2, 3, 5, 8, 13, 21, 34, ... 610, 987, ..., in which each number is the sum of its two predecessors, the ratios $8/13 = 0·615384 \ldots$, $13/21 = 0·619047 \ldots$, $21/34 = 0·617647 \ldots$ oscillate rapidly to the limiting value $0·618033\ldots$.

This and other information on the Golden Ratio was provided to the students [1].

3. Planning the project

A multipurpose room (54 × 54 × 23 ft) in the Student Union Building was chosen for the performance. The vertical from the center of the floor was taken as the axis or meridian from which measurements were made in feet. A pentagon with sides of about 21 ft and within it a pentagram or pentacle were marked on the floor with white tape. The following comment on these shapes is found in Ref. 2: 'It is traditionally held that Plato began the study of "The Section" as a subject in itself. The construction of the pentagon by means of the isosceles triangle having each of its base angles double the vertical angle (72°, 72°, 36°) was due to the Pythagoreans (Euclid, Bk. 4, Prop. 10). In this triangle the base forms a Golden Section with the longer sides. The triple interwoven triangle, the pentagram, which makes multiple "Sections", was used by the Pythagoreans as a symbol of recognition between members of the brotherhood and was called by them Health.'

To introduce a relationship between the timing of the performance and aspects of the Golden Ratio, it was decided to choose the number 987 in the Fibonacci series for the duration of the performance in seconds (16 minutes and 27 seconds). A temporal axis or meridian was located at the number 610 in the series and the duration of events in the performance were to straddle the meridian in accordance with successive numbers in the series as shown in Fig. 1, thus an event that began 13 sec before the meridian was to terminate 8 sec after the meridian or have a duration of 21 sec. This meant that events that began closer in time to the meridian would be of shorter duration. This permitted nine events to be scheduled and at the time corresponding to the meridian all the events would be occurring simultaneously and they began closer and closer

* Artist and teacher, Department of Art, Clack Art Center, Alma College, Alma, MI 48801, U.S.A. (Received 24 March 1975.)

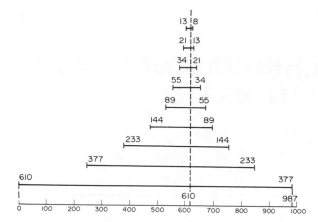

Fig. 1. *Diagram indicating time of initiation and duration of events in the performance '987'.*

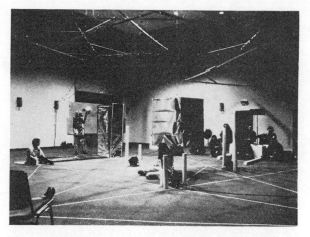

Fig. 2. *View of the set for '987'. On the left 'Iron Man, 34–21' stands beside the Golden Rectangle box; on the right sit the chanters of 'Eight Tones, 55–34' and at the center is the assistant to 'Iron Man'.*

together as the meridian was approached. The events were coded with the numbers corresponding to the number of seconds when an event began and terminated after the meridian. Thus, the event that was to be performed for the full 987 sec had the code 610–377.

After these guidelines had been established by the students, the project was discussed and the students were asked to submit proposals for events that might be performed. Several hundred events were proposed from which nine were selected, and a group of students was assigned to prepare each one.

A view of the set is shown in Fig. 2 and views of the performance in Figs. 3 and 4.

4. Description of the Events

(a) *'Metronomes, 610–377'*

This event, which lasted for the full duration of the performance, consisted of two metronomes, beating at the rate of 55 and 89 beats per min respectively (two successive numbers in the Fibonacci series). The beats were amplified and the room was in near total darkness at the start and the end of this event.

(b) *'Overhead Lights, 377–233'*

Five Golden Rectangles (approximately 13 × 21 ft)

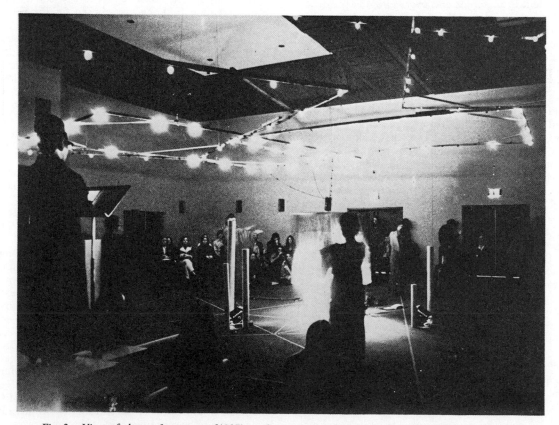

Fig. 3. *View of the performance of '987' at the moment when the event 'Flaming Lights, 89–55' began. During the performance the lights were dimmer, so that the supports for the overhead lights could not be seen clearly.*

Fig. 4. *View of the performance of '987' when all events were in progress.*

were constructed of thin wood laths and suspended from the ceiling of the room in a spiral arrangement around the vertical from the center of the pentagram.

Strings of colored light bulbs were attached to each Rectangle. The colors of the bulbs were arranged to correspond to numbers in the Fibonacci series that correspond roughly to the wavelength of five colors of the light spectrum, that is, indigo, blue, blue-green, yellow and orange.

The strings of lights for the Rectangles were wired separately, so that they could be switched on and off in different controlled time sequences.

(c) 'Chant, 233–144'

Two performers, dressed in black, stood together on a low box of Golden Rectangle cross section placed at a point on the pentagram and chanted letter combinations determined by a code based on the Fibonacci series. The shortest combination was 'ba' and the longest 'celojececefodig-ubida'. Letters were assigned to the numbers in the Fibonacci series corresponding to the numbered positions of the letters in the alphabet.

(d) 'Robed Dancers, 144–89'

Five students performed a slow ceremonial dance along the five arms of the pentagram. The designs on their robes and the tailoring of the robes were based on the Golden Rectangle and the colors used were selected from a color wheel of the following colors: green, yellow–green, orange, violet and turquoise. The cloth of the robes was a slightly glossy acetate, which reflected the colors of the overhead lights.

(e) 'Flaming Lights, 89–55'

A 5 ft solid object with the cross section of a pentagon covered with sheet aluminium was suspended 3 ft above the floor at the center of the room. It was spun slowly in beams of three light projectors. Filters of orange–red (600 mμ wavelength), yellow–green (525 mμ) and blue–violet (425 mμ) were installed on the

projectors. One obtained the impression that there was an intense multi-colored flame at the center of the room. The performers and the spectators had reflected upon them flashes of light from the spinning pentagonal object.

(f) 'Eight Tones, 55–34'

Eight performers seated opposite the chanters of event 'Chant, 233–144' produced penetrating sounds by stroking the rims of wine goblets containing water. The depth of water was different in each glsss, so that each produced a different tone. The depth in inches of the water corresponded to Fibonacci numbers.

(g) 'Iron Man, 34–21'

A male student, clad in polished metal parts of different geometric shapes, emerged from a silver painted Golden Rectangle box placed on the side of one of the pentagon arms. He made his way noisily across the area within the pentagram following an unpredetermined path. As he moved about, parts of the costume fell away. He was followed by a female assistant who acted as though she was taking notes on his journey.

This event was intended to provide an element of disorder to the otherwise closely controlled events. A spectator remarked that the event reminded him of a scrawl on graph paper.

(h) 'Pentatonic Vowells, 21–13'

Students seated in the audience chanted vowell sounds in unison with the chanters of 'Chant, 233–144', following a pentatonic musical scale, which has the tones of the Western major scale with the fourth and seventh tones omitted.

(i) 'Meridian Countdown, 13–8'

A voice over the speaker system counted off seconds and a small gong, barely audible over the din, was struck at the meridian. The seconds were counted in the sequence 13, 12, 11 1, 610 (or 0), 1 . . . 8.

5. Conclusions

It was not possible to decide whether the performance helped the performers or the audience to obtain a better grasp of the possible aesthetic or other significance of the Golden Ratio than they could have achieved by means of usual pedagogic explanations. Nevertheless, the conception of using the Ratio as a basis for stimulating the imagination of the art students was very useful and they fairly surely learned more of the mathematical and visual properties of the Golden Ratio than they might have done by other teaching methods.

References

1. J. Hambridge, *The Elements of Dynamic Symmetry* (New York: Dover, 1967).
2. *The Oxford Companion of Art*, H. Osborne, ed. (Oxford: Clarendon Press, 1970), p. 488.

PART IV
PICTORIAL AND THREE-DIMENSIONAL ART WORKS—APPLICATIONS OF DIGITAL COMPUTERS

COMPUTERS AND VISUAL ART*

H. W. Franke**

Abstract—*Computer graphic art is a logical outcome of graphic art produced by simpler machines and by calculation. Up to now digital and analog computers have been used that were originally designed for scientific and technical purposes, and they are adequate for the artistic task but their output still proves to be a bottleneck. A further difficulty arises from the fact that aesthetic theories suitable as a base for computer art are still in their infancy. The use of computers means breaking with some art traditions but, on the other hand, it may well lead to a breakthrough in art and a better, rational understanding of artistic phenomena.*

I. ART AS AN INFORMAL PHENOMENON

One way of regarding the application of the computer in the realm of art is to see it as part of the technological revolution that is transforming all departments of modern life, including those least concerned with technical production processes.

There is no doubt that some phases of art-creating processes can be mechanized and automated. If we set aside the mystic aura, the essential task in producing a work of art consists in designing a composition from basic elements—shapes, sounds or words. The sole condition that these elements must satisfy is that they have to be visually or aurally perceptible.

The production of a work of art consists of two phases:

1. Generation of signals.
2. Arrangement of constituent elements.

The first phase is a physical process that can be 'instrumentalized' quite easily. In music, for instance, the use of sound-producing instruments and machines is accepted as perfectly normal. The generation of visual symbols is likewise a physical process but an understanding of it did not become available until much later than acoustic techniques employed in music. Consequently, the view still widely held in academic circles is that the use of machines disqualifies computer graphics as an art form.

The second phase—the aggregation of the symbols according to certain rules of order—is an informational process that can now be handled by the data

processing systems of the computer and, for the first time, one can come to grips with the real problems of visual design through 'instrumentalization' [1–3].

II. THE THEORETICAL BASIS OF COMPUTER ART

A. Statistical analysis of works of art

The belief that the computer can be used to good effect in art rests on the assumption that works of art can be expressed in mathematical and, particularly, in statistical terms. This assumption receives support from the fact that the human brain with the organs of perception constitutes a data processing system that relies on much the same analytical processes as the computer in performing one of its most vital tasks, the recognition of patterns. Since works of art are perceived only by way of the sense organs and the brain—and not by any extrasensory means—there is no apparent reason why aesthetic arrangements cannot be expressed in rational terms. Accordingly, if we take a random selection of patterns and examine them with the aid of statistics for features of regularity, it follows that aesthetic arrangements will be reflected in the results.

Although the method of *statistical aesthetics*, of which the foremost exponent today is Wilhelm Fucks of Aachen [4], cannot be looked upon as a theory, it does provide a quantitative basis for computer art. Once laws of aesthetics have been ascertained statistically, they can be embodied in programs. The resulting compositions will show whether relevant aesthetic principles have been preserved. If, for instance, we use Markoff chains of a certain order for the analysis and construction of aesthetic compositions, it will be apparent whether the information resulting from that order exhibits the effective principles. Examples of this have been given by H. Kupper [5]. Similar procedures can be adopted in computer graphics. A. Michael Noll has

* This article is based on a text entitled 'Computer und visuelle Gestaltung' in *Elektronische Datenverarbeitung* (as of 1971, *Angewandte Informatik*) No. 2 (1970) published by Verlag F. Vieweg und Sohn, Braunschweig, Ger. Fed. Rep.

**Physicist and artist living at D-8195 Puppling 40, Pupplinger Au, Fed. Rep. Ger. (Received 26 March 1973.)

attempted to capture the characteristics of Piet Mondrian's style and apply them in programs for computer graphics [6]. F. Nake has worked with paintings by Hans Hartung and by Paul Klee [7].

B. Information aesthetics

The disadvantage of the statistical method is that it can draw upon only the rules of style of existing works of art and, consequently, it is not directly useful as a means of achieving artistic progress. To pioneer in the production of art by formulating hitherto untried design principles with the aid of the computer, we need quantitative guidelines for its production. The school of *information aesthetics*, represented by Max Bense and his students, derives these guidelines from philosophical reflection. Using Shannon's statistical information [8], the procedure can specify dimensional values for works of art. In the programs for computer graphics, these values can be assigned to produce compositions. This approach forms the basis of the work of the German computer graphic artists, Frieder Nake and Georg Nees.

C. Cybernetic theory of art

Bense's information aesthetics suffers from the drawback that the correlation between its dimensional values and the subjective qualities of pleasure, beauty etc. is hard to establish. It is clear, however, that his method makes it possible to take human factors into account and to define in quantitative terms when a pattern may stimulate aesthetic interest and when it may not. This school of thought is based on the processes of perception; it regards an artistic composition as having aesthetic value if it satisfies the following conditions:

1. A picture must be designed in a way that stimulates its perception [9]. To ascertain configurations that satisfy these requirements, the method employs the techniques of information psychology.
2. A picture must incorporate certain 'strategic' design features that keep the perception processes active for as long as possible and stimulate them to new activity again and again [9].

The science that concerns itself with the study of these processes is called *information psychology*, a branch of cybernetics. *Cybernetic aesthetics* can provide the first leads for systematic production. For the pioneer work in this field, we are indebted to Abraham Moles [10] and Helmar Frank [11].

The essential difference between Bense's information aesthetics and cybernetic aesthetics is that the former requires a high aesthetic content, given by:

$$M_A = f\left(\frac{O}{C}\right),$$

where O is the degree of order and C the complexity; there are specified rules of measurement for these terms [12, 13]. Cybernetic aesthetics, on the other hand, specifies certain optimum ratios of information and redundancy, suited to the receptive capacity of consciousness. If, for instance, a picture element is to stand out with maximum clarity against a background, the ratio of this element to other elements as regards dominance, according to H. Frank, would have the value:

$$p = \frac{1}{e} = 37\%$$

Needless to say, it is also possible to produce computer art, lyrics and music by the method of trial and error, that is, without any theory at all. This playful use of the computer may, of course, lead to pleasing results and, as the available theories are still very rudimentary, it is often the only course open to us.

III. CREATIVE POSSIBILITIES OF COMPUTER ART

The mere fact that it is possible to use a machine is not in itself a justification for using it [14]. In computer art or in any other machine application, there are two criteria by which this issue should be decided:

1. Is it possible, by using a machine, to achieve something that would not be feasible without it?
2. Is it possible, by using a machine, to do something better or faster than before?

It is obvious that not all areas of visual art lend themselves equally well to instrumentalization but there are some for which the answer to these questions is definitely affirmative. Two examples will illustrate the point:

A. Non-figurative or abstract graphics

The fact that many works of computer graphics are of geometrical design—that is, akin to constructivism and Op art—might lead one to suppose that these are the only styles the computer can handle. This is not the case. Since any distribution of form and color elements theoretically can be incorporated in programs, there is no style that must elude the computer. There are, of course, certain simpler aesthetic guidelines that it is particularly well equipped to follow and, undoubtedly, this is the case for geometrical art.

If we disregard the conflicting views of artists regarding their constructivist works, it will be seen that for these kinds of pictures mathematical precision has been discovered to be of aesthetic value. Mathematical precision, however, is one of those qualities that can be attained by mechanical aids far beyond the degree attainable by hand. The ruler and compass used by the classical constructivists obviously limit the range of lines that can be drawn. Curves of higher order, easily made by the computer, afford a much wider range of graphic possibilities to the artist. The fine construction of a set of curves to produce a translucent texture akin to the chords of a

musical composition calls for high precision. In design based on constructivist principles, at least, the computer enables us to go far beyond what was possible by conventional means.

B. Figurative graphics

Figurative art is another field where the computer can explore uncharted territory. Just like any artist engaged in representational figurative work, the computer must begin by using its 'eyes' to see objects in the environment that it wishes to use in a picture. An ordinary camera or a television camera will serve for this purpose. The special feature of representational computer graphics is that the visual information received can be altered in a great variety of ways. It is possible, for instance, to disintegrate human figures successively, or—more interesting still— process a number of pictures to achieve a blend. Examples of computer-controlled picture transformation are available in the work of Charles Csuri and the Japanese Computer Technique Group (CTG).

IV. IMPLICATIONS OF COMPUTER SPEED OF PRODUCTION

Even where the computer has nothing fundamentally new to offer but is merely a faster method of working, it can represent an important advance. Here again I will take two examples:

A. Calculated graphics

There are works of constructive art that, although not produced with the aid of a computer, are nevertheless calculated. The works of Klaus Basset and Hermann Stiegler, for example, were first computed and then executed by hand. The use of the computer equipped with a plotter system would make it possible to produce, within a matter of days, series on which the painters and graphic artists spent years of work. The time required for execution, which hitherto has accounted for the greater part of the total working time, would then be inconsiderable and the artist could devote himself to his proper task, the formation of ideas. Many of the works of Frieder Nake, for example, those based on matrix multiplications, belong to this class of calculated graphics.

B. Computer cinema production

The computer's speed of operation makes it an ideal instrument for the production of animated films. Since the movements a human body is able to make can be programmed, all that is required to produce a film with moving figures is a set of positioning instructions. An example of a computer film is 'Hummingbird' by Charles Csuri.

V. SHORT HISTORY OF COMPUTER GRAPHICS

Viewed historically, computer graphics are the result of two distinct lines of development. The first

Fig. 1. Electronic graphic design, made with the aid of an analog computer and a cathode ray oscilloscope. The elements used were various voltage waveforms, sine curves, saw-tooth curves, rectangular curves etc., generated by a Siemens demonstration unit. The basic elements were manipulated in a switching unit by addition, subtraction, integration, differentiation etc. via a mixer console. The composition was produced by H. W. Franke in 1961/62.

began with ornaments and led in a direct line, via constructivism and calculated graphics, to the computer. The second began with virtually unrecognized machine-based art that led by way of mechanical, optical and electrical systems to its culmination in electronically automated objects.

In 1952, computer graphics were generated with analog systems by Ben F. Laposky (U.S.A.) [15] and by myself, in 1956, (cf. Fig. 1) and by Kurd Alsleben and by Cord Passow in 1960 in the Federal Republic of Germany. Digital graphics were published in 1963, simultaneously but independently, by Frieder Nake (F.R.G.) (cf. Fig. 2) and by Georg Nees (F.R.G.) (cf. Fig. 3) and by A. Michael Noll (U.S.A.). The first examples of figurative art were made in 1967 by Charles Csuri (U.S.A.).

Large exhibitions of computer graphics have been the following:

Cybernetic Serendipity, London, 1968
Tendencija 4, Zagreb, 1969
Computerkünst, Hannover, 1969; Munich, 1970; Hamburg, 1970.

Since 1963 the periodical, *Computer and Automation*, published at Newtonville, Mass., has held an annual computer graphics competition.

Fig. 2. F. Nake: Distribution with a weighted random-ness, Series 2.1—1/2/3/5. The area of greatest density at the top left is a horizontal strip in the center of the picture; at the top right a vertical strip; and at both bottom left and right the most densely packed area runs diagonally across the square surface.

Fig. 3. G. Nees: 'Irrweg' (Maze). Generated from 2000 vertical and horizontal elements with a 'degenerate random generator' (based on an inadequate calculating statement for pseudo-randomness, which shows periodicity).

Up to now, chiefly mathematicians and engineers have achieved practical results with computer graphics. Few of them deliberately explore new artistic ideas. For them it is more a question of experimenting light-heartedly without any definite aim in view. Usually the starting-point has been some attractive design of scientific or technical origin, although occasionally the incentive has come from companies seeking demonstration material for their computers and plotters.

Otto Beckmann (Austria), a painter and sculptor, uses the computer for designing sculptures and choreographies (cf. Fig. 4). Lloyd Sumner (U.S.A.), an engineer and artist, designs computer graphics for sale, for example, in the form of Christmas cards. Little by little, computer graphic art is being given recognition by aestheticians and art experts. The latest evidence of this was the attention drawn by a special exhibition of some of these works by Franke, Lecci, Nake, Nees, Peterson and others at the Venice Biennale in 1970.

VI. RECENT ACTIVITIES IN COMPUTER GRAPHICS

During the last two years there has been evidence of mounting interest in computer art, not only on the part of the public but among mathematicians and artists as well. Without attempting to give a complete list, a few of the activities will be mentioned below.

Systematic cooperation between artists and mathematicians has been arranged at the computer center of the University of Madrid. The results have been exhibited three times there. The most recent exhibition 'Generacion Automatica de Formas Plasticas', organized by E. Garcia Camarero, drew international attention. The foremost Spanish representatives of computer art are J. L. Alexanco, M. Barbadillo, M. Quejido and S. Sevilla. Of special note are some graphic and sculptural works that were executed in plastic material by hand after the computer had produced a large number of combinations of simple elements (cf. Fig. 5).

Several Dutch artists, A. Eikelenboom, H. Koetsier, R. D. E. Oxenaar and P. Struycken (cf. Fig. 6) have been in the news, in particular, Oxenaar for his design that has been used on a postage stamp. Manfred Mohr (France) (cf. Fig. 7) has produced over 100 computer drawings, which he exhibited in May 1971 at the Musée d'Art Moderne de la Ville de Paris. In Austria, at Vienna and Wiener Neustadt, the group, *Ars Intermedia*, has been busy under the leadership of Otto Beckmann. Their aim is the application of the computer for the production of graphics, sculpture, poetry and music. Special mention should be made of their latest development, a hybrid system for the simultaneous production of computer films with sound. In Switzerland, G. Honnegger-Lavater has been occupied with the computer-aided generation of reliefs. Pictures are being made with the aid of the computer by Auro Lecci (Italy) (cf. Fig. 8, color illus. J, p. 312), by Zdeněk Sýkora in Czechoslovakia [2] and graphics by Waldemar Cordeiro and Giorgio Moscati in

Fig. 4. O. Beckmann and A. Grassl of the Ars Intermedia *group: Electronic computer graphics for the design of a sculpture. The output device was a cathode ray oscilloscope.*

Fig. 5. Computer copy for the production of a drawing. The computer runs through many possible combinations of elements; the selection is determined by subjective criteria. Project carried out by M. Barbadillo, University of Madrid.

Fig. 6. P. Struycken: 'Computer Structure, 3a', 1969.

Brazil (cf. Fig. 9).

Stimulated by the work on computer graphics of the CTG (*Computer Technique Group*) in Japan, the CEAC (*Centro de estudios de arte y comunicacion*) of Buenos Aires, Argentina, brought computer technicians and artists together and the resulting works by Luis Benedit, Antonio Berni, Ernesto Deira, Eduardo Mac Entyre, Osvaldo Romberg and Miguel Angel Vidal were shown in October, 1969, in an exhibition entitled 'Arte y cibernetica en Olavarria'. Works by the CTG and by artists from other countries were included.

Since examples of computer graphics from Great Britain and the U.S.A. are rather widely known, the illustrations for this article have been drawn chiefly from the less familiar material of the younger generation of computer artists mentioned above.

VII. THE TOOLS OF COMPUTER GRAPHICS

Nearly all computer equipment used for producing an art output has been developed for scientific and technical applications.

A. Analog computers

Analog computers, which were the first to be used, have proved particularly successful for drawing algebraic graphics, that is, the overlaying of curves (cf. Fig. 1). Complicated Lissajous figures, graphic solutions of differential equations, representations of space surface areas in the form of networks and the like have all resulted in patterns of aesthetic quality.

B. Digital computers

The range of possibilities has been greatly extended by the use of the digital computer, which allows the production of discontinuous patterns, for example, faster images. Frieder Nake uses matrix representation to assign colors, etc., to particular

Fig. 7. M. Mohr: 'Polygonal Course', 1969.

points on a basic raster. An example of digital computer graphics is shown in Figure 10. Georg Nees has written programs for hieroglyphic-type characters with which he fills sheets in the same way as with writing. Digital computers are also the means for making figurative representations. A well-known example is a series of human figures by William A. Fetter. The program he used was originally designed to determine the most favorable arrangement of instruments in an aircraft cockpit.

C. Output devices

The most suitable output devices are electron-optical systems, such as the cathode ray oscilloscope and the television receiver. To obtain a permanent record of the pictures displayed on the screen, however, a reproduction process is required; usually a photographic one is used. This has proved an obstacle to gaining recognition for these compositions as works of plastic art, as it is contrary to the traditional form of such works. Many computer artists, therefore, make use of mechanical plotters, which suffer from the following disadvantages: they are slow in operation (20 minutes or more are required for a drawing) and they cannot produce a continuous transition from white to black or from one color to another, as can be done on a screen. Thus, the fact that the majority of computer graphics are line drawings is due to the output devices and not to the computer.

There are conversion systems which are used in machine tool manufacture for milling computer-calculated workpiece shapes. This type of output device, a sinumeric system, has been used by Georg Nees for the production of computer reliefs.

Fig. 9. Waldemar Cordeiro and Giorgio Moscati: Two transformations of the basic composition "Derivative of an Image". Made with the IBM 360/44 computer at the University of São Paulo, Brazil.

Fig. 10. H. W. Franke and P. Henne: Two digital computer graphics, 1970. Produced with a program for overlaying algebraic and transcendental curves. Executed by Helmut Maier on a Siemens System 4004 computer.

D. Software

To produce programs for aesthetic purposes, a variety of computer languages can be used; two that are frequently employed are ALGOL and FORTRAN. Some authors have worked out special languages for computer graphics based on these two languages [16, 17]. The development of these logical systems that lead to the production of outputs with various artistic styles can be regarded as the actual creative phase of computer art.

E. Random number generators

In some computer art programs, special importance is attached to the use of random numbers. The reason for this seems to be the fact that many works of art are not fully described by artistic style and that, accordingly, provision has to be made for elements of randomness. The artist is able to use intuition, spontaneity etc.; the cybernetic equivalent of these faculties appears to be the random number generator [18].

For this purpose, one can use lists of roulette numbers as well as numbers provided by systems such as noise generators or Geiger counter tubes. More commonly, pseudo-random sequences are used because they are well suited to the computer and sub-routines are obtainable from most computer program libraries. A simple way of generating random numbers would be to calculate an irrational number and use its decimal digits as a random sequence. The result is not, of course, a sequence of pure random numbers but it is free from correlations with any of the rules embodied in the program and therefore fulfils the same purpose.

A simple example of a randomly generated computer drawing is the 'maze' [17]. The program provides for a sequence of horizontal and vertical lines, whose lengths are left to chance (cf. Fig. 3). The only other requirements are a break signal and an instruction to prevent the plotter from running off the drawing surface.

A more interesting type of program is the stochastic program, which uses the method of 'weighted' randomness, that is, predetermined probabilities and mean values for the variables. This is illustrated by the graphics of F. Nake (Fig. 2). In figurative computer graphics, randomness may lead to the deformation of the subject matter, resulting in effects of the kind that are found in the style of cubism.

VIII. FUTURE PROBLEMS IN COMPUTER ART

The recognition of the computer as a means of artistic production may well mean that some of the traditionally held views of the artist's profession will have to be abandoned. It can be foreseen, for example, that:

a. the unique value of the original may be open to dispute;
b. manual fabrication by the artist may no longer be regarded as essential;
c. the artist may lose the mystic veneration that surrounds him;
d. scholars and art critics will be encouraged to use understandable concepts.

Even outside the fields of computer art, trends of this kind are increasingly evident, for example, the trend towards art objects in the form of multiples. In part, they also can be attributed to sociological considerations, that is, to the artist's desire to reach a larger number of people than is the case at the present time. Computer art lends itself well to these aspirations. Rapid and inexpensive production and the ability to duplicate are integral to the method. If the day comes, as we are told it will, when every household is connected to a computer network via a display terminal, anyone will be able to tune in on a large variety of aesthetic programs. For this purpose, variable programs that permit intervention by the viewer will be far more suitable than the static programs that are available today [19]. Perhaps in this way the gulf that yawns between the producer and the consumer will be slowly bridged. It will be some time before these possibilities can be realized but they should be borne in mind in any discussion of the practical implications of computer art.

From the technical, artistic and art lover point of view, it has to be admitted that computer art has barely taken off the ground. Although it happens at present to be one of the talking-points of contemporary art, it may well be that it will disappear from public view for a while. Taking the longer view, however, there is little doubt in my mind that it will

bring more far-reaching changes than many of the art fashions that today dominate the scene in many countries.

I wish to thank the Siemens company for arranging the translation of my German text into English by Colin Jenkins.

REFERENCES

1. R. I. Land, Computer Art : Color-stereo Displays, *Leonardo* **2**, 335 (1969).
2. Z. Sýkora and J. Blažek, Computer-aided Multi-element Geometrical Abstract Paintings, *Leonardo* **3**, 409 (1970).
3. K. Nash and R. H. Williams, Computer Program for Artists : *ART* 1, *Leonardo* **3**, 439 (1970).
4. W. Fucks, *Nach allen Regeln der Kunst* (Stuttgart : Deutsche Verlagsanstalt, 1968).
5. H. Kupper, Computer und musikalische Komposition, *Elektronische Datenverarbeitung* **11**, 492 (1969).
6. A. M. Noll, The Digital Computer as a Creative Medium, *Bit International* **2**, 51 (1968).
7. F. Nake, *Bemerkung zur Programmierung von Computer-Grafiken. Programm-Information PI -21* (Darmstadt : Deutsches Rechenzentrum, April 1966) p. 3.
8. C. E. Shannon, A Mathematical Theory of Communication, *Bell System Tech. J.* **28**, 379, 623 (1948).
9. H. W. Franke, *Phänomen Kunst* (Munich : H. Moos Verlag, 1967).
10. A. Moles, *Théorie de l'information et perception esthétique* (Paris : Verlag Flammarion, 1958).
11. H. Frank, Grundlagenprobleme der Informationsästhetik und erste Anwendung auf die Mime Pure, *Dissertationsschrift*, TH, Stuttgart, 1959.
12. M. Bense, *Einführung in die Informationsästhetik, Grundlegung und Anwendung in der Text Theorie.* Rowohlt Taschenbuch Verlag, Oktober 1969.
13. S. Maser, Neue mathematische Verfahren zur quantitativen Beschreibung und Bewertung ästhetischer Zustände. *Habilitationsschrift*, TH, Stuttgart, 1969.
14. F. J. Malina, Comments on Visual Fine Art Produced by Digital Computers, *Leonardo* **4**, 263 (1971).
15. B. F. Laposky, Oscillons : Electronic Abstractions, *Leonardo* **2**, 345 (1969).
16. L. Mezei, Sparta, a Procedure Oriented Programming for the Manipulation Language of Arbitrary Line Drawings, *Bit International*, **2**, 81 (1968).
17. G. Nees, *Generative Computergraphik* (Munich : Siemens AG, 1969).
18. H. W. Franke, Ein kybernetisches Modell der Kreativität. *Grundlagenstudien aus Kybernetik und Geisteswissenschaft* **9**, 85 (1968).
19. H. W. Franke, Gesellschaftliche Aspekte der Computerkunst, *Bit International* **6** (1971).

COMPUTER ART:
COLOR-STEREO DISPLAYS

Richard I. Land*

Abstract—The fundamentals of producing graphic designs by a computer are reviewed. Examples of display techniques are discussed, in particular, printers, plotters and display scopes. A novel system of producing color-stereo displays, with which the operator may interact in real time, is considered in detail and examples of the displays are shown. The machine used was the PDP-1 Computer of Harvard University. The basic program for producing the displays was developed by Dan Cohen as part of his graduate research work.

I. INTRODUCTION

Computers draw, paint, make music, sculpt and do almost anything man can do! Rubbish. Computers do what men tell them to do and nothing more. The instructions may be sophisticated and the results rather distantly related to the initial data but there is nothing inside the 'black-box' of the computer which has taste. That is the prerogative of man. *Computer art* is produced by a sophisticated pantagraph, where the instruction set used is considerably larger than 'magnify by χ' where χ is the value determined by the programer setting the holes on the arms of the drafting machine. If such a machine is carefully operated and the input data is a sketch by Rembrandt, the resulting enlargement may well be deemed art, indeed, computer art of sorts. The fact that we have in this century devised a machine of almost unimaginable complexity and versatility merely taxes man's mentality in finding ways to put it to use and evaluate its results.

The initial intent of many early computers, apart from the abacus and similar mathematical engines, was recreational—to play tic-tac-toe, chess and similar games. It is only recently that the computer has graduated from the accountant's desk-top to the grand-scale instrument capable of advancing whole new industries and making possible man's reach into space. Yet almost every advance of the computer, from Babbage's first conceptions of 1833 to the present, has engaged man's fancy in fiction and games. Today it is usual for the first testing techniques of a new machine to take the form of games or the production of something with creative appeal, such as visual art.

As techniques developed for computer output in visible form, operators seized upon the recreational opportunity thus engendered and began producing images of various forms and qualities. This is another step in the continuum of history, where a new technique readily finds employment in artistic expression. Leonardo da Vinci is justly famed for both his anatomical drawings and detailed observations of fluid phenomena. Both have artistic distinction in addition to their scientific worth.

Since the earliest machines were developed by man, wheels and levers have come to the aid of artists in a variety of designing engines, culminating perhaps in the sophisticated machines used for engraving portions of forgery-proof security documents. The current mixture of chemical and optical techniques being applied defies any simple survey by its diversity. Using popular jargon, one might say that the computer is just another entrant in the media explosion available to the artist. The profusion of work that currently falls under the title *computer art* or *computer graphics* almost precludes any one person surveying the field successfully [1-4]. Any discussion will have to rely on personal experience and limited published material.

Although machine-produced art is in some elements indistinguishable from *computer art*, present-day opinion would likely restrict the term to works produced by the large computers primarily designed for general logical operations and only available in the last 25 years (commercially available in the last 15 years). The trend of modern thought on the subject is inclined also to eliminate from the category of *computer art* those instruments which seem to have artistic expression as their sole purpose, even though the control system used for it is in fact a computer of sophisticated elaboration utilizing combinations of mechanical and electronic elements.

In his *Lumia*, Wilfred used mechanical linkages to program his optical effects, Malina [5] and Schöffer [6] among others, have employed electronic and mechanical control elements in kinetic art, and like so many of the currently popular art objects, my *Chromara* [7] can be driven by a small electronic analogue computer using audio signals as a control input. The designation *computer art* seems destined to remain attached to those art forms produced by a machine originally designed

* Engineer-artist, Division of Engineering and Applied Physics, Engineering Sciences Laboratory, Harvard University, Cambridge, Mass., U.S.A. (Received 14 February 1969.)

R

for other purposes—the machine becomes an instrument of extra-logical expression only as the result of the operator's intention.

As the computer becomes an obiquitous servant of our culture, at once important to industrial progress and also an indispensible tool of the scientist, many of its features escape the general understanding of the public. Even the largest of today's machines are simple and direct actors of logical commands. Essentially, the process is 'do this', 'do that', where this and that refer to taking data from somewhere, performing elementary operations and putting data somewhere. The operations appear complex by virtue of the conditional logic that may be used and the speed with which long logical sequences may be followed.

One of the drawbacks of the computer revolution is the growth of a new language; this makes many people feel themselves outsiders, intimidated by the new words. It is amazing how fast one assimilates the new terms after working with these machines and then forgets to explain them in ordinary discussion. I will make an effort to introduce special computer language gradually and explain each term clearly. There are numerous projects considering 'artificial intelligence' and whether computers can be considered to 'think' but this falls outside these considerations [8].

II. BASIC PROCESSES

Most people think of computers as adding machines. They are really instruction performing machines where addition is just one of the fundamental techniques for executing an instruction. The operation of detecting a fit or match, for instance, is merely the negative adding of one thing with another and then observing a null result or 'not different'. When we match two lines, we place them together to see if they have the same length. The computer in its own perceptive way takes a description of the lines, their numerical length, and places them together, adding one, subtracting the other and notes the difference. When there is no difference, it declares a match. The modern computer can do this millions of times while man does it once. In this way it was not hard for a computer to scan a print of the Mona Lisa, read the output of a photo-sensitive device and transform these intensity measurements into a printed output using normal alphanumeric characters (letters, numbers and signs of printing) which rendered a remarkable likeness to the original. Artistically, this was primitive but it was an early step in what now seems to be a boundless excursion of computer activity in the arts. In science, the most elaborate use of such scanning techniques has been the enhancement of space probe photographs of the Moon and of Mars.

Perhaps it is easier to explain the artistic use of computers by reversing the usual discussions of computer basics where one first considers the logic used, then the details of *input* information and

finally *output* techniques. Once the simple level of operation is clear, elaboration of techniques will be more meaningful.

To start with the third step—the simplest output appears on a plotter. This instrument uses a pen to draw a line on paper and the computer must provide three commands for each point. Horizontal and vertical position relate the pen to some reference point (lower left corner, or center) previously determined and then the command to draw makes a mark on the paper. From this alone it is clear we can draw figures either by points, each with specific coordinates independent of the previous point, or by writing lines where one command to draw is followed by a series of vertical and horizontal instructions, each small enough to provide a smooth contour. Generally, the computer provides discrete incremental instructions which are smoothed out electronically as the pen moves.

To draw a square using the plotter, the only input needed is where to start, say the lower left corner at a certain location in relation to the fixed corner of the plotter page. Then we give instructions for the points one by one along each of the four lines, changing the direction at each of the corners of the square. We might say our picture consisted of a file of locations, the first location being the starting corner, with its associated instruction to draw, and specific points, one after the other, until completion with the final instruction to draw the last point adjacent to the first point. The detail of the drawing will depend on how many points we put in the file, unless the plotter is of a special sort where it makes straight lines and needs only commands for the end points. In this case only the corner points need be specified for a square to be drawn.

With the addition of a computer between the input and output, drawing a square becomes somewhat more complicated but in general much more powerful. First, we must instruct the computer what to read as *input* and what to say as *output*. This matches its internal handling of data with the operator and plotter. Then we must detail the instructions of how to take each input instruction and generate the points which are the only instructions understood by the plotter. Once we have given the computer this *program*, we may, depending on its sophistication, give very simple commands as input and let the computer do all the drudgery of generating the file of points for the drawing. All that is really required for a square is the length of a side, its orientation and the starting point; thus with a computer one can designate a position for the corner, what direction to start drawing in and the size, and let the program do the rest.

For a first composition we might give instructions that ask the computer also to remember the starting position, rotation and size of the design, and systematically change these according to simple rules. Thus we might fill a page with squares which grow and shrink in size, rotate and seem to follow a pattern. We would then have a computer composition of possible artistic merit.

We have essentially two choices at this juncture of programing our computer. As presented, it is clear that the program waits until it has all the information from the input and then it proceeds until it comes to the command which says it has finished. Thus one is required to specify the entire drawing from the onset and merely wait for the completed output, called *batch processing*. The other alternative is to instruct the program to halt from time to time to read a specific input, perhaps a dial set by hand. Using that information in a specified way, the program can proceed with its instructions. Here the operator and computer co-operate in processing the initial input. The progress of drawing the squares is continually controlled by the operator. The only limitation on his freedom of action is imposed by the input *hardware* (knobs, switches, etc.) and the original program given at the start. This direct interaction with an operator is called *real-time computer processing*.

There are many distinctions, advantages and disadvantages with these two major processing concepts but clearly the *batch process* technique requires much careful planning, since no revision is available during the active production. *Real-time production*, on the other hand, usually finds the computer wasting its considerable capacity just waiting for the operator to 'do his thing'.

From a large collection of instruction sets, a machine would be able to produce hundreds of patterns using the square generator as described. We could then throw away those without value and learn from the more successful ones how to make better ones. This might be more fruitful than manipulating the instructions in real-time over-carefully, producing only one or two labored drawings, each very dependent on the momentary whim of the operator. There are many fascinating subtleties in both of these methods and considerable thought should be given to their advantages and faults before becoming too committed to either one or the other. One should also note that there is often an economic question to be considered in making the choice between *real-time* and *batch processing* that complicates the alternatives.

The term *off-line* needs a word of consideration in this respect. Very often a computer does batch processing in its own fast-time and places outputs into storage, for example on to a magnetic tape. Later this tape is used to drive the plotter to produce the drawings. The transfer of the computed output to another station for the hard-copy is termed *off-line*. When the plotter is driven while the processing takes place, it is called on-line, and generally delays the computer operations (costs more money!).

III. COMPUTER FUNCTION

Although the output device must eventually have point by point instructions for any image produced, the computer can deal with an image in a more abstract manner. Certainly any file of points may be logically processed through any conceivable system of instructions but this usually requires excessive machine time and storage, and is cumbersome to control in the program. The first simplification would be to group the points into lines and then specify the file of lines and the operations with the lines. This may be still further simplified by logically describing a family of lines or figures and doing transformations on these compound elements.

As each higher abstraction from the detail of the image is achieved, the program generally becomes more elegant, saving time, storage and labor of the programer. The loss in this progression is intimate control of all details or of some specific detail that may come to appear important after the processing is underway. In every case, one expects to learn from an initial program what modifications must be developed to achieve specific effects in the ultimate result and be ready to change the program accordingly by modifying the initial one or devising an entire new scheme.

The basic instructions of a computer are not relevant here but the notion of *conditional statements* should be clarified. Often the system of instructions will ask for one transformation until some size is reached, then a change to another transformation. Doing one thing and then changing, *if* something happens, is one of the great powers of computers. But it also provides an interesting demand on the initial program, for one must anticipate *all* such conditional alternatives with appropriate instructions.

The major problem in programs is that one gives a system of instructions assuming that the available information coming into processing has a certain form but neglects the special case when the form is different. In such a case the computer may not recognize the input or may try the usual transformation that leads to an unusable result. Having no instruction what to do then, it may halt, or worse, it may blithely continue making something unrecognizable by anyone—'garbage'.

A simple example of this problem is what happens when the plotter of the previous example comes to an edge of the plotting surface. It is useless to have all the points piled up on the edge, so this situation must be tested for in advance and the decision to ignore all points 'off the paper' must be programed. Note that the actual computational transformations generally have to include all these unwritten points, so that later, when the transformations change, these unwritten points will reappear. There are often special built-in program aids that simplify operations of this type which the operator must know.

One of the most challenging problems in computer graphics is the solution of the 'hidden line' problem. This is the case of a figure being represented as eclipsing another and we observe lines apparently disappearing behind an overlying image. The conditional instructions must here seek out the intersections of all lines, test for the line that is supposed to be in the foreground and continue with the transformations, while remembering which lines are to be 'visible' or 'invisible'. Clearly the details

and complications that can be encountered here require sophisticated conditional logic.

It would seem relevant to consider how much effort of the artist should go into the program and how much into the input data. The more structure is included in the latter, the simpler the program may be for elaborate results. The opposite seems more satisfactory. The output reflects the ingenuity of the artist when the input specification is minimal and of high generality, and the program incorporates the adaptive instruction sequences.

Up to now the methods for communicating with the computer have not been simplified for the artist and only the mathematician and logician finds simple languages (sets of instructions which may comprise the program) available for most systems. Work is currently in progress on specific drawing languages of sufficient power for general graphic displays. All of this progresses as the hardware for illustrating becomes more satisfactory. The following recent advertisements indicate some of the possibilities:

(a) '*The Adage Graphics Terminal* is a general purpose, user-oriented product line (of input–output equipment) which will meet the needs of a wide variety of disciplines, initially centered in engineering and scientific research but potentially extending to architectural design and business management. These systems are designed to extend man–machine communication techniques by allowing the user to generate, observe and interact with complex images while they are dynamically displayed on a cathode ray tube.'

(b) '*The Sanders Advanced Data Display System 900* features a larger variety of display sizes and speeds than any other comparable system available today. High-speed vector, position and character function generators permit unrivaled density of displayed graphics and alphanumerics. ADDS/900 offers rotation and translation of data, and exclusive graphic overlay on TV or radar video data Data entry devices having a common interface for standard I/O (input–output) data transfer includep hotpen, trackball, joystick, keyboard, data tablet and cursor control' [9].

IV. INPUTS

Since the high-speed operations of the computer are electrical, the artist has to translate his intentions into the same terms. Electric typewriters are the most common starting point for input, requiring an alphanumeric code for all information being offered. There are several 'drawing' techniques for input called, *Light-pens*, *Rand Tablet* or *Wands*.

Drawing with a light-pen leaves a line on a TV-tube-type face. Input proceeds much like usual drawing but there are many special advantages in the computer-aided drawing, for one may move lines and change the mode of the pen from writing only, to participating in the instruction processing. The *Rand Tablet* is a limited surface (25 cm square) where each point located under the tip of a special pen may be accurately sensed by the computer. On such a surface, any drawing operation may be completely transferred into the computer's electrical terms. *Wands* are now becoming more numerous as devices whose position in space is read into the computer for three dimensional input [10, 11].

Special optical scanning techniques are becoming available and the variety of pictures or images that may be 'understood' by computers is limited only by the expense of the devices. The familiar punched cards and paper tape are merely a translation from the electric keyboard to a more easily stored form of input and generally this storage is further translated to magnetic tape for online processing.

V. OUTPUTS

Computers are designed to produce their results (*outputs*) as fast as possible in an attempt to keep up with the processing speed. Currently this means using some kind of magnetic storage device, such as magnetic tape. Later, what is on the tape may be converted into printed pages, drawings or the control of any imaginable instrument for the production of a result determined by the original program. In the real-time case, speed remains important. The operator must receive the output and comprehend it at a maximum rate for the processing to continue efficiently. This generally means some form of visual output: printed words, pictures or images produced by electrical and optical techniques.

Printers are presently capable of delivering hundreds of lines a minute with hundreds of characters per line. The characters available are generally letters, numbers or symbols used in printing. There is limited flexibility in arranging irregular spacing, overstrikes and the like. The paper must be of a specified quality and size to be handled with such speed. Plotters today are becoming both fast and flexible. In some cases, the pen moves in two directions over a fixed sheet of paper, up to a meter square and of almost any quality, color or surface.

In other cases, the pen moves in one direction only, while the paper moves in the perpendicular direction. In this case, the size of the paper may not be limited in length, only in width, but it must be of a certain kind to fit the moving surface mechanism. Both methods can produce accuracies better than 0·1 mm in locating points and are capable of remarkable renderings. Obviously, the pens may have ink of any color. The major problem is the consumption of time, for the average 20 cm drawing might take several minutes.

The *cathode ray tube* (*CRT*), in which electrons striking the phosphor screen produce a visible trace as in television, is currently being exploited in many ways. The only limit we need consider to writing speed for CRT output is the comprehension of the viewer or the speed of photographic techniques being used. The photographs accompanying this article generally covered about 20 cm square.

The computer could produce the complete color image in less than $\frac{1}{20}$ second but, since the photographs were exposures of 4 to 8 seconds, the computer had to continue repeating the same pattern over and over.

Most of the CRT outputs are single units having active areas about 25 cm square for producing images in black and white. Flicker has been a problem, so generally the phosphor is selected with a long decay time to permit low refreshing rates for the display commands. The image only exists when the electron beam strikes the phosphor, that is, it disappears during the decay time of the phosphor. For the picture to remain visible, the computer must be instructed to repeat regularly the same motions of the electron beam to refresh the image. This differs from television, where the fast changes of images demand fast decay-times in the phosphor and rapid refreshing rates (decay times are generally less than 100 microseconds and the repeat rate of pictures is about 30 times a second).

Color TV tubes are a simple choice for making color computer outputs. These tubes have until very recently all been of the shadow-mask type, where three electron beams are used, each focused on either red, green or blue dots of phosphor comprising the display screen. The information must be properly filtered, so that the three beams at every instant have the correct intensity instruction to produce the required color. Though this is relatively easy in the color TV case, where the information is received in the filtered (colored) state, it is time consuming to make the necessary transformations for generating a full color image from programed computer instructions.

Recently, penetration phosphors for color-display CRTs have been developed that are in layers, so that the energy of a single electron beam determines both the brightness of the color and the hue itself. While requiring the same color-filtering transformations, the operation of a single beam is easier and the detail rendered still has high resolution.

The development of the *storage tube* has helped visual output techniques in the black and white category. Here the CRT screen can be considered to have a memory that may be switched on and off. At the beginning of writing a picture one turns on the memory and writes the picture as fast as one can—it will then persist until the erase instruction is given.

A family of optical techniques are adaptable to computer output. Small-mass mirrors may be moved electromagnetically at high speeds, giving both a displacement or a change of focus. Small changes in pressure, produced in an electrical transducer, may also be used to change the focal length of lenses comprised of liquids within elastic membranes. The fastest technique of all is the control of light sources either directly or by using fast shutters electronically activated. This field of display is limited in development by the specific images produced.

Before leaving output devices I should point out that obviously visual stimuli are not the only ones used for communication with man. Computers can play music directly through Hi-Fi systems and may speak a limited number of words. Fortunately, in my opinion, not very much has been tried in the taste and smell category and when one smells something, it means there is electrical trouble in the machine room! The use of the tactile sense is receiving limited attention at present.

VI. COLOR OUTPUTS

Colored inks for the plotters and printers and the color TV techniques have been mentioned above. These might be considered intrinsic color systems. There are other color techniques not so closely incorporated in systems.

With black and white CRT displays, photographic techniques offer several approaches. Conceptually, the simplest color system is to have the computer produce a red display, photograph it on color film through a red filter, then proceed similarly with green and blue filters making a triple exposure. Processing of the film will then yield the full color photograph. In the same manner, using negative color media, one could separately make the three negatives and combine them in the darkroom, retaining the flexibility of adjusting the color balance at the same time. This process yields the best color reproductions at present.

These techniques require darkroom delay and are, therefore, *off-line* not *real-time* systems. However, it was clear to early TV experimentalists that all one need do is mount the color filters in a wheel and rotate it synchronously with the display. In this way, there are produced superimposed three color images within the eye response time, giving to the eye the appearance of full color. This was the system proposed by the Columbia Broadcasting System (CBS) just after World War II for color television. Note that if the display area is a 25 cm square, one needs a filter wheel nearly a meter in diameter, whirling at about 1000 rev/min.

After trying subjective colors using display techniques, I wanted to avoid the cumbersome large wheel. Ivan Sutherland suggested that the rotating wheel be hand-held close to the eyes like a lorgnette and then several viewers, each with a properly synchronized unit, might see full color. We quickly realized that this permitted stereo separation of the images as well. The necessary device was designed, the computer programs developed and full color, stereo images were easily obtained from any file of display data [12].

Diagrams of chemical molecules, curves of mathematical relationships and vision experiments have been enhanced or made possible by these techniques. Freehand drawings can be made in three dimensions. The draftsman can see the line in space (by stereo illusion) as he is drawing it.

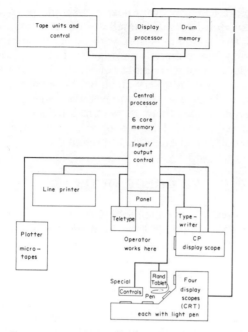

Fig. 1. *PDP-*1 *installation at Harvard's Cruft Laboratory.*

The diagram shows the layout of principal units of the computer. All peripherals are connected to the central processor (CP) except the four display scopes that are driven by a separate processor. The scopes receive instructions from the CP and can share the core memory.

VII. EXAMPLES OF COMPUTER ART

1. *The Harvard PDP-*1 *Installation*

The pictures accompanying this article were produced from displays on the PDP-1 installation at Harvard University. These are a byproduct of research being carried out to enhance man–machine relationships with rapid, unambiguous, high-information content output systems. Since vision appears to be man's widest bandpass sensory channel, the general emphasis is upon display techniques.

The installation shown diagrammatically in Fig. 1 consists of the central processor (CP) unit, its control panel and the peripheral equipment. The input devices include a teletype, paper tape reader, typewriter, Rand Tablet, light pens, switch boxes, rotating knobs and joystick (handle which inputs two directions of motion). In addition, there are magnetic tape units and telephone links capable of very high rates of information transfer.

Information storage can be achieved in several ways, most often in the six cores (arrays of magnetic storage units), or the drum (disks on a common shaft with magnetic surfaces) or the magnetic tapes. The output devices include a high-speed line printer, a plotter, four cathode ray tube (CRT) display consoles (the fifth is generally used only for editing programs), a Hi-Fi amplifier and speaker, and a number of other special devices.

For the uninitated, I will attempt to explain the purpose of the above items. The central processor (CP) is the 'brain' of a computer where the basic instructions are executed, from which all the rest of the equipment gets its instructions or to which the equipment gives information. The CP works directly from the core memory, various special input channels and with several instruction performing registers, called the *arithmetic unit*.

While remote units may continue without specific instructions from the CP, they only start on command and usually tell the CP when they have completed a job and are ready for another one. The instructions to the CP are executed in serial order, with the possibility of skips and jumps called for by the program. The CP is like a master chef who sees to it that all the other kitchen helpers do their job, while he supervises the procurement of food, makes all the important decisions and keeps the whole operation on schedule.

Often a special typewriter or a data-logging device prepares a punched paper tape for use during run time. This off-line prepared input information, including instructions and data may then be run through the paper-tape reader or easily stored for future use. A teletype and typewriter are alternative devices for putting instructions and alphanumeric data directly into the program under way or for manipulating the major processing operation of the entire system.

A Rand Tablet is a handy surface; its million points may be read as a pair of co-ordinates (x, y) by the computer, upon which one may by hand draw or trace a drawing for the computer to 'read'. Depending on the program that one devises to be 'read' from the tablet, the computer can acquire symbols, data or solely graphic elements. The tablet can, in addition, act as an instruction input device.

Light pens give similar results when used in conjunction with the CRTs and a proper pen 'reading' program. They offer the operator the chance of interacting directly with a drawing that the computer is in the process of displaying or to change, elaborate or give additional information. The switches, knobs and joystick may be used to provide continuous control of variables in the program while processing continues.

The magnetic tapes permit a large amount of data to be transferred and very great storage areas to be used. Generally, drum storage area is used as a back up for core storage. Though it is of large capacity it acts as an intermediate storage with slower retrieval speeds than the cores but faster than other larger storage devices.

Although I have already mentioned the plotters and printers, the CRT consoles demand further explanation. The main computer would be greatly delayed in its operations if all it could do was give point by point instructions to the CRTs themselves. In the PDP-1 system being described, the displays are actually controlled by a second or auxiliary computer driven by *Central Processor* (CP). This auxiliary computer receives special instructions and then proceeds to do the rest of the drawing without consuming valuable CP time. Thus, one may

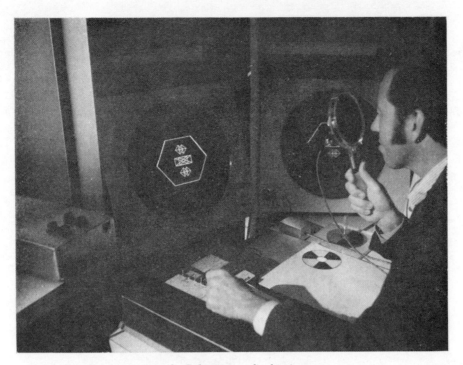

Fig. 2 Color-stereo display in use.

The operator looks through a hand-held rotating filter wheel held close to the eyes. Switches automatically change the colours of the display. The knobs on the left control the stereo depth illusion. Note the stereo filter wheel (uncolored) resting on a piece of paper.

designate a starting place in the memory at which the display is to begin and it will find the place and thereafter follow previously deposited instructions. There are many special instructions that permit communication between the two computers. For example, the light pens may interact with an image so that the program may be changed by virtue of what it has just accomplished (the point 'seen' by the pen). The advantage of having the auxiliary computer figure out character symbols, lines of a previously described nature etc. is that the operating program in the CP is greatly simplified and speeded up.

The hand-held, rotating filter device incorporates a small motor that is synchronized with the computer in such a way that the orientation of the disk mounted on the motor is known at all times. Thus, if the disk is half opaque, the computer knows when the left eye can see and only displays the view for the left eye. When the disk exposes the right eye, the display changes to right eye information and thus provides almost simultaneous stereo views giving the illusion of depth.

By writing on the Rand Tablet and moving the joystick back and forth for the third dimension, the unique experience has been developed where one may draw in space and see the result 'spacially' at the very time it is drawn. One needs considerable time to get used to the experience and, as we do not seem to be naturally adapted to space sketching, one particularly needs practice with the technique in which the pen and the sketch are in different spaces.

Color is easily added to the display by using color filters on the rotating disk. When the eye is looking through the red filter, the computer draws in white what is seen as red and, similarly, for blue and green. The colors may then be additively mixed so that a line drawn in both green and red will appear yellow, a line drawn twice in red and one in green will appeared orange, etc. Indeed, the sequence used for stereo color views is to have a six sectored filter disk with red, green and blue filters interposed by opaque sectors. Thus, when the right eye is eclipsed, the left looks through a filter, etc. The computer essentially displays six renderings in continuous sequence (red-right, blue-left, green-right, red-left, blue-right, green-left), synchronously as the color filters change so fast the eyes only see the sum of all the displays. Typically, one complete cycle of the six sectors takes 50 milliseconds, that is it repeats twenty times a second.

The photograph in Fig. 2 shows a demonstration of a hexagon (each of whose sides is a different color) with two rhomboids and a rectangle inside. The switches permit selection of the color of the central objects. The knobs at the left adjust the depth desired (hence the stereo separation which is calculated by the CP). Important to this system is the type of display screen chosen for the CRT. It must both provide enough intensity for each color filter in the system and be fast in the time it takes to darken after stoppage of excitation by the electron beam which writes the display. The P-4 phosphor surface used in the display screen is not an ideal white but has a large fast blue response and a slower and weaker yellow-green response, all rated at less than 100 microseconds decay time. (The decay is exponential, yet one may still see the

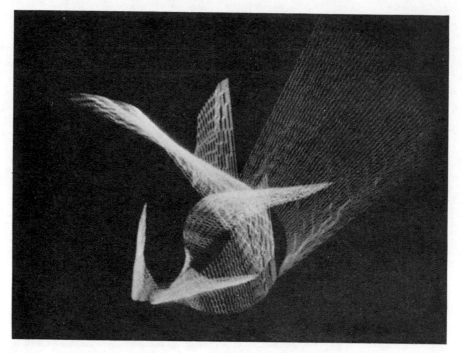

Fig. 4.

red component of this phosphor persisting at an observable level for what must be more than 20 milliseconds, 200 times the rated decay time.)

One should be aware that the spectral character (detail of color absorption) of the filters, photographic materials and printing techniques all served to degrade the color effect (Fig. 3, color illus. K, p. 313). To the observer watching the computer display the colors are highly saturated and cover a wide range of hues. With little effort, more than 30 colors in a single image may clearly be distinguished.

2. *Color 'flowers' and 'birds'*

As part of his graduate research program, while working on a variety of display interactive programs, where the operator consciously interacts with the display, Dan Cohen developed the basic program for the computer art shown here. I merely adapted the program to the color system, adjusted the constants to suit my taste and made the photographs. (Kodak Ektachrome, EHB-135 film, about 4 sec exposure at f/2·8 through one eye hole of the filter wheel.)

The 'Flowers' and 'Birds', as I call the images produced on the display, are sensitive to initial values set for the program, as well as to the many controls operated while the program is in progress (cf. Figs. 3 to 6). Essentially, the program generates a line. This line or vector has two controls which move the starting point (one end of the line) in two circles of different diameter and a third control which rotates the line itself in a circle. The number of lines in any given display may be selected up to some fixed maximum (in most of the illustrations about 500). Switches permit adjustment of the color synchronism, the stacking of displays one

over the other, erasure of the image for a new start and the freezing of a pattern so it will stop evolving while a photograph is being taken.

The observer views the 'Flowers' and 'Birds' through the hand-held rotating filter wheel synchronized with the display on the CRT. The pattern normally is changing continuously, evolving into successive patterns under the operator's control. The computer also continuously generates new instructions for the positioning of the line and stacks these one after the other in a memory file accessible to the display processor.

Perhaps the most fascinating aspect of the 'Flowers' and 'Birds' is the simple circle generating sub-routine (a small program used repeatedly by the main program) which positions and rotates a line. The discontinuities present in the circles are the result of not keeping the circle generation continuous but allowing a mathematical error to go uncorrected. Also there is a routine in the program which carefully prevents the lines from intersecting the margins of the display area (about 25 cm square).

3. *Other examples of computer art*

Life Magazine [13] recently featured several pictures of computer art. One picture demonstrated the use of the alphanumeric high-speed printer to produce what looks from a distance like a half-tone print of birds against a cloudy sky. There were also examples of off-line color techniques.

In the course of study of image processing and pattern recognition, John Mott-Smith [14] has developed several techniques of computer art. Currently his work is being exhibited internationally and he has been commissioned to prepare material for *Life Magazine*. He has developed displays both

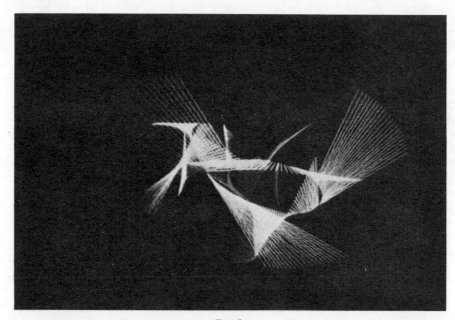

Fig. 5.

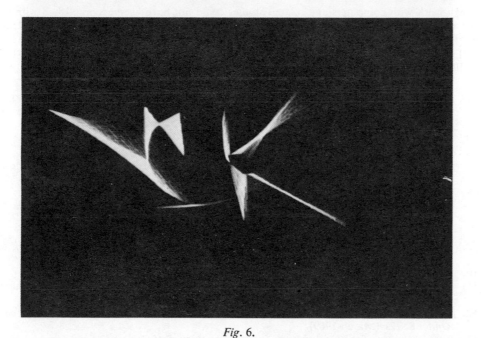

Fig. 6.

Figs. 4 to 6. Image produced by the Harvard PDP-1 computer from a program by Dan Cohen and the author.

in real-time and delayed-time for still and moving photographic techniques. He has apparently developed considerable flexibility in the handling of color, including the use of shadow-mask display tubes, synchronous filter techniques and individual preparation of color-separated negatives.

Working with the Cognitive Information Processing Group at the Massachusetts Institute of Technology (MIT), Charles Seitz has produced a fascinating series of dynamic programs which include sound. One may observe dancing circles and delicate 'splashes' with trills of notes that actually sound as though they belong to the pictures. Seitz's visual programs are run on a PDP-9 computer and the

sound comes from a loudspeaker driven by an amplifier using the x-deflection signal for the display as an audio signal.

Bell Telephone Laboratories have been involved in numerous display developments. Perhaps most attractive to artists are the programs that provide animation routines. Used in technology, they may design electrical circuits by gathering the electronic symbols into appropriate connected arrangements and then allow the computer also to display the characteristics of the electrical behaviour of the circuit so designed. Much of this type of animated display interaction stems from Ivan Sutherland's *sketchpad* innovations [15].

Other large industries have developed special graphic systems. In reference 16 it is stated that: 'The Electronics Laboratory of the General Electric Co., Syracuse, N.Y., has developed a computer generated simulation technique that involves: (1) storing the data describing the environment in computer memory; and (2) solving in real time the perspective equations that define the environment image on the display or image plane. All hardware for modelling and photographing in connection with the simulated display is eliminated and replaced by a computer with numerical data stored in its memory. A color TV monitor or set of monitors shows the actual display using a purely mathematical-scanning and perspective-image-computation process.'

General Motors Research Laboratories had the IBM Corporation design special computers for them. One of these, the DAC-1, permits the usual interactive drawing and data handling, and can also produce large photographic prints from pre-cision negatives and use data from scanned drawings as computer input. Another computer can form a full-scale model of an automobile in clay from numerical specifications, taking about thirty minutes for the job.

VIII. CONCLUSION

Perhaps the computer is more than a new medium. It is a challenge to artists in all media to learn the characteristics of this powerful tool and the ways in which it may give wider scope to their talent. Talent, taste and intuition must be brought to the computer by man, it has technique to spare. There is one major problem at present—computer time is very, very expensive.

A Computer Arts Society has been organized in London and interested persons may obtain information on it from Alan Sutcliffe, ICL, Brandon House, Bracknell, Berks., England [17].

ACKNOWLEDGEMENTS

My work with computers and related studies could not have been accomplished without the encouragement of I. E. Sutherland and the help of Dan Cohen among others, at the Harvard Computation Laboratory and, of course, without the basic support of departments at Harvard and of Grant No. F 19628-68-C-0379 from the Advanced Research Projects Agency of the U.S. Government.

REFERENCES

1. Cybernetic Serendipity, Ed.: Jasia Reichardt, *Studio International*, Special issue (1968).
2. L. D. Harmon and K. C. Knowlton, Picture Processing by Computer, *Science* **164**, 19 (1969).
3. 6th Annual Computer Art Contest, *Computers and Automation* **17**, 8 (Aug. 1968).
4. 7th Annual Computer Art Contest, *Computers and Automation* **18**, 8 (Aug. 1969).
5. R. Gadney, Aspects of Kinetic Art and Motion, *Four Essays on Kinetic Art* (London: Motion Books, 1966) p. 26.
7. *Nicholas Schoffer* (Neuchatel: Editions du Griffon, 1963) p. 50.
6. R. I. Land, Non-verbal 'Discussion' using Music and Kinetic Painting, *Leonardo* **1**, 121 (1968).
8. Information and Computers, entire issue of *Scientific American* (Sept. 1966).
9. Advertisement of the Sanders Advanced Data Display System /900. *Scientific American* (Feb. 1969).
10. L. G. Roberts, The Lincoln Wand, *FJCC Proceedings* 29 (1966).
11. A. E. Brenner, Sonic Pen Discussion and Private Demonstration of Unit at Dunbar Laboratory, Harvard (1969).
12. R. I. Land and I. E. Sutherland, Real Time, Color, Stereo, Computer Displays, *Appl. Optics* **8**, 721 (March 1969).
13. Luminous Art of the Computer, *Life Magazine* (Nov. 9 1968).
14. J. Mott-Smith, Private Discussion and Demonstration, Air Force Cambridge Research Laboratories, Bedford, Mass.
15. I. E. Sutherland, Sketchpad: A Man–Machine Graphical Communications System, *M.I.T. Lincoln Lab., Tech. Rep. No.* 296 (Jan. 30 1963).
16. Visual information displays systems, *NASA, SP*-5049, U.S. Govt. Printing Off., Washington, D.C., U.S.A., 1968.
17. Notes, Communications, *ACM* (Jan. 1969).

KINETIC ART: APPLICATION OF ABSTRACT ALGEBRA TO OBJECTS WITH COMPUTER-CONTROLLED FLASHING LIGHTS AND SOUND COMBINATIONS

Vladimir Bonačić*

Abstract—*The author describes three schemes for using digital computers for artistic purpose. He is sceptical of the attempts to produce computer art with commercially available display equipment and through play with randomness and by the deliberate introduction of errors in programs prepared for nonartistic ends. He favors the approach in which art objects are controlled by a computer with feedback from a viewer to the object or to the computer or both.*

He describes his kinetic object with flashing white lights in which the sequence of patterns is controlled by a special purpose computer for generating fields of abstract algebra or Galois fields.

The second object he describes is more complex in that the frontal panel of flashing lights is made as a relief; colored light is used; the sequence of Galois field patterns can be changed in rhythm; and sound combinations corresponding to the patterns can be produced by the object.

The mathematics of Galois fields generated by polynomial equatıons that was used for determining the sequence of patterns in the objects is described. One of the most interesting aspects of this work is the demonstration of the different visual appearance of the patterns resulting from the polynomials that had not been noted before by mathematicians who have studied Galois fields.

I. INTRODUCTION

Up to the present time art produced with the aid of digital computers has depended mainly on the use of commercially available display equipment such as line printers, plotters and cathode ray tubes [1–12] (Fig. 1(a)). I find that this is akin to an artist being limited to the use of only two or three colours in a painting. It is true that much can be done with such equipment but one can hope that ways will be found to take better advantage of computers. I am especially sceptical of the attempts to produce computer art through play with randomness and the deliberate introduction of errors in programs prepared for non-artistic purposes. Dedalus, in James Joyce's novel, *Portrait of the Artist as a Young Man*, debates the question of whether an object made by hacking in fury at a piece of wood results in an object of art. Even if one grants the possibility of arriving at an art object through the use of chance effects or of the arbitrary limitations of available computer programs, it appears to me that this is neither the best method nor even a promising approach for artists.

*Yugoslav computer scientist and artist, c/o *Leonardo,* 17 rue Emile Dunois, 92100 Boulogne sur Seine, France. (Received 2 January 1973.)

Characteristics (a) Static art object:
Random effects
Software – errors in programs
and other possibilities

Aesthetics

Characteristics (b) Kinetic art object:
Feedback from observer to object
Urban environment applications

Aesthetics

Characteristics (c) Characteristics (b) plus:
Feedback from observer to computer
Heuristic programming
New cognition and language possibilities

Fig. 1. Three schematic diagrams of the possible use of a digital computer for the production of visual art.

254 *Vladimir Bonačić*

Another way of making use of a computer in art is shown schematically in Fig. 1(b). Instead of using the presently available display equipment, the object is built and then controlled with the help of a computer [13–16]. The interaction of a viewer with an art object may be done by, for example, remote control. The fact that the dimension of time is a key factor in objects of a kinetic art type makes it possible to give artistic expression to visual and auditory experiences, perhaps of more significance than those that can be made by computer display methods that have been commonly used (Fig. 1(a)).

A further possible approach to computer art is shown in Fig. 1(c). Through additional feedback connections, for example, an electroencephalographic technique of tapping brain waves, it may be possible to obtain an even more subtle interaction with a heuristic program in addition to those obtained by means of the usual visual and auditory inputs. The feedback loop might be closed with an aesthetic output to an art object, which would then provide semantically relevant information to a viewer. I believe that such interactions will add to cognition, which will be reflected in language and perhaps provide improved means of communication [17, 18]. Discussions of the use of brain waves for artistic purposes can be found in Refs. 19 and 20.

It should be noted that the patterns of information that are semantically significant to the human nervous system do not always bear a readily verifiable mathematical counterpart in conventional symbolic notation. I have used in the work described in this article two types of pictorial representation instead of conventional symbolic methods generally used in mathematics [21, 22]. Some of these patterns (Figs. 2 and 3) represent *orbits* of finite fields of abstract algebra or Galois fields. E. Galois studied them by means of polynomial equations (cf. Appendix I) [23–28]. These polynomials are generators of Galois fields. If one compares in Fig. 3 patterns a to d, on the left, with those designated e to h, on the right, one notices that they have a clearly different visual appearance. This difference in the visual character of the orbits is difficult to anticipate from a consideration of the polynomials that symbolically express them and they were not, to the best of my knowledge, noted by mathematicians who study Galois fields.

II. APPLICATION OF GALOIS FIELDS TO KINETIC COMPUTER-ART OBJECTS

Kinetic objects making use of flashing lights have been described in *Leonardo* [20, 29]. If the flashing rate exceeds about 60 per second, the observer

Fig. 2. *Examples of patterns representing characteristic orbits of Galois fields.*

cannot obtain a meaningful perception of images or patterns presented. [If the flashing rate is near the frequency of Alpha brain waves, the observer undergoes visual illusionary effects and those suffering from epilepsy are greatly affected [20]. Ed.]

1. 'Dynamic Object GF.E 32–S69/70'

Four consecutive symmetrical patterns generated by this object are shown in Fig. 4 (cf. Appendix II). The frontal panel is built of a 32 × 32 matrix of squares, which are illuminated with electric light bulbs. The synchronous selective flashing of the 1024 squares produces the patterns. The squares represent Galois field elements. The flashing is controlled by a Galois field generator with whose

Fig. 3. Examples of patterns representing characteristic orbits of Galois fields.

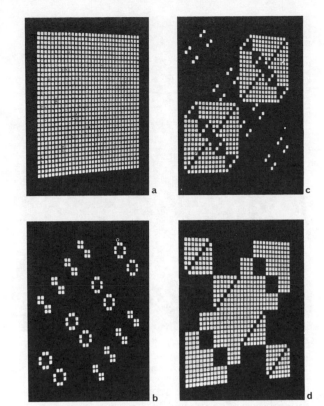

Fig. 4. Four consecutive patterns generated by 'Dynamic Object GF. E32–S69/70'; flashing lights controlled by a computer program, 64 × 64 × 12 cm., 1969–1970.

help maximal difference between successive patterns is maintained. This maximization of differences enables one to distinguish between the successive patterns in the sequence, which change at the rate of one pattern every two seconds. The total number of symbolic structures is 2^{32}. At the rate of change used, the same pattern will repeat only after 274 years, 140 days, 12 hours, 32 minutes and 20 seconds.

The dimensions of the object are 64 × 64 × 12 cm. It has electric light bulbs whose lifetime has been significantly prolonged by the use of special electronic circuitry. The field generators are part of the special purpose computer located inside the object. The unit is self-contained and performs the generation of the Galois fields. The object has a variable clock that allows the observer to control the speed of the pattern changes with periods ranging between 0·1—5 sec. On the rear of the object there are manual controls to start, stop, control the speed and for selecting or reading out any of the patterns. With the binary notation, 32 light indicators and 32 push buttons enable any pattern from the sequence to be read or set.

2. 'Dynamic Object GF.E (16, 4) 69/71'

A more complex artistic experience than provided by the first object described above can be provided if the frontal panel is made as a relief, colored light is used, the patterns are flashed rhythmically and sound combinations are incorporated. This I have done in 'Dynamic Object GF.E (16, 4) 69/71', which also makes use of light patterns controlled by a Galois field generator. This object is shown in Fig. 5.

The frontal panel, a relief structure, is a 32 × 32 matrix of 4·5 × 4·5 cm. squares. The overall dimensions are 178 × 178 × 20 cm. and the object weighs about one-half ton. The squares are transparent colored glass at the end of tubes of the length 8, 12, 16 and 20 cm. and they are illuminated by flashing electric light bulbs within the tubes (Fig. 6, color illus. L, p. 314). There are 16 different colors and 16 squares of the same color flash simultaneously in one plane. The sequence of flashes from plane to plane is controlled by a Galois

Fig. 5. 'Dynamic Object GF.E (16, 4) 69/71', kinetic art object with flashing lights controlled by a computer program, 178 × 178 × 20 cm., 1969–1971.

field generator and the sequence of flashes in the four planes is controlled by another generator. A light will flash only when directed to do so by both generators. The rhythm of the changing patterns is controlled by a third Galois field generator.

For each color in a given plane a tone oscillator is provided. Since there are 16 colors in each plane, there are also 16 different tones and there are two octaves of tones in each of the four planes (Table 1). The field generator that controls the sequence of flashes in a plane also controls the sounding of the tones and the same generator that controls flashes from plane to plane also controls the sounding of tones separated by octaves in the four planes. A tone will be sounded by an oscillator only when directed to do so by both generators, as in the case of the light flashes. The maximalization of differences between visual patterns takes place also in the

case of combinations of tones. The patterns and combinations are, therefore, intrinsically interwoven.

So far a satisfactory notation for electronic music has not been developed. I have, therefore, developed a notation that is inherent for the program used. Instead of the octaves of the tempered scale, I have simply doubled frequencies of each succeeding octave. The tone combinations are controlled by sophisticated mathematical relations, which can be expressed by the notation selected. Hearers of the sounds produced by the object have told me that they find them pleasant.

The total number of visual patterns and of tonal combinations that can be produced is $2^{16} \times 2^4$, where the exponents correspond to the 16×16 matrix in each plane and to the four planes, respectively. If the rhythm generator, which controls both the lights and the sound oscillators, causes changes every two seconds on the average, then the same visual pattern and its corresponding combination of tones will repeat only every 24 days, 6 hours, 32 minutes and 32 seconds.

A general purpose computer was used to help design the special purpose computer built within the object for controlling the patterns and tone combinations and their sequences. The electronic arithmeto-logical units for generating the Galois fields are physically separate from the object.

The object can be controlled by a viewer either manually or by remote control to the extent of the volume of the sound, the speed of change from pattern to pattern, the replay of sequences, the rhythm of the patterns and the exclusion of some of the production of tones. The patterns and their sequence cannot be altered.

REFERENCES

1. R. I. Land, Computer Art: Color-stereo Displays, *Leonardo* **2**, 335 (1969).
2. F. Hammersley, My First Experience with Computer Drawings, *Leonardo* **2**, 407 (1969).

TABLE 1.

TABLE 1. 64 DIFFERENT SOUND TONE FREQUENCIES IN THE FOUR PLANES OF PATTERNS CONTROLLED BY COMPUTER ('DYNAMIC OBJECT GF.E (16, 4) 69/71'.

	Δ F			Frequency F (Cycles per second)					
Plane	8	64	72	80	88	96	104	112	120
I	16	128	144	160	176	192	208	224	240
Plane	32	256	288	320	352	384	416	448	480
II	64	512	576	640	704	768	832	896	960
Plane	128	1024	1152	1280	1408	1536	1664	1792	1920
III	256	2048	2304	2560	2816	3072	3328	3584	3840
Plane	512	4096	4608	5120	5632	6144	6656	7168	7680
IV	1024	8192	9216	10240	11264	12288	13312	14336	15360

3. J. Hill, My Plexiglas and Light Sculptures, *Leonardo*
3, 9 (1970).

4. K. Nash and R. H. Williams, Computer Program for
Artists: *ART 1*, *Leonardo* **3**, 439 (1970).

5. H. W. Franke, Computers and Visual Art, *Leonardo* **4**,
331 (1971).

6. M. Thompson, Computer Art: A Visual Model for
the Modular Pictures of Manuel Barbadillo, *Leonardo*
5, 219 (1972).

7. Y. Kodratoff, On the Simulation of an Art Work by
a Markov Chain with the Aid of a Digital Computer,
Leonardo **6**, 37 (1973).

8. H. W. Franke, *Computer Graphics—Computer Art*
(New York: Phaidon Press, 1971).

9. J. Reichardt, *The Computer in Art* (London: Studio
Vista, 1971).

10. F. J. Malina, Comments on Visual Fine Art Produced
by Digital Computers, *Leonardo* **4**, 263 (1970).

11. S. Cornock and E. Edmonds, The Creative Process
Where the Artist is Amplified or Superseded by the
Computer, *Leonardo* **6**, 11 (1973).

12. J. K. Edmiston, Computer and Kinetic Art: Investiga-
tions of Matrix Configurations, *Leonardo* **6**, 17 (1973).

13. V. Bonačić, Possibilities for Computer Application in
Visual Research, *BIT Int.*, p. 45 (No. 3, 1968).

14. V. Bonačić *et al.*, Pseudo-random Digital Transforma-
tion, *Nuclear Instr. & Meth.* **66**, 213 (1968).

15. V. Bonačić, Art as a Function of Subjects, Cognition
and Time, in: *Computer Graphics 70* (Uxbridge,
England: Brunel University, 1970).

16. J. Benthal, *Science and Technology in Art Today*
(London: Thames and Hudson, 1972).

17. A. Katzir-Katchalsky, Reflections on Art and Science,
Leonardo **5**, 249 (1972).

18. A. Katchalsky, Private Communication.

19. D. Rosenboom, Method for Producing Sounds or
Light Flashes with Alpha Brain Waves for Artistic
Purposes, *Leonardo* **5**, 141 (1972).

20. R. Baldwin, Kinetic Art: On Producing Illusions by
Photic-stimulation of Alpha Brain Waves and Flashing
Lights, *Leonardo* **5**, 147 (1972).

21. V. Bonačić, M. Cimerman and S. A. Amitsur,
Structures in the Periods of Polynomials (to be
published).

22. V. Bonačić and M. Cimerman, The Pattern-testing of
PRDT (to be published).

23. L. Gaal, *Classical Galois Theory with Examples*
(Chicago: Markham Pub., 1971).

24. F. M. Hall, *An Introduction to Abstract Algebra*
(Cambridge: Cambridge Univ. Press, 1969).

25. N. Jacobson, *Lectures in Abstract Algebra–Theory of
Fields and Galois Theory* (Princeton: Van Nostrand,
1964).

26. G. Birkhoff and S. MacLane, *A Survey of Modern
Algebra* (New York: McGraw-Hill, 1970).

27. G. Birkhoff and T. C. Bartee, *Modern Applied
Algebra* (New York: McGraw-Hill, 1970).

28. (a) W. W. Peterson, *Error-correcting Codes* (Cam-
bridge, Mass.: M.I.T. Press, 1961). (b) W. W. Peterson
and E. J. Weldon, Jr., *Error-correcting Codes* (Cam-
bridge, Mass.: M.I.T. Press, 1972).

29. D. Smith, Kinetic Art: The Shift Register, a Circuit
for Sequential Switching of Lights, *Leonardo* **5**, 59
(1972).

30. E. R. Berlekamp, *Algebraic Coding Theory* (New
York: McGraw-Hill, 1968).

31. C. C. Hoopes, *Study of Pseudo-random Number
Generators*, Ph.D. Thesis, 1968 (obtainable from Uni-
versity Microfilms, Xerox Co., Ann Arbor, Michigan,
U.S.A.).

32. M. Cimerman and V. Bonačić, Report on Relations
Among Linear Pseudo-random Digital Trans-
formers. U.S. Nat. Bureau of Standards contract
No. NBS (G)—150, 1972 and Israel Acad. of Sciences
and Humanities grant No. 7255, 1973.

33. M. Cimerman and V. Bonačić, Report on the Criteria
for Classifying the Pseudo-random Digital Trans-
formers, U.S. Nat. Bureau of Standards contract No.
NBS (G)—150, 1972 and Israel Acad. of Sciences and
Humanities grant No. 05.7255, 1973.

34. S. W. Golomb, *Shift Register Sequences* (San Fran-
cisco, Calif.: Holden-Day, 1967).

APPENDIX I

GALOIS FIELD GF (2^n)

In abstract algebra finite fields are known as *Galois fields*, named after E. Galois and studied by him in connection with his work on the roots of polynomial equations. It can be shown that for each prime number p and each positive integer n there is one and only one field with p^n elements and that fields of such composition are the only finite fields that exist. The field of order p^n is called the *Galois field of order* p^n and is denoted by GF(p^n) [23–28, 30, 31].

The Galois field of 2^n elements GF(2^n) may be formed as the field of polynomials over *GF*(2), modulo $P_n(x) = a_n \cdot x^n + a_{n-1} \cdot x^{n-1} + \ldots + a_o$ [28, 29]. For example, if $n = 4$ and if the polynomial $P_n(x) = x^4 + x + 1$, which is irreducible and primitive, then the coefficients of the 15 polynomials that are 15 nonzero field elements are as follows (Table 2):

TABLE 2.

1.	1000	9.	1010
2.	0100	10.	0101
3.	0010	11.	1110
4.	0001	12.	0111
5.	1100	13.	1111
6.	0110	14.	1011
7.	0011	15.	1001
8.	1101		

In Table 3, below, the Galois field (2^4) is formed as the field of polynomials over *GF*(2), module reducible polynomial $x^4 + x^2 + 1$. The 15 non-zero elements are listed as three subsets or *orbits*, starting with elements 1000, 1100 and 1110, respectively. Pictorial representations of orbits of $GF(2^n)$ modulo $P_n(x)$ are shown in Figs. 2 and 3.

TABLE 3.

1.	1000
2.	0100
3.	0010
4.	0001
5.	1010
6.	0101
7.	1100
8.	0110
9.	0011
10.	1011
11.	1111
12.	1101
13.	1110
14.	0111
15.	1001

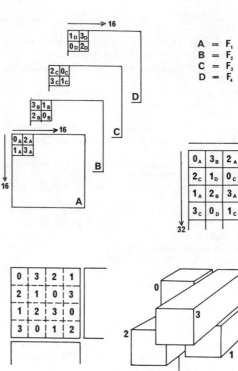

Fig. 8 Organization of patterns that determine relief.

A = F₁ → A = F_1
B = F_2
C = F_3
D = F_4

,0' 0. DEGREE PATTERN
,1' 1. DEGREE PATTERN
,2' 2. DEGREE PATTERN
,3' 3. DEGREE PATTERN

Fig. 7. Organization of patterns that determine the distribution of colors.

For the given orbit $A = [a_j]_{n \times s}$ of s elements, modulo $P_n(x)$, the coordinates $Z_j(\underline{x}'_j, \underline{y}'_j)$, for $j = 1, 2, 3, \ldots, s$, in pictorial representation are obtained as [21]:

$$\underline{X}' = \underline{X} \cdot \underline{A} = [\underline{x}_i]_{q_1 \times n} \cdot [\underline{a}_j]_{n \times s} = [\underline{x}'_j]_{q_1 \times s}$$
$$\underline{Y}' = \underline{Y} \cdot \underline{A} = [\underline{y}_i]_{q_2 \times n} \cdot [\underline{a}_j]_{n \times s} = [\underline{y}'_j]_{q_2 \times s}$$

where $q_1 = n - q_2$

$q_2 = $ integer $(n/2)$

Example: For an orbit of $GF(2^4)$, modulo $x^4 + x^2 + 1$, starting with element 1000 (Table 3) and for $\underline{X} = [\underline{I}, \underline{O}]$, $\underline{Y} = [\underline{O}, \underline{I}]$, one obtains:

$$\underline{X}' = \begin{bmatrix} 1000 \\ 0100 \end{bmatrix} \cdot \begin{bmatrix} 100010 \\ 010001 \\ 001010 \\ 000101 \end{bmatrix} = \begin{bmatrix} 100010 \\ 010001 \end{bmatrix}$$

$$\underline{Y}' = \begin{bmatrix} 0010 \\ 0001 \end{bmatrix} \cdot \begin{bmatrix} 100010 \\ 010001 \\ 001010 \\ 000101 \end{bmatrix} = \begin{bmatrix} 001010 \\ 000101 \end{bmatrix}$$

An orbit of the first six field elements in Table 3 is shown represented in Fig. 10. For the same orbit another arrangement may be obtained by choosing different values of \underline{X} and \underline{Y}.

Figure 3 shows pictorial representations for some polynomials $P_n(x)$, where $n = 10$. From the total number of 2^9 different polynomials the great majority have the structures as those shown in Fig. 3a, b, c and d, while a few of them have symmetrical structure as shown in Fig. 3e, f, g and h. Fig. 3e and f show orbits modulo $x^{10} + x^7 + x^2 + 1$, while Fig. 3g and h show orbits modulo $x^{10} + x^5 + x^4 + x^3 + x^2 + x + 1$. \underline{X} and \underline{Y} used were $\underline{X} = [\underline{I}, \underline{O}]$, $\underline{Y} = [\underline{O}, \underline{I}]$.

Some characteristic symmetrical structures for polynomials $P_n(x)$, $n = 4, 6, 8, 10$, are given in Fig. 2. It is expected that more information about fields, structures and their relations can be obtained by means of pictorial representation [21].

APPENDIX II

FURTHER DISCUSSION OF THE ART OBJECTS

In the objects I have described, the relations among distinct residue classes of polynomials from $GF(2^m)$, module polynomial $P_n(x)$, can be observed. The relations are presented by means of two-dimensional patterns. The patterns are at maximal distance one from another; this is obtained by forming a field of polynomials $GF(2^{2n})$, over $GF(2)$, modulo irreducible and primitive polynomial $P_{2^n}(x)$ [28, 30, 31].

The polynomials $D_m(x)_{j_1}$, $D_m(x)_{j_2} \ldots D_m(x)_{j_e}$ are in the same residue class, module polynomial:

$$P_n(x) = a_n x^n + a_{n-1} x^{n-1} + \ldots + a_1 x + a_0$$

if

$2^{n_1} = 16$

$2^{n_1}(x) = x^{16} + x^{12} + x^3 + x + 1$

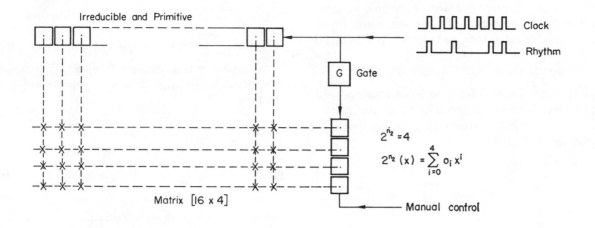

$2^{n_1}(x)$ Setting of residue classes and tones
$2^{n_2}(x)$ Setting of planes and octaves by 2

Fig. 9. Setting of residue classes, tones and planes by 2.

$D_m(x)_{j_i} \cdot S(x) = Q(x)_{j_i} \cdot P_n(x) + R(x)_{j_i}$ for $i = 1, 2, \ldots, e$

and if

$R(x)_{j_1} = R(x)_{j_2} = \ldots = R(x)_{j_e}$.

For any polynomial $P_n(x)$ there is the associated mask $\underline{M}_p = [\underline{k}_i]_{n \times m}$ [32, 33], by which one can describe multiplication and division procedures for all the polynomials from $GF(2^m)$ in matrix notation:

$\underline{R} = \underline{M}_p \cdot \underline{D} = [\underline{k}_1, \ldots, \underline{k}_m] \cdot [\underline{d}_1, \ldots, \underline{d}_{2^m}] = [\underline{r}_1, \ldots, \underline{r}_{2^m}]$

where

$\underline{D} = [\underline{d}_j]_{n \times 2m}$ and $\underline{d}_j \in GF(2^m)$ following in the natural order and

$\underline{R} = [\underline{r}_j]_{n \times 2m}$ and $\underline{r}_j \in GF(2^n)$

1. 'Dynamic Object GF.E 32 – S 69/70'

The raster for a frontal panel is accomplished as the two-dimensional presentation of the 2nd degree pattern and can be described as [22]:

$$\underline{F} = [\underline{f}_i]_{2^n \times 2^n} = \begin{bmatrix} \underline{r}_1 & \underline{r}_{2^n+1} & \cdots \\ \underline{r}_2 & \underline{r}_{2^n+2} & \\ \vdots & \vdots & \\ \underline{r}_{2^n} & \underline{r}_{2^n+1} & \cdots & \underline{r}_{2^m} \end{bmatrix}$$

An arbitrary field element from $GF(2^{2^n})$ is a polynomial of the form:

$T(x) = t_{2^n-1} \cdot x^{2^n-1} + \ldots + t_1 \cdot x + t_0$ where $t_i \in GF(2)$

If $t_i = 1$ then the elements are set on the positions of those \underline{r}_j for which

$\underline{r}_{j_1} = \underline{r}_{j_2} = \ldots = \underline{r}_{j_e} = i$

Fig. 10.

For this particular object, I had:

$n = 5$, $m = 10$

$a_5 = a_0 = 1$; $a_4 = a_3 = a_2 = a_1 = a_0 = 0$ (reducible)

$\underline{M}_p = [\underline{I}, \underline{I}]_{5 \times 10}$

$\underline{D} = [\underline{0}, \underline{1}, \underline{2}, \ldots, \underline{1023}]$ (decimal)

$0 \leqslant r_j \leqslant 31$ (decimal)

$P_{2n}(x) = x^{32} + x^{22} + x^2 + x + 1$ (irreducible and primitive).

The raster and some sequential patterns that are at maximal distance one from another are shown

in Fig. 4. The bulbs that correspond to the elements of a particular residue class, being set by t_i, will light during the time determined by a clock. Inside the object there is an arithmetical unit that performs arithmetical operations (modulo an irreducible binary polynomial). The arithmetical unit has a variable clock ranging from 0·1 to 5 seconds.

2. 'Dynamic Object GF.E (16, 4) 69/71'

The raster for a frontal panel is accomplished as the two-dimensional presentation of one quarter of the 3rd degree pattern (Fig. 7) and can be described as [22]:

$$\underline{F} = \underline{F}_1 + \underline{F}_2 + \underline{F}_3 + \underline{F}_4 = [\underline{f}_i]_1 + [\underline{f}_i]_2 + [\underline{f}_i]_3 + [\underline{f}_i]_4 =$$

$$= \begin{bmatrix} r_1 & 0 & \cdots \\ \bar{0} & 0 \\ r_2 & 0 \\ \bar{0} & 0 \\ \vdots \\ r_{2n} & 0 & & r_{2^{2n}} & 0 \\ \bar{0} & 0 & \cdots & 0 & 0 \end{bmatrix}_{2^{n+1} \times 2^{n+1}} +$$

$$+ \begin{bmatrix} 0 & r_{2^{2n}+1} & \cdots \\ 0 & 0 \\ \vdots \\ 0 & r_{2^{2n}+2^n} & & 0 & r_{2.2^{2n}} \\ 0 & 0 & \cdots & 0 & 0 \end{bmatrix} +$$

$$+ \begin{bmatrix} 0 & 0 & \cdots & & 0 \\ r_{2.2^{2n}+1} & 0 \\ \vdots & & & & \vdots \\ 0 & 0 & 0 & 0 & 0 \\ r_{2.2^{2n}+2^n} & 0 & \cdots & r_{3.2^{2n}} & 0 \end{bmatrix} +$$

$$+ \begin{bmatrix} 0 & 0 & \cdots \\ 0 & r_{3.2^{2n}+1} \\ \vdots \\ 0 & 0 & & 0 & 0 \\ 0 & r_{3.2^{2n}+1} & & 0 & r_{4.2^{2n}} \end{bmatrix}$$

where

$$\underline{D} = [\underline{D}_1, \underline{D}_2, \underline{D}_3, \underline{D}_4] = \left[[\underline{d}_j]_1, [\underline{d}_j]_2, [\underline{d}_j]_3, [\underline{d}_j]_4 \right]_{m \times 2^m}$$

and $\underline{d}_j \in GF(2^m)$ following in a natural order and

$$\underline{R} = [\underline{R}_1, \underline{R}_2, \underline{R}_3, \underline{R}_4] = \left[[\underline{r}_j]_1, [\underline{r}_j]_2, [\underline{r}_j]_3, [\underline{r}_j]_4 \right]_{n \times 2^m}$$

and $\underline{r}_j \in GF(2^n)$

The relief $\underline{H} = [h_{ij}]_{2^{n+1} \times 2^{n+1}}$ of the frontal panel (Fig. 8) is obtained by transforming each element from \underline{F}, so that an arbitrary element in the i-th row and the j-th column can be described:

$$\underline{h}_{ij} = \underline{M} \cdot \underline{r}_{ij} = [m_{ij}]_{v \times n} \cdot [\rho i1]_{n \times 1}$$

The rhythm of the change of patterns is accomplished by linear recurring sequence $\{a_c\}$ which satisfies the linear recurrence [34]:

$$\sum_{i=0}^{n} p_{n-i} \cdot a_{c-i} = 0$$

It is possible to choose a short or a long sequence.

An arbitrary field element from $GF(2^{2n_1})$, which controls light and sound tone, is a polynomial of the form:

$$T(x) = t_{2^{n_1}-1} \cdot x^{2^{n_1}-1} + \cdots + t_1 \cdot x + t_0$$

where $t_{i_1} \in GF(2)$

If $t_{i_1} = 1$ then:
(a) the elements are set on the position of those r_j for which
$$r_{j_1} = r_{j_1} = \cdots = r_{j_e} = i_1$$
(b) the i_1-th tones in all octaves are set.

An arbitrary field element from $GF(2^{2n_2})$ for panel selection and 'octaves by 2' control is also a polynomial:

$$O(x) = o_{2^{n_2}-1} \cdot x^{2^{n_2}} + \cdots + o_1 \cdot x + o_0$$

where $o_{i_2} \in GF(2)$

If $o_{i_2} = 1$ then:
(a) the previously set elements are prepared for lighting only in planes \underline{F}_{i_2}
(b) the previously set tones are ready for activation only in o_{i_2} 'octaves by 2'.

For this particular object (Fig. 9) I had:

$n = 4$, $m = 10$

$a_4 = a_3 = a_0 = 1$; $a_2 = a_1 = 0$ (irreducible and primitive)

$$\underline{M}_p = \begin{bmatrix} 1111010110 \\ 0111101011 \\ 0011110101 \\ 1110101100 \end{bmatrix}_{4 \times 10}$$

$\underline{D}_1 = [\underline{0}, \ldots, \underline{255}]$ $\underline{D}_2 = [\underline{256}, \ldots, \underline{511}]$

$\underline{D}_3 = [\underline{512}, \ldots, \underline{767}]$ $\underline{D}_4 = [\underline{768}, \ldots, \underline{1023}]$

$0 \leqslant r_j \leqslant 15$ (decimal)

$v = 2$, $n_1 = 4$, $n_2 = 2$

$\underline{M} = [\underline{I}, \underline{O}]_{2 \times 4}$

$h \leqslant 0 \leqslant 3$ (decimal)

$T_{2^{n_1}}(x) = x^{16} + x^{12} + x^3 + x + 1$ (irreducible and primitive)

$$O_{2^{n_2}}(x) = \sum_{i=0}^{4} o_i \cdot x^i$$ (variable)

The frequencies of the tones in the four planes are listed in Table 1 in the main text.

COMPUTER-AIDED MULTI-ELEMENT GEOMETRICAL ABSTRACT PAINTINGS

Zdeněk Sýkora* and Jaroslav Blažek**

Abstract—*The artist-author, in the first part of this paper, describes paintings he made since 1961 in which the composition resulted from the repeated use of one or more basic elements. These elements are characterized by unique shape (square or rectangular) and by specific internal geometrical patterns. The combinatorial complexities of arranging the elements according to specific rules led to the use of a computer.*

The mathematician-author prepared the programs for a small computer, the LGP-30, made by Eurocomp GMBH, Minden, Westfalen, German Federal Republic. In the second part of the paper, he gives the basic information required in preparing computer programs for this kind of abstract painting.

Examples of these paintings, in black and white and in color, are shown.

I

The principle of bringing elements of a structure into a precise relationship has already been applied by Cezanne. Especially his last works show that his original static solution of obtaining plastic balance was gradually changed into a 'dynamic' solution. At first, his elements were a tree, a mountain and a house. The shapes of the elements were formed of modulated warm and cool colors. In his last works, his interest is concentrated on the color relationships of elements. The development that Cezanne followed in his work is, I believe, typical of many artists of his time and of many artists today.

I began, in 1961, to make paintings of a geometrical, abstract kind in which the composition results from the repeated use of one or more *basic elements*. These elements were characterized by a unique shape (square or rectangular) and by specific internal geometrical patterns.

One of my first paintings using this scheme is shown in Fig. 1. The surface is made up of $18 \times 18 = 324$ rectangles, of which the basic element consists of four internal triangles forming a central rhomboid. The areas surrounding the rhomboid (which is usually white) may be black, light gray or dark gray. I followed, as much as possible, the rule of not having two areas of identical color in contact.

It was a surprise to find that in this composition there appeared an illusion of movement. This illusion is probably caused by the asymmetry in the

Fig. 1. '*Gray Structure*', *oil on canvas*, 150 × 120 *cm*, 1962–1963.

color patterns of some of the elements. Furthermore, there is an illusion of depth that results from particular color values dominating certain areas of the painting.

When considering other rules for making compositions from given elements, I realized that one ran into combinatorial complexities that might be more easily resolved by means of a computer. I turned to

*Artist living at Tyrsovo Náměstí 1686, 44001 Louny, Czechoslovakia.

** Associate professor in the Department of Mathematics, Charles University, Prague, Czechoslovakia. (Received 1 June 1969.)

Fig. 2. Geometrical elements used in the paintings entitled 'Black-white Structure'
(cf. Figs. 4 and 5).

Jaroslav Blažek, a mathematician, for help [cf. Refs. 1–15].

II

We prepared a program suitable for the small computer, LGP-30, manufactured by Eurocomp GMBH, Minden, Westfalen, German Federal Republic that was available to us.

The procedure for two-color paintings (e.g. black and white) is demonstrated by an example. First the elements to be used must be specified. Then these are grouped according to color density (cf. Fig. 2). Group 1 contains the 'lightest' elements 1z, 1b, 1y, 1i, 1r and 1d; group 2 contains elements 2z, 2b, 2y and 2r; etc. The numbers of the groups 1, 2, 3 and 4 are taken as quantitative measures of color density. Each element is related only to one other one simply by an interchange of color. Thus 1r and 4r are related, as are 1y and 4y, and 2r and 3r.

For the computer, each element is identified by code numbers designating the color (i.e. black or white) at each of the four sides and by additional code numbers designating the shape (i.e. the presence or absence of an open half circle) at each of the sides.

Then an initial diagram is prepared providing a grid for the placement of the elements (cf. Fig. 3). At the start, the artist must insert a number of initial elements of his choice and also + and − signs in locations where he desires an increase or a decrease in color density. The degree of change to a darker or a lighter density adapted for the painting is represented quantitatively by a numerical color density coefficient c, which must have a numerical value exceeding zero. In this case, the coefficient $c = 0.75$ was chosen. Lower values for c yield less change in color density; higher values yield greater change.

One of four rules must be chosen. Before giving these, however, the terms employed must be explained. We say that the *colors continue* if the color along a side of an element is the same as that along the adjoining border of the neighboring

Fig. 3. The placement of initial elements and the assignment of color density ratings supplied among the instructions to the computer for the painting 'Black-white Structure' (cf. Fig. 4).

Fig. 4. '*Black-white Structure*', *oil on canvas*, 220 × 110 cm, 1966 (*cf. Figs. 2 and 3 and Table* 1).

element. We say that the *shapes continue* at the side of an element if each half circle open to a side joins a half circle of a bordering element to form a complete circle or if two patterns join, neither of which is a half circle open to a side. Thus, for the joining pair 2y–3r, where 3r is on the right side, the color continues at their common border but the shape does not. For the pair 2y–1r, the color does not continue but the shape does. For 2z–4d, both the color and the shape continue.

The rules have been formulated as follows:

Rule 0: Both the color and the shape at the side of an element continue across the side common to another element.

Rule 1: The color at the side of an element continues across the side common to another element but the shape does not.

Rule 2: The color at the side of an element does not continue across the side common to another element but the shape does.

Rule 3: Neither the color nor the shape at the side of an element continues across the side common to another element.

In the application of any one of these rules the condition of color is decided before that of shape. Four additional rules could be added for the situation where shape is treated first.

The given elements (cf. Fig. 2), the initial diagram (cf. Fig. 3), the density coefficient ($c = 0.75$) and the selected rule (in this case, Rule 2) together state the problem that is presented to the computer. The computer starts with the element in the top left corner and proceeds to the right, each time deciding which element to employ. The second row is started at the right and ended at the left. Thus the rows are calculated in sequence until the bottom row is reached. The results of the complete computation are shown in Table 1. Those elements chosen initially are underlined. The final painting based on the information in Table 1 is presented in Fig. 4.

The determination of an element can be illustrated simply. The element at the position represented by row 1, column 8 (or 1:8) is typical. In such a case, the preceding positions 1:1, 1:2, 1:3, 1:4 and 1:7 were calculated previously and positions 1:5 and 1:6 had been assigned. The determination of the color density is based on an averaging procedure, employing the known color densities (assigned or calculated) of all elements whose sides or corners touch. The neighboring positions of 1:8 are 1:7 (containing an element of group 3), 1:9 (still undetermined), 2:9 (still undetermined), 2:8 (containing an element of group 4) and 2:7 (still undetermined). The average of the two known color densities is 3·5 (i.e. $(3 + 4)/2 = 3.5$). Since the + mark at 1:8 signifies an increase in color density by the amount 0·75, the value calculated for 1:8 is 4·25 (i.e. $3.5 + 0.75 = 4.25$). As the color densities are given only in whole numbers (in our present case by the numbers 1, 2, 3 and 4 (cf. Fig. 2)), the closest value is chosen, i.e. 4.

Now the computer must decide which element of group 4 should be placed at 1:8. Following Rule 2, the computer must first find all elements of group 4, for which the colors would not continue across the side common to another element, i.e. elements of group 4 which have both the left and the lower sides black. But this is impossible; therefore the computer must seek all elements which satisfy only one of these conditions, that is, 4z, 4b, 4r and 4d. Then the computer chooses from these four elements all those for which the shapes do continue across the border, that is, those which have a half circle opening on the left side but which do not have a half circle opening on the lower side, namely, 4z and 4r. The computer decides between these two elements by a random process, like the flip of a coin. Thus element 4r is selected.

The element for position 1:9 is determined next. In this case, the average is computed from the known values: 4 at 1:8 (not 4·25) and 4 at 2:8; therefore the average is 4. After applying the first part of Rule

TABLE 1. COMPUTER RESULTS*

	Columns										
	1	2	3	4	5	6	7	8	9	10	11
1	1y	1b	1r	2z	3r	1r	3y	4r	4i	2z	1b
2	1i	1r	3y	3b	1r	1i	2b	4z	4r	2y	2r
3	1i	2y	3z	4i	1i	1i	2b	3b	3z	3z	2r
4	1d	3y	4z	3y	1i	1r	1i	3b	4b	3r	2r
5	1z	2b	3b	3z	1r	1d	1z	3z	4y	3z	2y
6	1r	3r	3y	2z	1d	1y	1y	3r	4i	3y	1d
7	1d	3y	4z	3b	1r	1i	1r	2z	4r	3z	2r
8	2r	3y	3b	3z	1r	1y	1y	3b	3z	2y	2r
9	3b	3z	3r	1d	1z	1r	1d	2r	3y	4r	2r
10	3y	2z	3b	2r	1d	1d	1r	3y	3r	2y	2b
11	1z	1z	1z	1r	1b	1z	1z	1z	2b	1y	1i
12	1d	1r	1d	1r	1y	1y	1d	1r	1i	1y	1b
13	2r	4z	1y	1i	1d	1r	1b	1r	2z	2z	4r
14	2r	2y	2b	1d	1z	1r	1y	2z	1r	4y	3z
15	3b	3y	2b	1b	1z	1z	1r	2z	4z	3y	3r
16	2r	3y	3r	3b	2y	1r	2z	3b	4i	3y	2z
17	2r	3r	4y	3z	3z	2b	2b	3y	4r	3z	2r
18	2r	3r	3z	4b	3y	2z	1d	3z	3y	2z	1b
19	1b	2y	3z	3r	3z	2r	2r	3r	3z	1r	1y
20	1b	2r	3y	3y	2z	1y	3y	4z	3y	2z	1d
21	1z	2r	3b	3z	1r	1d	3z	4i	4i	2z	1b
22	1d	2r	3y	2z	2y	1r	3r	4i	4r	3z	1z

*(Based on Rule 2, Coefficient $c=0{\cdot}75$ and Fig. 3). Underlined numbers refer to the initial elements.

Fig. 5. '*Black-white Structure*', *ceramic*, 530 × 350 cm, 1969.

Fig. 6. Model, *in glass mosaic, of* 20 m *high ventilating towers for a tunnel in Prague.* Josef Koles, architect.

2 'the color . . . does not continue . . .' (that is, the left side is white) the elements 4b, 4y, 4i and 4d remain and elements 4z and 4r are eliminated. Then the second part of Rule 2 '. . . the shape does (continue)' is applied. It is clear, however, that in this instance the application of the shape restriction does not lead to any further selection, because *all* elements 4b, 4y, 4i and 4d are eliminated. Therefore, the random procedure is applied to these four elements and element 4i is used.

It is clear that a different picture results if there are changes in the initial diagram or in the density coefficient or if a different rule is employed. The procedure for large paintings has been to place the initial elements at intervals of four in each row, displacing them systematically in succeeding rows. Examples of using this procedure are shown in Figures 5 and 6. In the case of the smaller paintings, a less arbitrary procedure for the placement of initial elements and density ratings is followed in order to produce specific desired effects in various parts of the composition (cf. Figs. 3 and 4 and Table 1).

Multi-colored paintings can also be designed with the aid of the same computer (Fig. 7, color illus. M, p. 315). To accomplish this, we use the computer program twice. The first calculation is done to establish the geometrical pattern, in black-and-white, as above. Then, in preparation for the second calculation, we tabulate in groups a series of color pairs (for example: white–orange, white–red, red–green, etc.). This tabulation of color pairs is analogous to the tabulation of elements in Fig. 2. We also must decide on a rule to be followed.

Finally the results of the two calculations are combined. For example, if for a given position both the element 2z and the color pair red–green are selected by the computer, then the semi-circular area of 2z is made green and the remaining portion red.

REFERENCES

1. J. Padrta, *Nuove realta dell'arte Czech*, Exhibition Catalog (Genoa: La Carabaga, 1965).
2. J. Padrta, *V Biennale de San Marino*, Exhibition Catalog, 1965.
3. *Nova Tendencia* 3, Exhibition Catalog (Zagreb: Galerije Grada, 1965).
4. J. Padrta, *Konstruktivné Tendence*, Exhibition catalog (Louny, Czechoslovakia, 1966).
5. P. Restany, *d'Ars* **8,** 26 (1967).
6. J. Padrta, Konstruktivní tendence, *Výtvaruá Uméní*, Nos. 6–7, 327 (1966).
7. G. Brackert, Tschechische moderne, *Frankfurter Allgemeine* (29 Nov. 1967).
8. J. Sekera, Zdeněk Sýkora, *Dodekaer*, Exhibition Catalog (Prague: Galerie D, 1968).
9. J. Hlaváček, Obrazy Z. Sýkory a OP art, *Dialog, SKNV (Ustć n/L)*, **30,** 1966.
10. V. Burda, Pražský pochod, *Výtvarná Práce*, Nos. 22–23, 12 (1968).
11. H. P. Riese, Bildende Kunst in der Tschechoslovakei, *Der Architekt*, No. 9, 322 (1968).
12. *Dokumenta* 4, Exhibition Catalog (Kassel: Dokumenta, 1968).
13. J. Hlaváček, Otázky pro Z. Sýkoru, *Výtvarné Uměni*, No. 3 (1968).
14. *Bienale Nürnberg*, Exhibition catalog (Nürnberg: Bienale Nürnberg, 1969).
15. Exhibition catalog, Galerie Spiegel (Monatzeitschrift deutschen Galerien, Feb. 1969).

EXPERIENCES IN MAKING DRAWINGS BY COMPUTER AND BY HAND

Colette S. Bangert* and Charles J. Bangert**

Abstract—The authors discuss reasons for using a digital computer and plotter for making artistic drawings. An experimental approach was used since 1967 in developing computer programs for them. The artist–author's handmade drawings serve as bases for establishing and modifying the programs. In turn, the experience gained from the computer output of drawings provides new insight and ideas for her handmade drawings.

I.

Computers are formidable machines for the uninitiated. Even though society in the U.S.A. can no longer exist without them, many of the problems of learning to live with them are still unresolved. Artists without an appropriate technical background find the mode of operation of the machine difficult to understand and, therefore, to use for artistic purposes. Numerous artists have reported on their experiences with computer art in past issues of *Leonardo*. A discussion of digital computer operation can be found in Ref. 1. 1 (C.S.B.) have found that a computer's capability for producing various kinds of drawings is very impressive and that one's anxieties lessen as one gains experience with it. I have become much more aware of a rational approach to art since I started working with a computer. Adopting a very unfamiliar complex medium need not hinder artists; it may make their works more aesthetically effective.

In order to use a computer, I (C.S.B.) need the help of someone familiar with its ways. Collaborating with my husband (C.J.B.), I began in 1967 making computer drawings based on the work I had made by hand. My mathematics education, like that of most artists, does not go beyond algebra and geometry. I am not able to deal with the mathematics needed to write computer programs for making computer drawings that would satisfy me. The fact that my husband has also a degree in art, experience as a printmaker and a continuing interest in contemporary art has made it easier for us to work together in carrying out my artistic ideas.

* Artist living at 729 Illinois Street, Lawrence, KS 66044 U.S.A. (Received 10 February 1973.)

** Applications Programming Supervisor, Computation Center, University of Kansas, KS 66045, U.S.A.

We have had access to a Honeywell 635 digital computer and a University Computing Company Draft-O-Matic plotter at the University of Kansas. The programs are written in Fortran IV [2], which we find is the most widely used of the languages available for writing computer graphic programs.

The landscape drawings and paintings I make are aesthetically related to those done during the 17th century in Northern Europe and, in particular, to those of George Inness and T. C. Steele. Although I walk through my garden and tend house plants, I seldom walk through woods or countryside. Instead, I ride in my automobile through the highly cultivated areas of midwestern U.S.A. My visual experience of this prairie landscape is quite different from that of earlier artists who were inspired by the vast grasslands. The contrast of the flat plains with fields and grasses, with their colors and lights, through their seasonal changes, plays an important role in my pencil and ink drawings and in my acrylic paintings, as well as in our computer drawings.

My works have evolved in a linear graphic rather than painterly direction. Hand-drawn lines have been important to me in all their manifestations for many years (Fig. 1). As my work progressed, I have been able to see changes developing in the character of the lines that I draw and changes in the types of patterns constructed from the lines.

The experience I have gained from making pictures by hand contributes to the establishment and modification of the computer programs that we write. The resulting drawings produced by the plotter help me to understand and clarify my visual conceptions of what I have done, what I might have done and what it would be possible to do, and, thus, help me in making subsequent hand drawings. Each method, involving the use of either

Fig. 1. 'Landscaped', handmade drawing, pencil and black
ink on paper, 30 × 22 in., 1968.

the computer or my hands, advances the visual aspects of my work in ways that would be improbable without the other.

II.

Before we discuss our computer programs and their graphic output, a fundamental question needs to be dealt with: Why use a computer to do graphic art? [3, 4]. Are works made with a computer aesthetically comparable to those done in other graphic media? Most artists would probably pose these questions not knowing that computer drawings of quality can now be obtained and that some can even rival works in other graphic media.

There are two extreme viewpoints regarding the potential role of computers in art [3, 4]. At one extreme, a computer is seen as a tool, like a lithograph stone or a camera. At the other extreme, a computer is considered as though it were an artist. Our primary reason for using a computer is associated with the latter viewpoint. New ideas for drawing lines come from it as though we had an artistic collaborator who has an unconventional yet interesting approach in generating new ideas, new combinations of shapes and new stylistic devices for us to consider.

For a computer specialist, this would not be at all strange, for he would recognize that we are primarily concerned with computer software rather than hardware, that is, with complex programs that guide a computer in making drawings. An experienced programmer knows that there are very few programs that are thoroughly understood. A program is written, tested and used for a while, and then one day, owing to a fault, it produces an unforeseen output.

A programmer, working to get a company's payroll out, dreads the consequences of a fault or 'bug' in his program. He may have to work many hours to remove the 'bug'. The primary goal of an artist and a programmer working together is to produce a program that leads to an output with certain graphic ideas and a 'bug' may produce something particularly interesting. The artist then wants the 'bug' to be located, controlled and used to draw additional pictures of a similar kind. It is this experience of serendipity that makes work with a computer intriguing and that presents a real challenge to both the artist and the programmer.

Before mentioning our second reason for using a computer, we wish to point out very briefly the difference between handmade drawings and computer drawings. An artist with practice learns to draw quite easily a vast variety and combination of lines. But, for one who writes a computer program, the generation of desired lines is a much more difficult problem—it may take many hours to prepare it. Even then, the plotter produces not a continuous line but one consisting of a series of very short straight segments or dots (each 0·005 in. long) that to the unaided eye appears smooth.

Our second reason for using a computer is that the complicated process required to generate even a simple line may lead to a deeper insight into linear graphics. New insights may also be obtained into the basic aspects of form, composition, space and color in making not only drawings but also pictures and sculpture, generally.

It is important to realize that such new insights come primarily from an artist. Technologists provide means but it is artists who produce art with the means and are responsible for its quality.

We believe that important insights into traditional art techniques will be gained by the use of computers. The problem is that these insights do not result necessarily from an unprepared artist put in contact with a programmer. An artist must contribute meaningfully to the collaboration, if he is to expect positive results. Although an artist need not be knowledgeable in mathematics, he must be prepared to talk to a mathematician. He must be prepared to cope with the kind of hard exactness that is required in dealing with computers. What comes out of a computer is determined by the program and the parameters used. What may seem to be a computer error is most often the result of the lack of correct programming, a lack that, as

Fig. 2. '*Landscape Coils*', *computer drawing, black ink on paper*, 13⅜ × 10½ in., 1967.

we pointed out above, may be used to advantage by computer artists.

III.

The origin of our computer art activity was mostly the result of circumstance. While working as a programming supervisor in 1967 at the University of Kansas computation center, one of us (C.J.B.) had occasion to write programs to test the newly acquired Draft-O-Matic plotter. The result of these first efforts was geometric swirling lines that we have since labeled 'spirals'. These images are of a kind called Lissajous figures [5]. The ones that we obtained had little aesthetic interest for us and, at this point, I (C.S.B.) suggested that we try to produce more satisfying images.

The programs that we have used to make our computer drawings are described below. The manner in which we proceed in writing a program is illustrated by the following typical exchange:

C.J.B. I've just thought of an interesting piece of code that might draw pictures.

C.S.B. What will the pictures look like?

C.J.B. I'm not sure, maybe like this.

C.S.B. That line's not too well-placed there.

C.J.B. Well, maybe I'll think of a different code tomorrow.

We confront computer programming in this spirit and most of our time is spent wrestling with technical computer problems. It is very seldom that we know precisely what kind of image is going to be produced by the plotter according to a new program. We do anticipate the general appearance of the image but not its details.

The simplest Lissajous figure is a circle. Our first step was to modify it by introducing several random factors into the program and to have distorted circles drawn on a rectangular grid (Fig. 2). The influence of the random factors is suggestive of poorly drawn circles within the squares of a checkerboard. In the computer program, provision was made for the random placement of a circle's center within a square of the grid, for the random determination of the length of the curved line describing the circle and for the circular meandering of the line as it is being drawn by the plotter pen.

This computer program was quite simple but the resulting drawings permitted the occurrence of the serendipity mentioned in Part II. We discovered that this combination of randomness and order leads to compositions with artistic qualities. The figure in the upper left corner of Fig. 2 is just slightly separated from the rest of the drawing, yet it seems to contribute to the composition's balance. A viewer scanning the rows of circle-like shapes can enjoy the individual patterns they make.

A friend, seeing the drawing, exclaimed: 'Colette has a new drawing!' We replied, 'No. A computer did it!' We had realized that it is possible for the program, we had set up to produce a drawing that might easily be taken for one made by an artist. The drawing also has a linear look that particularly pleased me (C.B.S.). This drawing encouraged us to continue our efforts with the computer.

We next gave our attention to the possibilities of varying the appearance of lines. The variations of the circular paths in Fig. 2 intrigued us, therefore we decided to generate the direction of each small segment of the curved line recursively. A computer program may be one that directs all of the operations of the plotter. In our case, however, it was a small part or subroutine of the complete program. Our subroutine DRAW performs only one operation. In this case it calculates each successive step recursively in drawing a curved line. Subroutine DRAW uses very simple coding, is quite flexible and can be used with different programs.

Most subroutines are intended to perform a specific function. There is a small set of numbers, or parameters, that controls the functioning of the subroutine. In our case, some parameters determine the general quality of a line and another one its random path.

The computer is a strictly deterministic device. Given the same input, it will produce the same

Fig. 3. '*Line Studies*', *computer drawing, black ink on paper,*
each 5 × 5 in., 1969.

output. However, there are certain simple arithmetical operations that produce what are called *pseudo-random numbers*. A series of pseudo-random numbers appears random under certain tests and appears less random under other tests. Any series of numbers is determined by one parameter, called the *seed*. Thus, with a given seed, a series can be repeated. But, if the seed is chosen randomly, the numbers in the resulting series are not predictable. Subroutine DRAW has a random number seed as one of its parameters. We use it to draw a series of different lines having the same general character but none of which is precisely predictable.

When DRAW was first written, we did not know exactly how the choice of parameters would affect line character. We experimented and obtained the types of lines shown in Fig. 3. Again, we chose to place the lines within a grid as in Fig. 2 but this time the lines were wavy instead of circular. What we were doing was sketching with a computer rather than with a hand-controlled pen or pencil. Various possibilities were tried by varying the values of the parameters.

Our next step was to have been a conversion of a sketch into a larger, more complex picture. But we immediately encountered an unwanted effect that is commonly encountered by computer artists using random factors. We call this effect 'mud'. In the lower left section of Fig. 4 several of the lines' vertical tails overlap making a stronger line. Otherwise the lines are well-separated, so the effect is not objectionable here. But if the lines formed a much denser pattern, it is very likely that it would be objectionable, that it would be 'mud'. Avoiding the formation of 'mud' in our drawings has been

one of our preoccupations. One way to prevent its formation is to use geometric, nonrandom lines, since when they converge they tend to delineate a shape. But we have been trying to avoid making computer drawings that have a computer-made appearance.

Another method for avoiding the formation of 'mud' is by the placement of the linear elements in a controlled manner, such as a grid. But again we were not satisfied with the rather artificial or machine-made quality. What we wanted was a more interesting result. We noted that an artist drawing with a pen or pencil has no real problem with 'mud'. If an area starts to get dark, he just does not draw there any more or he lightens it. This suggested to us that the program should simulate this aspect of hand drawing. What was required was that the program be able to detect where it had drawn.

The method we devised for dealing with 'mud' involves two ideas. First, the picture is digitized. The picture is divided up into a grid of very small squares and a record is made that tells whether or not a line has been drawn in a square. If a grid square is empty, it gets a 'no' value function; if a line has been drawn through it, it gets a 'yes' value. There are as many noes and yeses as there are grid squares. If the grid squares are very small, the plotter can draw lines quite close together without losing detail. If the grid squares are large, then lines will be spaced far apart and detail is lost.

Fig. 4. '*Large Landscape, I*', *computer drawing, ochre and black ink on paper,* 33 × 23 in., 1970.

Secondly, the digitized picture is stored in *core*, in the computer's memory. Core is made up of words and each word is, in turn, made up of *bits*. Each bit can be just 0 or 1, that is, as 'off' or 'on'. One can store information in core in the form of words but under normal working conditions our program has only about 30,000 words available to it and yet our computer is considered a reasonably large one. This means that if we were working with a 20×30 in. picture and recording just 'off' or 'on', 0 or 1, the smallest grid that could be used would be about $\frac{1}{8} \times \frac{1}{8}$ in. We would use up the machine's given 30,000 words very quickly and the grid would not be fine enough to reveal much detail. We therefore decided to provide the extra time needed by the computer to a bit rather than a word and to draw our picture in core using consecutive bits.

We usually say that we use a *packed-bit core image*. We then began to write programs that deal with a picture much as an artist usually does, i.e. when he draws while looking at the lines he has already drawn.

Our first computer program that employed a packed-bit image and that drew interesting lines was called MELLY. We found, however, that the compositions produced by MELLY were not very interesting. Figure 4 shows that, in spite of our efforts, the drawing still has a grid-like structure, especially in the bottom part. The grid was modified slightly to make it more dense in the middle but this was more an expression of our growing dissatisfaction with the grid than any thought-out compositional attempt.

A drawing is executed with MELLY as follows: A shape is placed in the lower left-hand corner. Lines continue to be drawn moving to the right until the lower row is completed. Then the next row up is done, starting at the left and moving right. This process is continued until the top row is completed.

In Fig. 4 there are two basic shapes. The first one can be seen easily in the lowest row. This shape is drawn by starting upward as a straight line and then turning counterclockwise to form a loop. The second shape is seen best at the top right-hand corner. It is drawn by starting down at the right and turning to the left; upon reaching a low point it turns up and trails off to the left.

Shape transformation is a computer capability especially useful in art work. It enables one shape to be changed gradually into another. In MELLY the two basic shapes mentioned above are randomly produced by using DRAW. One of these is intended for the lower left corner, one for the upper right. Starting in the lower left corner (Fig. 4), the first shape undergoes a subtle change, showing more and more the influence of the second shape in the

upper right corner. The transformation can be seen more dramatically by following the shapes up the right side of the picture. Starting at the bottom, the first shape turns gradually. Half-way up, it elongates horizontally to the left. In the upper portion the characteristics of the other shape become more and more prominent as the top row is approached.

As mentioned above, a picture is stored in core primarily to reduce the possibility of 'mud'. As each little line segment that makes up a curved line is drawn, using MELLY, the line is continued until it reaches a square in which there is already a line. When the line reaches an occupied square, drawing of the shape ceases. It is as if the line bumps into a previously made line in the drawing. One should compare the third and fourth shapes on the left in the bottom row in Fig. 4. The fourth one is more complete; it makes almost a full turn around to the left. The third one, in contrast, is shorter. This is because, in turning, it bumped into the second one and stopped. Even the fourth one should be longer but it bumped into the third one.

How can lines cross at all? The lines do cross because the lines drawn are not recorded as lines but instead as a succession of dots. What is seen as a continuous curved line in the drawing is a series of dots when drawn or recorded in core. A parameter was adjusted when the program was run so that the dots that make up the lines would not be too close together. Therefore, the lines often do cross each other. If one line comes up to another in a certain way, it can pass directly through.

In using MELLY, which involves storage in core to deal with 'mud', we reaped an unexpected computer art dividend. We found that most of the compositional structure of the picture was due to the interaction of the lines in core. In Fig. 4, the structure of loops at the bottom, the whole area in the middle and the distribution of the shapes in the upper portion all result from the use of MELLY. The whole middle area, which is made up of short lines, can be explained on the basis of the transformation of the first shape into the second one. The initial part of the first shape, which has a steep upward trend, is transformed eventually to a pronounced downward trend. In the middle portion, the half-transformed figure starts up and down simultaneously, thus bumping into itself and stopping.

There are two accidental effects in Fig. 4 that should be pointed out, both of which are common to much graphic art. One is rather obvious: The edge of the top half of the drawing is shifted to the right relative to the bottom half. This is the result of a minor breakdown in the plotter. For a person drawing a map or a building, it would have been unacceptable but to us it was a satisfying result.

Fig. 5. *'Landscape: Rain'* (*detail*), *computer drawing, black ink on paper*, 10 × 110 in., 1970.

Secondly, in the lower right section, there are some very light lines tilting down to the left that were not in the program. They resulted when the pen did not lift completely off the paper as it moved to another drawing area. These lines would have ruined an engineer's drawing but to us they were a pleasant accident.

Figure 5 is the middle section of a 10 × 110 in. scroll-like drawing. The drawing, we decided, could be a depiction of a rain shower with the outline of a mountain in the background. This center section serves to hold the drawing's long left and right portions together, another compositional accident that pleases us.

We use also colored premixed inks in our drawings, since color, opaque or transparent, used for thick and thin lines, can add to the aesthetic interest of a work. In Fig. 4, we plotted one colored drawing on top of another. In Fig. 6, four different drawings that are slight modifications of each other are laid on top of one another in different colors. Making modifications of a whole drawing like this is quite easy to do with a computer; this is another application of the transforming process that has been discussed above.

Although we regard the gleaning of new ideas from computer drawings for use in generating more of them or in making hand drawings as something positive, we expect to be criticized for not having produced purposefully computer drawings that contain pleasing accidental effects. If computer art is so flexible, why do we not set out to compose a computer drawing using ideas generated from previous ones? In Fig. 5, the mountain outline appeared unexpectedly. Why should we not determine how to put it there? The answer is that up to now we find it much more difficult to compose a complex computer drawing than to proceed in any of the other ways we have considered.

In 1972, we felt bored with the use of a grid for arranging shapes and began to try other methods. Our first effort at making a composition resulted in a subroutine called RECHOL in a program called FIELD. One of the reasons for storing a drawing in core was to make the computer's process of drawing more like that employed by an artist. We wanted the making of any part of a drawing to be influenced in some way by the presence of its other parts. RECHOL extends this idea. This subroutine finds a hole, an empty place in a drawing stored in the core, fairly quickly and with relatively little coding. FIELD in turn operates one step at a time iteratively. It draws a shape roughly as large as the final drawing, then randomly picks an empty point, using RECHOL, finds a large rectangular hole but not necessarily the largest, and draws a new figure to fit within the hole. In addition, FIELD allows drawings to be made in different colors. The colors are associated with the shapes and sizes of the rectangular holes. Large shapes can be in one color, tall thin shapes in another, short fat ones in another and small ones in a fourth color.

In Fig. 7, there is a large green shape (light line) that starts on the lower edge, a little to the left of the middle, goes left to the edge, then across to the right edge, then to the top, then trails off in the middle. This shape was drawn first; it is the one that occupies roughly the whole picture surface. All the other shapes are the results of finding holes and filling them with the same shape having different proportions. There are also some accidents and some programming errors that make the drawing more interesting. The result is, obviously, not composed on a grid.

Fig. 6. *'Landlines', computer drawing, brown, grey, ochre and red earth ink on paper*, 14 × 12 in., 1971.

Fig. 7. '*Contained Contours*', *computer drawing, green, red and black ink on paper*, 14 × 24 in., 1972.

Our work since FIELD and RECHOL is continuing in four directions: more interesting compositions, the use of decorated articulated lines, greater dark and light contrast in drawings and better programming. We are also developing a more complete and flexible graphic system of interest to us.

IV.

Many ideas about my (C.S.B.) hand drawing are now clearer but they took appreciable time to develop and mature. In the early drawings I made before we worked with a computer, I used what I now see and understand as coiled shapes, small colored organic shapes defined by lines. They were similar to many of the small areas defined by the ink lines in Fig. 1. In succeeding work, these shapes gradually developed tails and, later, I was using coiled organic forms as well as uncoiling forms. In the handmade landscape series called 'Grassland' (Fig. 8), the horizontal and vertical lines are all slightly curved. Then followed my realization that my stretched-out lines were coiled lines, uncoiled versions of earlier lines such as I drew in 'Landscape' (Fig. 1). Most of my hand work since 1969 (Fig. 9, cf. color plate) has been concerned with uncoiled lines. In our computer work we learned that just by changing parameters a tightly coiled line can be stretched out into a straight line and back again. Thus, while we try to write programs that would generally simulate my hand style, I try to understand concurrently what influence the computer results have had on the hand drawings.

In those early hand drawings I intended to place the coiled shapes randomly, yet I did exercise some control. I often used horizontal areas or bands in order to break up the regularity of the structure of a work. I do not consider that those drawings had a very obvious composition or structure but, as I decided later after making computer drawings such as Fig. 2, each coiled unit is subtly related to the

others. I feel that these relationships are the meaningful elements of this kind of picture.

I found that by using a computer to draw lines somewhat randomly I could still compose my pictures as I had done by hand. Then I began to consider that subtle line changes can give the feeling of structure. For example, I consider that there is a definite feeling of structure in 'Landlines', a computer drawing (Fig. 6), and in 'Grassland: June', a hand drawing (Fig. 9, color illus. N, p. 316), both of which depict a line reproduced with many slight modifications. It is true that the range of variation of lines in any handmade drawings is rather large. But after making computer drawings such as 'Large Landscape I' (Fig. 4), I saw that I could greatly extend that range and, of course, if the lines were colored, the range of modifications could be extended still more.

My early hand work was done by drawing lines in color (in acrylic paint) separately, in layers. Often I finished a work by delineating the colored lines with pencil, black acrylic paint or black ink. This way of executing lines as separate units and in layers is one that can be repeated easily and extended in computer drawing.

In order to write a complete computer program, it is desirable to separate each step in the drawing process in a clear way from the final program. Our thinking while making our computer programs is a kind of layered thinking. Obviously, this kind of

Fig. 8. '*Grassland*' (*series*), *handmade drawing, acrylic paint and black ink on paper*, 29 × 23 in., 1969.

thinking is required in plotting a multi-colored computer drawing just as it is in the printing of a multi-colored lithograph.

A computer is excellent at compounding subtle differences and does not get tired as an artist does. After computer drawings such as 'Landscape: Rain' (Fig. 5), I saw that by extending the picture's format from a rectangle into a scroll format I could have a progression of very subtle changes that in total would represent a very significant change. Thus one long computer drawing can embrace a wide range of change.

I now think much more clearly about my hand-made work and have much more control as a result of having made computer drawings. In addition, I recognize that our computer efforts have led to unique and unfamiliar images, which I might never have considered introducing in my drawings. On the other hand, I consider that our computer drawings are extensions of my handmade drawings.

The computer medium may not be suitable for some graphic artists, just as watercolor is not a suitable medium for some painters. I feel that the computer medium, complex and logical though it may be, is a means that is suitable and interesting to me.

The authors wish to thank Colleen A. Grewing for her assistance and support, for, without her efforts in the preparation of this manuscript, it would not have been written.

REFERENCES

1. R. I. Land, Computer Art: Color-Stereo Displays, *Leonardo* **2**, 335 (1969).
2. *An Introduction to Fortran IV Programming: A General Approach* (Scranton, Pennsylvania: International Textbook Co., 1970).
3. F. J. Malina, Comments on Visual Fine Art Produced by Digital Computers, *Leonardo* **4**, 263 (1971).
4. H. W. Franke, Computers and Visual Art, *Leonardo* **4**, 331 (1971).
5. B. F. Laposky, Oscillons: Electronic Abstractions, *Leonardo* **2**, 345 (1969).

TOWARD AESTHETIC GUIDELINES FOR PAINTINGS WITH THE AID OF A COMPUTER

Vera Molnar*

Abstract—*The author makes nonfigurative drawings and paintings that are the results of a procedure in which simple geometrical shapes and their combination were successively altered in specific ways. In 1968 she began to use a computer to assist her. The computer displays (on a CRT screen) images in which shapes and/or their arrangement are altered successively. When she sees a pleasing example that she may wish to execute as a drawing or a painting, she instructs the computer to record it on a plotter.*

She has studied a number of such series in which alterations occur successively in small steps to determine which alteration is responsible for the appearance of a picture that she judges to be aesthetically superior to those that preceded it. She includes an example of of her judgment of the aesthetic quality of pictures chosen from a particular series.

I.

I am a painter, an image-maker, in particular, of images of a nonfigurative kind. I 'create' visual forms in the sense that they consist of combinations of shapes that cannot be found in nature.

I decided that I would become a painter when I was 12 years of age under the influence of an uncle of mine who, in his leisure time, painted a number of scenes of woodland nymphs in twilight. I began by making pictures of nymphs and trees but soon I replaced figurative subject matter by simple geometrical shapes. Later I began to make nonfigurative pictures that were the result of a procedure in which initial simple geometrical elements and their combination were successively altered in specific ways, a procedure that I continue to follow. In 1968, I was able to gain access to a digital computer to facilitate the execution of this time-consuming procedure.

I am forcefully impressed by the fact that viewers tend to agree on what they consider as 'beautiful', 'indifferent' and 'ugly' compositional arrangements, in particular arrangements of squares, triangles and dots, which can be produced readily on a computer display. Osgood made psychological tests on artistic taste and found that there is less divergence of taste than is generally believed [1]. Personally, I doubt that 'beauty' is amenable to definition but I shall not explore the question here.

II.

What I should especially like to know is what changes have occurred in a picture on which I am working when it begins to please me. What are the specific elements of a composition that cause it to give to me aesthetic satisfaction and then later to a viewer? I seek a concrete answer, one that entails experimentation rather than philosophical speculations. I am not interested in my subconscious or unconscious states. I should like to avoid even the notion of consciousness and to follow the objective approach of behaviorist psychology.

Of course, to make good pictures one should know not only about composition but also about the psychology of perception and about experimental aesthetics [2]. It would be most helpful to an artist to be able to apply principles of aesthetics but, despite the efforts of painters and others interested in art during past centuries, such principles continue to elude discovery. There are those who believe that such principles do not exist, that art is solely intuitive. Nevertheless, some of these same sceptics have formulated arbitrary rules that, because there were arbitrary, did not have general utility. The principles that I believe exist are in the form of laws that are determined by human physiology and psychology and recent achievements in the human sciences encourage my belief. But I am certain that in order to find them experimental methods of science rather than philosophical speculation will be required [3, 4]. In effect, art can profitably use experimental methods of the physical sciences. But I do not mean to imply that art will become science.

* Artist living at 54 rue Hallé, 75014 Paris, France. Based on a text in French (Received 22 May 1974.)

III.

I do not agree with those who believe that developments in art simply happen. I am convinced that initiative must be applied to obtain an understanding of these developments and I wish to do my part. Whenever I begin a picture, I have an initial idea of it in mind. The procedure that I use to arrive at the final work, to be described below, is tedious, if carried through by hand. Furthermore, the final picture rarely corresponds to my initial idea of it.

I develop a picture by means of a series of small probing steps and each step is followed by evaluation. In my opinion, painters should employ such a procedure, especially if they consciously wish to learn what of aesthetic importance is occurring on the canvas as the painting develops and what effect the work may have on viewers. Making a series of pictures that are alike except for the variation of one parameter is not uncommon. Many painters from those of Mount Athos to those of today have done this. Claude Monet, a good example, painted both a haystack and the Rouen cathedral repeatedly in different lighting.

When I have an idea for a new picture, I make the first version of it rather quickly. Usually I am more or less dissatisfied with it and I modify it. I alter in a stepwise manner the dimensions, proportions and arrangement of the shapes. When simple geometrical shapes are used, such modifications are relatively easy to make. By comparing the successive pictures resulting from a series of modifications, I can decide whether the trend is toward the result that I desire. What is so thrilling to experience is not only the stepwise approach toward the envisioned goal but also sometimes the transformation of an indifferent version into one that I find aesthetically appealing.

This stepwise procedure has, however, two important disadvantages if carried out by hand. Above all, it is tedious and slow. In order to make the necessary comparisons in a developing series of pictures, I must make many similar ones of the same size and with the same technique and precision. Another disadvantage is that, since time is limited, I can consider only a few of many possible modifications. Furthermore, these choices are influenced by disparate factors such as personal whim, cultural and educational background and ease of execution.

IV.

Using an IBM 370 computer, I have been able to minimize the effort required during the preparatory phase of making a picture. This computer can produce a series of images (the shapes and their arrangement may be simple or complicated) on an IBM 2250 CRT screen and/or of

Fig. 1. *Computer drawings*, 25 × 25 cm. Top, '*Carrés, 000072/00*', 1972 (Collection of Brys-Schatau, Brussels, Belgium); center, '*Carrés, 250173/1*', 1973; bottom, '*Carrés, 071273/21*', 1973.

drawings on a Benson plotter. A program for a specific kind of image determined by a number of selected parameters is employed. The input data consists of instructions specifying, for example, to what extent particular parameters are to be varied and the amount of change in each step. Similar procedures have been described before in *Leonardo*, for example in the work of Z. Sýkora and J. Blažek [5] and C. J. and C. S. Bangert [6]. There are differences, however, between my method and that widely used by other artists. Whereas they begin with an initial set of rules (a grammar) specifying the way parameters are to be varied, I try to elaborate the rules as a work develops.

In a series of pictures drawn on paper by the plotter each version will differ from its predecessor in that only one parameter will have been varied, such as scale, shape, line thickness or color. This control over the stages in the development of a drawing permits me to decide when the picture that I wish to realize is being approached or departed from. When a good approximation has been achieved, then smaller changes are introduced in the succeeding drawings produced by the computer.

Another method, which I mainly employ, is essentially the same as that described above but, instead of making a parameter change and then waiting for a drawing to be plotted (the plotting operation may require several minutes or several hours, depending upon the size and complexity of the picture), I make the parameter changes quickly while viewing the images on the CRT screen. This is the so-called 'conversational method'. I select only a few of the images shown on the screen for recording by the plotter.

This approach is not new; it had been applied long before computers were constructed. Erasing, scraping, retouching or covering part of a picture

Fig. 2. *Computer drawings*, 25 × 25 cm., 1973. Top, '*Carrés, 071273/26*'; center, '*Carrés, 071273/27*'; bottom, '*Carrés, 071273/34*'.

Fig. 3. '*Computer-Icône*', *polyvinyl emulsion paint on canvas, based on a computer drawing*, 110 × 110 cm., 1973. (Collection of J. and J. Mayer, Paris, France.)

are familiar techniques used by painters. Thus my computer-aided procedure is simply a systematization of the traditional approach. I should mention here another advantage in using a computer: it is possible to 'go back', that is, to repeat drawings that had appeared before certain modifications were made.

In spite of their advantages, computers, no more than other simpler tools, do not guarantee that a work of art of good quality will result, for it is an artist's skill that is the decisive factor [7].

V.

The computer drawings that I shall discuss were made by the 'conversational method' with a program called RESEAU-TO, of the type used for composing music, for example MUSIC 5 of Mathews [8]. This program permits the production of drawings starting from an initial square array of like sets of concentric squares. The available variables are : (1) the number of sets, (2) the number of concentric squares within a set, (3) the displacement of individual squares, (4) the deformation of squares by changing angles and lengths of sides, (5) the elimination of lines or entire figures and (6) the replacement of straight lines by segments of circles, parabolas, hyperbolas and sine curves. Thus from the initial grid a great variety of different images can be obtained.

To illustrate the possibilities of this program, I show an initial 5 × 5 array of sets of 5 concentric squares as drawn by the computer plotter (Fig. 1, top). In Fig. 1 (center) is a variation in which the array is now 7 × 7 and the number of squares in the sets is varied. In Fig. 1 (bottom) squares of different size are variously displaced within an

(a) *(b)*

(c) *(d)*

Fig. 4. Computer drawings, 25 × 25 cm., 1974. (a) 'Computer-rosace, 74.338-31'; (b) 'Computer-rosace, 74.338-39'; (c) 'Computer-rosace, 74.338-47'; (d) 'Computer-rosace, 74.338-54'.

11×11 grid. In Fig. 2 are shown variations of distorted squares. A painting that I made by hand in black on a gold background on the basis of one computer drawing is illustrated in Fig. 3.

I have mentioned my desire to learn what particular change in a series of changes to a picture gives rise to aesthetic satisfaction but my study so far has led only to some tentative conclusions. Fig. 4(a) is a picture that I find aesthetically 'indifferent'. Its aesthetic quality seems improved to me when some straight lines are replaced by segments of parabolas (Fig. 4(b)) and even more so when sine curve segments replace parts of the straight lines (Fig. 4(c)) but when the number and amplitude of the sine curve segments are increased, a result is obtained that I find aesthetically disappointing (Fig. 4(d)). I believe that the majority of those who view these examples will agree with my opinion as to their aesthetic quality.

In Fig. 5 (color illus. O, p. 317), is shown a reproduction of a painting on canvas whose design corresponds with high precision to a drawing produced by the computer plotter. The two hues were chosen arbitrarily but their Munsell values were kept the same.

VI.

I do not make drawings and paintings with the aid of a computer solely for personal satisfaction; I hope that others will also enjoy them. I do not agree with the notion of art for art's sake and of science for the sake of science. Sartre convincingly explains why this notion is untenable [9]. I, personally, know of no artist who refuses to let people see his work. On the other hand, I do not believe that an artist should go to the extreme of ignoring his own taste and convictions in order to please others. There should be an intermediate ground where aesthetic satisfaction is experienced mutually.

The reactions that viewers voice, often in very diverse and obscure ways, should not be accepted without qualification. Often they do not analyze their own feelings. But even if they did, they would find it difficult to express them in words or they might hesitate to reveal their thoughts because of social pressures. People do not necessarily like what they say they like. Their judgments are influenced by factors that have little or nothing to do with the art object that they behold. They are influenced by the opinion of others, by the bias of education, by an object's price, etc. Yet, in spite of these problems, I subscribe to the belief that the underlying principles for giving aesthetic satisfaction to viewers of drawings and paintings can be found and I hope that my studies will help to verify my conviction.

REFERENCES

1. C. E. Osgood, G. J. Suci and P. H. Tannenbaum, *The Measurement of Meaning* (Urbana, Ill.: Univ. Illinois Press, 1957).
2. F. Molnar, Experimental Aesthetics or the Science of Art, *Leonardo* **7**, 23 (1974).
3. M. Thompson, Computer Art: A Visual Model for the Modular Pictures of Manuel Barbadillo, *Leonardo* **5**, 219 (1972).
4. M. Thompson, Intelligent Computers and Visual Artists, *Leonardo* **7**, 227 (1974).
5. Z. Sýkora and J. Blažek, Computer-Aided Multi-Element Geometrical Abstract Paintings, *Leonardo* **3**, 409 (1970).
6. C. S. Bangert and C. J. Bangert, Experiences in Making Drawings by Computer and by Hand, *Leonardo* **7**, 289 (1974).
7. F. J. Malina, Comments on Visual Fine Arts Produced by Digital Computers, *Leonardo* **4**, 263 (1971).
8. M. V. Mathews, J. E. Miller, F. R. Moore, J. R. Pierce and J. C. Risset, *The Technology of Computer Music* (Cambridge, Mass.: M.I.T. Press, 1969).
9. J. P. Sartre, Qu'est-ce que la littérature? in *Situations, II* (Paris: Gallimard, 1958).

PICTURES BASED ON COMPUTER DRAWINGS MADE BY DEFORMING AN INITIAL DESIGN*

Ruth Leavitt and Jay Leavitt‡**

Abstract—The authors are interested in making nonfigurative pictures that convey a feeling of motion. The pictures are based on selected computer drawings that are made by the deformation of initial designs.

An initial design is a composition made up of a pattern of repeated units. Deformations are accomplished by applying displacement vectors, simulating deforming forces, at chosen locations in the design such that the points defining each of the units are displaced. Points closest to the tail of a vector are displaced most, in accordance with an assumed mathematical rule. The authors discuss their motivation for this work along with the computer program that they use.

Four serigraphs and a computer drawing made on the basis of the computer output from three rather different series are discussed. Several novel ideas for investigation in the future are indicated.

I. INTRODUCTION

Change is an ever-present phenomenon in nature. However, it is not simply that things change which is noteworthy, but how they change. We are interested in giving artistic expression to the latter aspect. In particular, we are concerned with the kind of shapes that appear in nonfigurative pictures, sometimes called 'geometrical abstract' and 'concrete art', and some of the ways that the shapes can be altered by a chosen procedure of deformation.

The work that we shall describe was done with the aid of a Control Data Cyber 74 digital computer. We begin with an *initial design* or a composition made up of a number of units and then deform it to produce a final picture (a technique bearing some resemblance to that employed by Colette and Charles Bangert [1]). The article by Vera Molnar in Ref. 2 will also help readers to understand this approach to computer art. Like Victor Vasarely, who also obtains variation through the use of the deformation of chosen geometrical shapes, we believe that our pictures preserve a feeling of the motion that units of an initial design undergo during the deformation procedure.

Vasarely wrote of his approach as follows: 'Let us make the square turn round an axis, at first central. The plane accedes to three dimensional space, changes its aspect, becomes rectangle, thins out, to vanish in a streak. Let us now make the square turn round its diagonal axis: it becomes transmuted into a lozenge, its section is the triangle which, evolving in turn, becomes points Let us trim away the four angles of the square, and we get an octagon, and then let us continue the operation until we get a circle which, undergoing the preceding manipulations, gives the ellipse and all the curvilinear forms imaginable. Distance, furthermore, giving the scale, we thus soon have the whole gamut of forms of the same kind, from the smallest to the relatively large' [3].

Bridget Riley works in much the same manner. She takes a unit, in this case a square, and, as she says, 'paces' it, that is, puts it through its paces, pulling it this way and that, squeezing it until it becomes a straight line or expanding it into a large rectangle. Triangles are paced through various stages from acute-angled to obtuse-angled: circles are paced through elliptical and ovular shapes. This pacing is carefully controlled so that the distortions of the unit set up a definite rhythm [4].

Our approach contrasts with that of these artists in that we deform a design as a whole rather than its individual units.

II. METHODOLOGY

To indicate the type of deformation that we use, it is helpful to imagine a sheet of rubber with its

* This work was supported, in part, by a grant from the National Endowment for the Arts, Washington, D.C., U.S.A.

** Artist living at 5315 Dupont South, Minneapolis, MN 55419, U.S.A.

‡ Computer engineer, Computer Science Dept., 114 Lind H., University of Minnesota, Minneapolis, MN 55455, U.S.A. (Received 10 March 1975.)

edges clamped on which a design has been drawn. The initial design consists of a pattern of repeated straight-line geometrical shapes or *design units* and a blank area is left in the middle of the composition. If forces are then applied at selected points in the design and essentially within the plane of the sheet, the design will be deformed. In some instances the forces act over distances that are sufficient to cause an overlapping of the sheet. An initial design can be deformed into countless variations of it by varying the magnitude, direction and location of the forces.

The design units that we chose for our computer drawings are selected for more than their aesthetic qualities. They also must be suitable for the introduction of color and for conveying a feeling of motion when deformed. A unit is a set of straight lines connecting certain specified points on a grid. A portion ($\frac{1}{4}$) of a one unit is shown in Fig. 1; it was employed in the initial design, a herringbone pattern, given in Fig. 2. The result of deforming a similar initial design (one containing more units) is shown in Fig. 3.

The points of a unit are numbered in the sequence in which the computer is ordered to connect, or not to connect, points by straight lines. In Fig. 1, for example, where a Y is defined by eight points on a grid, there is a line between points 4 and 5 but none between points 5 and 6, and none is assumed between 8 and its successor, which is 1. It is to be noted that two or more points may occupy the same location, for example 3 and 8.

The points defining a unit are represented by x, y coordinates on the grid, which runs from 0 to 1·00 along both the x-axis and the y-axis. A *data statement*, which is incorporated in the program, contains in consecutive order a listing of the coordinates of each point and an indication of whether or not a line is drawn to the following point. If a line is drawn to the following point, the number 1 is given; if not, the cipher 0 is given. The data statement for the unit in Fig. 2 is: 0, 0·25, 0·50, 0·50, 0·50, 1·00, 0·75, 0·50; 0, 0·25, 0·50, 0·75, 1·00, 0, 0·25, 0·50; 1, 1, 1, 1, 0, 1, 1, 0. Here the first eight numbers give the x-coordinates of the eight points, the second eight give their y-coordinates and the final eight numbers tell whether or not a line is to be drawn to the following point. Points 2, 4 and 7 allow the three branches of the Y to deform into curves. These points would not be given if the branches were to move, but not bend, as we shall show below in the cases of two other units.

When one of us (R.L.) is about to begin a computer drawing, she makes a series of sketches showing the overall compositions of the pictures that she wishes to obtain. These sketches, which are simply gestures of movement, are drawn on graph paper, each within a 1·00 × 1·00 grid defined by an x-axis and a y-axis. The sketches are then used to decide where and how deforming forces are to be applied to the initial design. Straight line vectors are the means for representing

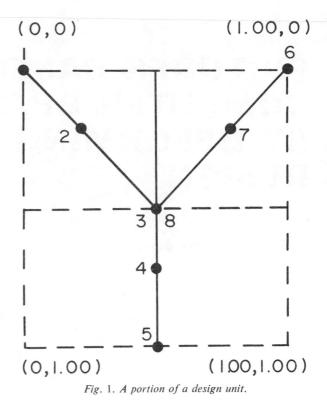

Fig. 1. *A portion of a design unit.*

applied deforming forces in the computer program. The coordinates of the vector's tail indicate where a deforming force is first applied; those of its head define where it is terminated. A force need not be applied directly to any point in the design. Neither the head nor the tail may lie on or be outside an outer edge of the design (the clamped edge in the rubber analogue). A list of the coordinate points of the heads and tails is compiled for instructing the computer.

The computer program is written in FORTRAN IV for a time-sharing system, which has the advantage that an immediate feedback is received. The program is stored on a disc. When the program is requested and execution starts, the machine asks: (1) under what file name should the results be stored for future processing and (2) the number of times a pattern should be repeated along one side in making the initial design. Our program permits the user to request from 2 to 9 repeats. The program first scales the units to yield an initial design of a desired size. It then generates the full set of points needed to represent the entire initial design. If the user requests more than two lines of units along one edge, the computer program will itself provide for a central blank area in the initial design. It is an area into which deformed units may extend, without resulting in an excessive crossing of lines.

The program poses three questions that are repeated for consideration while the picture is being made: (1) Is a print-out (proof) of the current location of all the points in the design desired? (2) Should the deformation be terminated and a picture (for example a microfilm) be made? (3) What are the coordinates of the tail and of the

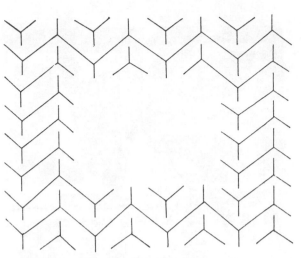

Fig. 2. An initial design.

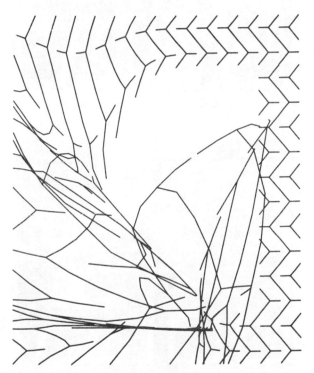

Fig. 3. 'Herringbone Variation, III', computer drawing, 6 × 4 in, 1974.

head of the next vector to be introduced as input?

As soon as the coordinates of the head and tail are introduced, the computer moves every point in the design. Below are the formulas that govern the displacement of each point. Let (p, q) denote the coordinates of the tail, (s, t) the coordinates of the head and (x, y) the location of a point of the design. The point (x, y) is moved to the point (u, v) according to the following formulas:

$$\Delta_x = s-p \; , \; \Delta_y = t-q \; ,$$

$$\sigma_x = \frac{x}{p} \text{ if } x \leqslant p \; , \; \sigma_x = \frac{1-x}{1-p} \text{ if } x > p \; ,$$

$$\sigma_y = \frac{y}{q} \text{ if } y \leqslant p \; , \; \sigma_y = \frac{1-y}{1-q} \text{ if } y > q \; ,$$

$$\rho = 1 - \left(\frac{(p-x)^2 + (q-y)^2}{2} \right)$$

$$u = x + \Delta_x \cdot \sigma_x \cdot \rho^k \; , \; v = y + \Delta_y \cdot \sigma_y \cdot \rho^k$$

The factors Δ_x and Δ_y represent the horizontal and vertical components required to translate a point representing the vector's tail to a point representing the vector's head. As a result of this translation, the entire design is affected. Each of the points defining the design units is displaced by the amounts given by $\Delta_x \cdot \sigma_x \cdot \rho^k$ and $\Delta_x \cdot \sigma_x \cdot \rho^k$, respectively. Each of the products $\sigma_x \cdot \rho^k$ and $\sigma_y \cdot \rho^k$ has a range of values between 0 and 1, hence no displacement of a point may exceed Δ_x and Δ_y. The displacement of a point is greater, the closer it is to the tail, a behavior that is governed by σ_x, σ_y and ρ, each of which may have values between 0 and 1. The exponent k modifies the influence of ρ. If $k = 1$ or 2, the distortions tend to have a blunt appearance. After some preliminary testing, we decided to use $k = 64$, which suitably reduces the influence on distant points and, hence, results in rather sharp deformations (Fig. 3).

It should be noted that the location of the head plays a minor role in governing the displacement of the points in its vicinity. Consequently, if the head is distant from the tail, the essentially unaffected points near the head are then found among points that were originally near the tail. This is equivalent to a fold in the rubber sheet resulting from a large distortion.

When work with our computer program is terminated, both the final coordinates of the points and the coded line-successor information for the selected pictures are stored on a disc for the next step, for example, that of microfilming.

A standard CALCOMP program is used that processes the information stored on the disc producing a tape carrying coded instructions for the connection of the points by lines. The tape could be used to drive a drum plotter, but we decided to use it with a microfilm electron-beam recorder available at a nearby film processing laboratory to make 16 mm microfilms. The primary advantage of microfilm is that reproductions in other print media and in other sizes can be made from it readily. It is also easier to store and significantly more economical. Usually, the microfilm plotter takes three minutes to produce 20 plots. The laboratory has also an enlarger copier machine that can produce 8 × 10 in. proofs. For producing paintings in oils, one of us (R.L.) projects 4 × 6 in. photographic negatives made from the microfilms onto the canvas. She also uses $2\frac{1}{4} \times 2\frac{1}{4}$ in. negatives to produce Kodalith separations for photo-transfer graphic processes such as those used in serigraphs and lithographs.

III. EXAMPLES OF OUR WORK

We have made three series of computer drawings, each series being characterized by a different

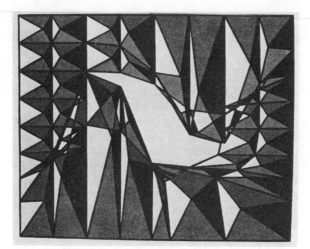

Fig. 4. '*Prismatic Variation, I*', *serigraph*, 23 × 29 in, 1974.

Fig. 6. '*Inner City, Variation II*', *serigraph*, 29 × 23 in, 1974.

Fig. 7. '*Inner City, Variation I*', *serigraph*, 23 × 29 in, 1974.

initial design unit. In the first series, which employs the Y in the unit, the emphasis is on lines rather than shapes (Fig. 3). In this and in the other series, we varied the initial design and the number, length, orientation and location of the vectors. It became apparent that a set of vectors suitable for one series was not suitable for the other two. Nevertheless, in all three series there is the feeling of motion that we seek. In a completed picture, we are later able to discern the locations of the original vectors. A few of the units are left in their initial shape, allowing contrast with those that are deformed. For example, in Fig. 3 the right side of the picture retains portions of the initial herringbone design. If one's eyes follow the composition in the counter-clockwise direction, one can see the gradual elongation of the units.

The unit in the second series emphasizes a feeling of massiveness by its heavily outlined areas and is particularly suited for the application of color. Fig. 4 and Fig. 5 (color illus. P, p. 318) give two examples of prints made from this series. The unit is readily deformed and combined into interesting compositions. Since there are no intermediate points, as 2, 4 and 7 in Fig. 1, all lines remain straight. A number of geometrical shapes may be produced: triangles, squares, stars and octagons. With increased deformation the family of shapes multiples. In Fig. 4, the triangle, which is an element in the design unit, becomes prominent. Other variants also appear in this picture that are due to the effect explained by the folding of a rubber sheet upon itself. The assortment of shapes obtained is particularly noticeable in Fig. 5. The 'fold' forms a Z across the middle of the picture, segmenting larger shapes and producing small pentagons, diamonds, rectangles and elongated triangles. The feeling of tension that one can interpret in the picture is due to the opposing forces that lead to the 'folding' during deformation. Fig. 5 also illustrates how a shape may be varied during expansion or contraction. The variant shapes assumed by the design unit are emphasized through the use of color. The tones of

the colors were selected carefully, so that no single subpattern would become dominant.

The unit used in the third series is suggestive of projected 3-dimensional forms. Figs. 6 and 7 show two examples of prints based on this series. The use of colors helps to depict 3-dimensional forms. This unit was the most difficult to deform satisfactorily. The massive quality of the unit allows neither aesthetically satisfying large deformations nor 'folds'. Great care was taken in the preparation of the sketches so that the depicted 3-dimensional forms would not collide. The picture shown in Fig. 6 was obtained through a series of small deformations disposed in a spiral arrangement. We find it noteworthy that, although there is less distortion in this series, the insertion of energy can

readily be imagined. In both Figs. 6 and 7 the smaller forms seem to be compressed by the shifting larger forms.

Several different avenues of investigation have become apparent to us in this work. One idea is to 'deform' color, that is, to use gradations to indicate stretching or contraction. Alternate procedures for deforming an initial unit are being considered. These include: (1) deformations related to the phenomena of magnetic attraction and repulsion, (2) the simultaneous depiction of stages in the deformation of an initial design, and (3) the use of compound nonlinear vectors (spirals, for example). The use of a vector-oriented computer display would be an improvement in the method because the user could see the computer drawing while it is being made.

IV. CONCLUSIONS

We have been concerned with deforming an initial design based on a repeated shape or unit to produce a composition for a picture. The computer program allows an artist to vary the design by changing factors in the program that determine the kind and degree of deformation.

We have found that the artist (R.L.), while making sketches of movement, proceeds in much the same manner as an action painter. Just as Jackson Pollock would control the amount and direction of paint poured on a canvas, so too an artist using this method controls the amount and direction of deformation of a pattern. Like an abstract expressionist painter, a computer artist also finds that 'nice accidents' occur. Each of the works discussed, in our judgment, begins its life in a static order, of emotional overtones. We feel that it becomes 'humanized' when an artist imparts a feeling of energy to the design. However the orderliness of the 'concrete' school of painting is not lost in the process of deforming the design. On the contrary, we feel that the 'expressionist' style intermingles with the 'concrete' style, forming a harmonious final picture.

REFERENCES

1. C. S. Bangert and C. J. Bangert, Experiences in Making Drawings by Computer and by Hand, *Leonardo* **7**, 289 (1974).
2. V. Molnar, Toward Aesthetic Guidelines for Paintings with the Aid of a Computer, *Leonardo* **8**, 185 (1975).
3. M. Jouraz, ed., *Plastic Arts of the 20th Century* (Neuchâtel, Switzerland: Griffon, 1965) p. 32.
4. C. Barrett, *An Introduction to Optical Art* (London: Studio Vista, 1971) p. 110.

MY FIRST EXPERIENCE WITH COMPUTER DRAWINGS

Frederick Hammersley*

My background of study in art was of the traditional kind. I have made drawings, paintings, prints and some sculptures. My paintings have evolved into a type that are more formed by the dictates of intuition than by preconceived ideas or conscious planning. The paintings in oils have taken the form of flat geometrical shapes. In my recent paintings the number of shapes has been reduced to very few, and they are closely related to the rectangle of a canvas. I came to realize that intuition feeds upon a certain fund of knowledge and experience with a medium. The intuitive or creative act seems to follow this sequence: spade work, planting, waiting and harvest.

The image-making process is to me a way of expressing a felt fact. The rightness and the order of the parts of an image, supplied by intuition, produces a sensation that is both new and familiar.

During my first semester of teaching at the University of New Mexico in 1968, I was invited by Charles Mattox to attend a computer drawing class. This happened to coincide with a time in which I had painted myself out, so I welcomed this new experience. I was shown how to prepare a computer program and how to transfer it to an IBM punch card by machine. The alphanumeric characters we could 'draw' with were: the alphabet, ten numerals and eleven symbols, such as periods, dashes, slashes etc.

The working area of the completed drawing is made up of a field of one hundred and five characters disposed horizontally and fifty vertically. The program prepared on one or more punch cards permits the making of lines, rectangles, triangles, circles and ovals, and also, exponential curves.

*Artist living at 608 Carlisle, S.E., Albuquerque, New Mexico, 87106, U.S.A. (Received 24 April 1969.)

Fig. 1. 'Yo-Yo Almost', computer drawing, 8·25 ×10·5 in., 1969.

Fig. 2. '*Enough is Plenty*', computer drawing, 8·25 ×10·5 in., 1969.

In addition, any character can be printed on top of any other. The drawings are printed by the computer in black on white paper.

It took me some time to get used to this medium. What I intended to make did not always correspond to the program I thought I had punched in the card. I made many mistakes which the computer, in its logical way, would not print. The intricacies and possibilities seem endless and I have spent a great deal of time simply trying to master the mechanics of this particular technique. It continues to fascinate me.

The great advantage of the computer is that one can see the results so quickly. It takes a considerable time to program a drawing, less time to punch the information on cards, then, only a few seconds for the computer to print it. Afterwards, it takes a very short time to punch out variations of the first program for other drawings.

I have been making computer drawings for only a few months and am just now getting warmed up. I find that working with the computer is, in principle, the same as painting. The elements are different but the end result, as in all visual art is the same —an image. It is not enough that an image be visually attractive. It must, I feel, be one of substance and of some significance. I am not concerned with the tricks and combinations forming computer drawings. I am trying, as in my approach to drawing and painting, to take advantage of all possibilities a computer offers me, and to exploit its limitations. I cannot, as yet, predict what might happen. Some ideas that I think are brilliant,

when printed, turn out to be unsatisfactory. Doubtful ideas at times turn out to be quite good. I am continually being surprised by the difference between expectation and the result. This I find, is part of the fascination and challenge of the computer.

There are two final points about computer drawing that intrigue and concern me—one is positive and one, perhaps, may be negative. The positive one is, as I have said, the seemingly endless and wonderful possibilities it presents. The second point is that I, myself, am not actually making the drawing with my hands. My involvement and participation is very different from my feeling when painting, which may be a shortcoming. It might, on the other hand, be an asset to me; it may furnish me upon return to either drawing or painting with new insights and added understanding.

The computer drawing 'Yo-Yo Almost', shown in Fig. 1, was the seventh one I made. It began simply. I liked the opposing directions of the apostrophe and the period. The first drawing of the Yo-Yo series was a page of alternate columns of five apostrophes and five periods. This page of dots of one value seemed to move quietly up and down. There then followed several trials of introducing a variety of horizontal blank rectangles coming in from either side of the drawing creating a movement which opposed the vertical movement of the dots. There is a secondary horizontal effect in that one set of rectangles does not reach the middle of the page, while the other set goes beyond it.

'Enough is Plenty' was my twenty-eighth drawing

Fig. 3. '*Jelly Centers*', *computer drawing*, 8·25 × 10·5 in., 1969.

(cf. Fig. 2). It is also based upon a root of alternate columns of apostrophes and periods. But in this drawing the columns are three dots wide. I then removed every other row (horizontal line). Next came the large circle of dashes, followed by the two smaller circles without dashes. Inside of these I placed still smaller circles of dashes only. The background surrounding the large circle is made up of columns of 'equal' signs placed every third column repeating the pattern of the three dot wide column. Here an up and down arrangement occurs in three different areas.

The drawing 'Jelly Centers' was my thirtieth one (cf. Fig. 3). Apostrophes and periods were again used as a base. But this time they were in rectangles of 12 rows by 26 columns. A field of dashes was printed all over, resulting in rectangles of dots which alternated above and below the dashes.

Next I removed ovals of dashes from every junction of four rectangles. Inside of these ovals I placed smaller ovals of zeroes. There resulted a regular pattern of ovals with a secondary up and down arrangement of dots in three different areas—the background, the large ovals and the small ovals of zeroes.

As to the significance of these drawings I can say that they are an outgrowth of the same ideas that I use, for the most part, in my paintings—a kind of marriage of opposites. Often this is demonstrated by the rhythm and sequence of the elements. In the positioning of the parts there is an innate requirement that must be satisfied—and that is that the elements must occupy the entire working area. When the elements are arranged properly they produce the remarkable effect of being in sum more than they are individually.

THE CREATIVE PROCESS WHERE THE ARTIST IS AMPLIFIED OR SUPERSEDED BY THE COMPUTER*

Stroud Cornock and **Ernest Edmonds***

Abstract—The advent of computing stimulates a desire to re-examine the subject of creativity. Though the computer can replace man in the production of graphic images, its function in the arts is seen as assisting in the specification of art systems and in their subsequent real-time management. An art of system or process is placed in the context of primarily the visual or plastic arts but the authors disavow concern with any 'new' or 'modern technological' art. Various types of art systems are mentioned and advantages of the fully interactive one are considered. It is pointed out that the inclusion of complex real-time responses in an interactive art system can frequently make use of a computer. In such work, the artist and the viewer play an integral part. The traditional role of the artist, composer or writer is thus called into question; it may no longer be necessary to assume that he is a specialist in art—rather he is a catalyst of creative activity. Three cases are discussed to illustrate the applications of this approach.

I. THE ART WORK—OBJECT AND SYSTEM [1]

1. The advent of the data processing machine introduces a novel element into the realm of the creative art process and stimulates a desire to re-examine the concept of such creativity. This may put into new perspective the role of artists, composers or writers, their art works and the role of viewers or audiences. We shall understand by the term *art system* or *process* an activity as a result of which an art object may or may not be produced.

1.2 As the extensions of man have grown more elaborate, we have seen a retreat from the number of specifically human characteristics and functions by which we (in effect) define ourselves. We may mention that the telescope has shown that our Earth is not the centre of the universe, that modern medicine has found that our chest contains a replaceable pump and we may further suggest that the frontiers of biology and behavioural science place us within reach of the ability to control and synthesize the most intimate substance of human tissue and character. It is therefore natural that the premium placed on those remaining characteristics by which we identify ourselves has increased and that the 'ghost in the machine' [2] has become a kind of grail, while the anticipation of machine cognition has spread an underlying note of fear throughout the literature of the 20th century. Jacques Ellul sums up this anticipatory fear: '. . . the machine is deeply symptomatic: it represents the ideal towards which technique strives. The machine is solely, exclusively, technique; it is pure technique one might say. For, wherever a technical factor exists, it results, almost inevitably, in mechanization: technique transforms everything it touches into a machine' [3]. We are concerned here with the application of data processing techniques to art systems or processes. We should like to refute the common and understandable extrapolation of Ellul's doctrine into this field, which sees its development as leading to the replacement of artists by the digital computer.

1.3. The sympathy with which the work of an artist is considered by an art consumer will be proportional to the degree to which control (technique) is direct and personal; the master potter would be considered to be at one end of this scale, the sculptor who delivers telephone instructions for the fabrication of a sculpture to an engineering firm,

* Based on a paper presented at the international symposium 'Computer Graphics 70', Brunel University, Uxbridge, Middlesex, England, 14–16 April 1970. (Received 29 June 1971.)

**School of Fine Art, Leicester Polytechnic, P.O. Box 143, Leicester LE1 9BH, England.

***School of Mathematics, Computing and Statistics, Leicester Polytechnic, P.O. Box 143, Leicester LE1 9BH, England.

at the other. It is against this background that the machine threatens to usurp what is assumed to be the essentially human function of control of making art works.

1.4. For the purposes of our argument, we shall treat the following as the elements of what may be described as the traditional art situation: the *artist*, the *art work*, and the *viewer*, where the artist is an individual who makes all of the decisions regarding the development of an art work, where the viewer is expected to be 'cultured', e.g. familiar with a set of rules and conventions. What we say is that the computer can be brought in as a tool to mimic certain aspects of this situation by having 'culture' incorporated in the programme by following certain routines (graphic, painterly or otherwise) that artists either have followed or might have followed in designing their works. Also the computer can govern other tools employed in the fabrication of an artifact [4]. In addition, we say that such mimicry does lead to the situation described above in paragraph 1.2. To escape this situation, we abstract the concept of *creative synthesis* from the traditional context of various kinds of artists who work alone and the viewers or audiences of their works and ask whether such a synthesis can be reached in other ways. This creative synthesis might be described as the ordering and re-ordering of information at various levels in our minds simultaneously, in order to achieve new or unfamiliar patterns of perception of awareness. We believe that it is a function of the arts to stimulate a high degree of this kind of involvement. Therefore, it is necessary to introduce at this point the term *participant* to replace the terms *viewer* and *audience*.

1.4.1. In the place of an art work we shall discuss the potential viability of what is, quite simply, a dynamic situation (this is necessarily an open term). The participants may be treated as one of the elements of this dynamic situation, while the sum of the elements comprising that situation may be regarded as an equivalent for traditional art situations. This alternative situation will be referred to as the *matrix*. Within this matrix there is an exchange and the digital computer, including the complex of real-time information processing capabilities now available, may be expected to organise and facilitate this exchange. This is clearly not the situation described above at the end of paragraph 1.2.

1.4.2. Since the matrix we have chosen relies on the involvement in the decision-making process by the participants, there will be an information exchange. The *art of system or process* or *process-oriented art* is a dynamic one in which control is exercised both in the design of the matrix and at each point of contact with it. Below we shall discuss further the nature and significance of the way in which the design is initiated. Ascott has drawn attention to the distinction between an art work as a container of information determined by the artist and an art work as a 'trigger' designed to stimulate unpredictable behaviour [5].

1.4.3. The role of the digital computer in the

potentially complex specification of such a matrix and in the 'real-time' processing, communication and cross-referencing of information within such a matrix can be considerable. There is no question here of programming the computer to mimic the traditional artist nor is its use limited here to the generation of 'random' choices.

1.5. Recent art history in the Western world shows a very strong tendency toward the kind of situations described above in paragraph 1.4.1. Burnham has written the following [without clearly stating that by definition visual or plastic art deals with objects. Editor.]: 'A major illusion of the art system is that art resides in specific objects. Such artifacts are the material basis for the concept of the "work of art". But, in essence, all institutions which process art data, thus making information, are components of the work of art. Without the support system, the object ceases to have definition; but without the object, the support system can still sustains (*sic*) the notion of art. Thus we can see why the art experience attaches itself less and less to canonical or given forms but embraces every conceivable experiential mode, including living everyday environments' [6]. The concepts used in the arts can obviously, by the same arguments, survive art galleries and museums. [However, it should be remembered that art objects are not made for commercial galleries but primarily for the contemplation of individual viewers. Editor.] It is also obvious that concepts of art can survive artists as we know them when their control of the situation is reduced [5] or where they are submerged in collaboration with engineers and others as in '9 Evenings, Theatre and Engineering' mounted at the New York's 25th Street Armory in late 1966 by Experiments in Art and Technology, Inc. We shall assume that developments in the contemporary arts no longer necessarily include any concern with aesthetic hypotheses. [As a matter of fact, artists seldom pay attention to aesthetic hypotheses, in any case. Editor.]

1.6. Before examining the matrix we have chosen we state that:

(a) We wish to speak not of a new art but of a way of looking at creative situations;
(b) we do not feel that new technology contributes (of itself) to the arts and it is not, therefore, our intention to praise or to condemn results obtained through the use of the computer or other 'modern technological art';
(c) and to avoid the question of value judgements, we say that, rather than confront this question, all examples of each class of art work are meaningful or significant for the purposes of our argument.

II. THE MATRIX

2.1. We now look in more detail at our matrix in the light of the above discussion and, in consideration of the way in which the participant interacts with an art work (which may be nothing

more concrete than a system of ideas), go some way towards a definition of the matrix (cf. 1.4.2. and 2.4.).

2.2. We have as a major aim the involvement of the participant in problematic thought processes. In this we follow W. Darby Banhard: 'To have human value, the work must ... have an overt complexity' [7]. But, rather than consider an art work, we shall concern ourselves with the behaviour of the participants in a dynamic situation. The function of any art work of which we speak therefore, will be to act as a trigger or stimulus and only incidentally to convey information. As noted above in paragraph 1.4.2. we shall assume that an art work may be used to trigger the participant within an open-ended situation such that he relates in some way to himself, his world and his attitudes.

2.3. An interactive situation can, we believe, be much more productive than a passive one. Thus, a dynamic situation where the participant plays an interactive part looks most attractive to us.

2.3.1. Let us look more closely at three possible situations. By *environment* we simply mean the sum

of factors external to an art work and to the participant or participants, other than the passage of time.

(a) *The static system* (Fig. 1(a)). In this case the art work is unchanging. This is, in fact, the familiar class of traditional art objects. We do not in any way deny that this system can be organized so as to satisfy our requirements but we wish to look at alternatives.

(b) *The dynamic passive system* (Fig. 1(b)). Here an art object is caused to change with time by the artist's program (e.g. kinetic art) or is changed by factors in the environment (e.g. the mobiles of Alexander Calder). (It is interesting to note that these factors could include another participant who is interacting with an art work as described below.) Within the system the participant has no control, he cannot alter anything.

(c) *The dynamic-interactive system* (Fig. 1(c)). This case enlarges the dynamic-passive system to include an output from the participant to an art work. We thus have a feedback loop. This system can be very rich, though the speed with which the participant may exhaust the set of possibilities means that the result could lack substantial interest or value.

2.3.2. An art work as discussed so far is conceived as a system, the definition of which either is or corresponds to the making of the traditional art object (bearing in mind what was said in paragraph 1.5.). As has always been the case, an artist is a participant in the work he makes, though he need not be considered a special case when he reacts in a unique way to process-oriented art. All participants need not react in the same way. (Note, for example, the situation in which a group of performers is asked to make decisions concerning an indeterminate piece of music (e.g. in the music of John Cage, Karlheinz Stockhausen and Christian Wolff.), while the audience, who know what is happening, look on passively.)

2.3.3. A special case does exist where an artist modifies the system or process in a way not allowed for in its original definition. We would then have a varying system (Fig. 1(d)).

2.4. The matrix (Fig. 1(e)) is the total system within which the art system and the participants perform. A varying system leads to a varying matrix.

2.5. Within the matrix the participant plays an integral and interactive part. The art work is the designed sub-system with which he interacts. A participant must be seen simply in terms of the inputs to that subsystem (as an exogenous variable), for to try to design a system that takes a total account of a participant would present an incommensurable problem. Were it otherwise, we should suppose him to be predictable.

2.6. The traditional role of an artist is clearly called into question by these developments: not only does he now find his ability to control the art situation necessarily circumscribed but he often encounters the need to collaborate with other artists

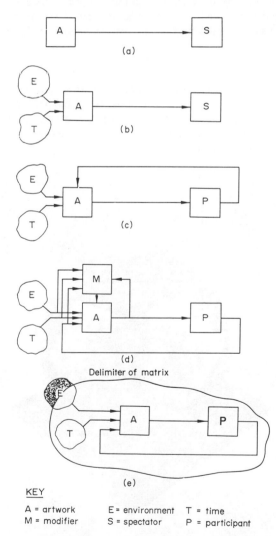

KEY

A = artwork E = environment T = time
M = modifier S = spectator P = participant

Fig. 1 (a) *Static system.* (b) *Dynamic–passive system.* (c) *Dynamic–interactive system.* (d) *Dynamic–interactive system (varying).* (e) *Matrix.*

or technical specialists ('Interplay' discussed below, for example). It may no longer be necessary to assume that an 'artist' is a specialist in art; a growing number of individuals whose activities centre on other disciplines are making contributions to the creative arts, so that when one speaks of an 'artist' one means he who is performing a kind of catalysis of creative behaviour within society and not a specialist working for a section of that society. His major function might, therefore, be to initiate.

III. CASES

3.1. The object entitled 'Nineteen', shown in Figure 2 (color illus. Q, p. 319), is an example of a static work where a computer has been used as a problem solver. The arrangement of the twenty elements of the object was found by means of a computer within specified constraints without consideration for the particular relationships with the final layout, which was simply a four element (30 cm × 30 cm) by five element array. It was intended that the assembly in the array be such that a feeling of finality be avoided. The variety of possible relationships between the elements is left for the viewer to sense without actually being able to move them about as he would in an assemblage.

3.1.1. Finding the range of available permutations that satisfied the constraints required the use of a computer. The attempt was made to condition as little as possible the set of relationships seen by the viewer between those elements, both in the design of each element and in the positioning of each element within the array. This may result in some initial annoyance on the part of the viewer who expects to be presented with an harmonious statement but finds, in fact, an 'unsatisfactory' whole that constantly threatens to break down into its constituent parts. The work is thus open-ended in that its visual richness is conditional not only upon the elaborateness of the possible relationships conditionally stated.

3.2. The project, 'Interplay', is a good example of the application of a computer to an art system in the role of management. 'Interplay' involves the design of an environment that would establish a strong interaction among a group of individuals who have no prior knowledge of that environment and where that environment would not contribute any programmed information (entertainment) to the individuals present. The situation is organized as a system that is able only to respond. In order to respond, it is necessary for the system to apprehend and, to this end, it was equipped with an array of sensors. A given input via one of the sensors may lead to a given output or combination of outputs in sound and light. 'Interplay' is, in effect, a large colour and sound organ where the keyboard is represented by the topographical floor surrounded by an audio-visual envelope. The project was exhibited at the British Pavillion of the VI Paris Biennale, October 1969. The movement of people on a sensitive floor was to cause changes in the illumination of a domed ceiling (15 meters in diameter) above them (Figs. 3 and 4). A given input would result in a given output. Clearly, in its simplest configuration, the system could play like a piano and the participants would immediately begin to sense a simpler relationship between their individual floor positions and a section of the audio-visual output. One may anticipate that a tendency to seek order will assert itself, leading to the establishment of control and communication within the group for a limited period.

3.2.1. To encourage these tendencies the inputs in the 'Interplay' project are processed by an on-line computer so as to amplify them (this is a more elaborate configuration). We would therefore consider this system as one leading to amplified play situations that are potentially creative. Some consideration has been given to the problem of enabling 'Interplay' to recognize certain larger patterns in the behaviour of participants and to selectively emphasize or ignore individual inputs so as to maximize such patterns. No simple logic circuit could handle such a problem. We may also note here that, since it was felt necessary to avoid misleading aesthetic choices, the basic configurations of random number tables were used to define the parameters of the topographical floor and the distribution of sound and colour through the envelope.

3.3. Our 'Datapack' (1969/70) art system is an example of a matrix that consists of participants, a display, a computer installation and a designated area around the Vickers Building next to the Tate Gallery in London.

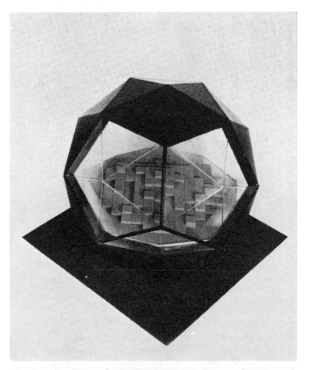

Fig. 3. S. Cornock, B. Faine, N. Nealson and D. Wood, 'Interplay' simulator (scale model) mixed media, 90 × 90 × 90 cm, 1969.

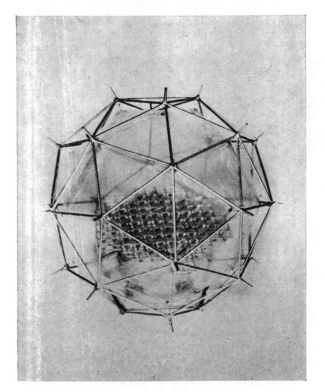

Fig. 4. '*Interplay*' *structural model, mixed media,* 30 cm diameter, 1969. (Co-ordination of structural analysis and architectural presentation by M. Brackenbury.)

3.3.1. This system is organized so that the participants are involved in three phases: (1) the initial contact with the display (explanations and instruction), (2) the use of a computer terminal and (3) possession of the output from the terminal in the form of a drawing by graph plotter of the Vickers Building in two elevations, against which (in different colours or line thicknesses) are plotted volumes of air space ('sculptures'). The number, shape, size and disposition of the 'sculptures' are determined by the interaction of the participant with the computer. The final output, including the typed record of the interaction or 'conservation' and explanatory material are presented to the participant in a transparent envelope ('Datapack' constitutes an edition of multiples).

3.3.2. This art system is an elaborate and, perhaps, curious game in which the casual spectator is invited to participate. He is, in effect, offered the idea of a sculpture but, rather than taking immediate possession of a determined artifact (sculpture) as the residue of an expressive act on the part of an individual (artist), he is asked to contribute (information) to a process whereby a selection results in his being allotted parcels of air space within a particular environment. The volume of air space has been chosen for the purpose of illustration to emphasize that the significance of the 'game' lies in the process by which the allotment is made and in the concepts formed by the individual concerned and not in the aesthetic merit either of the intentions of the designers of the art system or of the designated volume of air space. Some measure of entertainment

may be gained from the proceedings and from the edition of multiples which may be treated as having some aesthetic value or interest. But the burden of the exercise lies with the individual and his own conceptual behaviour when confronted with the art system using our chosen matrix.

3.3.3. This is a rather crude example of a dynamic interactive system (Fig. 1(c)). But note that, on completion of the 'Datapack', a tangible record of the proceedings becomes a kind of static art 'object' in itself and a reference to an idea of another and equally static art 'object'. The system is fulfilled.

What we have done is to suggest an approach to the general problem of computer art. We have necessarily limited our attention to certain points which we hold to be important and have avoided all consideration of the significance of style, expression, the distinction between art works read by references to conventions and other developed heuristically and dynamically with the participant; of the relation between the arts and technology; and of the role of artists, composers and writers as catalysts within the technological society. Nevertheless, we feel that the limited argument presented and certain of the terminology suggested could establish a basis for further consideration of the questions posed.

REFERENCES

1. A subsequent analysis of the conceptual framework within which we consider art as system or process was reported in a paper circulated in 1970 and later published in a revised version: S. Cornock, Towards a General Systems Model of the Artistic Process, (II), in *Systems Research and Cybernetics*, Vol. 2, F. de P. Hanika and N. Rozsenich, eds. (London: Transcripta Books, 1972).
2. G. Ryle, *The Concept of Mind* (London: Hutchinson, 1949), Chap. 1, Sec. 2.
3. J. Ellul, *The Technological Society*, trans. by Wilkinson (London: Cape, 1965), cf. especially introductory chapter.
4. R. Mallary, Computer Sculpture, *Artforum*, 7, 20 (May 1969).
5. R. Ascott, Behaviourist Art and the Cybernetic Vision, *Cybernetica*, 9, No. 4. 248 (1966) and The Cybernetic Stance: My Process and Purpose, *Leonardo* 1, 105 (1968).
6. J. Burnham, Real Time Systems, *Artforum* 7, 50 (Sept. 1969).
7. W. D. Banhard, Present Day Art and Ready-made Styles, *Artforum* 5, 33 and 35 (Dec. 1966).

COMPUTER AND KINETIC ART: INVESTIGATIONS OF MATRIX CONFIGURATION*

J. Kenneth Edmiston**

Abstract—*The author describes the development of his investigations of matrix configurations. The investigations follow two directions, the first dealing with a linear system of relationships, the second with square or quadratic systems. The systems exhibit complete sets of combinational relations between four or a multiple of four elements. The original visual elements have been coded, worked with numerically and then retranscribed back into visual form.*

Computer machinery has been utilized to produce both numerical and visual output. In addition, a variety of other materials and processes have been employed for system manifestation in art works. In each investigation, a geometrical transformation of the initial manifestation generated a second work, which is identical in combinational relations to the first but which is increased in dimension by a factor of one.

The author concludes with an observation regarding his working relationship with both the numerical–conceptual and visual–physical systems of the investigations.

I. INTRODUCTION

My initial idea of *matrix configuration* derived from an early painting, a diptych that consisted of two square canvases, each displaying a different image, and either of which could be placed on any one of its four sides and combined with any of the possible four sides of the other. At first, working intuitively, I made drawings of possible combinations of the two canvases; soon I was led into a more analytical approach as I began to search for every possible combination. Ultimately I came to see the manifestation of complete sets of possible combinations as an end in itself. This became the principal impulse behind my investigations.

In my investigations of matrix configurations I have followed two different but related directions, the first dealing with a linear system of relationships, the second with a square or quadratic system of relationships. Each investigation—linear and quadratic—has in turn taken two forms, an initial manifestation and a transformation of that manifestation. Although the transformation preserves the combinational relations developed initially, its manifestation has been dimensionally increased by a factor of one.

The works produced during the investigations were not subjected to any material or dimensional limitations and I have utilized a variety of materials and processes. However, the sets of possible combinations have, throughout the investigations, remained subject to two conditions. The first condition is that in each set there are four elements or a multiple based on four elements, which originally represented the four possible orientations of the square canvas but which evolved to represent a variety of visual elements. The second condition is that these elements combine in some way to produce a complete set or closed system of relationships, although the definition of closure for each set may vary. The specific image of the element plays a secondary role to its position as carrier for the overall structure of the system.

II. LINEAR INVESTIGATIONS

My linear investigations began with the diptych mentioned above. I coded the orientation of the canvas as follows: 1, 2, 3, 4 for the four sides on which the first square could be placed and 1′, 2′, 3′, 4′ for the four sides of the second. As a result, I could easily determine that the diptych produced the complete set or closed system of sixteen binary combinations: 1–1′, 1–2′, 1–3′, 1–4′, 2-1′, 2-2′, 2-3′, 2-4′, 3-1′, 3-2′, 3-3′, 3-4′, 4-1′, 4-2′, 4-3′, 4-4′. At the same time it also became evident that an identical set of combinations could be produced by utilizing a single image—from one of the canvases—as follows: 1-1, 1-2, 1-3, 1-4, 2-1, 2-2, 2-3, 2-4, 3-1, 3-2, 3-3, etc.

I thought I might further simplify things by stringing the combinations together in a line, rather

* Based on the thesis for a Master of Arts degree in the Department of Fine Arts, Louisiana State University, 1970.
**Artist living at 3865 Hyacinth Avenue, Baton Rouge, Louisiana 70803, U.S.A. (Received 26 March 1972.)

than thinking about them as discreet sets of two elements. One element would then relate to the element on either side of it. For example, the '1' in the middle of the string 1-1-2 is shared by the two sets 1-1 and 1-2. By stringing together the combinations so that all sixteen possible relationships were present, I produced one of many possible data lines: 1-1-2-2-3-3-4-4-2-1-3-2-4-3-1-4-1. I then repeated the line sixteen times, one under the other, to form a 'square'. In this way I produced the first matrix.

Any of several data lines could be used to develop a matrix. For instance, the data line 1-2-1-4-4-2-3-2-2-4-1-3-3-4-3-1 also fulfills the condition that all sixteen possible combinations be present. New conditions could be defined. Thus the condition that an element must relate to every other *excluding* itself would produce a data line exhibiting the twelve possible relationships: 1-2-3-4-2-1-3-2-4-3-1-4-1. In addition, simple rotational operations could be performed on the completed matrix to change its internal organization and therefore its configuration.

These cyclical permutation operations proceed as follows: for any line, all elements of that line move in unison one or more places in some direction. Elements pushed outside the large square move around the 'back' as if they were on a continuous band and come in to fill the place left open on the opposite side. For example, one might start relative to the bottom horizontal line of a 17 by 17 matrix and then make the following vertical axis permutation progression on the matrix: no moves (0), no moves (0), one place to the right (1R), two to the right (2R) . . . fifteen to the right (15R). The change in the total configuration of the matrix (in this case to a diagonal) produced by this permutation (listed to the right of the matrix below) is visually evident even in the numerical array:

```
2 2 3 3 4 4 2 1 3 2 4 3 1 4 1 1 1   15R
2 3 3 4 4 2 1 3 2 4 3 1 4 1 1 1 2   14R
3 3 4 4 2 1 3 2 4 3 1 4 1 1 1 2 2   13R
3 4 4 2 1 3 2 4 3 1 4 1 1 1 2 2 3   12R
4 4 2 1 3 2 4 3 1 4 1 1 1 2 2 3 3   11R
4 2 1 3 2 4 3 1 4 1 1 1 2 2 3 3 4   10R
2 1 3 2 4 3 1 4 1 1 1 2 2 3 3 4 4    9R
1 3 2 4 3 1 4 1 1 1 2 2 3 3 4 4 2    8R
3 2 4 3 1 4 1 1 1 2 2 3 3 4 4 2 1    7R
2 4 3 1 4 1 1 1 2 2 3 3 4 4 2 1 3    6R
4 3 1 4 1 1 1 2 2 3 3 4 4 2 1 3 2    5R
3 1 4 1 1 1 2 2 3 3 4 4 2 1 3 2 4    4R
1 4 1 1 1 2 2 3 3 4 4 2 1 3 2 4 3    3R
4 1 1 1 2 2 3 3 4 4 2 1 3 2 4 3 1    2R
1 1 1 2 2 3 3 4 4 2 1 3 2 4 3 1 4    1R
1 1 2 2 3 3 4 4 2 1 3 2 4 3 1 4 1    0
1 1 2 2 3 3 4 4 2 1 3 2 4 3 1 4 1    0
```

The possibilities seemed overwhelmingly numerous and quite impossible to research by hand. I decided to investigate the feasibility of using a computer to work out the matrices and, more importantly, to attempt to use computer graphics

Fig. 1. *'Computer Plot, II', IBM 360–65/Calcomp 750, 17 × 17 in, 1967–70.*

procedures to retranscribe the coded data back into its original visual form. This led me into some collaborative research with professionals in the computer programming field at the Louisiana State University Computer Center. Test programs to generate and permute the numerical matrices presented no problems on the IBM 1401 system but the first attempt toward a visual retranscription proved unsatisfactory. In the initial experiment, the different tonal densities of alphabetical and numerical characters (from a distance, a group of 'M's' appear darker than a group of 'I's') provided a very crude picture on the IBM 1403 line printer. I found this picture unusable, however, because the printer distorted the squares into rectangles and it was impossible to change its set of single-spacing within the line and double-spacing between the lines.

In the second and successful retranscription, I employed a piece of computer hardware specifically designed for visual output, the Calcomp 750 incremental plotter. This machine operates offline (i.e. not directly connected to the computer system), using programmed instructions and data via magnetic tape supplied by the main IBM 360-65 system. The plot program requires data for the images in numerical terms, in the form of x and y graph coordinates. For curves, a continuous line of coordinates must be hand or machine plotted; but for straight lines, such as may be used for shading, beginning and end coordinate points are sufficient. To control the orientation at which each image is reconstructed, a numerical matrix furnishes the second set of data required by the plot program.

The result of the linear investigations described above was a group of works plotted on the Calcomp 750 and utilizing 17 by 17 matrices. Figure 1 shows one of the works of the series, 'Computer Plot, II.' The 289 images which together form this plot have

been reconstructed using the permuted numerical matrix listed above.

III. TRANSFORMATION: "TORUS"

The 17 by 17 matrix of the computer plot series developed as a result of using a seventeen-element line that was necessary to produce the sixteen combinational relations required by the 'all sixteen possible' condition. In the 17 by 17 matrix, one of the four elements had to be repeated five times within each line, whereas the other three elements were repeated only four times within each line. In an effort to eliminate this 'inequity', I produced a work, the 'Torus' (Fig. 2), which manifests the identical combinational relations (i.e. 'all sixteen possible') exhibited in the 'Computer Plot, II' but which uses only sixteen elements, each element being repeated four times. The operation by which this was accomplished was suggested by the cyclical permutations performed on the matrices of the computer plot series. As I observed in describing the operation of the cyclical permutations above, one might view the elements of the matrix 'as if they were on a continuous band'. For the 'Torus' I 'bent' the original data line so as to make a closed circular form. This creates a connection and a relationship between the first and last elements of the line. The creation of this additional relationship made it possible to subtract one element from the data line—resulting in a 'line' of sixteen elements producing sixteen relationships.

If the bending operation is applied to the two-dimensional matrix, it may be performed on both axes. When the matrix is bent around the y-axis, the result is a cylinder; the bending operation performed on the x-axis joins the top and bottom of the cylinder. The result is a geometrical and dimensional transformation of the square matrix into a doughnut shape or torus.

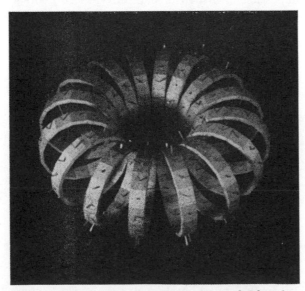

Fig. 2. *'Torus', wood, cadmium-plated steel, Plexiglas,* height 29 × diameter 36 in, 1969. (Collection of Don Nugent, Baton Rouge, La.)

The 'Torus' has been fabricated out of wood; each of the elements or facets had to be miter-cut on four sides in order that they might be assembled into the torus form. Instead of images on the surface of the facets, I utilized cadmium-plated square-cut flooring nails placed at right angles through the center of each facet, coding each one according to four different depths of penetration. A clear Plexiglas stand 'floats' the 'Torus' about 18 in. above floor level.

IV. QUADRATIC INVESTIGATIONS

Just as the diptych served as a point of departure for the linear investigations, another early work, 'Construct with 90° Elbow', provided the impetus for an investigation based on a square or quadratic system of relationships. The original visual element, a 90° elbow constructed within a square, was repeated four times to form a large square, with the four elbows oriented in such a way that together they formed a circular shape or movement within the large square. As with my early linear investigations, I was at first working intuitively and, although I knew that the four elements of the 2 by 2 matrix could be arranged in a variety of ways, I was not yet aware of the possibility of coding the material and systematically determining every combination. Thus, in the beginning, although there were numerous possibilities inherent in even so simple a matrix, I simply chose the combination with an obvious gestalt—the circle.

Upon further investigation, I realized that I could apply the orientation coding utilized in the linear investigations to the 90° elbow element. However, this should not obscure the essential difference between the linear investigations and this series of investigations, the quadratic, in which I concentrate on the matrix. While the linear investigations included matrices, they were line-generated and operations were always performed on them in terms of lines. By contrast, the quadratic investigations have dealt with the complete set of possible combinations of 1, 2, 3, 4 (i.e. elbow orientations) and all the relations between the four elements within the 2 by 2 *matrix as a whole*. The complete set of possible combinations resulting from these investigations numbers twenty-four:

| 1 2 | 1 3 | 1 4 | 1 3 | 1 2 | 1 4 |
| 4 3 | 2 4 | 3 2 | 4 2 | 3 4 | 2 3 |

| 2 3 | 3 4 | 4 2 | 4 1 | 3 1 | 2 1 |
| 1 4 | 1 2 | 1 3 | 2 3 | 4 2 | 3 4 |

| 4 1 | 2 1 | 3 1 | 3 2 | 2 4 | 4 3 |
| 3 2 | 4 3 | 2 4 | 1 4 | 1 3 | 1 2 |

| 3 4 | 4 2 | 2 3 | 2 4 | 4 3 | 3 2 |
| 2 1 | 3 1 | 4 1 | 3 1 | 2 1 | 4 1 |

A simulation of the corresponding set of elbow images is shown in Figure 3.

Since twenty-four items cannot be arranged in a square array, the twenty-four 2 by 2 numerical

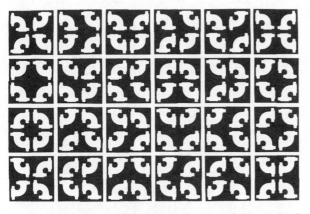

Fig. 3. *Simulation of the twenty-four possibilities of 90°
elbow images.*

matrices listed above and the corresponding elbow
images simulated in Figure 3 have been necessarily
arranged in an arbitrary rectangular array. A
significant manifestation seemed impossible to
achieve using a rectangular form, since conceptually
I was working with a quadratic theme and a square
form. But as in the case of the 'Torus' in the linear
investigations, the surface of a three-dimensional
form provided a solution to the problem. The
faces of four cubes, each having six sides, provided
the necessary twenty-four squares upon which to

display the elbow images; in addition, each face
retained its integrity as the image of a unique matrix
and the four cubes themselves comprised a set which
remained conceptually within the quadratic system.
The resulting manifestation, entitled 'Four-element
Matrix Configuration with 90° Elbows' is shown in
Figure 4.

The cubes for the 'Four-element Matrix Con-
figuration with 90° Elbows' were fabricated of clear
Plexiglas; a photographic silk screen process was
used to stencil the images onto the six faces of each
cube. The printed area bears a negative image of
four elbows and the inside of each elbow has been
left clear. By virtue of the resulting transparency,
the total image received from the 'Four-element
Configuration with 90° Elbows' includes not only
the image on the surface of one face of each cube but
also images from other faces seen through the
transparent elbows.

The four smaller screened cubes are arranged to
form a large cube in such a way that all six faces of
each cube may be viewed without interference.
Applying the quadratic concept to this arrangement,
it can be described as a three-dimensional matrix
(2 by 2 by 2), where any non-diagonal binary
relation within the matrix can be expressed as 0–1
or 1–0, where 1 represents one of the four cubes and
0 represents a negative space the size of one cube.

The large cube is 'suspended' over a solid base on
a transparent stand. The interlocking planes of the
stand describe a cube-form that is identical in size to
the large cube and that has two negative areas into
which are fitted two positive cubes of the large cube.
This effects an interpenetration between the large
cube and the stand, and provides the physical means
by which the individual cubes are presented as
described in the preceding paragraph.

V. TRANSFORMATION: "LIGHT CLOCK"

A kinetic art work that resulted from the quadratic
investigations, the 'Light Clock' (Fig. 5), manifests
the same quadratic combinations as 'Four-element
Matrix Configuration with 90° Elbows' but the
dimension of time has been introduced. The visual
element represented by 1, 2, 3, 4 is a different color
of light projected through a square translucent
surface. The complete set of twenty-four possible
quadratic combinations build one from the other by
means of axial transitions occurring within a visual
2 by 2 matrix. The complete set of possible com-
binations develops and recycles; the recycling
operation may be compared to the bending operation
performed in the development of the 'Torus'.

Figure 6 shows the complete program chart for the
'Light Clock': the twenty-four matrices are on the
far left; on the far right is the complete numerical
program listing of seventy-two displays, beginning
with the same full combination as shown in the matrix
on the left and followed by two interstitial displays;
the middle portion of the program chart shows
between which two small squares the axial transition
is taking place and the direction of the apparent

Fig. 4. *'Four-element Matrix Configuration with 90°
Elbows', screened Plexiglas,* height 19 × 12 × 12 in,
1969–70. (Collection of Louisiana State University
Union, Baton Rouge, La.)

Fig. 5. 'Light Clock', Plexiglas, wood, aluminum, incandescent bulbs, electrical components and 2 RPM motor, height 27 × 17 × 9¼ in, 1969–70.

Fig. 6. Program chart for 'Light Clock'.

motion. The operation of the 'Light Clock' is as follows: Between each of the twenty-four full combinational displays, the two interstitial displays appear; the interstitial displays have been programmed to read as cyclical permutations on the axes of the 2 by 2 matrix. From a full combination (completely colored 2 × 2 matrix), the color goes off in one of the four small squares (first interstitial display); the color from an adjoining square, on either the vertical or horizontal axis, moves into the darkened square—the illusion of movement is produced by turning the colored light on in the darkened square, while at the same time turning the same colored light off in the adjoining square (second interstitial display); the color that originally went off in the first square now reappears in the second square, completing the transition and displaying another full combination.

Mechanically, the 'Light Clock' is controlled by micro-switches which ride on circular cams notched to correspond to the program described above and shown in Figure 6. The cams were attached to a shaft which is rotated by a synchronous motor. As the cams turn, the switch arms fall into the depressions in the cams, each turning a corresponding colored light bulb on; then the switch arms ride up on the cams, turning the light bulbs off. Sixteen light bulbs, each controlled by a micro-switch, were needed so as to be able to illuminate, according to the program requirements, none or any one of the bulbs in each of four sections of a compartmentalized box. Each section of the box houses four different colored bulbs; the bulbs are of different wattages to ensure that all four colors of light illuminating the translucent surface are equally brilliant (i.e. the yellow and red bulbs needed only 15 W of illumination to equal the intensity of the 25 W green and 40 W blue bulbs). The compartmentalized wood box which houses the bulbs also has a section for the control system; this box fits into an exterior plastic casing. Five openings have been machined in the casing, four for the large square (the 2 by 2 matrix) which are backed with translucent Plexiglas and which the bulbs illuminate with colored light, and one at the bottom, backed with

clear Plexiglas, through which the machinery may be seen.

In operation, the full displays of the 'Light Clock' are 'on' three times as long as the interstitial displays. This internal timing rhythm, 3-1-1-3-1-1-3-1-1- etc., has been cut into the cams. The timing of the full program, however, is set by the RPM's of the cam shaft. This full-program timing must be fast enough to create a sense of movement and slow enough to allow the separate motions to be perceived. A variety of gears allows the machinery to operate at speeds ranging from 1 RPM (one minute for the full program cycle of seventy-two displays) to 4 RPM (1/4 minute for the full program cycle). Its present speed has been set empirically at 1.33 RPM.

VI. AN OBSERVATION

Reflecting on my preceding discussion of matrix configuration, I would like to point out that as linearity is a necessary consequence of verbal or written discourse as well as certain logical operations, there emerges an organization to the description of my investigations that is not quite correct. In each case I described the numerical–conceptual system first and the visual–physical system second. Also, although I tried to soft-pedal my words in these areas, many times it was necessary to describe the physical system as works 'manifesting', 'exhibiting' or 'resulting from' systems, as if fully developed conceptual systems existed prior to their 'physical' manifestations. I do not believe that this was actually the case. At least the relationship seemed one much more of reciprocity between alternate modes, the conceptual system being developed along with, interacting with but standing alongside, the physical system of the works.

I am expressing these ideas not for their own sake, as they involve various arguable aesthetic questions but rather in order to state that I personally find it necessary to work with both systems, since an exclusive concern for conceptual systems seems to me unrealistically abstract and an exclusive concern with a physical system seems simply unintelligible. In fact, it is not so much a matter of having worked with either system or with an interaction between the two but rather the act of having constantly tried to place myself at a point of intersection between the two 'alternate' modes which has been, for me, the real value of the whole investigation.

* * * * *

The author wishes to acknowledge the advice and assistance of the following members of the Louisiana State University community: Paul A. Dufour, Professor, Department of Fine Arts; John A. Hildebrant, Assistant Professor, and Charles Petrie, graduate student, in the Department of Mathematics; John A. Brewer, Assistant Professor of Engineering Graphics and Heinz Eichenseer, Associate, Physics Machine Shop.

GLOSSARY

ABSTRACT ALGEBRA *(in mathematics)*. The branch of mathematics that examines the methods of classical algebra in order to find the minimum number of algebraic properties that insure their success. The results of the examination are embodied in algebraic structures of which the number system is an example of one type.

ALGORITHM *(in mathematics)*. Some kind of special process of solving a certain type of problem, particularly a method that continually repeats some kind of basic process.

ALPHA BRAIN WAVES *(in physiology)*. Rhythmic changes of electric potential of the brain that can be recorded from the skull by means of an *electroencephalograph*. These waves occur during the normal conscious state of the brain and range from 8 to 12 cycles per second. Under stimulation, for example by flashing lights on the retina, the number of cycles per second can range from 4 to 60.

ANALOG COMPUTER *(in computer technique)*. A computer which represents variables and constants by physical analogies. Thus, any computer which solves problems by translating physical conditions such as flow, temperature, pressure, angular position or voltage into related mechanical or electrical quantities and uses mechanical or electrical equivalent circuits as an analog for the physical phenomenon being investigated. In general, it is a computer that uses an analog for each factor and produces analogs as output. Thus, an analog computer measures continuously whereas a digital computer counts discretely.

ANTICLINE *(in geology)*. A folded rock structure of arch-like form.

ART 1 **COMPUTER PROGRAM** *(in computer technique)*. A program specially prepared for artists to enable them to use I.B.M. computer equipment for making graphic art. It is in the FORTRAN IV language and was developed at the Department of Electrical Engineering and Computer Science at the University of New Mexico, Albuquerque, N.M. 87106, U.S.A.

ART 2 **COMPUTER PROGRAM** *(in computer technique)*. A modification of the ART 1 *computer program* that permits shading on a digital computer drawing by the single over-printing of characters.

ARTICULATED SPACE. A surface containing markings or a volume containing solid elements, as opposed to a blank surface or an empty volume.

ASYMMETRIC GRAPH *(in mathematics)*. A graph without symmetry, in that it has no other automorphism than the identity automorphism. The identity automorphism group of order 1 is the group for which points can be permuted only on to themselves.

ASYMPTOTE. A straight line that gets nearer and nearer to a curved line without ever meeting it.

AUTOMATA THEORY *(in mathematics and cybernetics)*. The theory concerned with deterministic systems and machines to which probability notions do not apply; in particular, with what kinds of behaviour can and cannot, in principle, be achieved by different kinds of systems.

AUTOMORPHISM GROUP *(in mathematics)*. The group of permutations on the set of vertices in a graph that preserves the adjacency relation.

BANDWIDTH *(in electronics)*. The range of frequencies within which the performance of a circuit, receiver or amplifier does not differ from its maximum value by more than a specified amount.

BATCH-PROCESSING *(in computer technique)*. A method of computer operation in which complete programs and related data are processed without external interaction, so that one batch may follow another at the computer's speed.

BEHAVIOURAL STRUCTURE. An art object that undergoes changes with time in accordance with built-in controls or external stimuli.

BINARY UNIT. See *Bit*.

BIT *(in information theory)*. The term is an acronym for binary digit. It is a measure of the amount of information using a two-fold choice as the elementary unit.

CALCULUS *(in mathematics)*. A branch of mathematics that deals with differentiation and integration of functions. It is applied to problems involving changes in continually varying quantities, for example, those of velocity, rate of chemical reaction, slope of a curve, etc.

CARTESIAN CHART *(in mathematics)*. A rectangular planar grid based on two perpendicularly intersecting axes, an x axis (horizontal) and a y axis (vertical).

CATHODE-RAY TUBE (CRT) *(in computer technique)*. An electronic device in which electrons strike a phosphor screen to produce a visible trace, as in television and in the oscilloscope.

CELL *(in mathematics, Graph Theory)*. A term denoting regions in a graph surrounded by a closed circuit and the region surrounding a graph.

CENTRAL PROCESSOR UNIT (CP) *(in computer technique)*. The part of a computer that acts as its 'brain'. It executes all logical operations required by the program and directs information to other components of the computer.

CHANNEL *(in electrical communication)*. A path for the transmission of electrical signals, often specified by its frequency band.

COEFFICIENT *(in mathematics)*. A number or letter put before an algebraic expression and multiplying it.

COGNITIVE MAPS. A term used to describe mental constructs of ideas.

COMBINATORIAL. Relating to any ordered sequence.

COMPUTER. A device capable of accepting information, applying prescribed processes to the information and supplying the results of these processes. It usually consists of input and output devices, storage, arithmetic and logical units, and a control unit.

COMPUTER ART. The output of a general purpose computer classified as art. It may be hard-copy, drawings from a plotter, black and white or color kinetic images on a television-type screen or pictures thereof, resulting from a program supplied to the computer.

COMPUTER DRAWING. A specific image prepared by a computer output device, usually drawn by a plotter but also includes drawings on phosphors, film or materials using special line-printing techniques.

COMPUTER GRAPHICS. A term designating anything relating to the pictorial output of a computer. It covers programming techniques, plotting, displaying, filming and other active output forms.

COMPUTER MEMORY *(in computer technique)*. A component containing registers in which units of information can be stored in machine language for future use.

CONDITIONAL STATEMENT *(in computer technique)*. A statement in a computer program offering a choice of alternatives in the processing, for example, *if* that is so, *then* do this or *else* do something other.

CYBERNETICS. The science that treats of the principles underlying the maintenance of a predetermined course (guidance) or of a specified parameter (regulation) in machines, organisms, society, etc. The phenomenon of negative feed-back is used to obtain control.

CYBERNETIC ART MATRIX (CAM). A term coined by R. Ascott to designate his proposal for a cybernetic system designed as a social instrument to generate, sustain and develop creative art within a community.

DISPLEGABLES *(in visual art)*. Term used by E.C.G. Sebastian for small sculptures that he has made of folded paper and cardboard.

DIGITAL COMPUTER *(in computer technique)*. A computer that processes information represented by combinations of discrete or discontinuous data, as compared with an analog computer for continuous data. More specifically, it is a device for performing sequences of arithmetic and logical operations, not only on data but on its own program. Still more specifically, it is a stored program computer capable of performing sequences of internally stored instructions, as opposed to calculators, such as card programmed calculators on which the sequence is impressed manually.

DYNAMIC-INTERACTIVE ART SYSTEM; INTERACTIVE ART SYSTEM. An art system or situation necessarily including an art work and its viewer, but not its maker, in which the art work receives and responds to an input from the viewer.

DYNAMIC-PASSIVE ART SYSTEM; DYNAMIC ART SYSTEM. An art system or situation necessarily including an art work and its viewer, but not its maker, in which the art work undergoes changes with time according to the artist's intentions or program, for example, a mobile or a kinetic art object.

ENTROPY *(in physics and chemistry)*. In a closed thermodynamic system, the measure of the amount of heat energy in it that is unavailable for conversion into mechanical work. It is a measure of the disorder in the system. The concept of entropy is employed in an analogous sense in information theory denoting the amount of information measured in bits.

EXPONENT *(in mathematics)*. *See Exponential.*

EXPONENTIAL *(in mathematics)*. Expressible or approximately expressible by an equation of the form $y = a^x$, where a is a constant and x is its variable exponent.

FACTOR OF A POLYNOMIAL *(in mathematics)*. One of two or more polynomials whose product is the given polynomial.

FEED-BACK *(negative)*. A universal phenomenon in both man-made and natural systems whereby a small part of the output of a system is used to control the input.

FIELD *(in mathematics)*. A generalization of a number system studied in abstract algebra. A field is an algebraic structure or set for which, between any two elements a and b, two operations are defined and possess specific properties.

FINITE FIELD *(in mathematics)*. A field having a finite number of elements.

FORMAL TOPOLOGICAL IMAGE *(in mathematics, Graph Theory)*. A term coined by Anthony Hill to denote a graph drawn in such a manner as to visually emphasize structure. A containing circuit would be drawn in the form of a circle. Other lines would be drawn straight and of equal length, whenever possible, and distributed with the greatest possible symmetry.

FUNGOID SYSTEMS. A term coined by S. Beer for computers invested with the properties of growth.

GALOIS FIELD *(in mathematics)*. For a polynomial p with coefficients in a field F, the Galois field GF of p relative to F is the smallest field that contains F and has the property that p can be factored into linear factors.

GARBAGE *(slang, in computer technique)*. A useless output of a computer because the machine is faulty or it has received faulty data or programs of instructions.

GAUSSIAN LAW *(in mathematics)*. A continuous distribution having a particular probability density function that characterizes certain situations or phenomena involving large numbers of independent random variables. (Sometimes called *normal law* or *normal probability law*.)

GENERAL SYSTEM THEORY *(in science and technology)*. Term for theoretical systems that are applicable to more than one of the traditional domains of knowledge.

GEOMETRIC NUMBER *(in mathematics)*. A value or ratio that can be derived by geometry from an integer or a number that is a root of a polynomial equation with rational coefficients. It is also called an algabreic number.

GRAPH *(in mathematics, Graph Theory)*. An abstract structure interpreted in the form of lines and points.

 (a) ELASTIC NETWORK. A structure or graph that can be given innumerable forms through continuous change. It can be visualized as being made of elastic threads and held together by knots (nodal points) that slide freely.

 (b) HOMEOMORPHICALLY IRREDUCIBLE GRAPH or TOPOLOGICAL GRAPH. A graph that has no points of degree two.

 (c) LATTICE NETWORK. A rectangular graph without any terminal points.

 (d) POINT-REGULAR NETWORK. A graph for which all points are of the same degree, that is, the same number of lines emanate from each point.

 (e) POLYHEDRAL NETWORK. A three-dimensional network in which each cell is made up of at least three lines and each line belongs to two and only two cells.

GRAPH THEORY *(in mathematics)*. The theory of arbitrary relations.

HAPPENING. A form of spectacle, apparently aimless and pointless, which relies heavily on improvisation and that may include spectator participation. The object of a *Happening* is to stimulate spectator responses by means of bizzare or provocative actions. (*Happenings* stem from the Dada and Surrealist traditions).

HARDWARE *(in engineering)*. The physical components of a vehicle, such as a spacecraft or of a machine, such as a computer.

HARMONIC MOTION. A periodic motion that has a single frequency or amplitude (as of a sounding violin string or swinging pendulum) or a vibratory motion that is composed of two or more such simple periodic motions.

HOMOGENOUS SPACE. An *articulated* surface or volume having the property of containing parts all of a uniform kind. A blank surface or an empty volume are also *homogenous*. (See *Articulated Space*.)

HYBRID. The term used by the artist J. W. Davis to denote a combination of disparate or analogous elements making up an art work.

HYPERBOLIC CURVE. The graph of $\frac{x^2}{a^2} - \frac{y^2}{b^2} = 1$. The hyperbola is symmetric about the $x-$ and $y-$ axes and cuts the x-axis in the points whose coordinates are *(a,0)* and *(−a,0)*.

INFORMATION THEORY, COMMUNICATION THEORY. A branch of mathematics applied to the study of the characteristics, properties and functions of any signal system designed to transmit information in the presence of extraneous disturbances, with special emphasis on the number of bits of information that can be sent in a given time by means of a particular system.

INPUT *(in computer technique)*. Information and instructions in the form of data and programs on, for example, magnetic tapes or punched cards for directing the operations of a computer.

IRRATIONAL NUMBER *(in mathematics)*. A number that cannot be expressed as an integer or the quotient of integers, as $\sqrt{2}$ and π.

LIGHT PEN *(in computer technique)*. A photosensitive pen-like device for interacting with a cathode-ray tube display. Lines may be drawn or moved or commands may be generated by pointing at displayed images.

LINE PRINTER *(in computer technique)*. A high-speed printing device guided by the output of a computer that can print an entire line of characters simultaneously.

MAGNETIC TAPE *(in computer technique, etc.)*. A thin ribbon of paper or plastic one side of which is coated with particles of iron oxide that form magnetic patterns corresponding to the electro-magnetic impulses of a tape recorder.

MATHESIS. A mental discipline, especially mathematics, that includes all the pure 'structures' of thinking.

MATRIX. A term denoting that which contains and gives shape or form to anything. *(In mathematics)*. A rectangular array of symbols or terms to facilitate the study of relationships.

METRONOME. A pendulum-type device designed to mark time intervals by a regularly repeated tick. It is especially used in music.

MICROSWITCH *(in physics)*. A small, highly sensitive electrical switch.

MÖBIUS STRIP *(in mathematics)*. The one-sided surface formed by taking a long rectangular strip of paper and pasting its two ends together after giving the strip half a twist.

MODULO *(in mathematics)*. A preposition usually used in the phrase 'congruence modulo *p*', which states that two elements are equivalent if and only if their difference is divisible by *p* (a number or a polynomial).

NETWORK. See *Graph*.

NODAL POINT. See *Point* (b), below.

NORMAL FREQUENCY CURVE *(in mathematics)*. A symmetrical bell-shaped curve or graph of the normal frequency function (sometimes called *normal* or *probability density function*) of the continuous random variable *x*. The probability of *x* having a value between any two numbers can be determined from this function or its curve. (Sometimes called *error curve* or *normal distribution curve* or *probability curve*).

NORMAL PROBABILITY LAW. See *Gaussian Law*.

NUMERICAL ART *(in visual art)*. Term employed by R. Kostelanetz for graphic works in which printed numbers are positioned in various ways to convey a 'meaning' though not exclusively in terms of numbers.

OFF-LINE *(in computer technique)*. Descriptive of a system and of the peripheral equipment or devices in a system in which the operation of the peripheral equipment is not under the control of the central processing unit.

ON-LINE *(in computer technique)*. Descriptive of a system and of the peripheral equipment or devices in a system in which the operation of such equipment is under the control of the central processing unit and in which information reflecting current activity is introduced into the data processing system as soon as it occurs.

OP ART. A form of visual fine art in which an object (usually consisting of clearly defined geometrical figures) is designed so as to produce a strong visual effect. The means for producing the effect may be simultaneous contrast, visual illusionary devices (including moiré), metallic reflections etc.

OPTICAL BENCH *(in physics)*. An apparatus formed of a long straight rail, or two like parallel structures, on which light sources and optical devices may be precisely located for testing and for the demonstration and measurement of optical phenomena.

OUTPUT *(in computer technique)*. The results of processing data according to a program supplied (input) to a computer, usually in the form of graphs and tables in printed form or on magnetic tape.

PARAMETER. A constant in a relation between variables, which is not irrevocably fixed, but, by its assumption of different values, makes the relation into a system or family of relations.

PHOTOMECHANIC TRANSFORMATION *(in photography)*. A term introduced by H. Gravenhorst for the process of making positive photographic prints of distinct superimposed images in black and white or in color. Precise superposition is accomplished by projecting light through two negatives, of which the first is fixed and the second is mounted on a table whose surface can be precisely positioned by translational and rotational adjustments.

PHOTOOPTIC TRANSFORMATION *(in photography)*. The process of making positive photographic prints of blended superimposed images in black and white or in color. Light projected through one negative is diffracted before impinging on the second negative that is mounted on a table whose surface can be precisely positioned by rotational or by translational adjustments.

PI *(in mathematics)*. The Greek letter π (pi), a symbol denoting the ratio of the circumference of a circle to its diameter and the ratio of its area to the square of its radius; $\pi = 3.14159+$.

PLOTTER *(in computer technique)*. An instrument provided with a pen to plot points or to draw lines on paper guided by the output of a computer.

POINT *(in mathematics, Graph Theory)*.

(a) ARBITRARY POINT. A point from which emanate only two lines (point of degree two).

(b) NODAL POINT. A point from which emanate three or more lines (point of degree three or more).

(c) TERMINAL POINT. A point from which emanates only one line (point of degree one).

POINT-REGULAR NETWORK. *See* Graph.

POLYHEDRAL NETWORK. *See* Graph (e), above.

POLYNOMIAL *(in mathematics)*. A sum of two or more algebraic terms each of which consists of a constant multiplied by one or more variables raised to a nonnegative integral power, e.g. $a + bx + cx^2$.

PRIME NUMBER *(in mathematics)*. A whole number that is divisible without remainder by no whole number except itself and one.

PRINTOUT *(in computer technique)*. A printed record produced automatically by a computer.

PROBABILITY *(in mathematics)*. Let n be the number of exhaustive and equally likely cases of an event under a given set of conditions. If m of these cases are known as the event A, then the *probability* of event A is m/n. For example, if one ball is to be drawn from a bag containing two white balls and three red balls, and each ball is equally likely to be drawn, then the probability of drawing a white ball is 2/5 and the probability of drawing a red ball is 3/5.

PROCESS or PROCESS-ORIENTED ART. A course or method of operations in the production of something.

PROJECTIVE GEOMETRY *(in mathematics)*. The study of those properties of geometric configurations that are invariant under projection.

QUADRANT *(in mathematics)*. A quarter of a circle or of a circular body, namely: (a) an arc of a circle, forming one-fourth of the circumference and (b) one-fourth of the area of a circle, contained within two radii at right angles.

QUADRATIC *(in mathematics)*. Pertaining to a square; an equation of the second degree.

RANDOM. A process without any definite aim, direction, rule or method.

RAND TABLET *(in computer technique)*. A surface on which each point located under the tip of a special pen may be accurately sensed by a computer.

REAL-TIME PROCESSING *(in computer technique)*. A method of computer operation in which the results of the operation on data are available as the data is being produced. For example, one sees displayed a drawing being formed at the same time as the input of points is made. This technique is useful when human decisions are required during the processing of the program before final results are obtained.

REDUNDANCY *(in information theory)*. A deliberate repetition in a message, in whatever medium expressed, in order to lessen the possibility of error.

SCHLEGEL DIAGRAM. A diagram or graph made by projecting a simply connected polyhedron on to any one of its faces.

SIGNAL-TO-NOISE RATIO *(in information theory)*. The ratio of the desired signal energy level to the energy level of the interfering noise.

SINE CURVE. The graph of $y = \sin x$. The curve passes through the origin and all points on the x-axis whose abscissae are multiples of π, is concave towards the x-axis and the greatest distance from the x-axis to the curve is unity.

SKETCHPAD *(in computer technique)*. A technique of manipulating drawn elements on a computer output display

to permit computer aided design. Relationships between elements can be developed as a design is being produced on the display.

SOFTWARE *(in engineering)*. The features of a machine that are not hardware, such as the program for a computer.

STATIC ART SYSTEM. An art system or situation necessarily including an art work and its viewer, but not its maker, in which the art work undergoes no changes with time intended by the artist, for example, a traditional art object, such as a painting or sculpture.

STATISTICAL SHADING *(in computer technique)*. The shading of a digital computer drawing resulting from the use of the *ART 2 computer program*. Different values are obtained by the single overprinting of different characters. The desired value gradient, characterized by a mathematical function varying between 0 and 1. If the random number exceeds that of the function at the point in question, then the computer overprints; if not, then it does not.

STOCHASTIC PAINTING. A term used by F. L. Whipple for paintings in which the designs, the distributions of colour and, possibly, the colour selections are made by chance, following a predetermined methodology or set of rules for making use of the chance factor.

STORAGE TUBE *(in computer technique)*. A monochromatic cathode-ray tube that retains an image until an erase instruction is given.

SYNCLINE CURVE *(in geology)*. A folded rock structure of an upside-down arch-like form.

SYSTEM *(in art)*. An orderly combination or arrangement of parts or elements for producing an art object.

TEMPERED SCALE *(in music)*. A musical scale that is adjusted in pitch to some mean temperament.

TENSEGRITY. A term coined by R. B. Fuller by contraction of the words *tensional* and *integrity* to describe a structure the shape of which is guaranteed by the tensional behaviour of the system and not by its compressional behaviour.

TORUS *(in mathematics)*. A surface or solid generated by the revolution of a circle or other conic section about an axis; for example, a solid ring of circular or elliptic section.

TRAJECTORY or CIRCUIT *(in mathematics, Graph Theory)*. Terms referring to the traversability of a graph or network wherein each line is traced once and only once.

TRANSCENDENTAL NUMBER *(in mathematics)*. A number that is not a root of any equation whose coefficients are integers (positive or negative whole numbers or zero). Examples of transcendental numbers are π, e and the trigonometric functions.

TRANSFORMABLE. A fine-art object made with the artist's intent that it be changed by the beholder.

TREE *(in mathematics, Graph Theory)*. A term denoting a connected graph with no cycle.

TROCHOID. The curve made by any point on the edge of a circle rolling like a wheel.

VECTOR *(in physics)*. A line representing a physical quantity that has magnitude and direction in space, as velocity, acceleration or force.

WAND *(in computer technique)*. A device that makes it possible to read as an input to a computer the three dimensions of a point in space.

WHITE NOISE *(in electronics)*. Electronic noise having a wide frequency range.

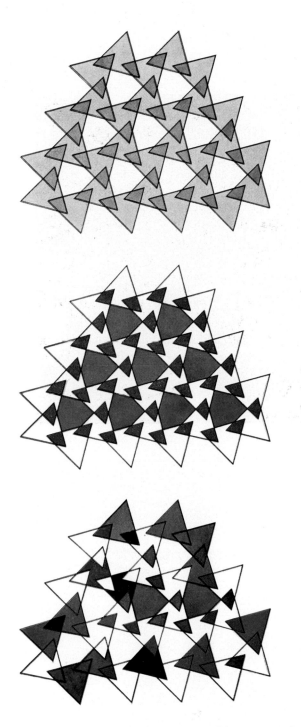

A. 'Gebonden Vrijheid' (Disciplined Freedom). Designed by A. L. Loeb and executed by Jean Hasch in 1971. (Fig. 11, cf. page 11)

B. *Ludmila Kodratoff. 'Jungerer Klang', oil on canvas,* 82 × 65 cm, 1971.
(Fig. 5, cf. page 107)

C. **Roy Ascott**. *'Inclusion', polymer = stained wood,* 72 × 50 in, 1966. (Photo: Roy Benson)
(Fig. 5, cf. page 140)

D. *Crockett Johnson. 'Division of a One-by-Two Rectangle by Conic Rectangles', oil on pressed wood*, 41 × 24 in, 1970. (Photo: J. Curtis, Norwalk, Conn., U.S.A.) (Fig. 8, cf. page 146)

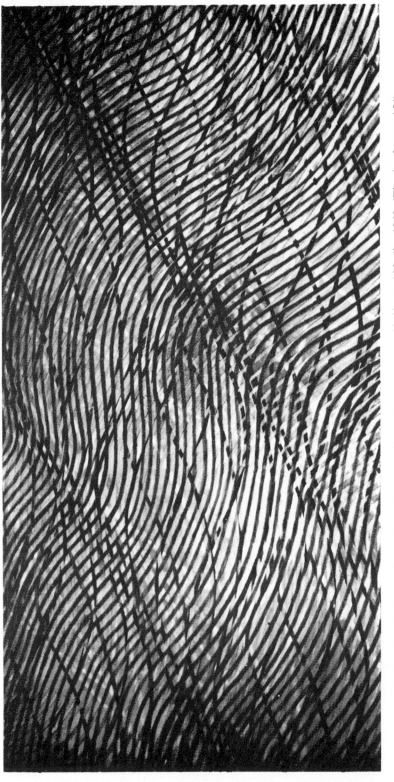

E. *Stanley W. Hayter. 'Transformations', acrylic painting on canvas, 6ft 8in × 13ft 4in, 1968. (Fig. 1, cf. page 154)*

F. *James W. Davis. 'Morphological Groupings in a Box', pencil and ink,*
56 × 51 cm, 1970. (Fig. 5, cf. page 158)

Fred L. Whipple
Leonardo **1,** 81 (1968)

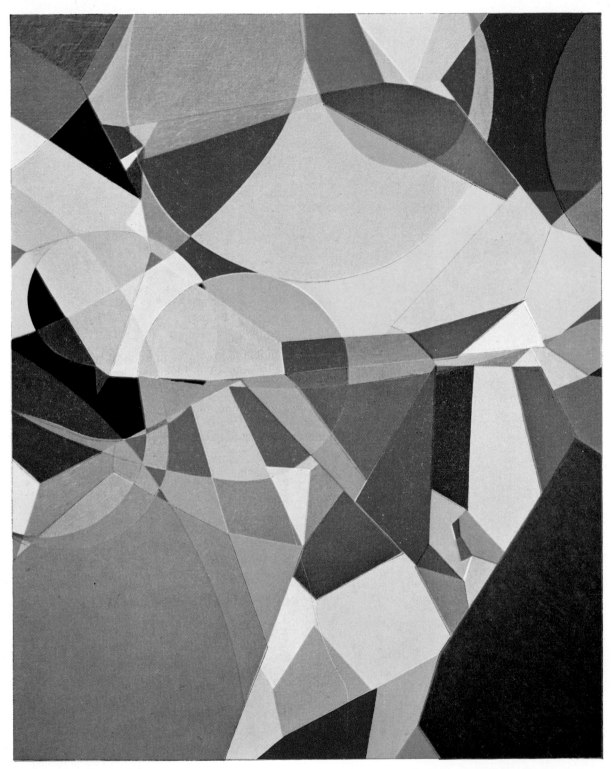

G. *Fred L. Whipple. 'Clarissa', stochastic* painting, 30 × 24 in, 1966. (Fig. 3, cf. page 179)

H. *Daniel E. Noble. 'The Mind-Extender', relief painting, fiberglass/acrylic caulking compound and acrylic paint, Masonite panel,* 48 × 36 in, 1973. (Photo: L. Zbiegien, Phoenix, Ariz., U.S.A.)
(Fig. 2, cf. page 185)

I. *H. P. Nightingale. 'Family of Hexagons', crayon,* 11 × 15 in., 1955. (Collection of H.
levy, Wimbledon, England.) (Fig. 5, cf. page 201)

H. W. Franke
Leonardo **4,** 331 (1971)

J. A. Lecci. 'Lattice', 1969 (at top). Produced by a program of stereometric images of hexahedral lattices that can be rotated in space. Lattice nodes may be connected in different ways and their density inside the framework can also be controlled.

'Shift', 1970, (at bottom). Produced by a program, starting from a static two-dimensional linear pattern, that through the progressive displacement of a focal point in the pattern itself leads to a series of related images, each of which is a mapping of the original displacement. Different linear densities are caused in certain regions of the image with a corresponding simulated effect of three dimensions.

Both pictures made with an IBM 7090 computer and a 29 in. Calcomp 563 plotter at the Centro Nazionale Universitario di Calculo Elettronico, Pisa, Italy. The programming language was Fortran IV, (Fig. 8, cf. page 238)

Richard I. Land
Leonardo **2,** 335 (1969)

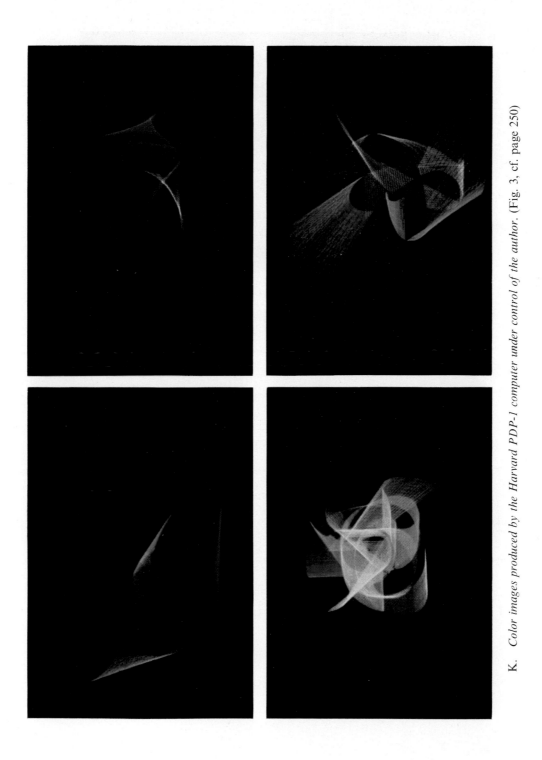

K. *Color images produced by the Harvard PDP-1 computer under control of the author.* (Fig. 3, cf. page 250)

Vladimir Bonačić
Leonardo **7,** 193 (1974)

L. *Vladimir Bonačić. View of part of a pattern generated by 'Dynamic Object GF.E (16, 4)
69/71', flashing lights controlled by a computer program,* 178 × 178 × 20 *cm.,* 1969–71. *(Fig. 6, cf.
page* 255)

Zdeněk Sýkora and Jaroslav Blažek
Leonardo **3,** 409 (1970)

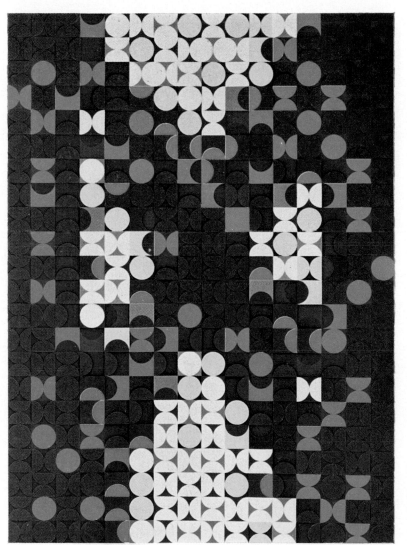

M. *Zdeněk Sýkora. 'Multi-colored Structure', oil on canvas,* 200 × 160 cm., 1969 (Fig. 7, cf. page 265)

Colette S. Bangert and Charles J. Bangert
Leonardo **7,** 289 (1974)

N. *Colette S. Bangert. 'Grassland, June' (series), handmade drawing, acrylic paint on
paper board,* **40** × **90** in., (Fig. 9, cf. page 272)

O. *Vera Molnar. 'Blue and Brown', polyvinyl emulsion paint on canvas, based on a computer drawing*, 110 × 110 cm, 1974. (Fig. 5, cf. page 278)

Ruth Leavitt and Jay Leavitt
Leonardo **9,** 99 (1976)

P. *Ruth Leavitt. 'Prismatic Variation, II', serigraph,* 29 × 23 in, 1974. (Fig. 5, Page 282)

Q. *Ernest Edmonds. 'Nineteen', mixed media,* 170 × 135 × 15 cm, 1968/69.
(*Fig.* 2, cf. page 290)

INDEX

A

Aesthetics xi, 78, 93, 167, 190, 205, 267, 274
 —algorithmic systems 93, 101
 —and computers 3, 8
 —cybernetic theory of 236
 —experimental 180
 —factors 104
 —informational 236
 —scientific theory of xi, 3, 27, 29, 30
 —statistical 235
 —tree patterns, graph theory 51
Alberti, L. 163
Alexander, Christopher 214
Algebraic theory of groups 170
Algorithm 8, 22
 —and aesthetic systems 93, 101
Alloway, Lawrence 162
Alpha brain waves 254
Alsleben, Kurd 237
Andre, Carl 35, 165
Anticline 155
Apter, Michael J. 18-26, 85-89, 228
Arakawa, Shusaku 164
Architectonics 43
Arnheim, Rudolph 31, 37, 40-42
Art, visual; see also computer art
 —abstraction 207
 —appreciation 85
 —as computer program 86
 —criticism 3
 —Constructivism xi
 —Cubism xii
 —definition and function of 4, 28, 188, 235
 —De Stijl group xiii
 —dynamic-interactive art system 289
 —dynamic-passive art system 289
 —figurative, pictorial 126, 180
 —futurists xii
 —Impressionism xii
 —kinetic 6, 91, 216, 243, 253, 292
 —machine produced (non computer) 24, 243
 —mathematical xi
 —Minimal 35, 182
 —module, use of 6, 109, 177
 —non-figurative or abstract (non computer) xii, 5, 35, 37, 40, 43, 48, 51, 61, 135, 143, 148, 154, 158, 167, 177, 188, 197, 202, 205, 215, 225, 227
 —constructions 135, 148, 202, 205, 215, 225, 227
 —pictorial 143, 154, 158, 167, 177, 188, 197, 202, 267
 —sculptural 215, 225, 227
 —numerical 197
 —Op art 164, 205, 236
 —process or system 104, 135, 167, 180, 216, 287
 —quantity production of 4, 91
 —semantic aspect of 87, 95, 101
 —structure 5, 12, 14, 32, 37, 40, 43, 163, 167, 188, 205, 225, 227
 —syntactic aspect of 79

Arp, Hans xii
Articulated space 207
Ascott, Roy 135-142, 288
Asymmetry; see symmetry
Automata theory 21, 228
Axonometrics 43, 57

B

Baird, John 12
Baljeu, Joost 196
Bangert, Charles, J. 266-273, 276, 279
Bangert, Colette, S. 266-273, 276, 279
Barbadillo, Manuel 109, 117, 130, 238
Barnhard, W. Darby 164, 289
Bartlett, F. C. 88
Bartók, Béla xii
Beckman, O. 130, 238
Beer, Stafford 12
Behavioural structure 137
Bense, Max xi, 236
Bergson, Henri 136
Berlyne, D. E. 87
Bernays, Paul 148, 189
Bertelanffy, L. von xi
Bill, Max xii
Binary unit (bit); see computer digital
Bionics 23
Birkhoff, G. D. xi
Blažek, Jaroslav 261-265, 276
Bonačić, Vladimir 253-260
Bouleau, Charles 196
Bourbaki, N. 148
Brouwer, Luitzen E. J. xi
Brown, Hilton 162
Burnham, Jack 162, 288

C

Cage, John 202
Carleton, David L. 48-50
Cathode ray tube (CRT); see computer digital
Challinor, Michael 167-176
Chandrasekaran, B. 126-129
Chirality 14-17
Chomsky, Naum 86, 151
Cinema
 —animated production by computer 237
Claus, Jurgen 226
Cohen, Dan 250
Cohen, Morris 212
Coleridge, Samuel Taylor 205
Color 3, 6, 77, 85, 90, 93, 101, 104, 109, 235
 —computer outputs 247
 —color-stereo display 243
Combinatorics; see mathematics
Communications theory; see information theory
Computer
 —analog 239, 243
 —digital; see also computer art
 —batch processing 245
 —binary unit (bit) 169, 270
 —cathode ray tube (CRT) 91, 126, 246, 276
 —central processor unit (CP) 248
 —conditional statement 245
 —feedback 19, 21, 136, 176, 254
 —garbage 245
 —graphics combined with photographic technique 130
 —hardware 245, 293
 —heuristic programming 23, 254
 —input 244